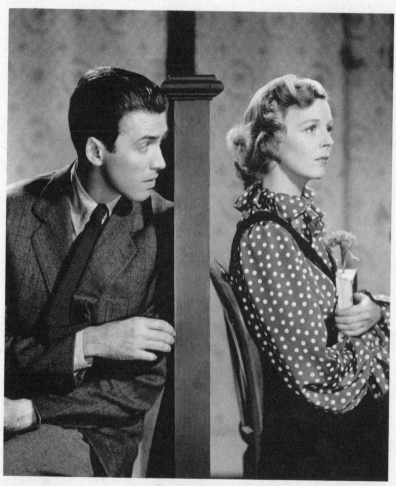

You have to see—James Stewart and Margaret Sullavan in Ernst Lubitsch's *The Shop Around the Corner*

ALSO BY DAVID THOMSON

DAVID THOMSON
THE BIG SCREEN

David Thomson, renowned as one of the great living authorities on the movies, is the author of *The New Biographical Dictionary of Film*, now in its fifth edition. His recent books include a biography of Nicole Kidman and *The Whole Equation: A History of Hollywood*. Thomson's latest work is the acclaimed *"Have You Seen . . . ?": A Personal Introduction to 1,000 Films*. Born in London in 1941, he now lives in San Francisco.

THE
BIG SCREEN

THE STORY OF THE MOVIES

DAVID THOMSON

FARRAR, STRAUS AND GIROUX NEW YORK

Farrar, Straus and Giroux
18 West 18th Street, New York 10011

Copyright © 2012 by David Thomson
All rights reserved
Printed in the United States of America
Published in 2012 by Farrar, Straus and Giroux
First paperback edition, 2013

Grateful acknowledgment is made for permission to reprint excerpts from the following previously published material: *Ragtime* by E. L. Doctorow, copyright © 1974, 1975 by E. L. Doctorow, used by permission of Random House, Inc.; *Empire of the Sun* by J. G. Ballard, copyright © 1984 by J. G. Ballard, used by permission of Simon and Schuster, Inc.

The Library of Congress has cataloged the hardcover edition as follows:
Thomson, David, 1941–
 The big screen : the story of the movies / David Thomson. — 1st ed.
 p. cm.
 Includes bibliographical references and index.
 ISBN 978-0-374-19189-4 (alk. paper)
 1. Motion pictures—Social aspects—United States. 2. Motion pictures—United States—History. I. Title.

PN1993.5.U6 T463 2012
791.430973—dc23

2012009140

Paperback ISBN: 978-0-374-53413-4

Designed by Jonathan D. Lippincott

www.fsgbooks.com
www.twitter.com/fsgbooks • www.facebook.com/fsgbooks

1 2 3 4 5 6 7 8 9 10

A NOTE ON THE ILLUSTRATIONS

The Eadweard Muybridge series on page 1 was provided by Lucy Gray and is used with her permission and that of Dover Publications. The *Passion of Joan of Arc* image on page 13 of the photo insert is used by permission of the Corbis Collection. All other images are used by permission of the Kobal Collection.

Title-page spread: William Holden and Gloria Swanson in *Sunset Blvd.*

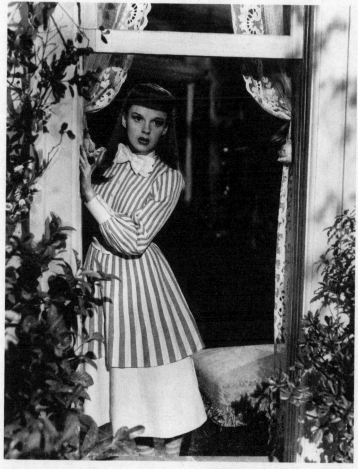

Judy Garland in *Meet Me in St. Louis*

CONTENTS

THE BIG SCREEN

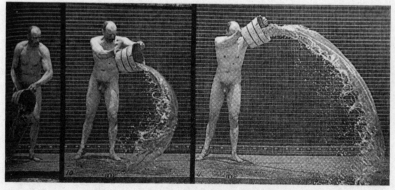

Eadweard Muybridge, splash!, a sequence from 1887

THE BIG SCREEN

PROLOGUE: LET THERE BE LIGHT

As I was writing this book, and trying to discover what it was about, I found myself muttering to friends, "Well, it's a history, I suppose." "Oh, a history of the whole thing," they said, "how nice." But when we pursued the matter, I tried to explain that "the whole thing" had to be more than Méliès to *Melancholia*—"it's Muybridge to Facebook," I said before I had entirely settled on that. I always knew it was a book about screens. Whereas the patrons of movie houses had once gazed at the imagery, the moving photography, the story, it was clearer now that we citizens are living with screens even if we don't go to "the movies" or really concentrate on the screens. The screens then and now are alike, but they were big once, as large as buildings, and now they may be thumbnail size—yet they are vast in their ubiquity and their constant use. They make a taunting offer of reality, but I wonder if that isn't a way of keeping us out of it.

This is a time for such a history, in which proper celebration is mixed with skepticism and some regret. Film as a commodity is going out of use; that thrilling name "Kodak" is passing away (it turns out Kodak was only a moment); and the 2012 revival of Abel Gance's *Napoléon*, as full as it could be at five and a half hours, may have been the last chance to see that passionate work as film. Moviegoing does not quite exist anymore as a consuming public preoccupation, no matter that the media and the Academy cling to the old notion. The technologies are carrying us forward so rapidly we become giddy with change—the motion smothers emotion.

I have sometimes wondered at the drastic changes that could occur between the writing and the publication of this book—not least at the continuing advance in the habit of reading a book on a screen. (Why not, if that's where books are written?) I was on a subway train the other day, going from San Francisco to Oakland, and three quarters of the people in

the crowded car were focused intently on tiny screens (parts of their phones, in most cases) or dreaming to the sounds coming through their earpieces. There was no talk and little noticing, and this strikes a movie fan as disconcerting in that the movies always seemed to be about looking and the quality of things seen—as mood, narrative, or even beauty—and about the possibility of seeing inner meanings. So this book will exult over great films (and urge you to see them), and it will worry, too, over the ways in which the multiplicity of screens now are not just metaphors for our isolation and feelings of futility in dealing with the world but a fuel for that helplessness. (Once upon a time, we defined *screen* as a place where things were shown. But now an older meaning has crept back: a screen can be a masking device behind which things and humans may hide.) In the earliest days, the primitive movie shows seemed to be life in our lap, but now the many lap devices often whisper to us that we are not to bother with life. Isn't it beyond salvation? Isn't it, as the movies have always hinted, just a show?

●

From the moment Eadweard Muybridge picked up a camera (in the 1860s) to the occasion of Georges Méliès setting his aside (as the Great War began), the world went mad with progress. It was a time of profound novelties: electricity; the telephone; automobiles; powered aircraft; psychoanalysis; women seeking the vote and so much more; immigration to America on an unprecedented scale; a new kind of city, or metropolis; the realization that the populace might be a mass, or a force, and a way of knowing strangers by their images. So many changes, so many needs, with photography and moving film striving to mimic the commotion. But moving film was a mixture of science and magic: when the film strip moved, the still world came to life. Or something so close to it as to be heartbreaking: it became lifelike.

In E. L. Doctorow's novel *Ragtime*, the family meet the Baron Ashkenazy, who has become an entrepreneur in the new craze of movies. This is the early 1900s. He tells them about the wonder of what he is selling:

> In the movie films, he said, we only look at what is there already. Life shines on the shadow screen, as from the darkness of one's mind. It is a big business. People want to know what is happening to them. For a few pennies they sit and see their selves in movement, running, racing in motorcars, fighting and, forgive me, em-

bracing one another. This is most important today, in this country, where everybody is so new. There is such a need to understand.

The possibility that in looking to see we might understand is the hope and the excitement in this book. It may be its tragedy, too.

•

Eadweard Muybridge was one of those men whose work was needed to measure out the changes in what people were seeing and thinking. He was a still photographer, and arguably a troubled and violent person, but the stills were not enough for him. He guessed that they could be restored to the progress or the continuum from which they had been taken—motion, life, time—and that that past could be made present and lifelike.

In advance of any official identification of cinematography and projection, audience or the show, he had divined key elements of what moving film, motion pictures, or movie* would do. He had made an illustrated analysis of our recent past that indicated a future medium, but he hardly knew whether to think of it as science or poetry. We are still grappling with the question of whether this thing is story or its own relentless technology.

He was foreign or he was English. He came to America first in 1855 in a spirit of hopeful enterprise. He saw the prospect of men and women walking the beautiful land, and he would be of the generation of photographers who helped colonize that place in our imagination. But for the moment, he was only looking, without a camera or a plan. Simply, he was amazed and moved. Perhaps he wasn't looking where he was going, because he had an accident while riding on a stagecoach and suffered a head injury. It may have been a concussion, or worse, and there was some suspicion after that that he was troubled in his mind.

Then he went back to England. He may have been homesick, or aroused and confused by America. He had some reason to wonder if he was ill. So he thought he would change his name, pumping a little air and light into it.

He had been born Edward Muggeridge on April 9, 1830, in Kingston, a small, pleasant Thames resort then regarded as safely out of London and to its west, on the salubrious side of the prevailing wind, the smell,

*I shall be using the word "movie" in the singular, as an equivalent of "writing" or "music," to indicate the widening range of moving film.

and the smoke. The river at Kingston was clean, so the place called itself Kingston-on-Thames. In 1830, Princess Alexandrina Victoria was aged eleven, and seven years away from being queen. The population of Great Britain was about twenty-four million, but the small country had imperial possessions all over the world and the most modern and expansive domestic economy. Charles Dickens was eighteen and a young reporter. He met and lost his first love that year, but he had not yet written a book. His London was just a few years into the great experiment of gas lighting in homes and on the streets. So night had lost its first urban battle, but gaslight was the start of mood, atmosphere, and anxiety, a twilight and a half-light. Gaslight turned black into noir. In the early 1830s, in many places, but in London, too, people were taking and printing and showing photographs. Look, it's the real thing, they said, it's you! It's yesterday's light shining today.

So it was. But it was something else, too: the photograph was a thing, not a being; it might make an identity card, but it was so much thinner than identity. In a few seconds its freshness became the past. You could tear it in pieces; you could watch it fade. It seemed like a precious imprint of reality, of love or desire—we usually take pictures of things we like or want—but the fragile and arbitrary nature of the picture warned us that desire was fleeting. We lose photographs; we forget them. But they helped people see that light was not just natural or divine. It could be a modern spirit, a mood, and a device. "Let there be light!" could sound like a hallowed principle and encouragement, the fundament of history, culture, and human purpose. But the photograph taught us that the light might be tricked up and manipulated—and now we live with that slipperiness all the time. We are close to the last moment when photography is still trusted as a record or a likeness. That steady social habit and function have been taken over by what we call effects. And "effects" are results, not primary wonders. The real thing is no longer definite or reliable. It's shopped.

He changed his name from Edward Muggeridge to Eadweard Muybridge. People had changed their names before, but this was such a bold attempt at romantic transformation. It was like an advertisement and an assertion, a talking to himself, and the suggestion of a "bridge" is on its way from fact to fiction.

It was in Kingston in the early 1860s, that he first discovered photography, and that seems to have persuaded him to go back to California and San Francisco in 1866. He was some kind of publisher in the first instance, and he became a connoisseur of the new city and the beautiful

wilderness to the east in the Sierra Mountains. He launched what became a successful photographic business and did pictures of the city and of the country—especially Yosemite Valley, which, two years earlier, had been identified by President Lincoln as a national treasure. There was no question about the spectacular quality of Muybridge's landscapes, and his was not the only eye or lens attracted to them. The "wilderness" of Yosemite was altered by the photograph: it became a marvel, an adventure, a resort, even if visitors still die there in its wildness. Yosemite was hailed as the proof of America's natural existence. Some felt God was there. The wildness was a kind of liberty, though taking pictures of it was a step toward restricting that.

Was it an action suited to wild times, or was it part of the damage he had suffered in his stagecoach accident? Whatever the cause, Muybridge murdered his wife's lover. In October 1874 he came to believe that his wife, Flora—they had been married two years, and she was his junior by twenty-two years; she was a photo retoucher—was having an affair with a former English military officer named Harry Larkyns, who was drama critic on the *San Francisco Post*. In that same year, Flora had been delivered of a son (Florado Helios Muybridge). So on the seventeenth, Muybridge left the city and made what was a lengthy journey north (by ferry and horseback) to Calistoga, where he expected to find Larkyns, and shot him dead.

He was tried for premeditated murder in February 1875, and in his defense he claimed insanity or personality change after his accident. The jury discounted that argument, but they acquitted him nonetheless, on the grounds of "justifiable homicide."

Muybridge behaved oddly in other ways: after the verdict, Flora asked for a divorce, but Muybridge would not permit it. She died later in 1875, and Muybridge refused to acknowledge Florado as his. He put the boy in an orphanage, despite the fact that many observers believed the boy resembled him.

He was also interested in gambling and in experiments with photography. Leland Stanford, a millionaire on the strength of business derived from the gold rush, a director of Wells Fargo Bank, and governor of California, had a ranch or farm at Palo Alto, south of San Francisco. He got into an argument, which led to a wager as to whether a galloping horse always had one foot on the ground. Many earlier paintings showed horses in motion as if spread-eagled in air—this was a heroic, romantic assertion that defied optics and the structure of a horse's legs. But time and again

we look through the facts before our eyes and prefer something we want to believe is there.

Stanford asked Muybridge if he could help settle the bet. So in the years 1877–78 the photographer devised a row of cameras whose mechanical shutters were triggered by fine string lines set off by the horse's motion. The result was a simple record of time and space, laid out in still pictures taken at what we might call split-second intervals. With the aid of a machine invented by Muybridge in the early 1870s, the zoopraxiscope, these images could be printed in sequence on the surface of a cylinder so that, with a peephole and a twirl of the cylinder, a viewer seemed to see the horse galloping. Understanding was altered by technology; time was separated into sections, or frames; the past and appearance could be studied on a kind of screen; and it was revealed that at many instants the horse was in midair, not spread-eagled, but with its legs tucked up beneath it.

Muybridge was essential and innovative in the proof; he was a technological wizard and a rare talent; but he was about to be wronged. This pattern is not unusual with the figures in film history. Leland Stanford later published some of the photographs in a book, *The Horse in Motion*, but he did not credit Muybridge. The photographer sued and lost.

Not long afterward, Muybridge went to Paris. He was already, by 1881–82, contemplating the work that would be collected as *Animal Locomotion*—the sequential study of ordinary animal actions—but in Paris he met and talked with Étienne-Jules Marey. The two men were the same age, and while Marey had begun as a cardiologist, studying the flow of blood, he became interested in the detailed photographic study of motion. In 1873 he had published a book, *La Machine Animale*, that centered on flight, and Muybridge had read that book and studied its series on birds and insects. Marey had invented what he called a photographic gun capable of taking ten or twelve pictures in a second. The two men talked, and Muybridge's plan came into sharper focus.

But he needed funding, so when he returned to America, with the help of painter Thomas Eakins (a Philadelphian), he sought a position at the University of Pennsylvania, where he could carry out his research. By then he was able to record as many as twenty-four sequential images in a second. He used as subject matter anything that was at hand, or anything that interested him. He did a series on a mastiff walking and another on a horse and carriage; he photographed men and women ascending staircases; he caught men sparring and fencing; he shot little dances and jug-

gling acts. He delighted in the manifestation of simple motion and passing time, and he trusted situations where nothing dramatic seemed to be happening. The pictures were the sensation. The viewer's ability to sit at a distance and hold the light, the past, the animal, in his or her hand—that was the drama. It offered a mastery that was new and thrilling. The world might be yours to dream over.

He shot people, but he also shot light, air, and passing time. He took special pleasure in the splay and splash of water poured out of a jug or tossed on a little girl. The wonder of seeing the commonplace in the light was more thoroughly celebrated by Eadweard Muybridge than by anyone before him. It's still the case that his sequences fill viewers with awe and excitement, no matter that they have no story or purpose. The pictures feel ravished by the play of light on ordinary physicality and by the tiny, incremental advances through time. If you're interested in movie, you should spend some time just looking at these still photographs.

Take whatever example you like from subsequent cinema, and its inheritance from Muybridge can be felt—take Astaire and Rogers spinning together in "Let's Face the Music and Dance" in *Follow the Fleet* (1936); take the door closing on John Wayne's Ethan Edwards at the end of *The Searchers* (1956); or think of that instant from Chris Marker's *La Jetée* (1962) when the still picture of the young woman comes to life briefly and she looks at being looked at.

Think of Julia Roberts smiling in *Pretty Woman* (1990) and the realization it gave you in 1990 that the archaic fantasy called "a star is born" was happening again with a knockout newcomer—a dream in which a hooker becomes a respectable, and possibly educated, woman and the sweet wife to a millionaire, and we enjoy all those faces and roles, without risk of infection, support payments, or boredom. *Pretty Woman* may be indefensible as "a work of art," but what a show, what an extraordinary metaphor for a daft society—and what a face! What a thing to look at. And what appetite she had then for being looked at—what young faith she had in being recognized.

Muybridge took well over a hundred thousand pictures in Pennsylvania in the mid-1880s, and they were published by the university in 1887 in eleven folio volumes as *Animal Locomotion: An Electro-Photographic Investigation of Consecutive Phases of Animal Movements*. Before the official invention of the movies (though many were on that track, and Thomas Edison took note of Muybridge's work), so many elements of cinema had been identified: time, motion, space, light, skin. And watching.

Don't forget the skin, or the way sunlight could caress it—as a rule, Muybridge worked in natural light. He was engaged in a project of scientific research, sanctioned by the university and by the Philadelphia Zoo, so he had some license. If the animals he photographed were naked, why not some similar views of those other animals, people? I doubt he could have published all that followed without the umbrella of academe (and he often did series of people opening and closing parasols).

One of the nudes was Muybridge himself—gaunt, stringy, white-haired, and noble. He had to believe in himself—he looks as confident as Julia Roberts did once. He must be the first auteur to go naked in front of his own camera, and he does not have too many rivals in the century or more since. I do not know who the naked women were, though they are usually young, strong, and appealing. Did Muybridge select them for that reason, or were they just Penn students on work study? Did he talk to some of them afterward? Did he . . . ? I don't know, but you will know what I am wondering if you examine the glory and the naturalness of the pictures.

Of course, these pictures are not loaded or touched with drama or seductiveness. They have no story content—except that of being looked at. But watching is so often the seed of story—that's what happens with Jimmy Stewart in *Rear Window* (1954), a film that teases him, and us, on account of the link between staring and starting up a line of thought that might become a story. What happens next? But why say "next" unless things follow in what screenwriters call "the arc"?

Aware of an arc, or not, as film and filmmakers watch, so they are led to "improve" what they see. They may alter the light and compose the image to fit the story developing in their mind. This is tricky, too, but you can't blame anyone for doing it. Watching and thinking are natural companions. It's only the camera that can do one without the other. But we are so eager to assist its shortcoming.

In Anthony Minghella's film of *Cold Mountain*, two lovers, Inman and Ada (Jude Law and Nicole Kidman), are separated for most of the action by the Civil War. At last they are reunited, and in 1864—or in a 2003 movie—it was natural that they might make love. But this was a film that had striven to look and feel like the wild country of North Carolina in the early 1860s, where very likely the real lovemaking would have been in the dark, with bodies roughened by hunger and other privations.

Cold Mountain was a movie that was going to cost $83 million, so it needed a sex scene with movie stars. Minghella knew that, but if he had

been in any doubt, Miramax and the Weinstein brothers (the producers) were there to remind him. Alas, in its fond amber light, with the players gracefully exposed and shielded, and with Law and Kidman qualifying as admirable bodies, *Cold Mountain* felt like a movie. The openness of Muybridge and nature was gone, along with 1864. But even Muybridge's own pictures do have some elements that signal the melodrama of *Cold Mountain*: his views are chosen and framed for us, and the men and women in the photographs do not know us or admit that we are watching. The voyeurist privilege had begun, and already its intimation of power and detachment was present. What is not natural is our looking. Yet by today we think we have a right, a human right, to look at anything.

Eadweard Muybridge went back to England and died in Kingston-on-Thames in 1904. He was an inventor, a creator, and a visionary, and nearly every picture he took prompts the inward cry "Oh, look!" That is what this book starts with: we like to look, and in looking we find what we like—or what we are afraid of: it's a pattern of dread and desire. Of course, by 1904, if he had been so inclined, Muybridge could have gone to some early version of a movie show, run on electricity, and seen the projector's shining light fall back from a screen on the huddled mass. He might have been pleased, for it would have seemed as if the crowd, buzzing with their sighs, were watching the pictures. They were. We still do. But by now we are challenged by a disconcerting realization—that we are also watching the screen, the process, and our distance from reality. Movie has so often seemed like the gift of reality—sometimes a lustrous, improved version of it—but by now it's easier to understand how the process let us give up on reality, and use it as a story, a dream, a toy version of life. That can be a worrying privilege, especially if reality threatens to become unmanageable.

•

This book is an attempt at history, but it leaves many things out, and sometimes moves sideways, despite an overall belief in a steady, forward narrative. From the early days of movies, it cuts forward to events as recent as *Pretty Woman* or *Cold Mountain*. In the middle of the book, there is a kind of movie, or a montage. So it's the story of the movies, but it begins with still photography and comes up to Facebook and all the screens in our lives today. The point in that extension is to say, well, be wary of isolating movies as a discrete or all-important subject. They are about their own imagery, of course, but they should not be separated from our

longing to see or from the medium's ultimate core: a way of realizing desire on the big screen. So it's a history of moviemaking, its atmosphere as a bittersweet collaboration, and its impact on our larger culture, but it tries to describe a theory of screens, too, which is not as cheerful or carefree as Fred Astaire. We used to believe the screen was there just to help us see the pictures, the story, and the illusion of life. But we are warier now and we guess that all these screens are the real thing, fabulous tools, of course, but subtle barriers between us and life.

We are all of us our own screens: we let the imagery of the world play on us, just as large theatrical screens carried every movie with impartiality. I have always been intrigued by the idea of screens retaining something of the spirit of all their films, of their all being there at the same time—it's a version of consciousness. In that mood, imagine the Fernando Rey from *The French Connection* (1971) becoming the Rey in Buñuel's *The Discreet Charm of the Bourgeoisie* (1972) on the same white sheet. The films are only a year apart, and it's positively the same man.

So this book has a lot of information and film titles, a lot of movies you might want to see, or see again. But it is personal and reflective. It tries to uncover the secret nature of film and the way it aids our dreaming. The book goes into raptures and it turns frosty: it has opinions, none of which is meant to be authoritative or decisive. They are there to urge you into your own. I hope it is useful and entertaining. But its chief purpose is just to make us think what movies have done to us and wonder how we feel about that. It's a love story, but you have to wait for the ending.

THE SHINING LIGHT AND
THE HUDDLED MASSES

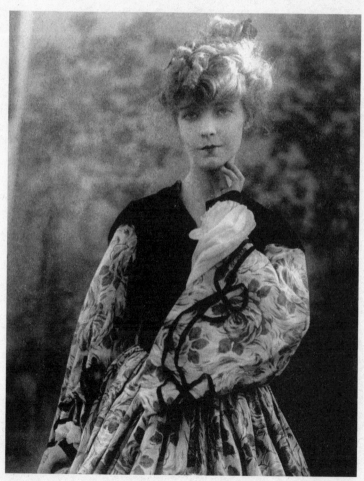

Lillian Gish in *The Birth of a Nation*

A CHEAP FORM OF AMUSEMENT

In 1911, William de Mille heard that a promising Canadian stage actress lately seen in *The Warrens of Virginia* (1907) was making the mistake of her life. He told the impresario David Belasco, "The poor kid is actually thinking of taking up moving pictures seriously . . . I remember what faith you had in her future . . . and now she's throwing her whole career in the ash-can and burying herself in a cheap form of amusement."

The actress was eighteen, and for the moment she was Gladys Smith—but the name Mary Pickford awaited her, along with perhaps the greatest success and fortune any woman has yet achieved in the movies. William was the older brother of Cecil B. DeMille and as disapproving as possible of Cecil's own urge to give up theater for this new, trashy sensation. Fraternal superiority seldom works. C.B. was on his way as not just an epic figure in the business being made but also, he hoped, an immense force for good and improvement. (The de Milles were the sons of a preacher who had become a playwright. Around the turn of that century, there were so many new technologies winning the minds of people.)

The longing for improvement and the fear of waste and worse—it is a pattern still with us, and maybe it speaks to the medium's essential marriage of light and dark, or as Mary Pickford put it in her autobiography (published in 1955), *Sunshine and Shadow*. Light and dark were the elements of film, and they had their chemistry in film's emulsion. They had a moral meaning, too. But not everyone appreciated that prospect, or credited how it might make your fortune.

At one of their first film screenings in Paris, in the 1890s, the Lumière brothers told Georges Méliès, a stage magician captivated by what the cinematograph might do for him, to put away his money: "It is an invention without a future." Yet Thomas Edison, a businessman to be sure,

wrote in *Moving Picture World*, a trade paper, in 1907, that "nothing is of greater importance to the success of the motion picture interests than films of good moral tone." But Dr. Anna Shaw, a "feminist reformer," believed that a policeman should be posted everywhere movies were shown because "These places are the recruiting stations of vice." In Boston, a girl, Irene Mayer, realized that her father, Louis B. Mayer, was in the picture business and doing so well that they were about to move to California! But years later she was still asking herself, "How could a man of my father's innate conservatism have chosen show business?"

Her answer was that Pop was "as emotional as he was"—a simple statement that requires constant examination. My experience with movie people is that nothing is more pressing or perilous in their lives than their headstrong identification with the emotion in the stories they tell. Other people in Mayer's life might have put it differently. Louis B. Mayer, once known as Lazar Meir, and born outside Kiev in 1885, was a small bull of a man who had grown strong heaving scrap iron. He was barely educated, yet he would be a shaper of minds. He was conservative but outrageous, high-minded and given to low blows, a pirate and a prison guard. As the dominant power at Metro-Goldwyn-Mayer for over twenty-five years, Mr. Mayer felt he owned the souls of his stars as well as their moving photographs on seven-year contracts. He had a cruel side, a violent temper, an unbridled ego. In urging his own properties to be "good," to respect their mothers, their Americanness, and his advice, he could move himself to tears. His daughter Irene admitted that she regularly confused him with God, and hardly noticed that she didn't believe in a god. Some observers decided Mayer was a fraud, the "greatest actor on the M-G-M lot." This misses a more disarming truth: he cried real tears; he was moved by his own dreams. There are still people who think they run the media who are swept away by that great hope.

When Mayer was an infant still, his father, Jacob, took the family to England simply to escape pogroms and poverty. That setting forth showed some means as well as the courage that every emigrant requires. Jacob was in the scrap business, but he could not prosper in England. So in 1892 they all moved on to St. John, New Brunswick, the town where Louis Mayer was raised.

Similar stories could be told about most of the founding fathers in the picture business. Adolph Zukor (the future chairman of Paramount) was born in Hungary in 1873. Samuel Goldwyn was from Poland, born in 1879. Carl Laemmle (the founder of Universal) was born in Germany in

1867. William Fox was born in Hungary in 1879. The eventual Warner brothers (Harry, Albert, Sam, and Jack) had their family origins in Poland. Harry Cohn's father, Joseph, was born in Russia—and Cohn and a brother would form Columbia, the company that employed the logo of the famous statue holding a torch up for those huddled masses, beckoning them into movie houses.

They were all Jewish. The only native-born Americans among the movie pioneers were Jesse Lasky and Cecil B. DeMille, and maybe that's why that pair worked together to make *The Squaw Man* (1914), allegedly the first feature-length picture produced in Hollywood. The Jewishness cannot be underestimated. The people who established the business were outsiders, anxious to be regarded as Americans, as well as people who had suffered every kind of ethnic prejudice from disdain to pogrom. When Victor Fleming (born in Pasadena) took over the directing of *Gone With the Wind* in 1939, he barely disguised his dislike of Jews (such as David O. Selznick, who produced the picture). So movies were made into a business by people who had recently escaped their own huddled masses, from families that did not always speak English. Against that set of anxieties, these early moviemakers were accustomed to storytelling, sentimental narrative theater, broad comedy, and the miracle of wondrous things never seen before: the dream that comes true. California was the embodiment of that change in life, the steady sunshine that followed European overcast.

By 1899, Louis Mayer was in St. John still, and Canadian (his father had taken citizenship), a teenager in the scrap business. It was in 1904 that he crossed the border and went to Boston. His purpose was to observe the familial duty of getting married. The Mayers had learned of a Margaret Shenberg, the daughter of a kosher butcher in Boston ready to be wed—letters and photographs had been the means of courtship (you can marry a photograph; at the movies you can fall in love with it). Margaret, according to their daughter, was "astonished by his single-mindedness and ardor." But others reckoned Mayer simply wanted to get to America.

This ardor, ambition, and naïveté fell on moving pictures. In 1907, Mayer learned he could purchase a six hundred-seat burlesque house in Haverhill, Massachusetts, the Gem (known locally as the Germ), for $600. He moved his family from Boston to Haverhill, refurbished the house, called it the Orpheum, and opened for business at Thanksgiving, with "clean, wholesome, healthy amusement." On Christmas Eve he ran a

double bill, two-reeler films (twenty to thirty minutes each) of *The Passion Play* and *Bluebeard*—Christian salvation and mass murder.

He had two daughters by then, and a rapidly growing business. "Never mind now," he told his family, "this is short. It is the future that counts; the future is long." He bought other theaters. He had an orchestra at the Orpheum. He hired live acts, too, and even a little bit of opera. The family moved back to Boston, and in March 1912, Louis Burrill Mayer took American citizenship. He elected to move into distribution, and for $4,000 he got the New England rights to DeMille's *The Squaw Man*. Then, in 1915, with money acquired from a syndicate, he put up $20,000 to get the New England rights to *The Birth of a Nation*. For everyone in moving pictures it was the turning point.

With Mayer, we are talking about a businessman, albeit one obsessed with the value of content. David Wark Griffith, who conceived of *The Birth of a Nation*, and made it, deserves to be considered an artist, even if the thing his film gave birth to was more a business than anything else. He was also someone who developed a future technology that would restore the past.

Griffith was born on a farm near La Grange, Kentucky, in 1875, the son of man who had fought all through the Civil War for the Confederacy and been wounded twice. David was a country boy, in awe of a father who had difficulty expressing love. He was wistful and dreamy, and in his autobiography he recalled this childhood feeling about media to come: "I have thought what a grand invention it would be if someone could make a magic box in which we could store the precious moments of our lives and keep them with us, and later on, in dark hours, could open this box and receive for at least a few moments, a breath of its stored memory." He was in love with nostalgia, and blind to the astonishing dynamics of the future he helped create.

The father died when Griffith was ten, and the family was left poor. The boy grew up tall and handsome, albeit with a soulful expression, and in Louisville he took up acting and singing. He joined a theatrical company; he had parts, and for a few years he was a touring actor—who never seems to have impressed anyone who saw him. He wrote stories, poetry, and plays—one of them, *A Fool and a Girl*, was produced, and flopped. He applied to the Biograph movie company in New York as an actor, and when they deemed him an unimpressive performer, they asked was he prepared to "direct."

In 1908, directing was still a stooge's job. In the mass of very short,

sensationalist movies (many of them just ten minutes, few more than twenty), the stress was on getting an adequate camera exposure (catching the light), having enough action (to avoid boredom), showcasing prettiness in its human forms (the embryonic age of stardom), and being wholesome. If you feel there's a contradiction between sensationalism and wholesomeness, don't let any glib argument dissuade you. Without any understanding of how it worked, or where it might go, the medium had let loose the alchemy of the real and of fantasy. A director presided over the shooting, without truly analyzing, let alone controlling it. He called "Action" and "Cut," or their equivalents, and he may have guided the actors. (Sometimes actors did the directing.) But scenarists, actors, and bosses had louder voices, and the cameraman was a small god with a machine no one else understood. A part of us now regards this condition as primitive, or unformed. If film is going to be an art—and some of us have longed for that—don't we need an artist? But time and again over the years the director's authority and glamour have receded. Ask yourself who directed which episode of *The Sopranos*.

In his five years at Biograph, Griffith directed more than four hundred short films, torn between the possibilities of a twentieth-century medium and the sentiments of popular Victorian theater. It's not that he alone invented every fresh way of looking or the grammar of cutting shots together. Mauritz Stiller in Sweden and Louis Feuillade in France were two men working out the same problems, and as creative figures they often seem more interesting now. In a few years, in Russia and Germany, explosive attitudes would change everyone's mind about what this medium could be. But these ideas were not American, and American business power was determining the character of the new show (and promoting America to the rest of the world). Movies had access to the most available and eager crowd, the new city people crying out for escape and amusement.

No one worked as much as Griffith; and no one else built a career and let the whole medium ride along on his wagon. Despite his roots in coarse theater, Griffith saw that camera positions could be varied, and made subtle with angle; he divined the power of close-ups in showing what people were feeling and to draw audiences into the suspense; he identified cross-cutting strategies that persist to this day—a way of saying "at the same time" or "meanwhile," so that a story develops. He saw that film stories needed to accelerate, to rise, and to grip more tightly. He made the chase a function of narrative and moral force. He used sets (and he liked them to be accurate to period), but he had a rural eye for real places and

natural light. To the modern viewer looking back at the surviving Griffith shorts, the sunlight and the human glance may be the most endearing things.

History acclaims him for his big pictures and the establishment of a business. But he was not always at his best with grandiose, epic narratives. He told short stories very well, alert to the interaction of people and place, of ordinary movement and the way we look at each other (the secret in cross-cutting and the way it could lead to inward thoughts, as opposed to feelings put on display). Many of his shorts have a facility and charm that is smothered in the big pictures. So *A Corner in Wheat* (1909, and only fourteen minutes) is a glimpse of rural life and big-city exploitation. The *New York Dramatic Mirror* praised Biograph for doing it, and said, "It is another demonstration of the force and power of motion pictures as a means of conveying ideas." But it did not mention Griffith—no one knew enough yet to notice who had delivered the ideas.

So the failed actor built a company of players and worked with them so often that they became film actors. Lillian and Dorothy Gish are the best known now, and Griffith was more interested in looking at women than at men, but there were others: Robert Harron, Donald Crisp, Henry B. Walthall, Harry Carey, Blanche Sweet, Mae Marsh, and Mary Pickford. Many of them became stars, but in Griffith's work they seem like supporting players—and in American film that is often a mark of honor. Stars are American, to be sure, but they are not a sign of all men and women being equal. So the fond, respectful regard for "supporting players" may be closer to many American ideals.

In his quiet but firm way, Griffith educated actors. Lillian Gish (his greatest project, his model, and perhaps his goddess) once called films "flickers" in his hearing, and Mr. Griffith, as she spoke of him, told her, "Never let me hear that word again in this studio. Just remember, you're no longer working in some second-rate theatrical company. What we do here will be seen tomorrow by people all over America—people all over the world."

We know he was right, but his earnestness was driven by hope and his own memories of failure in second-rate theatricals. So in 1913, Griffith left Biograph and began to make longer films: *Judith of Bethulia* was an hour long, and terribly archaic in its biblical material and attitudes. He felt challenged by feature-length films coming from Italy and France— ornate costume dramas fixed on re-creating the past and throwing spectacle at the audience. Given a machine that would shape the future,

many early filmmakers elected to revive the past—so Griffith dreamed of a remade Civil War.

His best biographer, Richard Schickel, has observed that, despite Griffith preparing to change the world, he was unworldly to a degree. He knew next to nothing about the latest steps in literature, music, or painting. And his pioneering looks nearly childlike when put beside his exact contemporaries: Joyce's *Dubliners* (1914) (just think of the depth in "The Dead"); the dynamics of Cubism; and the music of Mahler. But more than those artists, D. W. Griffith identified and enlisted the American crowd. He shone the light in the public face and he set off a mass medium—the first. Moreover, a mass medium carried a challenge: that the select media, the arts, might be redundant. Wasn't it nearly a democratic ideal that if there was something that was funny, moving, or exciting, it might work on everyone?

This was underlined by a real-world disaster that made everyone feel caught under the same gun: Griffith began shooting his big picture on July 4, 1914—war was weeks away. But his thoughts were of the war that had marred his own life and experience, the Confederacy against the Union. For his material, he chose—alas—Thomas Dixon's novel *The Clansman*. This is a big, baggy book, full of romance, but Griffith was not shy of saying that he smelled movie when he imagined the clansmen riding in flying white robes.

The Clansman had been published in 1905, to success and notoriety. Dixon believed in segregation and the inferiority of blacks, and he dramatized this without mercy, often in situations where white women were sexually threatened. There had been an adaptation for the stage, as successful as the novel. Griffith and his partner Harry Aitken sought the film rights. Dixon asked for $25,000, which was far beyond the filmmakers' means. Then he dropped his price to $2,000—but against 25 percent of the producers' gross income (trust the future, or gamble on it). Aitken was so pressed for funds that the $2,000 check was delivered to Dixon on Friday after the banks had closed, allowing the producer two more days to secure the money.

The film was shot in California from July through November, and it required horses, uniforms, guns, and several hundred extras—all of whose numbers were exaggerated by the time the film opened amid that other innovation, "hype." (Eighteen thousand extras were claimed.) California was winning the battle to be the center of the film business, after everything had been New York, New Jersey, or New England at first. Going

west brought better light and more of it; it distanced operations from the Motion Picture Patents Company that sought to license all equipment and film stock; and it meant a new world, days away from crowding and controls. The picture business helped establish California in America, which is one reason why the giant label HOLLYWOOD still looms over Los Angeles, even if local children hardly know what it means.

So the light in *The Birth of a Nation* and the terrain are not southern; they are Californian. The film cost $100,000, and it worked out to be a picture of over three hours. That entails a thing called production management—deciding what to shoot when and where as economically as possible (and Aitken was desperate about the funds all the time; Griffith and his cameraman, Billy Bitzer, put some of their own money into it). Yet Griffith was honest in the claim that he never had a script. He made the film up as he went along, which was the general method in the mass of short subjects that had prevailed. Many modern screenwriters lament that this habit or confidence has never been broken.

Still called *The Clansman*, the film opened on January 8, 1915, at Clune's Auditorium in Los Angeles, under heavy criticism from the NAACP, which feared for its consequences. Without question or protest, the audience sat still for twelve reels. It is said there was a stunned silence at the film's conclusion. (Was it over? would it go on forever?) (In December 1939, in Atlanta, there was a similar reaction to the premiere of *Gone With the Wind*. In both cases, some audiences felt the recent past and its tragedy had somehow been "explained.") Then there was pandemonium, not just cheering, but that roar of elation and surprise that greets an altering event. The noise went on until Griffith appeared—it was a stage actor taking a bow at last, acclaimed by the masses as a "hero." "He stepped out a few feet from the left, a small, almost frail figure lost in the enormousness of this great proscenium arch. He did not bow or raise his hands or do anything but just stood there and let wave after wave of cheers and applause wash over him like a great wave breaking over a rock."

In New England, as everywhere, the picture played to unprecedented crowds, and the event attracted people who had previously regarded moving pictures as too minor or soiled. But because the business was so large and novel, no one knew how to measure it—or keep track of the measurers. Louis B. Mayer is said to have made $500,000 from his deal, though it is believed he failed to report as much as $300,000 of his box office. By 1917, Epoch, the company behind *Birth of a Nation*, reported authenti-

cated receipts of $4.8 million, which meant a clear profit of $1.8 million. It is reckoned that Thomas Dixon pocketed $1 million and Griffith himself at least half that amount. Richard Schickel believes that, worldwide, the film may have taken in as much as $50 million. Fortunes were built on it that allowed others to move ahead. Louis B. Mayer would form his own production company. A few years later he was in California, too. Irene Mayer reported, "My father said people lost their heads in Hollywood, whether because of the movies or all the sunshine or all the freedom . . ."

Try all three! And remember the light of Los Angeles. Yes, it is reliable for about three hundred days a year, and it shines on an astonishing variety of terrains—the sea, the shore, a city, suburbia, high desert and low, mountains with snow on them, sand dunes, and forest. There are a few shots of hillsides in *Wuthering Heights* (in California, not Yorkshire) where cameraman Gregg Toland has gorgeous triangles of light and shadow patterning the ground that are as moving as Laurence Olivier and Merle Oberon. Robert Towne, who wrote the L.A. classics *Chinatown* and *Shampoo*, once said the city's winter light was as if "someone put the sun in the freezer overnight."

There is an essay on L.A. light by Lawrence Weschler that begins with him and his daughter watching the O. J. Simpson Bronco chase of 1994. The kid sees that Dad is moved. "Did you know that guy?" she asks, and Dad says, no, it's the light that's getting to him: "the late-afternoon light of Los Angeles—golden pink off the bay through the smog and onto the palm fronds." Weschler goes on to collect all kinds of light from different witnesses. David Hockney recalls the crisp shadows in Laurel and Hardy films that his dad took him to see in overcast Yorkshire. Others say it's the weather effect of the desert abutting the ocean. Astronomers find it's perfect for their work. And the cinematographer John Bailey (he shot *American Gigolo*, a fine slice of L.A. light) testifies that a sophisticated light meter gives you readings you wouldn't expect. Strangers to the city sometimes feel that everyone there looks beautiful.

Is the light in Los Angeles really unique and lovely, or uniquely lovely? I'm not sure it isn't just that the culture and identity of L.A. was movie light for long enough so that people took emotional possession of it. Of course, that was in the days when films were made from photographs and light burned into the silver.

Robert Irwin tells Weschler, the light in L.A. is "so radically different from day to day and then so incredibly specific on any given day." That's not crystal clear to me, but it sounds enough like life to give us the best

explanation: in L.A. for several decades, alert people lived on light—and surely that's a habit acquired from the screen. The movies were always about a shift in cognition, whereby looking became more important or more valid than knowing or understanding. There's a great deal of optimism in that shift—and a terrible price to pay when Americans tired of looking and realized the other hard work that needed to be done.

Louis B. Mayer and D.W. Griffith were alike in hoping that *Birth of a Nation* and its money had secured respectability. For the first time, a movie was shown in the White House, and Woodrow Wilson saw it. Thomas Dixon had wangled that break because he told the president, "A new universal language had been invented." Wilson was a Virginian and not a moviegoer, but he was so emotional after seeing it that he supposedly said, "It is like writing history with lightning. And my only regret is that it is all so terribly true."

No one knows quite what he meant by that last sentence, while the first showed an unexpected potential for the president as a booster. And what's lightning but light with a kick? One result was that the Ku Klux Klan rallied from a dormant stage. Membership increased, and there were more than seven hundred lynchings a year in the period after the release of the film. Lightning can do damage. The NAACP led the way in protests over the film, but some of its own members admitted to being swept away by its narrative and the sight of blackface actors threatening the virtue of sweet white women, even to the point of the latter's suicide.

People were swayed. In England, aged ten, Michael Powell was so stirred that he would say later, "It was David Wark Griffith who made up my mind for me that I was going to be a movie director and would settle for nothing less." But at the age of eight, say, it's unlikely he would have known what a movie director was.

To take just one instance of the movie business exploded by *Birth of a Nation*: in 1914 Cecil B. DeMille had "picturized" *The Virginian*, from the Owen Wister novel, with Dustin Farnum as the hero. It was a 55-minute movie and it did nicely by existing standards. It cost $17,000 and brought in $110,000. But now, the existing standards of business were in question. The lure of the blockbuster, of striking it rich or breaking the bank, set in very early.

Today we may be less certain that three hours is a guarantee of art or business. We are accustomed to shorter entertainments: a television commercial is seldom longer than thirty seconds; the average television episode in a series is twenty-five or fifty minutes. We are used to bites and to

being bitten. Moreover, we are in the habit of interrupting what we are seeing—by putting it on Pause, taking a phone call, or leaving the room. Sometimes the one-reel comedies that dominated in 1915—a very cheap form of amusement—can look very modern. Samuel Beckett was an avid filmgoer as a boy. But he mistrusted the medium whenever it turned portentous. True depth of feeling, even tragedy, he felt, could be best found in brief comedies, so he loved Chaplin, Keaton, and later Laurel and Hardy. To this day, the short films of Chaplin seem so much more agile and ambivalent than his increasingly solemn feature films.

•

One day, as a child in London, Chaplin was watching his mother perform on a music hall stage. She was not well (she was drinking) and her voice was failing. When some soldiers started to boo her, she fled. Whereupon a stage manager took the little boy onstage so that he could perform some song-and-dance routines he had learned. It did the trick: in a moment the delighted audience was tossing coins onto the stage. Then the kid showed his genius and authority. He said he hoped the public wouldn't mind if he interrupted his act to collect the money: "The stage manager came on with a handkerchief and helped me to gather it up. I thought he was going to keep it. This thought was conveyed to the audience and increased their laughter, especially when he walked off with me anxiously following him. Not until he handed it to Mother did I return to continue to sing. I was quite at home."

That pattern never altered. The more assiduously he exploited the theme of the waif, the richer Charlie became. But there's another pattern in that passage from *My Autobiography* (published in 1964): it's the flex of action and reaction—the stage manager does his business, and the kid's look signals alarm to the audience. A laugh begins. The anecdote is made into shots—and we are still following along in that line of sense.

The incident could suggest Chaplin was money-grubbing, but he was simply very poor, and as fierce at business as with film. If he had a passion close to a failing it was his dedication to sex, especially with underage girls. Of course, in his movies Charlie was gallant (until *Monsieur Verdoux*, in 1947, by which time he had been in court on unfounded paternity charges). If that Charlie had been exposed earlier he could have been drummed out of the business, the way Fatty Arbuckle was ruined. Los Angeles was a company town, and just because of its impact on young people, it tried to be conservative, yet there was also an undertone of

abandon in the city that relied on cover-up. The split between desire and restraint replicates the lure of fantasy that tests the crowd at the movies.

Chaplin said he was born in Walworth, in South London, in 1889. (The records don't survive for lives so humble.) He was never quite sure who his father was. (He played with the idea that he might be Jewish.) His mother's illness meant the child had to spend time in an orphanage and the workhouse. This was a Dickensian upbringing, with fulfilled expectations beyond a novelist's invention.

He was a child performer with minimal education who joined the Fred Karno Company (an English vaudeville group) and traveled with Karno to America in 1910 and 1912 to work onstage. He was spotted by Mack Sennett, an impresario of short comic films at Keystone, who liked Charlie's act as a drunken toff in *A Night in an English Music Hall*. In *Tillie's Punctured Romance* (1914), which is actually a Marie Dressler vehicle, Charlie is the cad and exploiter. But quite quickly Chaplin worked out a fresh image for himself in the movies: it took baggy pants, a battered bowler, a cane, a daub of mustache, and those accented sad-dog eyes. The Tramp was the eternal hard-up case, every bit as impoverished as the movie audience, but flattering them with his daintiness, his fine feelings, and the sturdy pluck that trusted good fortune.

There was something else. He addressed the camera and the function of the film. He implied, "Look, it's me!" The look was winsome and coy, not challenging, but it carried an endearing confidence. (It recognized that the audience was there, and it knew why: they wanted to think of being Charlie.) It said, You can trust me, you can like me. I'm so poor, but you know I'm rich. Every politician on television now strives for that specious intimacy with voters, and it's one reason Chaplin would inevitably become a political figure, an example to the world.

He started at Keystone in 1914 at $175 a week, and his success was so rapid that in 1915 he joined Essanay for $5,000 a week. A year later he went to Mutual for $10,000 a week. He relished the money, but depended on another aspect of his contract: the right to make his movies without interference. Chaplin would never be a movie stylist, though he became expert at filming jokes, especially if they carried a kick of malice. Without years of training or hundreds of short films, Chaplin mastered simple movie storytelling and let his narcissism flow. There were many rival comics, but Charlie dared to say, it's me! Only a few years earlier, the infant business had been taken aback when audiences asked, "Who is *that* girl?" on seeing a pretty girl in a bathing suit and wanting more.

This is not to be critical of Chaplin, for his ego was natural and heart-felt. He gave himself to the camera and the world of strangers. He is the light in his own films—though those movies often have a rich sense of place and sunlight, too. This stress on light is not to be underestimated. Time and again in American film—and this is true of Chaplin in the Sierra doing *The Gold Rush* and of John Ford in Monument Valley making Westerns—the light is like a gift, and the movie is constantly rewarding our plea "Show me!"

Show them something they have never seen. But beware if they ever decide they have seen everything.

American films film the light: it is their energy, their optimism, and their happiness. So Chaplin turned the snowy locations of Truckee (standing in for the Klondike) into a realm of threatening beauty. The discovery of gold had made Northern California; it was the model gambling coup, and gold has its own bright light. Chaplin was fascinated by stories of those miners, especially the tragedy of the Donner Party—that's why food is such an obsession in the picture. *The Gold Rush* (1925) is a comedy, but it was made at almost the same moment as Erich von Stroheim's *Greed*, in which the light and the Death Valley desert are metaphors for mania. Charlie stays cool and humble in *The Gold Rush*, but his gamble grossed $6 million (on a budget of over $900,000—or nine times the cost of *The Birth of a Nation*).

Chaplin was the most transforming star of early cinema and, by the early 1920s, the best-known image in the world. But his own reaction was ambivalent. For Chaplin did not look like Charlie. In life there was no mustache; he dressed fashionably; and his hair began to go white in the 1920s. He worked hard to erase his Cockney accent and make up on his education. He liked society parties and collected meetings with wise men, political leaders, distinguished writers—and women. Just as Louis B. Mayer courted Herbert Hoover, from secretary of commerce to president, Chaplin was a social climber.

There was some public resentment (and some amusement) that his pay was four times the combined income of the nine Supreme Court justices. He never applied for American citizenship. He took risks pursuing young women, yet many women wrote offering to take care of him. Something of the outsider remained, a need to defy the public that adored him. We love stars, for they tell us we can transform ourselves. But we envy their escape from anonymity, and with Chaplin, in time envy turned to hostility. From his point of view that split signaled a fickle, unpredictable

public, a pressure that would help drive the richest tramp in the world out of America.

His unstoppable rise soon carried him into a diminishing run of feature-length films, pictures he labored over and hesitated with. Nothing reveals Chaplin's authority or his economic power more than his waiting for days and weeks at a time until inspiration came along—while keeping his crew on salary. On *City Lights* (1931), shooting occurred on only 166 of 534 working days! Just when the film factory was insisting on tight scheduling and budgets, Chaplin behaved like Proust, brooding and experimenting until he had it "right." But in the ending to *City Lights*, with its dynamic fusion of recovery and loss, Chaplin managed a moment that is piercing and eternal: his own face, a rose in his mouth, filled with joy and anguish in a ravishing close-up as beautiful as the most adoring shots of women. Charlie invited Einstein to the premiere and was proud to see the great man weeping.

•

These days we say "Chaplin and Keaton" in one breath, though the case is often made for Keaton as the finer clown, or the more soulful performer. Chaplin's coyness, especially if it turns spiteful, can be grating. While Keaton's stoic calm becomes more interesting as the years pass. He was a hit in his own lifetime, of course, and then a disaster, but Keaton nowadays looks like a poet. Is that view accurate or just a measure of our longing for poetry?

Joseph Frank Keaton was born in 1895 in Kansas, but it might have been anywhere, for his parents were traveling performers in vaudeville. The story goes that he was called Buster by Harry Houdini, who saw the infant fall down a flight of stairs without breaking a bone—and without crying. As a youngster, Buster was part of his father's violent comedy routines in which the boy was the fall guy, or someone to be thrown around like a ball. Since the father was often drunk, the ball could be fumbled.

Was it a result of this treatment that Buster never had an ego like Chaplin's? Is that why his best films are more surreal than sentimental? He had a spell in the army at the end of the Great War—Chaplin claimed he could not return to Britain to serve in the war because his picture contract forbade it (and because he was so valuable selling war bonds in the United States). Then Keaton became a supporting player to Roscoe Arbuckle, a star of comic films who was hurrying toward his date with manslaughter charges in San Francisco in 1921.

The matter of ego is significant. Keaton seldom had sole credit as a director on his features—*Our Hospitality* (1923), *Three Ages* (1923), *The Navigator* (1924), and *The General* (1926) co-credit him and a professional functionary. As a businessman, he was dominated by Joseph Schenck, his brother-in-law. (Buster married Natalie Talmadge in 1921 and Schenck was married to her sister, Norma.) He never profited from his work on the enormous scale that Chaplin enjoyed, because he never invested his own money. Yet the films—including the sublime *Sherlock Jr.* (1924), a forty-five-minute dream in which he is the official director—have a beguiling stylistic consistency. It entails a detached camera and elaborate physical routines (which rise above the violence and the malicious glee in Chaplin) and a lot of slapstick, all sustained by Buster's delicate deadpan presence. We have to watch Buster, instead of identify with him. It is as if he expected failure and trusted disaster—but would not cry. This is the reserve that leaves Keaton mysterious still, as well as beyond funny. He had some instinct—vital in the history of film acting—to do less. Chaplin was desperate to move us, while Keaton understood something about cinema that was ahead of his time: that the emotional connection being advertised was indirect and a mirage. The watching is rooted in detachment.

So he never believed in being in control, and his career fell apart. Natalie divorced him. Schenck sold him to M-G-M, with a drastic loss of creative input. He followed the family line into booze and breakdown. By the late thirties he was washed up. Later, with some condescension, Chaplin offered him a cameo in *Limelight* (1952). At the very end, in 1965, a year before his death, Keaton worked on *Film*, a short written by Samuel Beckett.

By the 1950s, Chaplin was a millionaire exile in Switzerland, with a new family and a last bride, Oona O'Neill (she was eighteen and he was fifty-four when they married), and the stain of "Communist" on him. Charlie liked to be thought of as a man of the people: in *The Immigrant* (1917) he had celebrated the coming to America of the most humble hard-luck cases. But he was an elitist and a millionaire, too. Keaton was an uncomplaining wreck and a classic Hollywood failure—the kind of star who slipped away from glory. Chaplin had ignored sound for years before releasing his high, elocutionary voice in *The Great Dictator* (1940). Keaton sounded like a thick, ill-educated drunk when he spoke—and he knew sound crushed his persona. At M-G-M, Louis Mayer disapproved of Keaton's womanizing and drinking. The clown became a reject, whereas Chaplin set his own terms. He returned at last on April 10, 1972, for an

honorary Oscar, on one of the most emotional evenings ever known at the Academy. "Words are so futile, so feeble," he said from the stage. But he stayed at the party afterward until 1:30 A.M., chatting up a storm.

Chaplin and Keaton are beyond equal, even if W. C. Fields and Groucho Marx may be the most interesting comics American film produced. But you have to hear those two (the dreamy grump and the chronic fraud), while Chaplin and Keaton were true mimes. It's just that Chaplin made silence one more way of seeming above the world, while Keaton's quiet is as stricken as ruined philosophy. So Chaplin is silently noisy with protestation and pleas for affection, and Keaton suspects the deepest things cannot be told or uttered.

Chaplin, Keaton, Griffith, Mayer, and Mary Pickford—these are giant figures from the golden age. But today, more than thirty years after her death, despite unprecedented video recovery, how many young people would recognize a picture of Mary Pickford? "America's Sweetheart," she was called, a mature ingenue delighting the public by playing parts half her real age, an automatic maker of hits—she was on $10,000 a week as early as 1916; she would be married to Douglas Fairbanks in the first "storybook" Hollywood union (it lasted fifteen years, better than average); and she was the most hardworking and fiscally astute partner in United Artists, the distribution company she formed with Fairbanks, Chaplin, and Griffith in 1919 to protect the work of "artists," and to get them a fatter slice of the cake.

People still watch Chaplin and Keaton, Lon Chaney and Valentino. There are silent-film festivals that play to packed houses, with live music and restored prints. But the "perfect" couple from that great era, Doug and Mary, are in neglect, and they may not recover. It could be the aftermath of something Alistair Cooke noted of Fairbanks in a book he wrote in 1939 (one of the first on stardom): "'Doug' stood for the film industry's total respectability. He was not merely inoffensive, which is what parents were looking for: he was a positive ideal worthy of any small fry's adulation." Cooke added that it was the best fun to see D'Artagnan and Robin Hood playing Doug.

Fairbanks was adored in his own time. Didn't that define stardom? Yet Louise Brooks, playing bad girls, and behaving like them, and far less successful at the time, would become a byword in our cultural appreciation of ourselves.

Brooks was born in Cherryvale, Kansas, in 1906, the child of a lawyer. At fifteen she was a dancer with Denishawn Dancers, Ruth St. Denis's

company, and then in the Ziegfeld Follies. She was as smart as she was pretty, and even in the age of the flapper and the jazz baby, that was more than many men could tolerate. She had a wild affair with Chaplin just after he made *The Gold Rush*; she adored his cheerfulness, and the way he studied the dictionary while he shaved. She had made a few films, one of them, *A Girl in Every Port*, directed by Howard Hawks, in which she was so modern and sly that few audiences got her. She was a Paramount contract player, on $750 a week when the studio star Clara Bow was getting $7,500. She went in to see the boss, B. P. Schulberg, and took it for granted in her casual way that she'd get a raise—up to $1,000 a week. But Schulberg said no. It was stick with $750 or nothing—or was she rash enough to answer the letter from a German director, G. W. Pabst, who wanted her at $1,000 a week for *Pandora's Box*?

Such a mission went against the flow of traffic. Ernst Lubitsch had come from Germany to direct Mary Pickford in 1923. His star in Germany, Pola Negri, followed later the same year. Another director, F. W. Murnau, was about to start *Sunrise* in America. Erich Stroheim had left Austria before the Great War (and before the "von" in his name) and been an assistant to Griffith on *The Birth of a Nation*. The director Mauritz Stiller and his actress Greta Garbo had been imported from Sweden by Louis B. Mayer. In April 1930, Marlene Dietrich sailed on the *Bremen* to New York to join the director who had picked her out for *The Blue Angel*, Josef von Sternberg. She was put under contract at the same Paramount at $1,750 a week.

Derived from works by the German playwright Frank Wedekind, *Pandora's Box* is the story of Lulu, a prostitute and a reckless spirit in the German gloom. There is no daylight in the film, yet Lulu's white body glows like a bulb with the energy that fights her fate. She is a wanton who abandons conquests as a bored lion leaves one carcass for another. The film carries her all the way from the authority figure of Dr. Schon to a pale Jack the Ripper, who rids her of her life.

Although she spoke no German, and had little idea what the film was about, Brooks is riveting—sensual, funny, tragic, all at the same time. She would say later that Pabst (with whom she had a one-night stand) dismissed sex as a myth. "It was sexual hate that engrossed his whole being with its flaming reality." You may read the film now as a feminist statement, but who knew that at the time? What is most striking is that this is a film—impossible to be made in America because of its psychological candor and pessimism—that says, *Look*, look at her, look at the

light on her flesh, and see this great beauty destroyed. In 1929, Pabst believed *Pandora's Box* needed the spontaneity of an American actress who didn't give a fuck for the careerism that had driven Mary Pickford.

Pandora's Box is now regarded as one of the great silent films, deserving a place in the pantheon. As with Carl Dreyer's *The Passion of Joan of Arc* (1928), we hardly notice the lack of sound because the film's inward life is so intense. The sensuality is its intimacy. Falconetti's Joan is a "good girl," but the screen presence of the two women is not so far apart. They insist on our entering their heads and their dreams. So Louise Brooks, for one film, is among the immortals because, in an age of widespread romantic posing, her very look asks, "Isn't this about sex?"

Yet she did not even see the picture until the 1950s. She stayed in Germany for one more film with Pabst, and then limped back to America. When *Pandora's Box* opened in New York late in 1929 (cut by nearly a third, with a tacked-on "happy" ending), *Variety* declared, "Better for Louise Brooks had she been contented exhibiting that supple form in two-reel comedies or light Paramount features." Behave yourself!

Another review spoke of her "passive decorativeness," which leaves one marveling at how some eyes and nervous systems malfunction. Brooks would estimate in the late 1950s that she had earned barely $100,000 from all her movies. By then she was the backstairs mistress to powerful men, a charity case, and a budding writer, ending up in Rochester, New York, alone in a small apartment, uncertain whether a new generation would rediscover her. The vexed Pabst (he wanted more than one night but was horrified by all her other lovers) had warned her she would end up like Lulu.

The director couldn't grasp his own point. But you can see *Pandora's Box* any day, and its glow is damp still, as if Lulu has just had sex. She looks at the camera in her insolent way—existing, not acting—and she guesses we're there and what furtive, naughty dreamers we are in our dark. Amid the birth of a nation and a medium, a business and even an art, that's why people were going to the movies: to be voyeurs in the dark beholding an orgy of their own desires burning on the screen.

THE ERA OF SUNRISE

More than eighty years after it was made, the movie *Sunrise* (1927) is regarded as a major achievement, a monument to silent cinema, and a landmark in personal expression, all the more pointed or poignant in that it seems both American and German.

In 1958, when the magazine *Cahiers du Cinéma* asked its writers to name the best films ever made, *Sunrise* took first place. In the 2002 critics' poll organized by *Sight & Sound*, *Sunrise* placed eighth, one position below *Battleship Potemkin* (1925). That estimate surely grows out of the scholars' feeling that *Sunrise* is a Germanic lesson in America and a signal meeting of art with commerce. Can we reconcile those two attitudes? What do we think of *Sunrise* today? Is the picture stranded in history, or vital to where we are now? If that seems a tough test for a "classic," remember how progress abandons so many movies—leaving the historians looking like nostalgic chumps. Sensationalism at the movies happens now, not later.

We owe *Sunrise* to William Fox, who radically altered the life of its maker, F. W. Murnau (and may have hastened his death), out of his longing to have "a German genius" working for him. As Wilhelm Fried, born in Hungary in 1879, "Fox" was of German-Jewish descent. His name survives today in Fox Broadcasting and the Rupert Murdoch kingdom, with a mixture of notoriety and influence he might have enjoyed. His parents brought him to New York when he was only an infant, and at the age of eleven he quit school to work in a Garment District factory. But in 1904 he bought a penny arcade and then built up a chain of theaters in the New York City area. He formed the Box Office Attraction Company in 1912 to produce his own movies, less out of creative ambition than to expand in business and have more product to play. So he was making

pictures, distributing and exhibiting them, and in 1915 he started the Fox Film Corporation. By the late 1920s he owned extravagant theaters (such as the Roxy in New York, with 6,200 seats, for which he paid $15 million). He made successful films with stars such as Theda Bara, William Farnum, and Tom Mix and was trying to take over a controlling interest in the Loews releasing company.

He might have managed it, but for the effects of the 1929 Wall Street crash, which coincided with a disabling automobile accident. So many movie tycoons fell as fast as they rose. Fox was forced to sell off his own company. Litigation ensued, and he became bankrupt. He went to prison for six months in the early 1940s for trying to bribe a judge, and he died in 1952.

F. W. Murnau was a classier fellow. Born in Bielefeld, in Germany, in 1888 (given name Plumpe), he attended the University of Heidelberg (art and literature) before joining the Max Reinhardt company in Berlin as an actor and an assistant. He had been a pilot during the war—he was a tall, handsome redhead, with a deep tan—and he was gay. He began directing in 1919 and is famous now for the first notable Dracula picture, *Nosferatu* (1922), though that film did not open in America, for legal reasons. His great coup was *The Last Laugh*, or *Der Letzte Mann* (1924), a studied portrait of the humiliation of a pompous hotel porter who is reduced to being a lavatory attendant. That man was played by Emil Jannings (regarded as the great actor of those days), and the film was remarkable for its moving camera, its use of shadow, its accumulation of atmosphere, and its determination to live without intertitles wherever possible. It is also so labored as to be both sentimental and calculated, but in the America otherwise pledged to action, pace, and happiness on-screen, this portrait in sinking melancholy was received with extra respect. So William Fox resolved to get Murnau to America.

It's worth asking why Murnau accepted. He was doing very well at the Ufa studio (Universum Film AG) in Germany. He had his corps of craftsmen there, and an audience ready for his taste in material. He was living in a society more accepting of his lifestyle. But he believed the American studios were better equipped than those in Germany, and he was aroused by the thought of more money, creative freedom, and the universal audience American movies were reaching. All through the years, or until recently, most filmmakers have longed to come to America. Another reason for that, with Murnau and so many, was the naïve idealism that thought the world might be saved if one had a strong enough center of distribu-

tion, a lighthouse for the light: "The screen has as great a potential power as any other medium of expression. Already it is changing the habits of mankind, making people who live in different countries and speak different languages, neighbors. It may put an end to war, for men do not fight when they understand each other's heart."

In Germany, Murnau had been a studio director, filming in artificial light. But he was thrilled by America. "There is a tremendous energy. The whole tradition suggests speed, fastness, rhythms of nature. Everything is new. Nature has given her a vast and beautiful landscape. A marvelous variety of vegetation, a blue sea and all this within a hundred mile radius of Hollywood."

For his part, Fox sought class and novelty, a continental gravity to off-set any fear that American pictures remained crass, industrialized and trashy, and lagging behind the other arts. Fox would have been horrified to think he was seeking something Germanic—it was so important to him to be American. Yet he wanted something "infinitely cultured." Throughout the 1920s, Hollywood had experimented with European talents, such as Lubitsch, von Stroheim, Victor Sjöström, Garbo, and Pola Negri. And the results were often tragicomic.

Von Stroheim's attempt to make a piece of extended European naturalism from an American classic—*Greed*, based on Frank Norris's scathing novel *McTeague*—had led to a film so long and downbeat that Irving Thalberg, the production controller at M-G-M, had taken it away from the director and cut it down from eight hours to two. Stroheim was a true director, a visionary, and a pioneer in psychological realism, plus a nightmare to the system and a liability to himself, bound to be wronged. His attraction to sadomasochism and excessive detail alarmed his employers. It was predictable he was going to fail—but then he pioneered the place of grand failure in American films in delivering a raped masterpiece that still commands attention. But his fate made it clear that America was not really a safe haven for "Germanic genius."

Murnau's deal gave him everything he could think of asking for (including $125,000 for the first year). The script and the subject of the film were under his control. He was able to bring along coworkers from Germany, and he was indulged mightily in the most important element: the sets, or what we now call production design. The scale of the sets compelled Fox to buy new premises (in Westwood). No film of that era had an open budget, but Murnau does not seem to have been restricted. Some estimates are that $200,000 was spent on the elaborate sets—a huge sum

for those days. Above all, Fox made a public fuss of Murnau, and offered up Janet Gaynor and George O'Brien, both robustly American, to play German peasants.

Fox must have approved the German story line (even if he couldn't imagine what it would look like yet). His wife was his sturdy script adviser. Indeed, the script for *Sunrise: The Song of Two Humans* had actually been written in Germany before Murnau set out, by Carl Mayer, his regular scenarist. People said it read like a poem. It was taken from Hermann Sudermann's story "The Trip to Tilsit" (published in 1917), the tale of a young married couple living happily in the countryside until the husband is attracted to the maid. As they undertake their trip, the wife suspects the husband means to kill her.

But Mayer and Murnau changed it for the screen: in *Sunrise*, the married couple have a baby, and the maid is replaced by a City Woman, a type of vamp: dark-haired, flashily dressed, seen in her underwear once, and smoking cigarettes—Pauline Kael said she had "a dirty smile." Infatuated with her, the husband thinks to drown his wife. But the wife has no inkling of this plan until their boat trip and the menace in his attitude. The man wavers, and a heavy remorse strikes him. (Remorse is a recurring emotion in silent cinema, as if the system felt guilty over its liberation of fantasy.)

The couple's day in the city turns into a gradual reaffirmation of their love. But as they head home at night a storm comes over the lake and the wife is swept away. The husband believes she has drowned. He is racked with guilt. The suspense is tied in to moral dismay. But the wife is saved, and the love story ends in rapture and reunion, with the vamp slinking back to the city while rural serenity resumes without our having any memory that the husband had murder in his eyes or his large hands.

It was a keynote of *Sunrise* that Fox allowed Murnau to enlist his own people: not just Carl Mayer, but also art director Rochus Gliese (who had served on three of Murnau's German films) and cameraman Charles Rosher. Rosher was English and experienced in Hollywood (he had worked on several Mary Pickford vehicles), but he had met Murnau on a year-long visit to Ufa and had assisted him on his film of *Faust* (1926). There were also important German/Austrian assistants such as Herman Bing and Edgar Ulmer. This team supported Murnau and made American observers aware of him as a lofty authoritarian. He used to view the rushes, turn to his crew, and say, "Now we know how *not* to do it!" Janet Gaynor was of special value in softening her director's heart—though

Murnau himself had a romantic eye on George O'Brien, who may have been too virile to notice.

Gaynor had had to test for the part and win Murnau's approval (he had wanted Lois Moran at first), and she was amused by the way he acted so "German": "He had a German assistant director and I was told by people who could understand German that he was very cruel to him in his language, but he was absolutely marvelous to me. I adored him. I think he was a brilliant director. He was a hard task master, but you were willing to do what he said because you knew he appreciated it."

One of the things she noticed in Murnau sounds very simple, but it is vital. Directors had told players what to do, where to move, how to gesture—how to convey the plot. Murnau guided them in what they were thinking. He was known for "camera angles," but Griffith had realized a camera cannot exist without an angle—and oblique angles, done so the character does not seem aware of being watched, allow a sense of insight. "They say I have a passion for 'camera angles,'" said Murnau. "But I do not take trick scenes from unusual positions just to get startling effects. To me the camera represents the eye of a person, through whose mind one is watching the events on the screen . . . These angles help to photograph thought."

Using Germanic literary material, this team made a world for their story that is a giddy mixture of Ufa and California. For the lake and the country scenes, they went to Lake Arrowhead (to the east of Los Angeles, in the mountains) and built a German village that might be made of gingerbread, with pointed, expressionist gables. If that felt odd, they justified the décor by turning the brunette Janet Gaynor into a blond, braided Gretchen figure, straight from German folklore.

There were many night scenes (done back at the studio), where an early and lustrous version of noir was achieved. The husband goes to meet the City Woman in a marsh, with the moon hanging in the night sky like a scaffold. The marsh is a set with an atmospheric richness and botanical detail not attempted in America before. This sequence involved beautiful, searching tracking shots (done from overhead tracks), with the husband made more sinister by having twenty-pound weights in his shoes. O'Brien was urged to act with his back, for he is often seen as a hulk crouched in menace or guilt. Meanwhile, the vamp waits at the edge of glossy water, in her city clothes. The marsh is a state of mind; the lighting is mannered, moody, and strictly controlled. You feel you are there, hesitant and anxious to see what will happen—whereas with so many

American silent films, we are witnessing a tableau, a staged event, limited to a single emotional attitude. It is the difference between feeling you are at the theater and inhabiting the lifelike illusion of the movies.

In one of the most striking moments, the City Woman and the man talk of visiting the city. It appears, like a glowing mirage on the horizon, and we see the backs of the two lovers as they watch and imagine they are there, just like members of the audience. It may be one of the first images within a film that says, *this*, this is what the movies are about, watching and dreaming.

As befits a dream, that mood is nocturnal. But by day, the lake and the village are awash with American sunlight, which Rosher films with great tenderness. This is where you feel Murnau's delight in America. Then it is comic and charming that what should snake out of the deep pine forest is a trolley car on tracks. This is how the husband and wife go to the city after he has revealed his murderous instinct to her in their fragile rowboat. But as the two of them sit hunched in shock and silence on the trolley, Murnau creates a magnificent tracking shot (a full mile of tracks was required—people said he had "unchained" the camera) in which, through the windows, we see the country turning into the city. Then we are there, in the unnamed and archetypal city (less Tilsit than Broadway, though Gliese and Murnau wanted a "universal city"). This is another masterpiece of art direction, with models, painted glass, tricked perspectives (and even dwarves to match them), and the feeling that it is a wondrous thing to put a place—its space and its atmosphere—on film.

Nothing as rich as this had been done before in American film. But the backgrounds are subtler than the interaction between the couple. It's as if the world of a film eventually would need to deepen the human behavior. The same can be said for Victor Sjöström's *The Wind* (1928), in which Lillian Gish is a tremulous Virginia girl who moves to West Texas and is tortured by the elements (as well as unkind men). The feeling for place and weather (even without the sound of the wind) is so much more penetrating than the pieties of the story line. Lillian Gish is valiant and artful in *The Wind*, but she is doing too much—as if guessing the story was archaic and restricted. Gish had presented the subject to Irving Thalberg and functioned as a kind of producer. The film flopped and helped close Gish's career at M-G-M. Her natural replacement as icon and actress was Garbo, whose persona was so much more modern, inward, and flawed.

So the cinematic facility and the beauty in *Sunrise* keep bumping up against the film's daft situation. We relish the night in the marsh, feeling its seductiveness and its danger, but what should we make of the film's city? In an open boat on the lake, the wife has had every indication that her husband wants to remove her. Yet Mayer's script and Murnau's film ask us to believe that a day in the city (or half an hour in the movie) restores their love and trust.

The city scenes are enjoyable, but they are the part of the film where Murnau may have yielded to studio pressures. There is a "Comedy Consultant" in the credits, and there are scenes—at the barber shop, the photographic studio, the wedding they happen to observe, and the pig-catching adventure—that seem to come out of a standard American movie. So be it. Those scenes play well enough. But they contribute to the notion of the city as an expansive, amiable, and fun place, as friendly as it is lively. Nothing in this city is foreboding or indicative of real urban problems. Nothing suggests the vamp lives there, or that the city has made her. So it's hard to ignore this question: Should the couple who have come close to falling out of love in the country move to the city to have a more fulfilling life?

Moreover, can the husband be relied on? Throughout the picture, O'Brien's oppressive presence (his thinking) signals his violence as much as that hunched posture and the lead-footed walk. Murnau is teaching us that it can matter less in a movie what a person says than what he is. So the husband "sees the light" of sunrise, but we can't forget his ingrained hostility, the natural grasp of a strangler's hands, or the way he takes a knife to threaten a foolish man in the city. George O'Brien's husband needs more than his Gretchen, their plump baby, and the pleasures of Lake Arrowhead to be made whole. He has no apparent occupation. He is idle and dangerous. What is most penetrating in *Sunrise* is leading it past the guidelines of a prim scenario. The film says "come to the city" and "stay in love" at a time when Hollywood was in confusion over both the town/country split in America and the condition of marriage.

Around 1920, the balance of U.S. population first moved in favor of "urban" over country. Remembering that the population at the moment of independence was about 95 percent rural and 5 percent urban, in 1920 the balance was 49 percent rural and 51 percent urban. (It is by now three-quarters urban and a quarter rural.) As a mass medium, Hollywood was deeply concerned about that shift. It was in the business of building great urban theaters (such as the Roxy, which opened in 1927), but it had

to retain the rural audience, and honor its conservatism and adhering religious attitudes. At key moments in *Sunrise*, a church bell tolls as a sign of moral surveillance. This soundtrack, with music by Hugo Riesenfeld, was not synchronized at first, but played separately on Fox's Movietone system.

Janet Gaynor's wife is as vague and bright as a Madonna, and the film is loaded with disdain for the City Woman. But it can't take its eyes off her either. As played by Margaret Livingstone, she is vivacious, quick, up-to-date, and . . . here's the word: sexy. Why not? Isn't this a movie, and isn't looking at pretty women (from the safe dark) a terrific kick in movie-going? That's what distinguishes Louise Brooks in *Pandora's Box*, and it is likely that her director, G. W. Pabst, had seen *Sunrise*. Yet silent cinema was often shy of admitting its own voyeurism. We regard Lillian Gish as a hallowed figure, but was she ever sexy, or just the figurehead of an archaic notion of virtue? Cecil B. DeMille, who became a success just as Griffith faded away, was greedy, and horny for Gloria Swanson as the new woman. The scene in *Sunrise* where the City Woman walks into plain view, without coyness or embarrassment, in her black underwear is a gift that says, didn't you want to see this?

No character in *Sunrise* mentions divorce, but the public was already trying it. In 1900 in the United States the divorce rate was 84 per 100,000 men, and 114 for women. By the early 1930s, the figures were 489 and 572. (By 2000 they were 9,255 and 12,305.) No one would say the movies did that alone: the impact of the Depression and the wars played a part, and the overall liberation of behavior from stale rules was getting ready for feminism and gay marriage, to say nothing of divorce.

Moviemakers were well aware of the surge in divorce—but anxious not to be blamed for it. Still, the movies were a sensational public spectacle where audiences were encouraged to gaze at good-looking people (different ones every week) and dream of their chances. *Sunrise* is hailed now for its modernity, leading the medium into art, but it is a very old-fashioned film, harking back to the purity and deserving romantic aspirations of the young wife. Janet Gaynor is not that far removed from Lillian Gish in a film that never dares ask itself, perhaps she's dull? (How could someone so good be dull? That is a dangerous question for every young woman.)

Well before *Sunrise*, Cecil B. DeMille did a series of films with "daring" titles—*Don't Change Your Husband* (1919) and *Why Change Your Wife?* (1920)—that flirted with the possibility of divorce. As a rule, those

films settled eventually for the marital status, but not before Gloria Swanson, their star, had time for amorous experiments and taking a bath. DeMille liberated the bathroom as a locale, with hot water, steam, perfume, and undress as its extras. This was an era when the sale of cosmetics for women rose rapidly. "Max Factor" (real name Maksymilian Faktorowicz) came to America from Poland, and later he moved to Los Angeles. He brought a gold called makeup. That new room in the culture, the bathroom, became a site of dreaming, a dressing room in the slow shift where so many of us became performers. In his excellent life of DeMille, Scott Eyman tells the story of C.B. urging Swanson on in a bath scene: "Prolong it! Relish the smell of the rosewater. More rapture."

The director's note to an actress coincides with the audience's feeling about the promise of movies. So some spectators wanted nicer bathrooms, false eyelashes, pretty clothes in the latest styles, as well as more adventure in life. Swanson would say that "Working for Mr. DeMille was like playing house in the world's most expensive department store." Movies had an unstoppable affinity with shopping, and it showed in the credits for wardrobe or costume, facilities that many women had not guessed they might possess, or deserve. In 1924, Edward Steichen took a famous photograph of Swanson staring through a veil of elaborately decorated black lace. It could be the poster for the era.

As late as the early 1950s, in America and Britain, many middle-class women made their own clothes on Singer sewing machines from paper patterns. In the early years of feature filmmaking, most people bought clothes out of necessity, not for pleasure or self-expression. One revolution in films of the 1920s was not just looking at women, but also delighting in what they were wearing, or half-wearing. So pretty women became prettier in expensive and fanciful clothing, often made out of light-catching fabrics such as charmeuse, satin, and silk. Such clothes were beyond the budget of ordinary audiences, but movies cheerfully celebrated wealth and style, and brought them within a more common range. *Pretty Woman* lifts off as a dream when the Julia Roberts character goes to Rodeo Drive to shop for a transforming wardrobe.

Many movies of the 1920s had increasingly slim stars in very fashionable clothes. Designers were hired in, and sometimes they were only a step away from stores and lines of clothing. What was the romance of movies but the thought of changing your life? The most important thing about Louise Brooks in America in the 1920s was not her acting, or *Pandora's Box*; it was her haircut. The Oscar for costume was not introduced

until 1948, but the art, the cult, and the business consequences had been current for decades.

Travis Banton (from Waco, Texas) got a start doing Mary Pickford's wedding dress when she married Douglas Fairbanks in 1920. Then, from 1924 to 1938, he was in charge of clothes at Paramount, where he did the von Sternberg–Dietrich films, among hundreds of others. Edith Head, his assistant, would win eight Oscars for costume, and was essential to the looks of Audrey Hepburn and Grace Kelly. More recently, we have had Milena Canonero (*Barry Lyndon, Out of Africa, Damage*) and Sandy Powell (*Shakespeare in Love, The Aviator, Hugo*). And it's not just clothes for women: Giorgio Armani dressed Richard Gere in Paul Schrader's *American Gigolo* (1980), a landmark in the right to be stylish. Perhaps it was an old habit coming back: so many of the first moguls had begun in the clothing business.

Some observers were nervous about the glamorizing of clothes and bathrooms, and feared it could lead to libertinism and consumerism! For a moment there was a worry that foreigners (Jews maybe?) and upstarts were corrupting the respectable codes of behavior in the greatest and most moral country on earth. It passed. If you show people a half-dressed wonder when the person inspected seems unaware of being seen, and flaunting it, then the audience become voyeurs, floating on the dream that they might go further. "More rapture." It is the promise in the shining light, and it means a yearning for "stuff," clothes, and wanting to look like him or her, or both of them, that won't stop. Most movies ever made have been inadvertent commercials for the stuff.

Sexual suggestiveness was an elixir, but a hazard, too. In the year 1928, for instance, out of nearly 3,000 cuts made in new films as censorship, 509 were because of "Sex—Suggestive." The only topic that needed scissors more was "Display of Dangerous Weapons": 528. *Sunrise* has no guns, and guns were glorified by movies from the very start. (At the end of *The Great Train Robbery*, 1903, in a mood of defiance and bravado, a cowboy fires his six-shooter straight into the camera.) But *Sunrise* is tense with thoughts of murder and so it bears out another engine in movies— that of destruction and disorder, culminating in killing. In a hundred years, the movies have dissolved so much of our resistance to murder. That homicidal weight in the husband is never examined or questioned. He isn't expected to see a shrink! The menace is there, and implicitly it's just another aspect of restless manliness.

Sunrise had its premiere in New York in September 1927, only a few

weeks before the opening of Al Jolson in *The Jazz Singer*, the first significant talking picture, the addition that could have made *Sunrise* more dangerous, or immediate. Not that the film lacked admirers. The *New York Times* called it "a brilliant achievement," and in *Life*, Robert Sherwood (soon to be a playwright and screenwriter) said it was "the most important picture in the history of the movies." It played twenty-eight weeks in New York and ten weeks in Los Angeles, but it was not popular in the rural provinces. In Los Angeles, Irene Mayer wrote to her then-boyfriend, David O. Selznick, saying it was the picture that anyone young and smart *had* to see. Perhaps she got her father to see it.

Movie people were impressed by *Sunrise* because of its intimations of what films could do: the creation of a credible, living world (the city) and the way in which, in Molly Haskell's words, "Murnau's city often seems like a metaphor for the sound film, trying to burst into the peaceful haven of the country, the silent film." That's a retrospective insight, and a good one, but not one that occurred to Murnau. A comment closer to the director's gaze, perhaps, is Thomas Elsaesser's observation that in *Sunrise* we face "the open secret of film-making itself, intensely eroticizing the very act of looking, but also every object looked at by a camera." The sheen in *Sunrise* is the glow of desirability. It affects all three of the leading characters, but it is an illumination that hangs over the world. It is incandescence. People felt they had seen insight, and once glimpsed, that is nothing you ever want to lose.

•

But that is not all of the *Sunrise* story. What we see as erotic could be read as respectability in 1927, and respectability was as important a goal in pictures as money. The American movie business was an avalanche in the 1920s, the prime age of motion pictures. Going to the movies and thinking about them became a regular part of popular culture. But that only provoked an envious reaction in those other strongholds that believed they directed the national culture: the churches; academia; Washington, D.C.; the high arts.

If you want an example of that disdain, go to "The Cinema," a superior yet discerning essay written by Virginia Woolf in 1926, a year after the publication of *Mrs. Dalloway*, a novel that seems richly affected by film—not just in visibility, its present tense, and its unwitting but contingent circles of action, but also in the immediacy of feeling we are "there." In fact, in 1925 there were few screen moments as rich as *Mrs. Dalloway*

could be—and Mrs. Woolf was enough of a filmgoer to be in no doubt about that.

"The Cinema" starts off on a note close to contempt: "People say that the savage no longer exists in us, that we are at the fag-end of civilization, that everything has been said already, and that it is too late to be ambitious. But these philosophers have presumably forgotten the movies."

Woolf does not attack the movies. Rather, she notices the very thing about them that may be most profound and lasting: the altered relationship with reality. Speaking of the things seen (essentially documentary phenomena), she notes:

> They have become not more beautiful, in the sense in which pictures are beautiful, but shall we call it (our vocabulary is miserably insufficient) more real, or real with a different reality from that which we perceive in daily life? We behold them as they are when we are not there. We see life as it is when we have no part in it. As we gaze we seem to be removed from the pettiness of actual existence.

The closest Woolf comes to an example is in mocking the prospect of a movie made from *Anna Karenina* (there would be one in 1927, called *Love*, with Garbo as Anna): "For the brain knows Anna almost entirely by the inside of her mind—her charm, her passion, her despair. All the emphasis is laid by the cinema upon her teeth, her pearls and her velvet."

Love was an M-G-M film, made under Louis B. Mayer's aegis, and 1927 is the year of *Sunrise*. There's little chance that Mayer or Murnau had read Woolf's essay, but ideas critical of the cinema had been in the air ever since realization of what sway the new medium had with the public. The movies could have endured that worrying without stress. But scandal had been piling on the bandwagon of ill repute. And scandal is as much a part of the movies as popcorn and daydreaming.

As motion pictures were established in America as a factory system of production and a mass medium, so the frontier town of Los Angeles (bracingly far from eastern supervision and controls) observed the unsurprising behavior of attractive young people given money and adulation for their part in sensational scenes of adventure, frolic, and something close to orgy. That may not fit today's estimate of silent cinema, but it catches the thrill of photoplays and shimmering nitrate imagery larger than life in

the 1920s. In just a few years the vestiges of Victorian restraint and modesty were thrown aside.

Roscoe Arbuckle was a very successful comedian. For a moment, he was in the class of Chaplin, with a $1-million-a-year contract at Paramount. But he was known as "Fatty," and that was his persona on-screen. He was overweight; he had a drooping forelock and a naughty grin. Over the Labor Day weekend of 1921, Arbuckle drove up the coast to San Francisco in his brand-new Pierce-Arrow automobile and threw a party at the St. Francis Hotel. It filled three adjoining suites and went on day and night; it was what the press called a wild affair. At the end there was a corpse, Virginia Rappe, a starlet with a bad reputation, the kind of young woman who is often enlisted for celebrity parties. She had been found screaming, claiming assault, and she died in the hospital of a ruptured bladder. Stories spread that she had been raped and murdered, and since it was Fatty's party, manslaughter charges were leveled at him. Some said Rappe had actually accused the comedy star. Had Fatty done a foul thing? Did the facts matter in the furor of scandalous attention?

The suites were trashed, liquor was available, and more than fifty people were involved. Naked women had been seen—or so people seemed to remember. But at the movies, too, even in 1921, people sometimes believed they had seen outrageous things on that screen, things they could not touch but could not stop thinking about. There were three trials, and two split juries, before Arbuckle was acquitted. The third jury added to their verdict the thought that "A grave injustice has been done him." But the fiancé of the dead woman, the director Henry Lehrman, said, "This is what comes of taking vulgarians from the gutter and giving them enormous salaries and making idols of them. Some people don't know how to get a kick out of life, except in a beastly way."

It was hard for the public to regard Fatty as innocent when that face was on the front pages, the face that had made him. Paramount had cancelled his contract—there was invariably a morals clause in such deals, an opportunity for the studio to walk away if the star was beastly, or difficult. Arbuckle was never the same again. He had to work as a director under a pseudonym—Will B. Good was suggested—but he was dead by 1933, aged just forty-six.

Fatty's was the most famous scandal, but there were others. In September 1920 the beloved and sentimental star Olive Thomas—once called "the most beautiful girl in the world"—was found dead at the Hôtel de Crillon in Paris. She seemed to have taken bichloride of mercury,

a poison, but it was reported that she had also been using heroin and co-caine. The same year, Griffith's actor Robert Harron (the hero in the modern story from *Intolerance*), shot himself in a New York hotel; it was described as an accident. Then, in February 1922, the director William Desmond Taylor was found dead in his apartment in Westlake, Los Ange-les, shot by a .38. Studio agents got there ahead of the police. Love letters were burned and pornographic pictures were discovered. Very soon, the actresses Mabel Normand and Mary Miles Minter, both of them in Tay-lor's thrall, were implicated. Normand, a national sweetheart, was found on the Taylor premises searching for letters; she said it was "to prevent terms of affection from being misconstrued." The case has never been solved.

A year later, Normand's chauffeur shot and killed a millionaire who had been pursuing the actress. Her career was wrecked and she was dead by the age of twenty-six.

In March 1922, Wallace Reid, a popular actor and director, was taken to a sanitarium addicted to morphine. He had been given the drug after a car accident. Later he turned to booze—in all this period, the era of Pro-hibition, alcohol was as natural as the light, but its presence was a frisson for the public. Reid died in 1923.

Hollywood took fright. There was a fear among the business leaders that these scandals would assist the large but vague moral disapproval of the sensationalism in movies. So this is the moment when Will Hays, campaign manager and then postmaster general for Warren Harding, was hired to be the first head of the Motion Picture Producers and Distribu-tors of America, a post he held until 1945.

Hays couldn't police every love nest in the Hollywood Hills, but he set down a code of propriety and hypocrisy for the pictures. It was the Hays Code that would become the Production Code in 1930. It outlined a lot of subjects that could not be dealt with and sights that could not be shown. What no one admitted was that scandals added to the entertain-ment value of the picture business and seemed to endorse the suggestive-ness of the medium. The process was inseparable from a new press attention on the movie world, the founding of fan magazines through which the studios could promote their properties while offering pin-up pictures as fetishistic objects. Indeed, the public wanted to believe the worst of its idols (because that distant worship goes hand in hand with malice and a need for retribution), and took that hostility as a kind of right. It is the start of a weird and pious energy in the public, delivered

through mass media, a love-hatred for the figures in the light. (The huddled masses may have hurt feelings, resentment, and even murder in their hearts.)

In *The Day of the Locust*, his 1939 Los Angeles novel, Nathanael West felt the smoldering anger in the crowd looking at movie life on- and off-screen. These were the masses who had gone west, on the roads or in their spirit, hoping for so much. But the hopes were not met, and they festered in the sun:

> Their boredom becomes more and more terrible. They realize that they've been tricked and burn with resentment. Every day of their lives they read the newspapers and went to the movies. Both fed them on lynchings, murder, sex crimes, explosions, wrecks, love nests, fires, miracles, revolutions, wars. This daily diet made sophisticates of them. The sun is a joke. Oranges can't titillate their jaded palates. Nothing can ever be violent enough to make taut their slack minds and bodies. They have been cheated and betrayed. They have slaved and saved for nothing.

Perhaps that sounds more like today. Not many were as pessimistic or outspoken in 1939, and West was killed in a car crash in 1940, the day after F. Scott Fitzgerald died (he may have missed a STOP sign when he heard of Scott's death on the car radio). Still, in those industry leaders whose own lives had been transformed, there was no missing the dread of envy and worse in all those—like "everyone"—who had been disappointed. So perhaps it was better to have rules to stave off another insurrection.

Will Hays was the model for self-regulation by the industry, and the bosses also needed a shield to settle the risk of separate states taking action against "indecent" films, and as a preventative measure against federal intervention with movie content.

The scandals abated a little after 1921–23, but there were still ugly or mysterious incidents, such as the sudden death of Valentino (1926), the death of director Thomas Ince (1924) on William Randolph Hearst's yacht, or, soon after his body was removed from it, the breakdowns that afflicted Clara Bow in the late 1920s, or the death from narcotics of actress Barbara La Marr in 1926. Gone at twenty-nine, she had been married five times. Americans had not led such lives before—or not had them so widely exposed to the public.

Of course, those personal downfalls, so easily illustrated, helped mask

another type of scandal that was habitual in the film business: the misre-
porting of financial returns, the steady use of business malpractice, in-
cluding a defiance of antitrust statutes in a trade so new the lawyers were
laboring along behind the bosses' cunning. Remember, in the 1920s, when
so much money was made, agents hardly existed. The young talent had to
deal with the studios on their own, or through parents, husbands, and ill-
prepared lawyers.

Ahead of agents, there was another form of life feared and mistrusted
by the system: unions. In November 1926 the producers signed the Studio
Basic Agreement with the International Alliance of Theatrical Stage Em-
ployees and Moving Picture Technicians (known as IATSE), a union that
covered laborers, stage hands, carpenters, painters, electricians, and even
projectionists, but not the talent credited on movies. This was bad enough,
but it threatened the organization of actors, writers, and directors.

No one was more concerned over this than Louis B. Mayer, horrified
at the mania for collectivization that had swept his old country. So it was
Mr. Mayer who called the dinner party to inaugurate the idea of the
Academy. He was also eager to tame the atmosphere of bad behavior that
he feared was demeaning the movies. So he saw the Academy as a bland
uber-union, a forum where grievances could be aired and settled, and the
companies would act as benign arbiters. But he loved the other notion,
that an academy should identify excellence. If there could be something
like a "Best Picture," then by implication movies were striving to be good,
wholesome, and enriching for the public.

The Academy merely delayed the forming of unions, the Screen Ac-
tors Guild (established in 1933) and the Writers Guild (older but only re-
ally active from 1933), which would stir up trouble in the 1930s and '40s,
so that they were often thought to be "Red." The Directors Guild came
into being in 1936. But the Academy was a set of rose-colored spectacles
that substantially fooled the audience. To this day, the hope persists (just)
that our movies must be worthy because of that silly statuette, and the
show that marks its offering—it was called Oscar, probably, because
Margaret Herrick, the first librarian of the Academy, looked at the sketch
made by Cedric Gibbons (the top designer at M-G-M) and said it looked
like her Uncle Oscar.

The first Oscars were announced on February 18, 1929, to cover films
released between August 1927 and July 1928. There were special awards
to Chaplin for *The Circus* and to Warner Brothers for *The Jazz Singer*—
hardly good but certainly the future. Rochus Gliese on *Sunrise* lost for

"Interior Decoration" to William Cameron Menzies for his work on two films. Charles Rosher and Karl Struss won the first cinematography Oscar, for *Sunrise*. Janet Gaynor took the Best Actress Oscar, but for her work on three films: *Sunrise*, *7th Heaven* (1927), and *Street Angel* (1928) (all Fox productions). There was no single Best Picture that first year. Instead, there was one award for Best Production—it went to *Wings*, a Paramount picture, directed by William Wellman, a spectacular account of air combat during the Great War. And an award for "Artistic Quality Production" went to *Sunrise*. In fact, the board of judges had at first voted King Vidor's *The Crowd* (1928) the winner in that category. No matter that *The Crowd* was one of his own studio's films, Louis B. Mayer argued all night with the board that the award should go to *Sunrise*. He got his way. But that was the only year in which the Academy tolerated a split in its soul and acknowledged that art was not business. Thereafter, no such rift was permitted. The Best Picture would be the best picture. So *Sunrise* stands alone for both the crystallization of movie atmosphere and as a gesture to the system's desire for class.

Murnau had not long to live. He tried other films at Fox, without recapturing the status of *Sunrise*. His reputation sank as swiftly as it had risen. He found himself pleading a case now to a William Fox no longer smitten by German genius. For *City Girl* (or *Our Daily Bread*; 1930), Murnau said, "I should like to make a tale about wheat, about the sacredness of bread, about the estrangement of the modern city dwellers and their ignorance about Nature's sources of sustenance." He never quite realized that Fox dealt in corn.

In search of a purer existence and an elemental fable, Murnau took off for the South Seas on a sixty-foot yacht (skipper as well as director) with the documentarian Robert Flaherty. There they made *Tabu* (1931), with such burnished images of Polynesians you might guess Murnau was homosexual. It is a rhapsody to sunlight on the water and the perfection of young native bodies in which the central figure, Murnau thought, was like "a model for the Olympic Games" (to be held in Los Angeles in 1932).

Back in California, he hired a reckless chauffeur, an attractive Filipino, and was killed in a car crash in March 1931, days before *Tabu* opened. (So many car crashes—the battle between liberty and discipline on the new roads?) He was only forty-two, and more of a master than William Fox ever realized. Eleven people attended his funeral, one of them Garbo. If he had lived to find an American idiom, and worked with her, he might

have reached authentic tragedy in which sound let her heave a last sigh. As it is, *Sunrise* hovers on the horizon still, and asks whether we really prefer Janet Gaynor's wife to the excitement of the city and the allure of the City Woman. Perhaps the ultimate message is the white lie that we can have both in our dark.

THE CINEMA OF WINTER

The years immediately following the First World War were strange ones in Germany. The German mind had difficulty in adjusting itself to the collapse of the imperial dream; and in the early years of its short life the Weimar Republic had the troublesome task of meeting outside demands (the onerous terms imposed on Germany at Versailles) while at the same time maintaining equilibrium internally (the Spartacist revolt of 1919, the unsuccessful Kapp Putsch of 1920). In 1923, after Germany had failed to pay the war reparations laid down at Versailles, French and Belgian troops occupied the Ruhr, and inflation, which had always been a serious danger, could not be stopped. The material conditions which resulted led to a general decline of values, and the inner disquiet of the nation took on truly gigantic proportions.

—Lotte H. Eisner, *The Haunted Screen*, 1965

A cold, somber atmosphere pervades the opening scene of the film. Francis and an older man are sitting on a bench by a high forbidding wall which curves away into shadow. The leafless branches and twigs of a tree hang down above the heads of the two men: dead leaves carpet a path in front of them, emphasizing the lifeless, still quality of the setting. On the opposite side of the path to the bench are a couple of stunted fir-trees: winter is in the air. Both the men on the bench are dressed in black; their eyes gape wildly from pale faces. The older man leans over towards his young companion to speak to him; Francis, apparently not very interested, responds by staring blankly skyward.

—Carl Mayer and Hans Janowitz, *The Cabinet of Dr. Caligari*, the screenplay, 1919

If Charlie Chaplin had lived in this sunless world, he might have killed himself, for surely the Tramp had a disposition toward sorrow or gloom. But the light on Chaplin's street is the California light that inspires American cinema. If his pictures end on an iris into the Tramp and his girl

walking into the future, then they are headed toward the sunlight, too, and it warms them and promises to take care of them. Is that the abiding commercial cheerfulness in American film, the urge to spend money on a ticket and be with strangers in a shared mood, or is there some glow in the American screen, the sheen of burned emulsion, the wash of natural light, the promise of summer, the unforced imprint of a modest but habitual optimism? Who had heard (then) of the "inner disquiet" of the United States? But now that that despondency has set in, who can forget the influence of Germany on the light show? Imagine a book about Hollywood in the 1920s called *The Haunted Screen*.

The German army was the most efficient force fighting in the First World War, so the collapse of the country at the end of that war struck at the nation's confidence. There was the dismay of an army that believed it had never been defeated. There were the actual losses of the war and the inroads of influenza in 1918–19. There was the severity of the terms of the Versailles peace—including loss of territories, the reduction of the army to a hundred thousand, and then the crippling reparations meant to rebuke culpability in the war. There was the political chaos of 1919 and 1920, with attempts at Communist insurrection, rightist retaliation, the uncertain role of the mob, and the execution of figures such as Rosa Luxemburg and Karl Liebknecht. There was hyperinflation whereby in four years in the early 1920s the value of a gold mark went from one paper mark to a trillion. Instead of wallets, you needed sacks. And there was the determined exploration of decadence that set in, the seething variety of sexual behavior, the public performances verging on the indecent, and the attraction of Berlin as a residence for so many of Europe's young avant-garde. Plus the sense of violence coming.

The arts flourished, even if much of what was done frightened middle-brow tastes. In the ten years that followed the war, Berlin was probably the most exciting city in the world, a place where the crises were being enacted—whereas Los Angeles was a tranquil watering hole in a benevolent climate amid great natural beauty. That's one of the reasons, after Europe turned so cold, that creative refugees and Berliners such as Christopher Isherwood went to California.

This is the period and the mood associated with Isherwood's observations of Berlin made more famous in the musical *Cabaret*, which in turn is based on the 1951 play *I Am a Camera*, by John Van Druten. At the start of his 1939 novel, *Goodbye to Berlin*, Isherwood promises, "I am a camera with its shutter open, quite passive, recording, not thinking." That the sentence was so taken up suggests it met many needs. For Isherwood,

it was a lesson in staying wide-eyed, in seeing everything, without being judgmental, the sort of cry that rings through the first decades of cinema and attests to the way people and societies were struck by so many things, outward and inward, that they had not noticed before.

Surely there was reason for being less judgmental—though the 1930s in Berlin would end in that very decisive, moralistic decision to have a war. But Isherwood's words announce something more chilling: a time has come for the passivity that has abandoned thought. It is the detachment and the helplessness of the camera as a neutral machine that seem alluring and persuasive. Is that like a camera photographing the business of the concentration camps? Isherwood would have never wanted that. Nor would anyone—except for those cameramen who did record much of what went on in the camps, and who would say they were only following orders. Or were they helpless adjuncts of the camera? In fact, Isherwood had one thing wrong: you can't leave the shutter open; it has to open and close; decision and choice have to intervene. But his insight about our willful self-denial and our urge to be like a camera is vital.

Not to burden this point with the concentration camps. There are subtler issues. Last night my son and I watched one of the *Jackass* movies. These are crudely made anthologies in which a gang of guys does absurd and reckless things to be amusing. In the film we saw, people snorted wasabi and vomited extensively; they tried roller-skate tricks that ended in disaster; they had bullets fired at them; they urinated on slush and ate it; one man put a toy car into his rectum. Several times, my son and I asked ourselves, "Why are we watching this?" I could have said it was to bring the material to this book, but I was laughing sometimes, and in dismay at my own reaction—that is more to the point. These are American films (and they are very popular with teenage boys). They are—if you want to hear the critic for a moment—nihilist extravaganzas, shameful and shaming, but irresistible. What will these idiots do next? Will you watch this? My son and I didn't feel like a camera, exactly, but I think we felt overpowered by the screen and *Jackass* being there. I watched another film afterward, a "real" film, and for half an hour I could not shake the sensation that it was *Jackass* going on and on, infecting the rest of the schedule. Once upon a time, *Monty Python's Flying Circus* had that effect on any shows that followed it.

•

In Berlin in the 1920s, a movie was not always benign light show, the sustained fantasy version of reality and a stream of beguiling stories for

the public; it was a screen, often stark, tattered, and ominous, a place where Germans looked at a drastic portrait of melancholy. The audience was not invited in to the screen to relax; they were meant to behold it like children in a pitiless examination. For the screen now was not an easeful conveyance but a trick in a confounding demonstration of complicity and deception. For the first time—no matter from what disquiet—an essential question was being asked that endures today: "Are we mad to be believing in screens?"

This is not to minimize the confusion in Germany—in the next twenty years, this was the country that would film so many naked corpses being bulldozed into a waiting pit. The deepest questions in German society and movie experience would be, Do we see this? Do we believe it? Then why are we watching?

Let's start with that icy garden in *The Cabinet of Dr. Caligari* where Francis and an older man are companions in a kind of stricken oblivion. Its coauthor Hans Janowitz came from Prague, "that city where reality fuses with dreams, and dreams turn into visions of horror," as the cultural historian Siegfried Kracauer put it. Janowitz recalled a day in 1913: He was walking in the Reeperbahn, in Hamburg; he began to follow a pretty girl, until he realized that another shadowy male figure was also nearby; he heard a sinister laugh. Next day in the papers, he read that a pretty girl had been murdered in that area. He went to the funeral and there, also in attendance, was the shadowy figure from the night before.

The war intervened, and then a few years later Janowitz met Carl Mayer, an Austrian. They were bonded by their experiences in that war. Janowitz had a hatred of officers and authority because of the slaughter. Mayer was similarly moved, with this extra: he was himself often under suspicion of being insane—as if a man did not need to be crazy to endure that war. The two men agreed to collaborate, and wrote a story in which a strange fairground operator, Dr. Caligari, has a somnambulist, Cesare, who is sent on missions of murder and destruction. The hero, Francis, realizes this. He tracks Caligari down and is astonished to discover that the man has taken refuge in another guise—as the head of a lunatic asylum. Francis is then able to unmask the villain.

In October 1919, Janowitz and Mayer took this story to Erich Pommer, the head of the Decla studio in Berlin. Pommer bought it on the spot, and as soon as February 1920 the picture was being shown in Berlin. What more could writers ask?—and this is, evidently, an example of a film generated by writers (a much rarer event in America at that time).

But as the producer and the owner, Pommer exercised himself. He changed the script. He made the ending more palatable in that Francis turned out to be an inmate of the asylum. Caligari is the benign director of the place, and now that he has seen Francis pursue his "vision," he believes, "At last I understand the nature of his madness. He thinks I am that mystic Caligari. Now I see how he can be brought back to sanity again." And so the film ends with the Director's face, "a thoughtful, pleased expression on it."

In the original Janowitz tale there lurks this possibility: The young man follows the girl and sees a mysterious figure doing the same thing. The shadowy figure apparently murders the girl. But if the young man is disturbed, then, in following the girl, he may be revealing his own hostility as much as interest or attraction. So the shadowy figure may not be a stranger—he may be the darker side to the young man's nature, and the cover for his murder of the girl. So they are both at the funeral the next day because they are aspects of the same person.

This is akin to *The Strange Case of Dr. Jekyll and Mr. Hyde* (published in 1886), and a theme in so much nineteenth-century German writing—including that of Hoffmann, Novalis, and Freud. More important, this idea of the other, or the doppelgänger, is something that some Germans saw embodied in the essential circumstances of cinema. For instance: I go to the movies; I enter the darkness and confront a great light; I see a figure, or figures—some of whom may be antipathetic, but some of whom are so appealing that I imagine them as myself. I identify with a character, and I place my capacity to identify in the context of the story—so, in the case of Griffith's *Way Down East*, say, I am in love with Lillian Gish, I see myself as Robert Harron's hero, and I despise and disapprove of Lowell Sherman, the villain. I enter the melodrama and I come away feeling a little better about myself. Griffith pioneered so many ways of shooting, but his melodramas seldom required a more complex approach than this.

That is one way of putting American cinema in a nutshell—even today it catches the fantasy appeal of going to the movies. Whereas the German cultural tradition was more prepared to see identification itself—as a sign of error and illness. Freud had elaborate theories on "the screen" as a psychological mechanism for observing ourselves and admitting our doubled personality. Take an example from something more familiar than *Caligari*: *Psycho* (1960), the film made by Alfred Hitchcock, the English-speaking director most affected by the foreboding stylishness of German cinema.

In *Psycho* we concentrate on Janet Leigh. She is nice to look at, she is wholesome and pleasant, and three times in the first forty minutes of the picture we see her in her underwear (in ways that troubled the Production Code). So we watch more closely in case we may see more. We like her. We hope she will do well. Then her character does wrong: she steals $40,000. That impulse is folly, but it is understandable. We adopt a "double" stance: we say, I might have done that, too, but we add, "Oh, you bad girl." The voyeuristic tension of the picture builds so that we desire Janet Leigh *and* feel her need to be corrected—so the grail of her naked in a shower meets our longing.

Then a strange man appears: Norman Bates (Anthony Perkins). He resembles her lover—but he is more understanding than the lover. He talks to her, and we slip into that lengthy conversation. We like this Norman, and we see that his kindness helps her realize how foolish she has been. Could they ever be a couple? In so many American films, everyone looks at anyone with that prospect in mind. Janet is going to go home the next day and return the stolen money. Her problem seems to have been tidied up. But our tension, our desire, our feeling, has to go somewhere, and Hitchcock is sufficiently understanding of fantasy to see that if we can't quite have her—and, of course, at the movies, we can never *have* these beauties—then maybe murder is another way to go. The film is only forty minutes old. It can't be over yet, or entirely begun. Murder comes along. We half-suspected it.

Hitchcock's game is so cunning that he shows the murder so that we do not realize Norman has done it. Indeed, when he discovers what has happened, Norman reacts with horror and does one of the most diligent clean-up operations in cinema. So now we are on Norman's side. We'll go anywhere—we might even watch *Jackass*.

Psycho is American, of course, but it is intensely Germanic, not just in its use of two Normans, but also in its plan to confuse us through our passionate identification. In staring so hard at Janet Leigh, we have raised the possibility of some violent action. The suspense in Hitchcock is invariably erotic and threatening, and the screen is a weirdly calm, dispassionate presence, so full of a life we cannot join but must observe.

You need that screen or a white wall to show the process. But our responses to life and the screen are so different. The flow of images is a stream or a river that we want to swim in. But the screen—the helpless, blank surface—reminds us there is no river or stream; this entire operation has the potential for deceit or a lifelike lie. The picture is "believ-

able," but the screen is the warning guarantee of abstraction or removal. We are there and not there. It's cold with the German screen, not because the heating has been turned off, but because the implications are so unsettling.

•

A practical problem made life tougher as Decla came to film *The Cabinet of Dr. Caligari*. The circumstances of 1919–20 were so bad that there were severe restrictions on electrical power—a huge problem for the film industry, especially when *Caligari* was to be shot during the winter, a season in which Berlin regularly suffers prolonged overcast. As soon as you look at the film, you feel this quality. The opening garden does not seem to be in open, much less fresh, air. It is like an arcade where a pale light has been refracted through glass. There is no health or vitality in the light— and there is not an open-air shot in the whole film. Indeed, Erich Pommer and the virtual director, Robert Wiene, yielded to the suggestion of their designers—Hermann Warm, Walter Reimann, and Walter Röhrig— that the film be made in a completely expressionist style where not only were the shapes and forms of the décor part of a mindscape (that of the madman), but shadows and light areas were actually painted on the décor.

Pommer didn't believe this would work. "Look here, boys," he told his designers, "you're all crazy. It's impossible to put fantastic, unreal, flat sets behind real, solid people." But when tests were made, it did work—and so, for the sake of argument, the prairie cabin where the Kanes live in *Citizen Kane* (1941) looks and feels like what it is: a carefully fashioned set on a stage with a diorama. So *Caligari* has houses like witches' hats, windows like squashed triangles, and alleyways that are simply illustrations of perspective. Cesare is a character from a ballet nearly, granted his black garb, the immense lemur circles around his eyes, and the druggy, stylized movements that Conrad Veidt employs in the part. The result is in many ways theatrical, yet the shaping of the story is uncanny and the anxiety set up by the film never disperses. You can see why the whole world found *Caligari* arresting in 1920.

Janowitz and Mayer were pained to discover the framing Pommer and Wiene had put on their story. But this sanitization actually had so little impact. For the "derangement" in the décor, the rather studied, art-school attempt to make everything in sight look like something seen by a madman, is pervasive and infectious. So it doesn't really matter whether the madman in question is Francis, "our hero," or the Director. As it is, both

Caligari and the Director are played by the same actor, Werner Krauss, and he is so creepy that we assume a natural affinity between the two figures. "Correcting" the action does not repair the suggestion—and this is an important point in film appreciation. Stories lead film and shape them, but atmosphere is the character—and the atmosphere is a matter of the chemistry between us and the film. No one can watch *Caligari* without uneasiness mounting, just as no one can experience *Citizen Kane* without hearing Kane's sigh, the lament of "Rosebud" that hangs over every frame and all the regrets of his life.

So what was meant as a reassuring, hopeful last shot is actually a rather nasty conclusion—it is the clear implication that Caligari has won the day by his ability to pass as both a fairground performer and a respected doctor. This amounts to a trap: in this kind of cinema, no character can be identified with or simply written off to villainy. Every figure is part of the phantom elasticity that partakes of the opposed aspects in any human being. The difficulty in placing trust brings us to that essential enigma in German cinema, Fritz Lang, "Herr Director" to those he wanted to impress, but something far more dubious or disconcerting.

Lang lied about both his parents, but he existed in a dangerous world where the lie might be taken for granted. He said that his father, Anton Lang, was an architect, whereas he seems to have been just a construction chief who worked with architects. As for his mother, he said she was from the country and the farming class, but Paula Schlesinger was Jewish and part of a family in the clothing business.

Friedrich Christian Anton Lang was born in Vienna in December 1890. He was raised in bourgeois comfort, and he got fragments of education in studying architecture, painting, and design. But he was also a womanizer and a wanderer, and quite early on he was working in Viennese nightclubs when he told his parents he was doing more serious things. He claimed later that he had roamed over most of the world, but no one who knew him could determine when he had done this. When war broke out he joined the Austro-Hungarian army. He rose to the rank of lieutenant, saw a great deal of action, was decorated and wounded. One injury affected an eye and encouraged him to wear a monocle, which he learned to use to intimidate others. It was while in hospital, recovering from his injuries, that he began writing movie scenarios.

There is a group of movie people born, like Lang, in the 1890s (as the medium was born). It includes King Vidor, Kenji Mizoguchi, Carl Dreyer, Howard Hawks, Alfred Hitchcock, Buster Keaton, and Jean Renoir. As

kids growing up with the new sensation, they became founding fathers of film, but so many of them were drifters before film found or retrieved them. Lang would hardly have been willing to risk losing his sight to become a master of things seen, but he was sharp enough to see the publicity appeal of his disability once he was getting established—thus the monocle and the way he used it to send a flashing message to his actors and crew.

Once recovered and established as a scenarist, Lang rose quickly; it was part of the glamour of the movies that people could be "made" so fast. Erich Pommer did offer *Caligari* to Lang, but the novice was tied up on *Die Spinnen* (a big adventure film), so, by his own testimony, he did "no more" than suggest the framing device, the very thing the writers hated! I am inclined to believe this story in that it goes to the core of Lang's undermining gaze. He is never more disturbing than in his hollow happy endings.

Then, all of a sudden, he was seized by demonic energy and in the next few years he made the three-hour *Dr. Mabuse: The Gambler* (1922) and the three-hour film of *Die Nibelungen* (1924), which includes *Siegfried* and *Kriemhild's Revenge*. Lang's evolving style was not as strictly expressionist as that in *Caligari*, though he was prepared to use that manner sometimes. But his visual appetite (as if famished) fed upon studio settings, the intricate traps in décor and artificial light. He became increasingly interested in the geometry of the city, and there are few kinds of exhilaration in silent film to match the frenzy of activity in the Mabuse films. Lang was steeped in pulp adventure literature and he knew that films had to be about lines of sight—seeing and being seen. So doors open, cars halt side by side at a traffic light, men watch women—the intersection is that of friction, and usually it leads to explosions.

This exhilaration extends to the character of Mabuse, one of the first movie villains who had won at least half the heart of his maker. Lang would say that Mabuse represented all the chaos and wickedness of Germany in the 1920s, plus the coming evil of Hitler and his gang. But as a director, Lang could not take his eyes off the mechanics of plotting— Mabuse is a writer, a storymaker, a would-be director. Sometimes he is seen in bed, surrounded by scattered pages.

Cinema seldom loses or kills off its monsters: Kong could fall off the spire of the Empire State Building one year, but then his son would be back. Mabuse was a character who lasted Lang from the 1920s to the early 1960s, and if he is mad, it is a marvel that sanity can find him so interesting—unless you share Lang's Germanic instinct that there is

something like a heightened death watch in cinema. The good guys in Lang and a thousand other films are so banal, so bland, until they are exposed to the temptation of going astray. In one of Lang's Hollywood films, *The Woman in the Window* (1944), Edward G. Robinson is a solid, bourgeois citizen who dreams himself into a criminal situation.

Lang went to America in 1924 to open *Die Nibelungen* (a very classy production, building to a storm of battle and massacre). It's hard to believe he wasn't flirting with American offers. His reputation had soared, and Hollywood was greedy for continental talent. Ernst Lubitsch had been recruited only the year before to make *Rosita* with Mary Pickford, and when Lang got to Los Angeles, he spent time with Lubitsch, admiring his house and his pool and picking up Hollywood gossip.

Later on, as he amended his own history, Lang would say it was the sight of New York—the skyscrapers, the canyon streets, the density of a modern city—that most excited him. However, he did not explore the chance of making a film in those real canyons. He preferred to rebuild the idea of a modern city, at Ufa, with *Metropolis* (1927). And when he visited California, he observed a crucial difference between the two countries: Doug Fairbanks told him that American films were about stardom, so Lang decided that in Germany the director should be the star. He came back, apparently without an offer, saying, "They build things big in America. There's enough space. And Paradise has been created."

Not that Lang knew too much about that condition. In 1919, apparently, he had married a girl named Lisa Rosenthal. Not much is known about her—some say she was a hospital nurse; others claim she was a cabaret dancer; some believed she was Jewish. Later on, Lang gave no help to researchers and was inclined to forget Lisa. Why? Well, sometime in 1920, Lisa Rosenthal came back to their apartment one day and found Lang making love with Thea von Harbou. Thea was a leading screenwriter and the wife of the actor Rudolf Klein-Rogge, who would play Dr. Mabuse.

There was an ugly scene in which, somehow, Lisa was shot dead by a bullet fired from Lang's revolver, a prop he was inclined to brandish when he got overexcited. To this day no one knows what happened. It could have been suicide—though Lisa had made plans for later that day. It might have been something more sinister. Which plays better? No charges were preferred. From 1921 onward, Thea von Harbou became Lang's chosen screenwriter, and then his wife. Later, when he left Germany, she joined the Nazi Party.

She did not accompany Lang on his 1924 visit to America, but not too long after his return, he seems to have shared some ideas for *Metropolis* with her, and prompted her to write a novel that would be the basis of the screenplay (plus a way of securing more income). The story was set in the year 2000 in an immense city-state called Metropolis:

> When the sun sank at the back of Metropolis, the houses turned to mountains and the streets to valleys, and a stream of light, which seemed to crackle with coldness, broke forth from all he windows. A series of diagonal lines appearing from opposite sides of the screen form the opening title: METROPOLIS. Light shines through the letters in prismatic patterns, while the towers and tenements of the city appear in iris behind. Shadows move across the screen as we dissolve to a series of shots of the great machines of Metropolis.

That's the start of the screenplay, which may be the most ambitious and literary film script written until that time. In the film itself, we do not quite get the impression of the urban forms stealing the natural forms, but we feel the light that crackles with coldness and the absolute removal of nature—whether countryside, natural growth, or daylight. For years thereafter, people marveled at the prophetic accuracy of *Metropolis*: how far, seventy-plus years in advance, Lang had guessed at the look of the world. Now it's easier to see that this city is a vast prison of lifelessness, because real architecture and abysmal social planning have made such places for us.

Life goes on, and the machinery of production grinds at its slave labor. But there are qualms in the Metropolis: Joh Fredersen is the ruler of the place (without crown, uniform, or insignia); his son, Freder, is a playboy who begins to doubt the viability of the social contract; Maria is a pure girl who is a saint to the workers; and Rotwang is a warped genius, in part the creator of the place, but now the kind of mastermind we know from *Dr. Mabuse*, an overseer who longs for the destruction of everything. (He is another part for Rudolf Klein-Rogge.) To defy any hope of reform, Rotwang kidnaps Maria, takes her to his laboratory, and makes a robot-like replacement so that he can send this "other" Maria out into the city—seductive, lascivious, treacherous—to spread moral confusion and destruction. (Both Marias are played by Brigitte Helm.)

Too often the drama is at this trite level, and by general consent, the

resolution of *Metropolis* is not just foolish but also an evasion of the anxieties aroused by the film. The conclusion comes when Freder Fredersen brings his father and Grot (the workers' foreman) together with this handshake sentiment: "There can be no understanding between the hands and the brain unless the heart acts as mediator."

Siegfried Kracauer, who was bent on tracing how German cinema had paved the way for Nazism—his book was called *From Caligari to Hitler*—pointed out accurately enough that this cliché was awfully close to the way Dr. Joseph Goebbels appealed to the heart: "Power based on a gun may be a good thing; it is however better and more gratifying to win the heart of a people and to keep it."

Even as *Metropolis* opened at the Ufa-Palast am Zoo, in Berlin on January 10, 1927, there were lamentations over the abyss that separated its "content" from the cinematic power. This reaction was more to the point because *Metropolis* was the most expensive production ever mounted in Germany. It had taken 310 days of shooting (plus 60 nights), and the budget was reported to be 5 million marks. (This meant over $1 million in 1927 money.) Ufa had had to seek large loans to survive, and as the film failed to get its money back, the company passed into the power of Dr. Alfred Hugenberg, a newspaper magnate. He also owned or controlled more than a hundred theaters. (In American terms, he was a monopolist.) Worse, he was sympathetic to the Nationalist Party. So, in an oblique way, the hand-and-heart bromide of the film was swept aside by realpolitik. Because of the film's commercial failure, Ufa became a Nazi company.

No one could suggest this was the long-term aim of Lang or von Harbou; the film's inane but lofty ambitions are far from that. Still, Lang would be told later by Goebbels (he said) that when Hitler saw *Metropolis* in Bavaria in 1927, he declared that Lang was the man who might one day make the Reich's films.

Was Hitler a good critic, a good audience? I fear he may have been, for both the sentiments and the sentimentality of *Metropolis* mean all too little compared with the dynamic of the imaging—the radical view of the workforce as just that, a force without individuality; the inspired or enflamed treatment of the two Marias (still photographs of the shooting make it clear what intimate, voyeurist, or collaborative attention Lang paid to Brigitte Helm as the robot Maria, especially in her snaking, erotic dance); the apocalyptic crisis of the city as it is flooded, the vectors of escape and destruction; and the aura of Rotwang, the most striking human figure in the film.

Am I suggesting that Fritz Lang was intrinsically fascist, or was it the medium? I'm not quite sure. As of 1927 that charge could not mean what it would mean by 1945. The record shows that Lang quit Nazi Germany, went to America, and made several films (*Fury, Hangmen Also Die, Cloak and Dagger*) that have overtly antifascist themes. What is tougher to assess is that Lang's natural coldness, his severe analytic eye, and his thrill at disaster amount to a fascistic feeling in *Metropolis*. The crowd is a blunt instrument, gullible and dangerous—it makes an intriguing comparison with Nathanael West's mob-in-waiting. The coda and its reassurance are trite. The clear impact of the film—and this was not unnatural from someone who had lived through Germany's instability in the 1920s— was that the sociopolitical order was headed for disaster, and that the dynamism on-screen was a compelling message.

Or was it just that the basic circumstances of cinema—the overwhelming screen, and its eager but estranged audience—were suited to a fascist state?

At the time, and in the decades since, commentators have wrestled with *Metropolis* and the mixture of awe and dismay it produces, just as the film's power remains disconcerting. H. G. Wells said it was maybe the silliest film he had ever seen—though he thought it had borrowed things from his writing. Decades later, Pauline Kael called it "a wonderful, stupefying folly"—and if that is not quite an official genre of movies it's one we should leave open. It will have company before this book is over.

Luis Buñuel said the picture was two films cobbled together very awkwardly. One part was its text, which he deplored.

But on the other hand . . . What an exalting symphony of movement! How the machines sing in the midst of wonderful transparencies, crowned by the triumphal arches . . . Each powerful flash of steel, every rhythmic succession of wheels, pistons, and unknown mechanical forms, is a marvelous ode, a new poetry for our eyes. Physics and Chemistry are miraculously transformed into Rhythm. Not a single moment of ecstasy. Even the intertitles, whether ascending, descending, wandering about the screen, melting into light or dissolving into darkness, join the general movement: they too become images.

That last point is important: the titles within the film seem to have been written there by Freder or Rotwang by hand (and Rotwang has an

artificial hand). Throughout the film, they remind us that the screen is a screen, and not just the site of a story. It takes the film closer to graffiti and agitprop slogans. The writing is nervous, occult, and magical, but more human than most of the things the people in the film do.

Over the years, *Metropolis* has had several versions, including being accompanied by pop music. Yet it was known that part of the film was lost. Then it was found, in Argentina, and at the Berlin Film Festival of 2010 the longest version yet was played—in a large theater, but also on a special screen at the Brandenburg Gate for an open-air audience of several hundred braving a bad winter. Once more, the film looked amazing and felt alarming, even if the "lost" passages were of inferior technical quality. Never mind: Lang's *Metropolis* has the dread of impending apocalypse, which says so much of its era. It is evidence of Lang's disturbing genius and Germany's worse history.

•

Lang would make four more films in Germany at this time: *Spies* (1928), *Woman in the Moon* (1929), *M* (1931), and *The Testament of Dr. Mabuse* (1932). The last is a sound film in which Mabuse's gang is still plotting the overthrow of all order. Lang claimed that he put many Nazi slogans into Mabuse's mouth, and apparently the Party heard him. For in March 1933 they banned the film "for its cruel and depraved content." Whereupon Dr. Goebbels asked Lang to visit him in his office.

Lang gave several accounts of that testing interview. He said Goebbels was friendly, telling Lang about Hitler's admiration for his films. He apologized for the ban on the showing of *The Testament* and even indicated that a little recutting might solve the problem. Then he offered Fritz Lang the job of being in charge of moviemaking for the Third Reich.

Years later, Lang reported how he sweated through the interview, watching the clock advance—the clock is such a torture rack in *Metropolis*. He had reckoned as he listened to Goebbels that his number was up: he would have to leave Germany immediately; and he would have to gather what he could of his funds. The clock was urgent because the banks closed at three. But Goebbels talked and talked, and it was past five before Lang got away, promising to give Goebbels an answer as quickly as possible. He went home, gathered some money and jewelry from his apartment, and then that night took the train out of Berlin. He added in some versions of the story that it felt like being in a bad movie.

But it didn't happen. A great deal of research has been applied to the

case, culminating in Patrick McGilligan's 1997 biography, *Fritz Lang: The Nature of the Beast*. This includes perusal of Lang's passport and its exit visas. There was no sudden departure. Instead, Lang made several trips within Europe and did not leave Berlin properly until July 1933—he went to Paris then, where he had a deal (with Erich Pommer) to make *Liliom*. He and Thea von Harbou were divorced in April. There is no record of the meeting in Goebbels's appointment diary—and he was a movie fan. A number of people had always doubted the "escape" story and noted how its details had varied in different tellings. Gottfried Reinhardt (the son of Max Reinhardt) had this to say: "Lang could have stayed in Germany, there's no question about it. If they hadn't found out that he was half-Jewish. He tried to stay. He was a dishonorable man, a totally cynical man. I don't think he gave a damn."

It's not easy writing a fair history of cinema while locked into hero worship for directors. Yet many of us are resolved to be loyal to the medium, and to overlook the faults of its heroes. Are the pressures and opportunities in filmmaking so bound up with power over the millions, and so tied to money, that behavior suffers? Anyway, Lang didn't take the job with Nazi film. But there was another candidate, of course, and we'll be meeting her.

It can be hard being discovered. You may never quite possess yourself again. Fritz Lang would say later on that he had "discovered" Peter Lorre in the German theater. But Lorre had been acting for five years or so already, working hard. He was discovering himself, and so far as anyone could tell, he was set on a career onstage. But there were warning hints. A few people said that with his diminutive stature, his smart baby's face, his popping eyes (plus his weakness for drugs—begun after surgery, but extended to health), sooner or later Lorre was likely to be cast as villains or degenerates. He deserved better. He was accomplished at comedy and the grotesque, yet he had a plaintive streak in him, too. The photographer Lotte Jacobi could hardly stop looking at him and taking his picture. And Lorre had a girlfriend, Celia Lovsky, who believed that Peter should meet Fritz Lang.

This was 1929, in Berlin. Lorre was twenty-five, born László Löwenstein in a small town in Hungary. In just the last year he had had a dozen parts, including Ong Chi Seng, the intermediary, in a version of Somerset Maugham's *The Letter*, St. Just in *Danton's Death*, Dr. Nakamura in Brecht's *Happy End* (he and Brecht were friends), and the fourteen-year-old sex-crazed Moritz Stiefel in Wedekind's *Spring Awakening*. Lang saw that last show, at least, and was impressed. That's when he "discovered" the actor and asked him if he had made a movie yet. No, said Lorre (he was lying). Very well, said Lang, I want to use you in my first sound film. It is some way off still, so you must promise that you will not make a movie for anyone else.

What will this picture be? asked the actor, and Lang told him he could not say yet. Lorre agreed to the arrangement.

It's not clear if Lang had any real idea yet of *M*, or was just securing an

actor and a presence he found striking. But by 1930 he was determined to make a sound picture, and inclined to use the new refinement like a shot of cocaine. He wanted to make a smaller picture than he had been accustomed to, something more intimate. So he asked his wife and his screenwriter, Thea, what was the most loathsome crime she could think of. She mulled it over and settled on the writing of poison-pen letters. (It's a sign that Thea von Harbou may have been a modest soul.) But Lang came back a little later and asked her, what about a child killer?

There were several serial killers capturing headlines in the Germany of that time. In Berlin, there was a man named Großmann; in Hanover, there was a notorious "butcher"; and in Düsseldorf, there was Peter Kürten. Lang tried to make it clear that he and Thea had done their script for *M* before Kürten's story was revealed. But it hardly matters. I think we know that Fritz Lang could have imagined *M*, or what he had also thought of calling *The Murderer Among Us*. In addition, Peter Kürten was ready to kill anyone, while Hans Beckert, the character in *M*, has an eye that preys on children.

In 1931 no American studio would have entertained the thought of a film about a child killer—though Hollywood at that time was giddy with excitement (and box office) over gangsters. In *Public Enemy* (1931), James Cagney was made into a star as the street kid who becomes a hoodlum and guns down any number of people (more or less deserving of that fate, or employed to risk it). *Public Enemy* was rightly hailed as a "violent" picture, even if the most brutal moment in it for many people—because it is so unexpected—is where Cagney rams half a grapefruit into the face of his moll (played by Mae Clarke).

Violence is a tricky issue, and one we shall return to, but Fritz Lang protested that *M* was a film of "no violence—all this happens behind the scene, so to speak. I give an example: you remember the scene where the little girl is murdered? All you see is a ball rolling and stopping. Afterwards a balloon getting stuck in the telephone wires. Where is the violence?"

To be precise, Lang is correct (though he also tried to tell the same questioner that the scene in *The Big Heat* where Lee Marvin throws scalding coffee in Gloria Grahame's face was not violent either). You don't have to trust what film directors say; it's hard enough sometimes to handle what they show. No, we do not see the murderer in *M* killing a child. Still, I doubt that anyone has ever seen *M* and not been affected by the thought of that action. That is a tribute to Lang's genius and purpose as an

artist—which amounts to the attempt to show how thoroughly violence had eroded society. But if it was impossible to do *M* with the sight (and sound) of a child being strangled (and I hope it would be still), then it's worth asking ourselves what impact there has been in the seemingly endless and inventive spectacle of more or less attractive guys gunning down other guys—and this motif goes from *Public Enemy* to Michael Mann's *Public Enemies* (2009).

The thing about Lang's *M* that would have horrified an American studio in 1931 is the meticulous oppressiveness of the film and the airless dread in setting and mood that Lang carried over from *Metropolis*. That's why *M* is a great film, and so subversive. After all, the grim movie ends with a pious voice uttering the cry "We, too, should keep a closer watch on our children," while it is shot through with the gloomy conviction that another kind of warped child—Peter Kürten himself, or Hans Beckert— must have his way in a cityscape that can only endure such outrages. At the start of the film, a children's game is introduced as a guarantee of malign fate. We see a circle of children playing a game, a version of "You're out," with the chant "The evil little man in black will come . . . He will chop you up." And it's not just those words, or the ghastly symbol of the game, it's the way the "open" ground where the children play is so palpably a set, part of an inescapable urban enclosure, where air has been replaced by theatrical light. Forget the fate of the children—what life could they find in a city that seems to be buried underground? Time and again, Lang's city is a mortuary where human figures make their frantic dance.

So in *M* the very texture of cinematic expression amounts to a trap in which the children and Beckert are caught. This predicament presages the coup of the film, an image that resounds with the tricky nature of cinema and the age-old dread of the doppelgänger who will confound his better self. I refer to the image where Beckert—identified by the street life as a murderer, and marked down as such—suddenly looks over his shoulder and sees the reflection of a ragged white-chalk *M* on his dark overcoat, like a wound or a disease. Not even Lotte Jacobi ever made more of Lorre's fleshy face or his horrified eyes. It is a superb image, expressive not just of this one film or even of Lang's haunting career, but of the idea throughout film that we may meet our other and know the dismay of exposure. It is one of those moments in which we are physically reminded that a character looking in a mirror is like us looking at a screen.

The structure of *M* that drew so much comment—of the murderer being pursued by the forces of both law and outlawry—is another version

of the trap Beckert faces. And Lang is so expert at confronting two unwholesome gangs that we quickly devour the ironies whereby the good and the bad are equally determined to crush the deranged figure who has upset the balance of their city. Nothing in the movie bothers with the ugliness of that balance, or the degree to which it stands for a way of life that will suffocate true childhood—even if it disapproves of the strangling. Indeed, nothing in *M*, in *Metropolis*, or in *The Testament of Dr. Mabuse* really believes in an urban order or style in which life might be worth living. I think the same charge can be leveled at the best films Lang made in America—*The Big Heat* (1953), for instance, where Glenn Ford's avenging detective is left alone at the end in the ruins of a corrupt city, and may be perilously unbalanced. But it is a very American touch that he loses a wife and saves his daughter. Lang's first American film, *Fury* (1936), in which Spencer Tracy plays a man who is nearly lynched, was prompted by an actual lynching in San Jose in November 1933 (the last recorded in California), when two men were dragged out of jail, stripped, castrated, and hung up for public inspection. The town mayor and the governor of California, James Rolph, Jr., approved of the lynching, and no one was ever imprisoned for it. *Fury* is a tough film for 1936—Graham Greene called it an extraordinary achievement—but it never got close to the reality of San Jose. In America, the industry and its urge to be positive conferred a sketchy optimism on Lang in return for his sacrificing the bleak magnificence of his art.

There is no one to like or admire in *M*—so what happens to the energy or involvement that the film's authority commands? It descends on the woeful figure of Beckert and his frenzied assertion of helplessness. It's at this point that our not seeing Beckert kill—in the way we are spared overt violence, as Lang might claim—is so important. After all, Beckert has no life or identity except that of killer. All we see of him is that drape of overcoat and the drab hat in which he prowls the city. He has no other exercise, and not the least explanation as to why he is a child killer.

Yet it's clear that Peter Lorre is the star of the film, no matter how heinous a figure Beckert may be. The drama is waiting on that moment when Beckert, captured and undergoing an unofficial trial, will break down and let his words tumble out. This is where the harsh sounds of the city, the eery whistling, and the tramping noise of brutal men give way to speech and acting. We realize that *M* would hardly have been possible or inviting to Lang as a silent film. Its action might have played out, but Lang's incentive is wanting to hear the murderer speak. And the film will

end abruptly, without a verdict or a sentence in the "trial." There is no doubt about Beckert's being a serial killer. But *M* does not settle his fate. He is arrested by the police (as opposed to the criminals), and the film stops. If he were to go on to a proper trial we'd know his testimony already. It spills out in Lorre's unrestrained performance, one of the first on film that depends on synchronized speech and its revelation of a deranged inner being:

> I want to escape . . . to escape from myself! . . . but it's impossible. I can't. I can't escape. I have to obey it. I have to run . . . run . . . streets . . . endless streets. I want to escape. I want to get away. And I am pursued by ghosts. Ghosts of mothers. And of those children . . . They never leave me. They are here, there, always, always. Always . . . except . . . except when I do it . . . when I . . . Then I can't remember anything . . . And afterwards I see those posters and I read what I've done . . . I read and . . . and read . . . Did I do that? But I can't remember anything about it . . . But who will believe me? Who knows what it feels like to be me? How I'm forced to act . . . How I must . . . Don't want to, but must. And then . . . a voice screams . . . I can't bear to hear it.

It is a testament to helplessness, and there's a frightening link between human helplessness and the possibility that the camera can make irresponsibility available, because it so adept at "recording, not thinking."

Observers of the filming reported that Lang drove Lorre hard—as was his custom. He also discouraged other people on the set from talking to his lead actor. He wanted to isolate him emotionally, as if to induce the killer's state of loneliness. Lorre stood up to the ordeal, despite long days on the "trial" sequence. His only shortcoming was that he could not whistle adequately—so Lang did the whistling himself. You can see Lorre's performance still, and it shows a demented person, just as it reveals that we are watching a film about a murderer, not the act or process of murder and not the victims. Lorre's biographer Stephen D. Youngkin also unearthed a print of *M, le Maudit*, the French version made right after the German *M*. It had another director (identity not known), but Youngkin reports that Lorre's performance in the French version—in which his voice was dubbed—was far more unrestrained and markedly less effective.

So here is a "classic," and arguably Lang's greatest work. But notice how

far-reaching it is in its consequences. Though the American gangster films of the early 1930s never dared show a child killer, they did equivocate over their "monsters." *Scarface* (1932), with Paul Muni as Tony Camonte, was subtitled *Shame of a Nation*, in case the film was thought to be too enthusiastic about its gangsters. But that was the energy or vicarious thrill that made such films appealing, and which helped turn Cagney and Edward G. Robinson into flamboyant stars.

M is a quite different case, in which Lang effectively introduces the idea, fleshed out by Lorre's intense performance, that the child killer is driven beyond self-control or moral self-awareness. Our society still struggles with such issues, and the growing reluctance to execute murderers has gone hand in hand with an attempt to understand psychopathic personality. One of the most alarming things in *M* concerns what can only be called sympathy. We do not respond to Beckert as someone who has actually killed children—our children. Not that there is any question about his guilt. Still, the killer's explanation of himself in *M* does not have to be believed. It may be beyond that just because it is so well acted. But is it Lorre acting, or is it Beckert? Here is one of the insoluble mysteries in film, the deepest level of doubling and moral confusion. Because we watch this confession (without having to witness the murders), our point of view is subtly detached. We are in awe of Lorre, and that cannot exclude sympathy, or something more complex than horror or loathing for what his character has done. This is the first notable killer on film who steps over that line of identity, and clearly he is carried over by sound, by speech, and the noise of breathing or being alive.

Actors will tell you that, no matter the evil in a role, they have to like their characters to do a good job. We honor what they say, and their experience, but that concession is a first step toward the possibility that we are all of us always acting out our selves, presenting ourselves in everyday life, and are forever unreliable or promiscuous. So we may like or dislike people, but we can never be sure of them. This is an irreversible shift in the departure from humanity or humanism, for it is not a matter of calculated deception so much as an organic, helpless pretending: I pretend, therefore I am. It is not too far from Jean Renoir's feeling that everyone has his or her reasons—or their actor's sense of a role. That thought from *La Règle du Jeu* (1939) is often considered a sign of Renoir's generosity or openness. But it also conveys an epistemological solitude and the way existence has become performance.

These days, with censorship nearly exhausted, the process on film has

gone a lot further. In *The Silence of the Lambs* (1991), it is made clear enough for most tastes what Hannibal Lecter does to his victims. At the same time, his character becomes so helpful to the heroine Clarice (Jodie Foster), that a fragrance of attraction develops between them. Only a few years later, in the sequel, *Hannibal* (2001), there was what amounted to a love story between Lecter and the new Clarice (Julianne Moore). In addition, though playing no more than a supporting part in *The Silence of the Lambs*, Anthony Hopkins had won the Oscar while becoming a fond household bogeyman whom many of us took pleasure in imitating.

By then, Hopkins was so big as a star or versatile enough as an actor to resist the threat of typecasting. Peter Lorre was not so lucky. *M* was an international sensation in 1931. It established Lorre and effectively ended his theatrical career. But it also locked him into sinister or horrific parts. Like many, he left Europe in the early 1930s and kept busy in America. He had notable small roles (in *The Maltese Falcon* and *Casablanca*), but eight times he had to play the Japanese detective Mr. Moto. He was steadily more dismayed by the way his range as an actor had shrunk; his reputation and his offers were always under the shadow of Hans Beckert. Lang never worked with him again.

Do we understand child killers better because of *M*? Or have we only picked up a taboo thrill? Did this celebrated film introduce a line of films about psychopaths—fodder for great acting, perhaps, but steps in a process whereby society was expected to digest unspeakable actions? Perhaps there is no understanding of that sort of criminal process? Perhaps the attempt to assess it only makes it seem more accessible or "normal"? I don't place any reservations on the estimate of *M* as a major work, but who can deny that it helped open up the possibility of less-austere films about chronic killers where spilled blood and the lifelike illusion of slaughter run wild? In *Dexter*, we are coming up on another season for a TV show about a serial killer (who also works to catch killers).

Lang's pessimism is signaled in his every detail and nuance, but there are now so many films about psychotics that revel in and exploit the inexplicable violence. Lang's big lie, I think, was in denying his own appetite for murderousness and film's impassive but mounting ease with it.

STATE FILM—FILM STATE

If you look at the new sensations of the last 120 years, their impact on us has been so drastic, exhilarating, or dangerous you can see why the state has intervened with measures of control—I'm thinking of drugs, the television airwaves, the automobile and the highways, guns and gambling. You might add compulsory education, once regarded with awe and hope. All those invasions were regulated until some of us decided regulation was alien to liberty. But the movie, in America, was left to the marketplace and free enterprise. Not that that protected the people who owned and ran the film business from fearful anticipation of government intervention.

The history of Hollywood in the 1920s is one of a rapid economic expansion coupled with wild behavior on the part of some filmmakers that led to hurried self-imposed regulation. Better have Will Hays and his code, an Academy and its prizes, than government licensing. To this day in the United States, movies are rated as G, PG, R, and NC-17, and theaters are expected to enforce those "rules." But they are not laws, and you may have noticed that the caring system lets you take a three-year-old to *The Exorcist*, *Psycho*, or *The Silence of the Lambs*, so long as the child stays quiet. The child is said to be "with" you, or in your care—yet we all know how alone we are in the dark.

You might see that "care" as a cover for box office opportunism. It is an odd world we live in, however. If we discovered that at school our children were being taught pornography or murder, there would be outrage; there are already outcries over novels that some regard as classics. Yet on many cable packages, a home (to use that precious word) has access to pornography on some channels, after 10:00 P.M. or so, but to massive violence at any time of day. And to mindlessness and roaring advertisements always. This is taken as an American choice. It is also our decision to keep deadly

weapons, loaded or unloaded, in the house against that day when the mi-
litia calls. We are on treacherous ground when it comes to care.

So it's hardly a surprise that anything as volatile and potent as the
movies might have been regarded as a primed bomb in some countries.
Nowhere was that pressure more exciting than in Russia, a nation of un-
educated millions and an elite culture that suddenly decided "everyone"
was worthy of being enlightened and moved and raised to the highest lev-
els of citizenry.

We know very little of whether Anton Chekhov saw or was impressed
by movies; he died in 1904. But he helps lead the way for them. I don't
refer simply to the personal and social depths in his plays, but to their
physicality. The stage notes to *Uncle Vanya* (first produced in 1899) be-
gin, "A garden. Part of a house with a terrace can be seen. There is a table
laid for tea under an old poplar in the avenue. Garden seats and chairs; on
one of them lies a guitar. Not far from the table there is a swing. It is be-
tween two and three o'clock in the afternoon. The sky is overcast." The
stage director Konstantin Stanislavsky did his best with time of day and
the cast of the light, just as he fashioned a naturalistic acting style that
would affect the Actors Studio in New York more than forty years later,
and the movies that grew out of it. But just to read Chekhov's stage direc-
tion is to anticipate Jean Renoir as a fit director for *Uncle Vanya*. That
overcast was decades ahead of the blast of early movie light.

It was once a part of the Bolshevik history of cinema that nothing
much happened in Russia before 1917. That was not so. Filmgoing seems
to have been confined to the larger cities, but Yakov Protazanov (1881–
1945) was a significant director in the decade before the Revolution. He
made several good films in the era of D. W. Griffith's feature films, nota-
bly a version of Pushkin's *The Queen of Spades* (1916), with rich period
sets, intense acting, and the influence of Scandinavian cinema. Protaza-
nov absented himself from Russia at the moment of revolution, and for
several years thereafter, which did not endear him to the new regime.
Still, his *Aelita* (1924) is a quirky science-fiction picture, with dazzling
constructivist sets and Yulia Solntseva (the wife of director Alexander
Dovzhenko) playing the Queen of Mars.

The striking quality in *Aelita* is the bold, innocent, and amused juxta-
position of alien worlds—the contemporary Russia, shot largely in real
places, with air, light, space, and the passing parade of an actual city; and
the Mars that is imagined and furnished through elaborate, beautiful, but
comically stylized sets and costumes. (It's like an American and a Ger-

man picture of the time thrust together.) And it is the warring energy of
the two styles that is most entertaining. In the Russian scenes, we meet a
space engineer and his wife. But on Mars, Queen Aelita has a way of
spying on Earth (and falling in love with the engineer)—a magical view-
ing machine—that never disturbs the reckless ultramodern style of Mars,
a place where the slave population has paper bags on their heads to signal
anonymity, while Aelita wears a Deco headdress of erect tendrils.

I don't mean to claim *Aelita* as a great lost film, but it is inventive and
fun, absorbed in the wonder of film and its proximity to experimental
theater, and alert to presence, performance, and the spaces between
people. What does that mean? Two-shots, group shots, depth of vision.
The film's arty design is hard to attribute now. But one name figures in
costumes and set design: Alexandra Exter. We know enough about her to
feel her sophistication: she studied in Paris in 1907–8, where she knew
Picasso and Braque. By 1918–20 she led a production studio in Kiev that
trained several future directors, and from 1921 to 1924 she was teaching
in Moscow. But once *Aelita* was done, she moved to Paris, where she was
a teacher and a painter until her death in 1949. She apparently never
worked on another movie, but *Aelita* is sufficient proof of her talent,
her cosmopolitan sensibility, and her influence. In other words, there was
a tradition in Russia, essentially pre-Revolution, that thrived on the prox-
imity of theater and film and the chances it provided for avant-garde
experiment.

The thing to notice here is an alternative history to the Bolshevik or-
thodoxy that claimed cinema as its special child. There was production in
Russia before 1917, albeit influenced by German and Scandinavian com-
panies, with a small, sophisticated audience. Mikhail Bulgakov was writ-
ing satires for the Moscow Art Theatre. By the early 1920s, Vladimir
Nabokov was in Germany, interested in seeing and writing for films, and
especially delighted by the inadvertent follies of American movies—but
put off by their crushing sincerity. Nabokov is an instructive case, for he
shows an early appreciation of comic absurdity (as opposed to dramatic
earnestness) in cinema. One could add Rouben Mamoulian (born in
Tiflis in 1897), a student at the Moscow Art Theatre who was working in
London and America by the early 1920s; Lewis Milestone (born in the
Ukraine in 1895), educated at the University of Ghent, and in America by
1919; and Richard Boleslawski (born in Russian-controlled Poland in
1889), a director in Hollywood. Those men would make such films as *The
Mark of Zorro* (1940) and *Silk Stockings* (1956), *All Quiet on the Western*

Front (1930), and the Marlon Brando *Mutiny on the Bounty* (1962), *Rasputin and the Empress* (1932), and *The Garden of Allah* (1936).

At other levels, the company of film people who left Russia includes not just Akim Tamiroff, Gregory Ratoff, and Maria Ouspenskaya, but also Lewis J. Selznick and Louis B. Mayer, Al Jolson and Alla Nazimova, Irving Berlin and Dimitri Tiomkin. The first-generation children of Russia in American show business could include David O. Selznick, George Gershwin, and Kirk Douglas—feel that energy.

With that as introduction, we now turn to the famous directors of the Revolution and what Stanley Kauffmann (as late as 1973) was ready to regard as a moment akin to Elizabethan drama or Italian Renaissance painting: "A new revolutionary state was born as a new revolutionary art emerged, and that combination brought forth at least three superb creators in the new art: Vsevolod Pudovkin, Alexander Dovzhenko, and—the most important because the most influential—Sergei M. Eisenstein."

The early 1920s was an era of intense youthful excitement over the power of the new wonder—half mechanical, half dreamy—the movies. That statement could as easily fit Hollywood after 1917 as it could the Soviet Union in the same period. But whereas in California the movies were a new business, a fast way of becoming rich and famous, and an unplanned shift in the imaginary life of the public, in Russia the stress on business was nothing compared with designs for a new world. But the assertions of contemporary history are less potent than what the future makes of them. Maybe the most profound changes in society actually occurred in the conservative America, where no one bothered much to talk or think about revolutionary art, politics, or history.

This realization—far more candid and historical than cynical or dismayed—is not to minimize the outpouring of new creative energy in Russia after 1917. Nor does it deny the stimulation that came from the new state idealists or the opportunity of film to inform and unite the far-flung but barely educated people of the new Soviet Union. Still, it is our duty to observe what actually happened as much as what people hoped for.

Consider Pudovkin first. He was born in Penza in central Russia in 1893 and studied chemistry at the University of Moscow before being drafted into the Russian army. But he was wounded in 1915 and became a prisoner of the Germans for nearly three years, a time in which he learned several other languages. After the war, he was about to start working in a chemical plant when he happened to see D. W. Griffith's film *Intolerance*.

This was hardly a casual event. In the Russia of 1917 onward there was a serious shortage of films and film stock. The Revolution halted the regular distribution business, but the authorities were so impressed by *Intolerance* that they took steps to circulate the picture as widely as possible. Indeed, it did better in Russia than it ever had in the United States. Opening in September 1916, *Intolerance* was a grandiose survey of history, sharpened by Griffith's open wounds at the adverse commentary on *The Birth of a Nation* and its racism. So it was two reels longer than the Civil War picture, and it cross-cut from four narratives: a Babylonian story (that required the construction of the biggest sets yet built in Los Angeles); a Judean story, involving Christ; a French story attached to the massacre of the Huguenots in 1572; and the Modern Story, about two lovers (Mae Marsh and Robert Harron) threatened by the execution of the man on wrongful charges of murder.

Intolerance had cost $2 million—twenty times the cost of *The Birth of a Nation*. But whereas the first film exceeded anyone's hopes at the box office, *Intolerance* got fine reviews and a big initial audience, and then collapsed. Why did it fail? Perhaps because the audience felt no need for four stories saying the same thing—it seemed too close to a history lesson—and because it became confused and frustrated by the cross-cutting from one story to another. (Entertainment films seldom interrupt their own mood.) Some have suggested that the Modern Story released on its own would have been a hit: it is a gripping melodrama with exceptional performances (notably from Miriam Cooper as a fallen woman). In the Babylonian sequence, the set is stunning, but Griffith hardly knew what to do with it beyond having a camera in a balloon hover overhead. Dramatic events did not take place there. It did not help that the film had a recurring motif: Lillian Gish rocking the cradle of history (based on lines from Walt Whitman). Long ago, that image seemed laughable and a measure of Griffith's Victorian attitudes. But the cradle of history meant so much more in the Russia of 1917–20.

The new regime loved the didactic stress in *Intolerance* and the innocent faith in the comparability of all situations in history. More than that, it fell upon the process of cross-cutting and the dynamic of suggestion or inference that came from it, and the unproven hope that this could be educational for the masses. Of course, in history there is little evidence that the masses have gone to the movies to be educated, though there is every possibility that, blind to formal education, they are shaped by the light in the dark in ways they hardly appreciate.

If that realization requires irony, or humor, neither was in great supply in the desperate early days of the Russian Revolution. Lenin had told his cultural commissar, Anatoly Lunacharsky, that "for us film is the most important art." Some kino enthusiasts may have been encouraged by that; others heard it as a warning. For it meant that, at the outset, film was in danger of being appropriated for education, propaganda, or thought control. So it was part of the revolutionary zeal that, very early on, a national film school was established, driven by the need to use film "properly." Pudovkin was one of the students at that school, thrilled by the teaching of Lev Kuleshov.

Though the vital teacher at the school, Kuleshov was actually younger than Pudovkin. He had been born in Tambov in 1899, and as a teenager he was filming newsreels of the war. He, too, was inspired by the cross-cutting of *Intolerance*, and was prompted to construct an early theory about editing. There was a reason for this. At most film schools the world has ever known, the kids cannot wait to shoot film—of their girl friends, of their city, their dogs, their stories. They are captivated by the fun and the slippery trick of turning life into a screened thing. But at the Moscow school, this could not be indulged—because of the shortage of film stock. So Kuleshov began to teach his students about editing and re-editing in abstract—you can use drawings or stills, and the lessons may sink in. According to the precepts laid down in *Intolerance*, he began to establish equations, such as $a + b = something$ *entirely different*. He cut together shots of an actor's undirected face with objects he might be thinking of and, lo, the audience "read" the connection, the linkage. The man was hungry, afraid, in love, or whatever, according to the dynamic of cutting. This theory is not incorrect, but it can turn painfully narrow and predictive. There was another power in cutting: that the audience could be removed or shifted in time, space, and story at the whim of the medium. In that opportunity there was an inherent sense of authority or violence.

Kuleshov seems to have been a naturally inventive, humorous young man. For instance, his 1924 satire, *The Extraordinary Adventures of Mr. West in the Land of the Bolsheviks*, is a playful delight, full of jokes about Western foolishness over the Bolshevik enterprise. But that strain of comedy struggled to become a Russian tradition. The theoretical emphasis on editing, and what the Soviets would call montage, led to papers, books, and course curricula. And it had the effect of turning the shot (that basic element of film) into a still, as opposed to pieces of movie (things in which movement or duration were vital). Similarly, shots made for montage

tended to isolate figures (their function smothered their vitality), whereas there is a potential in film for people being together in the shot, related by space.

Pudovkin followed that line of thought. After a few short films, he embarked on a deliberate trilogy—*Mother* (1926), *The End of St. Petersburg* (1927), and *Storm over Asia* (1928). These are humane dramas of the Revolution, utterly worthy yet heavy-handed, and with so predictable an emotional slant that they are not easy to sympathize with today. Nothing really happens in the films beyond the execution of an idea; there is more ideology and example than immediacy. There is great spectacle and there is often a burnished Russian light that owes something to the primitive laboratory work in that country. (There is a harsh sensuality in Soviet black and white that is very compelling.) The rigorous reliance on montage, though, the linkage (a key word in the theoretical disputes), is usually related to people and their desires. Pudovkin is trying to identify human stories; it is just that the structures of duty in the revolutionary narrative are always tending to simplify them.

The bickering over schemes of montage, among friendly rivals and co-revolutionaries, seems comic nowadays, but fervent. In a 1929 essay, "The Cinematic Principle and the Ideogram," Eisenstein gives a concise account of the disputes:

At regular intervals he [Pudovkin] visits late at night and behind closed doors we wrangle over matters of principle. A graduate of the Kuleshov school, he loudly defends an understanding of montage as a linkage of pieces. Into a chain. Again, "bricks." Bricks, arranged in series to expound an idea.

I confronted him with my viewpoint on montage as a collision. A view that from the collision of two given factors arises a concept.

In practice, Eisenstein devoted much of several books to this argument, and he was bright enough to employ physics and cell structure as illustrations. But he seldom mentioned story. In addition, while friends say that Eisenstein was mercurial and amusing in person, and driven by the principles of montage in his writing as if they were part of the Five-Year Plan, the humor does not often hit the page or his screen. Moreover, the undoubted pathos of Pudovkin's films still works, despite a regret in the viewer that all his people have been made subordinate to the historic argument and the ideology. If you share that feeling, you should sneak a

look at Pudovkin's eighteen-minute *Chess Fever*, made in 1925, in advance of his features.

Chess Fever is an endearing screwball comedy. A young man is obsessed with chess, so that it is ruining his relationship with a girl. His clothes are checkered like a chess board. He sees chess problems everywhere. The girl grows wistful—it is akin to Howard Hawks's *Bringing Up Baby* (1938) with its quest for "fun." She leaves him and instead charms José Raúl Capablanca, the Cuban world champion (1921–27), in town for a chess tournament. Capablanca looks like a worldly Valentino cut with Irving Thalberg. He is so suave and self-sufficient; you can smell his cigar smoke and cologne. But in the face of his girl's cunning Russo-Cuban defense, the young man is reformed and reunited with her. (Maybe in foreplay he still favors the knight's move.) I don't mean to overvalue *Chess Fever*, but I want to insist on its surrender to comic incident, ironic narrative, and ordinary silliness. It is shorter than *Storm over Asia*, but it works better because of its greater sense of life and human vagary.

This matter of "still working for us" is not trivial or incidental: the cast-iron gravity and political portentousness in Pudovkin's features need to be set beside almost exact contemporaries—*Sunrise*, Carl Dreyer's *The Passion of Joan of Arc*, Victor Sjöström's *The Wind*, movies in which the screen comes alive with human uncertainty, transience, and a grasp of cinematic potential that exceeds the ideological textbooks by Pudovkin and Eisenstein. On-screen, saving the world (or crushing it) usually means less than the kind of glance that feels seconds passing like a breeze on your cheek. One could add to that list Dziga Vertov's *The Man with a Movie Camera*, the most lyrical optics-mad of all the Soviet films and the least apologetic in opting for movie over life and the Revolution's heaven.

Dziga Vertov was an invented name: it means "spinning top" and shows the man's love of mechanics, play, and perpetual motion, and his instinct for the movies as a machine that might transform reality. His real name was Denis Kaufman, and he was born in Białystok, Poland, in 1896. Though trained in music, he entered the Petrograd Psychoneurological Institute in 1916 to study perception. This was far from the show business path to the movies that operated in so many other countries. Kaufman was a kind of scientist as well as a painter in light and emotion. He was a bit of Picasso and a lot of Pavlov. But he was a Soviet at the moment of revolution, so he easily adopted the credo that film could save the world, bind the disparate Soviet republics together, and make manifest the ideology and practice of communism. He was crazy, but touched by genius.

On the one hand, Vertov fell in love with the notion of film as a source

of documentary record and inspired information. He thus became part of the film committee's drive for newsreel, which led to the famous kino trains. A train set out to cross the vast country. As it went, it had camera crews film what they saw. As the train moved on, a compartment was the site where this material was developed and then cut together to make a newsreel—using all the lessons of montage being formulated by Kuleshov. Then, at the next stop, a few hundred miles down the line, another compartment served as a theater, to be filled with citizens who could see how the new state and their neighbors were working. It sounds marvelous, and some of Vertov's work was as beautiful and exalted as the best constructivist designs. But modern art does not always fill the bellies or the anxious minds of peasants and kulaks. They are like the chain gang on which Preston Sturges's director (in the person of Joel McCrea) finds himself in *Sullivan's Travels* (1942): they will settle for a little relief.

Dziga Vertov filled the 1920s with newsreels, documentaries, and sheer footage of astonishing beauty and wit and convinced himself that all of this was to promote and accelerate the immaculate Communist plans, no matter that the real Soviet Union was being beset by the ugly compromises of a revolution making its way. So he fell out of favor and helped crystallize the growing Party dismay over "formalist" tendencies that were ignoring "social realism" (albeit a realism constantly burdened with propaganda). So Vertov's passion for documentary—the unblemished record, the unprejudiced observation—was betrayed by his own brilliance as much as by Party-line brutalism. When Lenin had identified film as vital to the Revolution, he believed in impartial truth for maybe a day. But as Stalin took over, the truthfulness of film was twisted out of all recognition. A film, it was clear, could mean whatever the state wanted it to mean. In which case, that volatility had to be under state control.

Some innocent audiences see *The Man with a Movie Camera* as characteristic of the young Vertov and the younger Revolution. But it was made in 1929, close to the end of his working life, and it came about not from an official state commission but as Vertov wandered away from official attention. Much of it was shot in Kiev and Odessa. For a moment, Vertov was free, and it is our good fortune that the film escaped intervention or state destruction. It is a tribute to the idealized figure of the cameraman, advancing with his camera and tripod, filming in the most extreme positions with cheerful aplomb, and delivering to the editor a catalogue of what the camera can do. And by then Vertov was blissfully resigned to his trusted spinning top as a compendium of trickery. So he exposes that falsehood in the beauty and the thrill of being depicted. *The Man with*

a Movie Camera is far from an endorsement of film's evenhanded way with reality. It takes orgasmic delight in the confusion of the real and the cinematic. A heart beats within it that says art is so much more important and useless than cockamamie claims for political salvation. As it was, Vertov lived on until 1954, in a merciful obscurity oddly indicative of the strange exile enjoyed by one of his greatest successors, Jean-Luc Godard, who wearied of being a conventional filmmaker and withdrew to his own Swiss laboratory finally aware that the world had declined to be saved, in part because film itself had done so much to spread a new alienation. People ready once to remake the world would instead gaze at screens as an alternative. It is a key transaction of the medium, the more profound for being inadvertent. A state of film had eclipsed state film.

The totality of Dziga Vertov's work is still not widely known, in part because its beauty is monotonous but also because its topics—the incidents of revolutionary history—are now as obscure as they are fraudulent. All too often, Vertov was documenting official lies. Still, his career is a vivid demonstration of the conflict between formal excellence and propagandistic meanings in state film. Vertov might receive more attention if we did not have Sergei Eisenstein to study.

And Eisenstein is not just a significant artist; he is the hero in his own melodrama—a role that would become nearly compulsory in the lives of filmmakers. Fortunately, his legacy as a human being is more interesting than his films.

Eisenstein was born in Riga, in Latvia, in 1898, and he deserves to be regarded as among the most diversely talented and broadly educated of all filmmakers. He was the son of a civil engineer and architect, a man he adored. It was a comfortable family, and the boy traveled a good deal: in 1906, in Paris, he saw his first film, a piece by Georges Méliès. He loved to look through his father's photograph albums, and he developed a precocious talent as an artist, often in the form of grotesque caricatures. But the likelihood remains (and is substantiated by sketchbooks exhibited in recent years) that Eisenstein could have been a graphic artist of the highest order. That skill, or talent, was shared with Fritz Lang and Alfred Hitchcock, and we should not underestimate the impact of drawing (or storyboarding) on early films. Of course, its greatest exponent would be a kid from the Midwest just three years younger than Eisenstein yet far more sweeping in discarding reality. His name was Walt Disney.

But there was no end to the young Eisenstein's appetite: he graduated from high school in Riga, and went on to study architecture in Petrograd. But when he joined the army, he found his facility in languages. And after

all that he went into the theater, at first to do sets and costumes, but then to take a growing interest in direction, under the tutelage of Vsevelod Meyerhold. There's no doubt that the first step on Eisenstein's part toward montage was in seeing how experimental theater could be self-interrupting, putting incongruities together (what he called "collisions") to jostle audience preconceptions. So, almost in advance of Communist needs, Eisenstein was possessed by an urge to reorganize human perception. This was as much Picasso-like as it was prompted by Lenin.

Suppose he had left the Soviet Union on any of the occasions that offered. Suppose he had become a Parisian, rather freer to indulge his Jewishness and his gayness. He might have become a famous painter or stage director—yet all his formal ability lacked was a touch of narrative sensibility. He made up for that, or tried to, by dedicated intellectual enquiry and a capacity for discussing theory. And so it was after early short films and the shooting of material to be used in stage productions (sometimes at the Proletkult Workers' Theatre), and assisting on re-editing Fritz Lang's *Dr. Mabuse: The Gambler* for showing in Russia, that in the summer of 1924 (he was a year older than Orson Welles at the time of *Citizen Kane*) he made his first film, *Strike*, like a kid demon scoring goals at soccer.

Years later Eisenstein would say that *Strike* (1925) was like so many first films, "bristly and pugnacious," the way he was at the time. Let's add "beautiful" and head over heels in love with its own medium. You can say that *Strike* is grief-stricken for the fate of its heroes, the strikers. But you don't feel too much grief amid all the exuberance of making a picture, and putting it up. *Strike* feels like an unbroken screening of a spectacular lecture-demonstration by a group of agitprop players bowled over by the fun of what they are doing. There are horrible scenes—an infant dropped to its death by a policeman on horseback; the ritual beating up of a striker; the pell-mell heap of dead bodies—but at every step, we feel the coup of its achievement and the flourish with which it's delivered. When the baby is dangled over an abyss at the workers' tenements, Eisenstein and his great cameraman Eduard Tisse revel in the depth and the light of the shot. When the strike leader is brutalized, the beating is staged as a kind of dance number. And in the field of corpses, you can't miss the marvel of all those extras and Eisenstein, with a megaphone, urging them, "Be still! Be quiet! Don't anyone move!" Some of the corpses are smiling! They all seem to be playing a game at a picnic. And you wish you could have been there.

It's a film in six parts, like the six steps in a lesson—and what is the point? You know what to feel in advance; it's the great handicap that the

film never quite confronts. The strikers are virtuous, brave, earthy, good-looking, energetic. They are wonderful. The bosses, the stockholders, and the police are ugly, fat, decadent—one has the lousiest teeth, which he bares as if they were weapons—prone or slouched in chairs, drinking, smoking, carousing, and issuing toxic orders on the telephone. Sooner or later you'll get the message. The strikers are honest and noble and saints. The bosses aren't. This could soon become tedious (and a threat of monotony hangs over state film), but for the rapture with which Eisenstein films it all, the unstoppable inventiveness of the actors, and the swaggering impact of the whole thing thrown up on a screen as if it were a blackboard in a classroom. This is theater, or pantomime, for a young experimental nation more than grown adults who realize that the struggle between capital and labor in a modern economy is very complicated. In 1925 no Soviet authority was prepared for the complexity. To strike was to overthrow corruption. Life was still very simple, even if the cinematic energy was without rival. So we never see the strategizing of union leaders or commissars. We are offered a plain choice, backed up by the terrible cruelty of the police. Yet in the real life of the Soviet Union, strike leaders became policemen soon enough. Nothing in Eisenstein's way of seeing was prepared to notice that in 1924–25.

Time and again in *Strike* (and this still works) we exult at the way Eisenstein the caricature artist has dropped pen and paints for a camera and the light. And if the topic announces itself as grave and brutal, the movie remains gorgeous. Nothing illustrates this better than the terrific range of gesture, attitude, and violent physical elan in the inspired company of the supporting cast. (There are no stars.) These are the Proletkult Workers' Theatre members, often staring straight into the camera, as bold as monkeys. In love with the screen, Eisenstein wants to advertise its stark role, so he rarely uses oblique angles to observe people "off guard." (He never reaches for the privileged "intimacy" or private moments offered in American cinema.) This is film thrown in our faces. It's like a balletic newsreel, jazzy with urgency and attack. (Had Sergei heard the first Hot Five recordings from 1925?) And in love with his players and the savage, uncritical "types" they present, Eisenstein wants to get closer to them, like a nose with cocaine, so he loves big close-ups and seething compositions where bodies writhe together in talk or battle. Never a dull or still moment. How could there be if you're making a movie where political necessity requires that you keep a fierce hold on audience attention at all times?

The idea behind the film says the company spies are odious and treacherous, but in filming them, Eisenstein falls in love with their antics and masquerade, the dissolves that reveal disguise and cunning. You can hear the laughter between director and players—"Oh, yes, do that!"— even if you're watching a version of the film that now has a driving, pounding score by the Alloy Orchestra, added only ten years or so ago.

When the police turn power hoses on the crowd of strikers, we see their humiliation and distress, but only for an instant, before we're dazzled by the swirling white shapes of the water and the sight of drenched bodies trying to avoid it. It's as if Eisenstein can hardly look at anything without being captivated by its cinematographic beauty. So the strike and its consequences become a show. There is the superb confidence of an expert circus in *Strike*. Imagine Cirque du Soleil putting on a new version of *O*—"Overthrow the Bosses"—at the Bellagio in Las Vegas, and doing it in black and white with the raw glow of gold just mined. We ought to be horrified at the police brutality and the bosses' cynicism, but the screen's frenzy is overwhelming. That flat form is bristling, pugnacious, and alive. It crawls with vitality and exults in the imitation of realism. I'm not sure that in 1925 anyone anywhere had made a film with a greater sense of discovery and miracle. Kino, we love you, the picture says. Does it add, you're better than life?

So why are we on our feet cheering at the end, when the portrait of working-class disaster is so grim? Of course that is the lesson meant for the huddled Soviet masses—believe in the great strike on which we are all embarked. Do what the union leaders tell you, and start off by seeing *Strike*! But then suppose the factory workers responded, "Great God! I don't want to stay in a factory all my life—not even a place as pretty as Tisse saw. I want to make movies!"

I don't think Eisenstein ever topped that debut. Of course, the next film, *Potemkin*, is better known. It made the director an international figure and the darling of film societies devoted to this lively Soviet art (and its promise of a new world), especially if they did not themselves have to live in Russia. For several decades, *Potemkin* and Eisenstein were emblematic of an alternative cinema to that of Hollywood—less controlled by money, more dedicated to the liberation of the human spirit, and supposedly more alert to social reality. For many judges, they were the acme of the art. That was wishful thinking, but we don't have to blame it on Eisenstein or lose sight of the conundrum in *Potemkin*.

There really was a battleship named *Potemkin*, and its mutiny was an

incident in the attempted revolution of 1905, if not as clear-cut or rousing as Eisenstein would have it. The ship was briefly taken over by an indignant crew. (The meat on board was bad.) The mutineers sailed to Odessa searching for supplies. That harbor city was indifferent. The ship sailed away. The mutineers quarreled, and the ship ended up back in the hands of the navy. There was no massacre on the Odessa Steps. But how many people would believe that now? Anything on film runs the risk of becoming a given for the future.

The film was shot in the late summer of 1925, and while Eisenstein had recently visited Odessa, he found more congenial steps in Sebastopol. Some commentators have claimed that the display of montage for which the film is most famous was the result of the prevailing shortage of film stock in the Soviet Union—so short ends of stock made for short shots? Not so. By the mid-1920s the Soviets had as much film as they needed. That's how Boris Barnet and Fyodor Otsep were able to make *Miss Mend* only a year later, at four hours and with so many entrancing, extended shots. No, Eisenstein did montage for his best reason in the world: it was what he wanted.

The question of why he wanted it is harder to answer. *Strike* is an accumulation of detail in which Eisenstein was less interested in developing a fluent sequence of events than amassing aspects of it. He liked to collage pieces of action. So the set pieces are a building up of angles and shots held in place by the scheme of the sequence. The editing in *Strike* seldom breaks into rhythm for its own sake, though there are cutaways near the end of the film to cattle being slaughtered in an abattoir—the slashing of throats, the rush of blood—that are cut into the reprisals taken against the strikers as nothing more or less than a metaphor or a symbol. The effect is clumsy and pretentious, a distraction from the film's heady energy.

But in *Potemkin*, the massacre scene was conceived and then edited as not just an accumulation or a buildup, but a buildup that vibrates with cutting's dynamic. If you need reminding, Eisenstein's setup has a civilian crowd (essentially middle class) gathering on the Odessa steps to applaud the mutiny, with the crowd then being attacked and dispersed by the tsar's troops (in white jackets and caps, dark pants and boots).

The script for the picture signals the design—both the termination of civilian life and the scourge of reprisal:

A small boy, wounded, falls nearby.
In terror the crowd runs down the steps.

The boy clutches his head with his hands.

In terror the crowd runs down the steps.

Relentless, like a machine, ranks of soldiers with rifles trailed descend the steps.

In terror the crowd runs down the steps.

Behind the balustrade a group of terrified women hide—among them the elderly woman in pince-nez.

Men leap from the balustrade onto the ground.

Behind one of the balustrades a man and a woman hide.

Behind the other balustrade an old man in pince-nez, a small schoolboy and a woman hide. The old man in pince-nez is unexpectedly hit by a bullet.

A rank of soldiers fires into the crowd.

And so on—six pages in the script and seven minutes on the screen. It is more decisive and cruel as a movie, of course, because while uninterested in depth of character, Eisenstein had chosen his extras and their expressions with greedy acuity. These screaming faces are among the enduring images of the twentieth century. They are like the agonized horses' heads in *Guernica*, or the paintings Francis Bacon would make from *Potemkin* stills. And after *Strike*, no one could doubt Eisenstein's ability to choose faces or to catch them at peak emotional moments—mirth or panic, frenzy or rage. Further, while it is clear that in 1925 no one had ever seen editing or montage performed with such relentless authority and plastic beauty, the impact of the Odessa Steps sequence is still so compelling that it's easy to forgive the minor flaw: that the massacre never happened.

But massacres do happen, and it has been the automatic assumption of film commentary ever since that Eisenstein was possessed by the idealizing pathos (his word) of the event and only wished to make us feel that.

Consider a little more: if you mean to put a massacre in a film, it is in many respects easier to make a great list of shots, angles, and close-ups and to tick them off. It may take time to shoot them, and more time to construct the edited assembly. But it is harder and far more dangerous to say to a few thousand extras, "You fellows, the ones in uniform, attack those in their own clothes. Here are your rifles, your bayonets and swords. Now, on the word, disperse the crowd. Camera! Action!"

Think of the shower sequence in *Psycho* (not so weird a companion to the Odessa Steps). It runs about a minute on-screen, yet Hitchcock took five days to film it, using a detailed storyboard as his guide. No knife

pierced Janet Leigh's skin, or that of her stand-in. The nudity of the char-
acter, Marion Crane, could be hidden because the angles were so precise,
mannered, and brief. One day, another shard broke in—the screams and
pounding of the music and the clear sound of a knife hacking through
substance. (They used watermelon apparently, but they were out for
blood.) The end result is devastating. But it may be an evasion or a fabri-
cation compared with a single, unblinking, full shot that simply observes
the ghost of Mrs. Bates murdering Marion. I think we know that would
not have passed the censor in 1960, when films were still not supposed to
show the act of murder. Instead, Hitchcock wanted to make it artistic.

But do we really need to be educated in the principle that massacres
of civilians by armed troops are wrong? Is there doubt?

On the other hand, there are acts of violence in cinema accomplished
in single shots—I think of the killing of the potter's wife in Mizoguchi's
Ugetsu Monogatari (1953), the murder of Batala in Renoir's *Le Crime de
Monsieur Lange* (1935), the climax on the cliff ledge in Michael Mann's
The Last of the Mohicans (1992), or the displaying of Lola at the end of
Max Ophüls's *Lola Montès* (1955). No, the last is not a murder, merely the
observation of a woman who is dying and cannot back off from the killing
show made of her life. The violence there is tacit, everyday, and societal—
and maybe more provocative than the massacre in *Potemkin*. We are old
enough now to realize that camera attention can destroy some people.
Those other moments are treatments of death in which a privileged thrill
is replaced by its sickening consequences.

There's the conundrum I spoke of. *Potemkin* does urge us not to hack
down innocent citizens who have come to see the big show. It even main-
tains that it is shocking to expect sailors at sea to eat maggots. But those
things hardly amazed many audiences. What gripped them was this new,
close-up scrutiny, this screening, of intolerable damage, to the extent that
we watched it and came back for more and called it the height of cine-
matic art. It did this without ever drawing anyone's attention to the ways
the film celebrated the "relentless" chorus line of bayonet-bearing troops
coming down the steps.

I hope that's shocking, because sooner or later, if it's going to last, the
cinema needs to be shocking. If all it can do is lull us into a kind of rhap-
sodic transport with the power of the montage and the beauty of the film,
we will be inert long before the medium gets its death certificate. What
I am saying is that Eisenstein was as thrilled by violence as Hitchcock or
Sam Peckinpah, and by the ways in which montage permitted it—just as

Hitchcock could not have murdered Marion Crane without the sharp blades of editing's tools.

Potemkin opened at the Bolshoi Theatre in Moscow on December 21, 1925. (He had been only three weeks at the editing, which shows how far the montage had existed in the script's concept.) He was so nervous that he prowled the corridors listening for audience reaction until he remembered (he said later) that the close of the film, the final length of physical film, was held together by spit, not film cement.

And here is the kid and the fantasist in Eisenstein, the way in which people knew him from the persistent but enigmatic grin beneath his wild, curly hair:

> In utter confusion I race through the semicircular hallways and spiral down the corkscrew stairs, possessed by a single desire, to bury myself in the cellar, in the earth, in oblivion.
>
> The break will come at any moment now!
>
> Bits of film will come flying out of the projector.
>
> The finale of the picture will be choked off, murdered.
>
> But then . . . unbelievable . . . a miracle!
>
> The spittle holds! The film races through to the very end!
>
> Back in the cutting room we couldn't believe our own eyes—in our hands the short cuts came apart without the slightest effort, and yet they had been held together by some magic force as they ran, in one whole piece, through the projector . . .

That's montage for you. You had to be there that night, or ready to swallow self-dramatization. But even at a distance you can see how the fragmented excitement of this autobiography resembles the stepping stones of his script. It was a great night, but Eisenstein would never have it so good again.

THE EXTRAORDINARY ADVENTURES
OF MR. BOLSHEVIK IN THE WEST

"Applause like the crackle of rifle shots" thrilled Eisenstein at the Bolshoi Theatre that opening night of *Potemkin*. (He really was a bit of a military man.) He won prizes and praise and gained entrée to the smart people of the world, celebrities as well as intellectuals. In the next few years, he was invited to Berlin to visit the studios there. He gave lectures. He chatted with George Grosz and Pirandello. In London, he talked to George Bernard Shaw (the dramatist wanted him to make *Man and Superman*) and then lectured at Cambridge. In Paris, he met Einstein, Joyce, and Cocteau. When they visited Moscow he greeted Douglas Fairbanks and Mary Pickford, and they told him he should come to Hollywood. He was excited and, having signed a vague contract with Paramount sufficient to get entry papers, on May 8, 1930, he, Tisse, and Grigori Aleksandrov set sail for New York on the *Europa*, where the meat was above reproach.

His first films had been endorsed by the Party. He was charged with making a picture for 1927 that would honor the tenth anniversary of the Revolution—that turned out to be *October*, or *Ten Days That Shook the World*, and it is a predictable rendering of insurrection against tyrannous reactionary forces turned into an exercise in montage. But the exercise is more studied now. There is not the Proletkult gang; there is not the fascination with violence. In addition, Eisenstein was ordered to omit any mention of Trotsky and Zinoviev.

There was another film, *The General Line*, which is a study in the old and new methods of agriculture—a subject that never taxed Orson Welles or Billy Wilder, but that patently began to erode Sergei's vigor and nerve. Even then, Stalin himself intervened and ordered that Eisenstein was not to show how the Revolution had disposed of inconvenient and disobedient kulaks. These are both films that try to convey the idea of the masses

as the film's heroic force. Alas, the real masses were unmoved, or unexcited. The Party might approve of the film, but the Soviet people gave every indication of being just like the American audience of the late 1920s: They were ready for Jolson and Garbo and Harold Lloyd. They wanted fun and relief. It was mainly in certain recesses of Beverly Hills, the Ivy League, and the Upper West Side that Marxist theory went down well.

Eisenstein by 1930 was in the habit of calling what he did "Intellectual Cinema." That was the title of some of his lectures (and he was usually able to speak in the language of the city where he was). And so he set out for the last place on earth where it was sensible for a filmmaker to give lectures or use the word *intellectual*. And yet he had fun—that was the inner bubbling that makes Sergei so appealing. So you owe it to him to remember his humorous gaze every time you find yourself reading things like this (from "A Dialectic Approach to Film Form," written in 1929). He begins with Marx and Engels on the "dialectic system," and plunges ahead:

> The projection of the dialectic system of things into the brain
> into creating abstractly
> into the process of thinking
> yields: dialectic methods of thinking;
> dialectical materialism—PHILOSOPHY
> And also:
> The projection of the same system of things
> While creating concretely
> While giving form
> Yields ART
> The foundation for this philosophy is a dynamic concept of things:
> Being—as a constant evolution from the interaction of two contradictory opposites.
> Synthesis—arising from the opposition between thesis and antithesis.
> A dynamic comprehension of things is also basic to the same degree, for a correct understanding of art and of all art-forms. In the realm of art this dialectic principle is embodied in
> CONFLICT
> As the fundamental principle for the existence of every artwork and every art-form.

The layout (the visualization) may be more interesting than what is being said. Still, the use of "art" and "correct" in the same sentence could make a Stalin, or others among us, feel for his revolver. There are diagrams and equations in some of the lectures, and they grind on and on. So never forget the lyrical cinematics of *Strike*.

On the East Coast of America, Eisenstein got the best of both worlds. In a rapid tour, he lectured at Harvard, Princeton, Yale, and Columbia. He also visited a Paramount sales convention in Atlantic City, to meet the people who would be selling his pictures, and he recalled company executives Jesse Lasky, Sam Katz, and B. P. Schulberg prepping him before he appeared:

> "A lot depends on personal impression."
> "But don't be too serious . . ."
> "Point out your shock of hair."
> "But at the same time don't frighten them off by being too trivial."
> "Though in general, Americans like speeches to have jokes."
> "In New York you'll have to stay at the Savoy Plaza . . ."
> "That's in your contract."
> "You've got to keep up both your prestige and ours."
> "Now, when the press meet you in the hotel lobby . . ."

There's so much comic accuracy in that montage, you want to see Sergei turned loose with the Marx Brothers (a Paramount property, and yes, his hair did resemble Harpo's). Alas, that teaming didn't happen. Paramount was paying Eisenstein $500 a week (with another $400 to be shared by Tisse and Aleksandrov), and eager for a project to emerge. They spoke of Eisenstein in Hollywood as "a noble project," and Sergei slyly noted that some Americans used the same phrase to describe the Soviet Revolution. Others were more hostile. Major Frank Pease, president of the Hollywood Technical Directors Institute, denounced Eisenstein's presence in Los Angeles as "more dreadful than an invasion by a thousand commandoes."

He was a new star in town, renting a house in the Hollywood Hills. For a moment, everyone wanted to see him. He was pals with Mickey Mouse and Rin Tin Tin. He watched Garbo at work and was surprised that she employed no "academic technique," just inspiration. He played tennis with Charlie Chaplin, who told him he'd recently screened *Potemkin*

again—"In five years it hasn't aged a bit," declared Charlie. The comedian marveled that Eisenstein had made his picture in just three months with only two weeks of editing. Chaplin himself was by then into the five-year plan of taking longer and longer on a picture, until he got it right.

There were many hopes. Eisenstein's first thought was a picture about a city made entirely of glass where everyone could look into anyone's private life. (Shades of our surveilled society, or Facebook.) B. P. Schulberg, the head of production at Paramount, killed that idea when he was told it would cost $1 million to build the city—which would then have no use as a standing set. So Schulberg encouraged another scheme, *Sutter's Gold*, about a pioneer figure in the California gold rush. The studio appreciated gold, but then it was perturbed to discover that Eisenstein saw gold destroying the people who found it; that sounded too close to Marxism.

The third project was the most promising: an adaptation of Theodore Dreiser's 1925 novel, *An American Tragedy*. Paramount were intrigued because the novel had caused a stir. They reckoned it contained the seeds of a "boy meets girl" story "without going into 'side issues.'" That was Eisenstein speaking: "What interested me here was depicting the society and the morals that impelled Clyde [Griffiths, the hero] to do everything he did, and then, in the hullabaloo of the pre-election fever, in the interests of getting the prosecutor reelected, Clyde is broken."

That had a smell of social criticism, and it was what had prompted Dreiser. The novelist was all in favor of Eisenstein's approach. On the other hand, another Hollywood friend, Doug Fairbanks, recommended Jackie Coogan (the boy in Chaplin's *The Kid*, 1921) to play Clyde. Eisenstein worked on a script with his own cohorts, Grigori Aleksandrov (an assistant since *October*) and Ivor Montagu, an English aristocrat-intellectual, cofounder of the London Film Society in 1925, a famous tennis player on the Hollywood courts (even better at table tennis), probably Sergei's lover, and a man who was also spying on Eisenstein and reporting to the NKVD (Soviet secret police) in Moscow. It was a complicated life—and could have made a good movie.

The boy-meets-girl story of *An American Tragedy* is this: Clyde, a poor man trying to make his way in America, meets Roberta in the factory where they work. They become lovers. She falls pregnant. But then Clyde finds Sondra, a rich girl, who smiles on him and offers a better future. What will he do with Roberta? You may recognize this outline: it is *A Place in the Sun*, the somber 1951 romance with Elizabeth Taylor and Montgomery Clift. More than that, the climactic situation of uneasy

lovers in a boat on a lake and a man with two women are familiar from
Murnau's *Sunrise*, made only a few years earlier and plainly a film Eisen-
stein knew.

The script for Eisenstein's version of Dreiser survives, and it suggests
the possibility of a film as good as *A Place in the Sun*. Here is a key mo-
ment from it, as Roberta drowns "by accident," yet in fulfillment of Clyde's
dread dream:

> Once more rings out the long-drawn booming cry of the bird
> [a loon]. The overset boat floats on the surface of the water.
> Roberta's head appears above the surface.
> Clyde comes up. His face showing terrible fright, he makes a
> movement to help Roberta.
> Roberta, terrified by his face, gives a piercing cry and, splashing
> frantically, disappears under the water. Clyde is about to dive
> down after her, but he stops, and hesitates.
> And a third time the long-drawn booming cry of the far-away
> bird.
> On the mirror-like calmness of the water floats a straw hat.
> The wilderness of forest, the motionless hills. Dark water barely
> lapping against the shore.

It's hard to believe we haven't seen that film, the mood and the flow
are so arresting. I suspect the eloquence in the writing comes from
Montagu—spies can be very ambiguous and talented figures, far more so
than *Strike* cares to understand.

The script was read at Paramount. No one was more deeply impressed
than the young David O. Selznick, making his way up the Hollywood lad-
der. Years earlier, as an apprentice at M-G-M, he had been struck by the
craftsmanship of *Potemkin* and urged the studio to hire Eisenstein. Why
not get every talented person out of the Soviet Union and into Beverly
Hills? When Selznick was just fourteen, his father, the pioneer Lewis J.
Selznick (born in Lithuania), had sent a cheeky cable to the beleaguered
tsar (and, at the same time, to the American press):

> When I was a boy in Russia your police treated my people very bad.
> However no hard feelings. Hear you are now out of work. If you
> will come to New York can give you fine position acting in pic-
> tures. Salary no object. Reply my expense. Regards you and family.

So David Selznick had some history on his side. But as he read the Eisenstein script for Dreiser, he had to admit to B. P. Schulberg that it was "positively torturing. When I had finished it, I was so depressed that I wanted to reach for the bourbon bottle. As entertainment, I don't think it has one chance in a hundred." Schulberg followed his advice, and Eisenstein's contract was terminated.

One chance in a hundred was not said casually. A thing that fascinated Eisenstein in Hollywood was the mania for gambling among industry leaders, ready to bet on anything and everything: "On pictures. On stars. On contracts. On scenarios. On races. On the supposed number of knots the liner will do in a day. And even more on elections—state and national (this gives every election campaign an added thrill.)" Add this: in just a few months' time (March 1931) Governor Fred Balzer of the state of Nevada would announce the legalization of gaming in his state. It is a cunning dilution of politics or social study to suggest that whatever happens is just the luck of the draw, and something to be gambled on. Imagine Eisenstein doing a history of Bugsy Siegel!

So Eisenstein was rejected by Hollywood, the place where Lubitsch had triumphed, where Murnau had made at least one remarkable picture, and where von Stroheim had become a grave-faced joke. Sergei was philosophical: he had had a good time. He sat and talked with B. P. Schulberg's son, Budd, sixteen at the time, a Hollywood prince, headed for Dartmouth College and a trip to the Soviet Union that would turn him into a young Communist, and one day the author of the scathing satirical novel *What Makes Sammy Run?* (1941), and of the screenplay for *On the Waterfront* (1954).

Budd reminded Sergei of B.P.'s desire to make *War and Peace*, but Eisenstein said tactfully that he was weary of Russian subjects. He preferred to do an American picture. He also made it clear to Budd that he was once a painter who had shifted his career to working with light. The kid was impressed, but he had enough of the business in him to conclude, "In retrospect, Eisenstein was one of those whose genius cannot accommodate any social system—as ill-fated for Zukor-Lasky capitalism as for Stalin's communism."

The adventure was only just started. Eisenstein was five months in Hollywood before the firing, and then he turned to the novelist Upton Sinclair with a project inspired by talks with Diego Rivera. The painter had suggested a picture about Mexico. He had itemized the sights and phenomena of that country, and Eisenstein was excited because he didn't

want to go back to the Soviet Union. Rivera guessed that the Mexican film could be done for as little as $25,000. So Eisenstein went to Chaplin, for whom that sum was minor. But Charlie reckoned it was more of a Sinclair venture, for the novelist and Eisenstein had been in contact. An admirer of *Potemkin,* Sinclair had written to Eisenstein years earlier, and the Russian had talked about filming Sinclair's 1917 novel *King Coal.*

There were meetings, and Sinclair helped get extensions on the Russian visas. A contract was made, with Sinclair's wife, Craig, acting for her husband. She would advance $25,000 for a four-month shoot in Mexico. The Sinclairs would control U.S. distribution, but the film would be free for use in the Soviet Union. Sergei was set to get 10 percent of any profits after the investment had been recovered. The movie-to-be was described in the contract: "a picture according to his own ideas of what a Mexican picture should be, and in full faith in Eisenstein's artistic integrity, and in consideration of his promise that the picture will be non-political, and worthy of his reputation and genius."

But if the film was to be "non-political," where could its genius go? Into picturesque travelogue? Eisenstein and Tisse were in Mexico by December 5, 1930. They went to a bullfight; they observed earthquakes. They were arrested for having the wrong papers. They aroused suspicions among peasants who believed the camera could see through women's clothes. And gradually Eisenstein's eye became captivated by the sights of Mexico. A script emerged and it is clearly a list of things seen:

> The grotesque laughing of the stone heads becomes still more grotesque in the cardboard "piñata" faces—Christmas dolls. And then becomes voluptuous in the suffering smile of the Catholic polychrome saints. Statues of saints that were erected on the sites of pagan altars. Bleeding and distorted like the human sacrifices that were made on the top of these pyramids. Here, like imported and anemic flowers bloom the iron and fire of the Catholicism that Cortes brought. Catholicism and paganism. The Virgin of Guadalupe worshiped by wild dances and bloody bull-fights. By tower-high Indian hair-dresses and Spanish mantillas. By exhausting hours-long dances in sunshine and dust, by miles of knee-creeping penitence, and the golden ballets of bull-fighting cuadrillas . . .

As you might imagine, the shooting expanded with every fresh piece of exotica they saw. Eisenstein would not quit Mexico until February

1932! He fired cables back to the Sinclairs asking for more money. He sent bits of footage that they found striking but incoherent. In the end, over $90,000 went into the project. As Sinclair grew more anxious, he wrote to Stalin, asking for advice. The answer came back, grim and misspelled (in November 1931):

> Eisenstein loose [*sic*] his comrades confidence in Soviet Union. He is thought to be deserter who broke off with his own country. Am afraid the people here would have no interest in him soon. Am very sorry but all assert it is the fact . . .

Eisenstein tried to return to the United States, but by April 1932 he and Tisse were on the boat back to Russia. Upton Sinclair looked at the footage and asked Sol Lesser to attempt to edit it. Lesser had just acquired the screen rights to the Tarzan character, but he did what he could to achieve *Thunder over Mexico*, a film cut from the Russians' material, but organized without their input. It opened in Los Angeles in March 1933, picketed by local Communists who claimed Sinclair was interfering with the purity of Eisenstein's work. In 1940 the scholar Marie Seton recut it as *Que Viva Mexico!*, but Eisenstein would never deliver his own vision of the material.

Nearly every shot in *Que Viva Mexico!* is a knockout, yet the film is no more than an assembly of sumptuous, lurid, and often cruel still photographs. Does it say anything useful about Mexico? Well, yes, but it also testifies to visitors being attracted by the sunshine, the dust, and the savage iconography of an unfamiliar culture. Years later Eisenstein admitted it was a catastrophe.

The Soviet Union lived up to his gloomiest expectations. Any revolutionary enthusiasm had passed. An All-Union State Institute of Cinematography had been placed over all production, and its boss was Boris Shumyatsky, who would become a stifling influence in Eisenstein's life. The Party was by then afraid of films, so it controlled everything and ensured a drastic reduction in the number of Soviet films being made. In the years from 1935 to 1937, Soviet Union production dropped into the forties, and then to twenty-four films a year. Couple that with the restrictions on foreign movies coming into the country and you can see how, in this most severe period, "entertainment" was hardly recognized. Lenin's notion of film's importance had been reduced almost completely to propaganda.

Eisenstein was in disgrace as terror mounted in Moscow. Projects were considered—notably a documentary on the history of Moscow—but nothing materialized. So he taught and wrote more articles, though it was evident now that he was not free to leave the country. Then, in late 1935, he was allowed to develop a script for *Bezhin Meadow* (taken from Turgenev) with Isaac Babel as a cowriter. Shumyatsky allowed this picture to proceed. Shooting started in 1936. But in the spring of 1937 it was stopped, and Eisenstein felt the necessity to publish an article admitting "The Errors of *Bezhin Meadow*." A year later Shumyatsky himself was put before a firing squad.

The intrigue was dense and paranoid, but in 1937–38 Eisenstein was permitted to develop what would become *Alexander Nevsky*, a spectacular historical epic, beautifully shot, with a score by Prokofiev, yet almost without thematic interest. It was a picture that summoned a spirit of Russian patriotism and military solidarity, and it opened in November 1938. The Party approved of it. The public liked it. It is a statuesque, inspirational, but heavy-handed version of something like the Errol Flynn *The Charge of the Light Brigade* (1936), and as historically preposterous, but without the romanticism that made Flynn and his director, Raoul Walsh, such a team. In 1939, Eisenstein was awarded the Order of Lenin.

He seemed to be rehabilitated. But the purges were endless. In 1940, both Meyerhold, Eisenstein's former mentor, and Isaac Babel were shot. More than 680,000 people were tortured and killed. There was a film project on the Ferghana Canal, in Uzbekistan, but that was interrupted so that Eisenstein could hurry back to Moscow to direct *Die Walküre* at the Bolshoi Theatre as a concession to the cynical, short-lived pact with Germany signed in 1939.

Once the Soviet Union joined the war with Germany, in October 1941, the Moscow film studios were moved to Alma-Ata, beyond Tashkent, near the China border. It was there in 1943 that Eisenstein began to shoot *Ivan the Terrible*, his first concerted film with actors, and with Nikolai Cherkasov (his Nevsky) as Tsar Ivan IV. The patriotic need of the moment seemed to liberate the venture, and for Eisenstein there was clear progress. Here, at last, he was making a developed story about a few people, albeit lofty figures very crudely caricatured. Was he trying to take on some vestiges of dramatic realism?

But this was only the first part of *Ivan*. In 1945–46 he shot *Part II*, with its gaudy color sequences. It was only after he had cut that film that he suffered a serious heart attack, in February 1946. But then, as he

recovered, he learned that the Party was uneasy with *Part II* and suspicious that the looming figure of Ivan had been used to make a baleful portrait of Stalin. So *Part II* was never released in Sergei's lifetime. He died on February 11, 1948, only a few days past fifty. His last months had been spent in hiatus, resting as best he could and writing the autobiography that would be called *Immoral Memories*.

With "Immoral" he didn't seek to trade on the regular meaning of that word, though there are stories that his homosexual life was unrestrained, like his taste for pornography. What he meant was that his memoirs "will not moralize. They will not set themselves any moral aims nor preach any sermons. They will not prove anything. Not explain anything. Not teach anything."

That sounds surprising coming from a man who could be so didactic and doctrinaire. Was there a complete confusion in Eisenstein or was he changing? Why be unduly frightened by complete confusion? He insisted that he did not understand himself very well, but "life had passed at a gallop, without a backward glance, in constant transit, leaving one train to chase after another. My attention riveted all the time to the second hand."

If only all his films had been as open and momentary. His memoir is less a book than notes toward a book, full of life and his anguish at the thought of quitting life, and it may be the first essential book written by a filmmaker. Today, Eisenstein doesn't mean as much as he meant in the years just after his death. His influence is hard to find. But the model of an untidy life, and his pioneering of the director as helpless outcast—those things survive, along with his smile and that corona of hair. We love the man.

•

"Leaving one train to chase after another!" Surely when Sergei went from New York to Los Angeles he took the Twentieth Century Limited, that brimming metaphor for smart America in the Depression. And surely Eisenstein was enough of a constructivist still to love trains, the sounds of the wheels and the thrill of such rapid alteration. Didn't he enjoy the people on the ship who had wagered on knots? On a train, you can bet on how closely the schedule will be met, or how many impassive Indians you'll see on the range watching the train go by, or settle into a three-day poker game with the blinds down. On a train, life becomes the dream of tracking shots.

Transportation is a minor key to the movies. Do you recall the *Europa*,

the German liner that carried Eisenstein across the Atlantic? Here it comes again, as ready to serve state cinema as glamorous careers, as ready to be a vehicle of destiny as a ship of fools. In 1938 another film person took the same *Europa* across the sea, with three prints of her latest movie, a small entourage, and seventeen pieces of luggage. She was booked as "Lotte Richter," but her real name was Leni Riefenstahl, and we are not supposed to love her.

Helene Bertha Amalie Riefenstahl was born in Berlin in 1902. There would be rumors that on her mother's side there was Jewish blood— Hitler officially denied it, but Goebbels (who never liked her) encouraged the dirty thought. Devoted to her parents, she was regarded as solitary and a dreamer. She wrote poetry, about nature more than human nature, and she was ambitious to be a dancer. There was something odd in her eyes (it never left her), but she was somewhere between pretty and hand-some, and she had a good body, which she was prepared to display (top-less) in some early film roles, notably *Wege zu Kraft und Schönheit* (1925), which translates as *Ways to Strength and Beauty*. It was a film meant to endorse health, exercise, and anything else you had in mind. A knee in-jury curtailed her dreams of dance, but she was still excited to be an athletic figure on the screen. And so she met Dr. Arnold Fanck, a man against the grain of German cinema in the 1920s in that he made open-air mountain films thrilling to the spirit and purity of the heights, and often finding a beautiful maiden up the mountain.

Fanck discovered Leni, trained her, made a star of her, and took her as his lover. Leni never flinched from any request. Thus, by 1931, she had appeared in *The Holy Mountain* (1926), *The Great Leap* (1927), *The White Hell of Pitz Palu* (1929), *Storms over Mont Blanc* (1930), and *The White Rapture* (1931). But she wanted more, and she studied Dr. Fanck more closely than he appreciated. She saw that he was making films about the mountain, whereas she would concentrate on the girl. Despite Fanck's ob-jections, and enlisting men as significant as Béla Balázs and Carl Mayer (from *Sunrise*) to do the writing for her, she proceeded to star in and di-rect *The Blue Light* (1932), where she plays Junta, a mountain girl who knows the secret of the light on top of the mountain. Is this meteorology, physics, or magic? Or might it be revelation? It is one more film about light and the grace wherever it falls.

The Blue Light premiered on March 24, 1932, in Berlin, at the presti-gious Ufa-Palast am Zoo. Many people went to see it, including Hitler, who took it upon himself to meet Riefenstahl and tell her that as and

when he came to power (not long now), "You must make my films." Maybe he said that to a lot of pretty women (as well as to Lang), but the competition among female directors was not great.

Hitler meant what he promised. Once he was chancellor, he proposed a Nazi Party rally in Nuremberg and told Goebbels that Riefenstahl was to direct the film of it. Her biographer Steven Bach established that Goebbels never passed that message on: he was jealous of his own authority and may have been disconcerted by the idea of a woman director. So Leni heard of the decision only at the last minute, leaving the hour-long *Sieg des Glaubens* (*Victory of the Faith*, 1933) to suffer from haste. "In the end," writes Bach, "*Victory of Faith* was more than a sketch but less than a portrait. Still, it was something new, a tentative joining of fiction and reality techniques in a trial run whose importance lay less in what it accomplished than in what it anticipated." Hitler was so pleased he gave Leni a Mercedes convertible.

Victory of the Faith was a rehearsal, as well as a lesson that "documentary" was a myth. The screen could not tell fact from fiction, and it was hell-bent (or heaven-bent, if you prefer) on ending the distinction. In 1934, there would be another rally in Nuremberg, and enough had been learned from the first film to control (or direct) the crowd. There would be no more scenes of drunkenness, aimless wandering, or ordinary, drifting human behavior (including unattractiveness). No one should look bored or vacant. Solidarity and purpose were the imperatives of the work. And, if necessary, the production could film a scene again and again until they got it "right." In real life, the alleged material of documentary, there is no such thing as a "right" way. But in fiction, there has to be. Leni Riefenstahl was setting out now to make a picture in an epic, or more American, style.

The rally in Nuremberg was a self-sufficient event, and a Nazi Party function. Riefenstahl was charged to make the movie of it, and she was allowed to shape or stage the rally for the cameras. Yet her own company, the credits claimed, produced the film, albeit with an advance of 300,000 reichsmarks from Ufa (not yet a nationalized company) in return for the distribution rights. This is important in that Riefenstahl claimed and received royalty income on the film for decades, even after it had been banned in Germany. She lived until September 2003 and never mounted another film after *Tiefland* (begun in 1940, but released only in 1954). She published a few books of her photographs—on handsome African tribes such as the Nuba—but she survived on *Triumph of the Will* (getting residuals way ahead of most American directors).

The rally lasted six days and Riefenstahl knew its program from the outset. She also had 16 cameramen, 16 camera assistants, 9 aerial photographers, and another 29 newsreel cameramen at her command. There was a lighting crew of 17—in all a crew of more than 215 people. Riefenstahl wore a white coat (to be recognized as the authority); only Hitler was more noticeable. She laid tracks and built crane-shot mountings. When it came to the platform speakers, she was able to have them in a studio for refined close-ups.

But any filmgoer knows this from the movie itself, and from its stunning opening. "Stunning" here is not fascistic, I hope. The film critic word is a simple response to the way film and the screen are used. It is a glorious day in Nuremberg as Hitler's aircraft comes down out of the pearly black-and-white sky. The music (by Herbert Windt) is as rousing as any score by Hollywood's Max Steiner (and Steiner was born in Vienna). There is a palpable blast of acclamation when Hitler is seen—the soundtrack was advanced and impeccable. He is lifted like an angel to an open car and is then filmed from impossible (or undocumentary) but glorifying angles as his car advances. When his hand goes up in his own limp salute, light spills on his palm. Such things are not accidental. They are movie. We are watching a sequence in which a rather odd, ratlike man is standing in for Gable or Gary Cooper—the film, the triumph, is Hitler's dream. But beyond dispute, Riefenstahl had the "talent" and even the love to envisage it and bring it to the screen as an edited whole.

Triumph of the Will opened at the Ufa-Palast am Zoo on March 28, 1935. The front of the theater had been dressed by Albert Speer, the official Nazi architect. After a series of ovations, Hitler presented Leni with a bouquet on the stage. The press called the film "A Symphony of the German Will." The Party paper said it was "the greatest film we have ever seen." In the first three weeks in Berlin, a hundred thousand people saw the picture. It broke box office records all over Germany. It would be folly to regard that as just a Party boast. In 1935, Germany was alive with the Hitler cult, and this was the masses' best chance to see and hear him up close. He was a star, and his aura was enough to make audiences overlook the scary thugs and typecast degenerates who shared the platform with him. No political leader had so grasped a mass medium to create his reputation.

Ufa said the film had covered its costs in two months. It played not just in theaters, but also in churches, schools, and public halls. We do not have to like it now, but the public loved it then, and there can be no doubt

but that the picture did a lot to foster German support of the Nazis and to build the confidence of the leaders. *Casablanca* did some of the same things for Americans in 1942–43.

Perhaps that comparison seems offensive to some readers. But no one ever charged that Leni Riefenstahl was a war criminal. She was investigated several times after the war, and at worst she was identified as a "follower" of the Nazi cause. When she came to America in November 1938, the press greeted her at the docks and asked if she was Hitler's girlfriend. She flirted with that question, just as she may have flirted with the Führer himself. It's more important to observe, from the movie, that she loved Hitler in ways that left actual relationship immaterial. But we all of us fall in love with people on the screen.

Riefenstahl went on to make *Olympia*, a film derived from the 1936 Olympic Games in Germany. (It was in an attempt to sell that picture that she came to America in 1938.) *Olympia* is dottily beautiful. It is mountain light at ground level, a hymn to physical perfection but a rather inept record of what actually happened in the sporting events. If Leni had made only the Olympic film she would be an arty curiosity, one of the people enamored of dance and the body given a camera (or fifty cameras).

Triumph of the Will is something else. You can say it shows her genius. Far more dangerous, it reveals the nature of the medium. That Riefenstahl was blackballed for decades, that the film cannot be shown in Germany still—these reactions are trauma turned into stone. Riefenstahl was not a Party member. She was not active in the war. *Triumph of the Will* comes before so many deadly stages in Nazi history. It's true that Riefenstahl never properly disowned her influence, or Germany. But Eisenstein went back to Russia after Mexico well aware of its crimes. They both ended up outcasts and they had earned that horrible privilege. Sergei is more fun than Leni, smarter and more talented. But they both fell afoul of film's tendency to adore storm trooper impersonality and the panache of uniforms. Riefenstahl looked away from some things, no doubt, but Eisenstein left Trotsky out of *October*. State film is a disaster and it undermined both of them, just as it had allowed their talent to flower.

To this day, *Metropolis* is reveled in, yet I think it is totalitarian in its blood and bones. *Triumph of the Will* is abhorred. The lesson is rather grim: We do as we are told so much of the time. Are we so shy of thinking for ourselves? It is a question too tough to be shelved as to how far film has helped in that. It's nice sometimes to have a shining light, but not if it leaves us a blurred mass, instead of a collection of alert, critical individuals.

•

Eisenstein had come and gone in Hollywood, but many Russians had stayed. In the 1930s, there were people in pictures who went to Communist meetings, and read the Marxist texts. But there were movies made about Russia that didn't give a damn.

One day in 1938, Salka Viertel was lunching at the Brown Derby in Hollywood. Mrs. Viertel was Austrian, and married to Berthold Viertel, a director. They had come to Hollywood in 1928 and lived in a house on Mabery Road in Santa Monica that was a salon for creative people, especially refugees. Salka Viertel was very close to Garbo; she had worked on the scripts of several of her pictures, including *Queen Christina* and *Anna Karenina*.

That day at the Brown Derby, she saw an old friend in the restaurant, Melchior Lengyel, an Hungarian playwright. She told Lengyel that M-G-M had come up with a new sales tag: they wanted to make a movie they could advertise as "Garbo Laughs" in just the way *Anna Christie* had been sold on "Garbo Talks." All they needed was the film. Do you have any ideas? she asked Lengyel. He said he'd think about it. Next day he called Mrs. Viertel and told her, yes, he did have something. "Come over to the house and tell her," said Mrs. Viertel.

By the time Lengyel got to Mabery Road, Garbo was swimming in the pool. She stroked over to the side and put her elbows on the tiling. She was naked. "Well?" she asked.

And Lengyel said, "Russian girl saturated with Bolshevist ideals goes to fearful, capitalistic, monopolistic Paris. She meets romance and has an uproarious good time. Capitalism not so bad, after all."

In a few days, the studio had paid $15,000 for those three sentences. Months later, Lengyel was nominated for the original story of *Ninotchka*, a picture that would not have been possible but for a quartet of Europeans who, one way or another, had come to the land of restaurants, pools, and fanciful money. As *Ninotchka* got under way it was agreed that Ernst Lubitsch, a Berliner, would direct it. Lubitsch had only lately returned from a visit to Moscow. He had gone there with high hopes, for in the late 1930s there were many in America, and among the Mabery Road crowd, who felt optimistic about the Soviet Union. But in Moscow, Lubitsch had been soured on the whole venture. He tried to meet Eisenstein, but was refused. He came home early, and though he never talked about the experience publicly, he was not the same man politically.

A small group of writers took over from Lengyel to do the script, including Walter Reisch (another Austrian) and the team of Charles Brackett and Billy Wilder. Samuel Wilder had been born in Sucha, in the Austro-Hungarian Empire, in 1906 and trained for the law. But he never pursued that career. He became a gigolo, a journalist, and then a screenwriter, and in 1934 he came to America. (He sailed on the *Aquitania* because he wanted to practice his English.) He took the Twentieth Century Limited and the Super Chief to Los Angeles, his English getting sharper by the mile, and he soon found work as a screenwriter. He was drawn to Lubitsch, not just because of their similar histories, but because Wilder loved Lubitsch's bittersweet tone. And so they made *Ninotchka* together, and Wilder was part of the collective wit that allowed for this exchange. As Ninotchka arrives in Paris, the three trade delegates she has been ordered to investigate meet her at the train station.

"How are things in Moscow?" they ask.

"Very good," she answers. "The last mass trials were a great success. There are going to be fewer—but better—Russians."

You may wince at that. (Taste is going to be Billy Wilder's tightrope.) And it is likely that in 1939 not many in the American audience knew what it meant. (*Ninotchka* opened in October 1939.) You may say it is no fit way to deal with the millions who died in Soviet Russia on the orders of the nation's leaders. And Lubitsch and Wilder and the others on the picture felt that Communists, no matter their intellectual integrity, lacked humor. But then you might consider the estimate of Maurice Zolotow, who wrote in the first real book on Wilder (in 1977) that "This movie is the most sublime and passionate political picture ever made in Hollywood."

1930s HOLLYWOOD

It was the best of times and the worst, and movies were the spit that was meant to hold the whole show together. The year 1933 saw the first speech by Chancellor Hitler (February 10) and the union of Astaire and Rogers in *Flying Down to Rio* (December 29). The movies assumed that the times would get better, but that might depend on Fred outlasting Adolf. It is a moment of crisis in which entertainment cannot be separated from politics, no matter how hard the business leaders tried to ignore the link. So there was an extensive and high-minded attempt to make pictures (and their viewers) more patriotic, while most viewers guessed that survival was the pressing test. So diversions were in order. In *King Kong* (it opened in April 1933), Ann Darrow (Fay Wray) is broke and starving, but the picture tells her the real thing to be afraid of is an enormous (though well-intentioned) ape.

Everything was happening at once. The movies were central in the crisis, and in crisis themselves as a business, but now radio was breathless with the simultaneity. Between 1930 and 1932, the price of a radio in America fell by half. Four million receivers were purchased, and by 1934 the medium reached 60 percent of the country. Census figures had nearly half the U.S. population living in rural areas, where the dark ruled at night. There were movie theaters within reach, but the small light in the radio was their rival, even if reception fluctuated in the remote places.

Not even rural distance could escape the outer world. Adolf Hitler was a voice on radio before most citizens in the United States knew what he looked like. Roosevelt was inaugurated on March 4. A few days later he put the banks on compulsory holiday. And the new president immediately seized on radio: the first fireside chat, on March 12, 1933, was about the banking crisis. Two days later there was a 6.4 earthquake in Long

Beach that killed 115 people, and for those impressionable storytellers in Southern California show business, it could not be missed as a metaphor. If this seems like ancient history, we still have crises that resonate with symbolic meaning. As earthquake, tsunami, and radiation struck Japan in 2011, America was hearing about its own fiscal downfall. But in 2011 there were so few movies that dealt with our troubles, or offered a delightful distraction from them.

In the 1930s the movies shared in the nation's troubles. Thirty-four million Americans were officially without income in 1933. From 1929 to 1933, national income dropped by half. Average weekly movie attendance in the United States sank as follows: 1930—80 million; 1931—70 million; 1932—55 million; 1933—50 million. And in 1933 the population of the country was 125 million. (Today the population is close to 300 million, and weekly attendance at movie theaters is 30 million—in a good week.) Ticket prices were lowered: the average went from thirty cents to twenty. But the production cost of movies doubled, if only because of the heavy investment required to soundproof studios, to equip theaters for sound, and to pay the new generation of talent who could make talking pictures. This entailed composers, songs, and music. But it meant the introduction of a generation of great stars who are still household names: Astaire, Bette Davis, Cagney, Bogart, Dietrich, Laughton, Jeanette Mac-Donald, the Marx Brothers, Shirley Temple, Katharine Hepburn, and Cary Grant, and the talent that could write their best lines.

Nearly every movie studio suffered in the impossible equation of costs and revenue. From 1930 to 1932, Paramount went from a profit of $18.4 million to a loss of $21.0 million. That was characteristic. Even Loew's Inc. (the parent company of M-G-M), the only operation to avoid serious failure, had its profits drop from $15.0 million to $4.3 million from 1930 to 1933. Every other enterprise suffered bankruptcy, or major reconstruction. Fox disappeared, to be replaced as Twentieth Century–Fox. The damage was done at the local level, too. From the late 1920s until 1933, the number of theaters in America fell from 23,000 to 18,000.

This history puts a spotlight on the success at M-G-M and the reign of its two chiefs, Louis B. Mayer and Irving G. Thalberg. The two men were very different. Mayer was older by fourteen years, and he would outlive Thalberg by another twenty-one. Neither had had a higher education, though Mayer had learned to survive the power of the tsar, migratory poverty, and the brutality of his own father. For Thalberg the worst

threats were the fragility of his constitution and overattention from his mother. Mayer's name was in the logo for M-G-M movies, but Thalberg was reluctant to be credited up there on the screen. Neither man thought of himself as an artist or a creator, because each believed there were more important tasks. And no student of film should overlook that assumption just because we don't have men like Mayer and Thalberg anymore.

They were bosses, for sure, though beholden to the authority of Nick Schenck in the East, the head of Loew's and the man who would eventually get rid of Mayer. They were editors, if you like, akin to the overseers of newspapers or magazines. Thalberg had the talents of a screenwriter and an editor, and Mayer was known as the most habitual actor on the Metro lot—to deal with him was to be caught up in a scenario where he was always right. And "rightness," or family, social, and patriotic propriety, were at the heart of the movies he wanted to preside over. Thalberg was more enlightened, but only marginally. Still, he was smart or self-conscious enough to see that he was in a position to permit himself some risk-taking in the overall programming of M-G-M films—averaging more than forty pictures a year in the time of their partnership (1924–36).

Thus, in one year, 1932, Thalberg personally produced and encouraged *Freaks* and gave the go-ahead to *Tugboat Annie*. The first was a criminal melodrama set in the circus and peopled by unseparated twins, bearded ladies, dwarves, giants, and other "handicapped" creatures—the material of the film's blunt title. The actors came from the circus itself. The film was directed by Tod Browning (who has a high reputation in suspense and horror). It was never more than sixty-four minutes (though it was often abbreviated further for taste) and it cost only a little over $300,000. But it was made at the studio of sunshine and domestic order.

Another producer at the studio, Harry Rapf, warned against the film. When they have seen it, he said, "people run out of the commissary and throw up." Thalberg took responsibility. He said he should be blamed— and he held to that when the film never made its money back. He added that he felt Metro should not dodge the new horror genre, launched at Universal with *Dracula* and *Frankenstein*, both of them big hits, but adroitly set up to frighten and reassure the public. *Freaks*, by contrast, is still honored as a Hollywood movie that defies every concern for comfort in the factory system. I doubt it could be made today—there would be protests at the exploitation of the disadvantaged cast members.

But there it is, side by side with *Tugboat Annie*, produced by the same Harry Rapf, as a continuation of the unexpected screen chemistry estab-

lished between Marie Dressler and Wallace Beery in *Min and Bill* from the previous year. Dressler was sixty-five in 1933, and she is the outstanding example in movie history of an actress being not just a star but also the object of public adoration, when she was beyond glamour or conventional attractiveness. Beery was only forty-eight, but as he said himself, "Like my dear old friend, Marie Dressler, my ugly mug has been my fortune."

Of course, it's easier for a man to be "ugly." Beery had a long history already: he could be a villain, a figure of fun, or a weary survivor—he had played Magua in the 1921 *Last of the Mohicans*; he had won the Oscar as the battered boxer in *The Champ* (1931); and down the road he would play Pancho Villa and Long John Silver for M-G-M. He and Dressler had been paired in *Min and Bill* as lowlife waterfront types with hearts of rough gold. It was for that film, a hit, that Dressler won the Oscar.

Beery and Dressler were contract stars, just like all the others. They were signed up by M-G-M and expected to make the pictures offered to them. Most of the contracts lasted seven years, with clear-cut raises in salary as the years passed. Some of the stars called this servitude, and Bette Davis worked as furiously as a Davis character to escape her Warners deal. But the studios looked after their preferred properties, and many stars built their reputation on the scripts, the camerawork, and the supporting players provided by the studio. Part of what Davis got out of Warners was *Marked Woman* (1937), *Jezebel* (1938), *Dark Victory* (1939), *The Old Maid* (1939), *The Private Lives of Elizabeth and Essex* (1939), *The Letter* (1940), *Now, Voyager* (1942), and *Mr. Skeffington* (1944).

The reunion of Beery and Dressler in *Tugboat Annie* exceeded expectations. The film is about a married couple who run a tugboat, but it's really about the liberated humor and ham in the players. It's a vehicle, like most Hollywood pictures of the 1930s—they would not have been made except to showcase their stars. One reason directors felt their power or authorship was modest was knowing most of the audience never read their names. Mayer and Thalberg were happy to run the show that way, and they regarded directors as figures to be assigned, along with other craftsmen and technicians, studio space and budgeted funds. *Tugboat Annie* cost just over $600,000 and it made twice that sum in profits.

No one was fonder of Dressler than Louis B. Mayer; she was an ideal recipient of his sentimentality. She was the epitome of the amusing yet trouble-free old age that Mayer and Hollywood idealized. It assists the total stress on youthfulness if old people are uncomplaining "characters." In fact, Dressler looked older than her real age. In the 1930s, Americans

(even well-paid stars) were not as healthy as they are now. (Clark Gable was only thirty-eight when he played Rhett Butler, roughly the age of Tom Cruise in *Eyes Wide Shut*, but they might be father and son.)

Marie Dressler had cancer at the end, though apparently she was unaware of this. Mayer encouraged that ignorance and told doctors to keep the news from her. But on location in Seattle, shooting *Tugboat Annie*, the actress saw a little cottage and told a publicity man she loved it. Whereupon, the story goes, Mayer had the studio buy the cottage and transport it down to Santa Barbara where the actress lived. So that the dying actress could sit in it during her last days! The screen can become your world, your residence.

It's a lovely story, good enough for a Dressler picture, but is it true? Such questions are a necessary response to the influence of the Hollywood system, out of which publicity and promotion passed into folklore, leaving legends so hard to confirm or deny that they undermine proof itself. It was regular practice for the studios to run articles, photographs, and interviews on their stars that were essentially fabricated. "Events" were fabricated. The atmosphere and values of a certain kind of movie story and its publicity have seeped into American culture as a whole, along with the overall hope that stories might be true. There is a moment common to two John Ford pictures—*Fort Apache* (1948) and *The Man Who Shot Liberty Valance* (1962)—at which characters surveying the "history" of the West say, "When the legend becomes fact, print the legend." Some Ford enthusiasts rejoice in that despairing attitude and may have to come to terms with an America in which people know and trust less and less. Suppose the legend says there are weapons of mass destruction in Iraq? It is a dangerous resignation, and it may sustain deplorable educational standards in the land of the free. The chief source for the Marie Dressler house story is Samuel Marx, a pleasant man and the author of the book *Mayer and Thalberg* (1975), who was himself employed for decades at M-G-M—as a story editor.

The pact Mayer and Thalberg made was in identifying their audience. For that they had to be a mixture of showmen, businessmen, and discreet political leaders such as had never existed before. In other words, their provision of a light for the masses is a part of national history (and the eclipsing of true history) and a thrust that would be reproduced in other countries. Adam Curtis's polemical documentary series *The Century of the Self* (2002) tracks the dire history of publicity with vigor and wit; it was made by the BBC.

Mayer and Thalberg came from humble origins, though Thalberg's family had a modest import business, and he graduated from high school in Brooklyn and considered going to Columbia. Within a few years of their alliance (in 1924), Mayer was said to be the highest-salaried man in America ($800,000 a year by 1927—in the same year, Garbo, signed up by Mayer himself, was on $3000 a week), while Thalberg had a high income and responsibility for a package of movies that had a profound influence in America. Still, Mayer was the senior of the two and the better paid. Others would have said Thalberg was the more enlightened and the easier to work with, which only spurred Mayer's feelings of rivalry. They were partners, but they watched their backs, and Mayer relied on Irving's dying young—for that reason he told his two daughters not to entertain romantic thoughts for the slender, dark, very attractive, and very smart Thalberg. Irving was never well, and his death in 1936, at thirty-seven, may have been the first notable occasion on which enough people said that Hollywood was dying, too.

Mr. Mayer would not admit it to himself, but he was not handsome, or ingratiating. He survived much longer (he died in 1957), by which time he had lost his job and his illusions. But his plainness was something he had in common with Marie Dressler and Wallace Beery and with those millions of customers who lived out of the light.

As the Depression set in, it was clear that the studios were making their money from increasingly impoverished people by selling them a dream of infinite success and remote happiness. They could tell the world and themselves that the movies preached the gospel that anyone could make it in America, and Mayer was generous with uplifting stories of his own journey. But that message was akin to the promotion that would come out of the Las Vegas casinos twenty years and more later: anyone can win. Exactly right, but only with the corollary that nearly everyone will lose. Except the house.

So it's instructive to clarify the creative character of the house, and to spell out the ways in which it defied or excluded the thing we call art. An example of this is the relationship between M-G-M and Thalberg and the director King Vidor, who is one of the most appealing talents in American film from the 1920s through to the 1950s, and someone interested in the issues that held a mass medium and a modern society together.

Vidor—he was actually named King—was born in Galveston, Texas, in 1894. His family was of Hungarian descent, but his father was a successful cotton factor in Galveston. So King was in the city on September 8,

1900, when winds of 135 miles per hour struck. About eight thousand people died (four times the number lost to Katrina), and the six-year-old King saw how "All the wooden structures of the town were flattened. The streets were piled high with dead people, and I took the first tugboat out. On the boat I went up into the bow and saw that the bay was filled with dead bodies, horses, animals, people, everything."

Vidor was a child of the generation excited by the chance to show such action in moving pictures to the millions. That excitement may never have been the same again as film became more commonplace. Everything in Vidor's life and work clings to the passion of that novelty. His father suggested a business career. But King was led on by having a camera and by working in a Galveston theater, watching the public watch the screen. He even restaged the Galveston hurricane in a "documentary," and trusted that it looked the way he remembered.

He went to Los Angeles in 1916 and started directing pictures. He was married to a girl from Texas, Florence, and she became a star for a few years. Anyone could win! He went to Metro, and when it became a part of M-G-M, he found himself working with Thalberg (five years his junior). The legend of the factory system is that Thalberg intended to suppress directorial vanity—he had just humbled Erich von Stroheim over *Greed*. But Vidor was so much more amiable or American, or Irving felt more relaxed with him.

Far from suppressed, Vidor was encouraged:

One day I had a talk with Irving Thalberg and told him I was weary of making ephemeral films. They came to town, played a week or so, then went their way to comparative obscurity or complete oblivion. I pointed out that only half the American population went to movies and not more than half of these saw any one film because their runs ended so quickly. If I were to work on something that I felt had a chance at long runs throughout the country or the world, I would put much more effort, or love, into its creation.

Is that the search for art speaking, or the need for personal glory?

Vidor wrote that in 1953, when the empire of movies was fading and when directors were not much esteemed in America. But Thalberg in 1925 was aroused by his hopes. Did Vidor have particular ideas? he asked.

"I said I had. I would like to make a film about any one of three subjects: steel, wheat, or war." Can you guess the one Irving picked?

This was the origin of *The Big Parade*, the film that established its star, John Gilbert; that vaulted Vidor from workman director to leading asset; and that secured Thalberg's reputation as a wizard. *The Big Parade* would be about a wealthy kid turned doughboy in France for the Great War, a guy who meets an adorable French girl (played by Renée Adorée). It's not that war is neglected. There are large troop movements plus combat, and good buddies who are killed. But the problem of the war is, above all, that it becomes an obstacle to the romance it has made possible.

Thalberg preferred war to wheat or steel because its melodramatic potential was so much greater—and because broken hearts were more palatable than shattered bodies or destroyed societies. Movie had come into its own in the time of the Great War, but only by reappraising and taming its true power and its historical lessons. For the masses the light shone on war was arousing and reassuring. No one in Hollywood believed they were involved in propaganda or advertising, yet the vast popular entertainment hardly dared move ahead without the idea of keeping the viewers happy and habituated enough to come back next week.

With Thalberg's enthusiasm, *The Big Parade* cost over $300,000. At one point, Vidor had dreamed of an epic panorama filmed on a long, straight road. A second unit shot it, and all they could find was a crooked road. It was an expensive scene—with troops, trucks, and aircraft—but when Thalberg looked at the footage, he told Vidor to go back and find a straight road, shoot it again, and get what looks "right."

The finished film opened in 1925, and its official profit was over $3 million. Vidor believed it grossed $15 million worldwide—and he was supposed to get 20 percent of the profits on a private deal Irving had given him. But before the film had loomed so large, the studio came to the director and warned him that it looked as if his percentage wasn't going to work out! So Vidor agreed to a modest cash settlement instead. That was the factory system at work, the conniving that waited beneath the guise of friendship and collaboration. More or less, everyone believed he was being screwed.

The Big Parade coincided with the other great venture, from M-G-M, *Ben-Hur: A Tale of the Christ*, but that cost nearly $4 million and lost money—despite being seen by multitudes. Together the two films put M-G-M at Hollywood's forefront, with Thalberg the winner on points, for his film hid the failure of Mayer's baby. *Ben-Hur* had been a problem child, begun in Italy and brought back to Culver City, where the unprecedented chariot race was shot. But chariot races are easier than complicated ideas.

The Big Parade is an impressive picture still, and its battle scenes demonstrate Vidor's eager eye for composition, action, and dynamics. But it is a love story, and it lacks any kind of pointed, let alone angry, commentary on why the war is being fought. It is an occasion for death and glory, for love and fulfillment, that ends in a lovers' embrace (even if the hero has lost a leg). In most ways the film depicts a nineteenth-century war, not just omitting but also not noticing the elements of horror and outrage that can be felt in, say, the poetry of Wilfred Owen, Picasso's *Guernica*, or the music of Shostakovich. It would be several years more, anywhere in the world, before anyone found the will to say the war should not have been fought, or that its existence was a measure of incompetent leadership or the failure of political systems. G. W. Pabst's *Westfront 1918* (1930), from Germany, and Lewis Milestone's *All Quiet on the Western Front* (1930) are notable developments in unease, and *All Quiet* won the Best Picture Oscar—it was respected, and its rentals* doubled its production budget. *All Quiet* had the appealing American actor Lew Ayres playing a young German soldier, and the story came from a German novel by Erich Maria Remarque. Among the many wretched consequences of war is how easily it looks good on film—we feel the "excitement" and the action more than the damage. The battles outweigh the politics. Remember Jean Renoir's lament: that his acclaimed antiwar film of 1937, *La Grande Illusion* (actually a tribute to comradeship), preceded the outbreak of a second war by just a couple of years.

Vidor moved on, confident but confused. He was a great director for his time, a dynamic picturemaker, but he had no consistency. Is that lack of character or the necessary opportunism of being a director in that system? He made *The Champ* (1931) with Wallace Beery and *La Bohème* (1926) with Lillian Gish. His energy could be assigned in so many directions—that's what the studio wanted. Not long after *The Big Parade*, Thalberg caught up with him again and asked what he wanted to do next. Vidor admitted later that he had no idea at hand, but you don't let a boss get away: "Well, I suppose the average fellow walks through life and sees quite a lot of drama taking place around him. Objectively life is like a battle, isn't it?"

"Why didn't you say this before?" asked Thalberg—he was a skilled entrepreneur, and a deft talker.

*"Rentals" are the money returned to a distributor or producer by the theaters. The "gross" is the total sum taken in at theater for tickets.

"Never thought of it before," said Vidor. We are in the days of the innocent pitch!

The first thought was to call the picture *One of the Mob*, but then *The Crowd* took over. (This is the movie Louis B. Mayer talked out of being Best Artistic Achievement in that first run at the Oscars, when *Sunrise* won.) Driven on by Vidor's own scriptwriting, *The Crowd* (1928) is as innovative as *The Big Parade* is old-fashioned. It's about an ordinary couple in New York City, John and Mary. They lose one child. Their fortunes sink, but they rally from the example of another child and because of their perseverance. The simplicity is as breathtaking as the style is soaring—much influenced by German camera movements and a dramatic shaping of décor. As the camera ranges over a panorama of desks in an abstract setting, it is as if for the first time modern America has been presented on film, without melodrama or false sweeteners. *The Crowd* can still break your heart—which never has happened with *Sunrise*. Nevertheless, M-G-M sent the picture out with two endings—one tough, one much cheerier—and they let exhibitors choose!

Another appealing characteristic of Vidor showed up in the casting. Mary was set to be played by Eleanor Boardman (the director's second wife), but for John he felt he wanted a fresh face, attractive, but an unknown—because *The Crowd* was about the ordinary members of the audience. A star personality would have defeated Vidor's idealism. One day on the lot a man brushed past Vidor. The director looked up and knew this was the type he wanted. He discovered the man was a humble extra, James Murray. When Vidor told him he was a director with a part to cast, Murray turned surly and dubious. Sure, he said grudgingly, he'd do a test, but only if he had bus fare to get to the studio.

Murray won the part, and he is so natural, so strong and vulnerable, he holds the picture together. Then he disappeared. Vidor had guessed he was a drunk. Several years later, Vidor was planning to do *Our Daily Bread*, a film about a collective farm, so radical it alarmed Thalberg. So Vidor had to raise the money himself and make it independently. But he wanted Murray back, because the man in *Our Daily Bread* was John a few years later. At last he found the one-time actor on the street begging for lunch money. He was heavier and unshaven. Vidor bought him a drink and offered him the new part. But Murray had lost hope. This was 1934, and so many Americans were huddled in their soul:

"Just because I stop you on the street and try to borrow a buck," said Murray, "you think you can tell me what to do. As far as I am concerned,

you know what you can do with your lousy part." In two years' time, Murray's corpse was pulled out of the Hudson River.

Vidor never forgot Murray or his un-Hollywood-like intransigence. Years later he tried to set up a film about Murray's life, but it was deemed too downbeat. Vidor was in the tumult of being a big-time moviemaker in the very testing 1930s. *Our Daily Bread* was attacked in some places as being inspired by communism. It even won a prize in a Soviet film festival. By 1936, Vidor felt compelled to play a leading part in the foundation of the Directors Guild, set up to defend directors against studio exploitation and part of the unionization of the business that occurred in the 1930s with the organization of writers and actors.

He was a popular man, a loyal friend, and a good director, but he seems without self-awareness. Within just a few years of *Our Daily Bread* and the Directors Guild, the same Vidor had helped found the right-wing Motion Picture Alliance for the Preservation of American Ideals, and then he directed (with blazing conviction) Ayn Rand's *The Fountainhead* (1949), perhaps his greatest film, in which that very noncerebral actor Gary Cooper plays Howard Roark, the willful architect whose genius defies society, convention, and the bromides about public spirit. As a metaphor for the Hollywood process it was so penetrating, the system had to ignore it. And this was three years before *Sunset Blvd.*

King Vidor is endlessly fascinating, and the dynamism of many of his pictures has not dated. He perceived the significance of "the ordinary fellow" for *The Crowd*, yet he was a relentless outsider led on by his appetite for visual melodrama. In 1956 he had the chutzpah to make a version of *War and Peace* (with Henry Fonda and Audrey Hepburn). The picture is not well thought of, and not what Tolstoy is about. But it carries the enthusiasm, and reckless confidence, of a man who clearly supposed that if Tolstoy had been born a little later and come to America, he would have become a screenwriter. How could he have turned down that enormous audience?

In his senior years, Vidor was unable to mount a project at a studio—in the system he had helped create. He wanted to do Cervantes or Faulkner, but he grew weary of pitching and bargaining. It had been so much easier and quicker with Thalberg. "I was glad to get out of it. They were diluting every idea, changing everything, and I was at a place in my life where I didn't have to prostitute these ideas and make these compromises. In *The Fountainhead*, Gary Cooper blows up the whole building because they change the façade and some of the other sections of the structure. That's what I felt like . . ."

By contrast, Josef von Sternberg was a business failure, very unpopular personally, and a consistent artist who saw no other subject for film than handsome men adoring and being humiliated by beautiful, self-sufficient women, all of whom looked like Marlene Dietrich. No one else in America in the 1930s—except perhaps for Groucho Marx (who had a wounded mustache just like so many von Sternberg protagonists)—started from the idea that movies were so absurd they deserved to be mocked.

Josef von Sternberg (or was it plain Joe Stern?) was born in Vienna in 1894. His early years were split between that city and New York. He was a man of all trades in the early picture business in New Jersey and he served in the Signal Corps during the war. By the mid-1920s he had directed the unusual realism of *The Salvation Hunters* (shot on the San Pedro waterfront, south of Los Angeles) and the early gangster picture *Underworld*, which is the first manifestation of his search for style: moody lighting, fatalistic men and femmes fatales, and a visual fetishism in which the image becomes an open wound of frustrated desire. It was in 1930 that he went to Berlin, working for both Paramount and Ufa, to direct the first talking picture with Emil Jannings, who shared the widespread public feeling that he was the greatest actor alive. Von Sternberg and Jannings had already made one film in America, *The Last Command* (1928), where Jannings played a tsarist general reduced to being a movie extra.

Von Sternberg, who acted out his own preferred style of laconic restraint, saw Jannings as an excessive bore so conceited he believed he could act with his back. In part, this clash of approaches was simply sound pulling away the carpet of silence. Von Sternberg was one of the first directors to see that beautiful people need do very little on film except be photographed. Dietrich's pensiveness in *Shanghai Express*, say, is still an acting class where we wonder what she is thinking. Such moments can encourage thought itself.

Von Sternberg's Berlin project was *Der Blaue Engel* (*The Blue Angel*), based on Heinrich Mann's novel *Professor Unrat*, in which Jannings would play the pompous schoolteacher dragged down by an insolent cabaret singer, Lola Lola. It is not true that von Sternberg discovered Marlene Dietrich (born in Berlin in 1901) for that role. She was known for a few small parts already. And von Sternberg went to see her in a play, *Zwei Krawatten*, by Georg Kaiser. It was a famous meeting:

> I saw Fräulein Dietrich in the flesh, if that it can be called, for she had wrapped herself up to conceal every part of her body. What little she had to do on that stage was not easily apparent: I

remember only one line of dialogue. Here was the face I had sought. And, so far as I could tell, a figure that did justice to it. Moreover, there was something else I had not sought, something that told me my search was over. She leaned against the wings with a cold disdain for the buffoonery, in sharp contrast to the effervescence of the others, who had been informed that I was to be treated to a sample of the greatness of the German stage. She had heard that I was in the audience, but as she did not consider herself involved, she was indifferent to my presence.

This is one of many such meetings in film history, and they have built the myth of "discovery" for all of us—that moment when we may be picked out of the anonymous crowd, identified, known, and loved. (If it never happens, you can try it in the mirror.) "Love at first sight" is a movie scenario concept, but it lives in the notion that seeing is the first step in falling. Dietrich and von Sternberg were both married, but not to each other. So the desire and the sex were the greater for the restrictions. That frustration is the heart of von Sternberg's vision, just as Dietrich's indifference was the lash to flay him.

In *Der Blaue Engel*, Lola Lola takes Rath for everything, while Dietrich's insolence and hesitations—her ironic glance—devastated Jannings just as Ali ambushed George Foreman in Zaire. Ufa didn't quite get the message that audiences would swallow, so von Sternberg and Paramount were able to steal Marlene away for American pictures. It was a great asset—as good as her legs, her eyes, or her nerve—that she spoke clear English with a sweet lisp that swayed from seduction to contempt in a single line.

At Paramount, then, they made six films in a row, from 1930 to 1935: *Morocco*; *Dishonored*; *Shanghai Express*; *Blonde Venus*; *The Scarlet Empress*; and *The Devil Is a Woman*. Those pictures earned less and less money and mounting critical abuse. It doesn't matter. They are sublime, radiant, and utterly undated, where earnestness, noble intentions, showing real life with pained sincerity (all plausible in the difficult times of the 1930s), have perished by the wayside. Take *Morocco*.

Its story was already a pastiche of movie scenarios. Amy Jolly is a cabaret singer who comes to North Africa. She is attended by a would-be protector (Adolphe Menjou, with mustache, a brother to von Sternberg in looks), but she notices Tom Brown (Gary Cooper), an American in the foreign legion who is crazy about her but averse to admitting it. In the

end, as he marches off on desert duty, she follows him in the gang of Arab groupies, discarding her fashionable high-heel shoes to manage in the dunes. (And that is the happiest ending in von Sternberg–Dietrich films.)

It is as daft as it sounds as a story, and no less artificial than *Road to Morocco* (1942), with Hope, Crosby, and Lamour, also shot at Paramount and with the same casual attitude to what North Africa looks like. Amy sings, of course, and in the cabaret scene, wearing a tuxedo, tails, and a top hat, she kisses a pretty girl in her audience. What was that? you feel the system asking itself. Was that You Know What? It was too swift and elusive for any censor to intervene, but if the movies are all about sex, it might as well be any sex and not just the usual kind of kiss. *Morocco* resists aging because von Sternberg inspired his two stars to be amused about the silliness of longing (even if they succumbed to it out of sight of the camera).

Von Sternberg was skilled enough to light and photograph his own pictures, and no one knew more about luminous passivity, the capacity to let the camera in past your eyes. It may be that no one else found such intimacy in Marlene. And he directed her as if she were his slave or his dream: "Turn your shoulders away from me and straighten out . . . Drop your voice an octave and don't lisp . . . Count to six and look at the lamp as if you could no longer live without it." He is speaking to an actress, but he could be describing the moviegoer in the dark.

He is maybe the greatest example of a director who appreciates that movie is a matter of beholding something you desire but cannot touch. And he prizes that as a sardonic joke. (Von Sternberg's *The Devil Is a Woman*, 1935, would be remade later by Luis Buñuel as *That Obscure Object of Desire*, 1977, where Fernando Rey is so besotted he cannot see that his beloved is played by two actresses!)

Von Sternberg must have guessed his way of working was doomed, because he didn't believe in being serious. He was lucky to get six pictures in America with Dietrich. After that, his career trailed away. Did he care anymore?

•

Frank Capra was a very funny filmmaker, and an unsurpassed entertainer, but his ambition was so intense he had no problems with caring. He was born in Palermo in 1897, and never made a Mafia picture. Coming to California at the age of six, he was later educated at what would become CalTech. He messed around in pictures for a few years and then,

in 1927, he got a contract to direct at Columbia, securely in the second rank of Hollywood studios and led by Harry Cohn, a boss Capra loved to hate.

Capra never abandoned the professional urge to entertain, and he was as good with actors as he was blessed by having the screenwriter Robert Riskin at hand. But he was obsessed with the question of social conscience (which is not always the same as having one). In the early 1930s, he made a string of intriguing pictures, often about sex and women's status, and often with Barbara Stanwyck, with whom he was having an intense affair—notably *The Miracle Woman* (1931), *Forbidden* (1932), and *The Bitter Tea of General Yen* (1933). His breakthrough occurred in 1934, with *It Happened One Night*.

Nobody liked the idea at first. And nobody wanted to play in the film. A dozen actresses declined—including Myrna Loy, Margaret Sullavan, Carole Lombard, and Constance Bennett. When M-G-M offered to loan a male star, Capra asked for Robert Montgomery. Louis B. Mayer said no, but then he thought to punish the cocksure Clark Gable, who required too much money, by sending him instead. At last, Claudette Colbert agreed to play the runaway heiress, with Gable as the reporter she falls for. The budget was set at $325,000 (Columbia was cheap and proud of it). Gable did the picture for just $10,000, while Colbert got $50,000. Gable was grumpy (not uncommon for him), but he liked Capra's touch. "You know," he said to Colbert, "I think this wop's got something!"

The picture opened in New York on February 23, 1934, and broke records at Radio City Music Hall. Then, without reason, business fell off, and the picture failed in many cities. But in the sticks it built steadily— and it is a film where urban smarts are mocked in favor of provincial good sense. The Capra common man was coming into view, and the public must have been flattered. It ended up with rentals of $2 million, a dazzling figure. Capra's contract gave him 10 percent of the net profits, but net is not gross, especially when Cohn block-booked his picture with poorer studio product—so Capra felt he had been cheated, and being wronged was at his core.

His bitter triumph was made complete at the Oscars awarded on February 27, 1935, at the Biltmore Hotel in Los Angeles. Capra won the award for Best Director. Robert Riskin won for his script. Then Gable won: "I feel as happy as a kid and a little foolish they picked me," he said. Colbert won, but she was at the rail station about to board the train for New York. A car was sent after her. Studio publicists implored her to

return, and so she did. She blurted out that she wouldn't have been there but for Frank Capra, and she survived the stony smile on the face of Bette Davis (who had wanted the part and then been overlooked for *Of Human Bondage*). Then Colbert rushed off to get the train being held in her honor. At last, Cohn stepped up to receive the award for Best Picture. He admitted, "I was just an innocent bystander."

For the first time, Columbia had won Best Picture, and for the first time in Oscar history a comedy had won and swept the top five awards. For Capra and the studio it was the beginning. Ahead lay *Mr. Deeds Goes to Town* (1936) and *Mr. Smith Goes to Washington* (1939), archetypal Capra pictures in their feeling for an America in which government is being subverted by cynical and corrupt leaders, so along comes the spirit of rural integrity, Deeds and Smith, Gary Cooper and James Stewart, who risk disaster and humiliation in their battle against compromise.

These are crowd-pleasing but deeply ambivalent works, in which the comic touch can turn somber and even hysterical—Stewart filibustering in the Senate to defend his honor is excruciating and filled with Capra's own paranoid instincts. On the one hand these pictures say they love the people, their natural decency, and the way it stands for American values. On the other, they fear the ease with which that crowd can be carried away by hatred and the lust for melodrama. Such pictures are still taught in American high school, and they have not faded as powerful shows. But they deserve warnings or caution, for they show how confused Hollywood and its best talents were over their place in an anxious society, coming out of Depression and anticipating war. As portraits of politics, the Capra films are so afraid of compromise that they seem poised for an urge toward extremism. And usually in a right-wing direction. So it was easier always for filmmakers to say they were mere entertainers and let the larger issues go fish. They still do that.

That is far from the whole Capra story. Between *Deeds* and *Smith*, he won for Best Picture and Best Director again with *You Can't Take It with You*, another comedy, from the play by George S. Kaufman and Moss Hart, and a film that has not survived as well as *Smith* and *Deeds*. In the late 1930s, Capra was nominated five times as Best Director. Then, after *Meet John Doe* (1941, another ambiguous picture about power and politics, with Gary Cooper anguished as the bum burdened by being a folk hero), Capra went into the military and made very effective propaganda films. He came back in 1946, with Jimmy Stewart, and they made *It's a Wonderful Life* (1946) together.

That Christmas perennial is a comforting piece of work (if that's how you determine to see it). It's a romantic comedy about a decent man and a marriage, about a cozy town and its community, but it's a nightmare, too, in which George Bailey, haggard over his own failure as a small-town banker, is on the brink of suicide and is then shown what will become of his town without him. That vision is as credible and as damning as anything Capra ever did, and the lasting record of how perceptive and worried he was. After that, he went off the boil and, like many Hollywood people, failed to grasp the postwar mood. He became a government informer and an uneasy rich man frightened by the way America was going. But he had always been as suspicious of the huddled masses as he longed to believe in noble souls from the hinterland.

No less esteemed and no less confused was John Ford. Sean Aloysius O'Feeney, or O'Fearna, was born in Cape Elizabeth, Maine, in 1894, the thirteenth child of Irish immigrants. As Jack Ford first, he did many jobs in pictures, including riding with the Ku Klux Klan in *The Birth of a Nation*. He was associated with Westerns in the silent era (when Westerns were common but not prestigious). To the end of his days, he stuck with the genre and turned Monument Valley (in southern Utah) into its ideal epic setting.

But he would try anything, and in the 1930s his range included Shirley Temple in *Wee Willie Winkie* (1937) and Katharine Hepburn as *Mary of Scotland* (1936; they were devoted), as well as a couple of Will Rogers pictures and Victor McLaglen as *The Informer* (1935), for which actor and director won Oscars—you have to see that one to believe it, and you may decide it is insufferable, embarrassing, and the worst kind of stage Irishness. Far more impressive, at the turn of the decade, Ford delivered three mature films in a row: *Stagecoach*, *Young Mr. Lincoln* (with Henry Fonda as Lincoln), and *The Grapes of Wrath*, derived from the John Steinbeck novel and the look of photographs by Dorothea Lange (though Gregg Toland shot it, and got a little over-pretty at times). *The Grapes of Wrath* is unquestionably a tribute to the people, even if it is sentential and self-satisfied some of the time. In hindsight, it seems odd that *Rebecca* won Best Picture that year, the second such win in a row for producer David O. Selznick, but a work blithely removed from the feeling of 1940 and which typifies Hollywood's love of England, or is it olde England?

Vidor, von Sternberg, Capra, and Ford were sketchily known as names, and at the time they worked, few people still could have told you what a director did. The public knew what actors did, and went to the movies for

them. In any study of creative power or auteurship (a term that was not current yet), you would have to deal with the stars—with Shirley Temple as well as Bette Davis, with Gable as well as Gary Cooper.

Cooper has figured already in this chapter. He is the figurehead of *Morocco, Mr. Deeds Goes to Town,* and *Meet John Doe.* His other work includes an indolently suave Hickok in DeMille's *The Plainsman* and his Oscar-winning role in *Sergeant York.* No one seemed more handsome, resolute, or taciturn than Cooper—don't forget that Clint Eastwood was born in 1930, an ideal boy for watching Coop. Then discover that in real life, Cooper was unreliable, promiscuous, and rather cowardly. We know that now. But the 1930s could not handle such difficult truths, and the studios had a publicity machine to protect their properties. The system and the nation had not yet turned on their celebrities.

And don't forget the franchises, by which I mean the people or the teams who made a string of films that now look like all one film—Temple for one, but also the Marx Brothers, W. C. Fields, Laurel and Hardy, Mae West, and Fred Astaire and Ginger Rogers.

"Fred Astaire" is the Americanization of Frederic Austerlitz, born in Omaha, Nebraska, in 1899. He danced from childhood with his sister, Adele, and he broke into films in the early 1930s after initial estimates that he was not very good-looking and rather thin in personality. Of course, sound made more of him than it did of Jolson. I don't just mean the singing voice, which becomes ever more endearing and ghostly. I mean the sly clatter of his feet. He made a debut in *Dancing Lady* (1933), with Joan Crawford, a vigorous but unappealing dancer. But then he settled at RKO, with Ginger Rogers, and they spun into a series as fanciful and lovely as the von Sternberg–Dietrich films: *Flying Down to Rio* (1933), *The Gay Divorcee* (1934), *Roberta* (1935), *Top Hat* (1935), *Follow the Fleet* (1936), *Swing Time* (1936), *Shall We Dance?* (1937), *Carefree* (1938), and *The Story of Vernon and Irene Castle* (1939). They reunited in 1949, at M-G-M, for *The Barkleys of Broadway.*

Astaire did not direct these films. He did not write them, or seem to care that they were so lamely written. He was not credited as choreographer. But he dominated the films and then had the cool nerve to act shy or deferential. The films are black and white. This is the famous era of panchromatic black and white, printed on nitrate stock: it's the medium for Fred and Ginger, von Sternberg and Dietrich, Toland and Welles. It is one of the finest inventions America ever made, and then it was largely abandoned.

The Astaire-Rogers pictures take place on sets that feel like hardened cellophane, or film stock. Is that coincidence? And they have the songs of Irving Berlin, Jerome Kern, George Gershwin, and Cole Porter. Was that luck, or did the country produce a wave of talents across the board who joined forces in the musical? Were they the true spit of the 1930s? The results are unsurpassed and a defense of film to put beside Renoir, Buñuel, Bresson, or Ozu. Fred's smile acknowledges the earliest impulse of the medium—hey, look at me move!—the thrill that gripped Eadweard Muybridge as it has any of us recording our child's first steps or his making a mess with profiteroles.

Astaire-Rogers were wildly popular, though as time went by, their films became more expensive and less profitable. Carefree perhaps, yet always linked to business calculations. Astaire would make other notable pictures after Ginger—*The Band Wagon* (1953), *Funny Face* (1957), *Silk Stockings* (1957)—and Ginger became a fine comedienne in the 1940s. But if you feel for the medium and its power in the late 1930s, you have to recognize how far they were a light unto themselves and cherished. Fred has been dead more than twenty-five years now. His films were foolish the moment they opened—seventy years ago and more—yet they are bliss.

FRANCE

With France, we have to start again, because the French know they invented cinema, and they live with a wry bitterness that says America then stole it away—as if theft could do anything except characterize an adolescent nation.

Several French pioneer figures were devoured in competition with America. Moreover, the French cineaste has lived all his life with very mixed feelings about America. When Jean Renoir (son of a great painter) began to think of doing movies, his older brother Pierre (an actor) warned him, "The cinema doesn't suit us [the French]. We must leave cinema to the Americans. French dramatic art is bourgeois; whereas the American cinema is working class." Forty years or so later, when the French New Wave broke on the shore (with Renoir as one of its gods), the new young films were defiantly French, modern, and insolent, but they had a nostalgia for American forms and moods. That paradox renews a persistent question: Are the people of the world an unmodified block, a global village, a web or a net, or are they just as different, unique (yet alike), as snowflakes in a blizzard?

In those first fragments of film or domestic newsreel shot by Louis and Auguste Lumière the populace is seen as a busy crowd, lively and idiosyncratic—it's like looking at the Parisians in impressionist paintings (some of them convivial groups by Auguste Renoir). Those moving photographs seem to be a measure of passing time and human vagary; the mood is comic, curious, and sympathetic. Years later, in La Règle du Jeu (1939), Jean Renoir would pass this verdict on his turbulent and tragic house party: everyone has his or her own reasons. And you can feel that as optimism in the father's paintings, in the Lumière fragments, and in the French tradition of still photography that stretches from Lartigue to Cartier-Bresson

(who was Jean Renoir's assistant sometimes in the 1930s). We all have our different reasons, but the light is shared.

In films as varied as *Metropolis, Strike, Man with a Movie Camera, Triumph of the Will*, and even *Mr. Deeds Goes to Town*, we have felt the tendency to regard the crowd as a force, or a shape—it may be cheerful or merry; it may be sullen and poised. That threat involves an aspect of huddling in which the light no longer sees individual faces. Whereas, the light in France—or in its paintings and photographs—is often warmer, more general and generous; it may even have a touch of democracy to it.

•

The condition is more subtly borne out in the case of Georges Méliès, the most notable instance of the magician turned moviemaker before Orson Welles. Méliès was born in Paris in 1861 to a boot and shoemaker who catered to the fashionable bourgeoisie. It was during his military service, at Blois, that Méliès visited the home of Jean-Eugène Robert-Houdin, who, though retired, had been the leading stage magician in France. Méliès was fascinated by the collection of tricks and contrivances Houdin had on show, and soon thereafter he went to London to study at Maskelyne and Cooke's Egyptian Hall, probably the leading magic theater in business in the late nineteenth century.

It was in 1888 that Méliès got together 40,000 francs and purchased the Robert-Houdin theater (on the Boulevard des Italiens) from the great man's widow. The theater was busy, but not commercially successful. Méliès was already intrigued by the potential of photographs. He grasped that, among other things, the photograph was a way of altering our faith in reality, the essence of magic. Antoine Lumière, father to the brothers and owner of a photographic business, had a shop above the Robert-Houdin theater. So it was no wonder that Méliès should attend their first professional screening of movies with a projector—at 14 Boulevard des Capucines, on December 28, 1895.

The Lumières' material was what we would call "documentary." It was a cinematic record of things that proved the viability of the cinematograph. It would take a strict historian to deny the legend that an eager Méliès approached the Lumières and asked to buy or rent their machine, to be met by the wintry assurance that it had no commercial future. Méliès never wavered. For 1,000 francs he bought a camera from Robert Paul in London, and soon he was on his way.

What followed is one of the outstanding early careers in film. From

1896 to 1912, he made hundreds of short films, most of them inspired to show his audience something even more wondrous and mystifying than his repertoire of stage tricks. In the process, in a primitive way—by double and multiple exposures, winding the film back in the camera; by matting different images together—he laid down the essence of a special effects system that would last for decades. But he also built fantastical sets and put many actors in fanciful costumes. So the aspiration to the miraculous is always offset in Méliès by a cheerful but untidy or improvised human action. He was a technician, to be sure, but he was as fond of people as any showman who relied on the loyalty of audiences. Some of his films are Jules Verne-ish, with trips to the moon and many other dream places, but they feel like homemade amateur theatricals. There is a nice messy reality to them, plus the bravura flourish of the voice that cries, "Ladies and gentlemen . . . Before your very eyes!"

Méliès was endlessly productive and truly inspired. What's more, he had a greater readiness for using the camera simply to record reality than is generally reckoned. But he was not a sophisticated businessman. There was an early enthusiasm for his pictures in America, and Georges soon sent his brother Gaston to handle those affairs. In time, Gaston began making Westerns out of San Antonio, as well as handling his brother's films. But those films' whimsicality and their literary roots were not always to American tastes, and the Mélièses' interests fell foul of the Motion Picture Patents Company, which liked to ban or fine productions that had not used their approved equipment. That monopoly was restrictive inside America, but it fell most harshly on foreigners.

So Méliès was himself out-tricked in America. But there was also a move toward realism and longer narrative films. Méliès never felt or developed the story fluency that impressed Griffith, and by 1912 his films were looking old-fashioned. Then, in 1913, his beloved wife died. A year later, with the outbreak of war, many French theaters closed. His studio became a hospital for war wounded. He faded away, and ended up running a small toy shop at the Gare Montparnasse. Many of his films were lost, as the celluloid was used to make military boots.

In 1931 he was awarded the Légion d'Honneur, and in his last years, he dreamed of a movie museum, a Notre Dame du Cinéma. He died in 1938, not unknown but largely forgotten. History has been kinder. In 1952, Georges Franju made a very touching film about Méliès. Today Criterion has a boxed set of most of the Méliès that survives, and it has served to restore childhood or innocence to moviegoing. In *Hugo* (2011), Martin

Scorsese had Ben Kingsley playing Méliès. More important still, we have passed through the way of seeing him as merely a fantasist or a magician. For he was a realist, too, as any photographer must be; he recorded what he set up. And while the surrealists formed an early attachment to Méliès, it is easier now to see how far he established the screen as a place where the real and the dream were married.

•

Whereas Méliès fabricated his world and tossed in the yeast of real people, Louis Feuillade had an eye for the actual Paris that lets us believe in conspiracy and secret purposes running the city instead of government. Those purposes are often criminal, but in the end it emerges that they are fiction itself, or its possibility. Without ever taking his eye from the real places, Feuillade is the first film artist who guesses that the real is a diversion.

Louis Feuillade was born in Lunel (between Montpellier and Nîmes) in 1873. It is an area of blazing sun, yet Feuillade is a poet of misty city prospects. His family was well-to-do from the wine business, and Feuillade's first thought was to be a writer. But he was swayed by the sight of moving imagery. By 1906 he had joined the Gaumont Film Company and begun to work as what we would call a storyteller for pictures. He furnished narrative material, and like many movie writers, he saw that the variations on plot, character, and action were repetitive and musical. So his serial films are the first in which we feel an elegant amusement at story itself. He reveled in great intrigues (and his films surely influenced Fritz Lang's *Mabuse* pictures), yet he intuited that plot (the interpretation of raw events) was the largest conspiracy.

I have said already that Méliès's career was terminated by the circumstances of the Great War, but Feuillade's was inspired by them. There are no rules: Méliès was ready to fade; Feuillade knew it was his moment to see the light. He was busy already in advance of the war, but his great works are serials: *Fantômas* (1913–14), with several sequels; *Les Vampires* (1915); *Judex* (1916); *Tih Minh* (1918).

Although Feuillade wrote his own scripts, Fantômas was a character created by Marcel Allain and Pierre Souvestre in 1911 in a series of books. He was a mastermind criminal, vaguely aristocratic, a man of many disguises, a thief, a murderer, and a sociopath, and opposed by Inspector Juve of the police. Prewar in his origins, Fantômas slips over into the war mood like a ghost and becomes a subversive figure. If we think of the protago-

nists of Griffith or his contemporaries, we may feel poleaxed by their virtue. The ambiguity of *Fantômas*, the mixture of charm and threat, is of a quite different order.

This allowed Fantômas, as image and character, to become a cult with the surrealists. Magritte painted the character many times. Suzi Gablik has observed the way this pulp character took on deeper and darker meanings—nearly ten years in advance of Mabuse:

> Fantômas was a genius of evil—a devil who could enter through any keyhole and commit lurid and brilliant crimes without leaving a trace. Crime was a sport at which he excelled. He was continually refining the rules of human treachery, constantly seeking to surpass his own record and to invent even more daring atrocity with which to petrify the mob. Parallels could be drawn here with the anarchic and destructive activities of the Surrealists, and their continued efforts to mystify society. The Surrealists' recourse to scandal, and their deliberate acts of defiance against conformism and the bourgeois system in general, were ways of seeking out the queer unsupervised roads along which the mind might escape from its captivity.

There is so much to study in Feuillade: the trembling air of danger that never alludes to the war; the subsequent implication that society is being undermined anyway; the interest in disguise and masquerade, as if everyone were an actor; the astonishing and beautiful use of real city views to evoke a haunted mindscape. Feuillade is a father of noir (if hardly known by today's noiristas); he is a surrealist and an anarchist; and he is the first author in cinema who asks, Isn't crime delicious? Isn't it one of the great taboos we have come to see? Every treasured screen assassin owes something to him. He is also the clear warning that in France it will be possible to have a flagrantly antisocial attitude in cinema, so distant from the attempts at group positivism in America or the Soviet Union.

•

Feuillade is too little known today, whereas Abel Gance is still a famous name. But when you hear people acknowledge Gance—a little vaguely— you guess they haven't seen the work or grasped the scale of his achievement. Gance is not even a large figure; he is a monster. He is so much

bolder and more ambitious than, say, Cecil B. DeMille, and he is as French, as overwhelming, and sometimes as regrettable, as Victor Hugo.

Only weeks short of the age of ninety, Gance, who was born in 1889 in Paris, attended the 1979 Telluride Film Festival (at nine thousand feet), in Colorado, for the splendid revival of his 1927 epic, *Napoléon*. Gance had nearly died as a young man from tuberculosis and, later, from the 1919 influenza, but the thin air of Colorado was wine to his soul, as stimulating as five hours of film; of course his own desired version of *Napoléon* would have been far longer.

Gance was the bastard son of a distinguished doctor, Abel Flamant. ("Gance" was his stepfather's name.) He was urged to pursue a legal career but gave that up to be an actor, and thus, at much the same time as Griffith in America, he seems to have realized that actors were putty in the hands of those managers who might be called "directors." Surviving great poverty and then tuberculosis, he made his first film, *La Digue*, in 1911 and then wrote a five-hour play, *Victory of Samothrace*, which Sarah Bernhardt had said she would have opened but for the outbreak of war.

Abel Gance was so physically depleted that he was not taken by the French army until 1918, but his service was shocking enough to inspire *J'Accuse*, a nearly three-hour antiwar tirade, with magnificent footage from the front itself and a shamelessly melodramatic story to back it up. No one ever accused Gance of subtlety; no melodramatic excess ever deterred him. But *J'Accuse* is from the appalling world of war experience, whereas Griffith's *Hearts of the World* is a distant reverie. In deliberately coopting the tradition of Zola and Hugo, Gance was asserting a vital French belief: that film grew out of the theater and literature, without compromise or concession. It was part of national culture from the outset.

J'Accuse (which opened in April 1919) was an international sensation, sufficient to get Gance invited to America. He met Griffith and rejected an offer to work in Hollywood at several thousand dollars a week. Instead, he returned to France to make *La Roue* (1923), a love story about railroad workers, and probably his best picture. In the same year, Gance directed a comedy, *Au Secours!* (1924), with Max Linder, a dandyish comedian who had a large American following in advance of Chaplin. Indeed, Linder thought he had been exploited and then abandoned by the American film business. But he had other disadvantages: he was the victim of a gas attack on the Western Front, and then he had double pneumonia. He and his wife killed themselves in 1925 (he was only forty-one), and in French history, Linder is marked as a tragic victim of American crassness.

So what should Gance do to honor film and France (and himself) but make an attempt on the life of Bonaparte? On the set, Gance makes Griffith seem shy and introspective. There is a story that when one big military scene was to be filmed, in which the army of extras was supposed to cry out, "Vive Napoléon!" they actually yelled "Vive Abel Gance!" It reminds one of the folklore from *Spartacus* (1960), when every slave defies Roman investigation by shouting out, "I am Spartacus!," but some said, "I am Kirk Douglas [the producer and star]," with as much irony as respect.

Gance began with a six-part outline that would carry Bonaparte from birth through the period of the Revolution to the Italian campaign of 1801. He meant to go further, of course. What he shot amounted to at least a six-hour film and it cost over 18 million francs (despite enormous complaint from his bankers). In June 1924, on the eve of shooting, he spoke to the cast and crew with a fervor that might have come from Bonaparte himself. It is an early example of monomania as the natural condition of filmmaking:

> This is a film which must—and let no one underestimate the profundity of what I'm saying—a film which must allow us to enter the Temple of Art through the giant gates of History. An inexpressible anguish grips me at the thought that my will and my vital gift are as nothing if you do not bring me your unremitting devotion . . .
>
> The world's screens await you, my friends. From all of you, whatever your role or rank, leading actors, supporting actors, cameramen, scenery artists, electricians, props, everyone, and especially you, the unsung extras who have to rediscover the spirit of your ancestors to find in your hearts the unity and fearlessness which was France between 1792 and 1815. I ask, no, I demand, that you abandon petty, personal considerations and give me your total devotion. Only in this way will you serve and revere the already illustrious cause of the first art-form of the future, through the most formidable lesson in history.

The "they" Gance sought to command included two hundred technicians, forty stars, and six thousand extras. He built a section of Paris, but he also went as far as Toulon and Corsica to find the authentic locations. He pioneered rapid cutting and extended shots. He moved the camera in ways not tried before. He had first-person shots. He threw the camera as if it was a snowball. He even created a thing called PolyVision for very

spectacular scenes, which was three screens, side by side, with a central site of action and sidebars of complementary or illustrative material. Anything he could think of he would try, which extended to persuading his actors that they were the people they were playing. One observer believed that Gance could have succeeded where Bonaparte failed! Not everyone admired this self-display or the melodrama of rhetoric.

It is also said that Gance read every book ever written on Bonaparte. That may be so, but the film itself leaves more feeling of Gance's seething, exuberant megalomania with this "art-form of the future."

Napoléon does not survive in its entirety. There are no more than five and a half hours. It was restored (thanks in great part to an Englishman, Kevin Brownlow), and it was supplied with scores, one by Carmine Coppola, another by Carl Davis. The latter is far superior, but the former was part of Francis Coppola's decision to rerelease the picture in America. And so it survives to this day, and many sequences (especially those with Bonaparte as a boy) are still remarkable and appealing.

As to the whole thing, its video life is probably not something Gance would have countenanced. *Napoléon* demands epic scale and a live orchestra. It cries out for the biggest screen available—yet it is hard to imagine *Napoléon* will often see that light again. It coincides nearly with von Stroheim's *Greed*—a superior film made for a Hollywood studio and "rationalized" into submission, so that the excised footage no longer exists. *Napoléon* was also made for a private production company, one that had taken an absurd financial risk that was not rewarded at the time. The film opened in Paris at the Opéra on April 7, 1927. It was so unwieldy that it played only in European capitals. M-G-M bought it for America and cut it drastically, refusing to show the PolyVision part of the picture.

Napoléon was "too long" for public taste or physical survival. Yet in France, most of the grand enterprise survived, and Gance lived to see the restored version. It played at Telluride first at an open-air screen, with Gance watching from his hotel window. He died two years later, certain that he was right, a figure in history. But as François Truffaut once observed, "Gance does not *possess* genius, he *is possessed* by genius."

•

René Clair was a Parisian, from Les Halles, born in 1898, the son of a soap merchant. As a child, he fell in love with puppet theater, and that controlling attitude toward performance never left him. He wrote poetry and he was wounded in the Great War (as an ambulance driver), but he

rejected soap for journalism, acting, and then an eagerness to try making films. In 1924 he made two short films—*Paris Qui Dort* and *Entr'acte*—that are the mood of slapstick comedy seen through the eye of an elegant, witty, and polite surrealist of the 1920s, aware of modern art and intrigued by the many ways in which cinematography can be used to help comedy: double exposure, slow-motion, reverse action, and so on. It's an approach that overlooks film as a new version of reality in favor of a fresh, jazzy treatment of graphic expression.

Clair was interested in making comedies for smart people. In 1927 he took the Eugène Labiche and Marc Michel play *The Italian Straw Hat* and delivered what Pauline Kael would call "simply one of the funniest films ever made and one of the most elegant as well." The farce was not a hit in France, but it quickly became a model all over the film society world for what wit could do. Clair was talked of in company with Lubitsch, and if Lubitsch was tougher, Clair was a master of gentle elegance and wry satire. Moreover, within just a few years, he managed the transition to sound with an inventive ease that was unsurpassed.

In rapid succession he made *Sous les Toits de Paris* (1930), *Le Million* (1931), and *À Nous la Liberté* (1931) and was regarded as one of the outstanding directors in the world. Clair loved Paris, but his taste was to recreate it on sets. (The Russian Lazare Meerson was his top art director.) He was a patron of meticulous art direction, and he excelled at the orchestration of music, sound effects, and talk and a very pretty, pearly black-and-white look usually achieved by Georges Périnal. His characters were puppet-like, not deeply examined, but seen with great affection and charm.

The historian Gerald Mast would say of Clair,

The clearest . . . traits are his delight in physical movement and his comic fancy (falling somewhere between wit and whimsy), which converts two things that are obviously different into things that are surprisingly the same: a funeral becomes a wedding party, a prison is a factory and a factory is a prison, a tussle for a jacket becomes a football game, a provincial French café becomes an Arabian harem. Clair's constant dissolving of differences into similarities is fanciful as well as satirical, designed as much for wildly fantastic, imaginative fun as for social commentary.

That point may be sound, but Chaplin "borrowed" from *À Nous la Liberté* to make *Modern Times*, and Clair's lightness can be penetrating.

His greatest horror was to be heavy-handed. His greatest vulnerability was his unshakable belief in comedy and his dread of solemnity as France turned very earnest about its own sinking fate.

So Clair left France and went first to England, for *The Ghost Goes West* (1935), and then to Hollywood, where he lived throughout the war. His pictures there were uneven—*The Flame of New Orleans* (1941), *I Married a Witch* (1942), *It Happened Tomorrow* (1944), *And Then There Were None* (1945)—and the critic Manny Farber believed that Clair had lost his touch and his creative self in America. Of course, departure did not endear him to the French. While he went back to Paris after the war and made several more films, he came under steady attack as part of the old guard, bourgeois, and precious, from the *Cahiers du Cinéma* critics of the 1950s.

To say the least, he is a subject for reappraisal (if that demanding discipline is available any longer in film studies). Still, he was the first director elected to the Académie Française. When he published the script of *Les Belles de Nuit* (1952), he wrote a foreword that expressed his determined urge to entertain and to avoid offering himself as a Gance-like monument: "We willingly admit that we've tried to amuse you by relating in this film an imaginary adventure that doesn't attempt to prove anything, that doesn't support any thesis, and that is, in a word, as perfectly useless as a nightingale or a flower." It could be Preston Sturges speaking, or Jacques Tati, who was so affected by Clair—and their vogue is still assured. "Perfectly useless" cinema goes against the grain of state cinema and of "important" films made in many free-enterprise situations. But it should not be forgotten, or dismissed as being as lightweight as it feels.

•

Clair was famous for taking on sound with such élan. But we are not done with silence yet. More impressive now than all of Clair's films, I believe, is Carl Dreyer's *The Passion of Joan of Arc*, made in France and released in 1928. Dreyer was born in Copenhagen in 1889, the bastard son of a Danish farmer and a Swedish mother. It's clear why *The Passion* was made in France—where else could any director raise 7 million francs for such a subject? But where else could a film be made that was unequivocally religious? Even in France, the Joan of Arc subject could easily have turned into a historical, patriotic spectacle (like the Joan film made in Hollywood starring Ingrid Bergman and directed by Victor Fleming in 1948).

In fact, Dreyer was offered a conventional script (based on Joseph Delteil's book about Joan), but he put it aside and turned instead to the court records of her trial. So the *Passion* has no biographical arc (and no Arc), no triumphant battle scenes, and not the least flourish. Instead, it is a series of interrogations reminiscent of the Stations of the Cross (as Pauline Kael noted). It is a film about faith and its testing ordeal, with just gestures toward the fifteenth century. In France there are always elderly castles, but Dreyer chose to build a new Rouen, not true to period, not modern, but a concrete abstraction, offset by accurate costumes and the words uttered at the trial. The designs were by Jean Hugo and Hermann Warm (who had worked on *The Cabinet of Dr. Caligari*).

But that background was like a painter's wash on a canvas. The real subject of the film are the faces, chosen with the utmost care, filmed in unusually large and confronting close-ups, often from slightly above or below to enhance the spiritual sensibility. The actors were not allowed makeup, and the photography (by Rudolph Maté) took advantage of the panchromatic black-and-white stock that had just become affordable and that permitted a new sense of carnal intimacy. The faces in Dreyer's films are as alive and throbbing as cell life—that is where the passion lives. *The Passion of Joan of Arc* has another resource. The film is silent (though it has had many musical scores added), and the titles that give the liturgical dialogue are not just informational cutaways, but a level of inner voice, a screen imposed in the minds behind the faces. *The Passion* is one of the few silent pictures in which the lack of sound seems a positive and even a measure of modernity. Thus the film is "musical"—it is heard and felt—without any score being applied.

Beyond that, it has Renée Jeanne Falconetti (credited as Maria Falconetti) as Joan, in a performance so absorbing of the audience and so exhausting it still holds a place among the greatest performances on film. She was from Corsica, a stage actress who made very few films, and nothing after Dreyer's trial. Instead, she did light comedies on the stage. Like Louise Brooks, she came and went in less than two hours, and left burn marks. Dreyer filmed her remorselessly until he found what he wanted. But did he know what he was searching for until he saw it in her face? It is nowhere near enough to call this acting: it is submission, it is ordeal and transcendence—the process of making the film is akin to Joan's cross-examination.

Over the years, critics everywhere have continued to rank the film very highly. For much of that time the version we had was incomplete—until

1981, when a print of Dreyer's cut was found in the closet of the janitor for a Norwegian mental institution. Is that a miracle—no matter that you don't believe in such things? Or simply a sign of the fragility and chanciness with which great films, or bad ones, may survive? Which cupboard is so safe or dead we don't need to look there? We are capitalists, gatherers, hoarders, collectors, and museum makers, but our story is of the things we have lost. Like Rosebud. Every time it looks, photography always hints, is this lovely face alive, "alive," or dead yet? The question hangs over Falconetti, the woman who moves in Chris Marker's *La Jetée*, and the next astonishing newcomer you will see on a screen.

The Passion of Joan of Arc is the movie that Anna Karina's Nana goes to see in Godard's *Vivre Sa Vie* (1962). She weeps at it, and knows it is about her. You will find the same pitiless conclusion—or rapture. Dreyer believed in God, but he trusted that movies are for people who know the screen is their mirror. Looking at Falconetti, you learn how to see. So it is a picture that ends blindness and reiterates that essential, primitive message the cinema cannot abandon: look at this.

•

Then, only months later, in the same infinite Paris, look again—if you dare, if you can stand the idea of a cutthroat razor slicing through a woman's patient eye, and if you can tolerate the more tumultuous violence of suggestion that lurks in a film called—with deliberate, insolent stupidity, and in a blithe boast of worthlessness—*Un Chien Andalou*. Could there be anything nastier, dirtier, or more rabid? "Beware of the dog," wrote a young man on seeing the film. "It bites." His name was Jean Vigo. But what is a film doing biting when so much of the movie world wants to assure us that a movie is just a sweet (wholesome) kiss?

Luis Buñuel was born in Calanda, in Spain, about a hundred kilometers from Zaragoza, in 1900. He was the child of a wealthy landowning family, part of the establishment in a country that led an eighteenth-century existence. He was too bored to be actively rebellious at first and he gazed on the institutions of his life—the Church, the brothel, the army, his family—with equal dismay. He had an ear for music, but his father discouraged that, so he thought he would study insects, or primitive life. With that aim, he set off for the University of Madrid, where he would meet a generation ready to explode. It included Salvador Dalí and Federico García Lorca. It was the moment of widespread European disil-

lusion with order, and it was the era of movies playing their games on screens or on white sheets put up in student rooms. Buñuel watched in the early 1920s and soon discarded the suggestion that movie was a record of reality. It was a dream, a frenzy, a secret imprint of madness. The young man from the provinces and the past had glimpsed the future and the passion in disorder. While hardly knowing the word yet, he was on the brink of "surrealism."

Film was the vague guide to his dissolute life. He assisted Jean Epstein and other serious members of the French avant-garde. And so, one way or another, he and Dalí agreed to make a little movie. Dalí was the younger of the two, by four years, but he was more handsome and far more charismatic than the rather surly, morose Buñuel. He had an easier time with women. He painted already in his showy way. He was probably more sophisticated about dreams. I put it this way because auteurship has elected to determine that Buñuel made *Un Chien Andalou*—because Buñuel would become a "great" director (*Los Olvidados*, 1950, *Viridiana*, 1961, *The Exterminating Angel*, 1962, *Belle de Jour*, 1967), while Dalí is now treated as somewhere between a madman and a charlatan (as if those were not interesting and legitimate responses to our world). They wrote the script together, or in fierce competition. Buñuel seems to have shot the film, and I suspect he learned far more from it. But the attitude was vitally Dalí, too.

The script is a fascinating document. Later on the boys would claim that they made *Un Chien Andalou* up as they went along, accepting every caprice and interruption. But it is actually a coherent, organized little picture—albeit one that thrives on the notion of connections beneath the surface of rationality or "plot." They said they used their dreams, and maybe they did, but in a wakeful, clever way. All that made them brilliant and dangerous was the insistence that the film would be about sex and death and the awareness that those forces waited for mankind in the wings of a moth and the face of a girl in the wind.

In a casual, absentminded way, Buñuel seems to have scrounged 25,000 pesetas from his mother, to match a dowry being given to his sister. And so they filmed, without skill or grace, but serenely confident that any image was beautiful and disturbing in that it was life excised from life and put up on a screen to be examined. They knew that no one watches a story so much as the process that comprehends story. It is the first modern film, and it still stings like a whip.

This is the script:

Once Upon a Time . . .

A balcony. Night. A man is sharpening a razor by the balcony. The man looks through a window at the sky and sees . . . A light cloud passing across the face of the full moon. Then the head of a young woman with wide open eyes. The blade of the razor moves towards one of her eyes. The light cloud now moves across the face of the moon. The razor-blade slices the eye of the young woman, dividing it.

This is the film:

The man (Buñuel himself) is a suave Spanish thug such as you might expect to see in a brothel—not a customer, but "security." He wears a striped shirt in a film full of stripes—things like that can mean more than reading all the books ever written on Bonaparte. He smokes a cigarette. Nearly everyone interesting in early movies smoked a cigarette—and the steady withdrawal of smoking from our movies does coincide with their drop in quality. Showing a cigarette on-screen is beautiful and absurd; it is life and death—think of Bogart and Bacall lighting up together at the end of *The Big Sleep* (1946). It is also a great dream of sucking on fire (that may have sexual connotations). The man is menacing and adorable: this is 1929, and it is the future of cinema. The woman is very cute, and as patient and open-eyed as someone watching a movie. The slicing of the eyeball still sends some people running out of the dark, but in fact, Buñuel used a dead sheep with a bit of makeup. The edit that goes from the woman's face to the sheep's eye is as tidy and correct as the basis of sequential editing would like every film to be.

What was the woman looking at before her eye was sliced? At the movie, at the screen, at its mirror? She was wanting to see herself. And in the seventeen minutes of *Un Chien Andalou*, there is an unsentimental parable of our search for sexual expression, with rapid intimations of infancy, homosexuality, lust, guilt, "happiness," and mortification. (It would play perfectly with David Lynch's *Blue Velvet*.) It would be so much easier to dismiss if *Un Chien Andalou* were truly as crazy and pointless as the boys liked to say. But you can't make a senseless film if anyone is watching. Watching seeks sense, and the pressing implication of the picture is to say, oh, please, don't let's peddle the old lies about good entertainment, movie stars, and a great evening out—this is a frenzy, bent on sex and violence, and we are growing older as we watch. Do you laugh or cry at that,

or are you driven to murder? Art is not a recreation, a consolation, a pastime, a business (though it is all these things); it is the stone on which your knife is sharpened.

The little movie played in Paris in the summer of 1929. Buñuel, at early shows, went behind the screen and tried to play records of tango music and Wagner's *Liebestod* to "help" or place certain moments. Some people were horrified and angry. There were small demonstrations. The surrealists rallied to Buñuel and Dalí and claimed them for the movement. An aristocrat gave them more money (close to a million francs finally) to make *L'Âge d'Or*, which is longer (sixty-three minutes) and better (I suppose), as if being better has anything to do with it. What these two films demonstrate is the cinema's short and ready fuse for insult and offense (for those open to it) and the uncanny subterranean power of association—so much more valuable and delightful than the montage theories pounded out by the Soviets—that everything cuts together, that on the screen, all images and ideas are playing or resting (like data in a computer). For the first time, a film whispers to us—you could play this film with *The Passion of Joan of Arc*, not just in a double bill, but at the same time, overlapping images, a perpetual dissolve. Because the screen is a place where all films live anyway. And they are fucking each other all the time. Just think of a movie where Bogart's Dixon Steele from *In a Lonely Place* (1950) is being pursued by his Philip Marlowe from *The Big Sleep*. No wonder he's so worried; no wonder he's so cocksure. No wonder he's dead. But see how lifelike he is. The movies are about this great ontological riddle, and they are only modestly contingent on art, entertainment, or money.

And Luis Buñuel? He made one other film after *L'Âge d'Or*, *Las Hurdes* (1933), a rather plaintive, conventional documentary about distress in rural Spain, with only a few jokes. Then he stopped. He didn't make another film for fourteen years, and then, in 1947 in Mexico, he made something called *Gran Casino* and then made his way toward his string of masterpieces culminating in *The Discreet Charm of the Bourgeoisie* (1972) and *That Obscure Object of Desire* (1977). Here, finally, he had arrived at a title that was a perfect slogan for cinema. The human tragedy is not our diligent wars, our arbitrary floods and earthquakes, our ordinary outrages of cruelty (though they can be entertaining). It is that desire is sometimes obscured, and impeded.

•

That was not all. The French screen of the early 1930s had another glory, and it came from the Jean Vigo who had warned about the Andalusian dog and its ability to bite, even if it left no teeth marks.

Jean Vigo was born in Paris in 1905 (our heroes are getting younger) and he would be dead in 1934. He was a sickly, impoverished child, suffering from the lung trouble that would kill him. He also observed the fate of his father, a virulent leftist-anarchist known as Miguel Almereyda, who was imprisoned during the Great War on charges of conspiring with the Germans, and who was found in his cell strangled.

Fighting to clear his father's name, Vigo entered the Sorbonne and discovered movies. He was a camera assistant and then, with money given by his father-in-law, he began to make his own picture. As his own cameraman, he took on Boris Kaufman, the younger brother of Dziga Vertov, who had just arrived in France. They made an essay film, *À Propos de Nice* (1930), and then another, *Taris* (1931), about a champion swimmer. Next came *Zéro de Conduite* (1933), a forty-one-minute picture about life (or imprisonment) in a French school, filled with the anarchist loathing of institutions and in love with what film can do. There is an ecstatic slow-motion pillow fight.

Vigo was dying—he was always dying—but he made one feature film, *L'Atalante* (1934), the name of a barge that works the canals and rivers of northern France, lyrically harsh in Kaufman's imagery. The young skipper (Jean Dasté) goes ashore and takes a wife (Dita Parlo). The barge moves on, but young love is soon troubled by the wife's dismay at this unromantic life. She talks to the old man, Le père Jules (Michel Simon), who helps work the barge. She runs away. The skipper goes in search of her.

This is a bare story about simple people—if such things exist. American cinema liked to glorify "simple" people. It was a way of reassuring everyone that a picture was for them. Think of Chaplin's little man and then notice his huge ego. This is a keystone in the American lie, that our lives can be small. Vigo believed that every life is just a pale skin wrapped around a seething inner life, and he knew that film could uncover it. *L'Atalante* is the first film dedicated to that principle made without concession to literary values or political orthodoxy, and free of the muddle that betrays *Sunrise*. Vigo died days after its opening—and the film was a commercial disaster. But regularly now it figures in the top tens of the greatest films ever made. Vigo was and remains the model French example of someone who will die for cinema. *Zéro de Conduite* informs Truffaut's *Les Quatre Cents Coups* in scene after scene (as it does Lindsay Anderson's

If). *L'Atalante*'s sense of the hopeless necessity of love (the obscurity of desire) affected Godard. Jean-Paul Belmondo does a tribute to Simon in Godard's *Pierrot le Fou* (1965). Michel Simon's performance as the barbaric, filthy, disgusting sailor lives forever, more endearing than movie presidents and the screen's forlorn trail of Jesuses.

But Simon's old man had a brother, a man known only as Boudu, another river creature. And the Boudu we come to now is part of the best story in French film history.

RENOIR

Almost the first memory for Jean Renoir was seeing himself in his father's paintings and drawings. One may be enchanted by this family tie, for the pictures done by Auguste Renoir are as loaded with charm as they are heavy with paint. They are "impressionist masterpieces," so the auction houses say, but pictures that have also been used as greeting cards such as grandparents may send to grandchildren. The faces look like ripe peaches. The paintings are steeped in nostalgia for perfect childhood. They do not ask awkward questions.

Jean Renoir was born in Montmartre in 1894, the son of Pierre-Auguste Renoir, so he was looking at these pictures in the late 1890s without quite realizing he had posed for them. His father had noticed him, seen the opportunity of a picture, and taken it—he had snapped it. This was before the boy could read. And in the 1890s, photography began to be a mass practice. Now it affects all of us, nearly all the time. Parents snap their children with cell phones and hold the bright pixels up to the infants' gaze, like a mobile to play with. "There you are!" they say, before the babies possess these words. There we are. It begins to become a basic form of identity, the level at which existence registers. We are our image. Our reality has been split, and that may be as significant as the more famous bifurcation of the atom.

This is not the customary way of approaching Jean Renoir. As a rule, he is called the sturdy bridge between French artistic traditions and movie modernism. Renoir is the medium's great humanist—you can see that in his Octave in La Règle du Jeu, so gregarious, so ready to help everyone, a jolly enabler in life, yet a man who conceals his own sadness. That Renoir does exist, and you can meet him as the author of Renoir, My Father, the book he wrote about life with Auguste, and in The Notebooks of Captain

Georges, a novel with the cool eye of Maupassant as well as the longing for affection from Renoir's best films. But Octave is perceived and treated in *La Règle* less as a real person than as an ebullient actor-manager trying to keep the house party and the picture in place. Renoir is complicated, and the complexity rests in the way of seeing he achieved, the style that went with it. As well as what he saw. It has not yet been surpassed or improved upon.

So he was the painter's son who became one of his father's subjects. What a happy household! Except that it is clear from the biographies that Auguste was what the auction houses would want him to be: a larger-than-life and obsessed painter of life and beauty who was like a lion on the veldt of family life, children, and house servants. What I mean by that is that if asked whether he would give up painting or the circumstances of his life (for example, family and home), he would have given up the latter, because he could always paint loneliness.

If we look at Auguste's human groups and wish we were there, or at his splendid female nudes and wish there was a there here, then we may recognize the domestic uneasiness whereby he required household servants who were lovely enough to inspire him. And this was a life Madame Renoir adapted to, for she had been his model once and was a favorite subject later as "mother." This helpless recycling of reality into art, with at least a caress in the transition, is something touched on in Renoir's film *French Cancan* (1954), where Danglard (Jean Gabin) is an impresario of live performance who seduces all his female discoveries and then moves on. Is that betrayal or passing time? "Why should Cupid have wings?" asks the epigraph to *La Règle du Jeu* (taking the line from Beaumarchais's *The Marriage of Figaro*), "If not to fly away again?"

Then you need to look at the face of Auguste Renoir—in photographs or in his own paintings—and admit the selfishness and the fierceness. Some will say that look comes from the pain of his arthritis. But then you should recollect his own wry admission, that as his hands became stricken, he painted with a brush tied to his hard-on.

Jean Renoir was the child of that man, his subject and his spectator. He was well educated and then, at the age of twenty, he went to war. As a lieutenant in the Alpine Infantry, he was so badly wounded he limped for the rest of his life. His mother, Aline, traveled to help nurse him after that wound—it was a close call—and she died soon thereafter. Recovered, Jean joined the Flying Corps, as an observer and then a pilot. He crashed and was sent back to Paris, where he began to look after his father (who

would die in 1919, aged seventy-eight). He was drawn to Andrée Heusch-ling, a beautiful young woman who had been hired as Auguste's final model. When his father died, Jean married Andrée, and it was as he looked at her that his vague plans to be a ceramicist fell away and he resolved to put her in a movie. "She was sixteen years old," Jean would write later,

> red-haired, plump and her skin "took the light" better than any model that Renoir had ever had in his life. She sang, slightly off key, the popular songs of the day; told stories about her girl friends; was gay; and cast over my father the revivifying spell of her joyous youth. Along with the roses, which grew almost wild at Les Collettes [their country house at Cagnes-sur-Mer in the South of France], and the great olive trees with their silvery reflections, Andrée was one of the vital elements which helped Renoir to interpret on his canvas the tremendous cry of love he uttered at the end of his life.

It's telling that Renoir places Andrée at the level of the flowers and the trees, and it prepares us for the remarkable sense of cinematic context in Jean Renoir's films—a thing that at first easily looks like "nature" or reality. But what settles in during the course of his long career is the theater-like subterfuge in which that reality is altered by the nature of the site where we meet it, the screen. Along the way, and in the 1930s especially, no one developed a more complete illusion of the rapport between filming and the world it looked at.

As a child, Jean had been introduced to the movie screen at a department store in the company of the family maid, Gabrielle. He didn't like it, and had to be taken out, crying. It was a film about a river—or that's what he said Gabrielle told him years later. But by then he had grasped the magic of rivers.

As a young man, Renoir saw movies, and generally preferred American films. He was trying to be a potter and a ceramicist, but he and Dédée (as he called his wife) were drawn to the screen. "We went . . . nearly every day, to the point that we had come to live in the unreal world of the American film. It may be added that Dédée belonged to the same class of woman as the stars whose appearance we followed on the screen. She copied their behavior and dressed herself like them. People stopped her in the street to ask if they had not seen her in some particular film, always an American film."

So they began as a team: he wrote *Catherine* (1924) and directed *La Fille de l'Eau* (1925), and they led to an ambitious venture: *Nana* (1926), adapted from Zola, two hours long, with the German actor Werner Krauss (he had played Caligari) as Muffat. It was an expensive failure and not good enough to conceal the conclusion that Catherine Hessling (Dédée's professional name) is not compelling. They did a few more things together, including two short films—*Sur un Air de Charleston* (where she dances with the American Johnny Hudgins) and *La Petite Marchande d'Allumettes* (from Hans Christian Andersen). But Renoir was making other films without his wife, a dangerous path in cinema history. Then, in 1931, with sound, he wanted to make a film adapted from a novel and a play. It was called *La Chienne*, and it was a good role for Catherine. But the studio willing to make the film had another actress under contract, Janie Marèse. Renoir yielded to commerce. "This betrayal marked the end of our life together. Catherine could not bear the disappointment. I offered to sacrifice myself by giving up *La Chienne*, and she refused the offer, hoping that I would insist. But I did not insist; and this was the end of an adventure which should have been pursued in happiness. The cinema was for both of us a jealous god."

Catherine Hessling appeared in only three more films and then retired from acting. She died in 1979, only months after the death of Jean.

The overlap of nature and contrivance was apparent from the start in *La Chienne*. It is the story of a henpecked clerk, Legrand (Michel Simon). He is a Sunday painter and a sad man, and he falls for a prostitute, Lulu. He steals from the office to meet her financial needs. But she gives the money to her pimp, Dédé (Georges Flamant). When Legrand discovers this, he kills Lulu. Dédé is arrested and executed. Legrand ends up as a tramp, who one day sees that one of his paintings is selling for serious money.

You could say the irony of the conclusion is "very French" (and when Fritz Lang remade the story in Hollywood as *Scarlet Street* [1945], he had trouble with the censors over a killer going free). But the story also shows an American influence, for this is a narrative hinged on desire: Can Legrand transform his life? Can he win and redeem Lulu (as Richard Gere cleans up Julia Roberts in *Pretty Woman*)? Can he be a success as a painter? Can he get rid of his wife, an odious shrew?

There's another twist: in life, Michel Simon fell for Janie Marèse, but the actress was infatuated with Georges Flamant, who in his own life was an underworld figure, as dangerous as Dédé. As the shooting ended, Flamant purchased an American car and took Marèse for a drive. There was

a crash. She was killed. Michel Simon was devastated. Filmmakers rather take the infection of melodrama for granted, while audiences crave it to end their boredom.

So the balance of France and America in *La Chienne* is intriguing. But whereas in Hollywood in 1931, for the most part, the storytelling machine was struggling with the challenge of sound, in France, Renoir was liberated by it. With sound to assist the action—through talk, music, and sound effects—Renoir seems to have identified the fluency of the camera and let it run. So what was once a stage play becomes casually cinematic. *La Chienne* is about the houses people live in, about a moving camera tracking and craning and panning, and a depth of focus that beckons movement, links one person to another, and all people to their setting, their context. With wonderful immediacy—and it has fragrance still, eighty years later—we feel we are there, turning to look, eager to see. In America, this enlarged reality is of enormous assistance in identification: we want to be there, we want to be these people.

In Renoir, that urge exists, too, but an ironic distancing still prevails. We feel we are being shown a story. We feel the intelligence of direction. We detect the irony. It has the same spirit as Renoir recounting the anecdote (bittersweet) of Marèse, Flamant, and Simon like a Maupassant story, an incident recounted over dinner, with us as eavesdroppers. But it is a story without prejudice: Legrand is a chump, Lulu is a slut, Dédé is spiteful—but so what? In an American movie of that period, those roles would be cast in iron, but in Renoir, we begin to take on the camera's patient and not unkind neutrality. There is no need for judgment. In life, after all, some things work out untidily, and not at the behest of fate.

A distributor took on *La Chienne* and decided to open it in Biarritz, with this proviso: he would advertise it in advance with the warning that it was shocking and unpleasant. The film was packed out, and soon duplicated that success in Paris. American methods were avidly imitated. Often so close to poverty that he was driven to sell some of Auguste's paintings, Renoir at last had a career of his own.

He moved forward now with new impetus. His next film was *La Nuit du Carrefour* (still little seen outside France), an Inspector Maigret story coscripted with Georges Simenon, and with Renoir's brother Pierre playing Maigret. Then he was back with Michel Simon on another play, *Boudu Sauvé des Eaux* (by René Fauchois), though it is scarcely credible from the easygoing documentary texture of its riverbank Paris that the stage lies behind this story. *Boudu* is Renoir's first masterpiece, though equal own-

ership belongs to Simon. (Let me modify "masterpiece"; it's the slick jargon of film reviewing. At Giverny, which lily is the masterpiece? Aren't they all ordinary?)

We are in Paris on the banks of the Seine, where a bookseller, Lestingois, is in the habit of watching the world go by through a telescope. He spies a "perfect tramp," Boudu, about to enter the river. Why? He has lost his dog? He is fed up with life? Or is he a natural river rat? Lestingois is brave and charitable enough to rescue the water creature.

If only he had known! Boudu comes into the household and spreads merry hell before—having been urged to marry the maid (Lestingois's mistress)—he sits in a boat and a bowler hat for his wedding ceremony, reaches out for a lily, tips the boat over, and returns to his river . . . like a cork?

Over fifty years later, the story was remade by Paul Mazursky as *Down and Out in Beverly Hills*. The bum was Nick Nolte now, shabbily glamorous, and a bit of a hippie genius in the end. The openness of Renoir's film could not survive. In *Boudu*, the satire is gentle but firm, and Boudu is an authentic savage, not too far from insane, without any of the coy canniness that Nolte had to have—stars hate to look stupid or alien. There is no river, either. And it takes a wayward copyist to redo *Boudu* without a river— though Beverly Hills may owe some of its nervous aridity to the absence of such a lazy, serene facility.

Renoir's film loves contingent space; it revels in the light of summer in the city; and it is drawn to the river, a constant flow not bothered to distinguish between prosperity and haplessness. Boudu is an outsider, or so it seems. But Lestingois is every bit as strange and "homeless." Yes, he has his house, but he is eccentric, or displaced. He is a fool—a character we suddenly realize is not often admitted in American cinema. Of course, Boudu and Legrand (both embodied by Michel Simon) are creatures who slip away from society and normality. What makes the films so ambiguous is the way Renoir's camera cannot mock them or believe they are wrong. Normality feels all the less likely in their absence. Twenty years later, in India, Renoir would emerge from something like despair with a film called *The River*, in which a well-to-do English family of jute merchants lives side by side with penniless mystics and beggars on the banks of the Ganges. No judgment is called for. No certainty is offered about the proper way to live. The story and particular human hopes are swimming in the river's flow. A war was to come between *Boudu* and *The River*, but nowhere on earth in the early 1930s was anyone delivering such films

in which the supple use of the medium, of space and context, could leave a small incident so durable and questioning.

Quite simply, Renoir enlarged our sense of human behavior in the way he looked at it, and in the assumption that we were adult enough to make up our own minds. The Lestingois household is tenderly satirized. The middle-class world is teased. At one moment, having been given five francs by a child, Boudu thinks to open the car door for a gentleman motorist, dreaming of a tip. But the self-important fellow has come out without a coin (a Warren Buffett habit), so Boudu gives *him* the five francs. All of this on a sunny day in the park where you can smell Paris—and no city has given itself to film more contentedly.

There are sets in the film for the interior of the house, but what is more striking is the use of real premises on a quai so that we see the outside framed by the inside. There are beautiful interior shots, of one person in another room, with action involving others in a room behind, joined by an archway or a corridor. (There are similar compositions to be found in Auguste Renoir paintings.) At a key moment, when Boudu is seducing Mme Lestingois, he backs into a door, it yields, and there are Lestingois and the maid cozying up. That's what determines that Boudu shall marry the maid. This is asserted in an instant, and it's a sign of Renoir's instinct for the daft sweeps of human error. Everyone makes mistakes—it is the prelude to his more famous motto, that everyone has his or her reasons.

All of this is so vibrantly casual and lifelike. Yet *Boudu Sauvé des Eaux* is not simply a slice of life. It's as pretty and organized as a tarte tatin. It begins with a theatrical tableau in which Pan (Simon) seizes a maiden. It artfully makes use of music—a slapdash marching band, a small orchestra at the wedding, a minor character who plays the flute, plus the sirens and horns of traffic and the city. The ear for rustling life is akin to the eye for background detail and the apprehension that human foreground is vain and silly—we are all other people's background. But foreground and background have been married on the flatness of a screen. Renoir fondly searches out the illusion of depth, but loves the staginess of the screen.

So much is en passant, offhand, and as if improvised; even the pan shots creak a bit. Simon's Boudu turns handstands, he sits jammed in a doorway, does a whirl and nearly falls over; he makes faces, like a baby trying out expressiveness. He is a vagrant but a dancer, too, a lost being and a found actor. The film is just a lily, but it persuades you to need lilies. And the love is Renoir's, as he comes into possession of this medium and realizes it is a way of seeing to last a lifetime.

He goes to Normandy to make a version of *Madame Bovary* (1933). It ends up three hours, and the system cuts it to two. Valentine Tessier plays Emma, and she and Jean are very close. Pierre Renoir is Charles. I lack the space to glory in every film. He goes to south to make *Toni* (1935), a melodrama taken from a newspaper story. He does the exhilarating *Le Crime de Monsieur Lange* (1936), a film about a collective, with the whey-faced Parisian hero writing cowboy stories about "Arizona Jim." Renoir moves close to the Popular Front and makes *La Vie Est à Nous* for the Communist Party. This is the one moment in his life when, alarmed by fascism, Renoir adopts answers—and he is not comfortable with certainty.

Then Pierre Braunberger asks him to make a picture of Maupassant's short story "Partie de Campagne." The Dufour family from Paris go out to the country one Sunday in the summer of 1860. They come to an inn run by Père Poulain (Renoir himself). Two young men, Henri and Rodolphe, are staying at the inn, and they fasten on the Dufour women, notably their daughter Henriette. Henri and Henriette have a tryst on the riverbank after he has taken her off in his boat. It is brief but intense. And then, on the sad wings of Joseph Kosma's music, years later, the lovers meet again for a moment, but then she is called away by her inadequate husband. People do bold things and make mistakes. How can anyone tell which is which? The rest is resignation and the remainder of life.

It was always Renoir's belief that the film should stay a short (it is forty minutes), though Braunberger seems to have been so impressed by the footage that he begged the director to go for feature length. That could only have meant showing the disappointing marriage and probably resorting to a second affair between the brief-encounter lovers. Renoir rejected that expansion, in part because he believed films should find their natural length, as opposed to set commercial forms. And because he felt the sadness was sufficiently conveyed to be left to our imagination. Of course, this is not another version of "they lived happily ever after," that keystone of popular cinema. It is not easy to name a Hollywood love story from 1936 (or any neighboring year) in which the perspective of growing older is so bleak. (Leo McCarey's *Make Way for Tomorrow* is a contender.)

The shoot took place near Marlotte, where Renoir had counted on summer. He had a remarkable corps of assistants: Henri Cartier-Bresson, Jacques Becker, Luchino Visconti, Yves Allégret. Winds blew and the rain fell, but the mistake in the weather suited the tone of the story. Still, it imposed delays, so Renoir was compelled to give up the project to honor his commitment on *Les Bas-Fonds* (1936). *Partie de Campagne* was left to

be edited by his lover, Marguerite Houle—she took the name of "Renoir" for a time—and it was not released until 1946. So it gained the reputation of a film "maudit" (one neglected or spoiled), and curtailed by events. In fact, if anything was left out, the omission adds to the impact of the picture.

Truffaut said *Partie de Campagne* was "a film of pure sensation; each blade of grass tickles our face." That indicates not just the father's influence but also the way, in the 1930s at least, a filmmaker could be ravished by the simplicity of filming a place, the light, a face. When the two men throw back the shutters at the inn to reveal Henriette and her mother on swings in the garden, the camera edges forward like a cat seeing a mouse. The grass may tickle, but the light has a dappled radiance—there was enough sunshine for it to be remembered, and filmed light is like a diary item, beyond reproach or dispute—that day near Marlotte, at three in the afternoon, there was some brief glory to be beheld. Renoir was a director who felt this was an essential duty or pleasure in filmmaking.

But the river in this film is so much more than radiance. And when love is made, there is a sudden close-up of Henriette (Sylvia Bataille) that is shockingly large and exposed—"trapped, almost wounded," said Pauline Kael. It carries the surprise of sex along with the dismay that this may be the first and last time, for Henriette knows she has been taken by a casual seducer. In a longer film, perhaps, Renoir would have had to allow Henri to fall in love with her. But sometimes sex means more to one person than another, and in sex everyone has his or her reasons. What is realistic in the story and the film is the simple, pitiless understanding that this is the way of the world. And for ships that pass in the night, or the day, the river is a facilitating medium, without memory or morality. So the movie needs only one brief reunion to measure the mistake, and the way in which Henriette will never forget it. It becomes a film about destiny, memory, and time—and a river is always the same, if always transient. It is like the present tense: beautiful but indifferent, the perfect subject for moving photography.

Renoir had reached fluency by then. He knew how to see his world; he had established the grouping of people and space and the rhythm of long shots. You can speak of it as mastery, or you could use the language of *la caméra stylo*, a theory formulated after the war by Alexandre Astruc (novelist, critic, and exceptional filmmaker—his *Une Vie* [1958], also from Maupassant, is a film worthy of Renoir). *La caméra stylo* means a way of writing with film, a kind of natural, eloquent, but unforced prose style—beautiful

without seeming posed or chosen. Renoir's camera always indicates a casual human observer who has magically been given privileged vantages.

But mastery in film can often push a director toward bigger or "more important" subjects. It's not quite that Renoir struggled with that dilemma. Still, he was a professional who wanted success or attention, and in practice he chose worthy subjects—*Les Bas-Fonds* (from Maxim Gorky); *La Marseillaise* (1938; an amiable, untidy version of the French Revolution based on the writing of the song); *La Bête Humaine* (1938; from Zola); and *La Grande Illusion* (1937), so telling a sermon against war and for friendship that it was actually nominated for Best Picture by the American Academy.

I am not as uneasy with *La Grande Illusion* as some other writers: the great Cuban writer Guillermo Cabrera Infante, thought its "cowardly pacifism" was "quite overrated." "Cowardly" is too much, but "overrated" is helpful. The film *is* a little too tidy or arranged. We are in a German prisoner-of-war camp. Two of the French prisoners are Boeldieu (Pierre Fresnay) and Maréchal (Jean Gabin). Fresnay is allowed to make Boeldieu a cut-and-dried aristocrat, whereas Gabin's Maréchal is a starry man of the people—not just common but dangerously archetypal. This is bearable, but then you reach the best (and worst) thing in the picture: Erich von Stroheim as von Rauffenstein, commandant of the prison, and a flying ace who has been invalided into this depressing post.

The point of the story is that a bond exists between Boeldieu and von Rauffenstein that is more significant than the ties among Frenchmen: class works. I think Cabrera Infante is correct in saying this is a throwback to the Great War (so relevant to Renoir himself) but alien to the mood left by the next war and at odds with Renoir's deeper sense of human isolation (if we all have our reasons we are alone). Von Stroheim is superb, enchanting, and immaculate—pick your own label, but serve it with ham. He is not a mess, and Renoir's greatness lies there. But von Stroheim was a problem for Renoir:

We had an argument about the opening scene in the German living-quarters. He refused to understand why I had not brought some prostitutes of an obviously Viennese type in the scene. I was shattered. My intense admiration for the great man put me in an impossible position. It was partly because of my enthusiasm for his work that I was in the film-business at all. *Greed* was for me the banner of my profession. And now here he was, my idol, acting in

my film, and instead of the figure of truth that I had looked for I found a being steeped in childish clichés.

As they fought, Renoir wept and said he would give up directing the film! You see how devious this genuine man could be—he was a director. Of course, von Stroheim yielded and then "followed my instructions with a slavish docility." Maybe, but the film can never quite shrug off the noble sentimentality attached to Rauffenstein and his indefatigable resolve to be a tragic hero—or a drama queen.

La Règle du Jeu was not nominated for Best Picture—that is a more promising sign—but its aristocrat, Robert de la Chesnaye (played by Marcel Dalio, a prisoner in *La Grande Illusion*), is one of the greatest messes in film history. Better still, the film was a complete flop, released at a time of chronic uneasiness in France (July 1939), and only upsetting audiences the more.

This was not a literary adaptation, but an original, written by Renoir himself, with Carl Koch and Camille François (uncredited). Renoir hoped it would be "a good little orthodox film," not a big subject. He added that "It was a war film, and yet there is no reference to war." It's a fascinating distinction, and a reason why in July 1939 the picture unsettled audiences afraid of war. Just a few months later the outbreak of European war helped build the audience for *Gone With the Wind*—though that movie has more confidence in heroines and society than Renoir could muster.

Shot in the La Sologne area in a sunless late winter, *La Règle du Jeu* is a country house film. La Chesnaye and his wife, Christine, have invited a group of society friends to the country for the weekend. This includes his mistress, Geneviève, and a transatlantic flier, André Jurieu, who blurted out his love for Christine on the radio as he landed at Le Bourget. Another member of this extended family is Octave, everyone's friend yet an isolated and classless figure. He and Christine have known each other since childhood, and Octave is willing to be go-between and amateur ringmaster to the whole weekend. He is played by Renoir himself, limping a little in a shabby raincoat and the battered hat the director preferred. So he is a director on camera as well as off, and palpably the other actors enjoy this game and its theatricality. In addition, Renoir fell in love with his script girl, Dido Freire, so he had a reason for acting. She would become his second wife.

Octave has another side to his life. His shifting status takes him below stairs, too, into a romantic intrigue that matches that among the classy

people. The gamekeeper, Schumacher, has a wife, Lisette, who is Christine's maid. Lisette is a flirt, and her eye will fall upon Marceau, a local poacher and thus Schumacher's worst enemy. As the weekend rolls out, so the several romantic affairs and the two classes become tangled in what seems at first exhilarating farce, but which will end as bleak tragedy—but not before Octave and Christine have declared their love. In a Mozartian whirl of assumed costume and mistaken identity, one character is shot by another—I won't name them, for some of you will not have seen the film (and you must).

Every sort of spatial relationship—of foreground and background action, and of the depth of field that covers them all—is put to work. The film feels utterly spontaneous, but of course it is carefully contrived. It's just that liveliness conceals the care. (This is a key to the best cinema.) And the collision of comedy and mishap is like a real accident. This fatality is foretold in the famous shooting sequence when the house party goes out with their guns to build a funerary pile of birds and rabbits. This is shot and cut as if by Eisenstein, though I think its unexpectedness (in a Renoir film) is more painful than anything in Soviet film.

La Règle du Jeu is graver and funnier than *La Grande Illusion*. Together, the two films capture the mood of the late 1930s. But changing history is not a reasonable aim for movies. They should be content with helping us to see life. Some viewers jump to the conclusion that the shoot sequence in *La Règle du Jeu* is a plea against hunting and shooting (and eating meat?). I don't think that's the case. Rather, Renoir is intent to have us see how animals die (animals *were* hurt during this filming) and to show us how more or less decent people do it. Everyone has his reasons. The spoiled rich shoot pheasant and hare, and soon they will live in an occupied country (that fear surely existed), but they are not evil or fit to be condemned. They are foolish.

They are like Octave, who hardly know what he wants or how to get it, or like La Chesnaye, who needs boundaries but no fences, who hopes to keep a mistress and a wife. There are two great moments for the film's La Chesnaye, and for Dalio, who plays the part. This man (Jewish) collects elaborate moving-part toys (an unforced comment on film directing and its perilous distance from life). He has a new acquisition, an organ with dancing figures, and he offers it to his guests like a show. The mixture of pride and modesty is enchanting. But then, finally, after the other shooting, La Chesnaye appears at night on the steps of his château as another shattered impresario:

"Gentlemen, tomorrow we shall leave the chateau weeping for this wonderful friend, this excellent companion who knew so well how to make us forget that he was a famous man. And now, my dear friends . . . it is cold, you are running the risk of catching a chill and I suggest that you go inside. Tomorrow, we will pay our respects to our friend . . ."

The chill was real. War was only weeks away. In 1938, Renoir had said his film would be "an exact description of the bourgeois of our time. I want to show that every game has its rules. He who breaks them loses the game." But after the war, he realized, "I was deeply disturbed by the state of mind of French society and the world in general. It seemed to me that one way of interpreting that state of mind would be to avoid talking about it directly and tell a light-hearted story instead."

Of course, it's more than a lighthearted story, but comedy should be a very serious business. That balance was beyond French audiences in 1939. The film was attacked. Renoir cut it down from 113 minutes, but it made no difference. In 1940, with Dido, Renoir went to Rome at the encouragement of the French government to make a film of *Tosca* (with Michel Simon as Scarpia). He began it, but then Germany struck at Belgium and Holland. He left *Tosca* to be finished by Carl Koch, and hurried back to Paris. Just before the German invasion Renoir and Dido went to the South of France, and then to Tangier and Lisbon on the way to America.

No film he made there is without interest, but none is quite French or American—or truly Renoir. He was perplexed and then dismayed when some in France regarded him as a quitter after the war. Everyone has his reasons, though this is the moment to defend another fine French director, Marcel Carné, who made moody noir films in the late 1930s—*Quai des Brumes* (1938) and *Le Jour Se Lève* (1939)—who stayed in France (and was afterward mocked or attacked for being gay and some kind of collaborator), and who made *Les Enfants du Paradis* as the war ended. That sweeping period re-creation and tribute to French theater is still one of the most beloved of French films. It may owe as much to its screenwriter, Jacques Prévert, and to its cast (Arletty, Jean-Louis Barrault, Pierre Brasseur, Pierre Renoir, María Casares), but it is as much a landmark and a celebration of France as Olivier's *Henry V* was of England.

Renoir came back. He lived in France for part of the 1950s and he would make three subtle and profound films—*The River* (in India), *Le Carrosse d'Or* (with Anna Magnani), and *French Cancan*—in all of which

the balance of life and theater tilts toward the latter. These are early modernist films in which the filmmaker realizes he cannot make a movie without admitting it. The director is a presence in the work. In other words, realism, or narrative naturalism—his great goal for much of the 1930s—is a bit of a fraud. Thereafter, Renoir went to live in Los Angeles, in Benedict Canyon in Beverly Hills, on a property he planted with olive trees to remind him of the South of France. That's where he died, in 1979.

Orson Welles was born in Kenosha, Wisconsin, in 1915. He was the son of an inventor and a musician. Neither parent was exactly happy or a success, and neither of them lived after the boy was fifteen. Orson was a large, brilliant, precocious child such as other children hated. He had these parents and an older brother who was of disturbed mind. Richard Welles was ten years in an asylum. He died in 1975 in poverty. Apparently he and Orson had met just once since 1938.

It's hard to offer a diagnosis, but the flights of exhilaration and the slumps in Welles are suggestive. Was he bipolar? Is that relevant? It is if we are prepared to see in Welles one of the cinema's most heartfelt attempts to find lasting meaning and value. If we want to know whether the movies might be important, then Welles is central and tragic. For every complaint that *Citizen Kane* is chilly, mechanical, and show-offy (and it has those traits), it is crammed with unbearable feelings. These range from Bernstein's recollection of the girl he saw on the ferry one day and has never forgotten, to the mother's face as she gets ready to send her boy away, to the revelation that "Rosebud" stands for a lost childhood. It is always loss—from a man who seemed to others so richly endowed.

Welles drew with skill and flourish. He was an expert and devoted magician. He was a talker who rarely lost fluency or grammar; he could be a charmer alike to men and women; and he was one of those people in whom the lack of formal education led to a forbidding knowledge of nearly everything. But I'm not sure he believed in a lasting tie in his life. He turned friends into enemies and waited for betrayal. He was a stranger to his own children.

He was determined to be out of the ordinary. But one way to start with *Citizen Kane* is to treat it as a film like any other. In 1941 the Amer-

ican picture business released 379 films. That total has not been matched in any year since 1941, and it was surpassed only in 1937 and previously in the last years of the silent era—in 1927 more than 500 movies were released by the factory system. Of the 379 put out in 1941, 44 came from RKO. On the studio files, *Kane* was project 281, and when it was released, its MPPDA certificate was 6555.

You hear quite generally, still, that it was made on an unprecedented contract. That is relevant, but it exaggerates to claim that *Kane* was made with more liberty than any other American film. The contract between Welles and RKO (signed on August 21, 1939) called for several unusual freedoms. Welles and his associates were invited to make a film of their choice. Still, the subject had to be approved by the studio, and there was a budgetary limit to what could be spent ($500,000). With those approvals, Welles had the opportunity to do the picture as he liked, and he had final cut—the studio could not interfere with the finished film. In return, Welles would be paid $100,000 for writing, directing, producing, and acting in the picture, and he would receive 20 percent of the profits. In fact, it was a two-picture contract; on the second picture, he would be paid $125,000 and would receive 25 percent of the profits.

At the time, half a million dollars was not unduly generous: *Bringing Up Baby* (a relatively simple comedy) had cost over $1 million; *How Green Was My Valley* (which would beat *Kane* for Best Picture) cost $1.25 million; *Gunga Din* (made at R.K.O.) cost $1.9 million; *The Wizard of Oz* cost about $2.7 million. A regular A picture at RKO was reckoned to cost out at $800,000. In other words, George Schaefer, the executive who made the contract, had placed the Welles project at below-average cost and insisted on studio right of approval on the material—which was duly exercised. In view of all his tasks on the picture, Welles was hardly being greedy. But something often missed in Welles is that he seldom complained about or understood money. He was never quite a film star, but he was a celebrity and a boy wonder, and he was what the studio wanted, ready to deliver in every possible way for a modest salary.

So "carte blanche" does not adequately describe the contract, except in the way it departed from the norm in which a director was hired, given a script and a cast, and moved out before the editing. Granted Welles's talent as already displayed on the stage and on radio and in the October 1938 production of "The War of the Worlds" on CBS Radio (the sensation that prompted the contract), it seems a tribute to Schaefer's business acumen. Moreover, if the picture lost money on its first release—which it

did, though not excessively—think of what it has earned in the seventy years since. Beyond that, Schaefer behaved like a prince and a friend.

But now study real independence. When Chaplin made *The Great Dictator* (1940), he took his time and paid for it all with his own money, or money he could raise. (It cost about $2 million.) On *Gone With the Wind*, David O. Selznick allowed the venture to override his business sense and planning. What had been reckoned at first as a picture to be made for under $2 million turned into a $4.25 million expense. Selznick found that extra money as best he could, and he made a distribution deal with his father-in-law, Mr. Mayer, in return for Clark Gable and cash. He hired and fired writers and directors; he changed his mind every morning. In calling for reshoots, in enlarging the script and the running time, Selznick tolerated no discipline. Final cut was always going to be his, unless someone got to his throat first. Both he and Chaplin were rewarded: their pictures made enormous profits. But Hollywood in that era allowed for this much indulgence and gambling. It was possible to proceed in a resolutely unbusinesslike way—against that, Project 281 was under control and an intriguing bet. In 1939 you could have found people who reckoned Welles was more talented than Selznick.

In the event, Welles's first scheme, to do Joseph Conrad's *Heart of Darkness*, was set aside, despite a script and a good deal of preproduction work, just because the studio estimated that it might cost $1 million. There were other false starts (*The Smiler with a Knife* and *Mexican Melodrama*) before Welles and Herman Mankiewicz started working together in February 1940 on the idea of a picture based on the life of some notable American. It was to be a fictional figure, yet based on fact. After that decision, the writing moved ahead significantly, but not according to contract terms: Welles had the assistance of a Hollywood professional who was getting $500 a week.

Years later, in her lengthy essay "Raising Kane," Pauline Kael argued that Mankiewicz rescued Welles from uncertainty. The boy had not known what to do, he was being made fun of in the town that resented his special opportunity. So the old pro Mankiewicz had come to his aid. This was mischief on Kael's part, her urge to be different, and even an early desire to bring *Kane* to heel, to shake it from its pedestal as the "best film ever made." It was also the story fed to her by John Houseman.

In the heady New York days of the Mercury Theatre, when it had been doing theatre and radio, "Jack" Houseman was Welles's crucial lieutenant and heartfelt admirer. Houseman was the producer and manager

who smoothed the way so the genius could do what he wanted. A great affection prompted that alliance in which Houseman believed in Welles's unique talent and Welles counted on Jack as a forgiving manager. But in Hollywood, in the hiatus as they puzzled over a script, there had been a falling out between the two men at Chasen's restaurant. Then, as Mankiewicz began to work with Welles, and to fill the gap left by Houseman, it was agreed that Mankiewicz would retire to the Antelope Valley Inn in Victorville (in the desert northeast of Los Angeles) to do the work. Since he was inclined to drink, he would have a secretary, and Houseman went with them—to see that the work got done before the sun went down. Houseman agreed to do this last service for Orson—but he had an ulterior motive.

Welles's plan was to make a picture—it was to be called *American* at the outset—based on the idea of a great American press lord. The model of William Randolph Hearst (among others) had been talked about—and just as surely this connection had been withheld from RKO, for they would have shied away from anything as legally dangerous. But our understanding of the film depends on another connection. The most astonishing American in sight for Herman Mankiewicz was George Orson Welles himself, still only twenty-five in 1940 as he worked on the script, and so precocious, so arrogant, so charming, so able, and so infuriating that it was hard to look away from him. That is how Orson was loathed as much as he was revered, for he did not let his talents settle lightly. He bullied, he teased, he patronized, and he outdid everyone in sight in creating, bullshitting, talking, eating, and living up to the ominous warning "There but for the grace of God goes God."

Moreover, it had been determined in advance that Welles was to play Kane. So if Hearst was one point of reference, out of an adolescent playfulness bound to spell ruin, Orson Welles was the other. And there at the Antelope Inn, ready to steer or help Mankiewicz, was the man who knew Welles better than anyone alive, Jack Houseman. So Mankiewicz wrote a draft (with Houseman feeding him Orson lines and anecdotes), but only after he and Welles had talked, and only in advance of Welles rewriting the Mankiewicz draft with his own.

"Mankiewicz's contribution?" Welles returned the question Peter Bogdanovich had asked him. "It was enormous." He then goes on to give a full, plausible account of how they knocked the idea back and forth to its great advantage. Conclusion? Just as the credit claims, the two men wrote the script together, not always in the same room, but wrestling with the

same problems. Look for anything else like *Kane* in Mankiewicz's erratic career and you will not find it, whereas Welles would be obsessed with the same themes all his life.

More important still, the way Orson talked, breathed, laughed, and lost his temper energized the script. Kane became a great role because it had its essential actor. Nor should we exclude the likelihood that Welles guessed how Houseman would help add those touches—and counted on it. He wanted it to be about him. He knew no other way. Welles made one ugly mistake. At a key moment, he did seek to reduce Mankiewicz's credit, and that may have come out of a regret that he had not done it alone— there was a possessive megalomaniac in Welles (as there is in Kane). It is possible that, on his own, Welles would not have produced as intricate or subtle a script. But that is another way of pointing out how much *Citizen Kane* conformed with the collaborative nature of the factory film. Yes, it would prove to be a rare portrait of self-destructive willfulness in the American character, but it had needed two such misfits to get it clever and beautiful.

The film was shot in apparent bliss. A bond developed between Welles and Gregg Toland, the leading cameraman of the day, who had volunteered to be his teacher and guide. Welles was fulsome in his praise of Toland until the end of his life, and in the joint credit (on-screen together) that they shared at the close of the film: Orson Welles, direction and production; Gregg Toland, photography. As for the acting, almost entirely from beginners from the Mercury Company, it is human and chewy, like a parade of characters from Dickens. (In some ways it is a very nineteenth-century movie.) It is an immense contribution to the ranks of American character actors and the beginning for Joseph Cotten, Agnes Moorehead, Ray Collins, George Coulouris, Erskine Sanford, and Everett Sloane, not forgetting Welles himself, who would be a ham in his time but who fed upon Charles Foster Kane as if it were his last meal. Kael was right in one thing: Welles played the part with nothing less than proud radiance.

Kane was done with relished Germanic perfection, all the way through to the dense soundtrack, where you can hear breathing and a lot of spiffy radio tricks, as well as Bernard Herrmann's first score. The film was cut and it came out at 119 minutes for $680,000. RKO honored the overage.

As befitted a private or special film, Welles had shot on a closed set, but in a town that thrived on gossip, word got out soon enough that *Citizen Kane* might be an attack on William Randolph Hearst. Rightly so— whether or not you are tempted by the rumor, passed on adroitly by Gore

Vidal, that "Rosebud" was Hearst's private name for Marion Davies's clitoris. We are already at a point where Davies and Hearst (if they had press agents still) might be relying on this wicked film for the survival of their reputations. But Welles did not need to offend Hearst or anyone— beyond in the schoolboy way in which he felt compelled to be naughty or defiant. That is borne out within the movie when Kane dares Boss Jim Gettys to break the love-nest story, instead of biding his time for another election. Like a kid, he cannot muster the patience.

Something like a campaign sprang up in the picture business on behalf of Hearst, led by Louis B. Mayer (a gang leader by instinct and upbringing), to kill the film. I'm not sure how far this is to be believed, but the story goes that Mayer raised a fund among the various studios to pay off RKO's costs and have the negative destroyed. I don't think such a thing has ever happened in Hollywood, and it didn't happen in 1941, because George Schaefer would have nothing to do with it. As Welles admitted, Schaefer "was a hero—an absolute hero. He was marvelous with me." The boss had reason. RKO was screening the picture for Hollywood people and getting very favorable responses. But Welles was annoyed when Schaefer rejected the idea of showing *Kane* all over the country in tents with the ad "The film they tried to stop."

The Hearst press did what they could to oppose or ignore the film. Welles claimed that it never played in major theaters or chains. But it did open on May 1, 1941, and it was Orson Welles's final cut—no one has ever denied that. It is reckoned that in its first run it did about half a million in business. That was not enough, and those were not days when film companies took the long view of things. But in 1962, 1972, 1982, 1992, and 2002, a *Sight & Sound* poll of critics determined that it was the best film ever made. That is a vulgar label and one that groans the more with every passing decade. But just consider the number of times the film has been shown in classrooms and remember that Welles was up for 20 percent of the profits. In all the books on him, not one has been able to discover how far he benefited from that—and the contract did hold. That's what deterred Ted Turner from colorizing the film while Welles was still alive.

But the picture was well reviewed in newspapers and magazines that did get into print. *The Hollywood Reporter* said it was "a great motion picture." *Variety* even thought it was "a film possessing the sure dollar mark." Those were the trade papers for a business supposedly disapproving. In the *New York Times*, Bosley Crowther said, "It comes close to being the

most sensational film ever made in Hollywood." Howard Barnes in the *Herald Tribune* wrote, "not only a great picture; it is something of a revolutionary screen achievement." In the *New York Post*, Archer Winsten believed it would win "the majority of 1941's movie prizes." And in *PM*, Cecilia Ager said, "It's as if you never really saw a movie before."

These are some of the reviews as Pauline Kael listed them in "Raising Kane" in showing that the film was not reviled, or missed, even if it didn't leave Welles a rich man. He made that point to Peter Bogdanovich years later, but by then the ways in which Welles had resisted becoming a rich man were legion. The film was nominated for nine Oscars, and it won for its screenplay. When Welles died, in 1985, aged seventy, he was living alone in a small house in the Hollywood hills. But he was not quite alone, for he existed in acclaim and fondness, and his authority and position have only grown in the years since.

At its opening, *Citizen Kane* was not a sweeping commercial success—in company with so many of our best films. The antagonism of the Hearst media had something to do with that, though that legend has grown fat on not much. There were other reasons for what happened in the very delicate year of 1941. The film was difficult; it still is. It did not offer an easy, fluent arc such as audiences were trained to follow. It did not give you a figure to identify with or admire, because its mood and method are set on dismantling him, not building him. While the work of a young man full of vitality it seemed, the film comes out of the depth of despair and solitude, when very little in the American movie had suggested that that was where America wanted to be. *Kane* had gone awhile under the working title *American*, but no one then anticipated that that word could be a synonym for personal disaster.

•

What happened next to *Citizen Kane* was what happened to more or less every "old" film. For it was an age in which just about every movie had to be "new." Other pictures, the used ones, went away. RKO was a company that suffered several ownership changes, from Floyd Odlum to Howard Hughes to General Tire and Rubber to Desilu (Desi Arnaz and Lucille Ball, the actress who had once been an RKO contract player). It was only in 1957 that a despairing film company sold off a package of its old pictures, seven hundred in all, to television for $15 million. In those days, with the weekly attendance at theaters down to forty-one million (it had dropped nine million in just the previous year) and television penetration

at 79 percent of households (it had gone up 7 percent in the previous year), movie companies were still uncertain about the value of old films for TV. That RKO trade-away was for just over $20,000 a picture.

So in the 1940s and the early 1950s, *Citizen Kane* floated, against a background in which Orson Welles himself was peripatetic, fascinating, restless, but hardly a tidy genius. His second picture, *The Magnificent Ambersons*, had been butchered. A documentary project in South America, *It's All True*, came to nothing. He tried to do *Around the World in 80 Days* onstage. He did a cheap version of *Macbeth*. He married Rita Hayworth (his second wife) and put her in a fanciful, nasty noir, *The Lady from Shanghai*. He was working on a version of *Othello* in Europe. His most noticed thing was his acting turn as Harry Lime in *The Third Man*.

No one step in that crazy-paving progress was dull, but how did it add up? Or look like anything other than a fat man staggering around? Not everyone recollected *Kane* with warmth or in a way that urged newcomers to see it. James Agee, one of the better critics in America, said that Welles was "fatuously overrated as a genius." In 1952, Manny Farber wrote an essay for *Commentary* called "The Gimp," which focused on *Kane*'s malign influence. He called it "an exciting, but hammy picture." He gave a lot of credit for arrangements of space and light to Toland, but he found the film "marred by obvious items of shopworn inspiration: camera angles that had been thoroughly exploited by experimental films, and the platitudinous characterization of Kane as a lonely man who wanted love from the world but didn't get it because he had no love of his own to give."

As so often, Farber gave as he took away. He didn't like *Kane*, or Welles for that matter, but he had an intuition that "*Citizen Kane* seems to have festered in Hollywood's unconscious," and he made this brief but very compacted observation:

> But by now the lesson has been learned, and the ghost of *Citizen Kane* stalks a monstrous-looking screen. The entire physical structure of movies has been slowed down and simplified and brought closer to the front plane of the screen so that eccentric effects can be deeply felt. Hollywood has in effect developed a new medium which plays odd tricks with space and human behavior in order to project a content of popular "insights" beneath a meager surface.

Festering or ripening? It's a matter of taste, maybe. But the observation—that a younger generation of filmmakers had seen *Kane* and

been changed by it—is persuasive. In that sense, *Kane* is the link between German expressionism and American film noir, even if Welles would say that Toland taught him all he needed to know about moviemaking in a couple of days. Not that the mood of *Kane* is one that Toland had been developing. In fact, he loved sunlight and terrain—just look at *The Westerner* (1940) or *Wuthering Heights* (1939). He was Sam Goldwyn's chief photographer, so he shot what he was assigned to: Eddie Cantor in *Roman Scandals* (1933) and Peter Lorre in *Mad Love* (1935); *The Long Voyage Home* (1940) and *Ball of Fire* (1941); *Kane*, *The Grapes of Wrath* (1940), and *The Best Years of Our Lives* (1946). You can trace Toland's interest in deep focus, though the emotional tone of *Kane* and *Best Years of Our Lives* is the difference between fatalism and hope. There's only one film before *Kane*, John Ford's *The Long Voyage Home*, that looks anything like *Kane*—so long as you forget the look of the Mercury stage shows (*Caesar*, for instance), which we know Toland had seen and admired.

Toland died in 1948, without ever shooting an official film noir. But if you track the work of Stanley Cortez, the links are more suggestive. Cortez (brother of the actor Ricardo Cortez) had made very few films when Welles hired him to do his second film, *The Magnificent Ambersons* (1942). That picture is ostensibly a family drama, but its feeling for noir is undeniable. Welles didn't like Cortez as much as he had Toland (he said he was too slow), but Cortez would carry on a vision that is hardly equaled—he did *Since You Went Away* (1944), *Smash-Up* (1947), *Secret Beyond the Door* (1947), *The Night of the Hunter* (1955), *Shock Corridor* (1963), and *The Naked Kiss* (1964). This is a history of adventurous noir projects, even if few of the films seem to qualify thematically.

Noir meant an existential agony; not just the underworld as a metaphor for human fate, but a means of working very economically. It was spurred by the disillusion and anxiety that came with the end of the war. The next generation of young filmmakers was excited by *Kane*'s prescient mood and look, and intrigued by the personal melodrama of Orson himself. Was he a rejected genius, or a flash in the pan? Could Hollywood be reformed? Could directors command their films? People from Nicholas Ray to Elia Kazan lived on that hope. But what about Welles? Had he really, as it seemed by 1950, given up on America? Who did he think he was? God?

When *Sight & Sound* took its first poll, in 1952, *Citizen Kane* did not figure in the top ten. Then, in the 1950s, Welles came back with two films, *Mr. Arkadin* and *Touch of Evil*. Somehow he was still only in his early forties! *Arkadin* looked like a victim of money troubles. It was a sur-

real sketch on the edge of farce. But it was so plainly a remake of *Citizen Kane*, as if done in a rushed, partygoing weekend, tongue in cheek, and with a bravado mix of charm and cynicism. By contrast, *Touch of Evil* was far more finished and more respectful of reality. (Its Mexican-American border was a new place in American movies, rancid and risky—as time has proved.) It was lit up by virtuoso passages that no one could ignore or dismiss. It was funny, sexual, frightening, and rife with betrayals—if anyone cared for the idea of a ruined great man betrayed by a subordinate, it was there on-screen. Lo and behold, there was Welles using Marlene Dietrich (she had done a magic show with him in 1943 in Los Angeles) to warn him, and the world, that he was all washed up.

Something happened with Welles in that period. *Kane* began to be shown on television. It was not the same film there, of course; it was a report of itself. But people sat entranced by the film, amazed to think that the small box could deliver beauty! There were theatrical revivals. And his new films suggested that Welles had not given up, or turned into a sleeping boy wonder. At the Brussels World's Fair in 1958, *Touch of Evil* won the Grand Prix in the film contest, and then a panel of filmmakers voted on the best films of all time. The panel included young directors: Satyajit Ray, Robert Aldrich, and Alexander Mackendrick. *Battleship Potemkin* was voted number one, but *Citizen Kane* was in ninth place.

Though hardly anyone quite appreciated it at that moment, we were at the start of a great wave of enthusiasm for film that would sweep though colleges and universities. In part, this was prompted by the French New Wave, by the freedoms in their best films and the shift in film knowledge that came with the vindication of publications such as *Cahiers du Cinéma* and *Positif*. That French generation loved *Citizen Kane*. When François Truffaut made his movie about movie, *Day for Night*, in 1973, the director (played by Truffaut himself) had a recurring dream in which he is a boy out in the city at night. He comes to a cinema that is playing *Citizen Kane* and he uses his own cane to steal a still from it.

As film courses proliferated, *Citizen Kane* became a new standard in curricula. Books began to appear. Charles Higham's *The Films of Orson Welles* was published by the University of California Press in 1970 and it started a line of interpretation that said Welles was forever abandoning his own projects (just as Kane never finished Xanadu). In the same year, Pauline Kael's "Raising Kane" was published in *The New Yorker* and then in book form, with *Kane*'s first script and the cutting continuity. The ensuing controversy fueled film classes examining Welles. And not to be

forgotten, Welles had meanwhile delivered *The Trial* (1962), *Chimes at Midnight* (1965), *The Immortal Story* (1968), and *F for Fake* (1973). Here was a new age of Orson: a comic version of Kafka shot in the abandoned Gare d'Orsay; his finest piece of Shakespeare; an Isak Dinesen short story about the perils of trying to bring a story to life; and an essay on fraud, conjuring, and the myth of being Orson calculated to enrage enemies and delight admirers.

•

When Welles died, in 1985, there were infinite tributes to the man who had done so many things in just seventy years—without ever keeping a buck—and who had left unfinished films behind. *The Other Side of the Wind* is still not seen: it's about a movie director (played by John Huston). There were bootleg recordings of Orson hilarious as he made humiliating commercials for frozen peas, and there were anecdotes of him keeping dinner parties awake with all he knew of life. There were stories, too, of how, near the end, he would take lunch at Ma Maison in Los Angeles, ostentatiously ordering steamed fish to show the town he was in shape and ready for work. Then he would go home and have a big steak lunch, to feel better about himself.

Commentators have noted how *Kane* is a closed-room mystery: just as we alone hear the dying word *Rosebud*, so we are the only ones left at the end to see the name burn off the sled from Colorado. What does that make us? Charlie Kane's faithful? The ones who will not give him up? As a device and as a narrative ploy, it seems to suggest that the story feeds on itself. It serves as an automatic locking device. It is like the thing we note so often in great movies, the way the project makes its final comment or reference about film, not that larger thing called life. And surely it was Welles's way of saying, look, it's me, doing it all, giving us the question and the answer. In all that Pauline Kael wrote about the film—some of it casual, some acute—she said it was a masterpiece, but a shallow masterpiece. And as the film stays imprisoned in first place, I wonder whether that doesn't confirm something dazzling but shallow about the whole medium.

AMBERSONS

It was Welles's mistake on *Kane* that he did not trust simplicity, the confidence that lets feelings stand alone for a moment so they can sink in. As Gilbert Adair put it, he "overdirected his masterpieces." That is a reason to stress his second film, *The Magnificent Ambersons*. It comes from a novel by Booth Tarkington, published in 1918, a minor classic of the Midwest, and a Pulitzer Prize winner. It was reckoned in its day that the novel caught the times and established its people fairly, and it was a favorite book of Welles's father. The Mercury Theatre had done it on radio in October 1939, in a version Welles adapted and in which he played George Minafer himself. In that production, Walter Huston and his wife Nan Sunderland played Eugene Morgan, the automobile inventor, and Isabel Amberson, the woman he loves in vain because her son, George—arrogant, stupid, spoiled—stands in the way of another marriage.

Welles turned to *Ambersons* for the second film on his RKO contract. The studio did not seek to terminate this contract, though this time they did require the right to make changes to the director's cut. Welles accepted that amendment, though it may be judged that he did not pay proper attention to it.

A key decision on the picture was to have someone else, the young actor, Tim Holt, play George. Welles told Peter Bogdanovich that that was a great relief, allowing him to direct the picture with more ease and simplicity. Stanley Cortez was the cameraman, and if he was a little less inventive than Toland, he was more a master of mood. So whereas *Kane* seems to take place everywhere, *Ambersons* is the story of one house and one town. It is a calmer, sadder film in which the sequence style of cinema I've described with Renoir reaches one of its heights. The space in *Kane* is stretched and distorted, it is megalomaniacal, like a tyrant struggling to

be born, not die. But in *Ambersons* space is authentic and treasured; it is as if we have lived in this house along with its inhabitants. In the ball sequence, there are camera movements and extended takes among the most beguiling in cinema. They cleave to the marvelous illusion that we were there, that we *are* there—for the moment lasts. In the scene where George eats strawberry shortcake and Aunt Fanny goes quietly mad, there are no cuts or asides. Quite simply, we are asked to watch people passing time. This is the most humane aspect of what can be a hectic, jittery medium.

All of this is there to be seen still in the first seventy minutes of *The Magnificent Ambersons*. And if you were chilled by *Kane*, here is evidence that Welles had human understanding and a love of character in his heart. Moreover, the cast—Joseph Cotten, Ray Collins, Agnes Moorehead, Anne Baxter (very young), and Dolores Costello—are transforming. The film reaches the point where the fortunes of the Ambersons decline. We have the superb passage when George walks home in a changed mood and a harsher city, with Orson's foreboding voice on the soundtrack— whatever you feel about Welles, he spoke like a ruined angel. But then, really, the film curls up and dies.

Orson and his cast shot a lot more: what is now an 88-minute picture was intended to run 132 minutes. George and Fanny, so ill-suited, were to be left in the house, the last of the Ambersons, as it became a boarding-house. The magnificence of the Ambersons had been eroded by the grim twentieth century, just as their city suffered from the invention of the automobile. The ease and grace are gone—the material of a great social tragedy—to be replaced by a trite and abrupt happy ending.

The film was shot happily enough, and Welles began supervising the assembly and the editing. But then, on February 4, 1942, he left for Rio de Janeiro. He had to leave then, to be in time for the Carnival. He was going south on a mission put together by the U.S. government and RKO. But he was going on the vaguest of orders: to make some kind of movie to improve relations between the United States and South America in a time of war. The government was supporting the venture but not paying for it. The money was studio money.

Welles began to film Carnival, an open party in which he carried on numerous affairs with Latin women dancers; Welles had a thing about dancers. Meanwhile, in Los Angeles, the editor, Robert Wise, and Welles's manager, Jack Moss, did their best to supervise the final work on *Ambersons*. The film existed as Welles wanted it, in a version that was flown down to Rio for him to look at and refine. But then attitudes changed. RKO

concluded that it had lost money on *Kane*. It was a little weary of its own campaign on behalf of "genius," and studio spies pointed out that *Ambersons* was long, dark, and depressing. There was a preview of the film, with very mixed results, that prompted studio intervention in the editing.

Welles was aware of what was happening, and yet he was still filming Carnival stuff, no matter that the Carnival was over. He was warned, and he had no reason to take for granted the benevolence of the studio. People urged him to return, and he could have done so. But he stayed on, and soon enough the picture was taken out of Mercury's hands and redone by studio people. The result is the more painful in that for over an hour it is easy to see what a film *Ambersons* was going to be. The script for the cut material remains, and there are even some stills. I am not alone in thinking that if *Ambersons* had been released in Welles's version, it might now be recognized as the greatest film ever made—for this simple reason: it has a more direct emotional kick than *Kane* could ever claim, and one that registers on first viewing.

In 1942, as *Ambersons* opened (to failure), there were changes at RKO. George Schaefer was dismissed and replaced by Charles Koerner. He soon gave orders for all the cut footage from *Ambersons* to be destroyed. As far as is known, it was dumped off the Pacific shore. A hope persists that something might be found one day; sometimes pieces of old movie do come to light. One grail is that the version sent to Rio is still there, somewhere, in some attic or favela, waiting on film scholarship. It is one of the several legends of Orson Welles.

But we have to say that Welles could and should have given up Rio and gone back to Los Angeles to defend his own picture (if he believed in art, importance, and posterity). He might not have prevented the studio from butchering it, though Welles could be intimidating in person and he might have rallied support. At the least, he should have been in a position to save or steal a version of his cut for posterity. But he had such mixed feelings toward posterity.

He was his own worst enemy. He could get into fights where he should have known to back down. And perhaps he had a feeling that nothing mattered, nothing truly survived. This is the sensibility of *Kane*: accumulate your wealth and then bear witness as it is submitted to the furnaces. In the end, too, there is a reappraisal of meaning itself. The dying man says "Rosebud" and hopes his life will crystallize in eternity on that thread. But "Rosebud" is a gesture, a McGuffin, if you like, a trick the magician has for keeping our gaze off his hands.

So one film is "perfect" but self-enclosed. (Jorge Luis Borges called it

"a labyrinth with no center.") Another film promised to be richer but was destroyed. Is that sequence accidental, or is it part of the helpless authorship of Orson Welles? Is it his bitter, bleak insight into the punishing rewards for seeking art in an unkind business? Some old pros resented Welles's original contract because they felt it defied the immutable laws of all filmmaking: do as you're told, do it as a group, do it for the money, but do your best. Is it a commentary on the nature of film and America that the attempt has been hopeless? Such questions nag at the achievement, but we are left in his thrall: *Kane* and *Ambersons* together can break our heart; and Orson Welles is that uncanny and disconcerting mixture of genius and monster to be found in many great filmmakers.

HOWARD HAWKS: THE "SLIM" YEARS

Nancy Gross met Howard Hawks on August 30, 1938. She was twenty; he was forty-two. She was born in Salinas, California, *East of Eden* country, and her father owned several fish canneries in Monterey. She was a beautiful convent girl, but a spirit of adventure and a sports car took her to the Furnace Creek Inn, a classy resort in Death Valley, not far from the Nevada border. There she met movie stars—William Powell (he called her the "Slim Princess"), Warner Baxter, David Niven, Cary Grant. Next thing, she was invited to San Simeon, and became friendly with its owner, William Randolph Hearst, and with Marion Davies. (Hearst was seventy-five in 1938 and Marion was forty-one.)

Very soon, Slim was in Los Angeles, and on that August 30 she had been taken to the fights by two men, actor Bruce Cabot, the hero in *King Kong* ("seriously dumb," she said), and Cubby Broccoli ("truly intelligent"—he would make the Bond pictures one day). After the boxing they went to the Clover Club, the most fashionable gambling nightclub in town. She was dancing with Broccoli when a tall, gray-haired man, immaculately dressed, passed by. It was Howard Hawks, just a few months off *Bringing Up Baby* (a flop in its day). He was known as the "Silver Fox," and he was watching her. Watching, it would prove, was Howard's most loving attention.

He asked her to dance and then he gave her the usual line: So, she wanted to be in movies? "No," she said, and she meant it, though in the end she would affect Hawks's work more than any other woman. Hawks kept a little black book with the names and numbers of pretty women who *did* want to be in pictures, and he called on them sometimes. He asked Nancy to come up to his house for a swim the next day, and she accepted.

They were soon in love, and then he told her about Athole. Hawks had been married since 1928 to Athole Shearer, the sister of actress Norma

Shearer and of Douglas Shearer, the chief sound recordist at M-G-M. It was Athole's second marriage after a union with John Ward. They had had a son, Peter. But Athole was not always well. Norma would say that Athole had first been disturbed when so many Canadian guys they had known—they were from Montreal—were killed in the Great War. She was depressed. She took to her bed. She heard voices or ghosts.

Athole was very pretty. She appeared in a few films; she's at the dance in Griffith's *Way Down East*. It was in 1927 that Norma Shearer married Irving Thalberg. So Hawks had joined Hollywood society and the croquet set. His biographer Todd McCarthy is properly skeptical of any suggestion that Howard didn't know about Athole's condition. They had two children, Barbara and David, but by the time Howard met Slim, he told her his wife "was ill a great part of the time." What did "ill" mean, especially when California law forbade the divorcing of certified spouses? Athole's illness had not gone that far, but it is estimated now that she was bipolar.

You may feel this is more gossip than film commentary, but the way Howard Hawks looks at women, or fantasizes them into movie life, is at the heart of his work and of a larger yearning in movies. Athole Hawks lived until 1985, and spent much of her last years in institutions. It's clear she was disturbed some of the time (but not all of it), and a husband's infidelities can aggravate that. We know that Hawks had affairs in the 1930s—with actresses Ann Dvorak and Joan Crawford, say—and it's evident that he was in the habit of "discovering" young women as radiant as Frances Farmer.

Hawks gave us some of the most arresting women in American film— beautiful, smart, brave, "independent," it seems, yet ultimately obedient to the man's dream. In *His Girl Friday* (1940), Hildy Johnson (Rosalind Russell) is on the point of marrying someone else (a man resembling Ralph Bellamy), but her ex, Walter (Cary Grant), the rascal newspaper editor, will win her back. These women are often loners—like Marie "Slim" Browning (Lauren Bacall) in *To Have and Have Not* (1944), who contrives somehow to be alone on Martinique in the middle of war, under the guise of an actress no more than nineteen. This "Slim" is a million miles from Hemingway's Marie in the novel, and famously Hawks warned Humphrey Bogart that Bacall would outdo him in insolence. Well, yes, if it's cross-talk foreplay you're interested in (and Hawks was wild for it), but the girl's independence dwindles away until she's ready to soft-shoe dance out of Frenchy's place and go with her Harry into the new dawn.

To Have and Have Not comes on sultry tough, and we all know the film's lines, with Bacall holding up a doorway in case it faints. It's a film

with marlin fishing, gunfire at sea, and taking risks with Vichy cops (especially the creepy Dan Seymour). But the film is as complete and serene a fantasy as anything Fred Astaire ever made, and it does keep edging toward a musical, led by the droll piano player Cricket (Hoagy Carmichael). Bacall for a moment had the reputation of a slinky noir girl with an acid tongue. Wouldn't it be pretty to think so?

This is the central film of the Slim years. There is by now an unshakable legend that, one day at home, Slim saw a picture of Betty Joan Perske in *Harper's Bazaar*—of a fashionably dressed young woman outside a blood bank, with the look of a vampire—and tossed the magazine over to Howard. Maybe as the magazine was in midair the wife had second thoughts. Did she guess that Howard might take a fancy to his discovery?

The film was under way from that moment, and the machinery of Hollywood's dream surged into high gear. Betty Perske was located. She was put under a personal service contract to Howard Hawks and taught to lower her deep voice. (She wondered if her Jewishness would be overlooked by the Hawks couple.) As a script developed, with Jules Furthman not bothering to keep a word of Hemingway, the man in the film would call the girl "Slim" and she would call him "Steve." These were the pet names Howard and Nancy had for each other. Hawks started to ask Slim what she'd say in certain situations. Furthman admitted he took some of the lines from Slim's lips—such as the whistling stuff. In Martinique, "Slim" ended up wearing a beautifully cut houndstooth suit exactly like ones Slim Hawks favored.

A rare game was being played, good enough for a Hawks comedy, in which a director is ready to fall for his actress but keeps his wife around to pretend it isn't so. When Bacall and Bogie fell in love, Howard was taken aback. (Bogart was forty-five; Bacall was twenty.) The director said their romance was spoiling the picture. Bacall burst into tears, and Slim asked, "But what do you do, Howard, if you're stuck on a guy? How do you handle it?"

Slim knew that difficulty. She had been torn over living with Hawks in 1938–39 and handling the awkward matter of Athole. But she went along with the compromise. She found Hawks not just sophisticated and dry but a complicated man who tried to make everything as smooth as his camera style. Slim began to see what directing called for:

If anything, he was slightly frightened of movie making, and I suspect, surprised that he was able to do it at all. He used to tell me that on the first day of shooting a new picture he would stop the

car, get out, and throw up a couple of times on his way to the stu-
dio. That process would go on for about a week until he got into
the rhythm of the work and the movie started rolling along . . . He
just made movies. Although his talent lay in being able to tell a
story, it always seemed to me that he told the same one over and
over. The characters never had any intellectual reactions, only emo-
tional ones. This always puzzled me because as a person, Howard's
emotional thermometer was stuck at about six degrees below 98.6.
He was frozen there. He did not take emotion into any part of his
existence; neither through his children, his wife, nor, I think, his
work.

Now, that *is* film commentary. Nancy and Howard had a daughter,
Kitty Steven, born in February 1946. Hawks had more affairs—Slim
named Dolores Moran (the Free French wife Hélène de Bursac in *To Have
and Have Not*, the woman "Slim" would like to anaesthetize). Then there
was Ella Raines, who is in *Corvette K-225*. But Slim was restless, too. She
and Ernest Hemingway noticed each other, and a crucial affair started in
1946 with the agent Leland Hayward, though not before Hayward had
brought his new client, Montgomery Clift, over to see Hawks about play-
ing Matthew Garth in *Red River*. Clift was wary of doing a Western, so
Slim took him for a walk in the garden. He told her he couldn't ride a
horse, wear a six-gun, or walk in big boots. She said Howard and John
Wayne would teach him those things—the task eventually fell to a wran-
gler named Richard Farnsworth. When they came in from the garden,
Clift said, sure, he would do it. The shoot took off for Arizona, but Slim
went with Hayward.

So Slim's years stretch from Cary Grant teasing Jean Arthur in *Only
Angels Have Wings* (1939) to Joanne Dru starting off with Clift by slapping
his face. And in the middle there is the timeless screwball bickering of
Bogart and Bacall, perhaps the sexiest talk in an American movie to this
day. Howard Hawks could do a two-shot of a man and a woman, with her
rubbing her knee (call it her lower thigh) and him telling her to scratch,
that any halfway-sane censor would have stopped. And Slim presided over
such relationships and scenes, though she saw the colder side of Hawks
that was hidden on-screen. She also realized why he had been at the Clo-
ver Club that night: he was a chronic gambler; no one knows the inside
story of Hollywood without understanding the gambling.

She wrote a book, *Slim: Memories of a Rich and Imperfect Life*, with
Annette Tapert (published in 1990, the year she died), and it includes this:

I don't know which was more unpleasant, Howard's gambling or
his infidelity . . . Beneath that jaunty exterior, I think there was a
great deal of sexual confusion and insecurity within Howard. When
I look at the role of sex in his films and compare it with his life, it's
very interesting. The love scenes in the movies are invariably the
same. There's a terrible fight, the woman insults the man, he in-
sults her back, she insults him again, and then suddenly they're in
each other's arms and slashing round in the hay. This scenario
was, I think, a way for Howard to put sex on the screen that didn't
make him want to gag. In his own life, he had a very tough time
with tenderness or sentimentality. Even at the height of our court-
ship he was a tentative partner. Sex was simply a physical need that
had no relation to the person he was with.

Red River was to have been the making of them, an independent ven-
ture on which they might secure their fortune. In the Slim years, Hawks
had prospered. With hit after hit, his salary rose, and *Red River* was his
own production, one on which he planned to clean up. But the expenses
on the picture got out of hand, and then Slim left him for Leland Hay-
ward. Hawks's salary was deferred against profits on the film, and they
weren't declared for a few years. The divorce was a long, drawn-out finan-
cial quarrel, in which Hawks resisted paying child support for Kitty.
As Todd McCarthy puts it:

Hawks's behavior in relation to Slim and Kitty is hard to fathom,
although it certainly stemmed from some combination of arrogant
stubbornness, a conviction that he needn't pay since Leland Hay-
ward and Slim had far more money than he did, a lack of liquid
cash, and a lingering resentment of Slim for having left him. Rela-
tions between the two were strained when they existed at all, and
Hawks undoubtedly knew that Slim bad-mouthed him to her
show-business and society friends. Slim remained very close with
Bacall, Bogart and Hemingway, whereas Hawks did not.

Bogart and Bacall knew how much Hawks had gone after the young
Betty. Hemingway could not forget that his most political novel had been
turned into an airy fantasy. There was a time when impressionable film
critics stressed how Howard Hawks flew planes and drove fast cars, how
he made films about men doing a dangerous job with laconic profession-
alism. There was a weird suggestion of realism. Whereas he reenacted a

dream, with hardboiled dialogue and allegedly blunt confrontations. "Laconic" was like "italic." He made absurdist, floating comedies—The Discreet Charm of the Cowboys, with the herd never reaching a railhead?—in which men pretended to be strong and the women challenged them and then subsided. It's like in *Rio Bravo* (1959), when Angie Dickinson tells John Wayne not to mess with her life with his preconceived notions, talks him into a heap of wet laundry, but ends up guarding his door and wearing tights for him.

By the time I met Slim she was no longer slim but she was great fun and a storyteller, who gave not the least hint she was dying. I got to meet her by submitting an essay on *Red River*. It was a serious, heartfelt piece, written for *Sight & Sound*, in 1977, though it did see that the strenuous cattle drive was usually the same valley shot from different angles. Slim thought Howard would have liked the piece; he admired admirers. She was fond of him again by then, I think, though he was dead. Then, gently, she tried to explain the kind of man Hawks was: talented, cold, a fantasist, a gambler. That is film commentary, and an insight into how American films functioned once upon a time. I doubt Hawks liked being laughed at in life, but he was a poker-faced comedian who dreamed the same dream over and over again—in which a man and a woman play word games and then decide they are in love. Until the next picture. The reason Walter has lost Hildy in *His Girl Friday*, a paragon of talking pictures, but too fast for audiences today, is to permit the adventure of winning her back again.

•

As we grow older, we watch the old movies over and over again. But it's asking too much to expect them to remain the same. Frame by frame, except for natural deterioration, they are the old films; but *our* deterioration is likely greater, and more concerned with understanding. The first time I saw *The Big Sleep*, at a Howard Hawks retrospective at the London National Film Theatre in 1963, I watched it three times in a row. I wanted to repeat the pleasure and the marvel as quickly as possible, and every screening showed something I hadn't seen, or noticed, before.

I loved Hawks once, and I am fond of him still. But whereas once I was an unquestioning kid diving into his fantasy, by now I cannot help but recognize the fantasist in the man and wonder at the damage it did to him, and to me. He romances romance—yet Slim said that in life he was cold and hurried. He womanizes the women, of course (just recall how

many pretty and ready passing women there are in *The Big Sleep*). But he "womanizes," or dreams up, violence, action, cars, clothes, flying, doing anything well, having fun, whatever you want to call it. In that sense, "womanizing" means realizing a dream on screen, trying to exist in that flat brightness. It's an impossible venture, but it is a legacy of American film—the gift of unreality. "Womanizing" is so much more addicted to imaginary beings than it is to real women.

Hawks went so close to the line sometimes, we wonder if he saw or understood it. Amid the delirious chatter of *His Girl Friday* (1940), Walter Burns (Cary Grant) sweeps the European war and Hitler off the front page of his newspaper to make way for the Earl Williams melodrama (though he holds on to the rooster story because that's human interest). In the same way, Mollie Malloy (Helen Mack) goes out of the window—and out of the picture. The furious game being played by Walter and Hildy (Rosalind Russell) obscures every object of pity. Then, in 1944, with war at its climax, Hawks made a fabulous film, *To Have and Have Not*, which is a travesty of the Hemingway novel. The Marie on screen—nineteen, Lauren Bacall, insolent yet pliant—is such a hottie, while the Marie in the novel is human and battered, humane and ordinary. For good and ill, Hawks defied the ordinary and celebrated "fun."

FILMS WERE STARTED

It would be said of British cinema that it was nothing until a band of Hungarians took it over. There was certainly a sheepish mood in Britain, disarmed equally by the way American films reached out for fantasy and wide open spaces without an atom of modesty, and then drove their business ahead in the home country as if there were no such thing as showmanship in Britain. Of course, the British were victims twice over in that American pictures seemed to use their own language, and then bastardized it with abandon. The author can recall a distinct, grieving disapproval in the parental class at the way American movies encouraged fanciful notions of glory and casual attitudes toward grammar and slang. My devoutly agnostic parents, who would not have dreamed of going to church themselves on a Sunday, still regarded Sunday moviegoing as improper.

More than forty years earlier, when Victoria was queen, young Alfred Hitchcock was raised in another part of London as a Catholic, and that may help explain his rapt feeling for the illicit glance, and the way peeping or spying might subvert morality and the social order. That's how, after all the solemn explaining, the mother's skull in Norman Bates is left smiling at us as the car in *Psycho* (1960) is hauled back from the swamp. In the real age of movies, there always was a battle between decorum and depravity, dutiful devoutness and dreams of disorder. Is that why Norman feels more plausible as a suburban Englishman than a Californian?

This is not just nostalgic meandering. There was an English skepticism that reckoned it was "silly" to look like Errol Flynn or Hedy Lamarr, in that the automatic movie equation between being good and good-looking was so obviously flawed and ready to make suckers of us all. The British press was especially fond of Flynn because his shortcomings were so evident. That was held to be a disqualification of the movies as "true"

dramas, in that the pictures were based on fraudulence and foolishness. In turn, this was another way of discovering how fully Americans did believe in the dream and the equation of looks with character. Once upon a time, that was part of the world's amused and half-forgiving awareness that America never quite grows up.

So British film was impeded—still is?—by a certain shamefaced squirming over fantasy and daydreaming? Does that seem plausible in the land that made Shakespeare, Dickens, and Hardy, not to mention Chaplin, Cary Grant, and James Mason? Yes, I think it may, for the imaginative leap with literature is earnest, respectable, and enlarging in Britain. Think of the stern arbiter of England's great tradition, F. R. Leavis, on those authors—and then imagine the attempt to take Leavis to see a Hitchcock film. Remember Virginia Woolf's disdain for cinema.

As for the country's ability to produce actors or stars who can beguile millions, my failure to add actresses to that short list is telling. The British man—handsome, eloquent, mysterious—can be a dream figure (and dreamy). But somehow the women are raised to lack that confidence, to laugh at themselves. Deborah Kerr had close-ups for Powell and Pressburger that could stop you in your tracks. But, later on, Jean Simmons did not much like herself in *Angel Face* (1952), her most iconic and erotic film. Vivien Leigh may be the closest to an exception—but the British opinion is that Leigh went mad, whereas her counterpart for years, Laurence Olivier, was a contented (if not smug) chameleon, a man whose attractiveness rested in his quick-change versatility.

I can think of other small examples that help build the idea of a wall against movies in Britain. Graham Greene recalled his own father, a schoolmaster, who encouraged boys to see Tarzan films until he realized they were anthropologically worthless. Then there is Greene himself, a terrific film fan, a good critic, and a serious screenwriter—and a true friend to the producer Alexander Korda—but someone suspicious of Hollywood's flimsy and frivolous escapism. Indeed, Greene was a man and an author suspicious about any idea of escaping—but then in life he turned out to be something of a fraud, a liar, and a hidden force. To take the matter to its ultimate level, in Britain Alfred Hitchcock was often teased away from full immersion in his own dream, so his pictures from the 1930s are deft, playful, knowing, ironic, and rather superior. But then he goes to Hollywood, embraces the technical sophistication and the habit of swimming in the dream, and makes pictures that are increasingly his own, truer to himself, naked and painful. Even the French, constitutionally

opposed to the thought of Anglo-Saxon cinema, have to admit that there is Hitchcock, who also became more comically English the longer he lived in America.

There had been pioneer figures in Britain, and by the 1930s there were British film stars, local heroes and heroines who seldom carried overseas—Jessie Matthews, George Formby, Will Hay, Gracie Fields, Leslie Banks. But the British had had no luck at putting together a native industry. There wasn't the funding; so American operations took over London. When Alfred Hitchcock first found movie employment, in 1920, it was as a graphic artist with the Famous Players–Lasky offices just opened. Filmgoing was very popular—there were said to be four hundred cinemas in London alone—but American pictures dominated the market and would lead to government action to ensure a minimal number of "quota quickie" English films. It was on those, in the early 1930s, that Michael Powell got a start.

Hollywood had another power, that of enticing British talent to California. That became even stronger after the coming of sound, but the list of British performers who went to America begins with Chaplin and Stan Laurel, and it includes Donald Crisp, Rex Ingram (Irish), Edmund Goulding, Clive Brook, Herbert Marshall, Ronald Colman, Frank Lloyd, Boris Karloff, Leslie Howard, Charles Laughton, Robert Donat, and Cary Grant.

Of those names, Laughton's is the most significant in that he played the lead in Alexander Korda's *The Private Life of Henry VIII* (1933), the film that, in Korda's view, introduced the idea of a worthwhile British film industry. The role of the king promoted Laughton to American stardom: *Mutiny on the Bounty* (1935), *Les Misérables* (1935), and *The Hunchback of Notre Dame* (1939).

•

Alexander Korda was born in Hungary in 1893, and we need not doubt his view of himself, even if he had a habit of ignoring competitors and copying Hollywood styles in a way that was counterproductive for Britain. Korda deserves his place on charm alone. He became a writer-director in Hungary and Berlin in the 1920s, and not a bad director. He discovered and married an actress, María Antonia Farkas, changed her name to María Corda, and then took her to Hollywood. When they divorced, Alex elected to try England, and English history.

He developed, or stole from Lubitsch, the trick of doing backstair views of upper-class life, and he determined that a candid, funny treatment

of Henry VIII might prove both royalist and modern. He had the wit to cast Laughton in the central role, with Robert Donat in support, and it suited his nature to have six different love stories to pursue. The wives included Binnie Barnes, Wendy Barrie, Elsa Lanchester (Mrs. Laughton), and Merle Oberon, who would become the second Mrs. Korda. The film was a big success everywhere, by which I mean that it was that rarity, a British film that cleaned up in America, and won Laughton the Best Actor Oscar. It wasn't a great film, and far from reliable history, but it was a satisfying and novel entertainment, and you may say that Korda had stumbled upon an essential ingredient of British television in years to come. Moreover, using his brother Vincent as production designer, Alex took great care of the sets and believed in putting a lot of money up on the screen.

What happened next is more fitting as a story than an account of real events. Korda took a liking to Englishness, and seeing a land full of great homes and tall stories, he went off in search of money. As elsewhere, these were the years of the Depression, but Korda persuaded Prudential, the country's most esteemed insurance company, to put up £1 million for picture production. He built a studio, at Denham, and in time he won even more money from Prudential.

All of which is tribute to a man of good humor and generous cunning. In the book *Charmed Lives*, Alex's nephew Michael, a champion publisher, with many of his uncle's qualities, tells a fine story. It is years later, Prudential is justifiably worried about its money. They call a meeting and are prepared to grill Alex. But he grills himself! He goes into a lavish, dramatic account of the perils of movie production in general, and of his own recent career. It is so funny, so compelling, and so involving that by the end of the meeting the directors of the Prudential are begging Korda to stay on and fight another day. Korda was not as handsome as his other brother, Zoltan. But he dressed beautifully, favored Rolls-Royces, an office on Piccadilly, and the finest cigars. He was always acting on his own advice, devised in his Hollywood years: arrive in town, stay at the best hotel, be seen with the most beautiful women, charge everything but tip lavishly—and wait for offers.

Alas, Korda did not have another hit like *Henry VIII* for years. But he made intriguing romantic pictures, often in Technicolor, and you can hear him pitching every one and wanting to be part of it. With Korda as director or producer, there was *The Private Life of Don Juan* (1934; with an aging Doug Fairbanks); Laughton in *Rembrandt* (1936; a very touching

picture); *Knight Without Armour* (1937; with Dietrich and Donat—one of her most relaxed movies, where she is plainly naked in her bath scene); Sabu in *Elephant Boy* (1936); and a host of others. There was even the attempt to film Robert Graves's *I, Claudius*, with Laughton and Josef von Sternberg, the actor's neuroses grinding against the director's aloofness, until the ordeal was mercifully concluded by Merle Oberon's car accident. And don't forget *The Four Feathers* or *The Thief of Baghdad*.

Above all, there was Korda himself, the fabled presence of the man, his knighthood in 1942, his cheerful strip-mining of "English history," and his flagrant disdain for English shyness. There were other ways to go, and one of them belonged to Michael Balcon.

•

Michael Powell, for one, found Balcon "very conventional, very suburban." He was not even a Londoner—born in Birmingham in 1896, he worked in the jewelry and rubber businesses before movies got his attention. In the early 1920s he set up a production company with Victor Saville and John Freedman. They formed Gainsborough Pictures (with a Gainsborough portrait of a woman as their logo), and they bought the Islington studio when Paramount tired of it. Among other things, Balcon made pictures with Hitchcock—*The Pleasure Garden* (1925), *The Lodger* (1927), and *Easy Virtue* (1928). He then made a deal to produce pictures for Gaumont-British, working at Islington and Shepherd's Bush, and that series included more Hitchcock: *The Man Who Knew Too Much* (1934), *The 39 Steps* (1935), *Secret Agent* (1936), and *Sabotage* (1936).

These days, it is critical habit to assume that Hitchcock was always solitary and driven, but examination of the times suggests that Balcon understood Hitch and stimulated him. Balcon trusted only modest budgets and simple, suspenseful stories, but he is the producer who let Hitchcock rewrite John Buchan's *The Thirty-nine Steps*, introducing female characters and a kind of voyeurism that still seems saucy. We don't have to adhere to the old English orthodoxy (that Hitch was at his best in Britain). But neither is there any reason to miss how these pert, shapely comedy-thrillers developed the director's prowess and his feeling for wickedness. Balcon saw that and admired it, whereas Korda could easily have dismissed Hitch the greengrocer's son as hopelessly East End and lower class.

Balcon attracted attention in Culver City and so briefly he was put in charge of M-G-M's London operation (*A Yank at Oxford*, 1938, and even *Goodbye, Mr. Chips*). That's the only reason his name is missing from *The*

Lady Vanishes. Still, it took Balcon less than a year to feel the oppressive hand of Louis B. Mayer, and in 1938 he quit Metro and took over the Ealing studio.

Korda and Churchill had been social acquaintances through much of the 1930s—they had the same tastes and a similar sense of cinema. Korda had gone so far as to buy the rights to Churchill's book about the Duke of Marlborough, as a way of cementing friendship. He never made that film, though decades later the BBC would do it as a very successful miniseries. Then, in the awkward interval between Churchill's becoming prime minister and America's entry into the war, Korda yielded to Churchill's pleas for a truly patriotic picture that might help erase isolationist feelings in America.

So Korda set up an American office (to make a film about Lord Nelson, and to serve as a cover for some secret service operations that kept an eye on Nazi movements in the United States as well as sentiments in Washington). This gentlemanly espionage was for real, but it appealed to the boys in Winston and Alex—it may also be felt as a harbinger of the British playfulness that would dream up James Bond.

Nelson was the subject, but Korda insisted on a love story to humanize the hero, so the picture became *That Hamilton Woman*, which also took advantage of the stranded status of Olivier and Leigh in Hollywood. There is a strong likelihood that, amid the passion that united these famous lovers, Korda himself had moments with Vivien Leigh and moments enough to discover that the celebrated lovers (Viv and Larry) nursed a serious competitive gulf. Scarlett O'Hara had swept Vivien past Larry—and he had little appreciation for such things. Whatever, *That Hamilton Woman*, with airy sets (by Vincent Korda), rich costumes, and model ships for Trafalgar, was shot in six weeks at the General Services Studio in Los Angeles, with Alex directing personally. Olivier looked like a ghost; he had so many Nelsonian wounds to accommodate, and research was never quite sure which arm or which eye the great man had lost. Churchill himself wrote one or two key speeches, and the picture was a hit on both sides of the Atlantic. Some in Washington were suspicious of Korda's game, and he had been subpoenaed to appear before a Senate committee on December 12, 1941. Five days ahead of that deadline, the Japanese struck Pearl Harbor and he was excused. Thus the knighthood for a resourceful and brave Hungarian who took Britishness so seriously.

Meanwhile, at Ealing, Michael Balcon pursued a very different course. He saw that the war itself was filled with dramatic potential, and he

trusted that a documentary-like approach would be in order. To that end, he was impressed by the work done in Britain in the 1930s by several government agencies inspired to make documentary films.

The driving force behind this work was John Grierson, born in Deanstown, Scotland, in 1898. (Another Scot, John Reith, would play a similar role in the foundation of the BBC and in the formulation of its duties.) Grierson attended the University of Glasgow and then went on a Rockefeller fellowship to the University of Chicago. On his return, he joined the film unit of the Empire Marketing Board and directed and produced a fifty-minute documentary, *Drifters* (1929), about the fishing industry. In 1933 he moved over to the GPO Film Unit, which in time became the Crown Film Unit.

Grierson was less a filmmaker than a preacher, a leader, and a managerial inspiration. He was also part of a British movement in the 1930s, leftist in sentiment, that believed in the precise factual observation of society. This led to the magazine *Picture Post* and to a sociological study known as Mass Observation. In the process, Grierson attracted a number of considerable talents, including the Brazilian Alberto Cavalcanti and filmmakers such as Harry Watt and Basil Wright.

The British documentary that evolved under Grierson could be sharply critical of society, but it had an educational thrust to let the citizen know how his country worked. (Of course, that depended on the shaky premise that the filmmakers knew the answers.) A key film made in this spirit was *Night Mail* (1936), produced by Grierson, directed and produced by Harry Watt and Basil Wright, with music by Benjamin Britten and a verse commentary by W. H. Auden, and sound supervision by Cavalcanti. The whole thing was just twenty-five minutes, and it was innocently admiring of the Post Office, but to this day it is a touching demonstration of the idea that movie could be a collaboration of all the arts in which the nation might commune with itself.

Grierson left for Canada before the war broke out (and he would prove a key figure on the Canadian Film Board), but at Ealing, Balcon snapped up Cavalcanti and Harry Watt and began to apply the lessons of documentary to the war effort. A real piece of heroism was recalled: a factory foreman had retrieved important machinery parts as the Germans invaded France. J. B. Priestley made a script of it, and Charles Frend directed *The Foreman Went to France* (1942), with actors in all the parts. Harry Watt was sent to a sand dune beach in South Wales to make *Nine Men* (1943), ostensibly about the North African desert war. With a script

by Graham Greene, Cavalcanti made *Went the Day Well?*, a film about an English village taken over by German invasion. And Charles Frend made *San Demetrio London* (1943), on the travails of Atlantic convoys. At the same time, Ealing was making very broad Will Hay comedies, such as *The Black Sheep of Whitehall* (1942) and *The Goose Steps Out* (1942). (In the latter, Hay impersonates a Nazi officer and addresses Germans on how to behave in Britain.) There was also Basil Dearden's *The Bells Go Down* (1943), a dramatization of the work of the London Fire Brigade during the Blitz.

The Bells Go Down used actors such as Tommy Trinder, Finlay Currie, and James Mason, but it had the misfortune of opening at the same time as *Fires Were Started*, a feature-length documentary made by the Crown Film Unit and directed by Humphrey Jennings.

•

Jennings was born in Suffolk in 1907 and educated at Cambridge. He was an intellectual, a part of Mass Observation, and the part-time compiler of *Pandemonium*, an immense anthology of Englishness. By all rights and qualification, he should have been a don at Cambridge, but he was interested in visual art (he was a surrealist by taste) and thus was drawn into documentary films. He was very productive in the war years, when his best works are *Listen to Britain* (1942), a montage of British scenes driven by sound; *Fires Were Started*; and *A Diary for Timothy* (1944–45), a kind of open letter to a baby born as the war ends, written by E. M. Forster and spoken by Michael Redgrave, with music by Richard Addinsell.

Jennings seemed lost after the war, and he died in 1950 in Greece, in a climbing accident. But he remains a British hero, and a man who could make *Fires Were Started* like a painter in his studio, with not a reference to the enemy. Moreover, *A Diary for Timothy* makes it clear that Jennings knew that victory in the war was a prelude to more intractable social problems. Had he been American, his work might have been banned, as he was marked down as un-American. In Britain, however, the feeling endures that Jennings was close to the national endeavor and a filmmaker touched by genius.

His career is a reminder of the difficulties Michael Powell and Emeric Pressburger overcame at the same time in their film *The Life and Death of Colonel Blimp* (1943). Powell had worked steadily through the 1930s, but seldom with the means to demonstrate his florid visual sense. But in 1937

his *The Edge of the World* impressed Alexander Korda, who introduced Powell to Pressburger, one of his many Hungarian hirings. The two men were very different, but that seemed to encourage them. Pressburger was the writer, Powell the director. They combined for the first time on *The Spy in Black* (1939), starring Conrad Veidt, and within a few years they had formed a company, the Archers. *Colonel Blimp* was their second film under this logo.

It was highly ambitious and daring: it was cut first at 163 minutes and was in Technicolor—the sets by Alfred Junge (who had worked for Balcon), the camerawork by Georges Périnal, who had worked with René Clair in the early 1930s and who had later shot *The Private Life of Henry VIII* and *Rembrandt*. The scale of *Blimp* was risky under wartime conditions, but the real problem in the film—and it would trouble Churchill himself—was that the story was a tribute to a lasting friendship between an Englishman, Clive Candy (Roger Livesey), and a German, Theo Kretschmar-Schuldorff (Anton Walbrook). In addition, by taking on the name Blimp—a figure in cartoons by David Low meant to ridicule idiocy in the British officer class—the Archers risked offending the army and the War Office. Churchill himself asked his aides for ways "To stop this foolish production before it gets any further. I am not prepared to allow propaganda detrimental to the morale of the Army."

Of course, we know now that *Blimp* is the first great film made by the Archers, and we know that it is as sympathetic toward the foolish Candy as it is to several redheaded women all played by the young Deborah Kerr. But in a history, it deserves its place for extra reasons—chiefly that it was made and shown despite official alarm. By 1943, I doubt any such picture could have come from the other major participants in the war. Late in the film, the aging Theo gives a long, hesitant speech about what has happened in Germany between 1919 and 1939 that is so absorbing we hardly realize how unexpected it would have been at the time. It is a scene that establishes Anton Walbrook as a great actor.

Powell and Pressburger had become a dynamic team in a way that neither of them would ever quite manage on his own. And as the war closed, they moved into their glory years, working for the Rank Organisation or for Korda. Their list is famous now: *A Canterbury Tale*, (1944), *I Know Where I'm Going*, (1945), *A Matter of Life and Death* (1946), *Black Narcissus* (1947), *The Red Shoes* (1948), and *The Small Back Room* (1949). Yes, *The Red Shoes* is the most famous—also the most beautiful and the one most devoted to artistic creation (Powell's godhead). But we should note

the cheeky wit of the films, the irreverence in days of rationing, a superb sense of craft collaboration, and the sultry performances—think of Walbrook's Lermontov in *The Red Shoes*, or David Farrar's cripple in *The Small Back Room*. Think of the redheads: Kerr, Kathleen Byron, Moira Shearer (and Pamela Brown—in black and white, but red in Powell's heart). There is one scene of Kerr in *Blimp*, with auburn hair and in a cornflower blue dress, in shadow and firelight, that must be among the most romantic shots made during the war. No one in Britain before—not even Korda with Oberon—had seen that you could make a film just because you were crazy about a girl.

•

For all their originality, the Archers were not exceptional in those postwar years. The country was dirt poor, but the English were wild for movies. A boy from South London, born a Quaker and raised so that he was not allowed to see movies, had gone into the industry as a teenager, to make tea and carry messages. He had chosen to be an editor and he had caught the eye of Noel Coward. His name was David Lean, and he had his list, too: *In Which We Serve* (1942; codirected with Coward and a bizarre tribute to a figure very like Louis Mountbatten), *This Happy Breed* (1944), *Blithe Spirit* (1945), *Brief Encounter* (1945), *Great Expectations* (1946), *Oliver Twist* (1948) *The Passionate Friends* (1949), *Madeleine* (1950). You may know David Lean because of later, bigger films—*The Bridge on the River Kwai* (1957), *Lawrence of Arabia* (1962), *Doctor Zhivago* (1965), *Ryan's Daughter* (1970)—but I'd like to suggest that these later pictures are not as satisfying as the films he made in the 1940s.

There were other marvels: Laurence Olivier moved into the breach in 1944 and offered to direct *Henry V*—after the American William Wyler had stepped aside. I don't mean to disparage Wyler, but how could he have competed with Olivier's exultant display of heroism and swashbuckling, or his knowledge of Shakespeare? All his life, Olivier had doubts over his masculinity—years earlier, in Hollywood, big actresses had felt he didn't cut it—so Agincourt was his redemption. Then remember the wondrous opening: the busy Globe Theatre and the glimpse we get of the real actor nervous about playing the king. *Henry V* became a patriotic duty for British moviegoers, but it is a magical picture, at ease cutting together paintings of a city and the sweeping green meadows of Ireland for its battlefield. Think of the rush of arrows in the air, William Walton's music, and the lusty courtship at the end. Remember the panorama of Englishmen,

and the sturdy eloquence of Leslie Banks as the Chorus. Seen at the age of four, *Henry V* could direct your life.

Hamlet, a few years later, is not as piercing, I daresay, but true to its time, it is a film noir about a trapped man. Olivier is an ambiguous figure in British film history, and it may be hard for the rest of us to like him as much as he liked himself. But in the late 1940s, on-screen as well as -stage, he was a flag blowing in his own wind and a hero to the nation. We do not need to call him a great director, but *Henry V* and *Hamlet* were events that thrilled the world (and the Academy).

Still, that's not all. Ealing carried on after the war under Balcon and it uncovered Robert Hamer, a Cambridge student expelled for homosexual behavior, and thereafter a terrible drunk. Before he was through, he made *Pink String and Sealing Wax* (1945), *It Always Rains on Sunday* (1947), and *Kind Hearts and Coronets* (1949), a landmark comedy about class, murder, and voice-over narration (just before *Sunset Blvd.*). Harry Watt was allowed to discover Australia with *The Overlanders* (1946) and *Eureka Stockade* (1949). And gradually there developed what would become known as "the Ealing comedy," a vein of social satire rooted in ordinary British life and eccentric characters: *Hue and Cry* (1947), *Passport to Pimlico* (1949), *Whisky Galore* (1949), *The Lavender Hill Mob* (1951), *The Ladykillers* (1955). Two names go with that list: the young Scot, born in America, Alexander Mackendrick, who directed *Whisky Galore*, *The Man in the White Suit* (1951), and *The Ladykillers*; and Alec Guinness, the first of an outstanding generation of British stage actors, who proved himself a subtle master of film. His first coup was playing eight members of the D'Ascoyne family in *Kind Hearts and Coronets*, all slain by the silky, murderous design of a social upstart, Louis Mazzini (Dennis Price), who has hints of Oscar Wilde and the thrill of being outrageous.

•

And one more: Carol Reed. Born in London in 1906, the illegitimate son of the actor Herbert Beerbohm Tree, Reed worked in the theater and with Basil Dean at Ealing. He began to direct in the mid-1930s, but it was after the war that he really became himself, with an unmatched trio of films—*Odd Man Out* (1947), with James Mason as an Irish bankrobber mortally wounded and on the run in Belfast; *The Fallen Idol* (1948), from the Greene short story, with Ralph Richardson as the butler and Bobby Henrey as the child of the Belgravia house who trusts him. That project was a fruit of the friendship between Korda and Greene. In the glow of its

success, the two men speculated over another project. Alex was keen for a spy story, to be set somewhere like Berlin or Vienna. In a world of intrigue and displaced persons, that subject was begging. Greene had a cue for him, an opening line, about one day seeing a man walking on the Strand in London, a man he believed was dead. Oh yes, said Alex, with enthusiasm, go with that. It was the start of *The Third Man*, a coproduction with Selznick on which Greene, Reed, and Korda overlooked all Selznick's mistaken brainwaves. The only American they listened to was Orson Welles: they gave him the cuckoo-clock speech in the scene on the big wheel in the desolate Prater playground. The result was an international wonder, with zither accompaniment.

Nothing lasts forever: "The fun has gone out of the film industry," wrote Graham Greene when he heard—Korda died in 1956. He was only sixty-three, the age at which David Selznick had died. But those two had both filled their time and they had been knockabout, disputing partners on *The Third Man* (and then in court afterward). Robert Hamer ended up a drunk. Carol Reed went off the boil in ways he never understood. Powell and Pressburger broke up. And Britain, in general, remembered that it was a land of literature, theater—and television, the scale of which seemed to reassure and intrigue the British temperament. Michael Balcon persevered at Ealing, and no one deserved a knighthood more. But the kind of movies he liked would come to be made for television.

Still, you have to appreciate the impact British films made in those postwar years. Olivier got an honorary Oscar for *Henry V*, and Best Picture for *Hamlet*. In 1947, Britain won four Oscars: Guy Green for black-and-white cinematography on *Great Expectations*; Jack Cardiff for color on *Black Narcissus*; John Bryan for black-and-white art direction on *Great Expectations;* and Alfred Junge for color design on *Black Narcissus*. Then there were the nominations. Oscar meant a lot more in those days than it does now, and it had been American territory. But the British had broken through, and they have never lost that ground, even if British film production is often lamented by the British themselves. But the lesson of Ealing was plain. The British were equipped to make modest films that surprised audiences with their insight about human behavior. In time that model would be revived by perhaps the best film studio there ever was, the BBC, and a new tradition that would include John Boorman, Stephen Frears, Mike Leigh, Alan Clarke, Terence Davies, and even Joseph Losey, who made some of the most insightful English films, from *The Servant* to *The Go-Between*.

Both those films had scripts by Harold Pinter, just one of many writers in other forms who are unthinkable without the influence of the movies. Pinter also inherited a genteel, oblique recognition of how emotional, intimate, and unspoken violence can be. Of course, that tone was established by Alfred Hitchcock, as repressed yet as overwhelmed by feeling as so many of the best English films.

There are English jokes about *Brief Encounter*, and eyebrow-raising whenever its lush Rachmaninoff music (Piano Concerto No. 2) starts up. It sounds so emotional, yet the characters do so little. Lindsay Anderson, once a fierce and smart critic at *Sequence*, used to pummel David Lean's polite indirection: "When emotion threatens, make your characters talk about something else in a little, uncertain, high-pitched voice."

There was a cliché about British understatement, and it was based on life. But was British restraint modest, brave, and civilized, or did the British really feel so little? That complaint might be turned into praise if we were talking about films as varied as those by Ozu, Bresson, or Hawks. There is a vein of deep feeling that prefers to evade the heart of the matter, and in English theater you can find that obliqueness in both Noel Coward and Harold Pinter. Does anyone come away from *Brief Encounter* unaware of its depth of feelings? There are times when it seems nothing less than a film about hysteria and the dysfunction between a stiff upper lip and a mind turning to jelly. The best English movies often play with masking their feelings, so it's a shock, at the end of *The Red Shoes*, when Lermontov shrieks with distress that Victoria Page is dead. Michael Powell's films are full of emotional autocrats who use cruelty or rudeness as a mask.

So the jokes miss the desperate futility of *Brief Encounter* and the way it elects to live without satisfaction, or despite it. It's a setup that could easily bend to the romantic pressures common at the end of the war. These lovers—fortyish, both married with two children, both settled, it seems—could elect to leave their spouses and follow their desires. There could be a turmoil of separation or divorce (as in Terence Rattigan's play *The Deep Blue Sea*), with the confusion of sexual liberation, remarriage,

and guilt. It could be a film like . . . well, there's the point. Search through the archive of American and British films in the 1940s and '50s and it's not easy to recall films that trace an overwhelming affair, the termination of one or two marriages, and the attempt to make a new one. In life, such actions were on the increase, and they might have been expected to affect the screen's story material. But the old precept of censorship seemed in place still, strengthened by a commercial fear that it was perilous to make heroes and heroines out of adulterers. Marriage in the English-speaking movie may be a disaster, a comic shambles, or a dead place, but it spurs more thoughts of murder than remarriage.

Nor is it fair to put all the blame for *Brief Encounter* on the emotional diffidence of David Lean—an extremely attractive man, often charged with having difficulty in talking to women, but a serial womanizer, the religious strictness of whose upbringing preceded a very untidy marital life. Adulterous relationships are common in Lean's work—*The Passionate Friends* and *Madeleine* (both of which star one of his wives, Ann Todd), *Doctor Zhivago*, *Ryan's Daughter*. The thought of attraction nags away at dull life without much prospect of ultimate satisfaction. Yet moviegoing, by implication, is a fantasy pursuit in which members of all the sexes are somehow encouraged to fall in love with different people every week in pictures that (in the 1940s especially) were inclined to end on a lovers' embrace, which played on the curtains of the theater as they were drawn. Was that a warning, that the dream was a ruffled contrivance?

In *Brief Encounter*, finally, Laura's husband, Fred—not a very searching portrayal, though he is meant to be a kindly man—will say of his wife that she seems to have "been a long way away." In fact she's been no further than a nearby railway junction, but the "long way away" is referring to the "somewhere" that had been invoked in *The Wizard of Oz*. It's like saying that the wife has been to the house of fantasy, the movies, where such journeys are catered to. I'm not sure that the husband in *Brief Encounter* has guessed or wants to know the awful truth, and there's no hint that the couple is going to have a "heart-to-heart" in which the whole thing is admitted. The British will overlook landfills of embarrassment. Still, Laura's voice-over (the engine of the film) is as if offered as confession. But she's talking to herself—that is going to be the discourse of the rest of her life. Her husband's suburban decency or discretion believes in keeping quiet or not knowing, and it doesn't consider revivifying a flat marriage. Laura has discovered the limits of her union, her "love life," and the impossibility of improving it. So what the film seems to say is go to the movies, have

your frictionless fling, and then get on with the limited benefits of a do-
mestic stalemate: stability, small talk, and Fred doing crossword puzzles
while Laura sits dreaming to Rachmaninoff. If you put it like that, the
comparison with Ozu becomes more meaningful.

The affair is closing as the film starts. These lovers will not meet
again; his hand on her shoulder is their parting gesture—because the
crass Dolly Messiter has blundered in upon them (there are three women
in the film who are of Laura's rank and class and they all seem frustrated
to a degree). So Laura tells the story, and I think it was deaf of Lindsay
Anderson to hear only a high-pitched voice. Celia Johnson had elocution,
but that never spoils her emotional honesty. She catches Laura's unex-
pected rapture, her recklessness, her shy lust, and her sense of crushed
dignity. None of which makes her character unduly intelligent or remotely
feminist. But it sets us up for the film's unflinching conclusion: the loneli-
ness that is left for Laura.

By contrast, Alec (Trevor Howard) is more interesting: he's a doctor
with a research subject and a plan of going to South Africa to pursue it.
(No one in Britain understood South Africa yet!) Yes, he's losing Laura,
and Howard leaves no doubt about that blow, but we are open to what life
has in store for him. Whereas Laura has nothing to anticipate. It may
come from Noel Coward—and the credits do introduce "Noel Coward's
Brief Encounter," with Lean's name mentioned only as director—but there
is a tacit admission of women's tragic position, whereas in Lean's best-loved
films (*Kwai* and *Lawrence*), the world is dominated by active men doing
big things to change history with hardly a female in sight.

The bond between Lean and Coward is not to be danced over. In
show business terms, Coward was of a much higher class when he ad-
opted Lean as a protégé. No one ever noticed anything like an affair be-
tween them, but they made four films in a row, and Coward was good at
being one of the boys, whether in a naval unit or a film crew. In the years
they were a team, Coward had at least one risky affair, with an ordinary
seaman—and Coward was not widely perceived in Britain as gay. There
were women fans who adored him, not too far from the Laura Jessons of
the world, and simply supposed that he was a "gentleman." Lean was very
good-looking, very smart, and ambitious—all of which leads to the rather
un-English fascination of *Brief Encounter* with the female mind.

So this women's picture looks noir. That's not just the lustrous, shad-
owed lighting by Robert Krasker (he did *Odd Man Out* and *The Third
Man*, too), but also the feeling of urban enclosure in the railway station,

where the lovers seem caught between railway protocol (as embodied by Stanley Holloway and Joyce Carey) and the thunderous nonstop passage of the express, which tempts Laura into suicide. Now, *Brief Encounter* is not often listed among the noirs, but it is a film about traps, feeling guilty, and being imprisoned against your nature.

So what do Alec and Laura do on their Thursday afternoons in Milford? They take a genteel lunch together and then go to "the pictures." Their cinema seems crowded. They rock with laughter at Donald Duck. She is bored by a "noisy musical." And they watch *Flames of Passion*—a silly Hollywood product (no details supplied)—before they walk out. What they need to see is *Un Chien Andalou* (or *Blue Velvet*), but such programs could not come to "Milford." What I mean by that is to say that a contemporary novelist—Graham Greene, perhaps—might notice that these two pilgrims of awakened feeling need to have sex. You can't say "f###" about the movie, because no one could say that on screen in 1945. Alec and Laura do nearly make it in a borrowed flat, but then the tenant, an odiously supercilious Valentine Dyall, returns, and they are humiliated. (Moreover, the brief talk between Alec and this man is heavy with homosexual suggestions.)

Alec and Laura are in love with each other, and in love with love, and it might be that a few ecstatic hours in bed could avert tragedy or divorce. But as it is, they are stranded between the fancy of *Flames of Passion* and love scenes that one feels Coward and Lean would rather not see, just as the audience of 1945 would have been horrified by them. Celia Johnson's large eyes are naked to our scrutiny, but that's as far as that word could go—all of which leaves the imagining more intense.

So Laura dreams. On her way home on the train, after their nicest Thursday, she gazes at the night through the window and sees idyllic visions: the two of them dancing beneath chandeliers; at the Paris Opéra; in a gondola on the Grand Canal in Venice; in a sports car traveling against a back projection; on the deck of an ocean liner in the moonlight, watching the ocean pass by, and on a desert island beneath palm trees. These are an anthology of a life at the movies, and we feel that that entertainment is Laura's key point of reference in thoughts of "love." Above all, the scenes in a romantic movie are serene and assured, whereas what she hates about her affair is how close it comes to the furtive, the "low and the common." There is a moment when she and Fred discuss what to do with their children one day—one wants the circus, the other a pantomime. So the businesslike Fred suggests leaving them both behind so that he can take Laura to the movies. When he proposes this she bursts into tears.

I think it's fair to feel unduly confined by *Brief Encounter*, and to say these characters need sex lives and, quite simply, more going on in their lives as a whole. But I'm not sure Coward and Lean were off the mark in supposing that not many people then really had sex lives, or the liberty to admit to them—and in part that is because their movies had not done much more than offer the vaguest romantic imagery. This would be a very different film if Laura learned to appreciate that Alec was better in bed than Fred and that that had some impact on her overall health and sanity. *Brief Encounter* is not that film, but the story of people caught between a sad reality and a great dream. The action begins to teach Laura to give up the dream, and recognize her own loneliness. So Trevor Howard is fine in the film, but he is the handsome, nice lover figure as seen from her point of view. The film's core is Laura's aching experience, and that is how it hangs on Celia Johnson's crushed gaze.

All over the world, in 1945 and the years thereafter, there were films that began to question the innocent romance of filmgoing (and its censorship of sexual action). Italian neorealism is the most obvious example in its blunt insistence on inescapable realities. In America, film noir opened up a kind of despair that had found no room for expression in the era of happy endings. That's why it is important to see noir functioning in more than the hardboiled thrillers. The woman's film was helped in its very gradual advance on feminism by the new appreciation of the difficult lives led by women—among the pictures that fit as noir weepies are *Mildred Pierce* (1945), *Letter from an Unknown Woman* (1948), *Brief Encounter*, and even *A Place in the Sun* (1951). For a new subject was building, and it wanted to know how far the cinema's lavish play upon our desires had been just a commercial trick rather than candid respect for that longing.

So the skittish response of some British intellectuals to *Brief Encounter* is not misplaced. It is one of the first films that wonders, when are women going to understand that they deserve sex and must find it for themselves? Trevor Howard believed there should have been a sex scene, and the preview audience mocked the film's chastity. So it's not easy to abide by the film now—until we face the haggard beauty of Celia Johnson and the roar of the express. As Roger Manvell said of Johnson's Laura, "She looks quite ordinary until it is time for her to look like what she feels." That is a model for film acting. There is even a moment, in the train station café, as she hears the express coming, that the camera tilts over, making her seem drunk or distraught as she goes to meet it. It's a calculated effect, and Lean easily gets overcalculated—but in this case the vibrato works just because the image seems to be willed by the actress.

The railway setting adds a lot to the picture: the train timetable is a version of duty's claim on everyone. But I wonder sometimes how it would have been if the entire *Brief Encounter* had taken place in the dark of a cinema, where the lovers hold hands, but that touch hardly impinges on the drastic penetration of their innocence by something better than *Flames of Passion*.

WAR

A world war is fought everywhere, and by the time of World War II, the screen was a battleground, too. Sometimes a young mind could confuse the real thing with screen action. In J. G. Ballard's novel *Empire of the Sun*, the boy Jim is stranded in Shanghai as the Japanese invade.

> He rested in the padlocked entrance to the Nanking Theatre, where *Gone with the Wind* had been playing for the past year in a pirated Chinese version. The partly dismantled faces of Clark Gable and Vivien Leigh rose on their scaffolding above an almost life-size replica of burning Atlanta. Chinese carpenters were cutting down the panels of painted smoke that rose high into the Shanghai sky, barely distinguishable from the fires still lifting above the tenements of the Old City, where Kuomintang irregulars had resisted the Japanese invasion.

That hallucination is vivid on the page. In his film version of *Empire of the Sun* (1987), Steven Spielberg had a spectacular view of a huge *Wind* hoarding as the city disintegrated, but without the two kinds of smoke.

The Second World War concluded more than sixty-five years ago. You wonder if it could be retired. But it never stops, or goes away. Is it really over? The First World War is beyond explanation: we understand it was terrible, but who knows now why it was fought? For the second war, we think we know that answer. It was the crisis of modern history, and it persists as a state of thought and feeling because of the Holocaust and nuclear weapons. Such dire things were done then, or revealed about us, that the atmosphere of our self-betrayal will not disperse.

Filmmakers—some of them not born until after the war—remain

gripped by the issues of war, and the ways ceaseless horror was identified in the years 1939–45. That may come from interest in the war itself, but we also realize how closely allied war and film were. War is the climax in the history of the movies as a public institution, and their vindication. It compelled the attention of masses of strangers in the dark, hanging upon the outcome. We know well enough that opposed governments produced films to "raise" morale, to make the war seem winnable and necessary. But the cinema itself—the place and its community—was as important as air-raid shelters.

That notion can easily seem sentimental; it could be that the public was misled in deciding what the war was about. But once conflict was under way, the leaders and the commanders had less time for ideology, geopolitical strategy, and secret meanings than for survival. Wherever battle was joined, it was total, ruinous or glorious. The German onslaught in Western Europe was savage and story-like—the conquest of several countries was achieved in months, in ways that made the stalemate of the First World War seem archaic. No matter the "phony war" of 1939, 1940 was a year of devastation and remaking the maps, and its high summer saw a battle such as the world had never known, a struggle for air control. The Battle of Britain (the phrase was used at the time) was a public crisis in which the British felt the threat of invasion, and sometimes watched the dogfights that might determine it. They could follow the war like a sports event, and they had no reason for not knowing how serious the outcome would be, even if in 1940, say, the British public had only a sketchy idea of the evil at work in Germany.

After that, it was one big match after another: the melodrama of Pearl Harbor, the struggle in North Africa, the sea battles in the Pacific, the German invasion of Russia, the invasion of Italy, D-day, the attack on Japan, and the steady map of Europe that ruled the front pages with heavy black arrows showing the convergence of Allied and Russian advance. People went to the movies in record numbers in these battle years. Few movie shows played without a newsreel. The public bought newspapers. They gathered around the radio. Many households followed progress with their homemade maps and paper flags to mark victories. The "news" was censored, obviously, but people trusted it—or needed it. The newsreels, when seen now, can seem embarrassingly facetious and rigged, but they were received with earnest applause in theaters. The home front mattered.

The film director John Boorman (born in South London in 1933) was

old enough to know: "How wonderful was the war! It gave common cause, equal rations, community endeavour, but most delightful of all it gave us the essential thing we lacked: it gave us a myth, a myth nurtured by the wireless, newspapers, the cinema that allowed us semi people to leap our garden gates, vault over our embarrassments into the arms of patriotism." In that spirit, Boorman would make *Hope and Glory* (1987), one of those films that knows the adult tragedy of air raids competing with the kids' feeling of a free fireworks show.

Boorman's dad, forty, joined up, and Mum was freed from a less-than-perfect marriage. Before the war, the Boormans had felt trapped in suburbia and knowing their own restricted place. So war was revolutionary: "There we were, marooned in this unformed fantasy, drowning but too polite to wave, when along came the war with lifelines for all. All our uncertainties of identity and dislocations could be subsumed in the common good, in opposing Evil—in full-blown, brass-band, spine-tingling, lump-in-throat patriotism. We had found our heroes—ourselves."

In Britain early on and in Germany later, movie theaters in urban centers were danger spots. A packed theater and a direct hit spelled disaster. For this reason alone, major sports events were restricted. But after the initial disquiet, theaters were allowed to function so that the great show of heroism could play. And if there was a problem telling the hero story at first—just because defeats were more common—then history was waiting as a treasure-house. That's how Churchill and Alexander Korda conspired to make *That Hamilton Woman* with Olivier as Nelson.

There were American filmmakers champing at the bit, eager to draw up battle lines on the back lot but restrained by America's official policy of nonintervention. So *Sergeant York* (1941) re-created the First World War and reveled in the imagery of Gary Cooper picking off German soldiers like wild turkey. It is one of Howard Hawks's few vulgar films, but the public swallowed it. Only a few months after *Sergeant York*, *To Be or Not to Be* suggested there might be finer movies made because of the war—and by a Berliner. Ernst Lubitsch was in agonies over the war, and he was not drawn to conventional, bloodthirsty heroism. Instead, he dreamed up the idea of Polish actors doing *Hamlet* for the Nazis, with the timid Jack Benny having to be brave. It is a film that has Sig Ruman marching around to the running joke "So they call me Concentration Camp Erhard, do they?" Something else added to the sting of this picture: by the time it opened, its leading lady, Carole Lombard, was dead, killed in a plane crash in the Sierra Nevada Mountains in January 1942 at the

end of a trip to sell war bonds. She would be the only American movie star lost in the war effort.

There were those who said no country capable of making *To Be or Not to Be* was going to lose the war. Yes, it was anti-Nazi, in a very witty way, but it was also a movie about show business—first things first, for Lubitsch: sex or show business—as if to say, war is no excuse for losing your priorities. So let's not forget that it is in the years of war that Hollywood produced some of its best comedies. *To Be or Not to Be* is a member of that class—and you'd have to include *To Have and Have Not* (1944), which makes passing references to Vichy and sometimes sniffs the proximity of war, and must have astonished the Hemingway unaware of having written a comedy.

The more earnest Hollywood became, the more fatuous it seemed. *Mrs. Miniver* (1942) was entirely well intentioned, and based on short stories by Jan Struther about being a housewife in Britain during the war. It was directed by a serious man, William Wyler, played by Greer Garson and Walter Pidgeon, and by many accounts it assisted the task of persuading Americans to join the war. As such, it won Best Picture for 1942 and did terrific business. Still, it is ludicrous, especially in its claim that these Minivers are "ordinary middle-class people" who buy exotic hats and a sports car and live on an acre or two. *Mrs. Miniver* is unplayable today, and in 1942 it was derided in the Britain it is supposed to depict.

There had been misunderstandings on *Mrs. Miniver*. The film was shot at M-G-M in 1941, before Pearl Harbor. There was a downed German flyer in the script, sheltering in the Minivers' spacious garden. He was drawn as a decent type, but in the filming Wyler (who was Jewish and had been born in Germany) turned him into a Göring-type thug. When Louis B. Mayer saw the dailies, he called Wyler to his office. What are you doing? he wanted to know. "We don't make hate pictures . . . We're not at war . . . We have theaters all over the world, including a couple in Berlin." The astonished director replied, "Mr. Mayer, you know what's going on, don't you?" Mayer paused and backed down, though Wyler suspected the boss might still reshoot the problem scene with another director. By the time the picture opened (on June 4, 1942, in New York, and a month later in London), Mr. Mayer had realized what was going on, and he stood behind his courage when *Mrs. Miniver* won Best Picture.

But it was a hit because it came at the right moment. It opened in America just a few months after war had been declared, so it was the ribbon on a fait accompli. Luckier still in its timing, and far more entertain-

ing, was *Casablanca*, a war film that follows the useful advice of having
no battle scenes. Showing your troops the vaguest picture of what battle
looks and feels like is generally less productive than giving them a movie
in which the guys sit around and talk big.

No one dreamed of *Casablanca* being the war statement it became. As
the title of the play that began it all (*Everybody Comes to Rick's*) suggests,
it is about a nightclub in an exotic place, the capital of French Morocco.
It is a love story set against the intrigue of a town where Vichy, the Nazis,
and as-yet-unassigned Americans are waiting. It was purchased by War-
ners and set up as a Hal Wallis production that might suit several of
Warners' contract players.

By now, it is a mythic work, and one of its legends is the credo of the
factory: that if everyone does his bit, the film will feel as if someone made
it. People tell stories about how George Raft or Ronald Reagan might
have been Rick, with Hedy Lamarr or Ann Sheridan as Ilse. And "might
have been" was a weather condition in the Hollywood factory. Still, most
shrewd heads thought Rick was meant for Bogart, even if that wisdom
came after he was seen in *High Sierra* and *The Maltese Falcon*. As for
Ingrid, she did it because David Selznick told her to, and because he
made a profit on the loan-out.

Michael Curtiz directed the film, and that flamboyant Hungarian was
the model of a factory system director who had a knack for turning every
assignment into the same cheap silk. Auteurists have not raised Curtiz to
the pantheon, in part because of the jokes told about his awful English
and the way he would telephone his wife, Bess Meredyth, a screenwriter,
whenever he had a problem. This is a little severe, or humorless. Curtiz is
in a class of directors, along with Mitchell Leisen and Gregory La Cava,
who seldom let a film down.

The script for *Casablanca* was by several hands—the Epstein brothers,
Howard Koch, Casey Robinson, and maybe others—and your parents
can quote lines from the film as if they were set in stone. There's Dooley
Wilson singing "As Time Goes By" at the piano that holds the letters of
transit, and Paul Henreid with an elegant scar on his face to prove he's
been in a concentration camp. There is also the hokum of a love triangle
in which two top lovers agree to let each other go for the war effort. When
it comes to Hollywood thinking, the money for ten destroyers is one thing,
a second front another, but letting your best girl go because it doesn't mat-
ter a hill of beans is what a real man was made for. Every boy deserved this
Second World War.

One of the delights in *Casablanca* is seeing how quickly Los Angeles had become a home for refugees: so there is Conrad Veidt (from *Caligari*) as Strasser, the German star who had to get out of Germany with his Jewish wife; there is Marcel Dalio (a Marquis not so long ago for Renoir), who knows how to bring up the right number at Rick's roulette table; and there is Peter Lorre, still marked down for murder, even if he's more viable as a victim now. All these engaging "supports" (including Sydney Greenstreet) have as their godfather Claude Rains, the one-time acting teacher at RADA (Charles Laughton was his student) who gave up London for Los Angeles and who was making his way through six wives as if they were just movies, becoming an epitome of cynicism as Captain Louis Renault.

Ask the man on the street today to name a Hollywood picture, and *Casablanca* will be there in the first list. It's such a nostalgia-encrusted classic that we are spared having to notice that it is fake, foolish, and fanciful beyond belief. Yes, it won Best Picture and it was blessed by one further bonus: just as the picture was ready to be opened, the Allied armies landed in North Africa and relieved another town, a real one, also named Casablanca, on November 1, 1942. There was no fooling the public: they knew providence had hit them and they went home singing "As Time Goes By" or "La Marseillaise." A movie is just a movie, and if you insist on seeing the Second World War as a song contest made for heroes and magic, *Casablanca* is the best fun.

When the real Casablanca was taken, Warners' first thought was to add a new last shot where Rick and Renault, entering the mist of their "beautiful friendship"—the sort available in North Africa?—hear FDR announcing the Allied landing. But Rains was out of town. Other spectators thought the film was just fine as is. Maybe someone even suggested that a single note of the outside world could crush the butterfly. The picture opened on Thanksgiving Day 1942, just as Roosevelt and Churchill met in Casablanca.

On its first run, through 1943, *Casablanca* had rentals of $3.05 million. But in 1942, for Paramount, *The Road to Morocco* brought in $4.0 million. You will say there is no comparison: the Hope and Crosby picture is a silly comedy, whereas *Casablanca* is played in earnest. Maybe they're closer than anyone thought in 1942, and let us remember that the number one box office attraction in the war years, and a man who endangered his own health by going to remote and dangerous places to entertain the troops, was Bob Hope.

The sight of movie celebrities in uniform, or on the road with the USO, became common. Jack Warner and Darryl Zanuck persuaded themselves into being honorary "colonels." Bette Davis helped organize the Hollywood Canteen. Gable put on an air force uniform and missed four years of moviemaking. Jimmy Stewart flew on twenty bomber missions and had a nervous breakdown as a result. David Selznick was mortified that no service would risk taking him, so he wrote and produced his home front movie, *Since You Went Away*, in which Claudette Colbert, Jennifer Jones, and Shirley Temple are women left at home, doing their bit, but really doing far too little for 172 minutes. It's a film from the heart, lovingly made and unquestionably respectful of its subject, but then real-life melodrama intruded. In the movie, Ms. Jones has a soldier sweetheart going off to be killed. He was played by Robert Walker (Mr. Jones in life). Behind the scenes, Selznick was having an intense affair with Jones that would ruin both their marriages. In truth, that was a more interesting scenario than *Since You Went Away*.

At the end of the war, the realities of combat and service crept onto the screen—or if not quite the realities, then the smooth version of them. *The Story of G.I. Joe* (1945; by William Wellman, an air force veteran from the first war) had Burgess Meredith as war reporter Ernie Pyle, and Robert Mitchum at his best as a fatalistic soldier. *A Walk in the Sun* (1945) was one of the first dogged tributes to the foot soldier. And John Ford's *They Were Expendable* (1945) was a melancholy account of the holding action in the Pacific as MacArthur withdrew. It was based on real figures, and it stressed how Ford was always going to be more moved by defeat than victory. Of course, this feature film grew out of Ford's actual service making documentaries.

A group of the guys, the manly directors, did the same sort of thing. Ford made *The Battle of Midway* (1942) and *December 7th* (1943). Frank Capra and Anatole Litvak did a series of documentaries, and John Huston made wartime reports and *Let There Be Light* (1946), the first halfway-candid account of shellshock, breakdown, and fear and the mess such things made of the real guys who were trying to be like John Garfield (*Pride of the Marines*, 1945) or Errol Flynn (*Objective, Burma!*, 1945). Five years later, John Wayne was the marine sergeant in *Sands of Iwo Jima* (1949), as if to say he knew what hell was like. Yet the Duke had carefully missed the war.

Once the war was over, a deluge of war films began. In the bad years, Britain had made a series of responsible documentaries and feature films

under the shadow of the real thing: *In Which We Serve*, *The Way to the Stars* (scripted by Terence Rattigan, based on his play *Flare Path*), *The Way Ahead*. There was a looseness in such films, as if to suggest the real untidiness of war. But secure in victory, the stiff upper lip turned to timber as the British film business sought out every positive incident from the war: *Morning Departure* (1950), *The Wooden Horse* (1950), *The Cruel Sea* (1953), *The Dam Busters* (1955), *The Colditz Story* (1955), *Reach for the Sky* (1956), *Carve Her Name with Pride* (1958), *Ice Cold in Alex* (1958). It was to ambush that advancing column that David Lean made *The Bridge on the River Kwai*, about different kinds of duty and military preoccupation, in which Alec Guinness's colonel is recognizably a version of that husband, Fred, we met in *Brief Encounter*.

Whenever the British made group films about the war, team spirit got in the way. But there are lonely individuals worth remembering. What about Trevor Howard's brusque Calloway, the military policeman in *The Third Man*, and his gradual revelation that Harry Lime's boyish charm may mask real evil and plots to give drugs to children? There isn't another British film that catches the postwar European mood so well, not to mention the dirty smile on the face of Vienna. But Orson Welles was so seductive as Harry Lime that within a year of the film, he was playing Lime in a radio series where the black marketeer had become a hero.

Or remember Richard Burton's Leith in Nicholas Ray's *Bitter Victory* (1957), a film that has precise desert action, the tragedy of killing your own wounded as you try to save them, and the sense of courage and philosophy being lost in a sandstorm. There is Alec Guinness's George Smiley, a cold war fighter, to be sure, but a man who has seen his own faith and life erased by duty and its duplicities. Let me add another figure: Susan Traherne, the woman Meryl Streep plays in *Plenty*, adapted from David Hare's smoldering play, a young heroine of the resistance who nearly goes mad in the subsequent betrayal of so many wartime rules.

The wartime scenes in *Plenty* take place in France, and they involve a war of occupation. French cinema goes numb in the war years and comes back to life only with René Clément's *La Bataille du Rail* (1946), which is not that far removed from the spirit of Italian neorealism. For France, the war was a devastating experience, not just the rapid defeat of the French army and the subsequent insignificance of French leadership. The war is a matter of resistance and its opposites, degrees of collaboration or compromise that reached as far as such leading filmmakers as Arletty and Marcel Carné.

Over the years, a number of French films have observed the war years at home and found disturbing complexity. As early as 1947–48, in his debut film, Jean-Pierre Melville turned to *Le Silence de la Mer* (1949), Vercors's novel about a smothered love affair between a French girl and a German soldier posted to her village. Melville had served in the Resistance, but *Le Silence* is remembered for its fairness and its view of the German as a human being. Decades later, in *Army of Shadows* (1969), Melville would deliver one of the classic films about the Resistance, in which there was no room for a sympathetic German. Instead, it is a cruel war in which the men determine that they must execute one of their own, played by Simone Signoret. There is another good German in Alain Resnais's *Hiroshima Mon Amour* (1959), a war film and a peace film, and one of the first movies to grasp the international level of the conflict. There is also Bertrand Tavernier's *Safe Conduct* (2002), which concerns the film industry during the war years and benefits from Tavernier's research in that period.

There are two other films that must not be forgotten and which are both marked by the impact of war and its consequences. Joseph Losey's *Mr. Klein* (1976) concerns an art dealer in wartime Paris (played by the impassive but imperturbable Alain Delon). He is sure of himself and his tranquil life until he realizes there may be another Klein who is Jewish and who is being hunted. *Mr. Klein* is about paranoia and insecurity and the idea of doubling—almost as abstract things—but Losey knew how far those conditions, the modern terror, were a legacy of the war. Few countries suffered a more depleting self-exposure than France: to be occupied is a severe test and one that continues to help define America's innocence or inexperience.

The other unforgettable film is *A Man Escaped* (1956), by Robert Bresson. This is a film of hands, glances, bars, rope, sounds, and music. It is Bresson. But it is a war film, too, about a man who is being held by the German authorities and who faces execution. When he escapes finally, the effect is of sublimity—keyed to Mozart's C-minor mass. It is a spiritual release, and one of the least-flawed moments of glory in the French war film.

Alas, war films piled on that lacked Bresson's tact. Robert Aldrich's *The Dirty Dozen* (1967) was a big hit, but it did not bother to conceal its own exploitation of stereotypes, heroism, action, and brutality. This was all the sadder in that Aldrich had made an earlier film, *Attack!* (1956), filled with authentic anguish. But *The Dirty Dozen* was much more influential,

and one can feel its ugly gusto behind *Inglourious Basterds* (2009), one of the first films that did not seem to understand what happened in the Second World War but took the crudest films as a matter of record. One day that reality will be offset, because there will be no one left alive who was alive in the war years. Already the firsthand experience of the Great War has passed on. In which case, who can say that the effective record of the Second will not depend on films as mediocre and complacent as *The Longest Day* (1962), *A Bridge Too Far* (1977), *The Guns of Navarone* (1961), *The Dirty Dozen* (1967), and *Patton* (1970)—instead of, say, *Bitter Victory* (1957), Anthony Mann's *Men in War* (1957), John Boorman's *Hell in the Pacific* (1968), or Bertolucci's *The Conformist* (1970), all of which are less known than the "blockbusters."

Men in War is the Korean War, but that film is so distilled a study of a platoon on patrol (with an unseen enemy) that it could be any war, anywhere. A larger issue arises with *The Conformist* (in which there is a political assassination—one of the most distressing murders on film), but Bertolucci's film mines the uneasy ground of what happened in Italy under fascism, and of the way weakness and ambition let tyranny thrive.

War is combat now; the cult of military hardware is married to film's code of special effects. *Saving Private Ryan* (1998) is unmistakably D-day (as if shot by Robert Capa), and the rifles made the correct noises. Whereas *The Deer Hunter* (1978) was a version of Vietnam vulnerable to charges of inaccuracy. The fact remains that both pictures see conflict isolated from politics. In this light, the scary immediacy of *Saving Private Ryan* is let down by Spielberg's muted but painfully proper political sensibility, while *The Deer Hunter* is colored by Michael Cimino's feeling of what a self-determined ordeal had done to America.

Saving Private Ryan trusts that its audience will agree—yes, this was a just war, and like Ryan, we need to deserve its sacrifice. But *The Deer Hunter* is braver in that, only a few years after actual withdrawal, it says we should not have been there and were there only because of our ignorance and the way that fed bellicosity. This is where we can see how far war and its links to modern terror are not going away. For just as in, say, *The Best Years of Our Lives* as much as in *Saving Private Ryan*, no one thinks to say Americans should not be fighting, so many modern films are still driven by the history that treats war and film as inseparable. The virtue or energy in *Inglourious Basterds* is Tarantino's assurance that today the war cannot be contemplated without the song and slaughter of its movies—and the increasingly weird realization of how obedient, how ac-

cepting the public was then. War films today have yet to deal with the public's loss of faith in movies themselves, and the comical yet hideous notion of how tidily battle can be handled. How do we retain patriotism, or anything that carries the same conviction? How do we see combat except as a war game?

So war has become, on-screen, a metaphor for uncertainty and disorder. The magnificent lucidity of the battles in *Saving Private Ryan* is also youthful. How can anyone believe in such accuracy in shooting and tactics? The last battle in that film is wonderfully exciting, but its precision probably inspired some video games. Can we still believe in heroes and expertise in war? We know that war is confusion, panic, friendly fire, mistakes, and nothing fit for lucidity. It is just as Tolstoy said of the Battle of Borodino. Ridley Scott's *Black Hawk Down*, in which a high-tech American mission is disrupted by Mogadishu rabble, is a more honest combat film, and accurate in its explanation of America withdrawing from Somalia. We have lived long enough to see that the vaunted heroics of the war movie can be a disguise for our political ignorance and helplessness.

Beneath this growing chaos, we are more than ever haunted by the terror that started with the Nazis and the fearsome test between resistance and collaboration that emerged from the French experience of war. We go back to those stories because they are not settled yet, and we wonder if such issues will come again. In his old Germany, Billy Wilder in *A Foreign Affair* (1948) gazed down at the ruins of Berlin with the music playing "Isn't It Romantic?" That felt rueful, not superior. Very little known is *Der Verlorene* (1951), the film Peter Lorre went back to Germany to direct, in which he gives an agonized performance as a doctor who may have been involved in Nazi experiments. That is only a few years before *Night and Fog*, Alain Resnais's stringent documentary on Auschwitz, the testament that would be shown in schools in so many countries and which stood for the world's belated recognition of what concentration camps had been, and what meanings they left.

In Poland, Andrzej Wajda chronicled the Polish resistance movement from the outbreak of war to the Russian takeover—*A Generation* (1955), *Kanal* (1957), and *Ashes and Diamonds* (1958) were major events in their time, but they are neglected now. In Russia, Larisa Shepitko's *The Ascent* (1977) was just one version of the war between partisans and German invaders—and it is still close to unbearable, despite too much religious reference at the conclusion. It is impossible to consider the work of Andrei Tarkovsky without constant reference to war, whether in terms of Russian

response to the Second World War (*Ivan's Childhood*, 1962, and *The Mirror*, 1975) or of being suspended under the threat of a new, more infinite shadow (*The Sacrifice*, 1986).

Tarkovsky's *Stalker* (1979) is not ostensibly a war film, but its action takes place on broken waste ground best explained by the passage of some devastating conflict. So many recent films, sometimes under the guise of "sci-fi," have sought to create the end of our world. *The Terminator* films are examples that entertained a huge audience and in which Arnold Schwarzenegger, a formidable opportunist, went from dread pursuer to desirable ally.

Designing and filming the end of the world is a queasy speculation, and Armageddon has its own clichés now, but in *Stalker*, Tarkovsky ends with the audacious mystery of a large, unexplained shaking. The same sort of thing happens in *The Sacrifice*, and it feels as if the theater, the screen, the film, and our culture are about to be shaken to bits.

If we compare Fred Zinnemann's box office hit *From Here to Eternity* (1953) with Terrence Malick's *The Thin Red Line* (1998), the linkage of James Jones as author seems implausible. Zinnemann made a picture about the army as an institution, a small but intense tragedy, and the scarring of several novelettish lives. For its day, that film was a breakthrough and a stirring display of acting. In contrast, *The Thin Red Line* is about a Pacific island where, for a moment, a war occurred. It is a botanical panorama in which the soldiers scurry and rant, like furious insects, lost in their attempt to win and survive. The island, its foliage, its fauna, and its light endure—as if the war was just a passing rainstorm. So war is put in its place, but only with a detachment that confined Malick's film to a small audience.

Our toughest films now are ruminations on our terror and the uncertainty as to whether life will go on, or deserves to. I do not mean the colossal, pluperfect battle scenes of *Star Wars*, *The Lord of the Rings*, and *Avatar*. I mean the settling gloom in *No Country for Old Men* (2007), where a shrewd and dutiful sheriff looks forward to death or retirement in a landscape where the drug trade is the war. I mean the confused loneliness of Colonel Kurtz in *Apocalypse Now* who has gone up the river on the current of soldiering and found disenchantment, the horror.

ITALIAN CINEMA

Some books tell you the Italians waited for the disasters of war to create their own modern cinema, and that they then laid down the principles of something called "realism" in a landscape and a funding system that had little else to offer. It was never as simple as that, just as "realism" keeps receding from our eager grasp, disarmed by the essential equivocation of the medium. If we like to think of "neorealism" as the movement made clear by three people—Luchino Visconti, Roberto Rossellini, and Vittorio De Sica—then it is plain that all three had active careers well before the end of Italy's war. That they were stimulated and provoked by the end of Italy's war is beyond question. Savage destruction of the fabric of a country does urge its inhabitants to consider what is real and what is not.

Realism and fantasy, like the entire history of film and screens, is the story of personality and circumstances making their imprint on action. So "Italian neorealism" is a label, part of the marketing hype of the movies. The history and the stories need to be examined for what they were. Thus our trio of neorealists came from different directions, and went off at remarkable tangents soon after their "collective" years. Was it really a collective? Not beyond the way in which one artist in any medium may see good work by a contemporary and immediately feel the need—a mix of admiration, envy, helplessness, and true education—to steal from it.

Italy's special place in the pioneer age—with epics such as *Quo Vadis?* (1913) and *Cabiria* (1914)—passed away, and when it comes to the 1920s and '30s, few of us have seen enough Italian films from that era, because so few of them obtained a release outside Italy. There is even a dismissive school of thought that says Italy in the 1930s was a land of vapid romances and society comedies, called "white telephone movies" because the characters were invariably talking on their stylish phones. Even if that

were so, it suggests a reason to be cautious (and expectant): the telephone in American pictures of the same era, white or black, is often a sign of life and fun. Films where people chat on the phone are always more promising than those where they read speeches to one another. And today the cell phone is a steady means of narrative progression and cross-cutting.

The fascist government of Benito Mussolini did not do as badly by the film industry as postwar revisionism tried to explain. It was under his leadership that the Cinecittà studio was built. A film school, Centro Sperimentale di Cinematografia, was opened. And the first notable film festival, at Venice, was begun. Mussolini liked films, and soon after he came to power in 1924, he joined the then-current Italian notion to remake those epic films from years before that had made such flagrant use of Italian buildings, sunshine, and money. Soon after, there was a second version of *Quo Vadis?* (1925), directed by Gabriellino d'Annunzio and Georg Jacoby, which imported Emil Jannings to play Nero. It was such a disaster it closed down a studio. Whereupon Carmine Gallone and Amleto Palermi came together to make *Gli Ultimi Giorni di Pompeii* (1926), with María Corda (the first wife of Alexander Korda) in a lead role. The film cost 7 million lire and it was another disaster.

Who can blame the fascists for modest retrenchment and for the new wisdom that Italy (with a limited home market and no natural sales overseas) should concentrate on smaller films? Were they great, or good? Who knows now? But one Italian film of the next era was great: it was made in 1934, for Novella Film, with the future publisher Angelo Rizzoli producing. It is the story of an Italian movie star, Gaby Doriot (played by Isa Miranda), or an investigation of her that wonders, if this woman can move so many, who is she at her core, and what does she want? The film is called *La Signora di Tutti*, and it is directed by Max Ophüls. As such, it is a small masterpiece filled with uncertainty about what happens to an actress, and clearly a movie that clears the way for a film such as *Lola Montès* (1955) as much as *Sunset Blvd.* (1950), or *Vivre Sa Vie* (1962). The editor on the film was Ferdinando Maria Poggioli, a name that might easily slip past with the other credits.

But we have reason to think that Poggioli is interesting. Born in Bologna in 1897, he was an editor in 1934, about to launch his own career as a director. In one of the few serious attempts to survey Italian film before neorealism, at the National Film Theatre in London in September 1980, Ken Wlaschin played four films by Poggioli and offered the estimate that he might be "major." These included *Addio Giovinezza!* (1940), about uni-

versity life; *Sissignora* (1942), about a maid working for difficult clients; and *Sorelle Materassi* (1943), about two sisters whose lives are jolted when a young nephew is discovered.

The same season ran several films by Mario Camerini, including *Il Signor Max* (1937), in which a news vendor falls in love with a teacher—the part being played by the young and very appealing Vittorio De Sica—and *Darò un Millione* (1935), in which a melancholy millionaire pretends to be a poor man so that he can give a million to anyone who treats him well. You might wonder how much this film was influenced by Chaplin's *City Lights*; parables of wealth and poverty are quite common all over the world in the 1930s. And the millionaire was played by Vittorio De Sica.

Almost by obligation, the 1980 season in London played the one other film from Italy in these years that was known in the outside world: *Ossessione* (1943), by Luchino Visconti, the least likely of our realists.

•

Born in Milan in 1906, as a count and then a duke, Visconti spent a decade breeding and training thoroughbred horses on his estate before, all of a sudden, he chose to leave Italy and find a place in filmmaking. Something must have happened to make life awkward. But Visconti moved in high circles, and it was the designer Coco Chanel who recommended him to Jean Renoir. He has no credit on a Renoir film, but it seems to be the case that he worked on or attended *Toni* (1935), *Partie de Campagne* (Cartier-Bresson recalled Visconti as a silent observer), and *Les Bas-Fonds*. Visconti would say later that, after fascist Italy, he was refreshed by the left-wing attitudes of Renoir and his associates in the time of the Popular Front. But Visconti made no move to leave Italy. Indeed, he went home to help Renoir make *La Tosca* in Rome, and he stayed on finishing that picture when Renoir left for America. As a parting gift, Renoir suggested to Visconti that he try a film of the James M. Cain novel *The Postman Always Rings Twice* (published in 1934).

Which doesn't make *Ossessione* a Renoir-like film so much as a clever transposition of Cain's melodrama to the Po Valley countryside. Although Visconti made no efforts to acquire or honor Cain's rights, *Ossessione* is quite faithful to the story of the drifter, the innkeeper, and his disaffected wife; the love affair; the murder; and then the falling-out between the murderers. The film is shot on location, but the title gives away Visconti's sense of fate and disastrous passion. So the narrative line is as ordained as in an American noir film. Massimo Girotti and Clara Calamai as the

lovers are sexy, attractive, just as iconic as figures from an American film, but more interesting and credible than John Garfield and Lana Turner, who did the overrated and undersexed American version in 1946. The "realism" in the Italian film is a superficial but classy look of rural grunge ably photographed by Aldo Tonti on one of his first jobs.

The picture had censorship problems in Italy, not because of any political or antifascist daring. Far more, it was the sordidness of the action and the unadorned amorality of the characters. The most realistic thing about the film must be Visconti's detachment—his literary distance from the film, his interest in seeing a certain hardboiled glamour in these wasted lives. There is no hint of a concern for the country people being depicted and no suggestion of a link between this story and the real circumstances of Italy in 1942. *Ossessione* could take place anywhere, which is a way of saying that it is occurring in Visconti's imagination.

The years of greatest turmoil in Italy, 1943–45, saw Visconti doing nothing. But then, with some funding from the Italian Communist Party, he went to Sicily. He was apparently preoccupied with the "southern problem," the predicament of that extreme of Italy, cut off from government or understanding. He proposed to make a trilogy, about the fishermen, the peasants, and the sulfur miners, and in a six-month shoot his plans extended but frustrated him. It's true that there was an immediate concern with social problems. The whole film was shot on location in Sicily with nonprofessionals. But the first scheme was abandoned so that the final film, the 160-minute *La Terra Trema*, is a portrait only of the fishermen. It is documentary-like, but it is also very beautifully shot (by G. R. Aldo) and a picture that cries out for a symphonic score. In a way, it can be compared with Orson Welles's aborted *It's All True*, ostensibly an attempt to present South America to Western audiences but, in the event, hopelessly compromised by Welles's romanticism and his inability to finish the job.

Once upon a time, especially among leftists, *La Terra Trema* was highly regarded. But it has gone way out of fashion now. As Geoffrey Nowell-Smith (an ally to Visconti) said,

> Visconti brought to the project a great amount of revolutionary fervor, and an even greater ignorance of actual conditions. The whole project can be fitfully compared to Eisenstein's really grandiose and even less successful *Que Viva Mexico!* Like *Que Viva Mexico!*, *La Terra Trema* suffered from being abstractly conceived

and unrealizable from the outset. Even (which was unlikely) if Visconti had received full cooperation from his producers and financiers, he could never have made the film as originally conceived. The contradiction was too great between what he wanted and what was there for him to see.

That observation predicts the progress Visconti would make. He was by inclination an aesthete, and a man who loved opera and theater as much as film. So he moved steadily away from realism: *Bellissima* (1951) has Anna Magnani over even her top as a stage mother; *Senso* (1954) is Visconti's first intoxicated re-creation of the nineteenth century, with Alida Valli and Farley Granger, and still a satisfying film. In time he found himself in the curious fusion of nostalgia and disgust in period pieces such as the exquisite, stately *The Leopard* (from Lampedusa, and with Burt Lancaster) and the embalmed *Death in Venice* (blending Thomas Mann, Mahler, and Dirk Bogarde into one of the first prestigious end-of-the-world pictures for affluent audiences). Along the way, in *Rocco and His Brothers* (1960), Visconti returned to the Sicilian figures he had encountered on *La Terra Trema*, but now he had them played by actors such as Alain Delon, Annie Girardot, and Katina Paxinou, where dubbing, art house pretension, and an unwholesome mixture of Dostoyevsky and Puccini turned the film into something only Visconti could have made. Realistically, he was set on being himself in an age of art house movies where directors were encouraged to look at their imagination more than the outside world.

•

A more intriguing and complicated case is presented by Roberto Rossellini, born in Rome in 1906, the son of a man who built movie theaters—so the kid got free admission and fell in love with the medium. He started off in the early 1930s doing sound effects; he became an editor and an assistant director; and thus, in the fascist period, he began directing pictures: *La Nave Bianca* (1942), *Un Pilota Ritorna* (1942), *L'Uomo dalla Croce* (1943). Later on, Rossellini was vague or forgetful about those films, but they were part of the time and spirit, one of them made with Vittorio Mussolini, son of Il Duce. Why not? Rossellini would reveal himself later on as a lively opportunist, despite valiant critical attempts to make a hero and a saint out of him. It's easy enough to believe that he loved the medium more than its possible message, though that verdict is still at odds with the reputation Rossellini would win.

Something happened, which may have been a matter of self-discovery or simply that Rossellini found himself suddenly in a situation of chaos where life hung in the balance and his country's future seemed up for grabs. So in the years when Visconti did very little, Rossellini became a driven man, begging, borrowing, or stealing ends of unexposed celluloid (or claiming that), wangling equipment, and devoting it all to *Rome, Open City* (1945). It began as a silent film, just because they had no means of recording sound—all that was dubbed in later. Just two months after the actual liberation of Rome, they began shooting a story of Rome and its resistance under the Germans. Yes, the movie looked rough and awkward sometimes, if only because of the physical difficulties it had faced. It felt "real" in that it told a story of resistance, occupation, torture, and sacrifice soon after the actual events. But if you look coolly at the film, you will observe that Rossellini has a natural facility with the camera. For example, look at the camera movement that links the several rooms at Nazi headquarters so that we feel the shocking adjacency of torture and relaxation; and witness the bravura melodrama of the scene where Anna Magnani is shot down in the street. And why are all the women in the film so attractive?

Magnani is an important figure in this story. Born in Rome (or Alexandria in Egypt—there were rumors) in 1908, she had been working since the early 1930s, in musicals, comedy, and drama. She had been married to the director Goffredo Alessandrini, and a star of the fascist period, making many successful films—including De Sica's *Teresa Venerdì* (1941). To most non-Italians, Magnani was a scorching presence and a newcomer in *Rome, Open City*, but she was an established actress, and by then she was also Rossellini's mistress. He was well aware of her glorious excessiveness: "You feel that she's extremely capable but in certain films it is too much. If you are fed too much cream, after a bit you don't want any more cream." Still, they were a team. When they ran out of money—as they ran out of everything except imagination—Rossellini and Magnani sold many of their possessions to keep *Open City* moving.

The film opened in Rome in September 1945 and in New York (cut by some fifteen minutes because of violence) in February 1946. The New York Film Critics Circle voted it Best Foreign Film of 1946, and it won a prize at the resumed Cannes Festival in the same year. More to the point, it got a limited release in the United States, and thus it was that a young woman in Los Angeles, passing the time of a bored day, could walk in on the picture and be changed by it. Her name was Ingrid Bergman.

In 1946, Rossellini made *Paisà*, which is the most audacious and jour-
nalistic of his early films, and which was surely influenced by his success
on *Open City*. The most realistic of its departures is to forsake any overall
story and to opt instead for six separate episodes or anecdotes that, when
put together, reflect the Italy of the resistance era. In part this film was
spurred on by the agency (and funds) of Rod E. Geiger, an American GI
who had fought in Italy and was convinced that the world needed to see
the true story, and by the assistance of the American writer Alfred Hayes.
There were conflicts over where Rossellini found the actors: he said he
had just looked around in the countryside and used faces he liked; but it's
clear that several of the performers had experience. In the end, this issue
is a conundrum: amateur actors can be carried in a film only if they play,
if they work on-screen. And professional actors are bearable only if they
can make the cream seem like milk.

Paisà was less successful everywhere, but by the account of anyone
who knew Italy, it was far more accurate. It teaches us that the structure
of a story is a profound element in perceived reality. It also helps us see
that "realism" is a purpose that grows out of our political needs or wishes
more than improved accuracy or candor. Like any treatment, filmmaking
is selective and reveals only predetermined choices. The widespread view
after the war was that movies—the movies of the war years and before—
had never bothered to treat the real issues, and that had made war and its
distress more likely. But after the war, and in Italy above all, there was a
feeling of guilt and responsibility over those facile films. That mood is
honorable, but it has not reliably settled any reality test.

As if making a trilogy, Rossellini next turned to *Germania Anno Zero*
(1948). It began with a brilliant idea, and if brilliant ideas may be the se-
cret of art, there is no reason to trust the pleas of reality:

> I made a child the protagonist in *Germany Year Zero* to accentuate
> the contrast between the mentality of a generation born and brought
> up in a certain political climate, and that of the older generation as
> represented by Edmund's father. Whether he excites pity or horror
> I do not know, nor did I wish to know. I wanted to reproduce the
> truth, under the impulse of a strong artistic emotion.
>
> Although the story of Edmund and his family was invented by
> me, it nevertheless resembles that of most German families. Thus
> it is a mixture of reality and fiction treated with that license which
> is the prerogative of any artist. There is no doubt that every child,

every woman, and every man in Germany would see in my film at least some phase of their own experience.

If you think about that last claim, it is hardly sweeping or exceptional. It's marketing. What you will never forget if you see the film is the actuality of Berlin in ruins. (Rossellini had little difficulty finding untouched bomb damage, but he also created or dressed some bomb sites.) The tragic predicament of the little boy living alone in these ruins is that of being driven mad in the process, just as he clings to the recorded voice of Hitler. But he does not look mad, because that is an interior condition—until it is dramatized. And talking of acting out, when Rossellini found that Berlin was so cold, he went back to Rome to shoot the interiors!

As usual, Rossellini found his players where he could, and he claimed that many of the scenes were improvised. But the arc of the film was as preset as a star's motion in the heavens. We see the boy deteriorate to the point of suicide, and the artistic result, as harrowing as that of any of the neorealist films, is a fable of absolute destruction. What we see is not really Germany at its year zero, ready to begin again. It is Germany facing the ultimate tragedy of its Nazi commitment. So it is a film about error and pessimism, a small opera from the devastated streets. Rossellini's trilogy is an extraordinary achievement, and it has to be said that the viewer will learn a good deal about Europe circa 1945. But the films are educational works, reports of terror and its large shadow hanging over any human future. The war had ended, but it was not over.

Anna Magnani had noticed that she had no role in *Paisà* or *Germany Year Zero*, and she was upset. Rossellini responded: he had a habit of suggesting that his life was a series of messy happenings prompted by one woman or another. So before going to Berlin, he shot, in a studio, Jean Cocteau's short play *The Human Voice*, in which a desperate woman is on the telephone to a lover who is leaving her. On his return from Berlin, he shot *The Miracle*, a short written by the young Federico Fellini, about a peasant woman who is seduced by a handsome wanderer because she believes he is an angel. Those two halves were put together, in shameless celebration of Magnani as a diva, in a film called *L'Amore* (1948), which, in the deepest sense, is about a director's indebted infatuation with an actress. Everything about both halves is invented, but I'm not sure that documentary has ever told us more about the embattled state of being an actress.

As is often the case, such passionate involvement with Magnani had left Rossellini ready for a change.

•

Vittorio De Sica was born in Naples in 1901, and he was an actor from 1928 onward, in any medium that would have him, from drama to vaudeville. He was always handsome, even in old age, when his ingratiating smile went with silver hair—indeed, as an actor he is the lover in Ophüls's *Madame de . . .* , and the title figure in Rossellini's *Il Generale della Rovere.* He had been a star ever since playing the chauffeur in Mario Camerini's *Gli Uomini, Che Mascalzoni* (1932). It was in 1940 that he became a director with *Rose Scarlatte,* to be followed by *Teresa Venerdì,* in which he himself played the doctor involved with three different women. In many ways, De Sica was an exponent of a kind of Neapolitan romantic comedy in which men and women couldn't make up their love-bound minds—and that was something he would return to in the 1960s with *Yesterday, Today and Tomorrow* (1963) and *Marriage Italian Style* (1964). In *Yesterday,* for instance, Sophia Loren plays three women, all of whom demonstrate their ability to trick their men. *Marriage Italian Style* is Loren again (with Marcello Mastroianni), and it is an adaptation of Eduardo de Filippo's play *Filumena.* Both are entertainments of a high order, and as realistic as bubblegum.

But something happened to De Sica and it seems to have been his meeting with the screenwriter Cesare Zavattini in 1935 on *Darò un Millione,* a comedy but also a rueful examination of rich and poor. Zavattini became a Marxist in the 1930s, and he apparently cultivated the friendship with De Sica as a way of putting his ideas across. They collaborated on *Teresa Venerdì* (1941) and then, three years later, made the crucial step of *I Bambini Ci Guardano,* or *The Children Are Watching Us.* Some of the novelty of this film was its discovery of a child as a pivotal character; it is disorder as seen through the eyes of a little boy whose parents are divorcing. At the time it was made, no one really identified it as realist, except for the way in which the child's experience was very tenderly spelled out. This did not escape being sentimental, but in hindsight one can see the development of an attempt at social realism and the emptiness of adult lives (without any reference to wartime).

Then, in 1946, Zavattini and De Sica collaborated again, on *Sciuscià,* or *Shoeshine.* Again, children are the leading figures. We meet two boys, urchins and orphans, who have the dream of owning a horse. This is dramatized early on by a superbly shot and edited scene of riding that entirely overlooks the question of how these impoverished kids managed to get

out to the country outside Rome to rent horses for a few hours. Still, it symbolizes the urge in the boys to change and improve their lives—they are bootblacks who serve the American soldiers in the city. Soon enough they get into a life of petty crime and they go to a prison, where the bond between the boys leads to betrayal and death.

Shoeshine is a devastating experience because it seems absolutely sure of a hellish condition in Italy in 1945–46—this despite the great vitality of the child actors. In many ways it seems to enact some principles laid down by the director Alberto Lattuada as a way of addressing a reality that has occurred in every developing country as it has attempted to make its first films:

So we're in rags? Then let us show our rags to the world. So we're defeated? Then let us contemplate our disasters. So we owe them to the Mafia? To hypocrisy? To conformism? Or irresponsibility? Or faulty education? Then let us pay all our debts with fierce love of honesty, and this world will be moved to participate in this great combat with truth. This confession will throw light on our hidden virtues, our faith in life, our immense Christian brotherhood. We will meet at last with comprehension and esteem. The cinema is unequalled for revealing all the basic truths about a nation.

That doesn't ring true in every detail. The "immense Christian brotherhood" is not palpable in many postwar films, even if priests have a few honorable roles (notably in *Open City*). And the self-examination omits altogether the mood that was prepared to go along with fascism—shall we say the "conformism" that is so disturbingly uncovered in Bernardo Bertolucci's great film of 1970. But the question of whether the cinema was or could be "unequalled for revealing the basic truths about a nation"—that gripped people in many countries after 1945 and amounted to a pressure toward realism or commitment. Of course, more than fifty years later, we may have reached the conclusion that whatever film can do with basic truths it is not nearly enough. Those realities may be too vast or obstinate to be trapped in the light. So many of them exist in the dark, or in places where cameras are prohibited.

Immediately, De Sica and Zavattini made *Ladri di Biciclette* (*Bicycle Thieves*), which still stands among the most celebrated films ever made. We are in Rome. A man needs a job desperately to support his family. He gets work pasting up posters on the city walls. But the job requires a bicycle so he can get around the city. The family pawns their only bedsheets

to obtain a bicycle. He goes to work—it is his task to put up posters for the American movie *Gilda*, with a lush full-figure portrait of Rita Hayworth. To do his work, he leans the bicycle against a wall and it is stolen.

How can he or the police make any progress in a city of bicycles? And here something quite profound emerges in the film, a sense of the city, sustained by endless gray perspectives, the rustle of bicycle bells, and the implication of some infinite life going on without regard for this one story.

As the man searches for his bicycle, he takes his young son with him; and so it is that the son has to observe the demoralization of the father, even to the point where the man tries to steal a bicycle himself. He is captured and rebuked, but he is let off and cast loose with a child who has seen and heard. No relief comes in the film. It ends on the question of what will happen to the man and his family.

This film about hopeless poverty opened in New York and played to full houses and laudatory reviews—how far that revenue could be translated into more bicycles in Rome is not clear. The New York Film Critics voted it Best Foreign Film. The Academy nominated Zavattini for Best Screenplay. But in the furor of the moment, the film was significantly interfered with. For some reason, in the United States it was called *The Bicycle Thief*—perhaps this was an attempt to build the father as a character and to distract from the child's helpless complicity or the larger social implications. Perhaps it was just an American idea that the man in a film has to be its hero—when David Selznick saw the picture he straightaway longed to remake it, but with Cary Grant as the man. People laugh at that story, but don't miss how it reveals innocence in 1948. Americans were moved by the film. They wanted to help. Yet in the retitling, an essential part of Zavattini's scheme was overlooked: the way in which theft is the ultimate behavior shared by all the poor in a shattered society. And so the country horrified at the thought of Communist influence suppressed the gentle Marxist interpretation of the title.

Otherwise sane minds were carried away. André Bazin called it "one of the first examples of pure cinema. No more actors, no more story, no more sets, which is to say that in the perfect aesthetic illusion of reality there is no more cinema."

Be careful of the word *pure*! Yes, the man who played the father, Lamberto Maggiorani, was not a professional actor. He was a factory worker. But he was handsome, with a grave, eloquent face, and he did make more films afterward. For a moment, Bazin was so excited that he started enthusing over the way all Italians seemed to be natural actors. The truth was that Maggiorani was asked to act, to register feelings and emotion; he

was charged by De Sica to *play* the man, and who would be astonished if sometimes De Sica acted the part out for him in the way so many directors had done with novices before? Acting is pretending. It is learning a script and working out what it means. And then it is striving to get a shot "right." But what is right in a world allegedly comprised of amateur actors and the trust that nothing will happen except what happens?

Bazin, and many others, gasped at the prospect of infinite reality poured out on our screens. He rejoiced at the lack of design:

> Plainly there is not enough material here even for a news item: the whole story would not deserve two lines in a stray-dog column. One must take care not to confuse it with realist tragedy in the Prévert or James Cain manner, where the initial news item is a diabolic trap placed by the gods amid the cobble stones of the street. In itself the event contains no proper dramatic valence. It takes on meaning only because of the social (and not psychological or aesthetic) position of the victim. Without the haunting specter of unemployment, which places the event in the Italian society of 1948, it would be an utterly banal misadventure.

Zavattini actually called for an end to the culture of people being moved by "unreal things": one day, he hoped, the cinema would be nothing but our chance to reflect on the real thing. You can see the temptation. But who is to say when or how the real thing has been delivered? For example, in the course of their mounting misery in *Bicycle Thieves*, the man and his son are caught in a rainstorm. Rain cannot help but be providential, visible, significant information—call it what you will. I don't know whether the rain was in the script, or it just happened so that De Sica jumped to take advantage of it. It doesn't matter, because the rain is so degrading and spectacular at the same time—it is cinema, just like the light. It cannot help but contribute toward an atmosphere. Yet no raindrops fall on the lens—which means that great care has been taken to get it "right." Or is that wrong?

I don't mean to make fun of *Bicycle Thieves*. When *Sight & Sound* polled critics in 1952 in their first attempt to identify the greatest film ever made, *Bicycle Thieves* came top. It was in sixth position in 1962. Today the film still plays; it works. And any film student should see it. But I don't think many people feel as strongly about it now. Is it that we realize Italy has grown out of its postwar poverty, or have we become more

accustomed to a cinema that concentrates on inward states of being? Have we become blasé about images of poverty and reports of suffering? In the last thirty years or so, our screens have brought us hideous scenes from Sarajevo and Srebenica, Darfur and Rwanda, Haiti and the last great natural disaster, so regularly, so loyally, that we have had to acquire the hardening process that says we are looking at a screen rather than reality. We can endure only so much. We wait to be put in the dire position of having to survive ourselves.

De Sica and Zavattini went on. After *Miracle in Milan* (in which sharp satirical comedy is employed to point up continuing hardship), their next film was *Umberto D.* (1952), which seems to me formally the most interesting of their works. It is a study of an old-age pensioner, a singularly charmless man, and his dog. He has nowhere to live, and the dog is an impediment to his chance of getting a place. Should he kill the dog? Should he kill himself? The bleakness is emphatic and it has always kept down the audience for *Umberto D.*

But there are great virtues: the carefully controlled restriction of sympathy for the man, even with the dog in evidence; the determination to observe ordinary human incidents at the risk of losing dramatic appeal. Indeed, we are very close here to a documentary that might simply record human loss and tragedy. Bazin stressed the way De Sica showed a maid getting up in the morning. "Have I already said that it is Zavattini's dream to make a whole film out of ninety minutes in the life of a man to whom nothing happens? Two or three sequences in *Umberto D* give us more than a glimpse of what such a film might be like."

There were many others caught up in the wave of neorealism. Giuseppe de Santis made *Bitter Rice* in 1948, which is ostensibly a portrait of the very hard life led by rice pickers in the Po Valley, but which also made a great star of the statuesque Silvana Mangano, whose dance sequences led us straight back to the allure of *Gilda*. In 1949, Mangano would marry Dino de Laurentiis, the rising business star of Italian film. In 1954 she would play Penelope (and Circe) in Mario Camerini's *Ulysses* (with Kirk Douglas as the hero). By then, Italy and Cinecittà were into the age of the Italian international coproduction.

•

Michelangelo Antonioni (born in Ferrara in 1912) was on the edge of the neorealist group. In 1943, as Visconti shot *Ossessione*, Antonioni made a documentary nearby, *Gente del Po*. He had helped write the screenplay

for Rossellini's *Un Pilota Ritorna*, and he had a similar job on De Santis's first film, *Caccia Tragica* (1947). He made another documentary, about street cleaners in the city. And by 1950 he would direct his first feature film, *Cronaca di un Amore*, with Lucia Bosé and Massimo Girotti. This was a tragic love story about beautiful people—it seemed like a throwback to old-fashioned melodrama or the salons of Paramount. You might even see a white telephone in it, and Bette Davis clutching it. But it also demonstrated an eye for the city that surpassed the poetry in De Sica and a sense of camera movement that could seem impersonal and undesigned but that became a keynote to the most novelistic Italian director. We shall meet him again.

Perhaps neorealism was always a diversion. There is another Italian cinema, stylish and stylistic, literary and operatic, rich in gesture and architecture. "Grand cinéma" is what Visconti gravitated toward with *The Leopard* (1963) and *Death in Venice* (1971). From *La Strada* (1954) to *Amarcord* (1973), Fellini loved the grandeur of the picaresque. Sergio Leone made infatuated rhapsodies to the Western—above all, *Once Upon a Time in the West* (1968)—with mock symphonic scores (by Ennio Morricone) and pastiche violence. Pier Paolo Pasolini went from the austerity of *The Gospel According to St. Matthew* (1964) to lavish art albums: *The Decameron* (1971), *The Canterbury Tales* (1972), *Arabian Nights* (1974). Décor and moral decay make the tension in Bertolucci's *The Conformist* (1970). And in Marco Bellocchio's *Vincere* (2009) there is a sense of the political-cultural passion of cinema. It's the story of Mussolini's abandoned first wife, Ida Dalser (Giovanna Mezzogiorno), but it draws upon newsreel and the thunderous example of Mussolini himself as an actor or national presence. He longs to have life become a movie, and you know he would have appreciated *The Godfather* or *Raging Bull*. Mussolini and Joe Pesci is one of the meetings that demand computer-generated enactment. If it resulted in madness, that was predicted in the two great earlier works by Bellocchio: *Fists in the Pocket* (1965) and *The Eyes, the Mouth* (1982), both driven by the alarming Lou Castel.

INGRID SEES A MOVIE

Ingrid Bergman was born in Stockholm in 1915. By the age of twelve she had lost both her parents, but she was strong—all her life people would marvel at her inner strength—and she was determined to go on the stage. She grew up tall and beautiful, with a dramatic energy such as few had encountered before. She began to make films in Sweden as an ingenue and she was under consideration for a contract in Germany with Ufa. (Her mother was German.) But in the New York building where David Selznick had offices, there was a Swedish elevator operator who had heard from home how glorious this Ingrid Bergman was. He passed on this opinion (elevator talk) to Kay Brown, who was one of the people who dug up things for Selznick. She had found *Gone With the Wind*, *Rebecca*, and later on she would notice the girl who became Jennifer Jones, but now she said, "There is this Swedish girl . . ."

To cut a long story short, Kay Brown went to Sweden to meet Ingrid. She found a young married woman with a new baby. Would you really give this up to come to America on a chance? asked Kay Brown. Oh yes, said Ingrid, wide-eyed. It is a modern legend that people will do anything for the movies.

She came. She came all the way across America. She went up to the Selznick house on Summit Drive in Beverly Hills on a Sunday, but David was at the studio—this was 1939 and he was working on *Gone With the Wind*. So his wife, Irene Selznick, looked after Ingrid (they would be friends) and took her out to dinner and a party. Still no Selznick. So Ingrid dozed, and then Selznick appeared. He looked at her and said, Oh my God, you're tall, and your teeth, and you need makeup, and that name is too German. Whereupon Ingrid drew herself up to the full five feet ten and said, look, this is what I am; this is what you get. Selznick smiled and said, Okay, we'll sell you as the natural woman.

She became America's darling in a matter of years. Selznick made *Intermezzo* (1939) and then loaned her out all over town: *Dr. Jekyll and Mr. Hyde* (1941), *Casablanca* (1942), *For Whom the Bell Tolls* (1943), *Gaslight* (1944), *The Bells of St. Mary's* (1945), *Saratoga Trunk* (1945). He even put her in a couple of his own films, *Spellbound* (1945) and *Notorious* (1946, one of her most moving portraits of victimhood). *Saratoga Trunk* is probably the only one you don't know; the rest are classics, stepping stones in stardom whereby the world believed that Ingrid was not just natural, lovely, and saintly, but good, good, Good. So what does "good-looking" mean? the public still asks. In fact, despite husband and daughter (in America by now), Ingrid was a compulsive man-izer. When men liked her and said so, she was touched and generous and she slept with them. It's a matter of reassurance: if strangers feel they must love a star, she may reward whomever she meets.

But Ingrid Bergman was not quite happy. She had an Oscar for *Gaslight* (and she is very sympathetic in that film), but she had made a lot of silly films, none sillier than *Spellbound* (a cockamamie story of psychiatry, with Hitchcock and Salvador Dalí and Gregory Peck), and she felt awkward playing a nun in *The Bells of St. Mary's*. She was European still, and one of her lovers, the still photographer Robert Capa, had shown her the bomb sites of Europe. She knew how sheltered and unaware Hollywood was, and she was growing weary of stupid escapism, even if it had brought her liberty. She had seen *Rome, Open City* already in 1946 and been impressed, but now she went into a theater to watch *Paisà* and she came out having seen the light.

She asked her friend Irene Selznick what to do and they agreed that Ingrid should write to this man Roberto Rossellini who had made the two films: "If you need a Swedish actress who in Italian knows only 'ti amo' I am ready to come and make a film with you." If you feed people enough scripts, sooner or later they are going to start sounding and thinking like them. More than that, amid all the dedication to salary and entertainment, there are people who go into the movies for the sex.

There's no need to be too blunt about it, or too censorious, but we are talking about a way of life in which the not inconsiderably ugly Louis B. Mayer (Irene Selznick's father) may have been getting midafternoon blow jobs from studio talent (beauty and the beast), and about the kind of screening room séance where we might all imagine being in the arms of Lana Turner or Robert Taylor (or both). Then there are actors and actresses who have to kiss rapturously for thirty-seven takes at a time and are in-

clined to get a little horny, though the actress may know that later that evening the director, too, wants to go over a few lines to get the mood right. Sexual possibility, the teeming virtual promiscuity behind a straight face, and actual sleeping around, are all in the air. So it's not that Ingrid was so uncommon. But hers was the kind of letter people write if they are in a movie, and not just in the movies.

There was a further paradox waiting to embrace Ingrid and Roberto. She was an international star who longed to find artistic integrity with a director who was not interested in money but who aspired to truth and art. He was an impoverished Italian director, compelled to work on wretched budgets with restricted crews, who dreamed of getting himself an honest movie star and some of that American money. There are earnest volumes in the film library that attest to the artist in Roberto Rossellini. Some of them are so hero-worshiping they may lose sight of the man who was a chronic gambler (and realists do not make good gamblers), a devotee of sports cars, a collector of spectacular women, and an habitué of expensive hotels. That Rossellini exists in the memory of his friends and in press accounts. The two seem at odds, but there is a synthesis: the same man can be a great artist and a fun-loving scoundrel bent on self-destruction.

The Bergman-Rossellini story played out as scandal and tragedy, but with the benefit of time we must see it as farce, too, and the comedy begins in the tangle of opposed desires, with Anna Magnani as an indignant onlooker once she realized she was Rossellini's former mistress.

Ingrid and Roberto met at last and they agreed that they must make a picture together, a work of insight and beauty. Roberto would develop a story and a script. But gossips in the press noticed how the two of them conspired together—we are on the verge of the new age of trash journalism, paparazzi, and the breakdown in the defense of stars by studio publicity departments. In America, Ingrid had had the Selznick organization looking after her. In Europe, Rossellini had no such defense. If stars are going to be free, they may find themselves alone.

Roberto's idea was a love story, though a very unhappy love story, in which a refugee woman from Lithuania (to be played by Ingrid) is taken up by and married to a fisherman who lives on the island of Stromboli, a small, volcanic upheaval to the north of Sicily. Of course, the film would be shot on the island itself. For a moment, at least, before seeing the grim place, Ingrid thought this was sublime and exactly what she wanted. Anna Magnani caused scenes and decided that she would go off and make her own volcano picture. Ingrid and Roberto drew very close.

With money from RKO, *Stromboli* (1950) proved an amazing mish-mash of a film—very clumsy in parts, heedlessly operatic in others. It does not seem remotely real. It feels like Ingrid Bergman struggling to make a testament or stake a claim to righteousness. The shooting was said to be appallingly difficult and ridiculous, yet there are phenomenal passages in the film where Rossellini's camera style and Ingrid's innate histrionic ability soar together. And Ingrid got pregnant, because there was not a lot to do on Stromboli.

By this stage the press was in a frenzy. Ingrid had deserted husband and daughter. Roberto had forsaken his wife and children. There was an outcry, with people saying that Ingrid had betrayed the public who believed she was a nun and a saint and Ilse from *Casablanca*. She was denounced on the floor of the House by John Rankin, a loudmouth from the House Un-American Activities Committee (HUAC), and from pulpits all over the world. In February 1950, Ingrid had a son by Rossellini. She got a divorce in Mexico; Roberto got a divorce. They managed to marry. In America, Bergman's husband, Petter Lindstrom, won custody of their child, Pia. Ingrid next had twins. (Isabella Rossellini is one of them.) And the lovers were trapped.

Roberto may have hoped they would all end up in Hollywood, where he would direct Ingrid Bergman pictures and drive a sports car on Mulholland Drive at sunset. But Magnani got there sooner, and won an Oscar for *The Rose Tattoo* (1955). Ingrid was effectively blacklisted in Hollywood, not because of actual political inclinations, but because of the scandal and the disbelief among America's stanchions of decency. *Stromboli* was a bust at the box office. Ingrid suddenly found herself with three young children, and she was edging up on forty, which can be daunting for those known for a natural look. They had only each other to make films with. They became increasingly unhappy because Roberto continued to play around with other women and because Ingrid realized her crushing mistake. But this is a moment for close and fair attention when, amid mounting hostility and regret, they made a few important films that still wait to be discovered by the smart filmgoer.

In *Europa '51* (1952), Bergman plays Irene, a society woman whose young son dies unexpectedly—seemingly from emotional neglect. Irene begins a kind of breakdown, and she spends time with a Communist magazine editor who educates her in how the poor are living. Irene grows closer to several poor people, with the result that her husband (played by Alexander Knox) has her confined to a mental hospital. The film has

traces of awkwardness (especially with the sound and the quality of the acting), but here at last is genuine social realism and the simple plot embodies the moral crisis of a rich woman in Italy.

In *Viaggio in Italia* (1954), Bergman and George Sanders play a married couple on the edge of divorce. They come back to Italy to arrange the sale of a property that represents their happiness. In the process, they visit Pompeii and come a little closer to the need for reconciliation. Once more there is a feeing of strain—Sanders by every account was miserable during the filming and very uneasy over Rossellini's attempts to improvise. Ingrid may have been more flexible, but in her diary she makes it clear that she found Rossellini's spontaneity disarming and unhelpful. Yet the film is complex, challenging, and often very beautiful. It is a step toward a kind of novelistic filmmaking, with the inner life made manifest in gesture and movement. It is a prelude to Antonioni.

In *Fear*, or *La Paura*, Ingrid and her husband (they speak German) run a chemical factory working on new painkilling drugs, using rats as experimental victims. The wife (named Irene again) is having an affair with a musician. Then a young woman approaches the wife and says she, too, is in love with the musician. She starts to blackmail the wife. The wife cracks under this strain and comes close to suicide, before realizing that the husband is behind the blackmail. It is the least of the three films, yet once again the situation is fascinating (and the cross-reference to *Gaslight* seems deliberate).

These films did no commercial business, and on their first release they received very little critical attention. Ingrid was increasingly unhappy, and beginning to see if she could get back to Hollywood. At last the marriage broke down. Roberto would move off toward documentary and work on historical subjects made for television. Ingrid came back into the mainstream in a film called *Anastasia* (1956), a piece of ahistorical hokum in which she plays a lost woman who agrees to masquerade as the last of the Romanovs, the tsar's daughter Anastasia. But is she the real Anastasia, too? Have your cake, and eat it: she was back in Hollywood. And she won her second Oscar for a performance in a film that comes close to betraying the substance of *Gaslight*.

After which Ingrid and Roberto went their separate ways and the middle-aged Bergman became a conventional fixture again on-screen and -stage: *Indiscreet* (1958), *The Inn of the Sixth Happiness* (1958), *The Yellow Rolls-Royce* (1964), and *Murder on the Orient Express* (1974). Her radicalism was gone as quickly as it had appeared. Her habit of making films that

were scarcely concealed comments on her own life and career resumed in Ingmar Bergman's *Autumn Sonata* (1978), in which she plays a concert pianist who has neglected her own daughter (Liv Ullmann) and has to face recriminations. I do not want to subscribe to the notion that *Europa '51*, *Viaggio in Italia*, and *Fear* are great films, but they are palpable imprints of a passion going cold (an unusual subject in movies in the 1950s) and studies in marital unease. They are pictures that nowadays have rather more to offer than the supposed classics of neorealism, and *Europa '51* suggests with pitiless clarity that the middle class cannot cleanse its conscience simply by enjoying *Bicycle Thieves*. One way or another these films testify to the fact that the pursuit of cinema still depends on story, acting, and faith in the inner life and not on doctrinaire claims for realism. But the way in which Bergman and Rossellini hoped to change the trajectory of their careers is a reminder of how muddled the quest for glory becomes when it bestrides money and art.

SING A NOIR SONG

Do you feel like a noir tonight, or a musical, the two genres that flowered after the war? You want both?

Martin Scorsese's *New York, New York*, which was regarded as a failure in 1977, opens with the news of VJ day hitting New York in August 1945. In all the joy and frenzy, guys and girls are kissing each other and looking to make out on the curl of the mood. We notice one such encounter, and it's weird: she is Francine Evans, a singer with a band, and Liza Minnelli (who was born in 1946) does a pretty job delivering a girl who doesn't think to argue with the sweet sentiments of her songs.

But she is pursued by this wild guy in a Hawaiian shirt, Jimmy Doyle (Robert De Niro), who will not let her go. Does he really want her, or does he just crave the challenge of winning her? He is torrential, a mile-a-minute talker, yet at the same time secretive or shut away. He might be crazy, or acting crazy to divert that aberrant energy. He is too much for her. But he will marry her. They have a child. Then the marriage comes apart—did it ever really come together except as his big show—because he is selfish, sinister, and a little psychotic. He plays tenor sax and will open his own jazz club while she becomes Doris Day—or Liza Minnelli, an adored movie star. She's fond of him always as she sings about "Happy Endings," but she's rueful, because she has learned there is a solitude and an intensity in Jimmy that doesn't do happiness or being together. He talks all the time or he says nothing. Francine is from the church of the musical, and Jimmy is film noir, together in one picture. It's the best movie Scorsese has ever done about a man and a woman.

"Noir" today may be the best known and most honored of American movie genres, and you can make a case for it as the most culturally influential. But in the era when the best noir films were being made, the word

would have meant nothing in America except an affected way of ordering your coffee. *Noir* enters American English consciousness only from French writing on film, above all in the book by Raymond Borde and Étienne Chaumeton, *Panorama du Film Noir Américain, 1941–1953*, published in 1955 (but not translated into English until 2002). It is one of the first examples of French eyes recognizing truths in American film, a search in which America itself was negligent for decades. What Borde and Chaumeton saw as noir was "oneiric, strange, erotic, ambivalent and cruel":

Oneiric, relating to dreams—*The Woman in the Window* (in which Edward G. Robinson dreams he's in a disastrous melodrama); *Point Blank* (where the dying Lee Marvin has a dream in which his honor and prowess are vindicated—it's another part of the dream to call him "Lee Marvin," instead of the character's name, Walker); *Citizen Kane* (in which a man dreams over the moments of his life and wonders if he meant anything).

Strange—*Rear Window*, where amid boring everyday routine in a New York City courtyard a man begins to wonder if the neighbor across the way has murdered his wife—or is the watcher dreaming?

Erotic—*The Woman in the Window*, where the dream involves Robinson's fantasy woman, and the director's (played by Joan Bennett)? *Double Indemnity*, where the crime has its roots in the sexual attraction between Fred MacMurray and Barbara Stanwyck.

Ambivalent—*Out of the Past*, where the apparently good guy, our guy (Robert Mitchum), knows an honest woman and a bad one when he sees them, but still he can't make up his mind, and has given up caring.

Cruel—*Detour*, when a man driving across the desert in a back projection has the rotten luck to pick up a woman from hell ready to tear him to pieces and then die on him. Of all the lousy luck! But luck in noir has become the poisoning of providence in movie romance. This is the one genre that admits we'll lose.

During the war, there was a gentleman's agreement in Hollywood to ease off on making gangster pictures, because they might present the nation in a poor light. But later, many noir films were B pictures, shot

quickly on low budgets, because the noir areas of the screen saved on décor. There is a legend that *Detour* was shot in six days for around $50,000. The truth is not as striking, but it's still typical: it cost $100,000 for a sixty-eight-minute film and seems to have been done in fourteen days. Its director was Edgar G. Ulmer, who had come to America in 1927 as part of F. W. Murnau's team on *Sunrise*.

Sunrise itself is oneiric, strange, erotic, ambivalent, and cruel, and it has all those scenes in the swamp where the hero and a femme fatale, the city woman, are lovers planning to kill an inconvenient spouse. There's more to Murnau's film—including light, an attractive city, love, redemption, and happiness—but there's no mistaking its resemblance to *A Place in the Sun* (1951), a story of gathering gloom in which the wretched Montgomery Clift is shut out of the sunlight of American opportunity, and thinks to drown his pregnant girlfriend in a lake, in imagery of encroaching darkness.

The conventional history of noir says that American hardboiled literature (Hammett, Chandler, and so on) had a lot to do with its development: casual violence, dames and hoodlums, and disenchanted dialogue. But they are both more robust than the neurotic personality of noir. Hammett is tough, practical, and cold; Chandler is romantic and funny—that's one reason Howard Hawks's *The Big Sleep* (1946) behaves like a noir thriller but deeply belongs as a screwball romance. Hammett and Chandler were upright men and battered gentlemen. There's no real doubt in their books about the place of good and evil. But an enigmatic possibility in noir is our growing uncertainty over which is which. So you can find its uneasiness in the light in paintings by René Magritte, and in the voice of Louis-Ferdinand Céline and Patrick Hamilton, too.

Hamilton is a fascinating figure, not just because of how regularly his books and plays were adapted to the screen—*Gaslight* (1944), *Rope* (1948), *Hangover Square* (1945), *Twenty Thousand Streets Under the Sky* (2005)—or because he was himself depressed and alcoholic in disturbing ways. But listen to this, the opening to his novel *Hangover Square*, published in 1941:

> *Click!* . . . Here it was again! He was walking along the cliff at Hunstanton and it had come again . . . *Click!* . . .
> Or would the word "*snap*" or "*crack*" describe it better?
> It was a noise inside his head, and yet it was not a noise. It was the sound which a noise makes when it abruptly ceases: it had a

temporarily deafening effect. It was as though one had blown one's nose too hard and the outer world had suddenly become dim and dead. And yet he was not physically deaf: it was merely that in this physical way alone could he think of what had happened in his head.

It was as though a shutter had fallen. It had fallen noiselessly, but the thing had been so quick that he could only think of it as a crack or a snap. It had come over his brain as a sudden film, induced by a foreign body, might come over the eye. He felt that if only he could "blink" his brain it would at once be dispelled. A film. Yes, it was like the other sort of film, too—a "talkie." It was as though he had been watching a talking film, and all at once the sound-track had failed. The figures on the screen continued to move, to behave more or less logically; but they were figures in a new, silent, indescribably eerie world. Life, in fact, which had been for him a moment ago a "talkie" had all at once become a silent film. And there was no music.

That is an insidious but overwhelming start to a book in which the mind of George Harvey Bone is slipped inside ours, or run as a movie on our screen. He is a pathetic man, living in the London of the phony war, waiting for the bombs to fall, and thinking of murdering the stupid, spiteful woman he loves—when the right "click" sounds. As in some of the best noir films, there is no escaping this insinuation of self-pity and criminal response. Thus the feeling of futility and calm in the narrative voice of Fred MacMurray throughout *Double Indemnity*. (You could add William Holden in *Sunset Blvd.*; Billy Wilder excelled at people luxuriating in their own fatal story.)

So perhaps Hammett and Chandler enriched the chat and the iconography of noir. But *Hangover Square* is an intuition of the physical or neurological experience of watching film as signs of human and social pathology. No one was bothered or able to spell this out at the time, but maybe the deepest significance in noir is a disquiet over film itself and the ways in which it has enacted and armored our detachment from the world.

In those same years of noir, there were obvious circumstantial events to contribute to uneasiness, or the age of anxiety. I mean the revelation of the banality of evil, of cruelty and torture, that spilled out in the imagery of liberated concentration camps. I mean the realization that weapons now existed with a destructive power that might be sudden and universal. In that mood, some people involved in picturemaking and its factory for

happiness felt ashamed of the foolish lies that had been perpetrated. Another betrayal came as the state turned on Hollywood for harboring subversive elements, and the craven picture business succumbed to that specious pressure and blacklisted some members of its own family.

That makes a heavy package of grief and regret, and after 1947 so many people in filmmaking lost their jobs and their confidence. Then came the chance to hesitate as American happiness was mocked by the shrill assertions of advertising (given unprecedented currency and life as the motor of television) that of course we all wanted to be happy, and would be nervous wrecks if we didn't make it. But what if our failure to make a community out of the huddled masses may have been assisted by the separating device of film itself? We thought we were looking at the world in fellowship with it, but the screen doesn't care if we are there, or who we are, so long as we have paid for the seat. The humanism that we hoped was the purpose of art doesn't quite travel in the dark or past the privilege of voyeurism.

In time, a number of films will see this alienation as a subject. In a teasing way, Fritz Lang's *The Woman in the Window* (1944) suggests, "Don't fall asleep—and then don't fall for sleep's screen," because it is a trap waiting for you. Joseph Losey's *The Prowler* (1951) hints that the cop who answers the call reporting a prowler may himself have been that prowler. Dixon Steele (Humphrey Bogart) isn't the murderer in *In a Lonely Place* (1950), but the investigation will reveal that he could have been, because he occupies that poisoned emotional solitude, alone in the movie city. *Sunset Blvd.* (1950) is a melodrama filled with gallows humor, an insider story that jabs us in the ribs; but it knows that even the successes in Hollywood go mad. In Otto Preminger's *Angel Face* (1952), we guess early on that the angel (Jean Simmons) is a deliverer of death, but we can't give her up any more than the Robert Mitchum character who falls for her. *Rear Window* (1954) is a step toward confession from Alfred Hitchcock about the uneasiness of the habitual watcher. That will come to a head in *Vertigo* (1958) and *Psycho* (1960), and nothing less than horror over film runs through Michael Powell's *Peeping Tom* (1960).

That picture is notorious for raising a stream of critical abuse in the London press sufficient to interrupt Powell's postwar career as a director. But Powell was not a defeatist, and he did not lack ingenuity in the face of opposition. So credit something in his withdrawal to at least a passing dismay over what film was doing. The very means of desire were being invaded by dread.

That emerging anxiety is more deep-seated than all the immediate

worries in noir: that the lovers in *They Live by Night* (1949) may be killed;
that people on the run could end up mad; that the great criminal enter-
prise may come undone; that Joe Gillis in *Sunset Blvd.* will end up face-
down in a swimming pool, still telling a story—the one thing he longed to
do on-screen; or even that the end of life may be approaching. Sometimes
noir faded into science fiction, and it's in *Invasion of the Body Snatchers*
(1956) that death by uniformity overtakes people when they fall asleep
and start to dream. You can say that is a metaphor for a society that could
not handle radical outsiders (such as Communists? Or blacks? Or
women?) or people determined to think for themselves, to be part of the
huddled masses but known, individual, different. Isn't that a crux of
America's dilemma now? Isn't it critical thinking that risks being snatched?
So in noir, outsiders (even the mad and the dangerous) begin to become
attractive.

The shift can be seen as part of a filmmaker's feeling that the old
code of happy endings and unmistakable virtue had to be abandoned if
film was going to grow up and earn respect. That's the first hint, on
"home" ground, that villainy (such a hokey word) might be a new facet of
our behavioral mix, that evil might be understandable. The bad guys were
becoming the glowing roles. In *Kiss of Death* (1947), a standard film noir,
it's hard to recall the hero, Victor Mature, not just because that actor was
so subdued, but because the film had lost interest in his character. In-
stead, we watch Tommy Udo (Richard Widmark), in a black shirt, a white
tie, and a filthy raincoat, who pushes an old woman in a wheelchair down
a staircase. And then he laughs in his giggly, whining way. He seems like
a concentration camp guard who got away. It was Widmark's first film,
and it launched his career while presenting him with the problem that
had dogged Peter Lorre: no one might take him seriously except as a
killer. (The film was cowritten by Ben Hecht, who had just been through
analysis.)

The medium seemed to grasp its own split—the lifelike without life's
detachment—so we could be allowed to appreciate a sadist, just as in the
future we would be encouraged to study a rapist, an act of torture, a mur-
derer . . . hell has no limit. In *Vertigo*, the fuss of the central story masks
a vital first: the killer, Gavin, a master of refined cruelty, goes free. In a
few years' time, Norman Bates was not free, but he was on show, holding
Psycho's screen and the identity of the film. You can chart the following
decades with dark characters not disowned by their films: Michael Cor-
leone, Travis Bickle, Hannibal Lecter, Tony Soprano.

•

Yet in the same years of film noir—as *Detour* (1945) crossed with *Meet Me in St. Louis* (1944)—Metro-Goldwyn-Mayer created a string of musicals that are still felt as an epitome of pure cinema and transcendent pleasure. Their dream was not simply that lovers found each other and lived in bliss in a flawless world. It was not even the songs sung in these films. It was that we might all of us sing and dance at the same time with the effortlessness that was the goal of Fred Astaire's relentless work. Of course, that unison was a white lie: in fact, the performers danced to a playback of the songs. But Astaire gave the musical a fluent cinematic style: he wanted to see full figures shot in unbroken coverage. He longed to believe the dream was real.

In hindsight, the color musical seems inevitable. Yet its example has never been attempted again, and it needed many circumstantial advantages, such as the acceptance of Technicolor. So explaining the musical historically is not simple. The genre goes against the grain of the postwar mood, and hangs upon a slight fellow with big ears, a high speaking voice, and no apparent desire to be an actor. Astaire remains one of the more implausible but most adored stars. The genre might not have taken flight without his elusive, cool manner, before "cool" had been noticed.

There had been earlier musicals. Al Jolson (far from cool) was the bearer of sound, talk, and song in *The Jazz Singer* (1927). Metro's *The Broadway Melody* (1929) won the second Best Picture Oscar. Warner Brothers developed what we call the Busby Berkeley pictures, black and white and often aware of the harsh issues of the Depression, but a choreographic lather of girls and orgasmic forms, where the camera was itching to plunge into the center of the big *O*. So Berkeley choreographed (and ordered the shooting of) the big numbers in *Footlight Parade*, *Gold Diggers of 1933*, and *42nd Street* (all three released in 1933), with players such as Cagney, Dick Powell, and Ruby Keeler. These films had aerial shots of waves, and whirlpools of chorus girls opening and closing their legs in time with our desire. It was as if the Soviet filmmaker Dziga Vertov had been assigned to a pornographic ecstasy: *Willing Comrades of 1933*?

At RKO, in the Astaire-Rogers pictures, still in black and white, the exhilaration of the set-piece numbers (as conceived and visualized by Fred) ignored the weightless framework of the stories and their inane romantic complications. In no other area had Hollywood so freed itself of obligatory naturalism, or ventured so close to surreal abandon.

Though everyone knew they wanted fun at the movies, the musical was flagrantly attuned to pleasure. Factory films often clung to common sense: Would the audience be able to follow it? Would it make money? But the musical ridiculed such solemnity. You could think of the picture as a transporting dream, or even an orgy—as in ballet, there was an eroticism in the musical that slipped through the sieve of censorship. Just recall Cyd Charisse putting on lingerie in *Silk Stockings* (1957), a scene that might not have passed the Code in a dramatic film.

At M-G-M, a stronghold of practicality and business efficiency, under the leadership of the producer Arthur Freed, Metro made a series of musicals that look like a campaign to keep people cheerful as war ended and darker threats loomed.

There was a history: Metro had made *The Broadway Melody* as sound dawned. It had produced the Jeanette McDonald–Nelson Eddy films in the 1930s, and it had won a Best Picture Oscar again with *The Great Ziegfeld* (1936), in which William Powell played the showman and the film was an anthology of his numbers. The studio had done *Babes in Arms* (1939) and *Strike Up the Band* (1940), in which Mickey Rooney and Judy Garland were kids putting on a show (and both films were in black and white). In *Broadway Melody of 1940*, Astaire (now under contract at M-G-M) and Eleanor Powell, all in white on a glossy black floor, had done the fabulous "Begin the Beguine" number so that the rest of the clunky picture was forgotten. In 1939 the confusion and hopes behind *The Wizard of Oz* turned into a pioneer fantasy with songs. When Dorothy sang "Over the Rainbow" she was behaving or acting like a character in a drama. "Over the Rainbow" introduced a new possibility of belief in which the studio embraced Technicolor and a bold, theatrical scheme of production design. The musical might be less a studio space—at RKO it was apparent that Fred and Ginger danced on sound stages—than a fictional place that only film could fashion. What is the Hollywood Walk of Fame (begun in 1958) but the Yellow Brick Road with product placement?

Come forward to *Meet Me in St. Louis* (1944). This need not have been a musical: it was based on a series of stories published in *The New Yorker* by Sally Benson about family life in St. Louis at the turn of the century. But the studio gave it color, an adult Judy Garland, and songs by Hugh Martin and Ralph Blane. One of them, "Have Yourself a Merry Little Christmas," comes near the end of the film. The Smith family is about to move to New York for their father's promotion at the bank. But not everyone is happy with the move. Esther (about eighteen) and her kid

sister Tootie (about seven) are looking out over their moonlit garden and the "snow people" on parade there. That's when Garland sings what may be the most melancholy of Christmas songs in a very sisterly manner. Tootie (Margaret O'Brien) is so moved she runs down and smashes the snow people. Father comes home, observes the emotional distress, and decides to forsake his biggest opportunity in life.

As delivered on-screen, the father (Leon Ames) pauses over his desktop (it is like Kane noticing the snowball; it is a scene from a drama) before making his decision. The family will stay in St. Louis. This was 1944, when many people longed to believe that an earlier order and home might be enjoyed again—as if nothing had happened. It's an un-American closure, denying enterprise and mobility, and one of the most touching scenes in a musical.

The film was directed by Vincente Minnelli, who had been raised as a stage art director. He and Garland fell in love on the picture (it shows, and it pushed them into an impulsive marriage). Garland was an actress, to be sure, but she acted best when she sang—the same could be said of Frank Sinatra as a movie star. Minnelli was an M-G-M contract director all his career, and his musicals include *The Pirate* (1948, again with Garland, though they were divorced by then), *An American in Paris* (Best Picture Oscar winner for 1951, and a gaudy vision of Paris as seen by some of its great painters), *The Band Wagon* (1953), *Brigadoon* (1954), and *Gigi* (1958).

The other essential director in this history was Stanley Donen, once a dancer and choreographer, and very close to Gene Kelly. Together the two men were recruited to M-G-M, where Donen would make *On the Town* (1949), *Singin' in the Rain* (1952), *Seven Brides for Seven Brothers* (1954), and *It's Always Fair Weather* (1955). One should add *Funny Face* (1957) to that list, though the inspired and tender pairing of Astaire and Audrey Hepburn was actually a Paramount picture.

How could any studio go wrong with Astaire, Kelly, and Garland? The coincidence of those three seems explanation enough for the surge of musicals at M-G-M. But there was also a stimulus coming from the theater. In this same period, Broadway premiered *Oklahoma!* (1943), *Carousel* (1945), *Annie Get Your Gun* (1946), and *South Pacific* (1949). These shows had a greater faith in story, character, and ideas than the review musical that had been dominant before 1939. They also shone a light on being American and treating an experience that extended beyond New York or Broadway.

M-G-M had ranks of stars. It also boasted Esther Williams, June Allyson, Van Johnson, Debbie Reynolds, and Howard Keel. One could add Lena Horne, who was at the studio and given a few songs (usually removed for the South) but never allowed to become a real star. There were other directors, such as Charles Walters (*Easter Parade*, 1948; *Summer Stock*, 1950; and *High Society*, 1956) and George Sidney (*Anchors Aweigh*, 1945; *The Harvey Girls*, 1946; *Annie Get Your Gun*, 1950; *Show Boat*, 1951; and *Kiss Me Kate*, 1953). To support them, Freed gathered a team of craftspeople: Roger Edens, songwriter and arranger (and the producer of *Funny Face*); Betty Comden and Adolph Green, scriptwriters (they did *On the Town, Singin' in the Rain,* and *The Band Wagon*); André Previn, who joined M-G-M as composer and arranger at the age of fifteen; Kay Thompson, who did so much to look after Judy Garland, and wrote the *Eloise* books, which had Liza Minnelli as a model; the choreographer Michael Kidd (*Seven Brides for Seven Brothers*); not to mention the designers, set decorators, costumiers, and photographers who collaborated on the exuberant prettiness of the studio musicals—audiences still gasp with pleasure at the fresh laundry brightness of *Meet Me in St. Louis* and the devotion to art behind *An American in Paris*, a film that is inseparable from the postwar surge in tourism and cultural expansion in Americans.

But these talents might never have been assembled or needed without the American songbook. These were years in which the nation and the world were singing the works of George and Ira Gershwin, Cole Porter, Jerome Kern, Irving Berlin, Harold Arlen, Rodgers and Hart, Rodgers and Hammerstein, and so many others, including Arthur Freed himself, who wrote the song "Singin' in the Rain." Was that the background of radio and live theater, or was it the weather we call confidence and optimism?

Why did the musical at M-G-M end? The studio was not the same by the mid-1950s. Its founding figures had died or retired. Louis B. Mayer was fired in 1951 and replaced by Dore Schary, who said he was looking for social realism. Production was in decline, and the studio was tempted by blockbusters that carried the company. In 1959 the studio had one of its last big hits, *Ben-Hur*, a reprise of the way it had started out. That Charlton Heston version cost $16 million and grossed $90 million. It won eleven Oscars, yet it's harder to watch now than the version from 1925. We don't want to hear what these earnest biblical folk are saying.

For the musical's demanding schedules, Judy Garland was too unreliable. Astaire was getting to be sixty, thirty years older than Audrey Hepburn in *Funny Face*. Gene Kelly's best years were passing. The songwriters

were fading away (though their songs are still loved). Plus, music changed. Just as the movie musical had been sustained by radio and sheet music, so now pop music broke out in the excitement of rock and roll and a teen-age audience who reckoned the old musicals were elderly, quaint, and sentimental.

Still at Metro, Arthur Freed was driven to make some wretched dra-matic films. Kelly, Garland, and Astaire all sought to be regular actors. A future was being set up where people not alive when they were made might take delight in a retrospective of musicals from 1940 to 1960. In war, cold war, and a new, existential distress, a legend of happiness had been created by those films. You can feel Scorsese's nostalgia for it in *New York, New York*. It had been a way of singing in the rain.

I don't mean to take the musical over the state line and into noir. If you are old enough, you don't forget Donald O'Connor's "Make 'em Laugh" in *Singin' in the Rain* or "The Night They Invented Champagne" in *Gigi*, or every other innocent celebration in the M-G-M musical. But young people don't know those songs, so their wistful moments and soliloquies become more affecting once you hear loss in the melody. It's hard to find a more hushed intimacy than Gene Kelly singing "Our Love Is Here to Stay," in *An American in Paris*, or Astaire coaxing Charisse out of her cold-ness and repression in "All of You" in *Silk Stockings*. The lasting virtue of those songs, and the dances, is their hesitancy on a perilous brink of inner life. It's as if, from somewhere, some sensibility is saying, well, sure, the musical is swell and lovely, but don't you feel warning signs?

Kelly and Astaire kept in search of talented and tireless partners, but two of their finest moments are alone: in *The Band Wagon*, Astaire's char-acter worries that his career and his agility may be over in the song "By Myself," and in *Singin' in the Rain*, Kelly's title number is just a man on a street, with some puddles, an umbrella, and a passing cop. Kelly sees the droll side of this situation, and Donen gives the climax a soaring crane shot. But both numbers speak to being alone, and that is the nagging presence in noir pictures and in a movie culture beginning to realize what was slip-ping away.

It was not at M-G-M, but at Warners that a tragic musical was at-tempted: the 1954 remake of *A Star Is Born*, directed by George Cukor. So much is wrong but provocative in that film. Judy Garland is supposed to be an ingenue who becomes a star, but Garland was at Warners after being fired from Metro. She was only thirty-two, but this was her swan song. Then there is the poignant marvel of James Mason as Norman

Maine, a painful version of the fallen-star story. All of this is done in dark colors and a wide-screen frame where space is a kind of solitude. Then recollect Judy's first song, "The Man That Got Away." Did no one notice how the song foreshadowed the suicide of Norman Maine and a Hollywood where stardom might be a cruel game played with vulnerable people? The studio boss in the picture, Oliver Niles (Charles Bickford), is an unlikely angel, but Matt Libby (Jack Carson), the publicist, is as vicious as they come. And when we see Maine or Mason in the alcoholic sanitarium, we can forget the alleged bliss of stardom. Here's another noir tradition: watch out what you wish for; it can destroy you.

"The Man That Got Away," "Somewhere Over the Rainbow"—do they share a wistful lilt? It could be, because Harold Arlen wrote the music for both. There are songs that have a common tonal character, just like the look of noir. We can no more get those refrains out of our heads than think of noir without shadowed faces. They are like good-luck tokens: "[I] whistle a happy tune, so no one will suspect I'm afraid"(from *The King and I*). Some musicals still cling to that brave principle, and some of us have seen *The Sound of Music* 137 times. But in practice we know how hard it is to shake our fears, despite the refrains, and there is hardly a worthwhile noir picture without some wreck being alone with the music and the camera, worried by the dark or where the music is coming from. Think of Bernard Herrmann's plaintive saxophone melody keeping Travis Bickle company in his cab in *Taxi Driver*, sighing of loneliness and romance, dread and desire.

SUNSET AND CHANGE

Robert Mitchum in *The Night of the Hunter*

Sometime in 1951, David O. Selznick was strolling through a movie studio with the writer Ben Hecht. They had been friends since the 1920s, and Hecht had served Selznick often—on *Viva Villa!*, *Nothing Sacred*, and *Spellbound*, as well as other fast, uncredited doctoring jobs, such as *Gone With the Wind*, where Hecht stepped into the perilous hiatus of January 1939, when director George Cukor was removed, and endeavored to reorganize the script. Hecht had been on $3,500 a day then, and he earned that money by locating Sidney Howard's original script, the one Selznick had rewritten to death, and saying it seemed pretty good.

By 1951, Selznick had sold off his share of *Gone With the Wind* for immediate cash, when there was so much more to come. The one-time independent had let it all be traded back to his father-in-law and M-G-M. He had also given up his first wife, Irene Mayer, and married Jennifer Jones, in a campaign to prove she was a great star. Some people in town said he was crazy and always had been. The double success of *Wind* and *Rebecca* (1940) had masked that for a long moment. But by 1951 he was in debt, at a loss on how to proceed, and downcast. He pointed to the empty stages and told Hecht, "Hollywood's like Egypt. Full of crumbled pyramids. It'll never come back. It'll just keep crumbling until finally the wind blows the last studio prop across the sands." Even in melancholy, he was still making pictures.

Selznick was crazy perhaps, foolish often, but seldom without insight. In his premature despair (things would get worse), he looked back on the past and lamented, "A few good movies. Thirty years—and one good movie in three years is the record. Ten out of ten thousand. There might have been good movies if there had been no movie industry. Hollywood might have become the center of a new human expression if it

hadn't been grabbed by a little group of bookkeepers and turned into a junk industry."

Movies without an industry? That was his most radical thought, yet he was never the man to bring that about. He had believed in Hollywood. Even now, in pessimism, his numbers were wild. In 1950 alone, Hollywood had offered *All About Eve, The Asphalt Jungle, Born Yesterday, In a Lonely Place, Winchester '73,* and *Sunset Blvd.*—not a bad year.

In hindsight, *Sunset Blvd.* looks like the start of a new adulthood, or the peeling away of "Hollywood" nonsense. Billy Wilder was at his peak in the years just after the war, and an archetype of the cynical smartness that has always flourished in Hollywood; it is wisdom done as a wise-crack. He got into pictures in Berlin and he was one of a group of friends who worked on *People on Sunday* (1930), that open-air un-Germanic view of a summer's day in Berlin, a group that included Fred Zinnemann, Curt and Robert Siodmak, and Edgar G. Ulmer.

In 1933, Wilder arrived in Los Angeles with talent and nerve, and shaky English. Under the aegis of his model, Ernst Lubitsch, he wrote scripts—*Bluebeard's Eighth Wife* (1938), *Midnight* (1939), *Ninotchka* (1939), *Ball of Fire* (1941), and *Hold Back the Dawn* (1941). (The last two got Oscar nominations.) Then, in partnership with Charles Brackett, he formed a production team at Paramount that delivered *Double Indemnity* (1944) and *The Lost Weekend* (1945). These are innately American pictures (dealing with insurance and alcoholism), but judged to the inch, sexy, bitter, and pulpy. Wilder would be known later for comedy, and *Double Indemnity* has an early flight of taunting dialogue between Fred MacMurray and Barbara Stanwyck that is not from James M. Cain, but sounds like Raymond Chandler, who wrote the script with Wilder. The couple are flirting on first meeting, and MacMurray is verging on dangerous ground, using insurance as foreplay to seduction.

Stanwyck snaps back at him: "There's a speed limit in this state—forty-five miles per hour."

"How fast was I going, officer?"

"I'd say about ninety."

"Suppose you get down off that motorcycle and give me a ticket."

"Suppose I give you a warning instead."

"Suppose it doesn't take?"

"Suppose I have to rap you over the knuckles."

"Suppose I bust out crying and put my head on your shoulder."

"Suppose you put it on my husband's shoulder."

"That tears it," admits MacMurray.

Does anyone in life talk in that heady rhythm of hardboiled, literary, and sexy? People in movies did for a decade or two. Wilder and Chandler didn't get on too well as cowriters, but the supposing is transcendent. Cain said the picture had things he wished he'd thought of. Yet it's faithful to his novel in that Walter and Phyllis—the leads, the stars—are unmistakably rotten. Their chance at redemption is zero—and not many Hollywood pictures had boasted of such scant hope, let alone in September 1944, when *Double Indemnity* opened and when guys overseas might be telling themselves, "At least my wife has the insurance policy on me."

But Wilder was European, too. He joined the army's Psychological Warfare Division and revisited a devastated Berlin. Wilder was Jewish and he knew the gamble in survival: his mother and grandmother had died at Auschwitz. Disruption and displacement were everywhere he looked. When he came back to America his marriage ended (not that he wasn't to blame for that). He feared his partnership with Brackett was going stale. He was irritable and restless and he could see not just that Hollywood was withering, but that it was increasingly cut off from the larger world it believed it fed.

So in 1948 the idea dawned for a Hollywood picture—not as brave or team-spirited as Selznick's 1937 *A Star Is Born*, not comic and reassuring like *Sullivan's Travels* (1941), but more of an autopsy. Wilder imagined the role of a silent-screen star who is in retreat, alienated from the new Hollywood. She has a name full of echoes, Norma Desmond, and she lives in a mansion on Sunset Boulevard set back from the road, a lost world. Wilder was so clever, but he wasn't "right" straightaway. His first thought was to give Mae West the part; she was horrified at the offer. Then he turned to Mary Pickford. In her late fifties, Mary was intrigued—if Norma could be the big role. But a young writer, D. M. Marshman, Jr., had suggested Norma ought to be a little off to one side. The real focus of the film should be a younger, failing screenwriter, Joe Gillis, who gets involved with her. It was to be a film about that man, and Montgomery Clift was lined up as Joe.

•

Now Clift could do brittle and unsound (he would be Morris Townsend in William Wyler's film of *The Heiress,* 1949), but the public preferred him romantic. You can weigh the tonal shifts in casting if you imagine *Sunset Blvd.* with Monty Clift; it becomes his tragedy. In fact, Clift cried off the

risky venture. He didn't think it would do him much good to be seen as the young gigolo to an older woman. (This fear was sharpened because, in life, Clift was filling that very role with the torch singer Libby Holman.)

So Clift was gone, and Gloria Swanson arrived as Norma. Swanson had been DeMille's big star in the 1920s. She was forty-nine in 1948 and hadn't made a picture for seven years. But she was alert, businesslike, and as sane as Norma was crazed. An old friend, the director George Cukor, persuaded her to play Norma. Then genius passed by—or was it luck? William Holden, thirty in 1948, was under contract at Paramount. He was good-looking, with a quick, friendly smile and a begging voice—yet he had a flaw Wilder noticed, a feeling that he was not to be trusted. The role of Joe Gillis made the actor, and Holden clarified the picture, because it's not enough that Norma Desmond is demented. Joe Gillis has given up the ghost, so death awaits him. He stands for the defunct system as much as she does.

Later on in the 1950s, Alfred Hayes wrote a novel about a screen-writer a lot more successful than Gillis but just as disenchanted. The book is called *My Face for the World to See*, and the unnamed scenarist has seen through the whole sham:

> But it seemed to me, or at least it had seemed to me in the last few years I had been coming and going from this town, there was something finally ludicrous, finally unimpressive about even the people who had all the things so coveted by all the people who did not have them . . . I thought I could speak with a certain minor authority on the matter because now for several months a year I earned a salary somewhat in excess of what they paid an aged vice-president of a respectable bank.

As in Wilder's best work, the coups in *Sunset Blvd.* come so fast you don't think about plausibility. The plot line is exact. The talk is honed. To have Gillis telling the story after his own death is a surprise; his being facedown in the pool is comic. Holden's sleazy charm was a new trick, and Swanson is an unrestrained and alarming Snow Queen, but sympathetic, too. There was more than the public grasped. When Wilder cast Erich von Stroheim as Norma's former husband and director, an edge of cruelty crept in—and Stroheim needed the job. So when Norma runs one of her old movies for Joe, why not use footage from *Queen Kelly*, the un-released picture from 1929 that marked the romance between Gloria and

her financier, Joseph Kennedy, which had been directed by von Stroheim? With von Stroheim's butler operating the projector?

Sixty years later, *Sunset Blvd.* is a milestone. But it upset some people in 1950. It had cost $1.75 million (Wilder was paid $300,000), but the first-run rentals were only about $2.0 million. The film's ending was pitiless. The sardonic touch troubled conventional viewers, bank vice presidents, and movie bosses. (Wilder had to cut a sequence where Joe is telling the story to the other corpses in the morgue!) After a preview screening at Paramount, where the picture was admired by many of the younger people, Louis B. Mayer strode up to Wilder and told him, "You bastard, you have disgraced the industry that made you and fed you." To which Wilder replied, "Fuck you."

There was a hush in the lobby. Mayer was still a force in the business—but only just. The next year, after twenty-six years in charge of M-G-M on the West Coast, Mayer resigned, having been pushed to the brink by Nick Schenck, the head of its parent company, Loew's.

So Wilder seems to win in that confrontation. But not in a sweep. *Sunset Blvd.* was nominated for eleven Oscars, including Best Picture and Director. But it won only for the script, the art direction, and Franz Waxman's score. Official Hollywood flinched from so acid a view of itself. Best Picture went to *All About Eve*, and the direction Oscar to Joseph L. Mankiewicz, for the same film. Of course, *Eve* and its lead character, Margo Channing, agree that show business is a nest of vipers, but a place where we're happy to revel in the great talk and the assurance that Margo (or Bette Davis) is going to be all right, a state of mind that began to run out on Davis herself not long after the glory of *All About Eve*.

•

Something was happening more challenging than David Selznick's vague fears of change. In *Sunset Blvd.* there is a piercing moment—it is still quoted—in which Joe Gillis meets Norma Desmond and realizes who she is, or was:

"You're Norma Desmond. You used to be in silent pictures—you used to be big."

She turns on him in fury. "I am big. It's the pictures that got small."

That remark was intended to cater to the superiority of the audience: it was a way of signaling that Norma was crazy, and that "big" indicated megalomania. But our pictures were getting smaller, and the big screen had competition. The black-and-white imagery of Wilder's film (by John

Seitz, who had shot *The Four Horsemen of the Apocalypse* in 1921) was luminous and state of the art, but we the people were preparing to look at a tiny, warped image in which the grain (the wavering lines) was hideous and tiring. You see, we have been this unbelievable way before and demonstrated that technology impresses us more than pleasure or beauty. We are not huddled for nothing—we are stupid, too, as we insist we are making progress.

In the first few years after the war, the picture business was carried away on a quick wave of optimism, no matter that anyone watching the audience carefully knew that attitudes had altered. But in the heady moment of victory, reunion, and reaffirmation, movie attendance reached a peak: from 1943 to 1946 the weekly attendance in the United States was steadily over eighty million.

It was a moment epitomized in the title *The Best Years of Our Lives* (1946), the Sam Goldwyn–William Wyler picture about veterans returning from war and trying to resume their lives. It is one of those occasions in popular entertainment that identified a widespread mood without strain. The film won seven Oscars, including Best Picture, Best Director, and the acting award for Fredric March, as well as an Honorary Oscar for Harold Russell (a real-life amputee playing Homer, the sailor who comes home to his girlfriend, Cathy O'Donnell, with hooks for hands). This was an impressive mixture of "real life" and novelette, and in 1946 few noticed any misfit. It was a great film when it opened, which is when the business says you need to be great. It got rentals of over $11.0 million on a total budget of $2.5 million (including a late boost for advertising). Moreover, the film was honest: it said vets faced tough problems, not least the greed and indifference of the mass of people who had stayed home. But it was a movie, too, so it assumed those problems would be overcome. Life would be okay—that confidence was there in the advertising, too, the air of reassurance after crisis had supposedly ended. Even the critic James Agee, who detected some coziness in the film, admitted, "This is one of the very few American studio-made movies in years that seem to me profoundly pleasing, moving, and encouraging." He set his reservations aside because he felt the picture was good for us, just as the title was passed on by word of mouth without a trace of irony.

The credible domestic interiors of *Best Years* (shot in absorbing depth of focus by Gregg Toland) are "perfectly" dressed. But in 1946, in its mythic Midwest setting, "Boone City," there is not a television set in sight. Television had been demonstrated before the war, and its technology had

been enhanced by wartime research. But the economic sacrifices of wartime had postponed its arrival as a domestic entertainment, just as the war had delayed the eventual decision in the antitrust cases leveled at the movie conglomerates. War is not always unkind to show business.

But in the late 1940s, as the first television sets began to appear for purchase (laughably archaic to our eyes now), movie attendance was already falling. In popular history, that fall and the rise of television are put hand in glove. It's not the real story. Something was making audiences lose faith in moviegoing before they recognized television. From 1946 to 1947, weekly attendance fell from eighty-two million to seventy-three. In 1948 it was sixty-six million; in 1949 it was sixty-one; in 1950 it was fifty-five; and in 1951 it was forty-nine. Thirty million customers a week were gone in five years—a drop of nearly 40 percent. No wonder Selznick was gloomy that day in 1951; no wonder the studio was empty of work.

What was happening? It is still an area for speculation: reunited lovers sat in the dark for a few years, then they were pregnant and the owners of new homes and families. Such people have never been steadfast moviegoers: their show is at home; they are tired, and a whole menu of practical realities has usurped the role of fantasy in their lives. Some of them had been educated, matured, or saddened by the experience of war and travel. One reason Harold Russell (who had lost his hands in a wartime accident) was cast in *The Best Years of Our Lives* was because of a new respect for painful realities. That same spirit brought several of the new Italian "realist" films to America and then urged Ingrid Bergman to Italy. It had encouraged Billy Wilder to make *Double Indemnity*, a study of corrupt but alluring people who betray that unimpeachable American rock: insurance. The same curdled humanism had reveled in the plight of Ray Milland's alcoholic in *The Lost Weekend*. Then it gave up the ghost, and offended Mr. Mayer, by saying there was dysfunction inside those Hollywood mansions and the factories that supported them.

Don't jump to easy conclusions. In the postwar years, the Best Picture Oscar went to a run of films that were "real," dark, culturally respectable, or suspicious of America: 1945, *The Lost Weekend*; 1946, *The Best Years of Our Lives*; 1947, *Gentleman's Agreement* (which admitted anti-Semitism as an American issue); 1948, Laurence Olivier's *Hamlet*; 1949, *All the King's Men*; 1950, *All About Eve*; 1951, *An American in Paris*.

•

To which you can say, well, all right, *An American in Paris* is none of the above, and who trusts the Oscars anyway? But in the same period, the Academy's stock was high, and other contenders included 1945's *Mildred Pierce* (more James M. Cain, with Joan Crawford's career woman getting it on the chin and her shadowed brow); *Crossfire* (1947); *It's a Wonderful Life* (1946; where the wonder survived only narrowly against a nightmare vision of Americana); *The Snake Pit* (1948); *A Place in the Sun* (1951); *A Streetcar Named Desire* (1951); and *High Noon* (1952; which says the cowardly, selfish Western town no longer deserves Gary Cooper as its sheriff). This is the moment of film noir, few of which were as prestigious as *Double Indemnity*, but which seeped into the American sensibility in a way only the Western had matched before.

On the other hand, the same years saw not just *An American in Paris*, but also the heyday of Danny Kaye, Bob Hope, and Bing Crosby; in nightclubs, in advance of movies, nothing matched the meeting of Dean Martin and Jerry Lewis. There were war films that celebrated war and the way it found character in the fellowship: *Battleground*, *Sands of Iwo Jima*, *Twelve O'Clock High* (where a leader, Gregory Peck, cracked, but morale and the unit held together).

Perhaps the deepest lesson (though few people perceived it at the time) was that the old unity of the audience no longer existed. There were many who still wanted fun, fantasy, happy endings, and a couple of hours of escape. But the atom bomb's shock waves passed through us, along with the truth about concentration camps and the witchcraft called the Red Menace. Was war really over?

We look back now on the late 1940s and the early 1950s as a kind of Norman Rockwell mindscape in which youngish people had new families, their first cars, and new homes. They seem impacted, or content, or like "the American people." But rifts were showing: Were you outraged by Communists or relaxed? What were your feelings about blacks and their occupying normal roles in American society? Jackie Robinson first played for the Dodgers on April 15, 1947. The incidence of divorce surged. Questions were raised about old guarantees: did everyone really admire their parents? More important, more Americans were going to college. Twelve million people went to school on the GI Bill of Rights, many from families that had never known that experience before.

Suppose the movies were no longer quite a mass medium. There was some unease over the old models of fantasy and escapism. There was a yearning for new approaches. There were alternative escapes—the car is

a movie unto itself; its windows are screens that give us a traveling show. And there were millions who wanted nothing to change. But there was not the reality or the illusion of a solid, unified mass. To be positive about it, you might say some of the previously huddled were standing up and looking around. But in a mass society, with so many fresh lessons on the ugliness of human nature, how do you allay chaos and panic, except with a mass medium? A new one was arriving.

By 1950 there were just under four million television sets working (sometimes) in the United States—if you recall Martin Scorsese's *Raging Bull* (1980), in the household of Jake LaMotta (a rich man), the reception was intermittent and close to invisible. Most TV sets were still on the East Coast, and in those places there was a sudden drop in movie attendance—like 30 percent. But as yet only about 9 percent of the national population had sets. By 1962 that level had reached 90 percent. It reached saturation point, but has begun to decline in this new century—because other screens are replacing the television set.

In Douglas Sirk's *All That Heaven Allows* (1955), the widow Cary Scott's (Jane Wyman) grown children are shocked when she contemplates a new marriage, to her gardener Ron (Rock Hudson). To calm her, or to fill her time, they make a Christmas gift to her of the one other thing she lacks besides a man—a cabinet television set. Sirk then cuts away to a piercing shot of Wyman's sad face reflected in the gray screen: she struggles with the age gap and the respectability gap between Hudson and herself. But she never notices the gap that any modern audience is waiting for— Hudson's fond, amused, but disinterested attitude to women. There is even a scene where Hudson's character passes some small talk about "being a man" in difficult situations, and Wyman's character responds, "And you want me to be a man?" Films are helpless in such winds of change, yet *All That Heaven Allows* contains pointed social criticism and a performance from Hudson that deserved a livelier actress.

Was that television set a kind gift? Although it seems a comfort, and a partner to the sofa, television is critically associated with crisis: the deaths of JFK or Princess Diana; an earthquake in Haiti; the tsunami in Japan; the end of the world. We guess if that moment comes we'll be close to our "set"—and then turn it off for final peace? That dread is wittily dealt with in *Poltergeist* (1982), officially directed by Tobe Hooper and coproduced by Steven Spielberg. The angered spirits in an old Indian burial ground turn nasty beneath a house in one of those infinite, bland and dead Southern Californian "developments." The house shakes, the furniture flies, and

the little girl is sucked into the television set, where the Beast lives. She is rescued of course (this is Spielberg), but when their house is ruined and the family retreat to a hotel, they quickly seize the television set in their room and put it *outside*, on the balcony. That is the last shot of the movie, and the stranded, dead eye of the set summoned the opening line of William Gibson's 1984 novel *Neuromancer*: "The sky above the port was the color of television, tuned to a dead channel."

The penetration of our society by television would far exceed that of the movies, even at their best moment. Television became not an entertainment but a service, and when I speak of the role of a mass medium as a safeguard against disorder and fear, just contemplate a sustained interruption of electric light and Internet service in our cities today. Out of touch, we'd be plunged back into the dark. Chaos is so close, and panic is waiting. Television is nearer to electricity than it is to movie, yet we were all raised to believe it had us watching moving imagery, constant sound, and programs or shows.

●

Samuel Paley was born in Brovary, a shtetl near Kiev in 1874. The family name may have been Palinski. His father, Isaac, brought him to America, to Chicago, in 1883, and Sam grew up there, tried a lot of different trades, and ended up making cigars. The business flourished, and his son William was born in Chicago in 1901—it is that first film generation again. Willie attended the Wharton School at the University of Pennsylvania and he was headed for the family business.

As part of that plan, in 1927, the Paleys bought up a struggling Philadelphia radio station, the Columbia Phonographic Broadcasting System. Willie was put in charge of it; his mission was to advertise the family cigars. In a year, sales doubled.

William S. Paley proceeded to gather in more radio stations, and in 1928 he changed his business name to the Columbia Broadcasting System. CBS enjoyed early success, but Paley was ambitious to become bigger, so he was in constant need of fresh funding. That left him open to a first approach from Paramount, the movie empire, which was intrigued by radio as a public show and as a means of advertising, and which had heard about the experiments toward television, though they were being led by David Sarnoff's RCA, which already had some investment in RKO, or Radio-Keith-Orpheum.

When asked about television himself, in 1929, Paley said it was hard

to know how it would be handled, but he predicted it would have to play
in theaters, "because of the size of the theatre screen . . . Perfections in
the projection of motion pictures will play a large part in making televi-
sion applicable to theater, rather than home." That seemed like the right
hunch: audiences were so accustomed to sitting at the foot of a screen as
big as a wall or a building radiant with light. But Paley was wrong, and in
time he resisted television as it intruded on radio. Then he changed his
mind, and rewrote the publicity. By 1948 he was on board, proclaiming,
"Television offers keener insights than printed or spoken words alone can
provide." So he was wrong again. It is the one reliable trait in hucksters.

But Paley always put his soul into negotiating, and gambling. In that
respect he was ready for the movie tycoons. The Fox Studio was interested
in Columbia, too. In 1929, William Fox himself invited Paley to dinner,
patronized him, and promised to "make something of him." He offered to
buy Columbia for whatever sum Paley had paid to put it together. Paley
took umbrage and went to meet Adolph Zukor at Paramount. He con-
ducted himself like a powerhouse: he would grant Paramount a half share
in CBS, for $5 million. Zukor agreed, though his deal was tough: Para-
mount paid not cash but its own stock, to be redeemed in three years. In
addition, it secured six hours a week of free advertising on the radio and
the obligation on CBS to be in profit before Paramount would buy back
its stock.

With the Crash of 1929, Paramount stock fell from $85 a share to $10.
In advance of that, Paley had sold $1 million worth of his Paramount
stock. The movie business faltered. But radio soared in the years of the
Depression; CBS's advertising revenue was up to $14.5 million in 1931. So
Paramount owed CBS $4.0 million for its old stock. It couldn't pay, so
Zukor offered to trade back the CBS stock he had acquired for $5.2 mil-
lion; $4.0 million of that would go back to CBS, which would once again
be controlled by Paley. But to get the $5.2 million, Paley had to go to Wall
Street in a fund-raising operation brokered by Prescott Bush (the father
and grandfather of future presidents) and Averell Harriman. And so poli-
tics and old money entered the mass media in its early days.

This is movie business, of course, with television some way away still,
but it is also the thing Noah Cross (John Huston) swears to protect and
possess in the movie *Chinatown* (1974): "the future." It is also a portrait of
a great operator: in the same years, Paley finessed a Crossley opinion poll
that said NBC was doing far better with the listening public than CBS by
mounting his own write-in response (in his favor). By the early 1950s,

Paley was a more important leader for American culture than any of the movie moguls, most of whom were his friends, obliged to suffer his condescending talk.

This history is also a guide to the driving force of advertising in these American media. Paley had been in advertising before he was a broadcaster, and so he took it for granted. How else was the public going to pay for its media? And here we should observe a contrast with what I have previously called "state cinema."

It was in 1922 that the British Broadcasting Company was founded. By 1927 it had become the British Broadcasting Corporation, with a royal charter defining its structure and ethos. Its chief purpose was to "Inform, educate and entertain," to represent the different areas and voices of Britain, and to address the whole world in its own languages. It was to be funded on a license fee required of all citizens and companies possessing a radio receiver. Later that fee was changed to apply to television reception, and it stood in 2011 at £145.50 a year.

As general manager first and then director-general, John Reith, a Scottish Presbyterian of forbidding austerity and moral principle, led the BBC until 1938. It was the Reithian insistence that the BBC, though funded by state order and policing, was to function as an independent entity, conceiving and making radio as its employees saw fit. Reith was compelled to observe government control during the General Strike of 1926: he was not allowed to air trade union or Labour Party views. He was forced out of the BBC in 1938 because of pressure from the Conservative government. But the principle of an independent broadcasting entity, funded by the public, held.

BBC radio always had its faults and it preferred the un-American attitude that viewers were at liberty to turn off if they wished. That much discrimination could seem elitist—the BBC spoke with an Oxbridge accent for decades—but its reliability as a source of information was not questioned during the Second World War. (Charles de Gaulle was one of many people who spoke to their occupied peoples from London.) It catered to many fringe interests; it calmly refused to be overwhelmed by majority tastes; it had a whole range of services—Home, Light and the Third, which went from mainstream, to entertainment, to intellectual—and it observed those distinctions without any shame. It carried no advertising. It still doesn't, on radio or television, though the pressures to pay its way mount all the time. Britain conceived and carried forward a kind of broadcasting that is self-sufficient and free from commercial pleas, interruption, and

the demented noise of the pitch. It has regularly broadcast things that many people disapprove of, and it has usually resisted that resistance. It has been in trouble with governments. For decades, this bred a mood that cannot be underestimated: that our discourse and our scrutiny deserve to be uninterrupted. Attention deficit was not a common concept in that era, but we struggle with it now and sharp kids use it in their own defense as they snatch glances at screens Bill Paley would have deemed hopelessly small.

This book is not interrupted every sixteen pages by a cluster of advertisements.

•

I hope you are startled to think that the bound signatures of books might be intruded on by advertisements. Isn't it just as ridiculous that on a CD of a symphony, an opera, or a jazz session there could be commercials separating the tracks, or that when you went to see a movie there would be advertising interludes every twenty minutes? We are not minds and beings ready for that sort of crass interruption—are we? And yet we are accustomed to newspapers where the text is mixed in with advertisements. On the Internet, we have to submit to ads to gain access to an item of interest, and we may realize that "interest" begins to be dependent on the necessary push of the advertising. In its first appearance, television assumed our minds were fit to be interrupted. It made a habit.

We have never given enough time to a consideration of the basic experience of television. By the end of the 1950s, it was clearly a force or a wan light shaping children's minds, yet the subject rarely penetrated our educational system to sit beside reading and writing as a fit part of the curriculum. In that same period, research discovered that most children were spending more time watching moving imagery than they were working with words.

In one way, television was less a departure than a return to something Thomas Edison foresaw and which was ignored or bypassed by theatrical movies. In the earliest days, Edison built kinetoscope parlors where single individuals looked into view-finding devices and turned a handle so they had a film show all to themselves. Edison thought it was the future—and he was correct, but not immediately. The first interaction between technology and audience preferred projection, though "preferred" suggests there was a conscious choice or a vote. Instead, the development speaks to the underground urging that will always occur in these things. So, in

the first decades of the twentieth century, people elected to see projected movies in large groups. A hundred years later we are watching images nearly too small to see, in an isolation bordering on secrecy. The question hanging over these changes is whether we ever had a choice, or are we just helpless victims of the light?

Television had a way of presenting itself as just for us. "We'll come to you!" It seemed like a rare facility that meant we had no need to go out at night, get a babysitter, or be presentable in public. It was just one more household service to make life easier. Did that smooth assurance distract us from the way the screen was tiny, the sound dreadful, and the picture quality enfeebled? Did it also prevent us from seeing how the shape and atmosphere of the home were being revised?

The television set was a light source and a piece of furniture reorganizing rooms and domestic patterns. It was placed in a focal or dominant position, and it is chance that the onset of television coincides with the decisions to reduce or stop domestic fires (especially coal burning) for some kind of central heating. So where people had once sat in front of a fire, a table, a piano, or a view, now the television set took over that place of honor or command. Many domestic pursuits, from music to game playing to conversation, suffered in the process. The television screen was not kindly served by being placed opposite windows or lights; such reflections confused or obscured the image. So the set was sometimes placed in front of a window (blocking some of that view) and so much in front of a light that the real light might be redundant.

In the early days of television, there was some confusion as to whether it was better, or safer, to watch with the room lights on or off. Folklore thought turning the lights off was dangerous to the eyes, but it hardly ever realized that television required our looking directly at the light (within the cathode ray tube), whereas in moviegoing we are looking at light that is reflected back from the screen, and therefore softer or kinder. To this day, this is seldom remarked on, yet if you tell people they spend hours in a half-darkened room staring into an artificial light source (through a passing veil of imagery) they are alarmed. There may be no need for that, but do not underestimate the primitive light worship that is involved and that has always been part of film and television. We love the light, even when it is artificial, and we cannot help the irrational assumption that insight and enlightenment may come from it. One thrill gone from theatrical moviegoing now is the beam of the projector, a seemingly solid wedge alive with the writhing smoke that came up from the crowd. As

kids, we sometimes watched the flickering of the movie in that swirl if
the stuff on the screen seemed tame. A theater was cavern-like, with
spells working in the air.

Television had so much more domestic a place; the way it occupied
our time made it as constant as the sofa. Movies gave us wondrous or in-
sane people, paragons and demons. Television offered familiars who came
by at the same time, the same night. *I Love Lucy* ran for six seasons, 181
episodes in all, at twenty-five minutes each. For the 1950s that was ap-
proximately fifty movies. In six years, that's over eight a year, a rate only
small-part movie actors equaled in that decade. The work rate in televi-
sion was extraordinary (it still is), and it exhausted Lucille Ball and Desi
Arnaz. But a similar intensity gripped audiences. In 1945–47, a movie-
goer might visit the theater twice a week. Allow him or her a double fea-
ture, and that is six hours of screen time in a week. By the late 1950s and
into the 1960s there were plenty of viewers (especially young people) who
clocked up that many hours in a day. Looking at the screen had shifted
from being a specific entertainment to a habit in which we might fail to
notice or follow what was playing. We put the television "on" in the way
we turned the lights on.

On its arrival, television seemed to foster company. The first families
with a television set would invite neighbors in to watch. On Main Street,
you saw clusters of strangers watching a television playing in a shop win-
dow. At home, the family group might be seeing more of one another than
they had for years. The best shows (or the worst) sparked talk and argu-
ment, and there were events in current affairs (minor and major) that
became perceived and understood in terms of the television coverage: in
Britain, the coronation of Queen Elizabeth II, in 1953; in Europe, the
Hungarian uprising of 1956 and the building of the Berlin Wall; in Amer-
ica, Nixon's Checkers speech, the Army-McCarthy hearings, the Nixon-
Kennedy debates; and all over the world, the Cuban Missile Crisis of
October 1962. Such things were covered in newsprint and on radio, too,
but screen attention met the urgency of the moment, and newspapers
were hurt. If the world was going to end, people wondered if they wanted
to see the mushroom cloud. Sometimes the medium simply stared at the
waiting. And if Nixon had won that key debate on radio or in press reports
(as many claimed), he lost it on live television. He seemed to be exagger-
ating, or striving. It started an imperative for media ease in politicians
that would find its hero in a former actor. Where had that illusion of com-
fort come from but the movies?

With television, a new form of shock cutting entered our heads. It was insolent but arbitrary, startling then commonplace, outrageous and banal. So we put shock in its place. The breaking news could break your heart, as on November 22, 1963—but two days later, when Lee Harvey Oswald was shot, the possibility of plot, or story, started up. The structures in television programming, or service, often felt more affecting than the shows themselves. There on the sofa, you had to be ready for the sofa exploding. The world seemed to be within reach, but even in a family gathering people felt more alone. With so many people out there, how could *you* matter?

David Riesman's 1950 book *The Lonely Crowd* could have been inspired by watching people watch television. In Arthur Miller's 1949 play *Death of a Salesman*, Willy Loman, an exhausted salesman, is a stranded American everyman who has such dreams of past happiness that he cannot see the living present of his family. We never know what he is selling. Could his suitcases of samples contain television sets? Remote controls? But when he talks about the great times, they are full of light. The play fixes on the idea of "attention," and, in hindsight, it's easy to realize how inattention had become a mounting concern in the most commanding country on earth. *A Place in the Sun,* the film based on Theodore Dreiser's novel *An American* Tragedy, was a key title of the early 1950s, and it asked that the humble be seen—for a moment. David Riesman talked about three human types—tradition-directed, inner-directed, and outer-directed—and there was a sense that victory, prosperity, anticlimax, and a lasting fear had left many Americans trying to decide which category fitted them best.

By 1957 Elia Kazan and Budd Schulberg had made *A Face in the Crowd*, in which a nobody, Larry Rhodes, becomes a monster on television under the name of "Lonesome" Rhodes. That sound had been there in "Willy Loman." Miller admitted that the name was not a reminder of "low man" (as some commentators still suggest). It was remembered from Fritz Lang's *The Testament of Dr. Mabuse* (1933), where Lohmann is a police inspector. The same character and actor (Otto Wernicke) had figured in *M.* "Loman" could also stand for "lonely man," the melancholy that was finding form in film noir, and in Edward Hopper's pictures of people alone in a room. As early as 1939, in his painting *New York Movie*, Hopper had bestowed that wistful mood on a movie theater usherette, a blonde, half asleep, half dreaming, wanting to be in the movie but stuck with her job. Photographers—Weegee and Diane Arbus—had noticed

the fun of the movie crowd, its wild faces lit up by the screen, but Hopper knew that the theater was also a place where lonely people went, people like Hopper himself.

On the opening night of *Death of a Salesman* (February 10, 1949), Miller began to feel lonely, watching the audience from a distance. He saw celebrities at his play: Florence Eldridge and Fredric March (March would play Loman in the very poor 1951 movie version), Lucille Ball and Desi Arnaz (though no one had heard of *I Love Lucy* yet).

But if that sounds downbeat, there were kids on the sofa who knew no other entertainment and who were captivated by a home screen and the prospect that it could reach anywhere. Why not dial up any show, any page of any book, and all the data in the world? Those kids grasped the power of the new medium, its surreal poetry in going from one channel to another, and they began to wonder about "the next big thing." Larry Ellison was born in 1944, Steve Wozniak in 1950, Steve Jobs and Bill Gates in 1955. Of the four, Wozniak was the only one who graduated from college; the others were too busy watching and thinking.

•

I Love Lucy is not just a production triumph and a classic show, but also something that embodied the need for comfort and glue available in television—and no one took the line that it might be art. The charm of comedy is that while you're laughing, you don't have to decide whether you're watching a show or art. Americans have never been more themselves with the screen than in that precious state of relaxation or submission.

Like the boss he was, William Paley enjoyed telling how a distraught Lucille Ball had come to him loaded with woes and worries and "What shall we do?" (it begins to be her show already), and he had calmed her down by saying, "Well, sure, we'll do *I Love Lucy*." But no one ever calmed Lucille Ball or took the desperate look out of her eyes.

She was born outside Jamestown, New York, in 1911, and by the age of fifteen she was in show business, where she soon acquired the chutzpah to try anything and everything. It was her impact as a Chesterfield cigarette girl (a figure in ads) that got her into the Goldwyn Follies in 1933, working with Eddie Cantor, and so she began her attack on the movies. She was pretty and talented and possessed by need—as if those things are enough without luck. She also had a look that could not hide her need, and the camera prefers people who seem as if they couldn't care

less—so her pal Carole Lombard soared; and later on Ronald Reagan went so far just by seeming relaxed.

Lucille Ball had her moments in pictures, in *Stage Door* (1937); *Dance, Girl, Dance* (1940); and *The Big Street* (1942), where her acting is pained and disturbing. She was under contract to Goldwyn and RKO, and she was known to the public. She came close to getting a part in Orson Welles's first big project at RKO, before it was *Citizen Kane*. But she knew she had never quite made it, and the frustration showed. She worked with Groucho Marx in 1938 (in *Room Service*), and he reckoned she was working too hard to be a comedienne when she was really an actress. "I've never found her to be funny on her own," he said.

Company arrived in 1941 in the form of Desiderio Alberto Arnaz y de Acha III. He was Cuban and six years younger than Ball, the son of a rich Havana politician, the mayor of Santiago. But when Batista came to power in 1933, the family fled to Florida. Desi Arnaz drove cabs, worked in a bird store, and did anything he had to before he formed a Cuban band. He and Ball had other relationships when they met (Desi always had other relationships), but their sexual connection was strong, even if he thought she looked "like a two-dollar whore who had been beaten up by a pimp." They clicked, and she began to call him "Dizzy."

Lucille Ball never stopped working, and by the later 1940s she had modest successes—*Easy Living* (1949), *The Fuller Brush Girl* (1950), *Fancy Pants* (1950)—but the increasing use of slapstick was breaking her down physically. She and Desi were forever on the point of separating. And she was closing in on forty, that uninsurable accident for every actress. But she had a radio show, on CBS, *My Favorite Husband* (Richard Denning was the man), which ran from 1948 to 1951. It was about a happy marriage (with comedy), apparently cemented by her frequent line "Jell-O everybody!" a ticlike nod to the show's sponsor. The writers were Bob Carroll, Jr., Madelyn Pugh, and Jess Oppenheimer and they were vital advisers to Lucy and Desi.

Oppenheimer had graduated from Stanford and become a joke writer in Hollywood. It was he who had changed the woman in *My Favorite Husband* from being a serene manager to a rattled kook and pratfall housewife—inspired by Lucille Ball herself. And it was he who picked up on a comment in *Variety*: if only radio audiences could *see* Ball's antic face. So he proposed a show to CBS television in which Ball would be a face.

Desi Arnaz was not first choice to play the husband, because no one had seen him act much, few were sure the couple would stay together,

and CBS was dubious about the public display of a mixed marriage. So Arnaz and Ball did a trial double act in variety that got good notices, and Oppenheimer schemed out a "situation" that he called *I Love Lucy* with Lucy and Ricky Ricardo:

> He is a Latin-American bandleader and singer. She is his wife. They are happily married and very much in love. The only bone of contention between them is her desire to go into show business, and his equally strong desire to keep her out of it. To Lucy, who was brought up in the humdrum sphere of a moderate, well-to-do, middle western, mercantile family, show business is the most glamorous field in the world. But Ricky, who was raised in show business, sees none of its glamour, only its deficiencies, and yearns to be an ordinary citizen, keeping regular hours and living a normal life.

It's striking how the show turned on the ambivalent relationship between the screen and the audience. The movies might be fading, ready to be supplanted by a new domestic version of screened entertainment, but the equation between movie fame and our nonexistence demanded attention. Nothing would be more influential about television than the suspicion that reality was being "disappeared," or conjured with. So *I Love Lucy* made celebrities out of people struggling to reconcile normality and show business glamour.

•

Susan Sontag does not seem like an obvious Lucy fan, but she got it:

> The show was built on an entrancing pseudo-effect of the real: that the very ordinary couple portrayed was played by a real couple, one of whom was extremely famous, successful, and rich. Lucille Ball, a real star, became a goofy housewife named Lucy Ricardo, but nobody was fooled . . . That was the fun of it—the confusion and mixture of televised fantasy and voyeuristically apprehended reality. A dose of fantasy. And the insinuation that we might be watching something real.

CBS television was intrigued by the Lucy project, but unconvinced. This is where Desi took charge. The couple had formed their own company, Desilu, in 1950, and they were resolved that if *I Love Lucy* went

ahead, it would be theirs. At every step that followed, Arnaz pursued that gamble. Told that CBS required an audition pilot, as a sample, he agreed to make it and pay for it himself. The audition was shot on March 2, 1951, and the wretched kinescope (it cost $19,000) was Desilu property.

The kinescope was shopped around to advertisers, and the tobacco company Philip Morris bought into it for a first season (thirty-nine shows at $19,500 each). So they were ready to go, but Desi hated the picture quality of the kinescopes and he was warned they would not last. He took advice and resolved to put the show on film. He was not the only pioneer in this, but no other show put on film reaped such rewards. The price for film was $24,500 an episode, so Desi and Lucille had to take a pay cut. But Arnaz went further: he worked out a way of shooting with three cameras—it was like a business school analysis of the factory system of moviemaking (more or less, all shots in interior scenes are from one of three angles). He decided to shoot in Los Angeles, not New York, to maintain the chance of a film career for Ball. And he said they'd do it in front of a studio audience. The public became part of the show. He is a founding father in so many things, not least in foreseeing our urge to be on or with television ourselves. The studio audience is now a crucial ingredient of many reality shows: *American Idol*, *Who Wants to Be a Millionaire*, *The X Factor*.

Desi took a last gamble: he told CBS, okay, we've caved to you on so many things, so let us own the shows. The network, including the idiotic Paley, agreed. (Of course, Paley was a "genius," too, but a lucky one.) Desi said later he thought CBS agreed because it believed the filming could not work! Instead, Desilu had what became a hit show on film, not perishable kinescope, ready for the big pay-off that would be called syndication. We are still watching *I Love Lucy* sixty years later.

The studio audience helped the comics judge whether and when something was funny; it built in the laugh pauses so hard to calculate without that "live" response; it made the show a theatrical event in Los Angeles, a kind of word-of-mouth; and it meant that the audience, the huddled masses, was part of the show.

Because it was film, Desi knew he needed a good cameraman, and he chose Karl Freund, someone we have met before. He shot *The Last Laugh* (1924) for Murnau and *Metropolis* (1927) for Fritz Lang, as a master of shadow and the cold, threatened light. But he was a professional, too, so after he came to Hollywood in 1929 he shot not just *Dracula* (1931) and *Murders in the Rue Morgue*, (1932), but also Garbo in *Camille* (1936), Luise

Rainer in *The Good Earth* (1937), and Olivier and Greer Garson in *Pride and Prejudice* (1940). Still, the photographer of *Metropolis* was hired to give America the radiant midwestern domestic bliss of the Ricardo household. Freund shot 149 of the episodes.

That was just one sign of the teamwork on the show. It was not simply the leads who were always there, with Vivian Vance and William Frawley in support. There were only ever three directors, and one of them, William Asher, did 101 episodes. Jess Oppenheimer produced 153 episodes, and he, Pugh, and Carroll did all the writing. They worked about three times harder and faster than the teams that had once made movies. The "situation" in what came to be called sit-com television, or family shows, began with the factory family, and that tradition persists to this day. Television, good and bad, is made by close teams working very long days, often on standing sets, and in conditions where the family story they are working on—whether it is Tony Soprano's family or the grouping in *Friends*—may mean more to them than their real families. Television played in domestic places, but its fictional families might be more attractive than your own.

I Love Lucy was the third most popular show in its first season, and then first in the next three, 1952–55, and then again in 1956–57—in the missing year, *The $64,000 Question* pushed it into second spot. *Lucy* won the Emmy for Best Situation Comedy for 1952 and '53 and Lucille Ball won as Best Comedienne in 1952.

Desi had exceeded his budgets, and CBS was afraid the show was going to be a disaster. But by 1952 the American Research Bureau reported that (with 2.9 viewers for every set), *I Love Lucy* was being watched by one fifth of the nation, or thirty million people. The total weekly attendance at movie theaters that year was forty-three million. Twenty-nine million watched the 1953 inauguration of Dwight Eisenhower, but when the episode of *Lucy* came along in which Lucy had a baby, forty-four million tuned in. And television penetration across the nation was still below 50 percent. We liked Ike but we loved Lucy.

Ball even survived the noisy 1953 revelation that, in the 1930s, to please her father, she had been registered as a Communist. Desi responded, "The only red thing about you is your hair, and even that is not legitimate!"

The show is astonishing, still. Time brings out deeper messages maybe, and it's easier now to feel the dysfunction or the frenzy in the Ricardo household. It comes as no surprise to learn that the Arnaz-Ball marriage ended (in 1960), though this early example of "reality TV" was thriving on impossible distinctions: Lucy was pregnant because Lucille Ball was.

Sometimes Karl Freund's high-key lighting is as alarming as anything in
Metropolis. Lucy is a child going out of her mind in the lead-up to femi-
nism in America, and the conservatism of the household is cast iron
enough to feel like a prison. But the comedy is ecstatic, and I refer not
just to Ball's extended silent-screen routines but also to Arnaz's mounting
skill as a straight man. In the tradition of American comedy, *I Love Lucy*
bows to no one, and it has the honor of introducing a woman in the lead
role and family as the disaster area. The show must have sold a lot of ciga-
rettes, which is another kind of dysfunction, and a sidebar in what hap-
pens to the huddled mass if it looks at the light too long.

Desi and Lucille made so much money that in 1957 Desilu bought out
the foundering RKO, the studio that had once doubted Ball's star appeal.
Desilu was grossing $25 million a year in the early 1960s. There is no
more compelling anecdote in Hollywood business history. Just as Desilu
had defined the place of film, a regular crew, and a studio audience, so it
became a factory with twenty-six sound stages that made hit TV shows:
*I Spy, Our Miss Brooks, My Three Sons, The Dick Van Dyke Show, Mission:
Impossible, The Andy Griffith Show, Star Trek*, and so many others.

•

If this sounds like a stretch, play with the links between Desi Arnaz and
Ben Siegel: they gambled and believed their life could be determined and
transformed by the courting of luck. One ended up fabulously rich and the
other was shot to death in Los Angeles on June 20, 1947, several years
before *I Love Lucy*.

Nevertheless, the cut from Hollywood to Vegas is promising. Part of
the potential of Las Vegas was its being just "up the road" from Los Ange-
les. Several years before Vegas became the site of large hotel-casinos, the
small Nevada settlement had been an escape for a few movie people, espe-
cially the gay community: Liberace first performed in Las Vegas in 1943,
when the population of the town was not much more than ten thousand.

The notorious Flamingo was not actually envisioned and created by
Siegel and the Mob. Its first owner and visionary was Billy Wilkerson, the
owner of *The Hollywood Reporter* and of several nightclubs frequented by
the movie crowd in Los Angeles. In fact, Wilkerson was bought out by
Siegel and his syndicate, but the famous scene (from *Bugsy*), of Warren
Beatty walking out into the desert and having his epiphany in imagining
the Flamingo never happened. What did occur was Siegel's extravagant
spoliage of Wilkerson's bright idea. (It is a further part of *Bugsy's* movie

romanticism that the film is in love with Siegel's creative idea, at the expense of the way he and his mistress, Virginia Hill, were skimming several million out of the venture. That's why he was shot.)

But the Hollywood connection never wavered. On that rainy night when Siegel's Flamingo opened just outside Las Vegas (December 26, 1946, six days after Capra's *It's a Wonderful Life* premiered in New York), Clark Gable and Lana Turner were among the movie stars brought in to give the occasion glamour. One of Siegel's close friends was another actor, George Raft, in a symbiotic alliance—Siegel was anxious to be seen with actors, while Raft was drawn to the thrill and money of real gangsterdom.

The flop of the Flamingo didn't last long. Once the careless Siegel had been removed and organized crime took over management of the business, gambling reverted to its normal ways: it made a profit for the house. In turn, the house and then the houses became attractions for visitors, for star performers, and for the considerable range of craftspeople losing work in the movie business from about 1947 onward. Dancers, musicians, set designers, costumers, and hairdressers, to say nothing of lighting artists, were needed in Las Vegas, where a very large set was about to be built (the Strip), and then remade with startling regularity.

Vegas was a screen thrown up in the desert, as if to prove that America had the technical know-how, the money, and the reckless imagination to do it. It was an assault on nature. There was another light show. By the mid 1950s, guests at the hotels would go up to the roof to watch this sensational projection: the testing of nuclear weapons in the desert no more than a hundred miles to the north. They gasped and sighed, as if at a fireworks show, which doesn't mean they weren't afraid, too, in their hearts. Las Vegas was a new city where there was a violent cut, from the real to the insane, every time you blinked.

In 1900 the entire population of Las Vegas (or the white population) was said to be twenty! By 1931, when gambling was legalized, the state had 91,000 citizens. In 1940 it was up to 110,000, with about 8,500 in Las Vegas. By 1960 the numbers were 285,000 for the state and 64,000 for the city. By 1980, 800,000 and 164,000. Today, the population of Las Vegas is close to 600,000 in a state with over 2.6 million. In the last decades of the twentieth century, the state and the city were unrivalled in their rate of growth in the United States. But with the new Depression (i.e., now), Las Vegas got ready for a magic trick only philosophers and hermits had predicted: going back to being a ghost town, or nothing. The cuts keep coming.

The state revenues from gambling were $21 million in 1946 and $550 million in 1970—that figure does not include the turnover from hotels, restaurants, shopping, and tourism in general. The revenue from the movie industry in 1970 was $1.1 billion. But since then, the revenue from gambling has surpassed box office income. By 1991 the gambling revenue for Clark County (which includes Las Vegas) was over $4 billion.

There are other factors involved: the absence of a state income tax in Nevada encouraging retirees who may never gamble; the early availability of cheap and spacious housing in Nevada; what is called a benign climate; the development of other industries in the state; and then the integration of gambling into so many other parts of the nation so that the unique allure of Las Vegas was diluted. But those factors cannot detract from one kind of fantasy competing with another in the field of American entertainment. Anyone visiting Las Vegas quickly (and few stay long) becomes aware that the city is a light show in which the sun is secondary or superfluous. The Forum shopping area, attached to Caesars Palace, is a beguiling theatrical environment where several times an hour the lighting scheme goes from day to night and back again. It is a vast sky-screen, a listless movie loop that makes us want to purchase.

The structures and the styles of the city were never meant to conform with the rest of America. Instead, they are founded on change, instability—the way in which film sets were built, struck, and then remade—and the larger aim to make their physical world a pliant enactment of desire and dream. Reyner Banham is one architectural historian who saw the crossover from movies to Las Vegas (this is from his 1971 classic, *Los Angeles: The Architecture of Four Ecologies*):

> Los Angeles had seen in this century [he meant the twentieth] the greatest concentration of fantasy-production, as an industry and as an institution, in the history of Western man. In the guise of Hollywood, Los Angeles gave us the movies as we know them and stamped its image on the infant television industry. And stemming from the impetus given by Hollywood as well as other causes, Los Angeles is also the home of the most extravagant myths of private gratification and self-realization, institutionalized now in the doctrine of "doing your own thing."

Banham added that the studio lots, with their anthology of different sets, were a prelude to the boisterous fantasy enactments of the Vegas

casinos. So there have been Parises at every major studio; there is a Paris in Las Vegas; and there is the Paris of films such as *Moulin Rouge!* (2001) and *Inception* (2010), where we are encouraged to believe that real places serve more usefully as backdrops for our imagination.

Las Vegas was noir in neon color before film noir had dared reach that far. It was, in its first decades, a site of brief but deliberate escape for the common, huddled America, a destination where working-class and lower-middle-class tourists could come for a long weekend, inhabit an unimaginably large hotel room at a low rate, gamble, get a hooker (or gaze at women who might be hookers), and believe they were brushing shoulders with gangsters and their dames. It was not so far from being in a movie. The leftover affection from that idyll can be felt at the end of Steven Soderbergh's *Ocean's Eleven*, where the movie just dwells on the lights, the fountains, and the mirage of the place. There were floor shows that aspired to the standards of the Folies Bergère and where star performers could be seen: Noel Coward, Marlene Dietrich, Judy Garland, Martin and Lewis, and then the Rat Pack, whose ongoing reality show in the hotel-casinos was more daring and less censored than their archaic movies.

So as Hollywood's own glamour began to decline, and feel the beginnings of shame, Las Vegas offered a remake, a parody, and then a pastiche of it. But the look of the place, even its amber glow in the sky seen from afar, like a vast drive-in, is all circumstantial compared with gambling's extension of the narrative fantasy of movies.

When we went to the movies, our pursuit of happiness was being courted at arm's length. For a very modest outlay financially, we could imagine ourselves in the arms of Donna Reed or Jimmy Stewart (it's a wonderful kiss) and think ourselves into the secure, stable happiness of Bedford Falls, even if we knew we lived somewhere closer to Pottersville (these are the opposed townscapes of Frank Capra's *It's a Wonderful Life*). In theory, we knew we were dreaming, or pretending, and the whole process was given the polite gloss in Americana of offering delight and consolation in hard times. Very few wondered if the play upon fantasy might be addictive or dangerous. It was enough that the cohesion of the growing society was assisted, and its morale helped, by the entertainment.

In Las Vegas (and all the subsequent sites for gaming) the deal was a lot blunter, but equally reckless. The fantasy was interactive: you could win, and lose, on the spot. You put down as much as you wanted, as much as you had, or as much as you could borrow, for the chance at a mythic happiness—the big win, the golden moment, breaking the bank. There

were many ways of describing this reward, but none of them made it more likely. In an allegedly conservative, hardworking, practical, and realistic nation, founded in God, honesty, and a fair deal, some of us persuaded ourselves that we could get the big Happiness of the right numbers coming up in a row. Everyone knew what a long shot they were following. But they took the chance, which was an early sign that soon the American habits of saving your money and being prudent with the economy were doomed. The adrenaline of fantasy was surging through our veins. Increasingly, the stock market was perceived as a casino, and in the great financial crash of 2007 and onward the practices of fraud, criminality, and deceit were institutionalized. The masses were as huddled as ever, and the light of entertainment was a blinding and imprisoning force.

Not the least result of this was both an astonishing adulation of the lucky winner as an American ideal, and the actual increase in the statistics for suicide in Clark County (the highest in the nation, with people 54 to 62 percent more likely to kill themselves than average citizens in the United States).

But even that new and deranged economic model is not the end of the transaction. Gaming, or picking directions at random and by whim, had altered the bases of narrative. When the movies began, the moral codes in narrative were strenuously underlined, especially in popular fiction, but in the great novels and dramas, too. Novelists from George Eliot to Henry James weighed the moral being of their characters, and even if the authors might have lost their own guiding religious faith, their humanism and their interest in social well-being were hinged upon the moral impact of how things turned out. In *The Portrait of a Lady*, Isabel Archer is left up in the air at the end of the novel—and we are there with her—but the outlines are clear on the choices she has made, the traps she has found, and the large things she still needs to do.

That pressure is very strong in silent film; indeed, it may now be a moralizing impediment to our pleasure with such movies. There was also an emerging contradiction between the helpless observation of appearance and the assertion of inner values. More and more in films, we watch people and refrain from judgment. The clearer and closer the scrutiny, the less easy it is to reach a moral conclusion.

Then add to that natural predicament the sheer overload of story, a slide that becomes an avalanche with television. Our stories, the narrative shapes we invent to explain the world to ourselves, resemble one another. And as you watch movies, where the formulaic begins to congeal,

that pattern becomes inescapable. Hollywood repeated stories that worked. With its great stars, it searched for "vehicles" for Joan Crawford or Bette Davis or whomever, so their films became copying devices, re-iterations of familiar typologies and principles—they became Joan Craw-ford pictures and not particular, fresh stories. That potential was drastically increased by television, where Lucy and Desi replayed the same "situa-tion" week after week: Lucy has a crazy scheme or need—can she get it past Desi? It will all end in a great sigh and a forgiving embrace.

It wasn't just that the audience was getting a shot of *I Love Lucy* every week. In the same week, they were getting *Amos 'n' Andy*, *Strike It Rich*, *The Jackie Gleason Show*, the various Arthur Godfrey shows, *The Red But-tons Show*, *Our Miss Brooks*, *The Jack Benny Program*, *The George Burns and Gracie Allen Show*, *I've Got a Secret*, *Two for the Money*, *The Million-aire*, *Topper*, *The $64,000 Question*, *The Ed Sullivan Show*—and these are just the CBS offerings. There was another large network, NBC, that had its own shows, and ABC was struggling to rival them. Some of the shows I've named were not strictly fiction; they were game shows, talk shows, or reality TV, but they were many of them thoroughly written and often rigged. So little could be trusted.

Comedy shows and game shows were looser, and we felt we were watching real people. (Remember Susan Sontag's words.) But coming along was a host of real fiction shows. They had the same characters epi-sode after episode, but they posed as crucial dramas; they solved prob-lems so relentlessly you wondered how problems kept arising; they were earnest and ponderously repetitive: *Gunsmoke* (the most popular show in America from 1957 to 1961, the moment of John Kennedy!), *Wagon Train*, *Have Gun—Will Travel*, *The Rifleman*, *Perry Mason*, *Rawhide*, *Bonanza*, *Dr. Kildare*, *The Defenders*, *The Fugitive*—hour upon hour of it, day upon day. I daresay some of you loved those shows for an hour and a season. We "all" watched them. And as we lived with them, how could we avoid seeing that story was like a game, with the same cards seeking a different arrangement every week, and the moral conclusion seeming increasingly unbelievable?

Few things are more decisive in the history of the mass media than this undermining of story as a thing of educational value. But the proposal in gambling is to subvert ordinary value or worth and to impose the arbi-trariness of chance on all other codes.

•

Once you've noticed the gambling instinct, you see it everywhere; soon you can't cross the street or get married without weighing the risk or the win. So, would you rather make *Harvey* or *Winchester '73* (both from 1950)? To make that decision, you must pretend you're Jimmy Stewart—hasn't everyone tried that impersonation? Didn't Jimmy and nearly every other actor ask that we try? (There's only one actor you've never heard an impression of, Spencer Tracy, and that thought comes from James Curtis, who gave years of his life doing a biography of the actor, so calm on-screen, so turbulent in life.)

James Stewart was born in Indiana, Pennsylvania, in 1908, the son of a hardware merchant. He got a degree in architecture at Princeton and joined the University Players in Massachusetts, a group that included Joshua Logan, Henry Fonda, and the actress Margaret Sullavan. He went onstage as an appealing but very thin romantic lead. There was a sweetness to him, a boyishness that attracted women and the liberal aspirations of directors such as Frank Capra, even if Stewart's own politics were to the right. As part of that charm, he leaned on his natural urge to hesitation and country drawl. Soon that act was a part of him.

He was put under contract by M-G-M, and he became a popular favorite. He formed an intriguing on-screen bond with Margaret Sullavan—he loomed over her, but she was the commanding figure, and their two voices (his shy, hers throaty) worked together. He felt like her lover and her child. So they did *Next Time We Love* (1936), *The Shopworn Angel* (1938), and *The Mortal Storm* (1940), and found their masterpiece as Alfred and Klara in Lubitsch's *The Shop Around the Corner* (1940), set in a studio-made Budapest, in a novelty gift store at Christmas, with two people cool to each other in person, unaware they are pen pals falling in love.

Beyond that, Stewart had several big hits: he was in Capra's *You Can't Take It with You* (1938), and then the soulful rural senator in Capra's *Mr. Smith Goes to Washington* (1939), filibustering for justice; he was the laconic cowpoke who tames and enchants Marlene Dietrich in *Destry Rides Again* (1939); and he won the Oscar playing the reporter in George Cukor's movie version of *The Philadelphia Story* (1940). That award seems a touch perverse: Cary Grant does have the lead role, but in his heyday no one really got Grant any better than the Academy understood that *The Shop Around the Corner* was destined to be a treasure.

At which point, Stewart went off to war (he was underweight and had to cheat his way in). He flew bomber missions over Germany and rose to

the rank of colonel, with decorations. But at the end of the war, he had a crisis, if not a breakdown, because of the stress. He came back a little heavier, with gray in his hair and more sadness in his eyes.

He was not sure what to do. "Frank [Capra] really saved my career," he would say. "I don't know whether I would have made it after the war if it hadn't been for Frank. It wasn't just a case of picking up where you'd left off, because it's not that kind of a business. It was over four and a half years that I'd been completely away from anything that had to do with the movies. Then one day [he] called me and said he had an idea for a movie."

That idea was George Bailey in *It's a Wonderful Life*, a man presented with an ultimate gamble: to live or die, to keep Bedford Falls intact or let it turn into Pottersville. At the time, the public wasn't bowled over, but history knows better. George Bailey is at the heart of the Jimmy Stewart legend, as a savings-and-loan manager dedicated to his hometown and identified with Christmas. It is an enchanting myth, even if Pottersvilles have won the bet in so many ruined places in America.

In truth, Stewart was more of a businessman. But when he came back from the U.S. Army Air Forces he found himself without an agent. His old handler, Leland Hayward (who had been married to Margaret Sullavan—it was a small world; she had married Henry Fonda, too), was going into theatrical production. Hayward's future was *Mister Roberts* (1955) and *South Pacific* (1958), on Broadway. So Stewart moved over to another stable.

•

Louis, or Lew, Wasserman was born in Cleveland in 1913, the son of a bookbinder from Russia. At the age of twelve he got a job selling candy in movie theaters and he was on the edge of the city's Mayfield Road gang as a wistful onlooker. As he grew up he became an agent in the local music business, joining Jules Stein, who had founded the Music Corporation of America (MCA). It was in 1940, seeking to grow, that Stein sent Wasserman to Hollywood, where he had no clients as yet. Things developed, and Wasserman is the most important show business arranger this book has yet touched. The MCA client list grew, because Wasserman had seen that the role of agents was changing.

Agents were fringe figures once, kept around to agree with their clients and to process paperwork. Those tasks abide, but Myron Selznick had altered the nature of the job. He was an older brother to David Selznick, and a son to Lewis J. Selznick, a big shot in the early picture business until he went broke. Myron longed to make good on his dad's name

and he was a tough businessman. As sound arrived, Myron saw a way to take some of the talents (actors, writers, and directors) and demand higher salaries as their contracts came up for renewal. He loved to insult and exploit the studios. But a contract generally lasted seven years, with set increases, so the agent didn't have a lot to do. Myron was a savage alcoholic and he died in 1944 at the age of forty-five. Leland Hayward inherited some of his clients and a lot of his methodology, including the realization that if actors became corporations and reported profits instead of income, their tax bill could be greatly reduced.

Wasserman was the heir to this scheme. He also saw that in postwar Hollywood, with studios looking to cut back on contracts, a few top stars had exceptional bargaining power. So he talked Stewart into not renewing at M-G-M, and he encouraged the actor to go independent. Stewart was smart enough to understand that prospect, though not every performer could have overcome the insecurity of being out on his own. The actor said he was doing it all for Frank Capra (and *It's a Wonderful Life* had a problematic budget, ending up over $2.3 million), but he did it for $200,000, more than Capra's salary.

Wasserman got him $300,000 for Alfred Hitchcock's *Rope* (1948). And then Universal approached Stewart and asked if he would do two films for them: *Harvey* and *Winchester '73*. *Harvey* was a play by Mary Chase that opened on Broadway in November 1944 about an eccentric, Elwood Dowd, who has as his best friend a life-size white rabbit (named Harvey) that nobody else can see. It was a gentle version of the doppelgänger theme. Frank Fay introduced the role of Dowd, but then Stewart took over and had considerable personal success. Talking to a rabbit, he could be as ruminative as he liked.

Winchester '73 was a Western, about a prized Winchester repeater rifle that changes hands several times, as if it were the ball in a game of roulette. For a time, Fritz Lang had worked on a script for it, but that had been dropped. The studio still liked the idea. Wasserman asked for $200,000 for each film, which was not out of line with Stewart's current value. But Universal was alarmed. By then the trend in audience decline was emerging. They liked Stewart. They thought *Harvey* was a natural, and *Winchester '73* appealed because it was about a gun. But they didn't like the fee.

In consultation with Stewart, Wasserman proposed that Stewart do the two pictures for nothing up front, but he would be in for 50 percent of the profits, granted that "profits" was a variable blessing that meant what was left over after the studio had applied the film's costs, an overhead,

a distribution fee, and anything else they could think of. There are still people waiting for "profits" from movies the world regards as hits. But Stewart told Wasserman to take the gamble.

Stewart could have looked like a chump, a man talking to imaginary creatures. The studio believed they couldn't lose. *Harvey* the play had run for 1,775 performances and is still revived onstage. But maybe everyone interested had seen it already. The film did not do well, which doesn't mean Stewart fans don't treasure it. *Winchester '73* was another story. Anthony Mann directed it in black and white, with a script from Borden Chase that saw Stewart winning the rifle in a shooting contest (presided over by Wyatt Earp), then losing it. The rifle passes through many hands: his evil stepbrother (Stephen McNally), an Indian chief (Rock Hudson), a sly trader (John McIntire), a coward (Charles Drake), and a raffish gunman (Dan Duryea). It is a brisk adventure Western, and Stewart has that hard edge that would distinguish him in the 1950s in a string of other Westerns made with Mann: *Bend of the River* (1952), *The Naked Spur* (1953), *The Far Country* (1954), *The Man from Laramie* (1955).

Winchester '73 took in over $2 million, and when the profits were dealt out, Stewart had $600,000. The first lesson was that star actors might be profit-earning businesses, or even their own production companies. Profit participation was not unknown before 1950, but it was rare, and when it happened it was often kept quiet. On most of our classic movies, the actors lived for years and decades without a residual dollar from their success. On *Gone With the Wind*, Clark Gable got $4,500 a week with a bonus of $16,666, and Vivien Leigh was paid $20,000. But there was nothing for them after that in the decades of *Wind*'s revenue.

Another lesson was that the Western was viable as it had not been before. There had been B picture Westerns and star figures such as Tom Mix and William S. Hart. John Ford had made Westerns, *Stagecoach* (1939) and his cavalry pictures, and, in the late 1940s, *Duel in the Sun* and *Red River* had done well at the box office. But the Western of the cold war era was a stern moral genre, about honor and justice and duty. It seemed capable of producing important pictures that turned on American resolve. There was a martial undertone, and guns were potent. Think of the scene where Shane teaches the boy Joey what a gun is, and of his final use of that gun to protect the farming community.

The Western was more violent now: the scene in the salt flats in *The Man from Laramie* in which Stewart is shot in the hand as undue punishment is still shocking. Righteous violence was a force in such films, and there were several that celebrated weapons: *Colt .45* (1950, with Randolph

Scott), *Springfield Rifle* (1952, with Gary Cooper), *Carbine Williams* (1952, Stewart again), Samuel Fuller's *Forty Guns* and *Run of the Arrow* (both 1957). These Westerns have an unequivocal sense of enemy, white or red, and that racial tension leads to Ford's *The Searchers*, where John Wayne sets out on a mission to find and eliminate the niece who has been taken away and "married" by a Comanche chief.

Meanwhile, Lew Wasserman sat in his office, wearing the black suit and tie that became the uniform for his growing staff, and doing more and more deals. One observer reported that MCA thrived because of Lew's drive and because "they were great tax people . . . They would show a star how to save more of what he earned than anybody else in the world could." That was how the agency broke down the reluctance among many actors to do television in the 1950s—a superiority that lingers even if it leaves a few big-screen loyalists looking very isolated.

One of the clients at MCA was an actor who had made some routine Westerns without much success. He was hard up; he had an ex-wife and two kids and a new wife. He needed a job. He was not important enough to command Wasserman's attention. But he had his own subagent, Arthur Park, who managed to get him $125,000 a year (a big lift) to host a TV anthology series. The advertisers took him on because he seemed "a good upright kind of person," and the stories to be told were subsidiary to the company image: *General Electric Theater*—it was a title worthy of Marshall McLuhan as a description of television itself and our role as "consumers." The actor was Ronald Reagan, though he was shifting over from actor to personality. The profit participation would come later, in 1966, when Reagan got another part, as governor of California.

•

No one thought *From Here to Eternity* could be made. James Jones's novel had appeared in 1951 and been a best seller (five hundred thousand copies in hardback in the United States). That prompted thoughts of a film, but Jones then had "ruined" the plans with a timid treatment intimidated by censorship. In his version, the officer's wife (the Deborah Kerr role eventually) was made his sister, the officer was a decent guy, and there was no real criticism of the army (The only person who criticized the U.S. Army at that time was Senator Joseph McCarthy, and it ruined him.)

Harry Cohn, the head of Columbia, had paid $85,000 for the film rights, and he was worried. "The New York office was laughing at him. "It was the typical gesture of a gambler," said Fred Zinnemann. Then a

screenwriter named Daniel Taradash said he believed he could lick it. He deleted the bad language, he simplified the book, and went for the core of what Jones had been scared to try. It wasn't easy or quick. As Taradash said, "Cohn always liked to talk primarily to the writers, and his whole method was to irritate you, ask the same thing over and over until he drove you to the wall. When he saw you were about to attack him physically, he said, all right, go ahead, do it, because he knew you really believed in it. But that can drive you crazy after six months."

Taradash and the assigned director, Fred Zinnemann, were following a path Frank Capra had charted with Cohn. But the film became a model of what the old system could do when inspired by the thought that times were changing. Hollywood was crazy about doing anything that had never been done before; it's a restlessness it learned from audiences. *From Here to Eternity* was an 800-page novel done in 118 minutes for the screen. The bad language was cleared away. The sex was almost eliminated—though the film would be famous for a love scene between Kerr and Burt Lancaster sprawled in the surf on an Oahu beach that was a model of sexual suggestion (and "splendor") before censorship cracked apart. (It was good for tourism, too.) The film was cleverly and luckily cast: Lancaster was an emerging figure in the early 1950s; Deborah Kerr took over when the first choice, Joan Crawford, got fussy and afraid over how she would look— Kerr had the charm of a "nice" girl turning dark; that sweetheart Donna Reed (the loving wife in *It's a Wonderful Life*) was cast as the coded whore; Frank Sinatra got the vivid role of Private Maggio, not thanks to underworld pressures but because first choice Eli Wallach was committed to a Broadway play (*Camino Real*, by Tennessee Williams); and the central character, Prewitt—a rough, rural, rather dumb kid in the book— was made adorable through the beautiful and valiant figure of Montgomery Clift. Cohn had wanted to use his star-in-development Aldo Ray—better casting for the novel, but a potential downer for the movie. Clift was an "elevated" actor; he made Prew accessible to millions who would have hated to join the army.

So here was a film opening only weeks after armistice in the Korean War, critical of army codes, with two failed love stories and the death of two heroes, leaving Pearl Harbor in tatters and without a hint of revenge, and it was an immense success. On a budget of $1.65 million, it earned U.S. rentals of over $12.0 million. And Taradash had an unprecedented deal of 2.5 percent profit participation—"I believe they went with it because they thought it would never happen." The film was nominated for

thirteen Oscars and it won eight (it tied *Gone With the Wind*). Even James Jones thought it "immensely fine."

Manny Farber was grudging but alert about the film in *The Nation*. He admitted it was a "fourteen-carat entertainment," and he thought Sinatra was the discovery as an actor, just as Donna Reed excelled unexpectedly when the camera "uses a hard light on her somewhat bitter features." The trouble for Farber was "that it is too entertaining for a film in which the love affairs flounder, one sweet guy is beaten to death, and a man of high principles is mistaken for a saboteur and killed on a golf course." He had a point: even the downer elements are given a high gloss. At the conclusion, when Kerr and Reed meet on the ship sailing home from Hawaii, it is with a note of being older and wiser, not quite destroyed. We fear they may go home to be "better women."

Farber felt the persona of Marlon Brando lurking behind the film. Clift was four years older than Brando, but they were both from Omaha, Nebraska. They were handsome, very talented, and they owed some allegiance to the director Elia Kazan and the influence of the Actors Studio that Kazan had helped found in 1947 (with Cheryl Crawford and Robert Lewis). They shared something else, not just as new faces, but in carrying themselves with a wary unease that was new to the screen. In some cases they could have swapped parts: Brando might have been Prewitt; Clift could have done Terry Malloy in *On the Waterfront* (1954)—but Clift could not have handled Stanley in *Streetcar* (1951), just as Brando would have overwhelmed Elizabeth Taylor in *A Place in the Sun* (1951).

Acting was on the public mind in the early 1950s. It was close to being a subject in itself, and that can't be just because professional actors in America were going through their stylistic revolution, the Method. It had to do with the way the public was becoming more interested in acting as a variant on ordinary behavior.

Both Clift and Brando had a romantic yearning, but Clift liked to think well of himself, whereas Brando was ready for any depth of darkness or confusion. There was something else: Clift was gay or bisexual (though the public had no knowledge of that—it was part of movie romance that gayness was as alien as TV), and Brando was not. Clift seemed like a man who wanted to be a movie star. But Brando resisted that hopefulness. Clift never holds back from the alchemy of the film that is making Prewitt saintly and emblematic; Brando yearns to keep Terry Malloy rough or stupid, despite Kazan's unstoppable urge to identify with his own hero, and Brando's innate grasp on elegance. Of course, it is rash to rule out

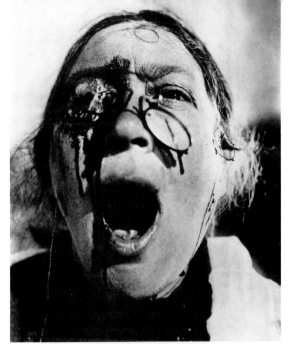

TOP: A famous wounded face from the Odessa Steps sequence in *Battleship Potemkin* (1925). BOTTOM: George O'Brien as the husband in F. W. Murnau's *Sunrise* (1927). The swamp is a set and the light is an early indication of film noir. This is the birth of modern movie atmosphere.

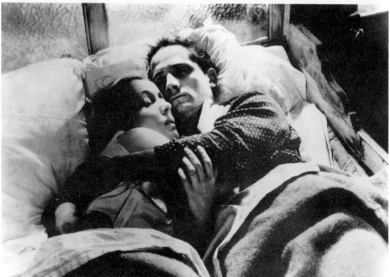

Cinema is about looking with intent and desire: A moment from *Un Chien Andalou* (1929), by Luis Buñuel and Salvador Dalí (*top*); and Dita Parlo and Jean Dasté as the newly wed couple in Jean Vigo's *L'Atalante* (1934; *bottom*).

OPPOSITE: Peter Lorre as the killer in Fritz Lang's *M* (1931) at the moment when he sees the white *M* on his back. The mirror, so often in film, is a menacing and confessional insight.

The production process: Frank Capra with Clark Gable and Claudette Colbert during *It Happened One Night* (1934; *top*); and Howard Hawks, Cary Grant, and Katharine Hepburn working out the joke in *Bringing Up Baby* (1938; *bottom*).

TOP: Marcel Dalio and Jean Renoir in *La Règle du Jeu* (1939). BOTTOM: Bette Davis blazing away at a treacherous lover in William Wyler's *The Letter* (1940).

Deep focus and megalomania: Charles Foster Kane (Orson Welles) refuses to play ball with Boss Jim Gettys (Ray Collins) in *Citizen Kane* (1941, photographed by Gregg Toland).

Marriage in the movies: Ingrid Bergman is being driven mad by Charles Boyer in George Cukor's *Gaslight* (1944; *top*); and Celia Johnson's wife is in a different world from her husband in the next bed—*Brief Encounter*, by David Lean (1945; *bottom*).

Hollywood after the war: Gloria Grahame and Humphrey Bogart in Nicholas Ray's *In a Lonely Place* (1950).

OPPOSITE: TOP: It's raining neorealism—the father and son in Vittorio De Sica's *Ladri di Biciclette* (1948). BOTTOM: More deep focus by Gregg Toland, but the mood is naturalistic, not emotional—William Wyler's *The Best Years of Our Lives* (1946), with Fredric March, Harold Russell, and Hoagy Carmichael in the foreground, and Dana Andrews in the background making a crucial telephone call.

TOP: The itinerant director—Max Ophüls talking to Danielle Darrieux during the making of *Madame de . . .* (1953).
BOTTOM: Claude Laydu and Nicole Ladmiral in Robert Bresson's *Journal d'un Curé de Campagne* (1951).

Is it a surprise gift, Pandora's box, or hell itself? Gaby Rodgers opens the case in
Robert Aldrich's *Kiss Me Deadly* (1955).

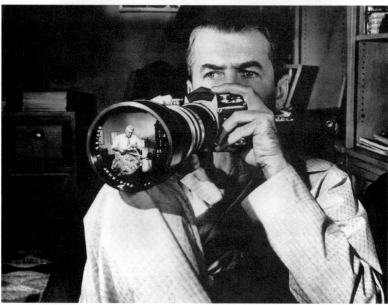

TOP: In love with a ghost? Masayuki Mori and Machiko Kyô in Kenji Mizoguchi's *Ugetsu Monogatari* (1953). BOTTOM: James Stewart in *Rear Window* (1954), looking out of his apartment and seeing the possibility of murder—with Raymond Burr under suspicion.

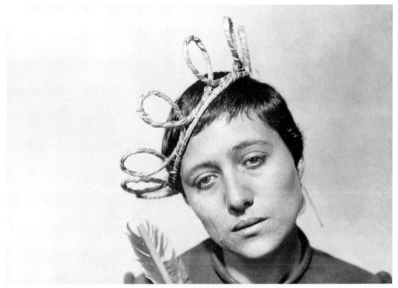

Spiritual inspiration: Maria Falconetti in Carl Dreyer's *The Passion of Joan of Arc* (1928; *top*); and the film seen by Nana (Anna Karina) in Jean-Luc Godard's *Vivre Sa Vie* (1962; *bottom*). Joan burns at the stake, and Nana is shot on the street.

TOP: Monica Vitti and Jeanne Moreau in Michelangelo Antonioni's *La Notte* (1961). BOTTOM: The original German poster from Rainer Werner Fassbinder's *The Bitter Tears of Petra von Kant* (1972).

TOP: Marilyn Monroe in a moment of splendor and joy, in Howard Hawks's *Gentlemen Prefer Blondes* (1953). BOTTOM: Dominique Labourier and Juliet Berto in Jacques Rivette's *Céline et Julie Vont en Bateau* (1974); Barbet Schroeder is studying the mirror, but he doesn't see them.

TOP: "What'll it be, Mr. Torrance?" When Jack Nicholson opens his eyes, his dream comes true—Joe Turkel as Lloyd the Bartender in Stanley Kubrick's *The Shining* (1980). BOTTOM: Kyle MacLachlan, the peeping Tom hoping his dream will materialize, but dreading it, too, and Dennis Hopper in David Lynch's *Blue Velvet* (1986).

self-love in any actor. That's the shine that gets people noticed and chosen. But cast your mind forward, to *Last Tango in Paris* (1972), and you can feel the drive of self-disgust in Brando and the likelihood that this exceptional guy might one day despair of doing the thing he was made for.

Still, *On the Waterfront* is a landmark for Brando and his director. Elia Kazan (or Kazanjoglou) was born in Constantinople in 1909. He was brought to New York when he was four, and he would remain a self-conscious outsider and a determined American. He was bright enough to go to Williams College, where as a poor kid he regarded rich WASP girls with hostility and lust. Homely in his looks, he was an attractive demon and an immense womanizer who could also conjure up fraternal relationships with male actors. He is one of the most interesting men who ever made movies, and probably more intriguing than his pictures.

He was an actor and a general assistant with the Group Theatre in the 1930s, and for a year and a bit he was a Communist in the way many creative young people were, though he resented the Party for its secrecy and bureaucratic controls. Kazan believed in himself as being uncontrollable. By the 1940s he was directing onstage: he cast Clift in *The Skin of Our Teeth* (1943) and helped discover Brando for a small but eye-catching role in Maxwell Anderson's *Truckline Café*. Then, in the late 1940s, he directed the two great plays of the era, *A Streetcar Named Desire* (with Brando and Jessica Tandy) and Arthur Miller's *Death of a Salesman* (with Lee J. Cobb).

It was out of this period that the Actors Studio emerged, affected by the writings of Konstantin Stanislavsky and the experience of the Group Theatre, but rooted in a belief that American acting deserved to come into its own. There was a notion that this country's acting had been unduly influenced by English approaches—so that it was too smooth, eloquent, and effete. This is a travesty of the range of English acting, but it was borne out in the way many people had acted in movies in the 1930s. The cultural shock of war, the arousing films of neorealism—all those things required acting that felt more real, that was based in a way of finding the character in the actor's own experience or sense memory (sometimes with the help of psychoanalysis). That "real behavior" was not meant to be eloquent or polished; it was rough, awkward, and inarticulate, but it was "honest"—or so the claim was made. Though this began as a theatrical revolution, it had the most impact at the movies—nearly all the Method actors ended up in Hollywood, for the close-up agonizing encouraged by the Method was begging for the camera.

Kazan was drawn to Hollywood in the late 1940s, and he made a

string of crafted but impersonal films—*A Tree Grows in Brooklyn* (1945), *The Sea of Grass* (1947), *Gentleman's Agreement* (1947) (which still won Best Picture), *Pinky* (1949), and *Panic in the Streets* (1950). He came more alive, working with Brando in *Viva Zapata!* (1952) and the movie of *Streetcar* (1951; where Vivien Leigh replaced Jessica Tandy). But his great autobiography, *A Life*, makes it clear that he was not pleased with his own pictures and did not feel he was "in" them yet.

Not that directors in America were yet supposed to be "in" their movies. The industry still thought of pictures as assignments, and most directors were wary of voicing artistic personality or ambition. The best ones did their jobs and kept quiet—that was the method favored by Hawks, John Ford, and even Alfred Hitchcock, all of whom settled for being entertainers, and had the commercial success to remind them of it.

Kazan was bursting with inner self. It was the way he handled actors: He wanted their inner life to escape. He saw them as his instrument. It was an attitude not too far from other explosive careers of the late 1940s and 1950s—Charlie Parker and Jackson Pollock, "free" forces spilling out on canvas and dancing all over the chord structure of popular songs. Norman Mailer's *Advertisements for Myself* (published in 1959) was a new kind of book—it had a big influence on journalism—and it believed a writer should be a star and movie-like.

The trigger releasing Kazan came in an unexpected way that changed his life. His prominence and his record as a Communist made him a target for the House Un-American Activities Committee (HUAC). He was warned that he would be asked to testify. He resisted, but then he was told that movie employment could depend on it. So, in April 1952, he testified. He named names and let his wife, Molly, publish a letter to the *New York Times* defending his position. For the rest of his life, he never threw off the shame from that incident. But shame confirmed him as an outsider who treasured his own curse and it matured him as a filmmaker because it drew his ego out into the open.

Kazan had imposed himself on texts before. On *Streetcar* he instigated the transformation of a play about Blanche into a production about Blanche and Stanley, the figure who dominated audience response in 1947 and seemed the source of the play's danger. Kazan needed to identify with his male characters. And so in *On the Waterfront* (written by Budd Schulberg after Arthur Miller had withdrawn), Terry Malloy testifies against the waterfront crime mob of which he has been a part.

It is a passionate, muddled film. Brando is electrifying, the supporting

cast is authentic, even the extras feel from the streets. The grittiness of the Hoboken waterfront (filmed by Jean Vigo's Boris Kaufman) is cold and abrasive, but the film is operatic, too, carried away by its emotional size. It's unclear what the ending means. It's far-fetched that the gangsters assassinate Terry's brainy brother, Charlie (played by Rod Steiger), when the sensible thing to do is to eliminate Terry. Never mind. There had never been such a bold attempt at street realism before, or a performance as achingly vulnerable as Brando's. It's just that the passion stems from Kazan: it was his film; he was "in" it.

Kazan did a certain range of material very well, though he lacked irony or humor. He was melodramatic, self-pitying, and so pledged to some actors that his films ran the risk of losing sight of anything else—thus the character of Aaron in *East of Eden* (1955), James Dean's brother, is fobbed off so Cal can be made appealing. Still, *On the Waterfront* and testifying start Kazan's richest period, which carries on with *East of Eden* (the discovery of Dean), *Baby Doll* (1956), *A Face in the Crowd* (1957), *Wild River* (1960; with Clift), *Splendor in the Grass* (which paired Warren Beatty and Natalie Wood), and *America, America* (1963), the story of a family like his own coming to the new land.

Kazan's influence lasted long after he had moved on personally from the Actors Studio. That school has been the breeding ground for exceptional actors—the first two *Godfather* films are stocked with Studio players, including Lee Strasberg who took over the school and became its essential if autocratic teacher.

•

Another name needs to be remembered in any survey of American naturalism. Paddy Chayefsky was born in the Bronx in 1923. After war service, and being wounded, he tried to write plays and scripts and he ended up in television. He did a version of Budd Schulberg's Hollywood novel, *What Makes Sammy Run?* He was coached by Molly Kazan, the director's wife. And then, in 1953, for the Goodyear Playhouse on television, he wrote *Marty*, the love story of a humble butcher and a shy girl, played by Rod Steiger and Nancy Marchand. It was live television, and it was meant to remind viewers of life.

Marty was directed for TV by Delbert Mann, and when the movie version was made in 1955 by the production company of Harold Hecht and Burt Lancaster, Chayefsky insisted that Mann do the film. But the cast was changed to Ernest Borgnine (the villain in *From Here to Eternity*,

fondly recalled by Burt) and Betsy Blair. The casting of Blair took more than usual nerve. The actress was under suspicion for Communist associations. Lancaster, too, at that time was being questioned. So Gene Kelly, Blair's husband, asked M-G-M chief Dore Schary to pull strings. "You play charades with Betsy every Saturday," he told Schary. "She's not going to overthrow the country." In this case, the friendly plea worked. Blair got the part and won a nomination as Best Supporting Actress. Borgnine won for Best Actor.

That *Marty* won Best Picture and the Palme d'Or at Cannes is a sign of how much naturalistic acting was in vogue, and it speaks to another hope for early television, that of showing life as it seemed to be lived. Walter Winchell predicted *Marty* would be a sleeper hit. *Variety* announced, "Rarely has a single picture so influenced the film industry." It earned $3 million on an outlay of just over $300,000 and it prompted reviewers to tell Hollywood to watch television more often—if they had sets in their houses.

Today, *Marty* is not easy watching. The "real" works for a moment, but then it feels studied and dull. Chayefsky would veer away from its sobriety and plainspoken characters: by the 1970s he was writing flamboyantly rhetorical scripts for *The Hospital* (1971), *Network* (1976; still a scathing and prescient attack on television), and even a sci-fi picture, *Altered States* (1980). *Network* is one of the liveliest talking pictures we have, and one of William Holden's best world-weary roles. But *Marty* was a marvel in its day, full of the hope that America had discovered respect for reality.

•

Humphrey Bogart was another actor who reckoned he would produce his own pictures—and make a killing from them. In the late 1940s he decided not to renew his old Warner Bros. contract. Instead, he set up Santana Productions, named after the yacht he cherished. He formed a partnership with Robert Lord, a writer-producer from Warners and the man behind *Black Legion*, an important Bogart picture of the late 1930s in which he played a man who joins the Ku Klux Klan.

Santana made four films, none of them profitable. *Tokyo Joe* (1949), *Knock on Any Door* (1949), and *Sirocco* (1951) were routine. But *In a Lonely Place* (1950) was remarkable. Bogart had befriended the new director Nicholas Ray—in fact, Ray did *Knock on Any Door*.

Born in La Crosse, Wisconsin, in 1911, Ray developed slowly. He

worked in radio, as a folklore researcher and as an assistant to Kazan. But in 1949, for RKO, with John Houseman as his producer, Ray released one of the most exciting of American debut films: *They Live by Night*, a rural noir in which Farley Granger and Cathy O'Donnell try to keep their love precious as fate closes in on them. The taut dramatization of endangered feeling had seldom been so striking. No one guessed it in the late 1940s, but Ray was to become an emblematic figure in the arguments over what a director was. In 1958 the French critic Jean-Luc Godard went so far as to claim, "The cinema is Nicholas Ray." In strangers' eyes, Ray had become a vagrant hero. But John Houseman, always an acute observer of talent, knew the man himself:

> Reared . . . in a household dominated by women, he was a potential homosexual with a deep, passionate and constant need for female love in his life. This made him attractive to women, for whom the chance to save him from his own self-destructive habits proved an irresistible attraction of which Nick took full advantage and for which he rarely forgave them. He left a trail of damaged lives behind him—not as a seducer, but as a husband, lover and father.

There was a bond between Bogart and Ray. In the early 1940s, Bogart had become someone the public admired, a guy with integrity, but the aggressive edge of his gangsters from the 1930s lingered. In life he was a famous needler, and Ray saw a way to get back to the innate hostility that had been genre conventional in the 1930s. In addition, they were two men with younger wives—Lauren Bacall and Gloria Grahame—who might have wandering eyes, or arouse their husbands' suspicions. Bogart had never enjoyed the Hollywood system: He had fought steadily with his boss, Jack Warner. He had been bruised and humiliated by the flight he led to Washington in 1947 to protest the early HUAC assault on possible Communists in the business. Bogey the resolute had been compelled to climb down and apologize, to protect his career. But he was an old pro, while Ray was an incipient and helpless rebel. Together they made a Hollywood picture that leaves *Sunset Blvd.* looking a little prim.

In a Lonely Place is the story of a screenwriter, Dixon Steele (Bogart), who has made too many compromises and who nurses his temper along with his disappointed talent. It is a portrait of idealism turned morose that nearly anyone reared in Hollywood would recognize. He meets a

woman, Laurel Gray (Gloria Grahame), and they fall in love. But their affair is put in jeopardy when Steele becomes a suspect in a murder case. He isn't guilty, but the events of the film will show Laurel that he is angry and violent enough to be dangerous. Indeed, he comes close to killing her. The "lonely place" is paranoia, or being out of control, but it is also the plight of creative hopes gone sour in the movie capital. The story was heightened by the fact that Ray and Gloria Grahame broke up during the shoot.

The *New York Times* called the film one of Bogart's best: he gave "a maniacal fury to his rages and a hard edge to his expressions of sympathy." But the film did no business and never seems to have inspired its distributor, Columbia. Their big film that year was *Born Yesterday*, an enjoyable stage-based comedy about a dumb blonde (Judy Holliday, one of Ray's lovers, who won an Oscar in it) who learns too much for the mobster who keeps her as a mistress.

Ray's career was as volatile as Dixon Steele's life. In the next few years he made several good films (though none of them unflawed): *On Dangerous Ground* (1952), produced by Houseman again, with Robert Ryan frightening as a violent cop; *The Lusty Men* (1952), about the rodeo world, with a world-weary Robert Mitchum; *Rebel Without a Cause* (1955), his great hit, James Dean's second film, and identification of the troubled American teenager; *Bigger Than Life* (1956), a study of megalomania, with James Mason as a man whose life is taken over by the "miracle" drug cortisone; and *Bitter Victory* (1957), a North African desert war story, with Richard Burton as one of Ray's most anguished heroes.

Nick Ray succumbed to gambling, drugs, wandering, and the general fury of self-destruction. He was at his best in the supposed confines of the 1950s, though he always believed he needed liberty. He also depended on structure and producers, despite railing against them. But in a few films and many scenes he was so exciting—with color, space, and with actors in desperate, trapped situations. You can feel Ray and his untidy desires and roaming instability in Dean's prowling, sighing talk in *Rebel*, and it's fair to say that while Ray was having an affair with the teenage Natalie Wood during that shoot, he also yearned for Dean. For all those reasons he became a test case in the 1960s for people who wanted to idolize thwarted genius. François Truffaut captured him in a comparison with Howard Hawks that speaks to the American tension over who should make films—and why: "In Hollywood, a Howard Hawks arrives on the scene and takes his time, flirts with tradition in order to flout it, and always

triumphs. Ray is incapable of getting along with the devil, and when he tries to make a pact for profit, he is defeated before the fight even begins."

•

Robert Aldrich was not as high-strung a talent as Ray, but he was better organized—and it's arguable that in *Kiss Me Deadly* (1955) he made a more complete film than Ray ever managed. Born in Cranston, Rhode Island, in 1918, Aldrich was the child of wealth disowned by his family after he abandoned law and business for pictures. But he made his way sensibly as an assistant director, an obvious path but one seldom taken— good ADs are so prized that they are seldom allowed to escape that managerial task. He directed Burt Lancaster in *Apache* (1954), one of the earliest movies to treat Native American life with respect, and an opportunity for Lancaster to be a surly, athletic god.

At that point, working on his own (through his company, Aldrich and Associates) he made a deal with the pulp fiction sensation of the 1950s, Mickey Spillane, to adapt his novel *Kiss Me Deadly*. Aldrich and his screenwriter, A. I. Bezzerides, dropped the conventional syndicate drug dealing of the novel and replaced it with a large, seething, magical box containing fire, a growling noise, and nuclear Armageddon. The metaphor was primitive, blunt, and poetic all at the same time.

That box comes at the end. Before then, we have Ralph Meeker's Mike Hammer. Strutting, odious, fascistic—all those descriptions have been used, but still Meeker is not just toxic; he is unrebuked. Ordinary viewers may wonder where the censor was. Hammer is set up as a private-eye hero, but he is truly an overflowing id. The villains are worse, yet less frightening. Then there are the women: from the automated, obedient sexpot Velda (Maxine Cooper) through the wounded and doomed Christina (Cloris Leachman) to the demented and depraved nemesis Lily Carver (Gaby Rodgers). There are no other American films from the 1950s where young women are so boring, desperate, or lethal. Hollywood still worshiped the female (as a way of neutralizing her, perhaps), and so you wonder how Aldrich dared present these creatures.

In addition, *Kiss Me Deadly* is an early example of filming Los Angeles as a built-up wasteland, instead of "home" or paradise. The final sequence, with Hammer and Velda stumbling into the Pacific as a beach house becomes an inferno, is spectacular and disturbing. And in 1955 Aldrich got away with it—anyone who suggests that the 1950s was a time of conformity and close-carpeted positivism needs to see *Kiss Me Deadly* and feel

how law, police, and decency have given up the ghost. The film is the more intriguing in that it seems too beautiful for its own director—he had *What Ever Happened to Baby Jane?* (1962) and *The Dirty Dozen* (1967) to come, complacent, moneymaking shockers. Whereas *Kiss Me Deadly* is an outrage, apparently without a care about its own success.

Aldrich had control over the film and shot it in three weeks for just over $400,000. United Artists released it, and it did nothing until the Kefauver Commission on crime said it was a major threat to American youth. (But who was looking after the grown-ups?)

In *The Night of the Hunter* (1955) our guardian was a fairy godmother looking like Lillian Gish. And if *Kiss Me Deadly* was an unlikely venture, *Hunter*, the only film ever directed by Charles Laughton, was so hard to credit or place that the public ignored it. Taken from a rural gothic novel set in the 1930s by Davis Grubb, it had a script by the former film critic James Agee. There is still dispute over how much of Agee's script was usable and how much of it Laughton had to rework. But the picture was always a far-fetched collaboration in which the famously neurotic Laughton and his producer, Paul Gregory, were supposed to command the whole enterprise.

A criminal gives stolen money to his two young children before he is taken away to prison and execution. But another inmate, Harry Powell, a self-styled preacher, learns enough to come after the children. He marries their widowed mother (Shelley Winters), murders her, and then pursues the children through a studio-made nightscape from the Grimm Brothers, or Audubon on acid, all photographed in nightmare black and white by Stanley Cortez, the man who shot *The Magnificent Ambersons* (1942).

For Harry Powell, Laughton thought first of Gary Cooper, but the actor declined because he feared for his public image. It would have been a very different picture with Coop—perhaps an impossibility. So Laughton approached Robert Mitchum. The story is that he told Mitchum he had an unusual part to offer, "a diabolical shit." "Present!" said the actor, and the two men proceeded to forge a bond. It was a part unlike anything Mitchum had done to date, yet it seemed to awaken the fiction writer and drifter he had been before he got into the acting trade he usually despised.

The babes in the wood find shelter with Lillian Gish, and her sturdy moral values will dispose of Powell. Laughton cast her as an evocation of Griffith's tradition.

United Artists released the film without a notion of how to sell it. The *New York Times* admitted it was "audacious," and some reviewers said

Mitchum had never been as good. But the film had cost $800,00 and it had rentals of only $300,000. As a result, plans for Laughton to film Norman Mailer's *The Naked and the Dead* were abandoned. Not that that sounds like Laughton material, or a suitable shoot for him, in the jungle. But who would have foreseen *The Night of the Hunter*? Decades later, that film would be taken into the Library of Congress as an American treasure. The lesson would spread that maybe anyone could direct. As Robert Benayoun, a French writer, said, "To make only one film. But to make it a work of genius: isn't that, in the context of a journeyman profession, the shining example that Laughton has given us?"

No small independent production company made a bigger splash than Hecht-Hill-Lancaster, with *Marty* as their greatest hit. Their product usually centered on Lancaster himself, an authoritative actor, to be sure, but not the easiest partner: he had radical ideas and enough ego to interfere and be difficult. The company was about to make its best film, the one that really startled and dismayed people, *Sweet Smell of Success*. (*Marty*, in comparison, was anodyne and cozy.) As its director, Alexander Mackendrick, observed at a San Francisco preview, the effect of the film on the public "was like dripping lemon on an oyster. They cringed with the body language of folding arms, crossing legs, shrinking from the screen." To make matters worse, the intended budget of $600,000 had climbed to $2.6 million.

Mackendrick was an odd bird. Born in Boston, Massachusetts, in 1913, he was raised in Scotland. He was drawn to film, and had a hand in British propaganda as the Second World War began. In fact, for the Psychological Warfare Division, he went to North Africa and Italy, where he helped set up Rossellini's *Rome, Open City* (1945). After the war, he joined Ealing Studios, where he directed several successful comedies. But he was drafted to take on a novella about the New York publicity scene written by Ernest Lehman and modeled on Walter Winchell. In time, several others came to the script, and in the end a veteran, the playwright Clifford Odets, was typing up dialogue only hours before Lancaster and Tony Curtis would deliver it.

For forty minutes or so it is a unique picture as the relationship emerges between a columnist, J. J. Hunsecker (Lancaster in a crew cut and horn-rimmed glasses) and Curtis as Sidney Falco, a publicist and "a cookie dipped in arsenic," a user, a hustler, and a person not seen in American movies before, even if his type was thick on the ground of show business.

The film was shot in a glittering, harsh black and white by James Wong Howe and looked like the hide of a crocodile in the moonlight.

Howe took advantage of fast film stocks just emerging to work on the city streets at night—real night instead of the offset fakery of day for night, where humans throw shadows. The film was proudly nasty, and the cross-talk manipulations were the lemon juice on the oyster. There are still people who run those dialogue routines; they have become treasured models for young cynics and the *Entourage* crowd. It was one thing for Burt to be that grim. He had always had that side, and you can see it in *Criss Cross* (1949), *Apache*, and *From Here to Eternity*, even if he had just had huge success as a mainstream Wyatt Earp in *Gunfight at the O.K. Corral* (1957).

It was Tony Curtis who got under people's skin. Curtis was what he himself would call an "American prince," a handsome kid with a lady-killer's smile and an aptitude for slick talk. He had been one of the last generation groomed for old-fashioned stardom (at Universal, where Rock Hudson was a fellow student), trained to fence, dance, shoot a gun, ride a horse, wear a costume, carry a line, and kiss the girl tastefully. He had made a long line of foolish adventures that had done very well: *The Prince Who Was a Thief* (1951), *Son of Ali Baba* (1952), *Houdini* (1953), *The Black Shield of Falworth* (1954), *The Purple Mask* (1955).

In 1951 he had married Janet Leigh in what the American public regarded as a picture-book union and a model of happiness, because that's how it was presented in the magazines that still ran a lot of Hollywood coverage, including intimate home pix. (In fact, Universal had offered Curtis a bonus of $30,000 if he would marry another studio player, Piper Laurie.) Curtis was ambitious—has there ever been a face in which that is so clear? He relished Sidney Falco and his spiteful dialogue. But Mackendrick was a perfectionist who liked to get everything right, and Lancaster soon grew angry at the delays. There was a famous scene at Hunsecker's table at the "21" Club. Who should sit where to play the scabrous talk? Mackendrick wanted a move.

> Burt and Sandy started arguing about it [wrote Curtis]. Sandy raised his voice to Burt, and then Burt went apeshit. He got up and pushed the table over, sending all the plates and glasses and food crashing to the floor. Then he raised his fist to hit Sandy. Sandy put his hands up to defend himself, but he didn't back down. He was a strong man, and he wasn't going to take any nonsense from anyone, even Burt. Burt took a deep breath, everybody calmed down, and we did it Sandy's way.

But *Sweet Smell* was only half a film. The setup between J.J. and Sidney is as intoxicating as it was anathema to the large audience. But once J.J.'s sister gets a hold on the plot and we have to deal with Martin Milner's jazz guitarist who has drugs planted on him, we are into pallid melodrama. The look of the streets and the clubs in the film cry out for wilder jazz men—Miles Davis, Art Blakey, Monk, then at their prime—but all we get is the genteel salon jazz of the Chico Hamilton Quintet (with a lot of white guys in the band looking like business majors). The second half of the script was never right. There is a possibility in there that J.J. and Sidney could become a monstrous father-and-son pair—or could it even be lovers?—talkers who feed on their own poisonous exchanges.

Today, cineastes treasure *In a Lonely Place*, *Kiss Me Deadly*, *The Night of the Hunter*, and *Sweet Smell of Success*. Those films stand for the 1950s more effectively than such forgotten hits as *The Robe* (1953), *Three Coins in the Fountain* (1954), or *Peyton Place* (1957). But they made no money; they gathered not a single Oscar nomination. They had central characters beyond sympathy and ready for fear and loathing, and not one of the films had a hopeful thing to say about the world or America. They were all black and white as color was taking over, yet Bogart, Mitchum, Lancaster, and Curtis were stars of the age, taking considerable risks. Actors, directors, and small companies felt the need to escape rigid habits of film material that was succumbing to the market and television anyway. Nobody on TV then dared talk like Sidney Falco. Winchell himself said the picture was shocking. Yet few of these elements of danger are to be found today in a Hollywood that cheerfully dismisses the 1950s as being old hat.

•

In the 1950s, Alfred Hitchcock found himself—though, in the end, his life was not comfortable. Whether in London or Los Angeles, he noticed just one thing: movie. He would become the emblem and the godfather of that single-minded attitude, but finally his work leaves us wondering how balanced or humane the obsession could be.

Hitchcock was born in East London in 1899, the son of a fruit merchant. As a youth he was a draftsman, and he got into pictures initially by designing titles. For ever afterward, he envisaged his films in advance and created elaborate storyboards that contained precise camera angles and length of shot. He liked to have the film in his head as a construct, a piece of suspense for us but not for him, and a work of celluloid fragments—or art, if you want to use that word. In 1926, as he began to direct, he married

Alma Reville, an experienced story girl and editor, and she worked closely with him for decades.

He had a period studying in Germany, and in the following years a policeman's eye could see him lifting details from Fritz Lang especially. But after the coming of sound, Hitch made a series of thrillers that were successful at the box office: *Blackmail* (1929), *The Man Who Knew Too Much* (1934), *The 39 Steps* (1935), *Secret Agent* (1936), *Sabotage* (1936), and *The Lady Vanishes* (1938). His representation in London was the Myron Selznick Agency, and thus he was hired by David Selznick in 1939 and brought to Hollywood. This was not appreciated in the British industry, where the patriotic call of war service beckoned. I suspect Hitch hardly noticed that reaction. When he arrived at the Selznick studio he was immediately given a sequence from the *Gone With the Wind* in progress to critique. He delivered an analysis so precise and smart it stupefied Selznick.

The boss and the director never got on, no matter that on their first project together, Daphne Du Maurier's *Rebecca* (1940), Selznick won the Best Picture Oscar. Hitch was nominated as director, too—he would be nominated five times, but never win that prize. *Rebecca* had been a power struggle between producer and director. Hitchcock's advance vision of the film clashed with Selznick's habit of having extensive coverage shot, the editing of which he could mull over as endlessly as he had rewritten the script. Hitchcock had come to America for the more sophisticated studio equipment, the stars, and the chance of greater success, but he had never guessed he would find such an indecisive dictator as his boss.

Still, *Rebecca* had something for both parties: it is a reasonable adaptation of the novel (an imperative with Selznick); it is a searching portrait of a woman (the Joan Fontaine with whom Selznick was romantically involved); plus it was a hit that won the Oscar. For Hitchcock it was a study in guilt and power in which he could pressure the woman, the unnamed "I," to the point of near breakdown. He found the character of Mrs. Danvers (Judith Anderson) and made a repressed demon of her. (She is his first baleful mother figure.) And he learned how expressive the beautiful sets in Hollywood could be, and how a sequence could be worked out in terms of décor and movement. The scenes in Rebecca's old bedroom, where Mrs. Danvers goes into dark raptures over her dead mistress's clothes, are the most sumptuous and perverse things Hitchcock had yet shot. They are a clue to his taste for voyeurism and necrophilia, an urge that would culminate in James Stewart's treatment of Kim Novak in *Vertigo* and the camera's hounding of Janet Leigh in *Psycho*.

In the 1940s, Hitch was still finding himself. There are several foolish films, such as *Lifeboat* (1944) and *Spellbound* (1945; he was nominated for both), the latter a testament to Selznick's forlorn adoption of psychoanalysis to save him from his greatest faults. *Rope* is a clumsy, portentous film, because of the laborious ten-minute-take experiment that hijacked the innate cutter. For some reason, as if waking up to a technological dream, Hitch suddenly thought of letting the camera run, a thing for which he had little talent. On the other hand, in 1946 he made his first masterpiece, *Notorious*—he was freed on it because Selznick was mercifully preoccupied with the extravagant *Duel in the Sun* and his infatuation with Jennifer Jones. *Notorious* was a process of discovery: a wounded woman (Ingrid Bergman), a cold hero (Cary Grant), an attractive villain (Claude Rains)— this is Hitch's frequent triangulation finding life and form.

The next major film was *Strangers on a Train* (1951), from Patricia Highsmith's novel. It is a cunning suspense plot, of course, but what distinguishes it is the interplay between a blank hero (Farley Granger) and a mad yet irresistible ideas man, Bruno Anthony (played by Robert Walker). There is also a murder in the film that our secret desire wants to have accomplished and where Hitch actually delivers the corpse as a gift, into our laps (without 3D). No one before or since had guessed as much as Hitchcock about the dynamic but enslaved respect we feel for the screen.

If anything inspired him next it was finding Grace Kelly. Hitch had always liked cool blondes, but he enjoyed looking at all women, and putting them under a plot pressure that required his rapturous gaze. After *Dial M for Murder* (1954), a complicated play adapted for a fussy film, he put Kelly in *Rear Window* (1954). It is one of his great moments and it may be the cinema's first inadvertent lesson in its own nature delivered as big box office.

L. B. Jefferies (James Stewart) is a press photographer with a badly broken leg, so he's up to his thigh in a plaster cast, laid up in his New York apartment. With nothing else to do, he starts to spy on his neighbors in the courtyard he can see. He has his own telephoto lenses to give him close-ups. The other windows are like screens he can watch. As he studies them, he observes an unhappy marriage across the way, but then the wife is gone and the husband, Lars Thorwald (Raymond Burr, but white-haired and looking like David Selznick!), is curiously alone.

In the Cornell Woolrich story that inspired the film, the Jeff figure has no girlfriend. But in the movie, he has Lisa Carol Fremont (Grace Kelly), a fashion model who spreads seductive company, smart chat, gourmet food, and flirt wherever she goes. Nothing happens sexually—this is 1954, and

if they had been making love, Jeffries wouldn't have noticed Thorwald—
but Lisa helps Jeff pursue his theory, the story he applies to one of the
screens: that Thorwald may have murdered his wife. Then Lisa goes over
to the empty apartment to look for the wife's wedding ring (Lisa is hot to
marry Jeff)—until here comes Thorwald returning home! Can you bear
it? I won't say what happens next.

Rear Window is a gripping suspense story, an amusing romance, a
showcase for its stars, and a lesson on looking at screens, trying to fathom
their stories and asking yourself whether you're involved with the story or
simply a spectator without identity or responsibility—because you're in the
dark. It's only at the end of the film that Thorwald looks at the camera,
and us, and realizes what is happening. The balance of entertainment and
analysis is unrivaled, and it's why I place *Rear Window* as the essential
Hitchcock film. (Not even nominated for Best Picture; *On the Water-
front* won. *Three Coins in the Fountain* and *The Caine Mutiny* were also
nominated.)

Hitchcock moved on with *To Catch a Thief* (1955), a holiday thriller in
the South of France, with Kelly and Cary Grant, the puzzle of choosing a
leg or a breast, and the dire mishap by which the actress met her prince
and we lost a comedienne who might have rivaled Carole Lombard. Hitch
never got over that loss, though it was while in France that he met some
writers from *Cahiers du Cinéma* for the first time. He did *The Trouble with
Harry* (1955), a remake of *The Man Who Knew Too Much* (with Doris Day
singing "Que Sera, Sera") and *The Wrong Man* (1956), a somber, neglected
warning of a film in which Henry Fonda plays a man falsely accused of a
crime. He is vindicated, but only as his wife has a breakdown. Hitchcock
dealt in anxiety and stress because he knew how much there was to be
afraid of in life.

Vera Miles plays that broken wife and does a good job. The story is that
Hitch would have cast her in *Vertigo* if she had not been pregnant. I sus-
pect he would have preferred Grace Kelly if she had quit Monaco. In the
end, he cast Kim Novak, and a case can be made that the complexity of
the part and its two aspects was a little beyond her—but maybe that is
what makes her so touching.

In San Francisco, "Scottie" Ferguson (Stewart again) is a police detec-
tive forced to retire because of disabling vertigo. Of course, he should leave
the city, which is not made to accommodate a fear of heights. But an old
school friend, Gavin Elster (seeming very English), hires Scottie to watch
his wife, Madeleine; Gavin thinks she may be going mad. There is then a

pursuit sequence through the city, one of the most sustained and satisfy-
ing displays of voyeurism rewarded in film history, because by the time
Scottie actually speaks to Madeleine, he is in love with her. So are we.

Madeleine is troubled—or she acts that way. But Scottie cannot save
her. He is there, once more afflicted by vertigo, when she kills herself,
falling from a mission tower. Scottie is criticized at the inquest. He has a
breakdown. He is a wreck. And then one day, walking on the streets of
San Francisco, he sees another woman, Judy (Novak again), a coarse red-
head where Madeleine was a serene blonde. He is drawn to her because
he sees a way of remaking her as Madeleine (or was it Grace?).

Vertigo is an uncomfortable, creepy séance, a test of credibility, and
Hitchcock's big box office flop from the 1950s. The story relies on unlikely
events, and is driven by Gavin's malignant cruelty, without his character
ever being explored. It is better read as a troubled dream: If we know Judy
is Novak, why can't Scottie see it? Reverie explains the foggy glow of San
Francisco, the somnambulism of Madeleine, and the increasing frenzy in
Scottie, who is another of Hitch's unwholesome heroes. But the most
fascinating thing about *Vertigo* is its commentary on the fantasy through
which a director, or an audience, brings a filmed woman to life in their
minds. I said that Hitch loved film (or knew little else), but *Vertigo* has a
helpless guilt, the first admission that voyeurism may undermine you, and
that acting is a metaphor for all of life. So the flop from 1958 is now often
included in lists of the best films ever made.

•

Vertigo is a necromantic rite, a story of love ruined and "direction" ex-
posed, and a lesson in what you might call the layers of performance. If
you reflect on its full story, there is this young woman, Judy Barton, who
has come from Kansas to San Francisco (a version of Dorothy getting to
an Emerald City). She's sexy but not too smart. She isn't a great actress.
But Gavin Elster, full of old-world charm and authority, and her lover, has
taken her over and directed her to play the part of his wife, Madeleine. So
he gives her Madeleine's gray suit to wear; he educates her in the wife's
blond hairstyle; he schools her in moving as if in a dream—this is impor-
tant because she has to be followed without giving any hint that she no-
tices the pursuer. She is the model of people in movies who are required
to behave "naturally" without noticing the camera, the lights, and the
crew. She is acting, but she might be said to be "presenting a self in every-
day life."

That phrase comes from a book by Erving Goffman, one of two academics in the 1950s, not exactly movie fans, but some of the first scholars or critics to see past the particular movies and wonder, well, what *is* happening with all our study of stories and actors and imagery—what is happening to "reality"? What happens to self once we realize it is something we are presenting?

Erving Goffman and Marshall McLuhan were both Canadian. Goffman was born in Mannville, Alberta, in 1922; McLuhan in Edmonton, Alberta, in 1911. McLuhan went to study in Cambridge and came under the influence of F. R. Leavis and I. A. Richards when the topic of "popular culture" was beginning to be explored there. Goffman graduated from the University of Toronto and was the brother of an actress, Frances Bay, whose many credits include *Blue Velvet* and *Twin Peaks*, both by David Lynch. McLuhan's first book, *The Mechanical Bride*, was published in 1951; Goffman's *The Presentation of Self in Everyday Life* came out in 1959.

I don't mean to offer the two professors as twins in harness, but the similarity in their area of interest had one other thing in common: their work was not known to the professional and creative classes working in film and television. If there was academic interest in such areas in the 1950s—and there was very little—it was to glory in classic films and sketches of the history. The "theory" behind the media was nonexistent as yet, along with common use of a word such as *media*. But McLuhan, who was handicapped by being an awkward writer, was beginning to examine television advertisements—both men were more attentive to the new rush of television imagery than to the movies. He was working his way toward saying that media were themselves a structure of technological messages more profound or influential than the storied or moral messages programmers thought they were pushing onto the screen.

McLuhan did not become a cultural figure until the 1960s, with books such as *The Gutenberg Galaxy* (1962), *Understanding Media* (1964), and *The Medium Is the Massage* (1967). By 1975 he was "himself" for a moment in a movie theater lobby in Woody Allen's *Annie Hall* (1977). Erving Goffman might have said this was not so much the real Marshall McLuhan as a presentation of him. Goffman's work was beginning to develop a theory—whether naturally or through the steady exposure of so much imagery and acting—that we all of us were learning to play or present ourselves in order to be understood. This dry, academic approach was actually more provocative or instructive than the whole doctrine of

the Actors Studio. After all, that was aimed at professionals, whereas Goffman had seen that acting is amateur and universal.

Before sound recording, people had had so much less chance to hear themselves; that addition to film's reality was as much an inducement to self-awareness as photography had been. A sidelight to that was the spreading culture of impersonation, by professionals, and by us, which only pushed actors into exaggerating their own voices. So vocal imitation became an entertainment, along with ventriloquism. Why not, and where's the harm if James Cagney, or Jimmy Stewart, or Bette Davis, were "doing" themselves? Just as we say "good-looking" about some people, so actors had to be "good-sounding."

This feels like a game, and one the public joined in—we can all do a sort of Cagney (if we remember him), as well as Al Pacino in *Scarface*. But then consider the case of Marlon Brando. So many people who knew him said that if he talked to anyone for half an hour he began to take on their speech and mannerisms. It wasn't usually malice or mockery; it was probably not conscious; and it was a long way from the teaching of the Actors Studio. But it was the helpless need in an actor to become someone else. There's one film—Arthur Penn's *The Missouri Breaks* (1976)—in which Brando displays this chronic versatility in a range of voices and personalities. In life he would often telephone friends in the voice of other people.

This was but a prelude to dubbing and the ease with which film could put someone else's voice in a player's mouth. Industrially, dubbing was a practice to make foreign films more accessible. But there are creative possibilities, too: How often is Marni Nixon dubbing songs in the American musical? How much Debra Winger was there in E.T., and how much Mercedes McCambridge in Regan in *The Exorcist*? Or, at another level, why doesn't Jimmy Stewart hear Kim Novak's voice making sisters out of Madeleine and Judy?

If we go back to Judy Barton in San Francisco, we may gain an extra perspective on *Vertigo*. Judy does a very good job as Madeleine. She doesn't get an Oscar, but Scottie becomes hooked on her and he carries us along too, as watching builds desire. Scottie falls in love with her because he feels the possibility of another Madeleine. Alas, Judy knows her script does not permit this development. It is building toward a crisis where her flight and Scottie's phobia will allow Gavin to toss the body of the real Madeleine (just as blond, just as gray-suited) from the top of the mission tower. So the real Madeline never appears in the movie: she is a

corpse, waiting to be disposed of—thus *Vertigo* has an odd link to *Psycho*, where an old dead body is re-presented.

Time passes. Gavin goes away. Scottie is a wreck. But Judy, like an idiot, stays around because she, too, fell in love in the course of her act. She had never been looked at so tenderly before, and it opened up her heart. This is where Kim Novak is so intriguing, for her own hesitation as an actress speaks to Judy's vulnerability. It reminds me of that moment in *Picnic* (1955) when Novak in a mauve dress appears at the water's edge at dusk for a Labor Day picnic and dances (to "Moonglow," or the theme from *Picnic*) for William Holden's character. As shot by Joshua Logan, it is a brief romantic idyll made heartbreaking by the way Novak, trying very hard, is not ethereal, or bound for Hollywood, but a girl from Kansas hoping to be as smooth as Ginger Rogers, but just a little too slow or shy.

Back in San Francisco, Scottie does see the ghost of Madeleine's face in Judy, though he can't recognize Novak. So he takes Judy in hand and coaxes her back into being the image of Madeleine. Judy cannot resist, yet she knows her real self is being lost or ignored in the makeover. And when at last she is Madeleine again, in a wan green light, the scene is orgasm for Scottie and death for Judy. The actress has lost herself.

This doesn't have to be tragic. I've already quoted Susan Sontag's amused view of the shifting pseudo-reality in *I Love Lucy*, and television was a never-ending celebrity show. I don't just mean that players such as Lucille Ball, Jackie Gleason, and Burns and Allen became constant variants on themselves, playing with what we thought we knew about them. In addition, so many television shows, *I Love Lucy* included, were loaded up with "guest stars," celebrity appearances, where it was plainly John Wayne or William Holden or whoever, being himself but presenting himself in simple written sketches. Beyond that, television developed a kind of personage never known before: the "host," always the same, always appealing, always intriguing, the ringmaster, yet never central or in the story. (That was how Ronald Reagan had hosted *General Electric Theater*.) The acme of this line was Johnny Carson, who took over the *Tonight Show* from Jack Parr in 1962. No one else occupied so many hours of viewing time, or became so familiar and endearing, while remaining enigmatic—and without cracking up. It is a remarkable career, and it offers maybe the most abiding model of manhood: funny, smart, cool. (McLuhan said TV had to be cool because that was the temperature of the medium), completely recognizable yet ultimately unknown.

Just about—Carson kept control of the balance in seeming immacu-

late but being close to empty. He had something we see in Cary Grant: a photographed ease, an illusion that filled Grant himself with envy. Both men had lives littered with problems, and distress. Was it possible, through television much more than movie, that they and the audience had been habituated and misled by the way stories on-screen seemed to settle problems? It was the way they stood, looked, and smiled—the way Johnny would play an imaginary golf shot, and you knew it landed on the green. Here is Joan Didion, a sharp observer of film's culture and a screenwriter, talking about American politics in that light. This is from an essay of 1968–70 called "Good Citizens":

> Social problems present themselves to many of these people in terms of a scenario, in which, once certain key scenes are licked (the confrontation on the courthouse steps, the revelation that the opposition leader has an anti-Semitic past, the presentation of the bill of particulars to the President, a Henry Fonda cameo), the plot will proceed inexorably to an upbeat fade. Marlon Brando does not, in a well-plotted motion picture, picket San Quentin in vain: what we are talking about here is faith in the dramatic convention. Things "happen" in motion pictures. There is always a resolution, always a strong cause-effect dramatic line, and to perceive the world in those terms is to assume an ending for every social scenario.

That was forty years ago and we may hope that our best films have become looser, more open-ended, less subject to "scenario," but don't we marvel at the many public events that have been turned into their own scenarios, scripted and available to be "read" by the public? Gesture and pose persist in politics, the more so when the politicians have digested the affect of Henry Fonda. They play themselves because they believe they get elected through their televisual persona. The week I am writing this, in the immediate aftermath of the Tucson shootings (January 2011), one senator has proposed that at the State of the Union address, members of Congress should not sit on their party sides of the House, but loosely, untidily, throughout the chamber, to show "solidarity" and civility.

It is a nice idea, and may make a touching scene on television. Do you wonder if you haven't seen it already, in a Frank Capra picture? It feels like a screen moment, having little to do with the deeper pit of politics—unless you still fall for the efficacy of big scenes and getting it all "sorted out."

The first troubled studies of performing lives in which real existence

might be overshadowed found company in early visions of the "life story" or even the personality as tradable items. In Norman Mailer's Hollywood novel, *The Deer Park* (1955), a handsome but damaged flier, Sergius O'Shaughnessy, comes to Hollywood from the war. He meets stars and directors—an actress on the rise, Lulu Meyers, and a director of quality dragged down by pressure to testify (Charles Eitel; say it out loud)—but the novel turns on the way Sergius may sell his very life story to the movies so that some actor can play him (with amendments, with loss of control, but with great reward). Or should he take the part himself?

Life stories were big in the movies of the 1950s: Jimmy Stewart had few popular successes to match *The Glenn Miller Story* (1954); a baby-faced actor named Audie Murphy played the most decorated American soldier from World War II, also named Audie Murphy, in *To Hell and Back* (1955). These were extensions of the "biopic" genre that had been popular since the 1930s (with Paul Muni playing so many heroes), but the newer films were edging into celebrity with very little self-awareness, and when John F. Kennedy appeared in America, it was suddenly apparent that someone might be a personage and a newsreel figure at the same time (and might get elected on the mixture).

It was that curious Lucy/Lucille syndrome peeping through again, and it was Groucho Marx on *You Bet Your Life* (begun in 1950) behaving just like Groucho Marx. In 1957, Joanne Woodward won the Best Actress Oscar for a film called *The Three Faces of Eve*—more talked about than seen, maybe—playing a woman with three distinct personalities. The film was dark and gloomy and it was said to be a sad portrait of split personality. But it was also a hint about the habit of acting out your moods. Paul Newman put on a tour de force playing Rocky Graziano in *Somebody Up There Likes Me* (1956)—he did his own boxing as well as his own talking and kissing. Wasn't that his own smile? (How much of a role did actors own?) By 1963 one of the uncontrollable forces in American film, Jerry Lewis, played opposite roles in *The Nutty Professor*. It was said to be a new version of Jekyll and Hyde, plus a comedy! But it felt like the confession of a demonic soul made by performing.

Screen presence was being talked about for the first time. That was nothing as intense as acting; it was being there, letting yourself be photographed, or being nearly as helpless as the camera. In Walker Percy's novel *The Moviegoer*, published in 1961, there is a lovely capturing of this state of being. The book's title refers to an unresolved young man who spends too much time watching movies, and Percy sees that as a kind of

estrangement from real life. Early on there is a haunting passage in which the young man is observing the streets of New Orleans when "Who should come out of Pirate's Alley half a block ahead of me but William Holden!"

Holden is an instructive figure of the 1950s in his engaging way of being his own unpretentious icon. So long as he didn't act too hard, he was marvelous. We are not quite sure whether the moment in Percy's novel is the real thing (a celebrity sighting), a dream, or a guest spot (where Holden appears as himself without having a part or a script).

But Percy knows his Holden—or should I say ours? "He is an attractive fellow with his ordinary good looks, very suntanned, walking along hands in pockets, raincoat slung over one shoulder." This is exactly what Holden did so well: be casual, be relaxed, be "on."

People notice him and are enchanted. They become his helpless extras for a moment, until "Holden has turned down Toulouse shedding light as he goes. An aura of heightened reality moves with him and all who fall within it feel it."

That is a piercing description of movie magic, the empty gesture of heightened reality, and our romance with it. But inside Holden there may have been less light. When he died, aged sixty-three, he was alone in his apartment in Santa Monica. He was drunk apparently—he had had drinking problems for years. He fell and cut his head on a bedside table. He bled to death. The body was not found for four days. It is the kind of awkward conclusion that is not supposed to happen to movie stars.

•

From about 1950 onward, the first generation of picture people began to die. By then, many of them were what was called old-fashioned. But they had invented a medium and given their lives to it, and some of them sensed that the medium was changing so fast they were in danger of being forgotten. All of a sudden there were funerals all the time.

In July 1948, D. W. Griffith died at the Knickerbocker Hotel on Hollywood Boulevard. He was seventy-three, broke, boozy, and his last wife had just walked out. As Lillian Gish put it, "He idealized womanhood on the screen, but when he had to live with it he could not make the adjustment." The body was taken back to Kentucky to be buried. Writing of the grave site, Richard Schickel would say, years later, "We have new ways of seeing and thinking and perhaps even being which literally did not exist until the man who lies buried there began his work."

In 1950, Al Jolson died, the man who had uttered the good news and the bad news—depending on your point of view. An unmatched celebrity in his time, he may be unknown to young people today. In 1954 three beloved figures, stalwart supports in fine films, died: Sydney Greenstreet, Eugene Pallette, and Lionel Barrymore. In 1955 we buried James Dean and Theda Bara; and in 1956 it was Alexander Korda and Bela Lugosi, a pair of Hungarians who had made it to the big time.

On January 14, 1957, Humphrey Bogart died, so physically reduced he went up and down his house in the dumbwaiter. Greer Garson had heard him coughing at a party and told him to get to a doctor. Was it the smoking that he had done so much to glamorize? One cherished shot from *The Big Sleep* is two cigarettes together on the edge of an ashtray, still smoldering. He was fifty-seven. In Paris, in May, Erich von Stroheim died: an assistant to Griffith, the maker of *Greed,* the commandant of the prison camp in Renoir's *La Grande Illusion,* and Max to Norma Desmond in *Sunset Blvd.* In October, in Los Angeles, Louis B. Mayer died. Since his removal from M-G-M he had labored to make a great movie, *Joseph and His Brethren,* but it never reached preproduction. He had presided over fifty pictures a year, or none.

In 1958 we lost two models of attractive men: Ronald Colman, and Tyrone Power, who actually dropped dead in Spain (sword in hand) while filming *Solomon and Sheba* for King Vidor. The descendant of actors, Power was forty-four. For 1959, the list was merciless: Cecil B. DeMille, Lou Costello, Ethel Barrymore, Preston Sturges, Errol Flynn, and Victor McLaglen. Flynn was fifty, though we were told he had used his time to the full. With Power and Flynn gone, what would become of sword fighting? In 1960, Clark Gable died, along with Margaret Sullavan and Mack Sennett. Gable was fifty-nine and there were cautious suggestions floated in the press that his heart attack had followed the physical exertion of doing *The Misfits* in the Nevada desert for John Huston and having to wait so long for his costar Marilyn Monroe. There was no reason to believe those stories (especially the hint that Monroe might even have been Gable's love child), except that going to the movies had always been a matter of believing in the stories about these people.

In 1961, without much warning, unless you had been watching his face, Gary Cooper died. He was only sixty, but he had been here forever it seemed. He had been silent once; he was a fatalistic fellow in *Wings,* Tom Brown saluting Dietrich in *Morocco,* Mr. Deeds, Wild Bill Hickok, Beau Geste, Sergeant York, John Doe, Lou Gehrig, Howard Roark, Will

Kane in *High Noon*. So many of America's heroes had needed him. Though something of a mess in life, he had walked or gazed across the screen and conveyed decency and virtue. Today, for good or ill, you could hardly ask an actor to "do" those things so simply, or with so little irony, and not be laughed at.

All but one of the deaths I've listed were received as the passing of veterans, even if so many of them were young by today's standards. Only James Dean seemed snatched out of youth, and that departure was a key step in the public relations for Youth as a newspaper topic. But on August 5, 1962, there was the loss no one has ever explained away.

•

Norma Jeane Mortenson (or Baker) was born in Los Angeles in June 1926. Her mother had been a negative cutter at a couple of studios, and that's where the Gable rumors came from. So she never had a father to speak of, and her mother was somewhere between disturbed and crazy. Norma Jeane was raised in foster homes, orphanages, or with friends, and she dropped out of high school at sixteen to marry a man who worked building aircraft.

Men began to take her picture. She was always in her glory in stills, like a kid raised on fan magazines and their suspended moments of desire and splendor. When she moved on film, in real time, she often became more awkward or exaggerated. But she was enough of a pinup girl—and there was a luxuriant but tasteful spread for a nude calendar—that she was signed up by Twentieth Century–Fox. They decided to call her Marilyn Monroe. She was one of the last studio fabrications and she would die still attached to Fox in anger, grief, and litigation.

She would marry Joe DiMaggio, the model of baseball, and then Arthur Miller, the intellectual, leftist playwright. It was a search for happiness, but a kind of nationwide casting, too. There were also affairs with, at least, the agent Johnny Hyde, Joe Schenck (a boss at Fox), Elia Kazan, Marlon Brando, Frank Sinatra, Tony Curtis, Nicholas Ray . . . Norman Mailer never quite got over the frustration that he was not included and he wrote a rhapsody to her that was driven by his never knowing her.

What was she like on-screen? More or less, fifty years after her death, everyone has seen some of Marilyn's films. A lot of them were thankless studio assignments. In many she is being mocked by her own pictures, a dumb blonde who doesn't get the joke. She had a funny cute voice for film, so she clung to it. She knew every way of looking sexy for a camera,

yet she was hurt when Laurence Olivier told her, "Just be sexy," on *The Prince and the Showgirl* (1957). There were dark opinions, too. George Axelrod, who scripted *The Seven Year Itch* (1955) and *Bus Stop* (1956) for her, believed "She was psychotic. Once you got to know her, one couldn't feel sexy about her . . . You just wanted to comfort her, say, 'It's going to be all right, child.'"

She wanted to do Chekhov or Dostoyevsky? She had Lee Strasberg on her side? She was a mess, struggling with her own attractiveness, her actual sexual frustration, with weight, drugs, and the raging publicity she could neither control nor do without. Studios no longer had reason or the skills to look after their wayward stars, and no one ever knew how to plot a career line for Monroe, or have her remember it. Perhaps she did have a week of fun, with Colin Clark, the third assistant director on *The Prince and the Showgirl* (1957)—if only she had been as good or as understanding as Michelle Williams in *My Week with Marilyn* (2011).

She is funny and glamorous in 1953's *Gentlemen Prefer Blondes* (was that Howard Hawks?); she is eye candy in *The Asphalt Jungle* (1950; call that John Huston's way of noticing a girl); she is heartbreaking in *Bus Stop* (but that relied on Josh Logan's kindness); she is a comic achievement and a figure of fun (not quite the same thing) in Billy Wilder's *The Seven Year Itch* and *Some Like It Hot* (and that was Wilder's lewd cunning); she was out of her depth in *The Misfits* (1961; put that down to Arthur Miller's helpless signing off on their marriage).

Marilyn Monroe was never in charge, and that is why the public felt a helpless responsibility at the news of her suicide. Or, was it that? That's where story crept in and fed the endless industry of autopsy and ghost-raising that goes from Miller's *After the Fall* to Mailer's *Marilyn*, from the Andy Warhol silk-screen series to Joyce Carol Oates's *Blonde*, and to *My Week with Marilyn*. With so much more to come. The year 2012 will be the fiftieth anniversary of her death.

She was the twentieth century's Lola Montès, less the real dancer and notoriety than the figure Max Ophüls established in his 1955 film. Her actual achievement, in stills and movie moments, was slight compared with the work of Katharine Hepburn, Barbara Stanwyck, Bette Davis, or Meryl Streep. But if anyone today is asked to do a painting of the history of the movies (or a book jacket), chances are they do Chaplin tipping his hat to Marilyn, with her standing over that subway grating in New York, where the rush of a passing train turned her white skirt into a parachute. She taught us to see that great images were lost children, and we walk on

in dismay. She fashioned a strange experiment that showed reality was slipping. She might as well have slept with the Kennedys, Einstein, Shakespeare . . . or you and me.

•

Step back and to the side for a moment, and consider a child in the 1950s, and wonder how far he might be aware of some remote but important part of the world through the movies or other forms of popular culture. For the sake of convenience, take a boy who was ten in 1951 and ask what did he know about . . . Japan?

He knew next to nothing, except that the Japanese were a cruel and bad people. If he lived in Britain, his indignation (or horror) at the Germans was greater, but there was ample room to despise the Japanese. In the 1945 film *Objective, Burma!* (in which Errol Flynn's Captain Nelson wins that war), there is this speech uttered by a Western journalist describing the Japanese:

> I thought I'd seen or read about everything one man can do to an-other, from the torture chambers of the Middle Ages to the gang wars and lynchings of today. But this—this is different. This was done in cold blood by people who claim to be civilized. Civilized! They're degenerate, immoral idiots. Stinking little savages. Wipe them out, I say. Wipe them off the face of the earth.

The boy didn't know yet that that could have been Hitler speaking, and he had only a vague sense of what Hiroshima and Nagasaki had entailed. (He did not know it, but he was waiting on the sheer educational input of Alain Resnais's 1959 film, *Hiroshima Mon Amour.*) But he had read a best-selling paperback of the age, Russell Braddon's *The Naked Island* (1951), about Changi Gaol, a Japanese prisoner-of-war camp in Singapore, and an alarming parade of torture, abuse, and execution. Braddon was Australian, and the comparable film, *A Town Like Alice* (1956), from a Nevil Shute novel, had Virginia McKenna and the Australian Peter Finch in love in a similar camp. It moved the boy a lot that British Empire love could sur-vive savagery.

There were not too many other films in that era that dealt with the Japanese as other than authority figures driven by a code of violence that seemed shocking and "unfair." One of the biggest films of the 1950s ($17 million in rentals on a $3 million budget) was David Lean's *The Bridge on*

the River Kwai (1957), set in a prison camp in the Burmese jungle. It had a fascinating cast: William Holden was there again (to ensure U.S. box office), being Holden, charming, a ne'er-do-well, but resolute finally. Alec Guinness was Colonel Nicholson, a noble English idiot, yet curiously dangerous, someone who believes in building a bridge for the enemy. And Sessue Hayakawa (who had played a Burmese in Cecil B. DeMille's *The Cheat* in 1915 and had a notable silent career) was brought out of retirement to be the Japanese camp commandant.

The film won seven Oscars, including Best Picture. Guinness won Best Actor, and Hayakawa was nominated as Best Supporting Actor. He lost to Red Buttons in a film called *Sayonara*, a Marlon Brando picture in which American servicemen in Japan fall in love with Japanese women. (Miyoshi Umeki won the Best Supporting Actress Oscar playing Buttons's girlfriend.) I believe that film provided the first Japanese women the boy had seen— though the man has to admit that he felt then the cinematic problem that "all Japanese people looked alike," except in *The Teahouse of the August Moon* (1956), in which Brando played an Okinawan. Still, *Sayonara* was a breakthrough picture in allowing ordinary Japanese characters an emotional life beyond the anger and violence of captors and commanders.

There was little more, though the ingenious Sam Fuller did make *House of Bamboo* (1955), a film about American crime set and shot in Japan. As late as 1961, in a film often rhapsodized over for its charm, *Breakfast at Tiffany's*, Mickey Rooney was allowed to deliver a toxically racist performance as the Japanese man, Mr. Yunioshi, who lives upstairs from Holly Golightly (Audrey Hepburn). Some people on that picture—the screenwriter George Axelrod, notably—fought with Blake Edwards, the director, about the characterization, but Edwards paid no heed. There were many complaints, polite complaints, but it was still part of Western attitudes toward Japan, I suppose, that people who look alike (call them a huddled mass) have to be polite.

But something else was happening. In September 1951 the Venice Film Festival awarded its top prize, the Golden Lion, to a film from Japan: it was called *Rashomon*, and it was directed by Akira Kurosawa.

Kurosawa was born in Tokyo in 1910. Having failed in a career as a commercial artist, he went into movies as an assistant director and then a screenwriter. He began to direct in the last years of the war—a disastrous period, of course, but he had done several films before *Rashomon*. Still, this was his breakthrough, a period piece in dappled black and white in which an incident of robbery and rape is described in turn by four differ-

ent characters, with variations. The word *Rashomon* by now has passed into English-speaking wisdom to indicate any situation in which the witnesses' testimony doesn't fit.

The fame of *Rashomon* spread. It opened in New York in 1951, and in March 1952 it received the Oscar for Best Foreign Language Film. (This was still an occasional, honorary award, initiated in 1948 with *Shoeshine*.) The Japanese consul accepted the prize for *Rashomon*, thanked the producer, but never mentioned Kurosawa.

Perhaps he hadn't been home in a while, or didn't know his own history. In America, a Japanese film had never won an Oscar, and it is hard to track down any prior Japanese picture that had had a commercial opening. But Edison and Lumière programs had been shown in Japan in the late 1890s, and their impact had been as complete as anywhere else, with this proviso: Whereas in the United States flicks were seen as lower class, film was treated in Japan as fit for everyone, especially the educated classes. By 1940, Japan was producing 500 feature films a year, for internal consumption in a country with a population of 73 million. The figure for American productions in 1940 was 363, for a population of 132 million.

To this day, despite the efforts of Japanese film promoters; of scholars and writers such as Donald Richie, Audie Bock, Mark LeFanu, and Tony Rayns; and enthusiasts such as Susan Sontag, we know too few of those films to be sure about them. *Rashomon* inspired further discoveries in the 1950s, but I fear many readers will scarcely know the name of another "unearthed" figure, Kenji Mizoguchi. Born in Tokyo in 1898, Mizoguchi would die of leukemia in 1956. He made more than eighty films, and just before his death he was "discovered," above all in France, with the release of *The Life of Oharu* (1952) and *Ugetsu Monogatari* (1953).

It is a silly game making lists of the best films ever made, but anything I can do to draw *Ugetsu* to your attention will benefit you. There are two men, Genjurô and Tôbei, the one a potter, the other ambitious to be a samurai. In the sixteenth century, in a time of great strife, they leave their village and their wives as Genjurô travels to sell his pottery. Tôbei stumbles into the role of a warlord, and then one day finds that his abandoned wife is now a prostitute. Genjurô is waylaid by a strange princess, the Lady Wakasa. He goes to live with her, but she is a ghost. He escapes and hurries home to what seems like desolation, but then the camera moves and we find a hearth, a home, and the wife. But she is a ghost, too—murdered, as we have suspected. Next morning Genjurô is alone with his child.

In framing and camera movements, in a concurrent simplicity of action

and complexity of feeling, Mizoguchi is not just in the class of Jean Renoir. He is a master of narrative cinema, of moral consequence, and especially of stories about women. The wife in *Ugetsu* is played by Kinuyo Tanaka, a great actress, and Wakasa is Machiko Kyô, who played a few years later with Brando and Glenn Ford in *The Teahouse of the August Moon*, one of those daft American views of Japan.

If you want a list of Mizoguchi films to track down—and we are still in the age of introductory lists, though there are good DVDs available—it would include all of these: *The Story of the Last Chrysanthemum* (1939; could this be the best film made in Hollywood's great year? Or is it Renoir's *La Règle du Jeu*?), *The 47 Ronin* (1941), *Utamaro and His Five Women* (1946), *Gion Music* (1953), *Sansho the Bailiff* (1954), *Chickamatsu Monogatari* (1954). It makes the 1950s seem rich, doesn't it? No wonder: by the time of Mizoguchi's death, 1956, Japanese film production had recovered from defeat in the war and was back to 500 again. In America by 1956 the number was down to 210.

The story has only just begun. In the year of *Ugetsu*, Yasujirô Ozu made *Tokyo Story*. Born in Tokyo in 1903, Ozu was an unruly kid who got a plum job as an assistant cameraman and began directing in the silent era. He would prove an unmatched observer of that subject often skirted in American pictures: ordinary family life. He developed a withdrawn, quietist camera style, filming in long shot in long takes, from a lower level than is customary, and letting characters move and interact in the frame. Some are tempted to think of it as "very Japanese," but in truth it is very cinematic and totally devoted to characters, actors, and the mood of interiors.

Tokyo Story is about parents who travel to Tokyo to see their children. But the children rather ignore or disdain them, not really out of unkindness but just in the natural way of youth and self-centeredness. Only a widowed daughter-in-law (Setsuko Hara) seems interested in them. They go back home. The wife falls ill and dies. That is all—there are no bank robberies, car chases, or chainsaw massacres. Satan does not appear. But such things are rare in life, too. Toward the end, one character admits, "Isn't life disappointing?" and it's like the voice of Chekhov, as well as the dark secret Hollywood never wanted to give away. Ozu is as important as Mizoguchi, as consistent and human, and as great an artist. From *I Was Born But . . .* (1929) to his last film, *An Autumn Afternoon* (1962, a year before his death), he is to be seen and pursued.

I should not shortchange Kurosawa. No Japanese director made such an impact in the West. But no Japanese director was so familiar with or

so stirred by Western classics, especially the films of John Ford. In 1990 he received an honorary Oscar, presented by George Lucas and Steven Spielberg, who had both learned a great deal from Kurosawa's samurai films. Spielberg called him "the greatest living filmmaker." The list of his films is long and honorable, but I will stress the early to mid-50s and two films made back to back: *Ikiru* (or *Living*), from 1952, and *Seven Samurai*, from 1954.

The same actor, Takashi Shimura, is in both films. In *Living* he is a minor city official who discovers he is dying of cancer and tries to establish a small playground for children. In *Seven Samurai* he is the leader of the band of warriors who come to the aid of a village threatened by bandits. In *Living* he is humble, crushed, and nearly helpless; in *Seven Samurai* he is robust and triumphant. The one film is a restrained view of suffering; the other is fully engaged with combat and valor. It is hard to believe the same man made both. But it is hard to believe anyone made either. We simply sit back in awe.

●

In January 1954, in Paris, a film magazine, *Cahiers du Cinéma*, published a lengthy essay, "Une Certaine Tendance du Cinéma Français" by a young critic named François Truffaut, who was opinionated, a very good writer, and determined to make his name and to define a kind of cinema he wanted to occupy as a director. The essay was reworked several times at the suggestion of the *Cahiers* editor, André Bazin, but it never lost its fierce attack on the allegedly sedate, literary nature of recent French cinema.

The essay became part of the *Cahiers* rationale for celebrating American films, and a spur to the gathering of what would be called the "nouvelle vague," the New Wave. Moreover, it was the kind of attack that might have been launched in other countries—in America even, if it had possessed a serious film magazine or the intellectual respect for film that had existed for decades in France. Such an attack might have been aimed at the mounting irrelevance of, say, *Three Coins in the Fountain* (1954), *Love Is a Many-Splendored Thing* (1955), or *Friendly Persuasion* (1956)—all Best Picture nominees. Still, in France the fuss Truffaut caused could obscure the extraordinary work being done in the 1950s.

●

One of the greatest of directors was emerging, a man so single-minded and austere in his work that he likely never noticed *Cahiers du Cinéma* or

much else going on in the France of the 1950s. Robert Bresson was born in Bromont-Lamothe in the Auvergne in 1901. He had tried to be a painter, and entered movies in a modest way in the 1930s. During the war, he had spent a year in a German prison camp.

So he was in his forties by the time he began what he regarded as his true work: *Les Anges du Péché* (1943), about a community of nuns; and *Les Dames du Bois de Boulogne* (1945), taken from a Diderot story, scripted by Bresson but with dialogue by Jean Cocteau. Hélène (María Casares) is dropped by her bored lover, Jean (Paul Bernard). In revenge, she sets up a meeting between Paul and Agnes (Elina Labourdette), who is close to being a prostitute. Only when that love has led to marriage does Hélène reveal the truth to Paul, yet he responds far better than the plot expects.

Les Dames is not typical Bresson: it uses significant actors; it has a lusher camera style than he would work toward; the dialogue is sharp and theatrical; the story is built on surprise; the melodrama is not denied. It is still a masterpiece, a "woman's picture," if you will, cut through with classical severity, the emotionalism countered by the dispassionate distancing of the filming. If we recall that is also a time of intense, barely restrained melodramas such as *Mildred Pierce*, *Brief Encounter*, and *Duel in the Sun*, Bresson shows a startling disciplining of that essential cinematic genre and condition.

Bresson was launched on an immense and perilous discovery, antithetical to all commercial impulses: that the emotion may be more powerful if reined in. He called for "not beautiful images, but necessary images." Our cinema is still grappling with this—and *Les Dames du Bois de Boulogne* was a drastic failure in 1945, a year of natural exuberance (and recrimination) in France when Marcel Carné's *Les Enfants du Paradis*, a tribute to French theater and theatricality, was the picture of the year.

Bresson paused six years, and then in 1951 he released *Diary of a Country Priest*, from a novel by Georges Bernanos, about a priest who is dying in a grim rural parish, haunted by the problems of some of his parishioners. Now the actors were nonprofessionals, playing not quite as amateurs (he called them models) but without attempting to act out the inner situations. More than the Italian neorealists at work in those years, and more than that other contemporary approach, the strenuous naturalism of the Method, Bresson had discovered a principal that had always existed in the thing we call underplaying (a method found in players from Gary Cooper to the Japanese actors in Ozu and Mizoguchi). It says that if the situation is strong enough, and the face eloquent, there is no need for

acting: simple presence will guide the viewer into the feeling and the idea. (And are there really any faces that are not eloquent? Bresson avoided professionals, and did not like to cast anyone more than once.)

Beyond that, *Diary of a Country Priest* shows Bresson's growing interest in simplicity or minimalism. He rarely moves the camera or bothers with expressive angles. He is more and more interested in sound, often off-screen sound—the scathing rake in the garden outside a window makes an anguished confessional all the more potent. Bresson would say, in his aphoristic and absorbing book *Notes on the Cinematographer*, "When a sound can replace an image, cut the image or neutralize it. The ear goes toward the interior, the eye to the exterior."

Cocteau said the *Diary* was less a film than the skeleton of a film. But if you care to follow its strict ways, the feeling was overwhelming and enough to suggest that too much regular movie feeling was overdone, trashy, or bogus. *Diary* was about the spirit as seen in what Paul Schrader would call "a man alone in a room." (*Taxi Driver* has that motif "Are you talking to me?," and Robert De Niro improvised that line from Schrader's script.) Bresson was often regarded as a Catholic artist. But his true inwardness was in his dedication to cinematic essence and abstraction.

Then came another pause before, in 1956, Bresson offered *Un Condamné à Mort S'Est Echappé* (*A Man Escaped*). Fontaine is a French Resistance fighter captured by the Gestapo. Can he escape from his prison in Lyon? Should he trust the other prisoner put in his cell? Still working in black and white, with the cameraman Léonce-Henri Burel, Bresson was refining his styleless style: this is a film of claustrophobic shots with a world of unseen sounds (as befits its situation); it is a series of faces and hands, and the implacable present tense that prison only emphasizes—of course it is the moment of film and of life. François Leterrier (who played or represented Fontaine) said of the process, "[Bresson] did not want us to ever express ourselves. He made us become part of the composition of an image. We had to locate ourselves, as precisely as possible, in relation to the background, the lighting, and the camera."

In 1956, Truffaut said *A Man Escaped* was "the most important film of the last ten years." What that meant was a new realism in which, maybe for the first time, the visual, the cinematic, was not primary but nearly incidental (albeit necessary). Now, of course, the cinema is the embodiment of "let there be light," but the light and the visual can amount to a tyranny. Bresson had understood that, and in the process he had liberated movies or brought them closer to the depth of literature and music. He

had seen everything he wanted, and then pared it away, until just that skeleton remained. Truffaut said that *A Man Escaped* made us feel we had been in Fontaine's cell for two months, instead of watching a one-hundred-minute film.

It is less the visual we notice than the human gesture and the human existence. Pauline Kael said this: "In this country [the United States], escape is a theme for action movies; the Bresson hero's ascetic, single-minded dedication to escape is almost mystic, and the fortress is as impersonal and isolated a world as Kafka's . . . I know all this makes it sound terribly pretentious and yet, such is the treacherous power of an artist, that sometimes even the worst ideas are made to work."

Four months after the Paris opening of *A Man Escaped*, Max Ophüls died in Hamburg in March 1957. As Max Oppenheimer, he was born in Saarbrücken in 1902. He is the epitome of the itinerant filmmaker, whose camera tracked and craned with the same soaring fatalism no matter where he was. Just as Murnau had been seeking a fusion of European and American approaches to the medium on *Sunrise*, so Ophüls was in quest of universal strains of romance, memory, time, and tragedy across the world. But he is treated here because his career ended and peaked in France.

He had been a stage director in Germany and already the father of the future documentary maker Marcel Ophüls when he made his first important film, *Liebelei* (1933), a love story taken from a play by Arthur Schnitzler about a young officer and a musician's daughter. He moved to France and then to Italy, where he made *La Signora di Tutti* (1934), that groundbreaking study on the life of an actress. Then it was France and Holland and France again before he went to Hollywood in 1941.

His time in America was always difficult. Howard Hughes fired him from a project called *Vendetta*, but then he did three remarkable pictures. The first, produced by John Houseman, was *Letter from an Unknown Woman* (1948), from Stefan Zweig, with Joan Fontaine as the woman in love with, seduced by, but then forgotten by a world-weary concert pianist, played by Louis Jourdan. Then, working closely with the actor James Mason, he made *Caught* and *The Reckless Moment* (both in 1949), the first about a young woman who gives up marriage to a Howard Hughes–like tycoon (chillingly played by Robert Ryan) to work for a doctor (Mason); the second a story in which Mason begins by blackmailing Joan Bennett, only to fall in love with her.

Ophüls was regarded as a failure in America. His name was misspelled and mispronounced, and he moved from one project to another

like a refugee. It was said that he made melodramas, but what few identi-fied at the time was his sympathy for stories about women misunderstood by men, abused, but trying to find their life. In *Letter from an Unknown Woman*, Joan Fontaine's portrait of a girl becoming adult, sadder but still misled by life, is desperately touching, yet the film was barely recognized.

So Ophüls went back to France and in his last years (he was never strong and would die of a rheumatic heart condition aggravated by stress) he made *La Ronde* (1950; his single hit), *Le Plaisir* (1952), *Madame de . . .* (or *The Earrings of Madame de . . .* ; 1953), and *Lola Montès* (1955). *La Ronde*, from Schnitzler again, has Anton Walbrook as a master of ceremo-nies who observes the infection and the gift of romance passed from one person to another. It is witty and elegant, with an all-star cast, superb production design (by Jean d'Eaubonne), and Ophüls's winding and un-winding tracking shots. It picked up an Oscar nomination for Best Screenplay by his frequent collaborator Jacques Natanson, and it was still dismissed as typical French "sophistication." French film in those days had a strange reputation in censorious countries (such as America and Britain) for being naughty and allowing some nudity.

Madame de . . . —the earrings were thrown in the title in America, to make shopping seem more available?—is about a wife, her husband, and her lover: Danielle Darrieux, Charles Boyer, and Vittorio De Sica. She is the heroine but she is silly and she will damn herself out of vanity and foolishness. She is also the endearing victim in a tragedy she cannot avert and hardly realizes she has caused. *Le Plaisir* (1952) is a trio of stories taken from Maupassant.

Then there is *Lola Montès* (1955), the masterpiece among abused mas-terpieces. Lola is the legendary courtesan of the nineteenth century and she could be every great woman in show business. Close to the end of her life, sick and demoralized, she is selling her life story as a circus act. Here is the finest film yet that seeks to deconstruct the career of a female star. Her ringmaster (Peter Ustinov) is her manager and probably her latest lover. In the circus as the camera whirls around her, she flashes back to her youth, to affairs with Liszt and the king of Bavaria (Walbrook again). At the very end of the show the camera tracks away from her exhausted figure over the line of men waiting to pay to kiss her as attendants collect the money in pots made in the form of her head. This is a pioneering im-age of the alienation that befalls people who live on or through screens.

It is also a high point in the history of the moving camera and the belief that in melodrama we can find the roots of film fantasy, the very force

that has celebrated and ruined people such as Lola Montès (or Marilyn Monroe). The actress Ophüls cast as Lola, Martine Carol, has been criticized over the years for being pretty but not too interesting. Though she was a notable star in France, the film might have been helped by an international figure. And Monroe in life was often an exhausted beauty, best filmed in dismay or doing nothing—which is what the part needs. Her half-desolate, half-alive face was right for Ophüls's view of Lola as a burnt-out beauty. Of course, given such a big, foreign opportunity, Monroe might have believed she had to "act" and have gone to pieces. She never trusted her presence.

Lola Montès looks like the nineteenth century, to be sure, but Truffaut caught its real aim exactly:

> For the first time, he [Ophüls] superimposed contemporary preoccupations onto his perennial theme of the woman burned out prematurely: the cruelty of modern forms of entertainment, the abusive exploitation of romanticized biography, indiscretions, quiz games, a constant succession of lovers, gossip columns, overwork, nervous depression. He confided to me that he had systematically put into the plot of *Lola Montès* everything that had troubled or disturbed him in the newspapers for the preceding three months: Hollywood divorces, Judy Garland's suicide attempt, Rita Hayworth's adventure, American three-ring circuses, the advent of CinemaScope and Cinerama, the overemphasis on publicity, the exaggerations of modern life.

Bresson and Ophüls could hardly be further apart. Yet in their different ways, both had reached a point of seeing that the old cinema not simply was in decline, but might be a reflection of a decline of civilization itself. At almost the same time, in 1954, Twentieth Century–Fox made a very poor film called *There's No Business Like Show Business*. (It starred Ethel Merman, Marilyn Monroe, Johnnie Ray, Dan Dailey, and Donald O'Connor—a mad family, if you like.) It was in Scope and minestrone color and it hurled out its musical routines, including that old, mindless assertion about there being no business like show business. More than *Sunset Blvd.*, *Lola Montès* sees that feverish claim as a subject for sorrow and pity. The old confidence behind "entertainment" was draining away.

•

David Selznick had been impressed enough by Ingrid Bergman to take Sweden seriously. In the years just after the war, he had box office monies accumulating in foreign countries not easily withdrawn because of currency restrictions. He also had several stars on his books who were not working enough. So he thought he would use that money to do a film in Sweden, and in his vague sense of culture, he thought why not do Ibsen's *A Doll's House*—wasn't that a story for the ages? Norway? Sweden? Were they different? He had in mind Dorothy McGuire and Robert Mitchum for Nora and her husband.

Using his dedicated agent and scout in London, Jenia Reissar, he found "talent" in Sweden that might make the film. There was a director much praised in Stockholm, Alf Sjöberg, and there was a young writer. Through Reissar, a contract was made with the writer, though she reported that he had long, unwashed hair and was rather dirty and quite odd. Still, for American money he did the script and gave it a happy ending to meet American tastes. I have read the script, though it was never made. It doesn't deserve to be made. The name of the writer was Ingmar Bergman.

Bergman was born in Uppsala in 1918, the son of a Lutheran pastor, and he was raised in severe strictness, a domestic atmosphere alleviated by his fascination with toy theaters. During his boyhood, Sweden was a country of around five million, but its contribution to film history was already remarkable. In the years of Griffith, Mauritz Stiller had shown himself to be a director of romantic comedy as sophisticated as that of Lubitsch and as skilled with the camera as Griffith. He had a rival, Victor Sjöström, so highly regarded that he had been invited to Hollywood where, as Victor Seastrom, he had directed Lillian Gish in *The Wind*. When Louis B. Mayer recruited Greta Garbo, she was actually baggage in the deal that really wanted Stiller. The couple came together, Garbo thrived, and Stiller was thwarted. A decade later, Ingrid Bergman arrived from Sweden to be an American star as important as Garbo.

Ingmar Bergman studied theater at the University of Stockholm. He wrote fiction and plays and he found work as a script doctor in the film industry. In 1944 he got his first credit on Alf Sjöberg's *Frenzy*, a film about a school where the teacher is a fascistic figure who intimidates the young. Its cast included the nineteen-year-old Mai Zetterling in one of her first roles. It was on the strength of *Frenzy* that Bergman was offered the Selznick job on Ibsen.

At the same time, he began to get directing opportunities. His first

films—*Crisis* (1946), *It Rains on Our Love* (1946), *Port of Call* (1948), *Thirst* (1949)—were essentially realist in their approach but marked by the psychological or neurotic unease that would characterize Bergman. He began to emerge as he found projects for the actresses he loved—*Summer Interlude* (1951, Maj-Britt Nilsson), *Summer with Monika* (1953, Harriet Andersson), *Sawdust and Tinsel* (1953, Andersson), and *Smiles of a Summer Night* (1955, Ulla Jacobsson, Eva Dahlbeck, and Andersson again).

These films were of a pattern: they were all in black and white; made modestly for Svensk Filmindustri, a state entity; with strong Swedish casts; but selling successfully to the international art house circuit. Bergman worked always as writer-director, a regular practice in Europe but far more unusual in America. The films were sometimes so sexually candid they had to be cut overseas: Harriet Andersson is often nude in *Summer with Monika*. It was released in America in 1956 and cut down by a third, as *Monika: The Story of a Bad Girl*, with posters stressing the nudity theaters could not show. The films won festival prizes: *Smiles of a Summer Night* played at Cannes and won for "Best Poetic Humor."

"Poetic humor" wasn't quite Bergman's style at home. He was already on his third divorce, but living most of the time with Harriet Andersson. And he was troubled:

> When Harriett had taken off her make-up and changed, we went home to sleep, neither of us having much to say to the other any longer . . . I owned two pairs of trousers, a number of flannel shirts, disintegrating underwear, three jerseys and two pairs of shoes. It was a practical and undemanding life. I had decided that a guilty conscience was an affectation, because my torment could never make up for the damage I had done. Presumably some inaccessible process went on inside. I had all kinds of gastric flu and ulcers. I vomited often and had troublesome stomach cramps followed by diarrhoea. In the autumn of 1955, after filming *Smiles of a Summer Night*, I weighed fifty-six kilos and was admitted to Karolinska Hospital with suspected cancer of the stomach. I was thoroughly examined by Dr. Sture Helander. He came into my room one afternoon bringing the x-rays with him. He sat down and patiently explained them. He described my ailments as "psychosomatic" and told me I would have to start looking seriously into this dimly-lit area, the border country between body and soul.

This is not the small talk of Hollywood parties, where most people boasted steadily of success and happiness. But it is the voice of postwar European existentialism, and of a spirit that regards the film director as an exemplary modern neurotic and artist, exploring angst, and sleeping with many of his actresses but feeling bad about it. Hollywood directors often behaved that way, but they found the grace to be cheerful.

Bergman took a break, time to observe the increasing fallout from bomb testing in our atmosphere, and came back for 1957, the year that altered his status forever and established the new world of art house movies. *The Seventh Seal* was derived from a play of Bergman's first performed on radio, and then in Malmö and Stockholm. It is set in the fourteenth century. A knight (Max von Sydow) has returned from the Crusades in disenchantment. He sees a land of madness, plague, intolerance, and savagery. Then the figure of Death (Bengt Ekerot) approaches him and they play chess for the knight's life—chess got as much of a boost from this film as it did from Fischer versus Spassky in Iceland in 1972. In the end, the knight wins a reprieve by his kindness to a family of traveling players (featuring the young Bibi Andersson).

The film is ninety-six minutes long and it cost about $150,000. It may have changed more careers than any film since *Citizen Kane*. It shared the Special Jury Prize at Cannes with Andrzej Wajda's *Kanal*, and played all over the world. *The Seventh Seal* pushed me to join the National Film Theatre in London to see a retrospective of Bergman's films. The theater was packed for that season. I was in awe of the film, so much so that I never quite asked myself whether I liked it. I know I like it a good deal less now than the second film Bergman released that year: *Wild Strawberries*, or *Smultronstället*—the hushed musicality of the Swedish language was dawning on us.

Bergman had written the script for *Wild Strawberries* in the Karolinska Hospital. It concerns Isak Borg, aged seventy-eight, a widower and a bacteriologist who is to receive an honorary degree from Lund University. He drives there with his daughter-in-law (Ingrid Thulin) and along the way he dreams or has flashbacks that examine his life and a lost love. She is played by Bibi Andersson, who also appears as a carefree modern girl Borg picks up on the road. Like *The Seventh Seal*, *Wild Strawberries* was shot by Gunnar Fischer, Bergman's genius before Sven Nykvist came along. (Nykvist's first Bergman film was *The Virgin Spring*, in 1960.)

In the role of Borg, Bergman cast Victor Sjöström, who was then Borg's age and in declining health. Sjöström was the father figure of Swedish

cinema and he had been an important mentor to Bergman. One day in the 1940s, Sjöström had walked onto a Bergman set, grabbed him, and said, be simpler, film from the front so actors relax, don't be unpleasant with everyone.

Wild Strawberries is a tale of futility and failure at last recognizing its own happiness or resignation. It has many symbols in a harsh, etched look that suggests some substance more enduring than film will ever be. It also has a passion for fleeting summer light that is so vital in Swedish film—few nations depend on the light as much or feel such meaning in it. If only the light were more elusive in California; we might treasure it more.

They were set to shoot the final scene of *Wild Strawberries*, where Borg's young love leads the old man to a hillside and he sees his parents in the distance waving to him. Bergman wanted to shoot at five because of the light, but Sjöström preferred to stop at 4:30. He was disagreeable sometimes and he needed his whisky. "Are we going to take those damned scenes?" he asked his director.

He was by no means in a better mood, but he did his duty. As he walked through the sunlit grass with Bibi in a long shot, he was grumbling and rejecting all friendly approaches. The close-up was rigged and he went to one side and sat with his head sunk between his shoulders, dismissing scornfully the offer of a whisky on the spot. When everything was ready, he came staggering over, supported by a production assistant, exhausted by his bad temper. The camera ran and the clapper clacked. Suddenly his face opened, the features softening, and he became quiet and gentle, a moment of grace. And the camera was there. And it was running. And the laboratory didn't muck it up.

That is what filming can be like: saving a moment in time and the light. And you can see it.

Wild Strawberries won the Golden Bear at the Berlin Film Festival. It was nominated for an Oscar for Best Screenplay—but it lost, to *Pillow Talk*.

Sjöström died in 1960; Bergman not until 2007. He continued to lead what seemed like a quiet life, with constant inner turmoil, going from one lover to another and one nervous breakdown to the next. In the 1970s he had embarrassing trouble with the Swedish authorities over income tax fraud. It passed; he had brought so much money into the country. He

dabbled in offers from Hollywood: he shot *The Touch* (1971) in English (with Elliott Gould) and he made *The Serpent's Egg* (1977) in Germany. But long before the end he was living on the island of Fårö, working steadily in Sweden. *The Seventh Seal* and *Wild Strawberries* may not be his best films, even if they are the turning point in his career. For the best, you can pick from *Persona* (1966), *Cries and Whispers* (1972), and *Fanny and Alexander* (1982). Other people will mount claims for *The Silence* (1963), *Through a Glass Darkly* (1961), or *Scenes from a Marriage* (1973). But you should not forget *Faithless* (2000), which he only wrote and which another of his actresses and lovers, Liv Ullmann, directed. *Faithless* is about Bergman—what would you expect? He is the first director in the world who takes it for granted that all the work is about him, his way of seeing and feeling. But *Faithless* is filled with regret over the damage he knows he has done to real people while creating great fictions.

•

In Hollywood in 1959 it was still possible to look on the bright side. *Pillow Talk*, a screen romance between Doris Day and Rock Hudson, had not been produced to make an ironic point with *Wild Strawberries*. Rather, it had been aimed at rentals of $7.5 million, the sum it reached. In 1959 the Hollywood major studios released 189 pictures. Weekly attendance fell to 32 million, and box office revenue was below $1 billion for the year, having been steadily over that amount from 1942 to 1957. And yet it was the year of *Ben-Hur* and *Pillow Talk*, *On the Beach* and *North by Northwest*, *Porgy and Bess* and Disney's *Sleeping Beauty*.

Of those, *On the Beach* was the only picture that addressed the real possibilities of 1959. Produced and directed by the earnest Stanley Kramer, it was a story about nuclear Armageddon in which Gregory Peck, Fred Astaire, Ava Gardner, and others faced the end of the world. The film was solemn and woeful, and in its views of a sunlit but empty San Francisco it was piercing enough. It was full of dire warning, presented as entertainment (it had rentals of nearly $5 million), and it left audiences speechless and depressed, if only because they felt so powerless.

Of those 1959 films, the madcap one has survived best: *North by Northwest*, which is as funny and exhilarating as ever. People said it was a Hitchcock comedy-thriller, with Cary Grant playing himself—all true. But its daring bears closer inspection. It is a ridiculous story: witness the crop-dusting aircraft working semidesert "fields," or the way in which the moment when the plot secret is spelled out is flagrantly smothered

by the sound of an aircraft engine. Between the melancholy of *Vertigo* and the shock of *Psycho*, Hitch felt the place for a film that said aren't movies ridiculous, especially when you're having fun? *North by Northwest* is a parody of a suspense thriller. It's camp, before that word was in common use.

•

In the late 1950s, without discussion, America happened to produce some surprising pictures that asked, "How seriously do you take the movies?" Douglas Sirk was yet another German director who had come to America. He was born in Hamburg in 1897 (son to a Danish father) as Hans Detlef Sierck. He had worked extensively in German theater and done some accomplished and stylish melodramatic pictures—*Zu Neuen Ufern* (1937) and *La Habanera* (1937)—both with the beautiful Swedish actress Zarah Leander. He came to America in 1940 and made dramas, thrillers, and women's pictures, with mounting success. *Magnificent Obsession* (1954) and *All That Heaven Allows* (1955), both starring Jane Wyman and Rock Hudson, had been great hits for Universal International, and they are films in which the personal crises are narrative cover for an unusual displeasure with American emotional honesty betrayed by social convention.

Written on the Wind (1956) goes just a little further. It is the story of money, love, sex, family, and oil in Texas, and it opened only weeks after *Giant*, a bigger production, taken from the Edna Ferber novel, but grown in the same soil. *Giant* takes itself very seriously; there is only respect in that title. But *Written on the Wind* has a breath of satire or self-mockery to it.

Its characters tremble on the edge of exposé: Kyle Hadley (Robert Stack) is heir to an oil fortune, but he's a lost soul—alcoholic and without sexual confidence. He marries Lucy (Lauren Bacall), a decent woman from New York. She will come to love Mitch Wayne (Rock Hudson), Kyle's amazingly stalwart and loyal best friend, but Mitch is lusted after by Kyle's sister, Marylee (Dorothy Malone), a restless nymphomaniac in the habit of cuddling up to toy oil derricks. The film had a theme song, sung by the Four Aces, with this opening line: "A faithless lover's kiss is written on the wind!" It was shot in florid, overdone color by Russell Metty. It has sets from a deluxe death hotel. The camera moves like a drunk. Malone won the Best Supporting Actress Oscar, and in 1956 audiences could take it straight if they wished, or they could see the expensive wallpaper beginning to curl off the walls. Here is part of a commentary on *Written on the Wind* from 1971, far beyond the estimates of 1956, yet

piercingly apt and a model of how the ways of thinking about movies were shifting:

> In *Written on the Wind* the good, the "normal," the "beautiful" are always utterly revolting; the evil, the weak, the dissolute arouse one's compassion . . . And then again, the house in which it all takes place. Governed, so to speak, by one huge staircase. And mirrors. And endless flowers. And gold. And coldness. A house such as one would build if one had a lot of money. A house with all the props that go with having real money, and in which one cannot feel at ease. It is like the Oktoberfest, where everything is colorful and in movement, and you feel as alone as everyone . . . Sirk's lighting is always as unnatural as possible. Shadows where there shouldn't be any make feelings plausible which one would rather have left unac-knowledged. In the same way the camera angles in *Written on the Wind* are almost always tilted, mostly from below, so that the strange things in the story happen on the screen, not just in the spectator's head.

It's unclear whether Douglas Sirk intended all that in 1956. But in 1971, Rainer Werner Fassbinder—the most radical of the young German directors of that age, and the delighted demolition artist of melodrama—saw that film, felt the satirical edge and the contempt for that world of money, the very source and image of the advertising that was dominating the television screen in America.

Or take Otto Preminger's *Anatomy of a Murder* (1959). The courtroom drama was a staple of American entertainment. *Perry Mason* was a television show that had begun in 1957 in which, week after week, Mason would defeat the addled efforts of the Los Angeles district attorney, Hamilton Burger. Innocent viewers believed the show was "educational" in that it gave guidance on how trials worked, and of how reliably justice was done!

Otto Preminger was a far warier man: in *Laura* (1944), he had dismantled a murder mystery to reveal the hero and heroine (Dana Andrews and Gene Tierney) as very ordinary and awkward people caught in a dream. Preminger took little at face value. *Anatomy of a Murder* (1959) was from a novel, but on-screen it was a breakthrough. To start with, the defense lawyer (played by Jimmy Stewart) was a sly trickster, ready for any maneuver; the accused man (Ben Gazzara) was plainly possessed by hostile

impulses; and the wife (Lee Remick), whose honor the accused was defending—he killed her rapist—was so flirtatious you had to wonder at what had happened. *Anatomy* proposed several fresh things about the law and movies based on trials. It said the law was a game in which the best player wins, because we can never be sure about truth.

Preminger kept the film at a level of smart entertainment. It has a superb score by Duke Ellington—it even has Ellington playing piano in a tavern in an upstate Michigan nowhere town. It has George C. Scott and Eve Arden. And to play the judge, in a characteristic marketing coup, Preminger enlisted Joseph N. Welch, the attorney known to America from the televised Army-McCarthy hearings. That's where Welch had asked McCarthy, "At long last, have you left no sense of decency?" *Anatomy of a Murder* deserved its big success, but it is clear about one message: keep your critical faculty sharpened, because the scheme of *Perry Mason* is monotonous junk likely to make an idiot out of you.

Or look at Howard Hawks's *Rio Bravo* (1959). This was a John Wayne film, and Wayne's career seemed sacrosanct. You had to believe you were in the West, where everyone played by the rules of the genre. Of course, not so far ahead—in films such as Sam Peckinpah's *The Wild Bunch* (1969)—we would learn that the West was nasty, dirty, and a place where no one played by any rules. But *Rio Bravo* is less an authentic Western than the amiable eavesdropping on a group of friends in 1959—not just Hawks and Wayne, but Dean Martin (the least nineteenth-century persona America ever put in cowboy clothes), Ricky Nelson, Walter Brennan, and the intensely immediate Angie Dickinson—there was no smarter woman on the American screen then—on a set where they are pretending to make a "Western."

The gap doesn't show, though Hawks had been kidding his own genres for years. But in *Red River* you do believe you are on a cattle drive. In *Rio Bravo* you know you are on a Hollywood lot.

The greatest coup of this shifting moment comes last. In that same 1959 the irrepressible Billy Wilder said suppose you pull the leg of such things as the St. Valentine's Day Massacre, the sturdy outlines of the gangster picture, male star authority, Cary Grant, Edward G. Robinson, George Raft, and the whole legend of Marilyn Monroe. And why not make it subversively gay, too? I am talking about *Some Like It Hot*, which really was made in the same year as *Ben-Hur*.

Some Like It Hot was written by Wilder and his colleague I. A. L. Diamond, vaguely mindful of a minor German film of the 1930s but locked

into America in 1959. Two hard-up musicians (Tony Curtis and Jack Lemmon) witness a gangster firing squad. On the run, they take jobs as bull fiddle and tenor sax in an all-girl band where Marilyn is the hapless singer, Sugar Kane. The action shifts from Chicago to Florida, states of the movie mind. Curtis goes after Marilyn, gets her on board a yacht, where he does a Cary Grant–sounding millionaire who is impotent. Sugar makes every attempt to give him a hard-on—yet again she is the oblivious dirty joke in her own picture. Meanwhile, Lemmon is pursued by an aging playboy, in the person of Joe E. Brown.

I'd like to think everyone knows *Some Like It Hot* in the way they know *Sunset Blvd.*—when Wilder hit a home run it was gone forever. You can see the film tonight and it has not dated. You may marvel that the absurd censor let so much get past him—he was losing confidence. You may need a little commentary to catch the allusion to the MCA talent agency, when Jules Stein and Lew Wasserman were just midwestern operators. You may need footnotes on how the son of Edward G. Robinson tosses a coin under George Raft's nose, with George snapping, "Where did you pick up a cheap trick like that?"—when it came from Raft's performance in *Scarface* (1932). But you'll get the point: Wilder's sharp mind has seen not just that sexuality is so slippery and appealing no one can claim perfection. This is a mainstream film that says, "You might be gay," as well as, "For Christ's sake, what have the movies done to us?," and it does so with the full velocity of barbed entertainment.

Some unexpected observers could feel the shift in the reliability of old truths and virtues. Saul Bellow, writing in *Horizon*, would say, "Plain goodness, blunt badness, the honor of strong silent men, simple love, and classical jealousy went out of fashion. Hollywood went on making action pictures, of course, but significant actions became harder to find as we entered this present age of disarray."

•

Out of the screen comes sound, breathing, and music, and the first streaks of light on skin. Or is it dawn?

Not the least wonder in *Hiroshima Mon Amour* (1959) is that it begins at night, in bed. As a rule, our films build up to love. We do not realize it yet, despite the title of the film, but the bed holds a French woman and a Japanese man. We see the bodies, or parts of them, and they are crystalline nearly. Is that the perspiration of lovemaking or the ashes from some burning? The script calls the residue "cendres atomiques," but when you

first see encrusted arms you do not know that yet. The bodies might be buried, in the night or in their love, and the flesh might be decomposing. The title is a riddle to be answered.

You hear a piano refrain. It is by Giovanni Fusco, probing, questioning, feeling, wondering. You see the skin change. The cinders seem to run, like sweat or putrescence, like rain or moisture or film's dissolve. And the voice of the man says, in French, "Tu n'as rien vu à Hiroshima. Rien"—"You saw nothing at Hiroshima. Nothing." But we are trying to see.

The nature of our engagement has been laid down: we are asked to look very closely, to identify something strange happening to skin, and yet we are told by a voice that shares the beat of the piano that we have seen nothing.

A woman's voice answers that she saw everything. She saw the hospital at Hiroshima. As if we are watching a documentary, the screen shows us a hospital—you know what a hospital looks like. But the man tells her, "Tu n'as pas vu d'hôpital à Hiroshima. Tu n'as en vu à Hiroshima." He is denying her, yet the rhythm of claim and response is also like the touching in lovemaking: touch me, please—yes, touch me there. Even though he insists on her ignorance, there is tenderness in the telling. Even though the film is in French, you are alerted to a rare feeling for the rhythm in words and speech. You are looking, as if your life depended on it, in this nocturnal embracing, but the words are like kisses.

The opening of Hiroshima Mon Amour begins to teach us how to attend; it is the same with every real film, or every departure in film. The night talk is very erotic. It speaks of love in the act of breathing. So these people never need to say they are in love. We know. We have felt it, even though they are a French woman, Elle (Emmanuelle Riva), an actress come to Hiroshima to make a film about peace, while he, Lui (Eiji Okada), is a Japanese architect who has met her. But their bodies are so alive with metaphor—Are they damp with love's heat? Are they rebuilding or acting? Are they turning into something else in radiation? Or are they dead already, buried? So much fluidity, but we have not seen their faces yet. There is more talk in this night, about how it was ten thousand degrees at the Place de la Paix, the heat of the sun. In documentary-like sequences, we see the story of August 6, 1945—there is even a clip from a Japanese feature film about the horror—as well as hospital footage where patients live with warped faces and sheared-off limbs.

Alain Resnais (born in Vannes in 1922) had been a documentarian previously: he made two films about Van Gogh (one won an Oscar) and Guernica; Les Statues Meurent Aussi (about African art), made with Chris

Marker; *Night and Fog* (about Auschwitz); and *Toute la Mémoire du Monde* (about the Bibliothèque Nationale). These are pictures about forgetfulness and the obligation of holding on to memory. *Hiroshima Mon Amour* is his first feature film, and he had asked the novelist Marguerite Duras to write the script.

The first passage ends. The sound level changes, from night to day, from reverie to life. It is the morning after the night of love and talk. She says she is from Paris. And before that, from Nevers, in the Loire region. A little later, the man is sleeping in the hotel bed. She is on the terrace, in the sun, wearing a kimono and drinking a cup of coffee. She comes back into the room and sees his arm, twisted a little oddly the way he is positioned. There is a cut to another arm at a similar angle, long ago, but not so long ago. In the war, when she was younger and had longer hair, in Nevers, she was in love with a German soldier. But he was shot dead, *his* arm was caught, and in her wretchedness she was abused, her hair chopped off, her face marked with dirt, or was it excrement?—the things that were done to collaborators. In Nevers.

In that first glimpse, we are shown only a fragment of Nevers—but we have been trained to watch closely, so we see it, we feel it. But as the war goes on, we get more of the past. We see her riding her bicycle on the wooded country roads hurrying to meet her lover, and there is a tumbling lyric tune on the soundtrack, written by Georges Delerue, quite different from the Fusco piano and the pulsing reed refrain we heard in the night. It's a lovely interlude, like a movie moment. We see her with cropped hair, shut in a cellar as punishment, licking at the walls in her distress.

There was a widespread fear in the late 1950s that came from the state of the cold war and the way in which two great powers were testing larger and larger bombs in what was called the atmosphere. This spoke of dangers to us all that we could not see or measure, but which were poetically delivered in the images of bodies that might be decomposing (or being remembered). Just the use of "Hiroshima" made this a film about war, even if it had no battles. The name Hiroshima is like a placard pushed in our face or a button pressed in our brain. "Auschwitz" is the same. And if the war is rendered as simply the story of two lovers broken apart, one lesson of that is why did anyone think you could make relevant films about war that put all their stress and imperative on courage? Is that an American habit? Other countries think of war in terms of luck.

As *Hiroshima Mon Amour* progresses, the conceit builds that the two characters, Lui and Elle, are really named Hiroshima and Nevers. They

are the crises in the woman's life and they are the evidence for an asser-
tion—it seems simple to utter, but it is profound—that human beings can
relate such things. They know to scan "now" and "then." They have names
and they live in time. You can still see *Hiroshima Mon Amour*, and Riva
and Okada look as young or as perfect as they did when they shot the film
(in 1958). But he is dead now—he was in Teshigahara's *Woman in the
Dunes*; he died in 1995 of a heart attack. Riva is still alive. She is in her
eighties, and perhaps in her way she looks like the old Japanese woman in
the film. If you know the picture, you know what I mean. Later on, the
lovers pursue each other in the city, and there is a moment when they
come to rest on a bench with an old woman sitting between them. They
talk. They are filmed. But it is a mystery as to whether the old woman was
cast as an eavesdropper—or was she simply there and did Resnais ask her
to wait while the scene was filmed? I love the moment because it is not
clear whether she is fictional or documentary. But she looks at the actors
as if they might be aliens who have elected to intrude on her existence.

It isn't just nostalgia, or a sense of history, that realizes *Hiroshima Mon
Amour* is more than fifty years old now. It isn't just that the world has
found other things to worry about beyond the half-lives in radioactive
fallout. Hiroshima is still a given, less a place than an event, a screen and
a scream, thrust into our discourse as something that might deafen us or
crush us. The youthfulness of these lovers means more now, now that the
actors are leaving us, and their passion can only become more touching as
each year passes.

Hiroshima Mon Amour puts certain matters pertaining to the Second
World War in their place, and asserts that in war, people will behave
badly, or privately—no matter the moralizing gloom you offer; that they
will attend to their own lives and petty affairs and be timid in most things
except for being in love. Resnais and Duras came together in a passionate
collaboration—without having to be in love with each other—in which
they tell us, look, listen, see what film can do. Their discoveries still move
us. Yet I am not sure today that anyone could deliver a picture with such
cinematic immediacy.

In its insistence that Elle has seen nothing in the city of Hiroshima
there is Resnais's admission that documentary can do only so much—
then fiction is the last way to answer abiding questions. And it is part of
fiction's recovery of our world that two drastic explosions—the shot that
killed her German lover and the bomb that achieved ten thousand de-
grees at ground level—can be passed over and made quiet. Those im-

pacts are no more potent than their signs of loss. But war should not be allowed to bully or intimidate us until we believe its explosions are all-important. In the long passage of memory they are just sound effects, so trivial compared with the way people grow older and sadder.

The 1959 film remains. Its light has not wavered yet, though that may be thanks to the mercy of black and white and the way film emulsion has a life of its own. It looks and sounds as fresh and questioning as ever. Begin the picture, and its haunting night returns you to the underground river that flows between Nevers and Hiroshima. Yes, there was a war once that linked the two places, but the war was only the superficial bond. The more enduring tie was the way lovers touch and the woman remembers. The thing she is most afraid of is not a bigger bomb than Hiroshima but the chance that she may forget. The thing she cannot bear is the thought that life might be without links or significance in the dark.

•

Sometime in the magic of 1958–59, François Truffaut remembered his friend Jacques Rivette saying to him, "We're going to make films, we all agree, we're all going to make films." You can guess the exuberance of the moment, the musketeer-like contract. Truffaut was born in Paris in 1932. Once the word *autobiographical* had been applied to his first feature film, *Les Quatre Cents Coups*, it became an axiom of foolish media that Truffaut had had a rough upbringing and that, really, the wolfish young actor he had found, Jean-Pierre Léaud, was playing him. I'm sure such dreams were exchanged, and Truffaut never really abandoned Léaud, even after his limits as an actor had been exposed. But every kid thinks he has a hard time. Not everyone puts it to such use.

Truffaut dropped out of school; he had an adoptive father; he was a semi-vagrant; and in 1946 he met André Bazin (the Spencer Tracy to his Mickey Rooney). Bazin (born in 1918) was a film critic and writer, the organizer of cine clubs, and a benevolent if not saintly figure. He talked to Truffaut; he kept in touch. François entered the army and was imprisoned for desertion. Bazin got the kid released, and he and his wife gave Truffaut lodging. Bazin found him a writing job at *Cahiers*, where Bazin was founder-editor. That's where, in 1954, the young man published his attack on the old guard in French film—and before his own pictures, Truffaut was one of the best critics we have ever had. At *Cahiers* he was part of a gang—Jacques Doniol-Valcroze, Luc Moullet, Jean Domarchi, Charles Bitsch—people you haven't heard of. And names you may know,

the "we" Rivette referred to: Jean-Luc Godard, Claude Chabrol, Eric Rohmer, Rivette himself.

Cahiers was founded in 1951. Its essential rival, *Positif*, began in 1952. One fiery magazine must have a rival to say it's talking rubbish. And that contest was sustained by several things that simply did not exist in, say, Los Angeles, the proclaimed capital of moviemaking: a great range of cinemas reviving old films, all of them versions of the Cinémathèque Française, an archive and a theater for the history of film, founded in 1936 by Henri Langlois and Georges Franju, and a hotbed of wartime conspiracy in the effort to keep its treasured prints out of German hands. It had been a private enterprise until 1945 but then it became protected by the state. Why not? If a culture requires the keeping of publications in a library of record, should it not preserve its films? Moreover, since 1943, Paris had had a school, the Institut des Hautes Études Cinématographiques. IDHEC, as it was called, was so lofty it would decline Jean-Luc Godard as a student—so he went to the movies instead.

The school was for filmmakers, of course, if they weren't watching or making films, but it was a measure of a culture that took it for granted that film should be discussed, as theory and practice. It was the case sometimes in 1959–60 that the nouvelle vague was depicted as a sudden flourish of youth. It was, but the youth had been raised in a culture that believed in the cinema. By contrast, as the same French kids reckoned, America had invented the mainstream movie but never taken it seriously or embarked on a proper cultural conversation.

It's not that Truffaut, or any single figure, led the way. The first feature film from the group was Claude Chabrol's *Le Beau Serge* (1958). A year earlier, Chabrol and Eric Rohmer had collaborated to write *Hitchcock*, the first attempt to convey the genius of that director, and one of the earliest critical books on film. Chabrol had two films in 1959, *Les Cousins* and *À Double Tour*. Jean-Luc Godard made short films, *Tous les Garçons S'Appellent Patrick* (1957) and *Charlotte et Son Jules* (1958), which used a young actor, Jean-Paul Belmondo. Rivette had made a short, *Le Coup du Berger* (1956), and he had plans already for a fictional panorama of Paris beset by a paranoia that came from McCarthyism, the blacklist, the Bomb, the Communists and an unshakable belief that the world was like movies, especially Fritz Lang movies. That would be called *Paris Nous Appartient*, but it wasn't done until 1961.

Every pot was bubbling. In 1957, Truffaut made his own short, *Les Mistons*, about a gang of country kids observing a teenage romance with

casual cruelty. The young actress Bernadette Lafont was the star, and the first object of Truffaut's habitual, gazing question "Are women magic?" No one really doubted his answer. Truffaut might be the harbinger of the new in media commentary, but he had instincts that came straight out of movie tradition, such as getting involved with most of his actresses.

But in October 1957, Truffaut married Madeleine Morgenstern, the daughter of Ignace Morgenstern, a Hungarian Jew who had come to Paris, survived during the war, and become a respected distributor in French cinema—with most of his work serving the old guard Truffaut had attacked. But he got on with Truffaut and said he would finance a feature film for him to the extent of 400 million old francs. Claude Chabrol's debut film had also relied on family money. Always, the money has to come from somewhere—if you can get it.

Not that Truffaut intended an extravagant film. He wanted to make a movie about a kid (fourteen or so) in Paris, bored with school and on the edge of delinquency, neglected by parents—a slice of life. You could not simply opt to direct a film then, even with a friendly father-in-law. Truffaut had to prove to the unions that he was competent. There had to be a script. For that he enlisted the aid of a novelist and screenwriter he knew, Marcel Moussy, and for his crew he got Henri Decaë, an experienced cameraman (he had shot *Bob le Flambeur* for Jean-Pierre Melville and *Elevator to the Scaffold* for Louis Malle), and Philippe de Broca as assistant director. In June 1958, Truffaut would write to Moussy:

> I won't conceal my anxiety from you; you've understood everything about my film so clearly and so quickly that I can't imagine being deprived of your collaboration. Working on these memories, I have in a sense turned into a "first offender" again; I feel insecure and rebellious once more, overly vulnerable and completely isolated from society. It was Bazin who, ten years ago, straightened me out by becoming what you might call my guardian; talking to you, I felt at the same time guilty and rehabilitated, you are like Bazin in so many ways. Just as he helped me "go straight" in life, you're going to help me make a film that will be more than just a whiny, complacent confession, a true film.

Jean-Pierre Léaud was found as an "unmanageable" kid of fourteen. His screen tests weren't overwhelming, but Truffaut liked the sharp-faced mischief in Léaud and he began to see ways of making the character,

Antoine Doinel, more than an imprint of himself. André Bazin died of leukemia in November 1958, just as Truffaut started the shoot. The film would be dedicated to Bazin.

It is a film with new names and faces, but it is conventional, too, full of fondness for an awkward adolescent. That warmth extends to Paris: the New Wave loved their city and helped make a cult of it that includes *Moulin Rouge, Inception*, and *Hugo*—as well as *Boudu Sauvé des Eaux*. Decaë managed to shoot in bad light—in winter, at twilight, using fast film stocks that got a viable image (just like *Sweet Smell of Success*). The film quoted from Jean Vigo, Renoir, and even Ingmar Bergman. It was funny, sad, tart, and wry and it had what would become a Truffaut signature: strong sentiments cut short out of shyness or fear. It was another sign of that modern worry: Can the movies really be so moving without turning maudlin or trashy?

At the very end, when Doinel escapes from reform school, he runs forever with the steady company of a tracking camera. But then as the boy reaches the sea—it was shot near Villers-sur-Mer, in Normandy—and runs down the sloping beach, the camera backs off and adopts a very beautiful track that is more lyricism than scrutiny. The boy steps into the sea, turns, and the film ends on a freeze frame as he gazes at us and wonders about the future.

Les Quatre Cents Coups was always a heartbreaker and a crowd pleaser—and Truffaut was never really comfortable if not winning an audience over. Previews were so good the Cannes Festival got word of it and persuaded André Malraux, minister for cultural affairs, to make it an official French entry. The irony was not missed that in 1958 Truffaut had been denied press credentials to Cannes because he was such a troublesome, aggressive critic.

Truffaut and Léaud arrived at the Carlton Hotel without so much as a poster for their film—and Cannes has always been a marketplace. Already the picture had been sold to America for $50,000, enough to cover the production budget. It screened for the festival on the night of May 4, 1959, with Jean Cocteau, the president of the jury, as host. There was great applause, and Jean-Pierre Léaud, in a rented tuxedo, was carried aloft out of the theater. Truffaut won the Best Director prize. The press went wild, from *Le Monde* to *Elle*, which proclaimed, "Never has the festival been so youthful. So happy to live for the glory of an art which youth loves. The twelfth film festival has the honor of announcing to you the rebirth of French cinema."

It opened on the Champs-Élysées on June 3, and 450,000 tickets were sold that summer. By November it was playing in London and New York. (It got an Oscar nomination for Best Screenplay, but it was one more film trounced by *Pillow Talk*.) Truffaut's income multiplied by a factor of twenty. He bought a sports car and felt he was like James Dean. *Les Quatre Cents Coups* remains a true and sweet film, with enough of a sour edge on the sweetness. By the end of 1959, Truffaut was shooting *Tirez sur le Pianiste*, with the singer Charles Aznavour, a figure in French show business. And every would-be filmmaker decided that Truffaut was like them.

•

As *Les Quatre Cents Coups* opened in Cannes, Jean-Luc Godard was kicking his heels in Paris. "It's disgusting," he told an acquaintance. "Everyone's at Cannes. What the fuck am I doing here? I've absolutely got to get the money to go down there . . . Truffaut is a bastard, he could have thought of me."

The two men had been allies at *Cahiers du Cinéma*. They saw film history in the same light. They had codirected a short film together in 1958, *Une Histoire d'Eau*, and Truffaut had once told Godard a simple story—about a thief who kills a cop and tries to hide out in Paris with an American girlfriend. Godard thought it might make his own feature debut. So he raided the petty cash at *Cahiers* and caught a train to Cannes. Once there, he told the story to Georges de Beauregard, a producer, and got Chabrol and Truffaut to assure de Beauregard that he could use their names—"story" by Truffaut, with Chabrol as "artistic supervisor." Beauregard was agreeable but he had no money. So Godard went to a film financier, René Pignières, and won a promise of around $100,000, because the business was suddenly alert to these kids in the excitement of *Les Quatre Cents Coups*.

Godard was born in Paris in 1930, but most of his childhood and youth was passed in Switzerland, at Nyon, where his father, a doctor, had taken the family when Jean-Luc was four. He entered the Sorbonne planning to study ethnology, but he spent his time watching movies. In the early 1950s, he visited America, to avoid military service, and then worked his way back into the *Cahiers* group. He was never as readable a critic as Truffaut, but he was often inspired, aphoristic, and abrupt. From the outset, it was likely that Godard would not be content to work as a regular storyteller, or as a director fond of his own characters. As a young man he

had stolen from his family, including a Renoir painting, which he sold for funds.

The story of À Bout de Souffle, or Breathless (1960), was as Truffaut had suggested, and no one remembers seeing a full script. Instead, it was pages or bits of paper delivered sometimes day by day. Raoul Coutard was hired as cameraman. He had done hardly anything previously and he was asked to film as simply or as directly as possible—no lights, handheld, nothing much in the way of equipment or crew—in a vérité manner. Coutard had too much natural feeling for light and motion to be as visually brusque as Godard wanted, but this was a film in search of a radical reappraisal of moviemaking. When the look proved too gentle or pleasing, Godard would embark on a savage editing to deconstruct the old fluency or pleasure.

He had promised the lead part, Michel, to Jean-Paul Belmondo, and he talked the actor out of a bigger picture on offer in return for a mere $800. For the American girl, Patricia, however, he suddenly thought of an American star, or a quasar, who happened to be there in Paris. Jean Seberg had been discovered in Iowa in the hype of a national search by Otto Preminger for someone to play the lead in Shaw's St. Joan. She was the one, from among eighteen thousand, who got the part! Many critics felt the role was beyond her, but Preminger—tough on her in person yet saving face in public—then took her to France to play the lead in his film of Françoise Sagan's 1954 novel Bonjour Tristesse. And there she had flowered, moving in the one picture from an awkward adolescent to a precocious but fatalistic young woman, and winning this ecstatic review from François Truffaut:

When Jean Seberg is on the screen, which is all the time, you can't look at anything else. Her every movement is graceful, each glance is precise. The shape of her head, her silhouette, her walk, everything is perfect . . . In the blue shorts slit on the side, in pirate pantaloons, in a skirt, an evening gown, a bathing suit, a man's shirt with the shirttails out, or tied in front over her stomach, or wearing a corsage and behaving herself (but not for long), Jean Seberg, short blond hair on a pharaoh's skull, wide-open blue eyes with a glint of boyish malice, carries the entire weight of this film on her tiny shoulders.

This may be the best review she would ever receive, and it must have helped persuade her to do Breathless. (She had sent a thank-you letter to Truffaut.) But Seberg had been trained in Preminger's Hollywood. She

found Godard "an incredibly introverted, messy-looking young man with glasses, who didn't look me in the eyes when he talked." She didn't think Patricia was likable in any way and she believed an actress's characters should be sympathetic. But her new husband, a French lawyer, François Moreuil, negotiated a full quarter of the film's budget for her, so she said she would do it. The shoot wasn't reassuring. The film was full of talk, but all the words would be dubbed in later.

"I'm in the midst of this French film," she wrote to a friend, "and it's a long, absolutely insane experience—no lights, no makeup, no sound! Only one good thing—it's so un-Hollywood I've become completely un-selfconscious."

Yet here was a picture where Belmondo's character begins by trying to imitate Humphrey Bogart as seen in a movie poster. And surely Patricia was meant as a bridge to the international market and because Godard was fascinated by Hollywood actresses, American girls—and what François could see in them. (Jean-Luc was never that generous to players.) As a critic, he had been devoted to American style—to Nick Ray, Sirk, Fuller, and the other *Cahiers* auteurs. As Richard Roud put it (and this fits so many crime films over the ages), "*À Bout de Souffle* was modeled much more on *Scarface* [Howard Hawks, 1932] and other American thrillers than on any direct knowledge Godard had of the underworld milieu." It's not just that Belmondo aims at the would-be American hoodlum with such existential zest; Godard is there in support, urging on the nihilist assault on moribund European values.

When the film was edited it proved too long and too slow: not much happens in stretches of sophomoric talk that are timid or evasive about sex. *Breathless* promised a blunt confrontation between attractive kids. It had a prolonged bedroom scene, under the sheets, yet Godard showed no instinct for having "it" happen on camera. Hitchcock's *Psycho*—a film of the same moment—was far sexier, far more voyeurist.

So to make its length manageable, Godard the cutter invaded his own film, showing a kind of contempt for his flimsy story and the whole scheme of narrative or moral development. He refined/degraded his own movie, letting jump cuts intervene where smooth editing once ruled the day. It was as if he was sneering at the viewer: you're not actually watching this as if you believe it or care, are you? But enough viewers responded to this curt treatment for a revolutionary style to be acclaimed and regarded as modish. *Breathless* played at ninety minutes and it felt like a revelation. In a seven-week Paris run in the spring of 1960, it sold more

than 250,000 tickets. It won the Prix Jean Vigo and made a profit of fifty times the budget. Then it became an international sensation. Observers outside film felt compelled to comment. Jean-Paul Sartre said it was "really very beautiful." Referring back to Alexandre Astruc's essay of 1948, proposing the "caméra stylo," Gerard De Vries said *Breathless* was a full-fledged work made in that approach.

The truth was more complicated and less organized. Godard's deconstruction of a narrative film's form was not too far from those American films of 1959 that were abandoning narrative sincerity for parody or an explosive camp reappraisal. But *Rio Bravo* and *Some Like It Hot* still ran smooth; their subversion lay in their ironic attitudes. Godard sensed more, spurred on by the anthology called television, where the audience had seen everything—so make it different. In advance of the remote-control device for self-editing with television, *Breathless* had a scattered dynamic that said, next, next, hurry on. More than telling a story, *Breathless* had the world-weary attitude "let's get this over with," and so the film was always plunging toward the last blank look on Patricia's face as the dying Michel tells her she is "dégueulasse."

A few years later, talking about *Pierrot le Fou* (1965), Godard admitted, "The Americans are good at story-telling, the French aren't." He added that by the mid-1960s a great film almost had to be based on a misunderstanding, or something done by accident. The old grammar of film narrative, he felt, was archaic and useless. But "everything is possible on television." More or less, people watched that screen in the way they observed life, bored yet expectant. So he concluded that he wanted *Pierrot* to be not so much a film "but an attempt at film."

He was a theorist, but a careerist, too. As if aware how he had outflanked Truffaut and Chabrol, and left them looking old-fashioned, Godard the deadpan opportunist and chronic word player started to do interviews. There's a comparison with the Beatles here: their radicalism lay not just in the freshness of their music—tough as well as lyrical—but in the indifference they flaunted in interviews. No one had talked to the press like that before; no one had taken their own fame and said, look, it's stupid. Not that the Beatles or Godard were free from the pleasure of being hits. Godard could be dismissive one minute and charming the next; his own evasiveness was a kind of cutting. He could say that his film was really just his film criticism applied by different means—it was an "essay," an analysis of a process that had to change fast now to keep up with the unstable culture. But then, talking about *Breathless*, he could slip back

into being the art student in love with artiness: "For a long time the boy has been obsessed by death, he has forebodings. That's the reason why I shot that scene of the accident where he sees a guy die in the street. I quoted that sentence from Lenin, 'We are all dead people on leave,' and I chose the Clarinet Concerto that Mozart wrote shortly before dying."

Godard liked to seem unreachable and superior. He wore dark glasses most of the time. He tried to be impassive. He spoke lucidly but in a monotone—there was something of Alpha 60 there already, the all-knowing computer from *Alphaville* (1965). But the new movie order he was introducing should not conceal his own disarray—European yet besotted with Americana, emotional but cold, an avant-gardist but eager for movie hits to surpass the rest of the gang. The confusion was intensified once he met Anna Karina, and his work took on an emotional force that he would not regain without her.

Hanne Karin Blarke Bayer (her real name) had come to Paris from Denmark as a model and perhaps an actress. Godard had considered her for a small role in *Breathless*, but it required that she bare her breasts, and Anna Karina (the professional name she adopted) was reluctant to do that. So Godard pursued her for his next film, *Le Petit Soldat* (1963). He even put out an advertisement suggesting that the actress in the new film might end up his lover. There was a recognition all through the New Wave that even on a shoestring budget you made movies to get girls. Karina said she didn't like Godard much at first, but she took the part and then they were inseparable—until they separated.

In the next few years, Godard embarked on one of the most creative periods in the history of film. One by one he made pictures that took the surviving genres and ideals of American film and broke them apart before our eyes: *Le Petit Soldat* (a political thriller), *Une Femme Est une Femme* (1961, a romantic comedy according to Lubitsch), *Vivre Sa Vie* (1962, a woman's picture), *Les Carabiniers* (1963, the war film), *Le Mépris* (1963, a movie about movies), *Bande à Part* (1964, the young gang), *Une Femme Mariée* (1964, a woman's picture with sociology), *Alphaville* (1965, science fiction, or liberty threatened by occupation), *Pierrot le Fou* (1965, a noir in full sunlight, escape leading to death), *Masculine-Féminine* (1966, sexual politics), *Made in U.S.A.* (1966, noir), *Two or Three Things I Know About Her* (1967, prostitution and society), *La Chinoise* (1967, world politics, infant Marxism), *Week-End* (1967, automobiles, society equals traffic, the crash as destiny). Karina was in seven of them, made before and after their breakup.

That remake scheme isn't tidy or exact: as always with Godard, the cynicism spilled over into the romanticism. Montage meant interruption and self-contradiction; it allowed anything you could think of. Moreover, in the years of Godard's surge, there was a sexual revolution, the onset of Vietnam, the aftermath of Algeria—its independence was gained in 1962—and the discovery of torture, an era of assassinations, the growing disquiet with the United States in Europe, the use of drugs (though that was always missing from the ruthless sobriety of Godard), the dawn of feminism, and the flooding of a culture by television, to say nothing of the decline of conventional Hollywood confidence. This would also build toward the events in France of 1968, the attempt at a revolutionary alliance between students and workers, the street demonstrations, and the government attempt to remove Henri Langlois from leadership of the Cinémathèque Française. Plus the marriage between Godard and Anna Karina broke up. These newsreel items may seem obvious, but you will not find them in Truffaut or most other filmmakers of the period.

Godard was fire and ice, without much prospect of reconciling the two. So *Vivre Sa Vie* (1962) is not a story but a series of numbered episodes with a dispassionate essay on the facts and logistics of prostitution. But when the film crosscuts the face of Karina beholding Falconetti in *The Passion of Joan of Arc* it is impossible to miss the director's love for her or for the process of watching and desiring that is the original essence called cinema.

The finale of *Vivre Sa Vie* is casual, an untidy shootout on a shabby street—don't bother with the big noir setup; haven't we seen it so many times?—but when Karina dances to the jukebox in the café, she is as exhilarating as a teenager imitating Cyd Charisse. There is an agonized rapture at work that says, I love this woman, I love this thing called movie, but I can hardly believe in it any longer because I'm too postmodern. Truffaut would not have dared interpose so analytical an intelligence in his films. In truth, the critic in Godard was battling the storyteller. The film is called *Vivre Sa Vie*, and to a point it is feminist just as it made an icon of Karina, but it is also nagging away at this other riddle, How Do I Make My Film?

With contempt was the eventual answer. Yet *Le Mépris/Contempt* is an anguished rhapsody in color, wide screen, camera movement, and the elegy of the music by Georges Delerue (who had become Truffaut's composer) laid over the elegant Capri villa that is the picture's chief location. It is one of the most beautiful films ever made, and that includes its mocking use of the naked Brigitte Bardot (a contractual obligation) at a time

when we suspect Godard would never have shown Karina naked; she is always treated chastely in their films together. The producer in *Le Mépris* is a florid monster, played by Jack Palance as a brother to his Attila in Douglas Sirk's *Sign of the Pagan* (1954)—but this is Attila in an Italian suit. The director is Fritz Lang as himself (aged seventy-three), surveying his own humiliation. And the screenwriter (Michel Piccoli) has pimped his wife to assist his career. *Le Mépris* knows the filmmaking process is inherently corrupt.

Then there is *Pierrot le Fou* (1965): it's a disenchanted husband-meets-old-girlfriend story, and a reworking of the Godard-Karina breakup where she is asked to gaze into the camera with remorse, recrimination, and ultimate defiance: look at me, I'll lie to you, she seems to say. (She is Vivian Rutledge from *The Big Sleep* cut with the bad sister Carmen.) Her face suddenly exposes the hurt boy in Godard posing as a brilliant intellectual. Karina and Belmondo (Marianne and Ferdinand) make love with a bloody corpse in the next room: terror and torture have begun, so we have new insight into why lovers might cry out in their sleep. But in the film's rapturous descent into the South of France and summer (moving "like spirits through a mirror") there is maybe for the last time a sheer delight on Godard's part with movie itself—the convertible driving into the sea and its brief arc of rainbow, the girl playing tennis, the movement in space, animal locomotion, the colors, her hair, their skin at sunset, the jazzy combo of parrot and fox; the songs (music by Antoine Duhamel); the bitter island idyll; Belmondo doing Michel Simon (if anyone remembered Simon); Karina as a noir nymph, the more treacherous the more she is watched (the first pressure of Godard's misogyny); and a stranded Samuel Fuller at a Paris party (a soiree for the exchange of advertising clichés), proclaiming the need for "emotion" in film above all else. What makes *Pierrot* crazy is not simply his self-destructive romanticism; it is the archaic faith he still shares with Fuller for action cinema, the nostalgia that on-screen resolution might count toward anything. So there are vivid action scenes and isolated fragments of storytelling (the holdup scene codified by references to literature—Godard still read!). Ferdinand wants to read and write, but Marianne tells him, "You talk to me with words and I look at you with feelings." It's such a considered line from a spontaneous woman.

The critic and essayist in Godard is telling us, this cannot go on much longer. This world is too ghastly for us to tell ourselves we are being entertained by movies still. It is an end to cinema, sometime around 1968, but because Godard was perverse, cruel, and brilliant, it is delivered as

breathtaking beauty. As *Week-End* finishes, the titles announce, "End of film . . . End of cinema." Yet if we are going to lose this, aren't we losing a lot? Preston Sturges does rescue the director in *Sullivan's Travels*, and we hope that lofty chump is going back to Paramount to make more comedies. But Godard would not save himself.

The Godard films of the early 1960s are a compressed history of the medium, and revivals over the years have usually played well with new audiences. It is fanciful, I fear, to claim that any body of work since has surpassed it or made so clear-eyed a commentary on movie history and its pathology. There has seldom in any of the arts been anyone with such a command of beauty and so wilful in his urge to eliminate it. The topic of "contempt" is pervasive and so rich it covers Godard himself and us, the audience. Like most chronic romantics, he turns into an unendurable pessimist. He is alive still and he goes on working, and there have been valiant attempts to say he is as interesting and as important as ever. I fear it's wishful thinking. Godard had always guessed his frenzy in the 1960s might serve to undercut his own faith in the mass medium. The "End of Cinema" was not just a cheeky aside; it was a foreboding. There was a period—fifty years, if we are generous—in which the light was enlightening and moving and even transforming. But then a change set in where the shining light might become a mockery of enlightenment and a means of imprisoning the mass.

•

There is a moment in *Vivre Sa Vie* when Anna Karina's character, Nana, writes a letter. It is in episode seven of the film. The letter is an application, pen on paper, to join the staff of a brothel. The actress, or is it the character, actually writes the letter. So it takes time. As one watched this scene for the first time in 1962, it was impossible not to think, "Ah, a letter-writing scene. He'll show the start of the action and then he'll cut to the finished letter. It's just a matter of a couple of shots and editing them together. That is how movie works." But then you watched, and the action of writing stretched out in time. It became the scene. So you could resume an amiable analysis by saying, "Ah, this is his way of showing how naïve, how uneducated, yet how diligent Nana is. It's an opening up of her character." And that was fair enough. But then something else dawned on the viewer: Godard was saying, just look at the now of it, look at her presence, her being. Isn't this movie? Isn't this something we might call "vérité"?

But here was what ended up an eighty-five-minute movie, and whole minutes were ticking away. The London Film Festival press screening oc-

curred at the height of the Cuban Missile Crisis. Going into the film and
its dark, critics made nervous jokes that this might be the last film they'd
ever see. So these moments of passing duration (unstressed as narrative),
these minutes of observation, felt unusually precious or nerve-racking. It
made us think of the film's title and the sophomoric question—are you
living your life or passing time?—which can still be compelling if you're
twenty-one.

It happened that Elia Kazan visited the set of *Vivre Sa Vie* one day.
Here was one of the top directors in the world, on the cutting edge when
it came to handling performance, and shooting material in the approved
Hollywood manner: master shot, close-up, crosscut close-up—matching
the action and making it seamless, an accepted coded version of reality.
But Godard's script girl, Suzanne Schiffman, reported this: "It was a very
long take, a fixed-focus shot. The camera didn't move, the actors entered
and left the frame, they continued acting and talking outside the frame.
Kazan asked me, 'Which angle will he shoot the action from next?' 'No,
he never shoots a scene from more than one angle.' Kazan didn't under-
stand."

The Godard of the cryptic interviews had his slogans, such as "cinema
is the truth twenty-four times a second," but he was subtler than that, and
interested in something more profound and more direct. He was getting
back to the origins of film and photography. He was as eager to be as-
tounded as Eadweard Muybridge or his spectators the first time the pho-
tographer showed the run-on stills that recorded a woman opening a
parasol or a man tossing away a jug of water. D. W. Griffith and the prac-
titioners of his era had done the great service of seeing there might be
camera angles—useful, insightful—that could be cut together. But Go-
dard was in love with the primacy of seeing and of an age before angles,
when we were amazed. He could sound very modern, but he was a ro-
mantic, too, harking back to originality and the nowness that came and
went every second, or twenty-four times a second. No, it wasn't truth; it
was mortality—and that's why the Cuban missile crisis was providential.

There are several sequences in *Vivre Sa Vie* that adopt a similar ap-
proach: the first conversation in the bistro where Nana is leaving Paul,
filmed from behind their backs (with reflections in a mirror); and then the
lengthy conversation with the philosopher (Brice Parain). Those scenes
were written, or they had a script basis, but their stillness (and their open-
ness to distracting ambient sound) is dedicated to the idea of the event, the
human presence, the "being" of it all, the liveliness of lived life. The tech-
nology was palpable. Going beyond the handheld, sound-free athleticism

of *Breathless*, Coutard now had a heavy Mitchell camera, lights, and a microphone that had to be carefully placed and that picked up talk, background, and even the sounds of the crew. You can almost feel the weight of the machinery—and yet Godard often gains an amazing lightness or momentariness in the film. "What I want," he said, "is the definitive by chance."

You can say this was all because he loved Anna Karina. I hope so, but Godard seldom did one thing at a time. For all its stress on immediacy and being, *Vivre Sa Vie* was very formal—the numbered episodes, the camera's gravity, the use of genre scenes (the musical number, the final shootout), the philosopher-meets-whore set piece, the use of the Edgar Allan Poe story "The Oval Portrait," and the whole notion (beginning with Falconetti as Joan of Arc) that this tart has a soul. In all the scripted scenes, Anna was still herself. Some observers said, well, yes, she's very pretty and "the camera loves her, et cetera," but is she really an actress? This was another version of Kazan's wondering which angle came next?

In the same year, 1962, a film was released of Eugene O'Neill's *Long Day's Journey into Night*. It is usurpassed filmed theater. Sidney Lumet directed with devoted skill and sympathy. Boris Kaufman photographed it in black and white and delivered the fog-bound house as well as its inner fogs. Richard Sylbert made the interiors believable and claustrophobic. The central actors were Jason Robards, Dean Stockwell, Ralph Richardson, and Katharine Hepburn as Mary Tyrone. People call it a master class in acting, but that's unfair. It's a family, not a class. The enacted text is so complete, so moving, you feel you are caught in its emotional atmosphere. Hepburn was nominated as Best Actress (she lost to Anne Bancroft in *The Miracle Worker*). I mention this to admit that Anna Karina could never have played Mary Tyrone. She was the wrong age, she was not fluent in English, she was "too pretty," she was bad "casting," and she never had the resources that Hepburn possessed as an actress. She was not even quite an actress in that old sense. And yet . . . her being in *Vivre Sa Vie* is more immediate, more cinematic, and some of that is simply because she was the director's girl and wife and because he had a new understanding of "vérité" that was vital to the moment. Katharine Hepburn was spectacularly accomplished. But Anna Karina was trying, and she was letting herself be photographed. It was another suggestion that acting, especially "great" acting, might be archaic.

Godard's biographer, Richard Brody, has spelled out the ways the director emphasized this, with an element of unkindness:

Vivre Sa Vie suggests a disturbing analogy between Karina as an actress and Nana as a prostitute—between prostitution and acting, in general. The film is studded with references to Nana's desire to pursue a career as an actress. She complains to her spurned husband, Paul, that he did not help her pursue her dream, and she mentions having appeared in a film with Eddie Constantine (as Karina had done in Varda's *Cléo*).

So it's important not to sentimentalize the relationship. There were quarrels and arguments over Karina's fidelity, an issue Godard almost urged upon her. Karina actually attempted suicide during the shoot, when Godard dropped a strange happy ending to the film and replaced it with death—but actors take those omens very seriously. Though *Vivre Sa Vie* established a career for Karina, and gets her in books like this, the actress felt the director had made her look ugly.

Vivre Sa Vie is a test case, but the issue of presence or being was everywhere. The availability of the lightweight Arriflex camera and the Nagra tape recorder had helped enable a whole "cinema vérité" movement, a series of documentaries aimed in the first instance at television, but wishing to be "in the room" with some important event, recording without intervening. Its exponents included Robert Drew, D. A. Pennebaker, Albert Maysles, and Ricky Leacock, who had once assisted Robert J. Flaherty (Murnau's colleague on *Tabu*) on a classic documentary, *Louisiana Story* (1948), more picturesque than journalistic.

These films and their new withdrawn but devouring style won a lot of attention: *Primary* (1960) was about the race between John Kennedy and Hubert Humphrey in Wisconsin in 1960; *The Chair* (1963) observed a man on death row; and *Jane* (1962) was a portrait of the young actress Jane Fonda rehearsing a Broadway play. The hope for nonintervention was not always realized. Some reckoned that Fonda's play flopped because her performing energy had been depleted by the nagging documentary presence. On the other hand, Kennedy, a natural or even desirous actor, relished the treatment, and when, a few years later, he rose at a state banquet to introduce himself as the man who had accompanied Jacqueline Kennedy to Paris, he seemed to have assumed the charm of Cary Grant, and the timing—things that Grant himself was candid about never quite understanding or possessing for himself.

But part of the Kennedy mystique was a camera-ready persona that no one had quite noticed in politics before. It helped that he was said to have

won the television debate with Richard Nixon (while losing on radio) because his cinematic ease had outstripped what he said. People wanted to see JFK.

The power of television, in newscast or documentary, to show us something was hard to resist. In Britain in the late 1950s, John Freeman invented a series called *Face to Face*, one of the first significant interview shows with famous people. It was talking-head television before that term grew stale. And Freeman admitted a strategy: he would ask his subject a question; the subject would give his or her answer; and then Freeman would wait until the pause made the subject so anxious he or she blurted something else out—the thing he or she hadn't meant to say or wanted to admit. Sometimes a person broke down, and audiences had never seen that before outside dramas. The voyeurism and the live moment were overwhelming.

Another thing to see in 1961 was the new communications satellite. It was called Telstar, and the first time it worked for an audience in Britain, on July 23, 1962, the wavery picture suddenly solidified and there we were at an afternoon baseball game in Wrigley Field, Chicago (the Cubs and the Phillies). You could see America now, and it was intoxicating. Some spectators in Chicago, alerted to the occasion, smiled and waved at the camera. For the first time, the hypothetical simultaneity of life—the idea that we are all doing everything at the same time—felt real. Today, we take such power and intimacy for granted so we may no longer notice it, much less be touched. But it was invented, just like every other step in the movie process, and the first time was a thrill beyond words.

In 1962, Chris Marker made a short film called *La Jetée*. He was an extraordinary figure, born in Neuilly-sur-Seine in 1921 (not in Ulan Bator, Mongolia, as he once confided to me). He was a writer, a member of the Resistance, and then a traveling essayist filmmaker. In the 1950s he made engaging films about China, Siberia, Cuba, and Israel. Then he did *La Jetée*. It is a science-fiction story composed of still photographs. But within the body of the film, amid the stills, there is a moment, a few seconds, when one photograph—of a woman (the actress was Hélène Chatelain)—breaks into life or real time. It's not that she does anything. It's just that she is alive, or that time is passing through her. Anyone who has seen *La Jetée* knows the instant is nearly spiritual, and feels the lesson—that this thing movie, this passing light, is a gift to us.

Let's mention something else from 1962: the poignant screen test Marilyn Monroe made for *Something's Gotta Give*, the film she was fired

from only two months before her death. The test is in color but silent. She
wears a white dress with a black floral pattern and she is talking to the
director George Cukor. She is herself, not the character for the film, and
as beautiful and confident as she ever managed on film, as if aware it was
her best shot. Some said that, in the last couple of years, Monroe was so
drugged that she had difficulty focusing her eyes. That doesn't show in
this test. She is presence itself and suggests she might have been a smart
woman and not just "Marilyn."

In late November 1963, in Dealey Plaza in Dallas, a man named Abra-
ham Zapruder was out with his 8 mm camera. A president passed by in a
motorcade, and Zapruder did his best to film him. The 486 frames he
recorded would be the best record of the assassination of JFK; it may be
that no single shot from the 1960s was scrutinized as closely or used so
often to describe passing time. The Warren Commission and every cri-
tique of their report relied on the film and its timeline, and we were soon
asking ourselves where gunfire had come from if a body recoiled this way
or that. Neurologists and ballistics experts had their answers, but movie-
goers were sure they *knew* how guys who had been shot fell.

Two days later, live on television, in the muddle of the basement at
Dallas police headquarters, a man came out of the crowd, thrust a gun at
the body of Lee Harvey Oswald, held by guards, and fired. Now we knew
why we had been watching television so much. We were waiting for real-
ity to turn into our story. The devastation at the death of Kennedy and the
readiness to accept the idea of a deranged lone gunman went to hell. This
looked like film noir, no matter that it might have been filmed by Ricky
Leacock or Jean-Luc Godard instead of an unknown man with a camera.

•

Godard's willingness simply to film Anna Karina and let a movie grow
around her was not an isolated gesture. In Manhattan in the early 1960s,
Andy Warhol had felt the appeal of letting time and some very humdrum
activity unfold in front of a camera that might be screwed to the floor, or
unattended (like an early surveillance system). Warhol the painter and
conceptual artist fell on the camera with drained glee because it made
"art" so much easier. You turned the thing on and it happened; if some-
thing occurred in front of the camera that was a bonus—especially if the
people were pretty, yet not professional, not fierce. Stars were archaic,
Warhol thought, because of their foolish ambition and earnestness, and
because you had to pay them. But a "star" might be made, with quotes for

earrings, if he or she didn't care about anything. So Warhol sometimes sounded like Louis B. Mayer on Novocaine. He was a new studio boss, and his whole enterprise was shooting film and getting the "talent" fucked. Many people were horrified by the lavish tedium of it all, but an insight existed in the hours and miles of film: looking was cool, if you stayed awake. If not, just film *Sleep*.

Ronald Tavel was Andy's scenarist from 1964 to 1966, so long as nothing happened in the movies:

> I wrote a great number of the Warhol films. Warhol and I were very uncomfortable together. I never knew what to say to him, and he never knew what to say to me. In fact, we almost never said anything. The only time we really worked together, co-directing for about a week was with *Kitchen*. Andy really liked it; he said it was the best script that I had done, and he liked it as a vehicle for Edie Sedgwick.
>
> As best as I can articulate about the average Warhol film, the way to work was to work for no meaning. Which is pretty calculated in itself: you work at something so that it means nothing. I did have one precedent—Gertrude Stein. In much of her work she tried to rob the words of meaning. So my problem as the scriptwriter was to make the scripts so they meant nothing, no matter how they were approached.
>
> I worked on getting rid of characters. Andy had said, "Get rid of plot." Of course, Samuel Beckett had done that in the fifties, but he had retained his characters. So I thought what I could introduce was to get rid of character. That's why the characters' names in *Kitchen* are interchangeable. Everyone has the same name, so nobody knows who anyone is.

Warhol was happiest with "a sloppy, offhand, garbagy look," and a film like *Rio Bravo*, say, had still been resolved to look professional and elegant. But within *Rio Bravo*, there was a comparable relaxation over plot and character and things to say. It was a forerunner of a Factory movie, where you came close—and wanted to get closer?—to prolonged coverage of Angie Dickinson, say, talking to herself over what it was all about. Furthermore, in Edie Sedgwick, Andy had hooked up with a persona who might put her own quotation marks to rest. Edie was cute and of the moment. The painter Robert Rauschenberg said, "Her physicality was so refreshing she

exposed all the dishonesty in the room"—and that hope is key to many films of the 1960s. No one could trust the moment would last long (Edie was dead by 1971, at the age of twenty-eight), but she was a media rage in those mid-and late '60s. People wanted to look at her, and she did all she could—twisting, writhing, pouting, staring back, wearing clothes, or not—to keep the camera running.

If anyone had had the nerve they might have put Edie Sedgwick and Jeanne Moreau together—Moreau could have been Edie's mother, if she'd had the child at fifteen. Of course, Jeanne Moreau was and is a very professional star of the international cinema, an actress in the old sense and clever at it, but a new face, too. In 1958, aged thirty, she had done *Elevator to the Scaffold* for Louis Malle (her lover). She played the girl-friend to Maurice Ronet, who has committed a perfect murder. Moreau is on the streets of Paris at night expecting to meet him. But an elevator jams, and Ronet is trapped. There then follows a passage, shot on the streets at dusk by Henri Decaë, with Moreau waiting and growing more anxious. Her drawn face in the streetlights becomes the movie.

Nothing happens except for the building of tension and the feeling of her anxiety. It is sufficient, and it was the moment with which Moreau gained stardom. Then Malle went further. He screened the footage and asked Miles Davis to improvise a blues as he watched. That track was laid on the scene. There are happy pictures of Miles and Moreau. But the "mar-ried" print, the mixed moment, made something richer than its separate elements. You could have gone further: you could have had another shot of Edie at home blowing her nose and waiting, crosscut with Moreau on the street, Miles wailing, and Edie wondering, "Is Momma coming home?" This is just making pictures, I know, but people were beginning to see that actual films could be composed or gathered in this way.

For a few years, Moreau was the look, more even than Jean Seberg, Anna Karina, or Edie Sedgwick. And in her skill and knowingness, it was a face closer to that of Katharine Hepburn. But for extended moments, very good directors wanted to use her, like Edie, for the face itself, for the vérité and the moment. So she was the capricious bundle of contradic-tions, as fatalistic as she was vivacious, in Truffaut's *Jules and Jim* (1962)—she made that picture a great hit. But for moments in Malle's *Les Amants* (1958) she was just a face in bed in the gloom having a pioneering orgasm. In Joseph Losey's *Eve* (1962), wallowing in her bath, exposing her armpit hair, she was a serpent the man should never have brought into the house.

In *La Notte*, made by Michelangelo Antonioni in 1961, she is the wife

to Marcello Mastroianni's successful but disenchanted writer in Milan. Their friend is dying in the hospital. Yet Marcello is too weak and complacent to resist a sexual overture from a deranged female patient. The marriage is slipping away. So Antonioni has Moreau's character simply walk the streets of Milan in the summer afternoon, with nothing else to do. In story terms, it is a zero, except in establishing her unhappiness and her isolation. Beyond that, the director asks her to stroll, without too much design, though he has the camera follow her in unfailingly elegant shots. She notices things. She sees men watching her. She peels a piece of old plaster from a wall. She sees a fight develop and is intrigued, until the men fighting want to fix on her. Then she meets up with Marcello and they decide to go to this party they dread, but a place where important people will be. Including Monica Vitti (though they don't know about her yet).

La Notte (1961) is the middle film in a trilogy, along with *L'Avventura* (1960) and *L'Eclisse* (1962). We have met Antonioni already, the maker of documentaries in the late 1940s, and features of growing interest in the 1950s—*Cronaca di un Amore* (1950), *La Signora Senza Camelie* (1953), *Le Amiche* (1955), and *Il Grido* (1957). Then some greater ambition overtook him. He met a screenwriter, Tonino Guerra, and an actress, Monica Vitti—in this age, so many films partook of a love affair between a director and an actress. These ties were real, consummated, and difficult, but they were love affairs with cinema, too, a way of testifying to the pitch of desire and attraction involved in looking. *L'Avventura* is all about looking.

A young woman, Claudia (Vitti), is invited on a trip by her friend Anna (Lea Massari). Anna is in an affair with Sandro (Gabriele Ferzetti), but it is not going well. The party takes a boat and lands on a rocky island off Sicily. After a few hours they realize they cannot find Anna. There is a lengthy search as the day draws in: the ebbing light (shot by Aldo Scavarda) is exquisite, and the framing and the camera movements are consistent with Antonioni's taste for austere beauty.

They have to give up. Anna has disappeared. She is never found. But as time goes by, gradually another affair develops, this time between Claudia and Sandro, until she finds him early one morning making love to an American starlet/call girl named Gloria Perkins.

That's all, at the level of plot, in a 143-minute film. When *L'Avventura* opened at Cannes in 1960, there was booing at first and great controversy over the pointlessness of this enigma. The fans of mystery at the movies were accustomed to having their puzzles explained: Anna might have been murdered, run off with another man, been kidnapped by the CIA, been

hijacked by space aliens, fallen down a hole in the ground, whatever—but vanished? The jury rallied—its president, Georges Simenon, was an expert on mystery—and *L'Avventura* shared the Jury Prize with Kon Ichikawa's *Kagi*. (The Palme d'Or went to Federico Fellini's *La Dolce Vita*.)

Against many expectations, *L'Avventura* became an art house box-office hit. There was an audience far from disconcerted by Antonioni's failure to deliver a narrative payoff, but intrigued by the openness and uncertainty and well aware that time and memory had their ways of erasing people. The failed search was as hypnotic as one with a tidy conclusion—perhaps more so. We still don't know where Anna went in *L'Avventura*. But we may recall how in the 1920s, when the surrealists discovered cinema, they would walk into a theater in the middle of a picture, and watch until they made sense of it. Then they'd move on to another picture. The moment. The presence.

L'Avventura had been a tough film to mount financially. But once it was a hit, Antonioni had international backing to do more. He followed with *La Notte*, a story of a failing marriage and a possible affair (between Marcello Mastroianni and Monica Vitti). It won the Golden Bear at the Berlin Film Festival and it was another hit, no matter that some critics called it listless, uneventful, depressing. Antonioni managed to accept those words as praise or as a mark of what he had intended. (Manny Farber renamed the actresses Monica Unvital and Jeanne Morose.)

The third film, *L'Eclisse*, was produced by the Hakim Brothers, a sign of unbridled commercial support, though Antonioni declined to be interfered with. In this story, Vitti is Vittoria, a translator just coming out of one love affair and caught up with Piero (Alain Delon), a broker on the Rome stock exchange. They are as unsuited as their jobs, but they have an intense attachment—and Delon was an uncommonly energetic and charismatic actor for Antonioni. There is a dynamic sequence on the floor of the stock exchange, abuzz with action—you feel Martin Scorsese might have shot it.

The affair is uneasy, but the lovers agree to meet on a street corner one summer evening. The sequence that follows is the bookend to the trilogy, if you like, for the only "person" at the crossroads is the camera. The lovers do not arrive, but the camera watches the world go by, and simultaneously we feel life passing in all its heedlessness and time advancing.

L'Eclisse won the Jury Prize at Cannes, too. There were steadfast opponents of the trilogy who claimed pretension, indulgent "beauty," navel-gazing, star-making, literary affectation, inertness, slowness, and boredom. Others said the trilogy amounted to the arrival of cinema at the level of

modern fiction—to see these three films, to absorb them, was like read-
ing . . . Musil, Mann, or Joyce. To which some replied, try reading those
writers instead of invoking them. Why should a movie be justified by
comparisons with literature? In which case, you have no option but to
watch the trilogy, ideally three films in three nights. Every hostile charge
against it has some substance, but why should movies not arrive at a point
where they can be pretentious? Hadn't the cinema always been about
pretending?

Let me add the words of an eloquent defender of Antonioni, Seymour
Chatman, talking about *L'Eclisse* but placing the trilogy in an age of larger
anxieties. The trilogy, it seems to me, is a peak of cinema. Seen today, it
can prompt lamentation—that once we had a medium prepared to ad-
dress all our feelings and the range of our world:

> *L'Eclisse* . . . continues the thematic of the first two films. But it
> also extends it. The earlier films limit themselves to the personal
> impact of the malattia dei sentimenti—the uncertainty of emo-
> tions, anodyne sex, the problem of communication, escapism. But
> *L'Eclisse* raises the specter of a generalized, over-riding, nameless
> dread whose grounds are so real, whose possibilities are so genu-
> inely terrifying that it cannot be written off as merely neurotic. It
> is fear of the unknown—not only of the atomic bomb, since weap-
> ons only top the long list of means by which modern man can de-
> stroy himself. The fear is intensified by the fact that few people are
> willing to articulate it, not a syllable concerning this brooding
> anxiety is spoken. Our only hints are commonplace sights: the
> headline—"Peace Is Weak"—in a newspaper that an anonymous
> pedestrian is reading, jet vapor trails in the sky, two men watching
> from a rooftop, a man whose face is taut and unsmiling, and so on.
> The montage of such shots, which state nothing explicitly, creates
> a deep sense of foreboding. No one speaks of fear; the ambience
> makes it hard to say exactly what one is afraid of. Such fear feeds
> on itself, hanging in the air like the failing light. In an atmosphere
> of unexpressed and even unconscious apprehension, a love rela-
> tionship, indeed any relationship, seems impossible to sustain.
> Surely it is the trace of fear (the only thing they truly share beyond
> sexual attraction for each other) that shows in the faces of Piero
> and Vittoria as they huddle like children together in the last scene
> in which we see them.

L'Eclisse is about an eclipse, a natural event and a helpless metaphor, and it's not possible to watch its coda without seeing the fading light as a cultural omen. But the Antonioni trilogy is persistently concerned with the light and its loss. It was made in the years 1959–62, and I have been harping on that time, when the world and the medium turned and ideas about light shifted from pioneer innocence to existential disquiet.

FILM STUDIES

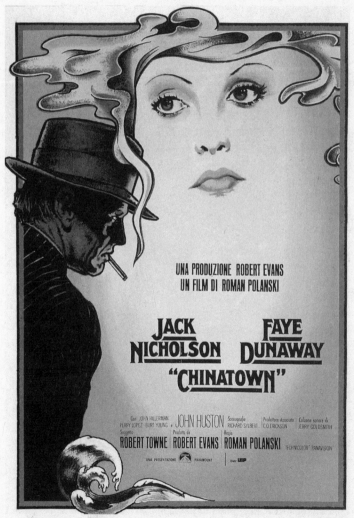

The Italian poster for *Chinatown*

In the early 1960s, there was confusion over what to call this transaction—was it film, the movies, or cinema? You could tell a person's taste and agenda by the word he used most often. "Cinema" meant the history, and the suggestion that it had been superior then; "film" was the essential function and might be covering an urge to make the stuff; while "movie" usually meant America and fun. In preparing *Jaws*, Steven Spielberg told Richard Dreyfuss, "I don't want to make a film, I want to make a *movie*." The choice of words was especially delicate in a surprising new area. For the transaction had caught the attention of academia. But if it was going to get traction there, how could it be managed without the correct language and a reading list on the cinema of existential disquiet? You couldn't use "movie" in that context.

If a disillusioned English teacher had walked into the office of his academic dean at an American university in the early 1960s and said, "Look, I'm not getting anywhere with *Paradise Lost* or Gerard Manley Hopkins. Suppose I switch to a seminar on Fred Astaire or Cary Grant?," he would have been endangering his tenure prospects. I'm not sure there were people with that much nerve, let alone the instinct to watch Astaire or Grant until the ideal of an American gentleman sank in. But if the reckless suggestion had been made, the dean would have turned to frost and asked, "Are you proposing we give young people credit for watching motion pictures?"

The University of Southern California offered a few courses in film from 1927. It was a kind of local specialty, well intentioned and useful, bringing practitioners to the university to tell stories, and perhaps opening up lines of future funding. The practitioners liked it because it gave them a feeling of respectability. But this was an isolated instance. In 1945

the University of California at Berkeley started to publish a magazine, the *Hollywood Quarterly*, but by 1958 it had become *Film Quarterly*. Apart from that, there were several illustrated fan magazines, not reliable in what they printed, but part of the promotional thrust that sold movies. The modest film bookshelf consisted largely of the self-serving ghosted memoirs of industrial leaders and a few novels that were more valuable and educational. So anyone interested might be better off reading Scott Fitzgerald's unfinished *The Last Tycoon*, Nathanael West's *The Day of the Locust*, Gavin Lambert's *The Slide Area*, or Norman Mailer's *The Deer Park*.

In Britain, there was the British Film Institute, established in 1933 and resolved after the war to encourage the appreciation of "filmic art" rather than get involved in production. It had a quarterly magazine, *Sight & Sound*, begun tentatively in the 1930s but developed by the editorship of Gavin Lambert and Penelope Houston. Another BFI facility was the National Film Theatre, started in 1951 as part of the Festival of Britain but moved to its Waterloo Bridge site in 1957 and devoted to the regular screening of great films from all over the world. In 1960, America had no national film institute or theater, no national archive, and no magazine like *Sight & Sound*, except for *Film Quarterly* and *Film Culture*, started in 1954 by Jonas and Adolfas Mekas but aimed principally at independent, avant-garde filmmaking.

In 1960 there was not a single place of higher education in Britain that offered a film class, let alone a major area of study in film. There was just the London School of Film Technique, located in Brixton, in South London, with a title that signaled professional training. Alas, the school lacked the funds, the equipment, and the regular teachers to carry that out. But it was better than nothing, and it tempted me to give up a place at Oxford, where I would have read history. When I say there was nowhere in higher education that taught film, I should add that there was also no school that sought to take five-year-olds and upward and ask, "Do you realize how much film you are seeing in 1960? And have you thought how far this affects your sense of reality?"

Filmmakers were invited into the teaching system. Surely they knew what they had been doing well enough to advise the young? In the early 1970s, Nicholas Ray was hired at Harpur College, in Binghamton, New York, to do whatever he could. He and his students started to shoot film for a project that was never quite identified. He died (in 1979) with the project unfinished. It would be called *We Can't Go Home Again*, and in

2011 it was finally assembled and shown by Susan Ray, his last companion. I fear it is unwatchable, yet it was an experience—like knowing Ray in those years—that changed many lives. In 1980, Michael Powell taught a term at Dartmouth. He went down to New York one weekend to see Martin Scorsese editing *Raging Bull*. That's when he met the editor Thelma Schoonmaker, who would become his wife.

June 1962 had seen the first publication in London of *Movie*, a magazine edited by Ian Cameron, with Mark Shivas, V. F. Perkins, and Paul Mayersberg as associates. This was influenced by the writings in *Cahiers du Cinéma* and by the way so many of those writers had become filmmakers. Its first issue included what the editors called a "talent histogram," a table of evaluation of British and American directors, with the categories "Great," "Brilliant," "Very Talented," "Talented," "Competent or ambitious," and "The Rest." Only two people made it as "Great": Howard Hawks and Alfred Hitchcock. "Brilliant" was Joseph Losey, George Cukor, Stanley Donen, Anthony Mann, Leo McCarey, Vincente Minnelli, Otto Preminger, Nicholas Ray, Douglas Sirk, Jacques Tourneur, Raoul Walsh, and Orson Welles.

So the French heroes were saved again. But further down the line—and this was aggressive or "rude" in a British publication—"Competent or ambitious" included David Lean, Michael Powell, Carol Reed, Tony Richardson, Billy Wilder, William Wyler, and Fred Zinnemann. This was meant to upset the old guard, and the *Movie* group was happy to deride the way *Sight & Sound* had barely reviewed (or had omitted) works such as *Psycho*, *Rio Bravo*, and *Written on the Wind*.

At much the same time, in *Film Culture*, in an issue dated 1962–63, Andrew Sarris published an essay, "Notes on the Auteur Theory in 1962." This was in the spirit of André Bazin's 1957 article in *Cahiers*, "La Politique des Auteurs," in which he generally accepted the idea that directors made films and good directors tended to make them well. Bazin knew that some hero worship and professional ignorance fostered this attitude, but he understood it was one of the best ways for a newcomer to approach the vast body of unseen films. He concluded:

> The politique des auteurs seems to me to hold and defend an essential critical truth that the cinema needs more than the other arts, precisely because an act of true artistic creation is more uncertain and vulnerable in the cinema than elsewhere. But its exclusive practice leads to another danger: the negation of the film to

the praise of its auteur. I have tried to show why mediocre auteurs can, by accident, make admirable films, and how, conversely, a genius can fall victim to an equally accidental sterility. I feel that this useful and fruitful approach, quite apart from its polemical value, should be complemented by other approaches to the cinematic phenomenon which will restore to a film its quality as a work of art. This does not mean one has to deny the role of the auteur, but simply give him back the preposition without which the noun auteur remains but a halting concept. Auteur, yes, but what of?

The intellectual openness of that—to collaboration, commercial pressure, the personality of stars, of genres—is worth recalling in the furor that would spring up in America over auteurism. Andrew Sarris—talented as both writer and critic, and not shy of argument—did believe in auteurism, and he would offer his own grading system in the 1968 book *The American Cinema*, where his ranking of directors was argued with wit and insight. Still, he became caught up in fierce controversy—with Pauline Kael, above all—in which the principle of auteurism came under attack as a nearly un-American elitism. After all, wasn't film a business where many hands contributed? And if auteurs had really been responsible for it all, where did that leave Hollywood standing? (Of course, Hollywood was collapsing, and that was a large reason for the auteur theory.)

In time, Kael found her own auteurs—Altman, Bertolucci, De Palma, for instance—and the thrust of personal adoration or discovery should never be forgotten. But something more fundamental was at work, for now the disaffected teachers of Milton and Hopkins could go to their academic dean and say, Orson Welles is an American artist, Alfred Hitchcock is a unique figure, Ingmar Bergman is very serious and important. You had to be careful, still, in the 1960s: you couldn't really float a whole course on Nicholas Ray or Vincente Minnelli or Jacques Tourneur. But academia rejoiced in the idea of artist figures—especially those who might have been wronged and misunderstood by commerce—and so such figures worked their way into the curriculum.

In the late 1960s and early '70s, universities and colleges began to present film courses in their catalogues. And if you were going to offer a seminar on Hitchcock, didn't you also need Film 101: a historical survey; an introduction to criticism; film and the novel; and even an introduction to filmmaking? Was there a reading list to make these courses seem substantial? It was growing year by year. In 1967 the National Endowment

for the Arts set up the American Film Institute. In 1968, Pauline Kael—
who had once programmed a repertory movie theater in Berkeley, Cali-
fornia, and been a freelance film writer—took up a position as film critic
at *The New Yorker*. Sarris taught, at Columbia, but Kael never accepted a
teaching position—indeed, it was her opinion that if anything could ever
kill the movies it was academia.

The audience for such writers was the young generation excited by
Godard, Truffaut, Bergman, Fellini, and Antonioni and beginning to reap-
praise American film history. The sources for that still were films on tele-
vision, or films at repertory theaters and university museums. Television
had fallen on old movies with a vengeance: How else could it fill all that
air time cheaply? The pictures might be cut, interrupted with ads, and in-
troduced by charming idiots—but there they were. And dedicated reper-
tory theaters—such as the Brattle in Cambridge, the Surf in San Francisco,
the Electric on Portobello Road in London, the Thalia in New York—
were springing up. There were film festivals to showcase the new work:
the New York Film Festival began in 1963, at Lincoln Center, led by
Amos Vogel and Richard Roud, who had also been an inspiring figure at
the London Film Festival, begun in 1956.

•

One of the regular courses in the new discipline of "film studies" was
"Film and the Novel." It was the obvious escape route for jaded literature
teachers, just as Hollywood had appealed to novelists who felt celeb-
rity and money were passing them by. From Joe Gillis to Gore Vidal, the
writers tell the best Hollywood stories and have the most mixed mo-
tives. As early as 1926, Aldous Huxley wrote to a friend who had gone to
Hollywood:

> A good subject to talk about, cinematography. But is it a good me-
> dium to work in? I say no, because you can't do it by yourself. You
> depend on Jews with money, on "art directors," on little bitches
> with curly hair and teeth, on young men who recommend skin
> foods in the advertisements, on photographers. Without their co-
> operation your ideas can't become actual. You are at their mercy.
> What a disgust and humiliation!

Later on Huxley yielded: he took $1500 a week and easy sexual liai-
sons in Hollywood, and he worked on *Madame Curie* (1943; uncredited)

and *Pride and Prejudice* (1940): "One tries to do one's best for Jane Austen; but actually the very fact of transforming the book into a picture must necessarily alter its whole quality in a profound way."

Many writers have been diverted by the movies and television. That opportunity, "going Hollywood," led to famous crack-ups, like that of Scott Fitzgerald, who died in Los Angeles in December 1940 before he had made up his mind over the balance of condemnation and envy in his unfinished novel, *The Last Tycoon*. Monroe Stahr, the central character in that book, is a Thalberg figure, and Fitzgerald had known Thalberg, and complained at how the young boss had treated him.

I don't think William Faulkner was ever heard complaining—though, in private letters, after a stint in Hollywood, he would admit to having to get the air of the place out of his lungs. But he went back time and again, and he never seems to have eased his vulnerability by telling himself he was doing great things.

Faulkner tried Hollywood in the early 1930s, as he published *Light in August*. At Universal, in the summer of 1934 he was on $1,000 a week, working for Howard Hawks and doing a hundred-page treatment on a Blaise Cendrars novel, *Sutter's Gold*—it sounds like the Eisenstein idea. Why not? Story ideas hang around in Hollywood longer than some marriages or buildings.

At $1,000 a week, Faulkner seemed "hot." Paramount had bought *Sanctuary* (published in 1931) and turned it into *The Story of Temple Drake* (with Miriam Hopkins). This was not *Sanctuary*, but Faulkner had not expected it to be. The association with Hawks is the root of the matter, though it would be hard to think of a more unlikely pairing. They drank together. Hawks was a snob who may have been tickled by the southern gentleman. They both loved flying. Whatever did it, they stuck together. *Sutter's Gold* was never made, but Hawks got a studio to buy a Faulkner short story, and he let the novelist work on isolated scenes.

There must have been something like respect between them. But can we imagine Hawks reading his way through *The Sound and the Fury* (1929), with its run-on stream of consciousness, times flying and memory's talk colliding with half-glimpsed scenes? Did he ever say to Faulkner, look, put down the book, just tell me the damn story so I can follow it? Someone else might have told Hawks that the stream-of-consciousness stuff was exactly what film could do: cutting disparate elements together, going from past to present, throwing up a glimpse of a little girl's muddied underwear so you never forget it.

There is a terrible film of *The Sound and the Fury*, made in 1959, directed by Martin Ritt, with Yul Brynner, Joanne Woodward, Margaret Leighton, Jack Warden as Benjy, and Ethel Waters as Dilsey. Perhaps I'm making this up—it doesn't sound possible, but I think I saw it, and I suppose it was the result of someone working out what the story of the damn book was. Faulkner has never been done adequately on film. You can sum up the misguided attempts in the notion of Paul Newman as Flem Snopes in *The Long, Hot Summer* (1958, when it was enough in movies for the South to be sultry, lazy, and remote). There are good moments in Douglas Sirk's *The Tarnished Angels* (from *Pylon*), and for *Playhouse 90* on television, in 1958, John Frankenheimer did a version of *Old Man* that I think was decent.

Faulkner abided, as he might have said, resilient against every blandishment. He adapted his story "Turnabout" into a script and suffered the ridiculous studio imposition that the story needed Joan Crawford (there had been no woman's role). The film that emerged was *Today We Live* (1933). Later, Faulkner's movie salary fell off precipitously as his own economic situation deteriorated. By the early 1940s he was dangerously broke and most of his novels were out of print. So he worked for Hawks at Warners for $400 a week (he said he would have taken $100), and all he got for credits were *Air Force*, *To Have and Have Not*, and *The Big Sleep*. We don't really know what he did, except that he wrote John Ridgely's death scene in *Air Force* and the scene where the crew, in midair, hears Roosevelt explaining Pearl Harbor on the radio. Faulkner admitted that on *To Have and Have Not*, Hawks came up with most of the business. Jules Furthman was on the picture, too, lifting things Slim Hawks said for the Bacall part. Films like that weren't written. They were gathered here and there. But the money kept Faulkner going; it was a kind of grant.

He must have been appreciated on the set, and people realized he was Howard's man. But Howard loved fast talk, sexual innuendo, and farcical undertones in perilous places. Perhaps Faulkner enjoyed such scenes; he never passed an opinion. Nor did he exhibit one sign of being educated by the movies in seeing how a narrative could move once you realized what film editing was. In that respect, he wrote in a different world from, say, Graham Greene, Georges Simenon, Patrick Hamilton, or Ernest Hemingway. Read this:

We stood against the tall zinc bar and did not talk and looked at each other. The waiter came and said the taxi was outside. Brett

pressed my hand hard. I gave the waiter a franc and we went out. "Where should I tell him?" I asked.

"Oh, tell him to drive around."

I told the driver to go to the Parc Montsouris, and got in, and slammed the door. Brett was leaning back in the corner, her eyes closed. I got in and sat beside her. The cab started with a jerk.

"Oh, darling, I've been so miserable," said Brett.

That's chapter 3 of Hemingway's *The Sun Also Rises*, published in 1926, when movies were still silent. Not that this kind of dialogue, with its sense of the unspoken, would be heard on-screen for at least twenty years. But the moment is cinematic: the transition from "slammed the door" to "Brett was leaning back" is a cut. Hemingway didn't depend on being aware of that, and no one had yet used a sound effect to bridge two shots in a movie. But unconsciously, he was following the energy of film's editing. So many fiction writers were. The value of the movies was simple and sweeping for writers: film helped you see your own scene in your head, and you could count on readers having the same instinct. Soon enough, literature would find that dispassionate observation as almost a policy or philosophy. Seeing was so potent and immediate, you could overlook its consequences. Nabokov once told his son that everything he wanted to write in the future was already there in his mind, "like film waiting to be developed." We don't really have film anymore, but to write a story is very often running a movie, or different cuts of it, in the writer's head. As if he hadn't had to think of it?

"I am a camera." No one is, but the technological shift it gave writing was profound, even if it might foreclose the potential of an inner life— Faulkner's pressing concern. This is one of the things we should have been talking about to our childen for a hundred years. And our children are too old now, and too uncertain about having an inner life. We have "streaming material" all the time, and god knows what that sauna does to us, but maybe consciousness has been shelved. It's something else we have to learn not to worry over.

•

I have described how Hitchcock flowered as artist and entertainer in the 1950s. This progress culminated in the unacademic shock of *Psycho* (1960)—was that "movie" or "cinema"?

Many people, including his studio, Paramount, had warned against

this project: the material threatened to be nasty and gruesome, without Hitchcock's urbane and attractive people—you couldn't cast Cary Grant as Norman Bates (and I doubt Hitch could have brought himself to murder Grace Kelly). The shower killing and the looming mother seemed like exploitation, or Grand Guignol, as well as trouble with the censor. With his agent, Lew Wasserman, Hitchcock persevered. So long as he worked cheaply, using the crew from his television show, and staying in black and white, *Psycho* could be set up in a deal to make more money for Hitch than he had ever known before.

Step by step, he crafted his way past the censor. He cast Anthony Perkins as Norman; the audience knew him as a soft-spoken, decent young man. He set up the amiable Janet Leigh to be slaughtered; she was mainstream, as well as a blond movie star. And Hitch did it as what he called "pure cinema": a series of effects made out of camera angles and cutting, invitation and withheld information, a delicious ordeal. He also made it a personal venture. In the theater lobbies there was a lifesize cardboard figure of the director—familiar from his cameo appearances on his television show—warning that no one would be admitted after the picture had started. More than just an auteur, he was in charge of the show. And the $800,000 film had rentals of $15 million. Hitch walked away with at least $4 million.

The reviews were all over the place. *Psycho* became a test case in the auteur debates; some said it was unpleasant, meretricious, ridiculous, and grisly, while at the other extreme it was regarded as a masterpiece, the introduction of breakdown as a subject, and a disturbing essay on the rhythm of voyeurism and detachment, suspense and distancing, in film history. Yes, we watched the story, to the point of nausea or compulsive reaction, but we followed the process, too, the way it was done. And in that analysis there was the start of a rare, chilly detachment. Was Hitch just a poker-faced entertainer or a modern genius?

François Truffaut had no doubts. He had cherished Hitchcock's films for years and had interviewed the maestro in the South of France during the making of *To Catch a Thief*. On June 2, 1962, between *Jules and Jim* and *The Birds*, Truffaut wrote to Hitchcock saying, "Since I have become a director myself, my admiration for you has in no way weakened; on the contrary, it has grown stronger and changed in nature. There are many directors with a love for the cinema, but what you possess is a love of celluloid itself and it is that which I would like to talk to you about."

He proposed eight days or thirty hours of recorded interview toward

the making of a book that would assess every Hitchcock film and all the director's ideas about the medium. As soon as I've finished *The Birds*, promised Hitch. They sat down together for a week in August in Hitchcock's bungalow at Universal, with Helen Scott (one of Truffaut's most valued friends and consultants) present to help with translation issues. They talked for six days, and the book was not published until 1966, in part because it contained spectacular illustrations with frame-by-frame analyses of certain sequences. There had never been a book like it before, either in celebration of an individual director or in its close attention to the celluloid detail Hitch had given his life to.

This book became a key text in the mounting number of university seminars on Hitchcock, backing up the 1964 publication of Robin Wood's *Hitchcock's Films*—and Wood was a writer close to the *Movie* magazine group. By 1967, Hitch was sixty-seven, and there was a somber irony in the way his films became less interesting as he was the more esteemed. Was there a connection? The audience mood of the 1960s was changing rapidly, and directors of Hitchcock's age ran the risk of losing touch. The man who had made such inroads on censorship with *Psycho*, and judged its titillation to the frame, began to seem clumsy or overwrought with sexual violence by the time of *Frenzy* (1972), in which his interest in disturbance felt out of control and uncomfortable.

Hitchcock never won an Oscar for Best Director, though he was given the Irving Thalberg Award in 1967 and the AFI Life Achievement award in 1979, the year before his death. But he was at the pinnacle of success in the early 1960s as he made *The Birds* (1963) and *Marnie* (1964), and sat down for the Truffaut interview book. The inhibited voyeur was never drawn out of his shell. To study Hitchcock's films is to feel the deep yearning for his actresses and the concurrent suppression of it. Hitchcock had wanted Grace Kelly to return for *Marnie*, but the protocol of the principality of Monaco would not permit it. So he used Tippi Hedren again, his actress from *The Birds*, and made a crude pass at her. That is her account of it, but it is not really doubted. She rebuffed him, and Hitchcock was left crushed in his moment of glory. It was a strange and embarrassing revelation that the man in charge might be not just an omniscient auteur—someone who always had the whole picture in his head—but also a desperate person crying out from the back room of his being. Rich as it is, the Truffaut book does not discover that man. Hitch was too professional, too superior, too Hollywood, to let him be seen or to own up to his pressing subject, the loneliness.

The question often arises with Hitchcock as to how well he understood himself. Planning everything in advance, and claiming to be a little bored during the shooting, could be a droll way of not noticing yourself. Or was he just the wry if slightly wicked entertainer he found viable in public relations?

In 1964, he had an exchange with Vladimir Nabokov on ideas for collaborating on a picture. They came to nothing, though some plans were put forward on both sides. Hitch suggested a plot concerning a woman in love with a defector. The correspondence includes this, from Hitchcock:

> Anyway, Mr. Nabokov, the type of story I'm looking for is an emotional, psychological one, expressed in terms of action and movement and, naturally, one that would give me the opportunity to indulge in the customary Hitchcock suspense.

"Naturally." But by 1964 Hitchcock had revealed so much about himself—not least the passionate voyeur, as intense as Humbert Humbert beholding Lolita. Could it be that some film directors, if they are to gaze with such longing, are safer and freer if they don't ask too much about their own motives? Is it possible that a similar liberating restraint applies to us, the viewers? One of the charms in "I am a camera" was always its insinuation that if you become that mechanical you may not need to think or question what you are doing. The same facility is useful in torture or playing golf.

Perhaps stricken artists did make the movies. That would help account for why the pictures were not the same anymore. Ingmar Bergman had breakdowns. Alfred Hitchcock was expected, and himself expected, to preside over a series of successes and offer his famous dry remarks, like, "It's only a movie!" Which was the easier path?

•

Hitchcock sounded English still in the 1960s, but he took America for granted as a place to work. Still, England was becoming attractive, or necessary, to several American filmmakers. Although American visitors might not appreciate this, it was only in the late 1950s that Britain began to regain prosperity and confidence after the war. That money would let young people buy records of the new music—the Beatles, the Stones— and it ran over into design, clothes, sex, drugs, and moviemaking. The look of the country changed in the early 1960s. Clothes suddenly lost

their uniform drabness. And filmmakers notice such things. There was also a wave of new writers in the theater, and even on television: John Osborne, Harold Pinter, John Hopkins, Dennis Potter. Sometimes they were called "angry young men," and the anger was directed at the remnants of an archaic England, but it was full of high spirits and new ideas, too. To Americans, increasingly disenchanted with their own country, this vigor and candor was very appealing in a Britain that could still seem safe, pretty, and cheap.

•

Some Americans had had a tougher time. Joseph Losey had a lengthy period in London. He married Englishwomen and had English children. But he had not really arrived of his own volition. Born in La Crosse, Wisconsin, in 1909, Losey attended Dartmouth and Harvard before working for ten years in the theater. He traveled in the Soviet Union and the rest of Europe and became a Communist. Having directed Clifford Odets's *Waiting for Lefty* in Moscow in 1935, he came back to America and helped with the Living Newspaper project and a scheme called Political Cabaret. Losey was in the line of educated, creative liberals in the 1930s when communism seemed a natural response to the threat of fascism.

Then he served in the Signal Corps in the war and afterward, at close to forty, he started to direct films in Hollywood: *The Boy with Green Hair* (1948), *The Prowler* (1951), a remake of *M*—small but adventurous films. *The Prowler*, say, is apparently a standard noir story about a creepy cop (Van Heflin) who preys on a woman who has reported a prowler. It turns into a downcast love story with intimations of a sick society. The remake of *M* (1951), set in Los Angeles, with David Wayne in the Peter Lorre role, was attacked as being opportunistic. But it is a worthy picture and one of those noir movies aimed at the real corruption of America.

Then, in the early 1950s, Losey had to get out of America because of the blacklist. He ended up in London and struggled to survive. He worked in theater, and doing television commercials; he made a couple of pictures under pseudonyms; and he began to gain a more critical awareness of Britain. He collected a few sympathetic people—a production designer Richard MacDonald, the jazz musician Johnny Dankworth, the actors Stanley Baker and Dirk Bogarde. Losey was proposed to direct a Bogarde picture in 1954, *The Sleeping Tiger*. The actor was wary, but then he looked at *The Prowler*, and a friendship began. Losey's films became more personal and uneasy—*Blind Date* (1959), *The Criminal* (1960)—

and he directed *Eve* (1962), in Italy, with Baker and Jeanne Moreau. But *The Servant* was the picture that made it clear how much was changing.

Robin Maugham's novella of *The Servant* had been published in 1948. Its portrait of a servant taking over his master was said to be too shocking for a movie then. But around 1960, Harold Pinter, just beginning his career, was asked to try a script by the director Michael Anderson. That plan fell through, but then Dirk Bogarde wired Losey (in Venice for *Eve*) and said the script was intriguing. Losey looked at it and started writing notes.

"There was a meeting," Losey would say later,

> with Dirk, his business manager, Harold, his agent and myself at the Connaught Hotel. I confronted Harold, who was—if any-thing—no less arrogant because he wasn't sure that he was Harold Pinter yet. And he said, "I'm not accustomed to writing from notes and I don't like this." He thought that I was going to try and dilute his theme. As for Dirk's business manager, he was afraid that I was going to make it, as he put it, "a completely homosexual picture" which would discredit Dirk, who was still a big English film idol.

The venture nearly came apart that night at the Connaught. But Losey and Pinter were made for each other: the new screenwriter and the director ready to get his teeth into the meat of English society, with Dirk Bogarde reckoning to preserve his cover but eager to show his range as an actor, something not permitted in his prolonged run of British war heroes or as Simon Sparrow in the popular *Doctor in the House* movies. Losey and Pinter worked on the script. They brought it up to date: as recently as 1959, in the trial of Penguin Books for obscenity in publishing an unex-purgated text of *Lady Chatterley's Lover*, the prosecuting lawyer had raised laughter in court when he'd asked the jury whether this was a book they'd let their wife or servants read. There were still servants in Britain, but there was growing mockery of the old class privileges and a new, young voice abroad—you got it at the BBC, at Penguin Books, the Royal Court Theatre, in the *Manchester Guardian* newspaper and in *Private Eye* (started in 1961), and at the new English universities, the "redbrick" schools that were not "Oxbridge." (The universities of Sussex, Warwick, East Anglia, York, and the Open University were all started in the 1960s.)

The film of *The Servant* is about sexual confusion, raw power, and intimidation, but it's also a critique of a society that was passing away and

an early event in what would soon be known as "the sixties." Leslie Grade put up about £140,000 for the movie (Losey got £15,000 and Pinter £3,000) and it was shot at Shepperton Studios, where MacDonald did a series of elaborate adjoining sets—the rooms in the Chelsea house—so that space and décor could be explored in the filming. Later on, the critic Penelope Gilliatt would say the film made the house "almost malignant." The young man, Tony, was James Fox; Bogarde was Barrett, the manservant; and Sarah Miles was the "sister" brought down to town to help destroy Tony.

When *The Servant* was finished, the money people were scared: Bogarde had never dared be this nasty or perverse. The sex was palpable, and class was viewed as a rotting carcass in a Francis Bacon painting. The film played at the Venice and New York festivals and it opened in London on November 14, 1963 (just months after John Profumo had admitted lying to the House of Commons in the Christine Keeler affair). Philip Oakes in the *Sunday Telegraph* called it "the best film of the best director now working in Britain," and it was hard to separate its attitude from the impending end of Tory rule (after thirteen years).

The Servant was not isolated. In 1958 the playwright John Osborne and the director Tony Richardson had formed Woodfall Film Productions, and their films included two Osborne plays—*Look Back in Anger* (1959, with Richard Burton as Jimmy Porter) and Laurence Olivier in *The Entertainer* (1960)—and *A Taste of Honey* (1961, with Rita Tushingham), *The Loneliness of the Long Distance Runner* (1962, with Tom Courtenay), rising toward *Tom Jones* (1963), which won the Best Picture Oscar for 1963, made a star of Albert Finney, and sent a few people back to read Henry Fielding.

Olivier doing Archie Rice was the kind of audacious "slumming" that had pushed Bogarde into risking *The Servant*. The upper class of English actors was feeling the temptation of new material: by 1975, John Gielgud and Ralph Richardson would open in Pinter's *No Man's Land*. Just as important was the strain of new young actors and voices, many of them provincial and "uncouth" to old ears. John Schlesinger did *A Kind of Loving* (1962), *Billy Liar* (1963), and *Darling* (1965, an uneasy teaming of Bogarde, Laurence Harvey, and Julie Christie), not a fluent film now but judged a marvel in its day. Lindsay Anderson made *This Sporting Life* (1963, with Richard Harris), and Karel Reisz made *Saturday Night and Sunday Morning* (1960, with Finney).

These were grittier films than Britain had had before, working-class stories often, with darker visions of life and its prospects. When most of

the films were successful on both sides of the Atlantic, it only made British ideas and London talent attractive to Hollywood money. Many of those talents would go to America, sooner or later, but another American, Richard Lester, in London to do advertising films and some shorts with Peter Sellers, became the director of two inevitable smash hits: the Beatles films *A Hard Day's Night* and *Help!*

•

There was another, momentous American landing in Britain. Stanley Kubrick was born in 1928 in the Bronx. He was a brilliant kid and a precocious still photographer who was contributing work to *Look* magazine by his late teens. He started making his own movies in the 1950s, doing nearly every job on them, and he graduated to *Fear and Desire* (1953), a mini-epic on combat; *Killer's Kiss* (1955), a rather maudlin story about a boxer in love with a beautiful but unreliable blonde; and *The Killing*, an immaculately precise account of a racetrack robbery, just eighty-three minutes, and a big influence later on Quentin Tarantino. Then, for actor-producer Kirk Douglas, he made *Paths of Glory* (1957), a stylish First World War story as pitiless as it is handsome. Because of Douglas, he got to do *Spartacus* (1960, replacing Anthony Mann), but everyone knew that hymn to freed slaves was Kirk's special property.

At which point the New York and Hollywood man determined to film Vladimir Nabokov's *Lolita*, but resolved to make that heartfelt elegy to Americana in England—and thus, Home Counties roads vanishing in the mist stand in for the bright West of all that driving and motels where Lo takes Humbert, so long as he thinks he's taking her.

Why did they do *Lolita* when it was impossible? One answer could be that James Mason and Shelley Winters were merely perfect as Humbert and Charlotte, while Sue Lyon was a very cool sixteen-year-old (fourteen in fact during the shooting), instead of the twelve-year-old Nabokov had written.

But why did Nabokov do it? His book had sold fourteen million copies in the world, the publishers said. It was in July 1959 that Nabokov had been approached by Kubrick and his associate James Harris about writing a screenplay from the novel to which they had acquired the movie rights a year earlier. They had paid $150,000 for the book and promised Nabokov 15 percent of the producers' profits. There were prolonged discussions and a meeting during which Kubrick told the novelist that the venture might be less risky if Humbert and Lolita were actually married.

So Nabokov declined to write a screenplay and attended to butterflies and other books. Time passed, and then he thought he saw a way— "unusually compelling in sheer bright force"—that the script might be done. "Magically" a telegram came from Kubrick asking again, and promising a freer hand. A deal was done: $40,000 for the script, plus travel and living expenses, and another $35,000 if Nabokov ended up with the sole writing credit.

Vladimir and Vera Nabokov traveled to Los Angeles. He met Tuesday Weld, "a graceful ingénue" but not right for Lolita, and he wrote a script that Kubrick estimated would make a seven-hour picture. Kubrick urged the novelist to cut and rewrite. When the second version was delivered, Nabokov was told it was the best script ever written in Hollywood.

He was lied to. He went away, the film was shot, and the Nabokovs were brought back for the premiere. Nabokov noticed two things: he thought it was "a first-rate film," but "that only ragged odds and ends of my script had been used." That was less than accurate, too. Still, Nabokov got the sole credit and $75,000, while Kubrick had the promotional prestige of the great man's name on the film.

Nabokov stayed polite; he had a long-term view: he wanted to publish his script. And so he did, at last, in 1974—and so he should have done, for the script is a valuable variation on his great novel, not least in the stage note he offered the director in the scene in Room 342 of the enchanted motel when Lo puts words in Hum's ear: "could one reproduce this hot moist sound, the tickle and the buzz, the vibration, the thunder of her whisper?" But sharp-eyed readers might note that the copyright in the published script belonged to Metro-Goldwyn-Mayer.

In his foreword, Nabokov showed his need to emerge with superiority. He admitted that he was no dramatist, though if he *had* gone into the screen business, he said (and he was fond of movies), "I would have advocated and applied a system of total tyranny, directing the play or the picture myself, choosing settings and costumes, terrorizing the actors, mingling with them in the bit part of guest, or ghost . . . [and] pervading the entire show with the will and art of one individual." It's the author theory.

No one acted on that advice more than Kubrick. He and his wife were disenchanted with New York: it was dirty, unsafe, and vulgar, they felt. In that era, a lot of Americans came to Britain for a nicer life. Bit by bit, Kubrick did the most unlikely things in England. *Dr. Strangelove* (1964) is gallows humor about the Strategic Air Command, but he filmed it in English studios because America lacked the space and the facilities, and

crews eager to please or obey him. The film *2001* (1968) was a numb elegy to advanced technology, the American space program, and the kind of depersonalized heroes who manned it. But it was shot at Boreham Wood, with cameramen and designers from England. Soon enough, the Kubricks moved to an estate near St. Albans, in Hertfordshire—that is where he lived and died for everything from *A Clockwork Orange* (1971) to *Eyes Wide Shut* (1999). (Five films in twenty-eight years.)

In Britain he became a quiet-spoken emperor who often told his patron, Warner Bros., very little of what he intended to do. He promised the studio that *Barry Lyndon* would gross in nine figures—it earned just $3 million in the United States. But no one ever denied or controlled Kubrick. His career, like his best films, was black comedy. The actor George C. Scott (General "Buck" Turgidson in *Dr. Strangelove*) said of him, "He's an incredibly, depressingly serious man, with this wild sense of humor. But paranoid."

Anyone who worked with him said that Kubrick was obsessed with perfection—seventy takes; special lenses; recasting roles after shooting had started; every detail, shoot forever, then edit for longer. Days after the release of *The Shining*, he decided to cut its prologue and sent editors by bicycle through New York and Los Angeles, the only cities where it was playing so far, to trim off the unnecessary opener. Yet in so many of his pictures the perfect plan goes wrong: the robbery in *The Killing* falls apart; the computer in *2001* goes rogue; the military training in *Full Metal Jacket* doesn't help in action; and Jack Torrance's ideal writer's colony in *The Shining* turns out to be a very haunted house. But maybe that's what Jack wanted—all work and no play could make him a dull boy. He is the kind of writer who would rather get into the movies than sit alone with blank paper. So the Overlook Hotel is his Room (as in *Stalker*).

You might say that *A Clockwork Orange* was hardly a fitting thank-you to Britain or St. Albans for its tranquil living conditions—and in time, in Britain, where he controlled the film, Kubrick had *A Clockwork Orange* withdrawn from circulation because he feared the picture inspired copycat killings. But he resided in England and in his own creative head, beyond challenge. This eminence is the more remarkable in that *2001* was his last modest success at the box office (it had U.S. rentals of $25 million on a budget of $10 million). He had overawed the system as no one else has ever done. More than an auteur, he was an emperor—and he did think of filming the life of Napoleon, with Jack Nicholson. At a more domestic level, amid the surreal expanses of the Overlook Hotel, Nicholson

had already done a tyrant in *The Shining* (1980), which seems one of Kubrick's greatest works, the more disturbing because it is so funny and because it is about that central theme: making up a story and then entering it.

There are moments in *The Shining* that will never lose their sense of hallucination. When the morose Jack Torrance shambles into the superb but abandoned Gold Room bar at the Overlook, he closes his eyes, imagines for a moment, opens them, and there is Lloyd the eternal barman (played by a Kubrick favorite, Joe Turkel) asking, "What'll it be?" We suspect this dream means doom, but it's picture-perfect. The risky delight of thinking yourself into the screen, and belonging to fantasy, had seldom been captured so well.

•

Is there something English I've forgotten? Could it be the biggest franchise the movies have ever had and the phenomenon that brought more money into the British picture business than anything else has ever done? Is that Ursula Andress in a white bikini striding out of the ocean? Are we shaken or stirred?

The Ian Fleming books about James Bond had been around some time. (*Casino Royale*, the first, was published in 1953.) The role had been tried out on American television (with Barry Nelson as Bond). But no one could see how to turn the rather brutal, old-fashioned books into something more modern. And it was plain in the 1960s that Britain was greedy for anything modern. Real spies were still in the news: Kim Philby vanished from Beirut in 1963 and turned up in Moscow. But popular taste felt that secrecy and espionage might be laughed at.

The producers on Bond were Harry Saltzman and Cubby Broccoli. But it was Kevin McClory who had the idea of reappraising the books as espionage parody, with the sex and violence done in an insolent tongue-in-cheek manner. The pictures had double entendres instead of real dialogue, with Bond girls by the yard, splashy minor-key music from John Barry, and those booming theme songs delivered like artillery by Shirley Bassey.

And they had Sean Connery. So many actors were considered for 007. But history would prove, with painful regularity, that while others might do a decent job, replacing him was like trying to be Groucho Marx. Only Connery had the insolent touch and tone. He was upper-class British, if you liked, but he was saucy Scottish, too. Right in the first glorious age of British auteurs, the actor made the Bond series, and the films came run-

ning: *Dr. No* (1962), *From Russia with Love* (1963), *Goldfinger* (1964), *Thunderball* (1965). The total box office income from 007 is said to be $4.8 billion, and it can't be over yet.

●

Despite the changes and the new seriousness, the business could not give up on the marriage of art and silliness—getting respect and earning big money at the same time. Look at *Blow-Up* (1966), they said. Who could have believed that Michelangelo Antonioni could leave Italy, land in swinging London, and have a sensation?

Antonioni had come to London with a far-fetched package. Carlo Ponti (an old-style producer and Mr. Sophia Loren) and M-G-M were putting up the money for a short story by Julio Cortázar. Antonioni and Tonino Guerra had done the script, but the English dialogue was by playwright Edward Bond, whose *Saved* had given Royal Court audiences the shudders in 1965 with the onstage stoning of a baby. No one felt sure Antonioni could understand English talk.

Thomas (David Hemmings) is a modish photographer of a type springing up to fill the new Sunday newspaper color supplements. He covers all of life, he thinks. He does fashion work—the film has a famous sequence where he drives Veruschka (a real model) to a point of dry orgasm to get the best shots. But he spends the night at a doss house to catch the poorer underside of London. In the actual magazines of the day, faces like Veruschka's stared at reportage shots of derelicts or famine victims, and the cross-cut was reckoned to be deadpan, or worldly.

Thomas is the film's protagonist, but he's a shit; he knows it, yet he reckons the knowingness lets him slip by. So he visits a suburban park in the middle of the day and starts to take a few shots—snaps, really—without much purpose. Then he sees a couple caught up in some obscure crisis. The woman (it's Vanessa Redgrave, one more new English beauty) sees Thomas and demands the negatives. She comes to his studio in pursuit and seems ready to trade her body for the film. Then, later, Thomas starts to process the pictures and wonders if, inadvertently, he has photographed moments in a murder. There is a lengthy sequence where he makes a storyboard of these frames, and we begin to see the pattern, too. As we read the line of the stills, we hear the foliage in the breeze from the park. It is an exquisite mix: a distillation of *Rear Window* and a witty reference to all the controversy over the Zapruder frames. *Blow-Up* is both a mystery film and an absurdist comedy in which Thomas gives up

368 THE BIG SCREEN

on distinguishing reality from imagery and decides to regard the plot he thinks he saw as a joke.

There are other assets. The summery color is pretty (shot by Carlo Di Palma). There is music by Herbie Hancock and the Yardbirds. This is a visitor's view, and an acute portrait of London just before the merchandising frenzy of "swinging" took over from the real novelty. So it's a document of its time as particular as that out-of-the-way park (it was Maryon Park in Charlton). *Blow-Up* also offered the first female pubic hair in a mainstream film, and from M-G-M, too, less than ten years after the demise of Mr. Mayer. (You had to be quick to see it, but it's a film predicated on the sharp glance.) Vanessa Redgrave veers in an instant from gauche to perfect. Hemmings is an ill-mannered child. *Blow-Up* has that astringent unexpectedness that made *Some Like It Hot* so unnerving. It leaves us saying, "This is a movie, isn't it? But how am I supposed to take it?" Budget, $1.8 million. Worldwide gross, $20 million.

The comedy was made complete when the numbers on *Blow-Up* were so stimulating that Ponti and M-G-M decided Michelangelo must go to America and do the same thing there for that emerging youth culture. In Panavision, with an orgy sequence in Death Valley. The result was *Zabriskie Point* (1970), perhaps the most beautiful, empty, and pretentious film Antonioni would ever make. On a budget of $7 million, it had gross income of under $1 million.

For M-G-M, the gamble was fatal; in 1969 the studio was sold to Kirk Kerkorian. He assigned control to James Aubrey, who had come from CBS. Aubrey cut back film production, trashed studio files, and sold off memorabilia, including Dorothy's red slippers from *Oz*. (The rightful museum of Hollywood is still a pipe dream.) Gradually, what had been the most secure studio became a trading card in obscure deals of real estate, resorts, and technical bankruptcies. A movie lesson was also there for the seeing in *Zabriskie Point*: solemn, auteur beauty could turn out foolish. Still, the endless slow-motion repetition of its exploding desert house (with Pink Floyd on the sound track) was like a mantra for the new antimaterialist mysticism. Yes, it was gorgeous—so long as it wasn't your house. But slow motion could be another drug in this frantic age.

•

When *Blow-Up* arrived in America, the Motion Picture Association of America (MPAA) declined to give it a seal of approval. The major distributors were signed on to a voluntary agreement to seek and accept that

imprimatur for every movie. But M-G-M passed the film over to a subsidiary company (Premier Pictures) that was not an MPAA signatory. They went ahead with its release. Nothing happened, except that *Blow-Up* made a lot of money, received ecstatic reviews—Arthur Knight said in *Playboy* that it was as important as *Citizen Kane, Open City,* and *Hiroshima Mon Amour*—and Antonioni's direction and the script were nominated for Oscars.

One concern over the picture was for its flashes of nudity. Yet the more suggestive scene in *Blow-Up* was that photo shoot with Veruschka. She wore enough clothing to escape protest, but the scene's sense of an exploitative thrust in photography was reason to be disturbed. It was asking the old questions "Is this a movie? Is it for us? Why are we looking?" Such questions were more radical or disconcerting than a tuft of pubic hair glimpsed in a scrum. But censorship didn't always get its own point, and censorship was on the ropes in the 1960s.

In 1958 Louis Malle had made *Les Amants*, in which his own lover, Jeanne Moreau, played a dissatisfied socialite who finds sex and love with a younger man she meets by chance. The film contained a good deal of nocturnal nudity, elegantly done, and a moment when the man performs cunnilingus on the woman. We do not see his action, but we see her face and hear her rapture—it is quite like the famous moment in Gustav Machatý's *Ecstasy* (1933), where the young Hedy Lamarr (called Kiesler then) runs around naked and feels a rush like that enjoyed by Moreau. *Les Amants* was a big hit in France, but when it came to America, in 1959, a theater manager in Cleveland Heights, Ohio, was charged with the public depiction of obscene material. He was convicted, but he appealed all the way to the Supreme Court, which overturned the verdict in 1964. Justice Potter Stewart, writing about pornography, said, "I know it when I see it, and the motion picture involved in this case is not that." (However, later in life—he died in 1985—Stewart said he regretted the decision.)

Increasing time and talk were given over to our "need" or "right" to see more sexual frankness on-screen, but very little consideration was given to how far this medium, with its breathtaking manipulation of reality, had always been about desire. Ever since the rule of Will Hays, American audiences had been resigned to the industry's pious warning that it needed to be careful on our behalf. Otherwise local authorities might take the law into their own hands and ban films, or cut them. (Pennsylvania was one state that banned *Ecstasy* outright.)

In most cases, motion pictures had always been stories about attractive people in which the lush craft of photography and the stealth of music combined to make them seem lovelier still, and more seductive. In nearly every genre (even the Western), love situations were obligatory, and Howard Hughes had seen no reason why a Western should not be about sex—witness Jane Russell in *The Outlaw* (1943), with the producer's diligent efforts to create a bra for her that seemed not to exist. It wasn't just that we learned how to fall in love, like "love at first sight." There was a deeper message: that we *should* fall in love, because that was what life (and seeing) was about. Movies were dating events then—and usherettes had flashlights to make sure couples in the back row were not completely imitating the screen's indicated action.

So there were rules on-screen, the Code's conditions: no nudity, no undue suggestiveness, no hint that sexual relations outside marriage were pleasant, no miscegenation (no cegenation, either) and no undue kissing. The rules didn't always work. For *Notorious* (1946), Alfred Hitchcock looked at the standards for how long a screen kiss could last and simply had Cary Grant and Ingrid Bergman kissing and talking, and kissing again—who could have guessed that a lover might like to be talked to, or need to draw breath? On *The Big Sleep* (1946), late in the day, Howard Hawks threw in a conversation between Bogart and Bacall about horses and jockeys and being in the saddle, and the censors apparently missed the message and the lewd grin on Bacall's face.

With the pill, shorter skirts, rock and roll, and young purchasing power, it was only a matter of time before the Code gave up. But there were other pressures to take into account. The movies, as they withered, were looking for any possible advantage over the small screen. One had been to make the movie screen wider (CinemaScope) or "explosive" (3-D). Another was to get people to take their clothes off and talk dirty.

In May 1966, Jack Valenti (formerly a special assistant to President Lyndon Johnson) was appointed to head the MPAA (a move engineered by Lew Wasserman). Valenti knew that changes had to be implemented before ridicule set in. The undermining had been years in the making.

As early as 1960, Alfred Hitchcock had dined and finessed Geoffrey Shurlock, director of the Production Code Administration, over *Psycho*. Hitch had been warned by many people that *Psycho* would never be approved by the Code. So he cultivated Shurlock and talked to him about the problems an ingenious, creative movie director faced. Shurlock was flattered; he took an interest in the project and the dilemma. Just as a plot

point, Hitchcock needed to have a toilet being flushed. Then there was the matter of the slaughter in the shower, to which Hitch said he would do it as quickly as possible and take care that we never saw a knife piercing skin. He was persuasive, and the times were ready. So a toilet was flushed, and the idea of a woman was slashed to pieces. You can hear the knife working on the sophisticated soundtrack.

There was another pressure, a way of confusing other desires. With the coming of television, the ordinary, old-fashioned rapture in which people followed filmed fictions clashed with the commercials interrupting every story. "Why are we watching commercials? Is it to pay for the medium, this new toy? Is it because we want to have these things? Or are the advertised products kin to the ideals in the story?"

Television commercials became small movies, shot with care and skill and sometimes with resources that outstripped those of feature filmmaking. The commercials of the 1950s and '60s look quaint today, but that doesn't mean they weren't compelling at the time. (Didn't Don Draper and *Mad Men* make them?) The shining light was working in a quite new way. Viewers might laugh the ads off and say they were fanciful, and advertisers learned that a touch of humor helped sweeten the selling—it relaxed the suckers—but the public soon knew some ads by heart, and if they observed the marketplace, they realized that advertising succeeded. The huddled masses paid heed. Only desire, that precious, fundamental urge, was compromised.

Jack Valenti looked at the disarray of 1966: at *Blow-Up* and *Who's Afraid of Virginia Woolf?* (1966), which had so much "bad" language it was warned in advance by the MPAA. (Then a Warner Bros. executive saw the light: "We've got a $7 million dirty movie!") Valenti was not happy that "individuals" seemed to be making movies their way, instead of working in the system. So he introduced a new set of ratings to replace the seal of approval, and to keep some control: G—all ages could see it; M (for Mature)—all ages could see it, but parents were advised to take care; R—no one under the age of 16 could see it if not in the company of a parent or adult guardian; X—no one under 17 could see it.

A board was hired by the MPAA to view the films and award the ratings, and soon it became clear that the board was willing to talk to filmmakers and negotiate. It became practice to trade scenes and words, glimpses and cuts. By 1970 the concept of "Mature" had raised so many uncertainties that it was replaced with PG, for "parental guidance." In 1984 the system was G/PG/PG-13 (an age indicator)/R/X. By then, the

X rating, awarded to *Midnight Cowboy* (1969) and *Last Tango in Paris* (1972), among others, had become hopelessly confused with "pornography." Two years later, the rating on *Midnight Cowboy* was amended to R, after it had won for Best Picture. A true X had restricted commercial viability: many localities and newspapers were so alarmed by X that they would not review or advertise such pictures. And so, in 1990, NC-17 was introduced as a new label, its first unhappy recipient was Philip Kaufman's *Henry and June* (1990).

By now the availability of direct sex, soft core, hard, and harder— sometimes of startling physical detail and cruelty—seems to have diminished the quest for sexual action in movies. Instead, violence has occupied the vacant taboo space, though it was not a cause, like sex, in the 1960s. It was Kaufman who, at the time of *Henry and June*, remarked that if America was nervous about a shot of a hand caressing a breast, it seemed happy to see a sword slicing it off. If a child—the seven-year-old, the three-year-old—sits between both parents at such an excision, doesn't the power of the process strike at something that is always alone? Call it the singularity of self; call it independence or loneliness. Or will the child assume that, because everyone else is watching, the act must be an established item of discourse?

I know this leads into infinite and unanswerable questions on the influence movies have had, but that is a central task of this book, and I will not dodge it just because the "evidence" is scattered and contradictory. Just because it's so hard to measure the impact of movies quantitatively does not mean the impact is a myth.

I am not saying movie violence is responsible for this or that recent massacre. (I won't name one for fear of being outdated). I am not sure Stanley Kubrick was sensible to withdraw *A Clockwork Orange* in Britain— after he had made it, and made it so scary. But the ability to observe such things passively, or as spectators rather than participants, is deeply influential.

Consider: if I were to propose that movies of the 1930s and '40s helped teach us how to smoke, and made smoking seem cool as well as hot, who would disagree?

If I added that over a period of fifty years moviegoing indicated a scheme of being "good-looking" and lovable and attractive that helped define attraction, you would say, well, maybe so. And you might snatch a quick look in the mirror to make sure it was you. The mirror is still in our top-ten technologies.

If I asked whether the "silly" ads for everything from vodka to soup have been effective, you would admit that the evidence of American business tends to support that notion. Would it have persisted with advertising without some certainty of result? Or is business insane?

So, don't movies affect us? Don't we want them to move us? Aren't we talking about one of the most profound appeals to desire the human race has ever created out of nothing?

•

You can always feel honest desire. It is what makes people write and see and make films. It is what makes us want to see and feel. It is all we hope for in the light. This is October 28, 1972, Pauline Kael in *The New Yorker*, as later published in a book called *Reeling*:

> Bernardo Bertolucci's *Last Tango in Paris* was presented for the first time on the closing night of the New York Film Festival, October 14, 1972; that date should become a landmark in movie history comparable to May 29, 1913—the night *Le Sacre du Printemps* was first performed—in music history. There was no riot, and no one threw anything at the screen, but I think it's fair to say that the audience was in a state of shock, because *Last Tango in Paris* has the same kind of hypnotic excitement as the *Sacre*, the same primitive force, and the same thrusting, jabbing eroticism. The movie breakthrough has finally come. Exploitation films have been supplying mechanized sex—sex as physical stimulant but without any passion or emotional violence . . . This must be the most powerfully erotic movie ever made, and it may turn out to be the most liberating movie ever made . . .

We have to feel bold about greatness (because it inspires us). Still, Kael's excitement at *Last Tango in Paris* is poignant because the film is her testament. It asserts not just eroticism (which mattered to Kael), or what she called "the breakthrough" of film as a liberating force, but the hope that great sex and great movie could ride together—and save the world? That was a momentary prospect in the early 1970s, when inchoate issues of desire (the pursuit of happiness even) sometimes seemed to rest on the fate of cinema. It is what leaves Kael's cry of recognition close to tragic now.

Just two years earlier, Bernardo Bertolucci had made a masterpiece, *The Conformist* (1970), from a novel by Alberto Moravia. It is the story of

Clerici (Jean-Louis Trintignant), a tense and masked young Italian in the age of fascism, who becomes an agent assigned to murder a former teacher, an antifascist, Professor Quadri. At the same time, Clerici is getting married to the lovely, foolish Giulia (Stefania Sandrelli), but falling in love with Anna (Dominique Sanda), the wife of Quadri, and someone whose smart gaze sees through Clerici's mask. *The Conformist* has a complex series of flashbacks and an intricate camera style that build toward the final pursuit and its foul murder in a dark forest. What holds it together is the signal from the title, that Clerici is being drained of life by his urge to be conventional—and this is captured in Trintignant's hunched stance, his numb face, and his scuttling walk. What shocks in *The Conformist* is not simply its cinematic richness, but also the way that style expresses a numb dread of being exceptional, the terrible need to conform.

The film's beauty—often compared to that of Ophüls and von Sternberg—comes from the fraternal collaboration of Bertolucci with the photography of Vittorio Storaro and the work on design, décor, and costumes by Ferdinando Scarfiotti. *The Conformist* was an independent production, but its period craftwork had the layered look of a new kind of studio picture, more sophisticated than most things attempted by the old studios. It was a look that proved influential in America: the style of *The Conformist* encouraged the morally shaded Italianate New York of *The Godfather*. Indeed, *The Conformist* was one of those works made around 1970 that said, why should a movie not be as measured and beguiling as anything available in other arts?

For his next venture, Bertolucci was determined to deal with sex. He reasoned this was the moment—with censorship falling away like discarded clothing—to take on the real thing, the ultimate action of desire. Perhaps for decades the secret purpose of the movies had been simply to guide us, the subservient mass, from a culture of sanctioned love and marriage, ignorance, repression, and guilt into the glory of sexual liberty—as a right, as part of that larger happiness deal. So Bertolucci had a dream that, artistically (of course), he could make a film in which movie stars did the thing it was said hardcore performers were doing: they would fuck on camera—no more simulation. Wasn't that what we had been waiting for? Wasn't that what Viva and Louis Waldon (amateurs, or lovers) had done in Warhol's *Blue Movie* (1969), another of those films that said, look at the moment, look at their skin . . . look at *that!* At the end, Viva stares at the camera and asks, "Is it on?," a question waiting for the future.

Bertolucci had a story about a haunted, middle-aged American in

Paris whose wife has recently killed herself. Then, by chance, the man encounters a young woman in an empty apartment. Almost without a word they couple, urgently and comprehensively, and so for a time they use this apartment as their love nest or brothel. It is their sensual "now," the present tense of film shutting out past or future. They promise to stay in the moment, without exchanging names or histories, so they can have "pure" sex. But the orgy gets out of hand, his past comes in and "love" intervenes (on the part of the man). It all ends badly. We foresaw that because, in our first sight of him (Marlon Brando in a shit-colored overcoat), the man was howling at the air of Paris and the miseries of mankind.

Bertolucci had intended to cast Dominique Sanda as the girl, but she was pregnant. Sanda had been so knowing and fatalistic in *The Conformist* it is hard to imagine *Last Tango* with her. She was twenty-four in 1972, more elegant, more ironic; and Sanda never seemed prepared to be as naked as Maria Schneider agreed to be. Schneider was four years younger and without experience, though she was the illegitimate daughter of the French actor Daniel Gélin (he had been in Ophüls's *La Ronde*). She was baby-faced, voluptuous, and impulsive, and people who knew her said she was not too stable. Of course Marlon Brando would have said he was mixed up, too.

But Brando was as famous as any actor on film. He had had his ups and downs in the 1960s, but no one had forgotten his first films, and public faith had been revived by his skilled rendering of Don Vito Corleone in *The Godfather*. Close to fifty, Brando was so beautiful still that romanticism and sensuality survived in his restless glance. His deal on *Last Tango* was $250,000 against a percentage of the profits. Maria Schneider was getting $4,000. Such disparities are not uncommon in the film business. An agent or a lawyer could say Brando was world-famous, at the top of his art, and on commercial form; the allure for the public of Marlon Brando doing it was beyond compare. (Jean-Louis Trintignant had turned the role down.) Schneider was a beginner, without reputation; she was pretty, and willing in ways thousands of girls might match.

But if you went to see *Last Tango* (and the film had worldwide rentals of $37 million on a budget of $1.25 million, even if it seldom left viewers pleased or satisfied), you could not miss Schneider being naked so much of the time—while Brando kept his clothes on. This was a film about sexual commitment—that was made clear to the players from the start, and it was a boast to the audience. Brando had been hired on the understanding that he would bring his own experience and memories to the

role of Paul. When he went back to the character's past, he was often talking for himself—this was the gist of the Method he had been raised with. But we do not see Brando's penis, and there was still uncertainty in the movie business as to whether that would be permitted. So the girl's erogenous zones are on show, while the man's are withheld, and a secret power is given to them, a withholding that feels unfair now if *Last Tango* really means to be about the orgiastic ideal or about characters who meet on open ground.

In preparation, Bertolucci had told his two players he wanted them to have sex on camera. "Is it on?" In his autobiography, Brando said that he tried:

> I had one of the most embarrassing experiences of my professional career . . . I was supposed to play a scene in the Paris apartment where Paul meets Jeanne and be photographed in the nude frontally, but it was such a cold day that my penis shrank to the size of a peanut. It simply withered. Because of the cold, my body went into full retreat, and the tension, embarrassment and stress made it recede even more. I realized I couldn't play the scene this way, so I paced back and forth around the apartment stark naked, hoping for magic. I've always had a strong belief in the power of mind over matter, so I concentrated on my private parts, trying to will my penis and testicles to grow: I even spoke to them. But my mind failed me. I was humiliated, but not ready to surrender yet. I asked Bernardo to be patient and told the crew that I wasn't giving up. But after an hour I could tell from their faces that they had given up on me. I simply couldn't play the scene that way, so it was cut.

You notice that Schneider, the likeliest encouragement Brando might have had, does not seem to be present or considered. When Bertolucci said, have real sex, Brando demurred because, "it would have completely changed the picture and made our sex organs the focus of the story." Again, there is no evidence that Maria Schneider was asked. Whether the "focus" of the story would have been changed is one question. The other—and this is more important—is whether the thing itself could ever have been believable.

The first coupling, where the characters begin by being fully clothed, is acted—and it is stunning. Their embrace and the camera movement feel affecting. The later scenes become more revealing but less convincing. At one point, with Jeanne naked, Paul turns her over and uses a stick of

butter to aid anal penetration. That is simulated, and deeply disturbing, because Schneider the novice conveys a distress beyond her talent as an actress. There is a sense of invasion, and we wonder, "Why are we watching?" The actress would say later that Brando and Bertolucci came up with the scene on the spur of the moment, so she felt powerless and even raped. To which the movie business customarily has answers like, well, weren't you paid?, and, surely you could have said no?, the ugliness of which is not to be shrugged off.

Why were we watching? Surely there was some expectation in wanting to see the movies and sex good together. Years later an inescapable disquiet glares through. For all the naturalness of Paul's talk from Brando's past and the being "on" of Jeanne's nakedness, there is the unnatural intervention of us watching. You don't really have to think yourself too far into the process of the film to say, well, suppose they were fucking; how would I ever know or trust it?

This realization about sexual desire on-screen being bypassed didn't dawn "suddenly"; the lesson had been sinking in since around 1960, that the more boldly a movie tried to deliver sexual experience, the more surely it exposed its own artifice or falsehood and the more clearly it told us we were in our "there," in the dark, not on the screen, not having sex. The desire was thwarted. The overwhelming promise of the medium was a fleshless seduction. Desire was being manipulated, just as it was in advertisements. The light was a trick to keep the audience in its dark. Enlightenment, liberty—those great dreams were for suckers. A bleak new citizenship was in prospect.

Last Tango seemed a scandalous event in 1972. William F. Buckley called it pornography. In Italy, Bertolucci had his civil rights withdrawn, and the film was banned for fifteen years. In America it was promoted— and Pauline Kael's review was a part of that. But the film has shifted. In 1972, the apartment near the Bir-Hakeim bridge in Paris was a real place, albeit one staged by Scarfiotti and Storaro in a color scheme of flesh tones that felt "right" or suggestive. Now it seems less a set than a metaphor for the screen itself, the displacement that allows them to perform and us to watch—and which permits nothing else. More and more in our movies the prison-like isolation of the screen has invaded the form, the stories, and the experience. What's left isn't exactly life. And we wanted it to be.

Once you've seen through the movies' handling of sex, you may notice the same dilemma affecting many other extreme situations. The dead on film are pretending—they'd better be, because if ever real killing is filmed, the thing called "snuff," then the outrage goes beyond entertainment. But

that possibility is a rumor that never stops. So we peer at the dead bodies on film to see if they're still breathing, still pulsing. Can you read a "dead" face waiting for "Cut!," ready to crack a joke and ease an awkward posture? When people are chopped or chainsawed to pieces, we gaze through the ruin and ask only how it was done.

So what's wrong with simulation and pretending? They are the wellspring of acting, and, for myself, I mistrust the codes or conventions by which actors believe they have become their part or gotten lost in it. It is a vanity that nearly always adds time and money to a schedule. It leads to a "truth" that defies the nature of the medium.

Still, the advance on sexual glory and revelation so touchingly invoked in Kael's words and the reference to *Le Sacre* are a prelude to disappointment. Perhaps the chemistry of fantasy, and the censorship that withheld fulfillment, were essential to the power of cinema. The rapture people felt was contingent on the limits. The removal of censorship was an undermining of the medium (if you want to be solemn) or a natural, helpless progress. It wouldn't have been so grave a consequence if the history of film was not so tied up in the larger history of ourselves. For the great question we face in life is what to do with our desire or identity (the hope that lets us endure reality). Can we sustain these things, or must they turn to ashes? Do we still believe in the pursuit of happiness or has it become an advertiser's trick and a fool's errand?

In his coy way, Brando would say, "*Last Tango in Paris* received a lot of praise, though I always thought it was excessive. Pauline Kael in particular praised it highly, but I think her review revealed more about her than about the movie." By 1972, film critics had become deserving, too. They had a voice and their own desire, and in her way, Kael was as ready to go naked as Maria Schneider. That's why she was so cheerful about Jeanne in the film:

> Maria Schneider's freshness—Jeanne's ingenuous corrupt innocence—gives the film a special radiance. When she lifts her wedding dress to her waist, smiling coquettishly as she exposes her pubic hair, she's in a great film tradition of irresistibly naughty girls. She has a movie face—open to the camera, and yet no more concerned about it than a plant or a kitten.

Kael was so readable. But even in 1972, I think, more anguish or confusion was showing, and being felt in the dark. Maria Schneider died on

February 3, 2011. She was fifty-eight, and hers wasn't a movie face any-more. She had done drugs and had breakdowns and had not made many films—though she is excellent in Antonioni's *The Passenger* (1975). There's no need to make her into a forlorn icon, or another Marilyn, but still, the pattern cannot be denied—it goes from William Holden to Maria Schneider—that being the object of intense, impossible desire can suck your life away. Perhaps it has a similar effect on us in the dark.

•

The test of how to determine what we were seeing was becoming increas-ingly complex, and the alleged process of education was lumbering along behind the serene technological innovations and the unruly cultural de-partures. In most big cities, by the early 1970s, you could see "serious" pictures that involved sex and nudity—films such as *Midnight Cowboy* and *Carnal Knowledge*—where, more or less, the artistic conscience of the works was actually adhering to one old Production Code tenet: that if you were going to show extramarital sex, you had to make clear it was no fun and a lot of anguish. But around the corner, in officially designated red-light districts, you might get Warhol's *Blue Movie* (1969), the Swedish *I Am Curious Yellow* (1967), *Behind the Green Door* (1972), or *Deep Throat* (1972). The overlap of taste and tastelessness was becoming more chal-lenging. And the inherent disorder of experience was forcing its way into our systems of seeing.

In *Pierrot le Fou* (1965) there is a moment when the lost lovers, Ferdi-nand and Marianne, have met again. She takes him back to her place, and it is clear that they have slept together, though Godard does not show us that. But here's what happens the morning after, as she makes a little breakfast for her man:

> Long shot of the other room, Marianne enters from the patio roof and goes and pours the water from one pan into another. She opens the door of a fridge, looking over her shoulder anxiously all the time to the left. The camera pans with her as she moves left, passing a photograph of Tshombe and a Modigliani painting. She bends down at the side of a double bed on the left of the room and, as she takes a breakfast tray from the bed, we see for the first time the body of a man lying face downwards. A pair of scissors is embedded in his neck. His shirt is covered with blood. She picks up the tray, as if the body did not exist.

Then, as Ferdinand eats his breakfast, she sings a love song to him.

In Godard's coolest manner, the adjacencies are never explained, but the film and Godard's whole approach know that the cut has entered into our sensibility in a new way—things are simultaneous but irrational, until we begin to appreciate that the rhythm of experience and the impossible challenge of understanding are embodied in this kind of tranquillized shock cut. *Pierrot le Fou* feels like the audacity of a new artistic vision, but when we watched television, it was also a function of that neglected but radical breakthrough, the remote control (which became generally available in the late 1970s). It wasn't long before a kid on his own sofa could travel through the multiplying range of American TV channels, observing the gravity of Walter Cronkite reporting on some trouble spot and mismatching it with the hollow earnestness of a daytime soap opera, going to third and ten in one more "big game," to Johnny Carson being wry about it all, to an airy ideal kitchen where a pretty housewife with a great hairdo and porno eyes was offering a Butterball turkey, to floodwater lapping in Arkansas, to some strange studio fabrication where another Butterball turkey might fall at the feet of a man looking like Richard M. Nixon, who looked up and said, "Sock it to *Me!*" while a daffy blonde in a bikini and bodypaint shimmied past him.

At first television had been hard to see; then we stopped bothering, and treated it as radio with pictures. The awesome power of the imagery of movies, the way it monopolized us, was traded away. Did we prefer to relax? And yet I remember and treasure certain television programs, and here I cannot extinguish the experience of being British until 1975.

Many of the attitudes in BBC broadcasting were still paternalistic. But just because the system was saying "these things are good for you" didn't always preclude their benefits. So I recall four "educational" series that had profound effects: *Civilisation*, "a personal view" by the art historian Kenneth Clark (1969); *America* (1972), "a personal history" by Alistair Cooke; *The Ascent of Man* (1973), yet another "personal view," by Jacob Bronowski; and *The World at War*, produced by Jeremy Isaacs (1973–74)— and done on ITV, the commercial television channel. Still, in a concession to taste, the episode that dealt with the concentration camps was not interrupted by commercials.

The BBC series (sometimes with Time-Life as a publishing partner) stressed the personal touch but came loaded with authority. All three shows had an on-camera host or professor, and those three men were immaculate performers, even if Clark might have been created by Trollope,

Cooke by Scott Fitzgerald, and Bronowski by Primo Levi. The series were expensive productions that won high viewing figures and led to best-selling books. They were filmed with an absolute confidence in the documentary process and an approach to it that belonged to the 1930s: look at this, it's the real thing and it's amazing, whether it's a painting by Titian, the Hoover Dam, or the soil at Auschwitz. But it worked, and the "personal view" was eclipsed by the epic scale and institutional thrust of the programming. Moreover, this was a documentary confidence and a television showmanship that did not seem to exist in America, though the series all played well in the United States.

The BBC soon fell upon the idea of the nation's classic or semiclassic literature. A series of novels by John Galsworthy was adapted by producer Donald Wilson into a twenty-six-part series that played in 1967 as *The Forsyte Saga*. In fact, the story had made a dull 1949 movie, *That Forsyte Woman*, with Greer Garson and Errol Flynn. The material was novelettish, but the BBC produced it with meticulous period detail, accomplished acting (Eric Porter was a notable Soames), and the same confidence that had inspired the educational series. By the last episode, the British audience was eighteen million (over a third of the nation). In turn, the series was shown in America on the new Public Broadcasting System, started in 1967, and that would lead to a years-long parade, Masterpiece Theatre (launched in 1971), introduced on camera by Alistair Cooke in a comfortable library/salon set. You can always trust a masterpiece.

All of this may make Britain of the late 1960s seem a staid and settled country. The truth was more complicated. British television had created a live Saturday night show (hosted by the newcomer David Frost), *That Was the Week That Was* (1962), which provided a satirical look at the news, and found a surprisingly large audience at the end of Saturday evenings. The drama format that still regarded its material as "plays" presented *Cathy Come Home* (1966), a story about working-class people thrown out of their home and at risk of losing their child. This was written by Jeremy Sandford, directed by Ken Loach, and produced by Tony Garnett, and its neorealist treatment of unhappy lives in Britain got an audience of twelve million (playing right after the news and, in some eyes, deliberately confusing fact and fiction). It was not as "nice" or as well furnished as *The Forsyte Saga*, but people watched and seemed to be troubled by the point of it all.

There was a wide range of comedy on British television—Tony Hancock, Morecambe and Wise, Benny Hill, and then, in 1969, the BBC

gave a modest go-ahead to a show that ended up being called *Monty Python's Flying Circus*. It was surreal, elitist, essentially made out of university talent and writing; it was startlingly amateur and irreverent; but it ran four years, and still plays all over American cable television. Moreover, it was a show permitted to hijack the BBC's standard logo of the day—a revolving globe used to separate different programs—to convey the delightful threat that the whole of the BBC, the whole medium, might be taken over by this dementia.

So, at that time, there was never any question about the chance for "quality" work on British television, or educational value. The careers of the writer Dennis Potter and, filmmakers Alan Clarke, Stephen Frears, and Tony Palmer were in many respects television achievements. Moreover, British television regularly flirted with programs that might be banned, such as Peter Watkins's 1965 film on a world after nuclear war, *The War Game*. The young Ken Russell was doing his best work in a series of dramatized portraits of artists: these included films on Elgar, Debussy (with Oliver Reed playing the composer), and Delius. More than that, the BBC had the apparatus and the will—most notably in a live show called *Late Night Line-Up* (begun in 1964)—to examine itself. As the last show at night, it could run for as long as the talk was worth it—sometimes longer.

I don't mean to call American television a wasteland. *Rowan & Martin's Laugh-In* (1967–73) was a Hollywood equivalent of *Monty Python*—fragmented, impulsive, satirical, and based on the inherent craziness of TV's vulnerability to self-interruption. There had always been comics of high daring—Sid Caesar, Ernie Kovacs, Jackie Gleason, the Smothers Brothers (canceled by CBS because their satire was too "dangerous"). There were sit-coms such as *All in the Family* (actually derived from a British series), and shows that commanded great affection and delivered the same amount of reassurance: the Dick Van Dyke and Mary Tyler Moore shows, *The Waltons*, *The Rockford Files* . . . Shows without end that worked off comfortable star personalities—such as James Garner, who had never quite made it in the movies (Garner's all-time coup may still be the Polaroid commercials he did with Mariette Hartley)—and that reiterated standards of personal and public morality stale for decades but likely to facilitate the digestion of the advertising funding the show.

There was very little documentary, next to no open-ended talk, and hardly any purpose-made drama after the first wave of live productions in the 1950s. Instead, there was a remorseless supply of series fiction (sit-coms, Westerns, crime stories) that usually came out of television studios

in the Los Angeles area, where different genres actually followed the same rutted narrative tracks. There were some interesting talk shows: *The Tonight Show* had smart guests who were sometimes given a chance to talk, and there was the opportunity of beholding or being with Johnny Carson. There was also Dick Cavett, bright enough to appreciate rare talent and let it talk; he once had Jed Harris on for five nights in a row (but maybe you don't know now who Harris was).

There are at least two other American television events of the highest order. One is the steady newscast coverage of the war in Vietnam, with color from 1965 onward—which meant red blood. At that stage, the government was still too innocent to restrict or "embed" journalistic coverage of the war. Cameras might go wherever their operators were brave enough to be, and the networks took on the challenge of the coverage. It was regarded as a turning point when Walter Cronkite (the CBS anchor) declared in 1968 that he feared the war was unwinnable. Liberals would later argue that the TV coverage helped take away confidence in the war—helped end it, even. The proof is elusive. Another reading is available: that a steady viewing of slaughter may habituate or numb the viewer. For if television seldom seems "beautiful" (in the way of movies), can it ever get ugly? If it's always "on," doesn't that encourage the thought that its material is not quite our concern? Does the mass really want to make trouble? Or does its unease explain the media diet of reassurance? It's easier to worry about body odor than world hunger.

On the other hand, the prolonged and often tedious TV coverage of the various Watergate hearings seemed compulsory viewing. There had never been anything like it before, and it was a tempting mix of the news and a courtroom drama. (In other words, did it risk becoming a show, as opposed to a real event with consequences and responsibilities?) Nearly forty years later, can we credit American television as an ongoing education on "the news" in which the public's critical faculty has been honed?

In fact, by the late 1970s, many enlightened and responsible writers were troubled by television, and most of them were the parents of children who might be spending five to seven hours a day with the small screen. One of the most striking expressions of anxiety was Jerry Mander's book *Four Arguments for the Elimination of Television* (published in 1977)—it was much to the point that Mander came from the advertising business. But as a man of the TV age, informed by brainwave research on how television was a passive experience while reading was active, Mander headlined his arguments. Here they are:

1. As humans have moved into totally artificial environments, our direct contact with and knowledge of the planet has been snapped. Disconnected, like astronauts floating in space, we cannot know up from down or truth from fiction. Conditions are appropriate for the implantation of arbitrary realities. Television is one recent example of this, a serious one, since it greatly accelerates the problem.

2. It is no accident that television has been dominated by a handful of corporate powers. Neither is it accidental that television has been used to re-create human beings into a new form that matches the artificial, commercial environment. A conspiracy of technological and economic factors made this inevitable and continue to.

3. Television technology produces neuro-physiological responses in the people who watch it. It may create illness, it certainly produces confusion and submission to external imagery. Taken together, the effects amount to conditioning for autocratic control.

4. Along with the venality of its controllers, the technology of television predetermines the boundaries of its content. Some information can be conveyed completely, some partially, some not at all. The most effective telecommunications are the gross, simplified linear messages and programs which conveniently fit the purposes of the medium's commercial controllers. Television's highest potential is advertising. This cannot be changed. The bias is inherent in the technology.

Mander's book may be as rarely retrieved now as the name Jed Harris (the most famous American stage director of the 1920s and '30s, and a phenomenal bastard). But it's hard to read his warnings without an extra chill sinking in as we project his concerns forward to the age of the Internet. The only thing that seems dated or nostalgic—I hope I'm being ironic instead of tragic—is his note of distress. (We have had to learn Godard's cool: if there's a bloody corpse in the room next to where our lover is waiting for breakfast, try not to notice it.)

A couple of years after Mander's book, while teaching at Dartmouth, I sought to introduce a course called An Introduction to Television. If approved, it would be the first course at the school to consider that medium. This required describing the course to the Committee on Instruction.

One member of that committee was Leonard Reiser, the provost at Dartmouth and a man who had been part of the Manhattan Project when younger. He heard my case and noted that I had said that television for some of our students was the central experience of their lives. In fact, I had suggested that while Dartmouth taught spelling, grammar, logic, and writing, it offered nothing that taught students to examine the experience of television or its ways of finessing "reality." (I could have pointed out that Dartmouth's neglect had already educated Pat Weaver, inventor of the *Today* and *Tonight* shows, and Grant Tinker, the head of Mary Tyler Moore Productions.) I didn't say what I believed: that this instruction should have begun when the kids were five.

But surely, asked Reiser, aren't nuclear weapons the most profound shadow hanging over our students? I never want to minimize the Bomb, but I replied that while "it" was undoubtedly up there, out there, a threat and a shadow, the television was "on" six hours a day. It was a moment when I realized what could have been grasped earlier: While the movies might be great or satisfying, they were no longer what the world was really looking at. We were looking at screens.

•

So, in 1967, on television we were still turning on for *Bonanza, The Red Skelton Hour, The Andy Griffith Show, The Lucy Show* (minus Desi now), *The Jackie Gleason Show, Green Acres, Daktari, Bewitched, The Beverly Hillbillies*—were we living in a rest home? Or a place trying to ignore the actual tumult of the United States?

Or you could go see *Bonnie and Clyde* and feel the blaze, the ringing gunfire, and the thrill of the big screen. This was a picture from Warner Bros., who once had owned gangster movies—but with this one the studio was at a loss, and doubly perplexed when it turned into a hit. The violence, the talk, the cars and the motor courts, the music, the blood, and the lipstick—all looked spiffily American. For Texas, they went on location to Texas. But it was a picture with French blood in its veins, too. Seen from this vantage it looks like an inspired throwback as well as the start of a new age.

Robert Benton and David Newman were on the staff at *Esquire* under the editorship of Harold Hayes. In 1963 they saw Truffaut's *Jules and Jim* in New York and felt that it deepened their excitement over *Les Quatre Cents Coups* and *Tirez sur le Pianiste*. There really was a stylistic urgency and a respect for behavioral daring in French films that put American

cinema to shame in the somnolent season of *Cleopatra, How the West Was Won*, and *It's a Mad, Mad, Mad, Mad World*. So it occurred to them to write an American script, one they might even offer to Truffaut. Benton recalled Clyde Barrow and Bonnie Parker, Texas outlaws of the early 1930s. His father had been to their funeral, and the son had grown up in Waxahachie, Texas, hearing stories of their exploits. The two men didn't know how to write (or type) a script, so it ended up more like a treatment or a novella: "We described a scene, including camera shots . . . but we didn't put dialogue in . . . The next day we would talk about the scene, and say, no, that's all wrong, and if David had written it, I would take it home and rewrite it, and if I had written it, David would redo it." They loved the freedom and speed of it all, and they told themselves that most American pictures were being planned to death.

Elinor Jones and her brother Norton Wright, friends of Benton, took the project on as producers and sent the text to Truffaut. His English wasn't good enough to read it himself, but Helen Scott and a few others told him it was exciting. Truffaut was close to taking it on. He thought of Jane Fonda to play Bonnie. But at the same time he was considering making *Fahrenheit 451* (from the Ray Bradbury story) and he was visited by Leslie Caron, who was then in an affair with Warren Beatty, who was hopeful about the lead role in *Fahrenheit*. The three of them met, and when Truffaut praised the *Bonnie and Clyde* script, Beatty resolved to get a look at it. He flew to New York and met Benton. Meanwhile, Truffaut had also shown the script to Jean-Luc Godard, who said he would love to do it. This musical chairs happens on nearly every film, enough to persuade everyone that casting is a helpless gamble—so keep changing your mind until you can't any longer, and then you shoot a piece of film and it may last forever.

Jones and Wright wanted Truffaut to accept a movie star for Clyde. Paul Newman? No. Warren Beatty? "Actually," Truffaut wrote to Jones, "I have no admiration for Warren Beatty and, moreover, he seems to me an extremely unpleasant person." As if to demonstrate a point, Beatty waited for the Jones-Wright option to lapse, bought the script from Benton and Newman for $75,000, and announced he was going to produce it himself. The two writers were swept along like corks on a stream. Truffaut went to England to shoot *Fahrenheit 451*, with Oskar Werner in the part that had tempted Beatty.

Beatty was only thirty in 1967, the year his film opened. He had had a fine debut in Kazan's *Splendor in the Grass* (1961). He became notorious

for his love affairs and his aloof intelligence act, and he took it as his duty to be difficult. Two of his films were uncommon ventures, *Lilith* (1964, with Jean Seberg) and *Mickey One* (1965), both failures and distressing to him because of that, but indicators of a taste for risky material. Moreover, on *Mickey One* he had been directed by Arthur Penn, raised in television and the theater, who had won praise and Oscars with the movie of *The Miracle Worker* (1962). The two men got on, which was a measure of sympathy and of Beatty's guess that he could handle Penn. In fact, Penn had had an early look at the Benton-Newman script and turned it down. Now he was hired to direct it for his one-time actor. And if Penn was to make something of *Bonnie and Clyde* that was personal (and he was that kind of director), he knew he had to let the young actor feel in charge. So musical chairs turns into poker, and then moviemaking becomes more tiring than answering a hundred questions every hour, staying on your feet while looking beautiful.

Beatty was patronized and disdained by Warner Bros., the studio he had gone to with the project. This was a very old guard. (Jack Warner was still active, but he was seventy-five by 1967.) The cameraman on the picture, Burnett Guffey, was sixty-two, though he had shot *All the King's Men* (1949) and *From Here to Eternity* (1953). He soon concluded that Penn and Beatty were modernist upstarts who didn't know how to shoot a picture the proper way. Benton and Newman were the scriptwriters of record, home in New York, but they heard that Beatty had taken a friend and script doctor, Robert Towne, to Texas on location with him, and Towne was rewriting every night at Beatty's instruction. So the sexual triangle they had intended, with Bonnie, Clyde, and C. W. Moss as a threesome, proved too problematic—C.W. was tossed out of the bed, and Warren had the girl to himself.

On the other hand, Beatty had approved Michael J. Pollard as C.W., just the kind of unpredictable actor who worried Warners. He had cast Faye Dunaway as Bonnie (after Tuesday Weld turned it down), and in addition he had Gene Hackman, Estelle Parsons, all the way to Gene Wilder and Evans Evans, both indelible as the bourgeois couple picked up by the gang. And then there was Penn's direction. The gentlest of men in person, Penn had an unexpected instinct for violence: few scenes in American film are more revealing of physical and emotional combat than the one in *The Miracle Worker* where Annie Sullivan gets Helen Keller to fold her napkin while the room is reduced to wreckage. *Bonnie and Clyde* would disturb people, not just for its killings, but because of the rapidity

with which such assaults were bumped into humor on jaunty music. The first urge to get something fit for Truffaut was surviving in the shifts of tone.

It was a battle: the production designer, Dean Tavoularis (on his first big job), was arguing with Burnett Guffey. Penn and Beatty began most days with a half-hour dispute; it was called "artistic fighting" by observers. And Estelle Parsons would comment later on Faye Dunaway:

> Nobody was too keen on Faye. We were all kind of annoyed with her. We'd be ready to do a shot, and Faye would need the makeup woman. We'd all be set to roll, and oops, Faye would have to have her hair combed. There was a lot of that. We'd go in early to get made up, five or six in the morning, and she'd be there with rock and roll blasting. Listen, that was the way she kept herself going. She's got a temperament, but I love her, and I understand the way she is. Don't get me started on being a woman in a situation like that.

For good reason: Faye Dunaway looked like a movie star, while Bonnie Parker had a face like raw wood shaped with a hatchet (there are photographs). In an early scene in the film, Beatty's Clyde sits down with Dunaway's Bonnie and, like a producer, redoes her hair. It's such a cute lift for Bonnie, why wouldn't Faye fuss over her hair throughout the shoot? *Bonnie and Clyde* is a gangster film of the early 1930s and a movie about young liberation and sexual self-discovery to stir 1967. In addition, it dramatizes the quest for fulfillment that possessed Beatty and Dunaway on the project. This was their breakthrough, and that's how the emotional climax of the story comes, when Bonnie writes the poem about them and Clyde says, "You know what you done? You told my story!" Isn't that what we have always wanted?

But the sweetest thing of all—and it affects so many fine films over the years—is that this aura of discovery is available for the audience, too. It is us grabbing at some light for ourselves. So the film hangs on the marriage between Penn's eager eye for human animalism, Guffey's alertness to light, and editor Dede Allen's rescuing of brief flashes of life, looks, and reactions—especially in Dunaway and Beatty. This gang kills people, but how they yearn for life in scenes where they are wounded. It is a film of desperate glances, like the loving exchange when the two outlaws seize a last sight of each other before the comprehensive fusillade. That execution is the orgasm they (and we) have been longing for. No matter that the

bodies are clothed and untouching, it may be the key erotic scene of the 1960s (brilliantly edited by Dede Allen and rendered in several different time speeds by Arthur Penn).

In 1967 this was one of the most devastating but complete endings to an American picture, and an unprecedented fusion of sex and violence. For the young audience, there was hardly a more desirable commodity; it surpassed the chic of Bonnie's clothes or the satisfaction felt by Warren Beatty at bringing the picture in. The outlaws were removed (as killers had to be), but their fame and being recognized were the point of the film—and the cause of grief to come as its battle carried on in the critical reaction. The film's selling line would be "They're young . . . They're in love . . . And they kill people."

Beatty's job was far from over. The cutting of the movie had been kept in Manhattan, to avoid Warner's interference and to stop the studio from witnessing the prevailing artistic fights. But one executive had seen enough to send warning messages back to Burbank. The studio threatened to cut off funds as the editing extended: the costs climbed to $2.5 million. When Beatty and Penn at last reached Los Angeles they were required to show the film to Jack Warner himself, in his private screening room, that symbolic lair of old authority.

"If I have to get up and pee," said Warner, "I'll know it's a lousy movie." As Arthur Penn would say later, with the boss on his bathroom trot, it felt like "the most diuretic film in human memory." The mood was so bad that Beatty offered to buy the picture back—this was a bluff, for he lacked the funds for repurchase. Then fate intervened: the Six-Day War broke out in June in the Middle East and Jack Warner was emotionally energized by the Israeli success. Gambling is a matter of mood and impulse: so the picture would open, on August 13, 1967.

In the *New York Times*, Bosley Crowther began what became a campaign against *Bonnie and Clyde*. He called it "a cheap piece of bald-faced slapstick comedy that treats the hideous depredations of that sleazy, moronic pair as though they were as full of fun and frolic as the jazz-age cut-ups in *Thoroughly Modern Millie*." Crowther was sixty-two and he had been at the *Times* over twenty-five years. He was also increasingly distressed by the violence in movies: "The film critic," he said, "is performing a function akin to a pastor—he is a counselor of a community about the values of a picture." A lot of educated people were scared in the 1960s.

In *Newsweek*, Joe Morgenstern was half-impressed but half-troubled: it's "a squalid shoot-'em-up for the moron trade," he wrote. But he felt

uneasy. So he asked his wife, the actress Piper Laurie, if she'd care to see the film in a theater. What they found—and this is a lesson for us all—was that the movie that had seemed squalid and rowdy in a sedate screening room had a packed house excited. So Morgenstern tried another, friendlier review—second thoughts from a film critic?

That's when Pauline Kael jumped in, with Bonnie Parker's flourish. She had planned a long essay for *The New Republic*. When they turned it down, Kael went to *The New Yorker* (where she had appeared just once before). This was her own career being built, and why should that not help her love the film more? She identified with the kids and with Beatty! (Ten years later, in a wild misstep, she would go to work for him in Los Angeles.) She did a seven-thousand-word piece (revolutionary in its length) and she uttered a sweeping cry such as we heard in the *Last Tango* review. She was at the cultural barricade, going over the top:

"*Bonnie and Clyde* brings into the almost frighteningly public world of movies things that people have been feeling and saying and writing about . . . *Bonnie and Clyde* needs violence; violence is its meaning."

At *Time*, Stefan Kanfer overthrew the magazine's first dismal notice and supplied a rave for which editors ordered up a cover collage by Robert Rauschenberg. By the end of the year, *Bonnie and Clyde* was not just a rerelease hit but a cultural talking point.

Over forty years later the violence in *Bonnie and Clyde* may prompt nostalgia. The picture is farther away now than the Barrow gang was in 1967. But in its moment, it split age groups and attitudes to the cinema. Kael was on the mark in divining the passionate involvement some people felt for the characters and the film's effrontery in a time when public danger seemed out of control. Antiwar marches were on television news, including clashes with police. One outrage in *Bonnie and Clyde* was its contempt for those nasty Texas Rangers. When Bonnie kissed Ranger Frank Hamer, on or in the mouth, he spat in her face—it was an iconographic incident for the 1960s, separating those who wanted satisfaction from those embarrassed at its prospect.

"You know what you done? You told my story!" Clyde's epiphany was infinite and embracing: a deft glamorization of the 1930s had caught a current longing in America. This dream may have been fanciful, yet no sillier and no less potent than what *Casablanca* had meant in 1942–43. Beatty became a role model for a changing industry. The film clawed its way back into the light, after being withdrawn by Warners in early October. It would end up with rental income to Warner Bros. of $22 million.

Pauline Kael was established at *The New Yorker*, not that that eased her insecurity. And the film can be regarded now as a halcyon moment, when American movies mattered.

Who did it? Benton and Newman saw the opening, and Beatty insisted on its happening. He came out of his shell as an actor (he was usually too guarded and smart to give that much of himself). Dunaway was uncannily present—but was she ever there again? Arthur Penn deserves credit for that as much as for Estelle Parsons's wailing discord and Michael Pollard's sleepy-boy mumbling. The music and the clothes became marketable. Careers were launched for Benton and Newman, Gene Hackman, and several others.

But it was the audience that made the picture and would not abide by Bosley Crowther's counsel. The critic was replaced at the *Times* in 1968—not that he was simply wrong. (Renata Adler held the job for a year, and then Vincent Canby took over.) Jack Warner had sold his interest in the family company to Seven Arts. It was a heady moment, though the long-term consequences of liberated violence would one day spill beyond control. Of course, 1967 was also the year of *The Graduate* (a cool, ironic show over which many lost kids identified with Dustin Hoffman and allowed the deadpan first two thirds to dissolve into a daft escapist ending). But *In the Heat of the Night* won Best Picture, with racial liberalism and narrative predictability. That was a "statement" film the Academy could congratulate itself on.

Bonnie and Clyde was nominated for ten Oscars, but it won only for Estelle Parsons and for Burnett Guffey's photography. In the Best Actress category, Katharine Hepburn in *Guess Who's Coming to Dinner?* beat out Faye Dunaway's Bonnie—which one would you take home to meet your parents? But which one wrote the poem in your dreams? The past has always lingered at the Academy. Dede Allen was not even nominated for the editing. The old guard of Hollywood was in shock from the alarming rhythms she'd put in the film, but America knew the pacing already from television's montage.

A Hollywood window opened as many moguls took their big sleep. The owners and the new corporations in American pictures were less likely to grasp the power and the knack of making movies that made an audience say, "You told my story!" Instead of taking the public's money and hearing their reactions afterward, the new leaders had been to law school and business school. They would treat pictures as actuarial case studies. A sensation was at risk of being organized. So in history, we have

to see how this pivotal moment called *Bonnie and Clyde* had glimpsed the exit sign as well as the modern orgy.

•

Critics and commentators on film who came into their own in the years from 1967 to 1976 (roughly from *Bonnie and Clyde* to *Taxi Driver*) often refer to the period as a "silver age." That is meant to balance the golden age, which is more or less from sound until the end of the war. But in American film studies, any attribution of an "age," with the promise of shared attitudes or consistency, is loaded with danger. Yes, it's true that the brief span of time saw the arrival of a band of new filmmakers, many of whom were at least wary friends. (Film is always a competition.) It would include Bob Rafelson, Robert Altman, Martin Scorsese, Alan Pakula, Sam Peckinpah, Francis Ford Coppola, Steven Spielberg, Brian De Palma, Hal Ashby, George Lucas, Dennis Hopper and Peter Fonda, Peter Bogdanovich, William Friedkin, and tangential or visiting figures such as Roman Polanski, Bernardo Bertolucci, John Schlesinger, John Boorman, Milos Forman, Bob Fosse, John Cassavetes, and that recurring American in Hertfordshire, Stanley Kubrick.

You don't have to like all the silver age films, but the grouping that follows is such a departure from pictures of the early 1960s. It is marked by a concern with current realities, with bleak endings and a mounting unease over the state of America. It is a new attitude toward movie entertainment, more challenging, less universal. Still, several of these films made serious money: *Easy Rider* (1969), *Five Easy Pieces* (1970), *The Last Picture Show* (1971), *The Long Goodbye* (1973), *The Wild Bunch* (1969), *Mean Streets* (1973), *A Woman Under the Influence* (1974), *Klute* (1971), *Chinatown* (1974), *Jaws* (1975), *One Flew Over the Cuckoo's Nest* (1975), and the most intricate and ambivalent of them all, *The Godfather* (1972).

At first, it seems enticing to view that group as the result of youngish, robust talents (many of whom had been to film school or some equivalent) stepping into the wreckage of the studio system and taking power for themselves in a way that meant looking at their world "for real" and seeing it accurately. It was something to be excited about. Alas, in time it led to the reassertion of business reorganization in American film—and for the worse. Moreover, it coincided with technological developments—the culture of special effects and the onset of video—that few could foresee or control. In addition, the "silver age" also had its share of films that had nothing to do with reality and every sign of playing the old game of re-

assurance that a mass medium took as its duty: *Doctor Dolittle* (1967), *Guess Who's Coming to Dinner?* (1967), *The Lion in Winter* (1968), *Oliver!* (1968), *Butch Cassidy and the Sundance Kid* (1969), *Airport* (1970), *Love Story* (1970), *Patton* (1970), *The Sting* (1973), *The Towering Inferno* (1974), *Rocky* (1976), and even *Jaws*.

Yes, *Jaws* is on both lists, and a sign of how tricky it is to read trends. Everyone agreed that *Jaws* was a very frightening film, but the source of its fear was a ridiculous rubber toy and a concocted threat. As a rule, that's how Hollywood handled fear directly. It was rare for a movie, like *Psycho*, to offer lurid "horror" as a mask for the inner dread of loneliness, or like *Chinatown*, which used a murder mystery and a nasty case of incest to highlight the way Los Angeles had always been a show run by the bosses. Sharks and scandalous incest can be games for the huddled masses that may divert their attention from political and economic failure, from racism and unnecessary wars. Combat war games sometimes serve to make us bored with the real thing. Worrying films often give us the wrong thing to worry about. Thus, the lasting question in *The Godfather*, both parts, was whether we ended up loathing the Corleones or wanting to be part of their protective family. It was said, fairly enough, that Michael Corleone, the most fascinating character of the silver age, carried a hint of Nixon. But was the film liberal or conservative?

When it came to the second part of *The Godfather*, in 1974, Coppola offered a thank-you, from a movie kid to a one-time patron. He gave Roger Corman a small part in the picture.

•

Born in 1926, Corman was educated at Stanford and Oxford. But he was a messenger boy at Fox in the late 1940s, and he couldn't forget the thrill. So he went back to Hollywood and started to direct low-budget action movies—Westerns, horror, rock music, bikers, gangsters. He worked fast, cheap, with Hollywood stars on the slide, good technicians, and the new breed of film students to help out for next to nothing and the chance to see a picture being made. His movies had titles such as *Swamp Women* (1956), *Gunslinger* (1956), *It Conquered the World* (1956), *Attack of the Crab Monsters* (1957), *Machine-Gun Kelly* (1958; that was early Charles Bronson), *A Bucket of Blood* (1959), *House of Usher* (1960; that was Vincent Price in Edgar Allan Poe, the closest Corman came to respectability).

Along the way, if he trusted a novice, he would let him make a picture if it was very, very inexpensive. The unofficial "school" he presided over

had an impressive group of students: Irvin Kershner made *Stakeout on Dope Street* (1958), Monte Hellman did *Beast from Haunted Cave* (1959), Coppola directed *Dementia 13* (1963), Peter Bogdanovich's debut was *Targets* (1968), and Martin Scorsese made *Boxcar Bertha* (1972).

If you wanted to see one of those now, it would have to be *Targets*. Bogdanovich was not a film-school kid, but he had trained as an actor with Stella Adler and worked in the theater while making himself a film buff in the French style. He got to know filmmakers (and he learned to imitate their talk as a way of hoping to become them) by writing about them and mounting retrospective surveys of their work in New York in the early 1960s. *Targets* was an odd mixture of Corman quickie and film scholarship. The producer gave him some sets, $130,000 for a budget, and a few days of Boris Karloff's time; the veteran actor had been doing horror pictures for Corman. So Bogdanovich and Samuel Fuller threw a script together in which a young director—Bogdanovich took that part himself—is working with an aging horror star, Byron Orlok, and their story intersects that of an apparently ordinary young man who goes on a shooting rampage.

This figure was based on Charles Whitman, who had climbed a tower on the campus of the University of Texas at Austin in 1966 and killed sixteen people with his rifle and telescopic sight—he sees the people before he shoots. But in *Targets*, the tower was replaced by the screen of a drive-in theater, with the killer shooting through it at audience members as the real Orlok advanced on a screen playing his own image. (The same movie included a quote from Howard Hawks's *The Criminal Code*, from 1931—because Karloff had been so menacing in that film.)

Targets' sketch of real-life outrages provoking guilt in moviemakers was ahead of its time, and the use of the screen as a site of action was witty and very well filmed. It's a B picture and a reminder of how inventive that subgenre could be. In addition, it suggests that in the Corman era, Bogdanovich was the most sophisticated of the kids. Of course, *Targets* was the same year as *Bonnie and Clyde* and a more foreboding assessment of gun violence than Beatty or Penn managed. The young shootist was not explained, but the empty blandness of his life and his Marine service in Vietnam seemed to have pushed him over an edge. When that character murders his own wife and mother, something beyond routine movie horror was being glimpsed. There was a disconcerting balance between the telescopic sight and the drive-in screen in the composition of his detachment from self or society.

Bogdanovich's next picture was *The Last Picture Show* (1971). It had another Hawks quote (from *Red River*, the last film playing in the movie house of a windswept Texas town). It came from a novel by Larry Mc-Murtry and was shot in heartfelt, gritty black and white. For its cast it gathered relative veterans, Ben Johnson and Cloris Leachman (they both won supporting Oscars), and newcomers—Jeff Bridges, Timothy Bottoms, Cybill Shepherd, Randy Quaid. There's a French mood to this Texas, but it's more Renoir than Godard, and it has sadness and respect for its people. It's the first of a remarkable trio from Bogdanovich—followed by *What's Up, Doc?* (1972) and *Paper Moon* (1973)—that suggested the Hawks quotes were not just for show. Bogdanovich had a versatility and an assurance that reminded you of the classic director from thirty years earlier. For a moment it seemed that the new kids might be like their heroes.

The Last Picture Show was a BBS film. This was a company—B for Bob Rafelson, B for Bert Schneider, S for Steve Blauner—that flourished in the early 1970s and that was set up after it had seized on *Easy Rider* when Roger Corman let the maverick escape. He had said he would do the Terry Southern script, though he was a little suspicious of Dennis Hopper as its director. Then a partner, Samuel Arkoff, winced at the thought of the heroes selling deadly drugs. In the hiatus, Jack Nicholson told his friend Bob Rafelson about the project. Rafelson was directing *Head* (1968) for Raybert Productions—it was BB before S came along—and he took the *Easy Rider* idea to "Bert," Bert Schneider, who asked how much money it needed. "$350,000," was the reply, and a deal was done.

That farrago of drugs, motorbikes, music, sex, and the road had been one of the most successful films of the age (a world gross of $60 million), and it started a line of pictures from BBS, made for just $1 million each, to deal with an authentic America, using new actors. Their debut picture was *Five Easy Pieces* (1970) and it featured Jack Nicholson, who had got the role of the disaffected lawyer in *Easy Rider* only when Bruce Dern refused and his first substitute, Rip Torn, turned difficult.

Taken from a script by Carole Eastman, *Five Easy Pieces* was another version of the double-man story, itself a model of the ordinary fellow getting up in the light of the screen: Bobby Dupea (Nicholson) seems like a rowdy, redneck oil-rigger in Bakersfield; but he's also the talented escapee from a musical family living up in the Pacific Northwest. The film goes from one location to another, and it reveals that Bobby is emotionally dysfunctional to such an extent that when life gets too much for him he

dumps his girl and his jacket and hitches a ride to Alaska at the end of the film.

Nicholson and Rafelson were old buddies. They had met at a Los Angeles film society and written *Head* together, using the actor Harry Dean Stanton's apartment when he was working and they had nowhere else to go. Nicholson had been in L.A. nearly ten years, doing whatever he could (often for Corman), but not making much impression. That he began to become a national favorite around 1970 is akin to the way perceptions of Bogart shifted in the early 1940s. The audience, the filmmakers, and even the actor himself found the deadpan sarcasm of an existential outsider who just can't make it.

Nicholson was the common man, working class even, and that guy hadn't been on-screen since Cagney in the 1930s. (Both men had Irish roots.) He's not quite a tragic victim, because much of his loss is his own fault, but Nicholson's screen character—and it reaches from *Five Easy Pieces* through Jake Gittes in *Chinatown* to Randall McMurphy in *One Flew Over the Cuckoo's Nest*—is that of a restless loner who becomes a fall guy. That made him more than Bogart in his successes of the 1940s. Jack was a failure, and we knew it. By implication, the most interesting American men might be failures, too. No one had admitted that in movies before, or possessed Jack's wry, snarly humor. "Does it hurt?" he is asked in *Chinatown* (its script by Robert Towne) when his nose is slit (the work of a slim thug played by his director, Roman Polanski). "Only when I breathe," replies Gittes, and there was a new fatalism. But his cool air of defeat made Jack famous and very rich—his points deal on *Batman* (1989) earned him $60 million.

Five Easy Pieces took in a lot of money and it was nominated for Best Picture. It was released through Columbia, because BBS had family contacts there, but it was a picture made the way Rafelson wanted. It was followed by not just *The Last Picture Show*, a second success, but *The King of Marvin Gardens* (1972, with Nicholson and Bruce Dern as brothers, depressive and manic) and some other films that did less well. BBS lasted only a few years, because the partners got bored and wanted to move on to other things. Rafelson has admitted he got out of BBS when it was his turn to collect the rents in the building the company owned—he dropped out the way Bobby Dupea had done in his own film. BBS hardly noticed its own significance as a production model, because the initials wanted to make movies and live better. It's sentimental to believe the movie brats, as they were sometimes called, had anything but their own

interests at heart. And those interests were the usual ones in pictures: money, girls, and a better life. The urge to imitate Howard Hawks worked in so many ways.

•

Robert Altman was more persistent, and difficult, but he was never quite a movie brat, even if *M.A.S.H.*, the biggest hit he would ever enjoy, is a 1970 film. Altman was from Kansas City (born in 1925). He fought in the Pacific war and had a long training in the Midwest making industrial films before moving into television. He was in his forties by the time he got to *M.A.S.H.*, fourteen years older than Bogdanovich, and never a clubbable man. But Altman had a similar urge to address the old Hawksian models. That drew him to *The Long Goodbye* (1973), a new version of Raymond Chandler's world (scripted by Leigh Brackett, who had worked on the original *The Big Sleep* in 1946).

But this was now the Los Angeles of the early 1970s, filmed in wide screen with an easygoing zoom photography by Vilmos Zsigmond, and a total reappraisal of Chandler's Philip Marlowe. The knowingness and the biting wit of Bogart's private eye was replaced by Elliott Gould, untidy, hapless, perhaps a little druggy, a sucker most of the time, talking to himself, and a man who has a neurotic cat but no girl. Hawks's fantasy had been immaculate and irresistible, but Altman saw Marlowe as a dreamy loser, falling behind the money race of L.A., inclined to trust the wrong people, but ever amiable. His single comfort in the film is the fond, mocking way the song "The Long Goodbye" (written by John Williams, lyrics by Johnny Mercer) is the only score to the picture, a refrain that keeps coming back in so many different styles and versions.

But *The Long Goodbye* opens and closes with the old standard "Hooray for Hollywood," and it concludes with a gesture toward the unyielding conclusion to *The Third Man*. So Altman knew his history but he distrusted it and felt sick over the white lies of the factory system. In a sour Altman touch, Sterling Hayden plays the alcoholic writer who has given up the ghost, trading on our knowledge of Hayden's own remorse over having been a friendly witness for HUAC. No one ever accused Altman of being a gentle fellow. He had a mean streak. But its offsetting benefit was the mistrust, solitude, and breakdown in his films, and it went with a helpless sympathy in the way he looked at the oddity of people.

This was Altman's third coup in three years. For in 1971 he had re-drafted the Western as a melancholy love story about a fool who cannot

impose his story on the world but who ends up with an epic triumph that no one notices in the falling snow and the lamenting songs of Leonard Cohen. *McCabe and Mrs. Miller* (1971) had Warren Beatty as John Q. McCabe, in a beard and derby hat, a brothel-keeper of sorts in the Northwest, taken over and smitten by Mrs. Miller (Julie Christie), but such a chump at handling the local syndicate that he signs his own death warrant. (It's another film about the defeat of the individual.)

As photographed by Zsigmond, *McCabe* and *The Long Goodbye* proposed a new way of seeing. For decades Hollywood had constructed and composed its images as framed things: they were the brickwork of stability. But Altman and Zsigmond substituted a slippery wide-screen vista where the slow zooms oozed in and out, and we were left as searching eyes. "What should I look at? What is there to see and what is hidden?" Altman often seems to film in what Gavin Lambert, referring to a part of Los Angeles, once called "the slide area."

That was as radical a stylistic departure as Godard's jump-cutting, for it argues that the screen's threshold is a place for searching, instead of somewhere we receive decisive, chosen sights. The imagery relinquishes its old assurance, but we are drawn deeper into the maze and the illusion. And the melancholy in both these pictures is part of a forlorn inquiry, wistful over the old, vanished indicators. Altman went further still. Where once sound had been skillfully miked and the final soundtrack mixed, cleaned, and clarified, for sense and meaning, these two films leave us asking ourselves, "What did he say? Did you quite hear that?" The spatial confusion was aural, too, and the players were miked separately, often with the new radio mikes, and a mix was then made that brought voices in or out and was seldom clean and not always audible. This may seem perverse, but a movie where looking and hearing are muddled or compromised may get closer to our uncertain experience of life than the emphatic precision of the golden age, when a shot or a frame did not pass without being completely informative and "correct." "Was that take 'okay'? If not, take it again."

Another facet to his style was Altman's developing interest in groups—and that was another novelty in American film, where the hierarchy of stars, supports, bit parts, and extras had been set in stone. Altman was always close to scorning or bypassing stars—he and Beatty got on badly because of this—and he loved crowded shots and group scenes. The first destination for that approach would be *Nashville* (1975), a whimsical portrait of the real place, with twenty-six roles of more or less the same size.

Further down the road, *Short Cuts* (1993), derived from stories by Raymond Carver, was a panorama of Los Angeles in which the pattern of overlapping events conveys a very fresh sensibility for real turmoil held in place, or kept calm, by the principle that no single story, person, or self-centered universe really matters enough to be the center of attention.

That's one explanation for how Altman was making the most innovative American films in the moment of *The Godfather*. By reputation, Coppola's picture is violent. But Brando's Vito Corleone is as adorable as he is magnificent. Think of Joe Pesci in *Casino* (1995), and you realize how much hideous pathology is left out of Vito. He has a kitten in his lap in that opening scene; the enchantment goes all the way to the moment he is playing with a grandson in the garden and has his heart attack. He is gracious, kind, and sad.

If you want to confront real psychotic danger try Mark Rydell's Marty Augustine in *The Long Goodbye*, a sort of stand-up comic gangster until he smashes a Coke bottle in his girlfriend's face. That unexpected moment is something rare in violent movies: it truly conveys the hideous damage of broken life. And that was what Altman was always searching for. Show audiences today the killings in *The Godfather* and they follow the ritual with reverence and satisfaction. (Those final executions are intercut with a baptism service.) But show them the Coke bottle sequence in *The Long Goodbye* and they turn away in distress. "Why did you show me that? Because such things happen?"

•

"Why should I do it?" Francis Coppola asked his father, Carmine. By chance, they had crossed paths at Burbank airport. Francis had been at the Paramount building all day. "They want me to direct this hunk of trash," he told his father. He may have heard through the grapevine that the Mario Puzo novel *The Godfather* had already been turned down by Arthur Penn, Peter Yates, Costa-Gavras, Otto Preminger, Elia Kazan, Fred Zinnemann, and Franklin Schaffner. But those guys weren't thirty-one and in debt, like Francis. He told his father he preferred to make art pictures, not lousy anti-Italian mobster stuff. But Dad said take the money and then do your own things. The money turned out to be $125,000 against 6 percent of the rentals.

The Puzo novel had been published by Putnam in 1969 on a $5,000 advance. It sold a million copies in hardback and had a paperback advance of $410,000. With the best will in the world, critics admitted it was

a piece of trash, but one the public enjoyed. Paramount, in the person of its production chief, Robert Evans, bought the book on a $12,000 option against $85,000. They hired Al Ruddy to produce it, gave him a copy of the book, and asked what sort of movie he could foresee. Ruddy replied, "An ice-blue terrifying movie about people you love." These are the first words close to sense on the project.

Ruddy and Paramount chose Coppola for several reasons: the kid had won an Oscar writing the screenplay for *Patton*; he had had his training with the UCLA film school and Roger Corman; he had directed a few films—*You're a Big Boy Now* (1966), *Finian's Rainbow* (1968), and *The Rain People* (1969), none of which had made money—plus, everyone else they asked turned them down; Francis was of Italian descent; and they still couldn't reckon how enormous or prestigious this venture would be. If they had known, they might have got Luchino Visconti, which shows it's best not to know. I realize this sounds irreverent. We take it for granted *The Godfather* is a masterpiece, but that came later.

Puzo had done a script no one liked, but then Coppola sat down with him on a second draft. Meanwhile, the great gamble of casting set in. Paramount had its own ideas: Robert Mitchum, Frank Sinatra, and Burt Lancaster had all been mentioned as Vito, but Coppola had his mind set on Marlon Brando. This outraged the studio: Brando had done a lot of bad work in the 1960s, and the legend was that he had destroyed *Mutiny on the Bounty* with his salary, his demands, and his delays. Puzo himself had approached Brando, and the actor had warned him that no one would make it with him. Dino de Laurentiis told Paramount that if they used Brando, the film was dead in Italy.

But Coppola had his own casting director, Fred Roos, who had first worked on *Five Easy Pieces* and who was in the habit of going to small plays off Broadway and asking the advice of other actors. That's how Roos saw John Cazale and knew immediately that he was Fredo. No one at first quite grasped the significance of the role of Michael, though the actors under consideration included Robert Redford, Ryan O'Neal, James Caan, Tommy Lee Jones, and even Robert De Niro. But Roos knew Al Pacino and believed he had the eyes for the part, even if his two films so far, *Me, Natalie* (1969) and *The Panic in Needle Park* (1971), suggested nothing like the necessary strength. Robert Duvall would be Tom Hagen, but a Roos pal, Jack Nicholson, had been a contender, too. Francis's sister, Talia Shire, would be Connie. Diane Keaton was cast as Kay, but there were others on the possibles list, including Jill Clayburgh, Blythe Danner, Michelle Phillips, and Geneviève Bujold.

The issue of Vito was still unsettled. A casting list existed, crazy with speculation: George C. Scott was sensible; John Huston was intriguing; but Paul Scofield, Victor Mature, and Laurence Olivier? You have to realize how lucky you have been.

When Coppola insisted on Brando, Paramount turned ugly: they would only take him if he signed a bond guaranteeing no delays, if he agreed to a per diem salary, and if he did a screen test. Those obstacles were meant to provoke anger and refusal. You can understand how Brando had become so "difficult" over the years, and you may appreciate his generosity here. He consented to the screen test. Francis flew down from his home in San Francisco. He hired Hiro Narita as cameraman. And they arrived at Brando's mansion on Mulholland Drive.

The actor put black boot polish in his blond hair. He stuffed a few tissues in his mouth to change the shape of his face. He experimented with a husky voice and a thin mustache. This took half an hour and then they shot some footage on video. When Charles Bluhdorn, the head of Paramount, looked at the test he didn't know who it was, but he said, "Hire him!" So the deal went down whereby Marlon Brando played Vito Corleone for $50,000, with $10,000 a week as expenses and a profit percentage on a rising scale from 1 to 5. Then, when he saw the cut of the film and reckoned it would flop, Brando went to Robert Evans and traded back his points for $100,000. No one ever knows, not even the geniuses.

They shot the film, despite early hints that Coppola might be fired. The cameraman was Gordon Willis and the production designer was Dean Tavoularis. Willis was an East Coast cameraman, masterly but testy. He had just shot *Klute* for Alan Pakula, a study in colored gloom. Coppola encouraged a similar look for *The Godfather,* on the principle that Italian interiors were usually brown and black. Still, the two men argued a lot as Tavoularis (he had been on *Bonnie and Clyde*) delivered sets of such warmth, texture, and shadowy intimacy that we feel at home. But *The Godfather* was never bright or energetic—and those attributes usually attended big American pictures. It was still the industry's idea that the audience deserved and expected a lot of light—for therapy or sizzle. You can say *The Godfather* feels authentically Italian and of the 1940s—Coppola had insisted on doing it in period—but the subdued look is more profoundly emotional. It is a darkness, not too far from wickedness, maybe, yet just as close to comfort, security, and home.

They shot most of it in New York and Sicily, and the costs climbed. When Coppola had trouble with the final conversation between Michael and his father, he asked an old friend, Robert Towne, to come to

the location and provide some rewrites. In the end, a film always gets shot, even if everyone there thinks it's a disaster and they can't wait to go home.

It was filmed in the summer of 1971, with Paramount pledging itself to a December opening. But as the editing set in, at the offices of Francis's American Zoetrope, in San Francisco, the picture seemed closer to three hours than two, and not ready until 1972. There were bitter arguments, most of them lied about later in the glow of success. Two editors were at work, William Reynolds and Peter Zinner, with another longtime Coppola friend, Walter Murch, as postproduction consultant. The length of the movie edged back and forth between two hours fifteen minutes and nearly three hours. With the final cost at $6.2 million, it became clear that a Christmas opening was impossible.

There had to be a score, too, and Coppola upset Paramount when he proposed Nino Rota, who had done *La Dolce Vita* (1960) and *The Leopard* (1963). Al Ruddy admitted he had never heard of Rota. The studio had had Henry Mancini lined up. But today, Rota's elegaic score is not simply as familiar as the Tara theme from *Gone With the Wind*. It is another keystone to the emotion of the picture that gives access to a level of feeling not heard in Mancini's music (including the syrup of "Moon River" for *Breakfast at Tiffany's*). Of course, Coppola's father, the dad encountered at Burbank airport, had once played the flute in Arturo Toscanini's NBC Orchestra, and he wrote extra music for the picture.

In the end, Paramount respected the work: they let it play without an intermission, when most theaters wanted that to make their money on refreshments. The film opened in New York on March 14, 1972, and the audience was appreciative, without standing to applaud. Many were taken aback by the violence and the endorsement of this Mafia family. There were some who wrote it off: William F. Buckley said, "it will be as quickly forgotten as it deserves to be." Arthur Schlesinger found it "overblown, pretentious, slow and tedious." But in the *Los Angeles Times*, Charles Champlin thought it the fastest three hours in movie history. In the *New York Times*, Vincent Canby called it "one of the most brutal and moving chronicles of American life ever designed within the limits of popular entertainment." Pauline Kael remarked on "the spaciousness and strength that popular novels such as Dickens's used to have."

Those instincts about popular appeal proved prescient. For the biggest American shows, movie or otherwise, the reviews rarely matter. Paramount had planned to charge $3.50 for a ticket (more than twice the going rate). But they put it up to $4.00 when they felt the interest in the

picture. In its first week, the movie grossed over $7 million. By April 12, it was at $26 million. The eventual gross would exceed $130 million; the rental income to the studio was over $80 million. For a few years, *The Godfather* could claim to be the biggest box office winner in history—it took over from *The Sound of Music* (1965) and would yield to *Jaws* (1975).

Theaters were packed and audiences thrilled in ways that reclaimed the past, especially the mid-1940s, when most of the action takes place. Once again, a three-hour film felt normal, if it worked. The whole value of young filmmakers out of film school seemed like wisdom. If there was a silver age, then *The Godfather* is its crown. So many people were vindicated (if their furious disagreements could be forgotten): Puzo, Robert Evans, Al Ruddy, and Coppola. An ensemble of actors passed into steady careers, and Marlon Brando was back to his old glory for a moment. The gangster film was made respectable, though soon people who knew enough about the Mafia said it was pipe dream. Martin Scorsese delivered *Goodfellas* (1990) to show what the real thing was like, and David Chase's TV saga *The Sopranos* would be slice upon ugly slice, the cold cuts of a dysfunctional family. The Corleones are not dysfunctional. Try heroic.

There's the dream we have always cherished. Willis and Tavoularis had made it plausible. The cast had poured their truth over the screen. Who could dispute the toughness of it all? Still, it was a superb, arranged show, from the moment when a humbled supplicant seeks the Don's grace to the calculated affront to conventional morality that links drastic business slaughter and religious ritual. Coppola had said at the outset, and would reiterate, that it was a study of American capitalism, of crime getting so organized and so American it no longer seemed like crime.

The film is as dark as Michael's having Fredo killed in *Part II*. But we do love these sinister people. On-screen, it became clear Michael was its center, and his dramatic arc is one we have followed so often: the ordinary, decent guy who gets into the light or the limelight and rises to its opportunity. Michael's hitherto secret dream of himself becomes ours.

Audiences had often gone with gangsters before. But Cagney's outlaws paid with their lives, in payment for our fun. Michael is revealed as lethal, cold, a liar to his wife, a man who hires killers and arranges massacres, but he is not repudiated. His authority works on us as much as on his henchmen. Once, he was the white hope of the family—he went to Dartmouth and served with honor in the war. But honor never convinced him. Something else was weighing. "That's my family, Kay," he says. "It's not me." But in the film, we realize that becoming his wife does not

qualify Kay as family. Michael may be more impressed by his Sicilian bride, Apollonia. He has sex with her, not with Kay (just heirs). Yet he doesn't seem to mourn Apollonia when she is murdered, because death and vengeance have become his trade. It is his code to let business bury personal things. He might kill anyone—he says as much in *Part II*. Forty years ago, nearly, those messages slipped by. But now they seem like a premonition of America.

There are matchless moments. Outside the hospital, trying to guard his wounded father, Michael notices that his hand does not tremble in the crisis. At the family gathering to discuss a response to the attack on Vito, the camera slowly identifies the seated Michael as the new leader. These scenes lead up to the restaurant confrontation where he takes the gun planted in the lavatory and kills Sollozzo and McCluskey (Sterling Hayden again). It is his coming-of-age with courage we participate in. That scene is characteristic of the film's epic pitch: the gunfire, the music, and the noise of the subway are so orchestrated (by an uncredited Walter Murch) that the room becomes a far-fetched place—can you imagine a working restaurant where every subway train is so loud?—but where the cinematic opera is vibrant and triumphant.

It is a film about a force taking over the family, with Michael surpassing Sonny, and that's where it is autobiographical. In childhood, Francis Coppola felt outclassed by his older brother, August, widely perceived as smarter, more creative, and more handsome. Artists need to tell their own story, and *The Godfather* contains the seething emotional drives of an overlooked son coming through.

That leaves less room for a critique of American capitalism. In life, by 1972, government attacks on the real Mafia were finding success. It was also the year of Richard Nixon's dirty-tricks reelection. Yet this movie offers the Corleone family as a place where we might belong and it presents a model leader bleaker than Nixon, yet more effective, too. The film is deeply conservative in its inner being: for it says to us all, come inside, join the family, be a part of something large and strong. It says to the huddled mass, fly to this bright light, rest in its amber gloom, and savor the meatball sauce and the companionship. This is not an attack on Coppola or ourselves, the people who have loved the picture for forty years, but *The Godfather* is a patriarchal encouragement about a haven and a stronghold that Clerici from *The Conformist* might treasure. The outstanding modern American film says to the huddled mass, join us, we'll lead you on.

What happened? First *The Godfather* won Best Picture and Brando was awarded (and declined) Best Actor. In the Supporting Actor category, James Caan, Robert Duvall, and Al Pacino all lost to Joel Grey in *Cabaret*—Pacino was still misread as a support. Grey was memorable and very clever—plus lucky. Bob Fosse won as director for *Cabaret*, which now looks like a fevered Nazi nightclub, dominated by Grey and Liza Minnelli but abandoned by everyone else. Puzo and Coppola won for their script. Gordon Willis and Dean Tavoularis were not nominated. The Oscar for Best Score went not to Nino Rota but to Charlie Chaplin, for the belated appearance of *Limelight*. (It was claimed that Rota had used some of his music before, in another film; Chaplin used most of his on every picture.)

There was a sequel, *The Godfather: Part II*, which opened in 1974. (Don't forget that Coppola squeezed *The Conversation* in between the two parts!) The second part was a business decision for the studio, of course, though it did less well ($57 million gross on a budget of $13 million—the cost doubled, the revenue halved). But it was a sign that Coppola wished to expand and reappraise the first film. (His fee went up, too, to $1 million, plus 13 percent of Paramount's rentals.) As Kael saw it, Coppola had inherited "the traditions of the novel, the theatre, and—especially—opera and movies."

Part II won Best Picture. Coppola at last won as director. Dean Tavoularis got an Oscar, Nino Rota (and Carmine Coppola) won for the music, and Gordon Willis was once again not nominated. (*The Towering Inferno* took the cinematography Oscar.)

The sequel has more dramatic intelligence, yet it is not as shapely or gripping a film as the first. It has many new virtues or discoveries: De Niro conjuring a youth for Vito based on Brando's bearing (he won for Best Supporting Actor); Mulberry Street in New York at the turn of the century—Tavoularis's triumph; much more of Fredo, which builds to tragedy in John Cazale's drained pathos; the starched quiet of Lee Strasberg as Hyman Roth (he was nominated); the Havana scenes; the re-creation of Lake Tahoe in the 1950s; a Washington hearing; Michael's frozen stare as evil consumes him, like plastic surgery; and the continuing minimization of all the women in the story. If the two parts of *The Godfather* have a debilitating weakness, it is that Kay is not allowed to stand up against wickedness. In the drama, it is agonizing when Fredo is disposed of. But if Michael killed Kay as she sought to speak out against him, that would be an outrage; and if the film was ever going to be a proper critique of America, it required outrage.

•

In the era of America's silver age, there was a ferment of movie ambition in other parts of the world, especially Europe, so that it is often hard to determine where the real silver was being mined. Just as *Bonnie and Clyde* had begun life as a "French" movie, so many non-American directors were looking at America and bringing fresh visions; and many pictures made in Europe were given courage and creative excitement by the thought of finding a revenue-bearing audience in America. More than ever before, there was a natural feeling of internationalism and the exchange of ideas. It's hard to say now whether "national cinema" exists still, except in countries isolated by language or political inclination.

•

In the year of *Bonnie and Clyde*, 1967, a young Englishman, John Boorman, came to America, found an unexpected ally in the actor Lee Marvin, and made *Point Blank*, a dream of film noir, about a criminal outsider's wish to reclaim a mythic $93,000 that the Syndicate owes him. It was shot with immense dynamism and violence in Los Angeles and San Francisco, and you felt the English eye eager for those hallowed locations. It looked more alive or ambitious than so many American films. But what was unique in *Point Blank* was its inner mystery: that Marvin's character, Walker—or was it sleepwalker?—might be dead the whole time and just dreaming the stages of revenge. It was as if a film theorist had taken up a familiar noir story and redone it to address the rapture of fantasy we require in a movie.

But the film depends on an unexpected rapport between a young English director and a famously difficult rogue actor. Walker is a burnt-out case, a dangerous ghost, and Boorman discovered in Marvin the kind of grief that often exists in stardom. So many great actors believe they have lost themselves. As Boorman put it:

> The young Marvin, wounded and wounding, brave and fearful, was always with him. The guilt at surviving the ambush that wiped out his platoon [in the war] hung to him all his days. He was fascinated by war and violence, yet the revulsion he felt for it was intense, physical and unendurable.
>
> His power derived from this. He should have died, had died, in combat. He held life, particularly his own life, in contempt. Yet he

was in possession of a great force that demanded expression. So *Point Blank* starts with a man shot. Lee knew how to play a man back from the dead. Superficially seeking revenge, but more profoundly trying to reconnect with life.

In the next few years, Boorman went to the South Seas with Marvin and the Japanese actor Toshirô Mifune, as marooned wartime soldiers in *Hell in the Pacific* (1968), and then he did *Deliverance* (1972), from a James Dickey novel about city guys who go canoeing, get lost in the Georgia mountains, and face an epic ordeal of rape, murder, and panic-stricken survival. What was most striking about *Point Blank* and *Deliverance* was how someone raised in South London seemed to have such a grasp of America—was that from personal experience of the country, or because every filmgoer anywhere in the world had had the chance to absorb the American imagination, and found the country itself trapped in its own imagery? It was one of the new German directors, Wim Wenders, who observed that America had colonized the world's imagination. Surely no American could have caught the desolation of American lives as well as Wenders did in *Paris, Texas*.

Bob Rafelson, once of BBS, visited Paris a lot and so he became uncredited producer and adviser on Jean Eustache's *The Mother and the Whore* (1973), one of the least inhibited and most pained studies of human sexuality, a film that makes *Last Tango in Paris* look like a magazine article next to a novel. François Truffaut had a debacle in London with *Fahrenheit 451* (1966), but he maintained his international art house career (with films such as *The Story of Adele H.*, 1975, and *Two English Girls*, 1971), and in the late 1970s he appeared in Hollywood in dazed rapture as the scientist who can play music for aliens in Steven Spielberg's *Close Encounters of the Third Kind* (1977). ("It's occasionally amusing," Truffaut would say, "but very slow, very long." Spielberg had lost all sense of how quickly some people had to work.)

In the mid-1960s, in Czechoslavakia, the liberal stirring that would go critical in the Prague Spring of 1968 made for a generation of enterprising filmmakers, working on very low budgets but with a new, ironic sense of human behavior in a conformist society. Jan Nemec made *Diamonds of the Night* (1964), Milos Forman directed *Loves of a Blonde* (1965) and *The Firemen's Ball* (1967), Vera Chytilová made *Daisies* (1966), Ivan Passer delivered *Intimate Lighting* (1965), and Jiří Menzel's *Closely Watched Trains* (1966) won the Best Foreign Language Film Oscar for 1967. Most

of those films had openings in America and Europe, and several of the
directors would go to America as the hopes for Prague deteriorated. For-
man had the happiest landing: *Taking Off* (1971) was a funny picture
about American youth, and then, for 1975, with Saul Zaentz and Michael
Douglas as his producers, Forman made a film from Ken Kesey's *One
Flew Over the Cuckoo's Nest* (1975), which had defied every previous ef-
fort. No one doubted that Forman's experiences under communism had
stimulated his vision of the unfriendly mental hospital where Jack Nichol-
son's Randall McMurphy becomes a sacrifice to repressive order. *Cuckoo's
Nest* won five major Oscars, including Best Picture and prizes to Nichol-
son and Forman. No film had swept the top awards since Frank Capra's *It
Happened One Night* (1934). When it opened in New York, there were
audience members crying out in support of its in-patients in a mixture of
anguish and elation. It seemed as if movie was at the forefront of populist
sensibility again, and the idea of Prague and New York being kindred cities
hung in the air.

Forman was set with an American career. He would win Best Picture
again (with Saul Zaentz), for *Amadeus* (1984); he would do the icy wit of
Valmont (1989); and he would provide one of our least-acknowledged de-
fenses of American libertarianism, *The People vs. Larry Flynt* (1996).
Alas, by then, the public did not welcome such appealing subversion in its
films. The other Czechs had far less success, though we should make
space for Ivan Passer's *Cutter's Way* (1981), another film that failed to find
its deserved audience. By the early 1980s the audience had lost its pro-
pensity for feeling alarmed at its own state and nation—it was the year of
energetic escapism (*Raiders of the Lost Ark*), familial sentiment (*On Golden
Pond*), and that curious example of a detached film about communism,
Warren Beatty's *Reds*. At the same time, 1980 saw Louis Malle working
in America on *Atlantic City*, a nostalgic recollection of American crime
films, in which Burt Lancaster was able to show how his toughs from the
1940s might have grown sad and wise, without giving up their act.

Not every crossover picture was worthwhile. Some people agreed with
the solemn air of Luchino Visconti and his star Dirk Bogarde that *Death
in Venice* (1971) was a masterpiece—what else could it be, unless you had
room in your head for "lofty rubbish"? Bogarde would quote Visconti: "Bo-
garde and I made it for ourselves"; then the actor added, "which was true,
but rather naughty and not to be at all encouraged!" Three years later,
Federico Fellini's *Amarcord* (1973) won more support in the masterpiece
race, and received the Best Foreign Language Film Oscar. Fellini had

won that prize before, for 8½ (1963), the first sign that self-awareness or self-centredness had become his subject. Fellini had rare success in his own time, and great support. I don't think he's watched with the same respect now, and that could be because we needed him in person to explain or embody his own charm. Fellini acted out the role of the helpless, chronic director, at a loss but somehow in charge. It might also be that there was often less there than some noticed.

Every Ingmar Bergman film in that era opened in London and New York, and the same applied to most of the films by the New Wave directors. Thus the six moral tales by Eric Rohmer became an art house staple, and *My Night at Maud's* (1969) and *Claire's Knee* (1970) were especially popular. No one bothered to think of Roman Polanski as limited by being Polish. He had flourished in London with *Repulsion* (1965) and *Cul-de-Sac* (1966), and when he came to America he not only grasped the smoke of witchcraft in Manhattan for *Rosemary's Baby* (1968), he also helped turn *Chinatown* (1974) into one of the most American and Los Angeleno of movies musing on the real gold of the West, water.

It was Polanski who looked at the gentler ending to Robert Towne's original *Chinatown* script and determined that the proper conclusion needed to have all mercy abandoned. So Jake Gittes, the private eye, a slicker version of Philip Marlowe, is led away a broken wreck and we have to accept that Los Angeles stays under the wicked thumb of John Huston's Noah Cross. That didn't stop *Chinatown* from being a hit when it opened, and a fond reference ever since. But it relied on an audience not deterred by the worst news, and aware that water meant Watergate, too. By common consent, with times needier now, a picture as dark as *Chinatown* would not be attempted today. Towne's deepest hope—to follow Gittes and the city through the 1930s, the '40s, and the '50s—came adrift. He wrote the 1940s sequel, *The Two Jakes* (1990), and was about to direct it himself. Then chaos and mistrust intervened. The picture was shelved, and when it came back a few years later, Jack Nicholson was its director. That part two didn't work, and we will not see a third film in the Jake Gittes series. In just a few years, Roman Polanski found his own exit from L.A., and he hasn't been back.

A year after the original *Chinatown*, Nicholson signed on with Michelangelo Antonioni to make *The Passenger* in various parts of Europe and North Africa, but in the English language. Nicholson plays David Locke, an American journalist living in London, with a wife and a house. But he is disenchanted with his life in all respects. In a small African

country, in a simple hotel, he meets a man one night and then finds him dead the next morning. With as little talk or reflection as slows Marion Crane in *Psycho* when she decides to take the money, he swaps identities with this dead man. In both cases, we know why the escapees do it: it is their longing for something better; it is a version of why we are at the movies.

"Locke" will discover that the life he has cast himself in is that of an international gun runner. Going back to London to spy on the ashes of his old life, he sees a girl in a public space. (It is Maria Schneider.) Then, following his new itinerary, laid out in the dead man's diary, he meets her again in a Gaudí house in Barcelona. Is that coincidence? What is coincidence in a story except purpose? Is the girl following him as part of some intrigue, or is she just a chance encounter ready to become his witness?

Very soon he is being pursued by both his old and his new lives, and the film concludes—at the Hotel de la Gloria, somewhere in southern Spain, at the close of a day—in one of the most elaborate and beautiful sequences ever filmed. As Locke dies in his hotel room, the camera slowly passes through a window to the courtyard beyond. We have a feeling of being drawn up into the screen itself by the motion. It is one of those sequences that has to be felt on a large screen, with baited breath and alertness. You want to be there. Looked at again, thirty-five years later, it seems like a swan song to the cinema of rearranged actuality, of caméra stylo and mise-en-scène, the moment, presence, and the passing light. This is what cinema was. Just as with *Blow-Up*, the mystery story keeps a very straight face so that it can vanish under our eyes.

•

Another pleasant surprise in these years was the return of a director once regarded as a guarantee of outrage. After *Un Chien Andalou* (1929) and *L'Âge d'Or* (1930), Luis Buñuel did no films of his own until he turned up in Mexico in 1947. *Los Olvidados* (1950) brought him back to attention (it won Best Director at Cannes in 1951) when it seemed like a neorealist study of slum kids lit up with his old interest in dream. He worked steadily then in Mexico, and after that, in France and Spain. It was as if he had always wanted to be a filmmaker. But the mood of his surrealism had shifted from anger or nihilism to amusement.

In 1967 he made a masterpiece, *Belle de Jour*, in which Catherine Deneuve plays a respectable bourgeois wife, Séverine, who occupies her afternoons by working in a brothel. It was in chic color and as thrilled with the ambiguities in Deneuve's persona as Polanski had been on *Repulsion*

(1965): she was a very good girl, but a very naughty girl, too—she was the well-behaved person who imagines herself into something sensual, dirty but irresistible. In her own dream, Séverine is tied to a tree so that mud can be thrown at her—the dark brown on her white skin is passionate and revolting. *Belle de Jour* found an arousing chasteness in Deneuve, but the suggestions of depravity were more erotic than films that boasted of intercourse. The actress would say, "Physical scenes don't bother me; on the contrary, they help me to overcome my withdrawn side, to get out of myself." Perhaps the best screen performers have intuitions about us.

Buñuel was over seventy, but with Jean-Claude Carrière as his friend and screenwriter, he now made *The Discreet Charm of the Bourgeoisie* (1972), in which a group of socialites (played by classy movie stars) are endlessly thwarted in their desire to enjoy a good dinner together. Shot in polished color and Champs-Élysées clothes, *The Discreet Charm* is a taunt to anyone who resembles its characters—it says, what a shame you keep missing your meal, while letting everyone else see how absurd you are. The texture and tone are from magazine advertising as employed to make a teasing portrait of our neuroses. And the audience liked it: the movie was a hit and it won the Best Foreign Language Film Oscar. It is still timeless, pretty, and as pointed as a finger pressing on an old wound.

Could this be surpassed? In 1977, Buñuel and Carrière returned to a story von Sternberg had used for *The Devil Is a Woman* in 1935. Fernando Rey would be a man preoccupied with a lovely young woman who flirts with him but witholds her body. He goes politely crazy. The role of the woman was meant for Maria Schneider, but she proved unreliable, or too ill at the time. So Buñuel calmly destroyed the sanctity of casting in one stroke: he would have the woman played by two actresses: the sensual Ángela Molina and the more reserved Carole Bouquet. The director told his worried producer to think of Dr. Jekyll and Mr. Hyde.

How can a man be chasing two women and think they are the same person? He simply doesn't notice the difference. (This had been suggested before, by Preston Sturges, in *The Lady Eve*.) Now you understand how, at the movies, on the screen, all people are alike—lovely shapes made alike by that white plane, the screen. The film is called *That Obscure Object of Desire* (1977), a title that might easily refer to the whole of cinema, and the result is a comedy of unsurpassed intelligence and erotic pathos in which desire itself, that creaking old engine, is seen as fit for retirement.

Is this the last sublime comedy in the movies, made just six years before Buñuel's death in 1983? That the director of *Un Chien Andalou* should have survived to do it is a touching lesson for film history and a

reward to us for being the loyal audience the pictures relied on. *That Obscure Object of Desire* may seem like a dry testament of old age, but now we wonder if it was the medium itself that waited to be retired.

One year before Luis Buñuel took his last sigh (the title of his autobiography), Rainer Werner Fassbinder died, probably with a groan and a roar. He was thirty-seven and he had crammed his life with all varieties of sex, drugs, booze, theatrical productions, and movies. In appearance and his working life he was untidy, uncool, frenzied, and uncouth, in search of the ultimate overdose. Yet his camera style was simple, classic, and a recording device for teeming melodrama, and his compassion for all outsiders was driven by the sense of us all acting out our lives.

As an "artist," he was beyond cataloguing or ordinary attention. At film festivals, he was ready to seem "disgusting" to the very people who fund such events. "I wanted to make them angry," he said, "As angry as I was." He defied the regular scale of such careers by making more films than audiences could keep up with—four a year sometimes, forty by the time of his death. Think of the opposed work rates of Kubrick and Fassbinder.

"I worked so fast," he said. "The less shooting days you have, the cheaper everything is, and the more films you can make." He was ready to start a film every day, and if it had to record his own exhaustion or breakdown, so be it. He made a nonsense of deliberation; he filmed as he might drink, or fuck, or breathe. When he finished making Alexander Döblin's novel *Berlin Alexanderplatz* (fourteen episodes, more than nine hundred minutes of TV time), on which he came in weeks ahead of schedule, he was seriously prepared to do the whole thing again, with a different cast, for a theatrical movie!

He had anticipated the technologies that would permit unceasing work—being "on" without rest, letting it take over life? The measured pace of a professional career was something he disdained and defied, for he had seen that recording machines kept going until they stopped, like the human organism. Anyone who values his own moderated judgment should sample at least *The Bitter Tears of Petra von Kant* (1972), *The Marriage of Maria Braun* (1979), *Berlin Alexanderplatz* (1980), and *Veronika Voss* (1982). (These are some of the declared "classics.") But Fassbinder saw and did everything—if he ever bothered to take a second look. What he said about Douglas Sirk applied to his own struggle: "You can't make films about things, you can only make films with things, with people, with light, with flowers, with mirrors, with blood, in fact with all the fantastic things which make life worth living." His headlong work has gone

out of fashion since his death, but he guessed how soon young people would become more interested in making films or being in them than watching them.

Several of the films from this era address the nature of film itself: *The Passenger, That Obscure Object of Desire, Persona, Point Blank*. As film subsided as a dominant entertainment, it became more intriguing or necessary to ask how it worked and to be obsessed with reality and fantasy being woven together. *Céline et Julie Vont en Bateau* (1974), directed by Jacques Rivette, was a rare, lyrical comedy about this self-reflective dance.

The setting is Paris in the summer, in a sleepy urban park where cats watch birds, and wait to pounce. Two women meet: Céline (Juliet Berto), a cabaret magician, and Julie (Dominique Labourier), a librarian. They are not suited at first, annoyed at misunderstanding, but they become friends, and then in their friendship they learn about a mysterious rather removed, or apart, house: 7bis rue de Nadir aux Pommes. They seek entrance, one by one, then as a couple, and while they cannot be seen by the occupants, they realize that a sinister melodrama is unfolding in the house in which three adults (Bulle Ogier, Marie-France Pisier, and Barbet Schroeder) are plotting against a child named Madeleine (Nathalie Asnar). How can they save this girl? It's hard enough to get into the house, but can they enter its action? And do you notice how the action itself begins to look increasingly stylized and drained of color—like a black-and-white film running in a colored world?

Céline et Julie is a gradual film (three hours, thirteen minutes)—some call it slow, but only if they are out of the habit of looking and noticing. Once you begin to attend, the film grows shorter and quicker by the minute. The friendship between the two women enlists us, and unconventional female friendships are a treat in our pictures. In time you appreciate that 7bis is not exactly a movie house, but a house that has become a movie (like the Overlook Hotel in *The Shining*), and the Madeleine story is a show these two friends must watch in the mounting delirium of continuous performance. I will not give away the ending, except to assure you it is not unhappy. But you cannot settle for the happiness or trust it applies to life in a thorough way that will keep you ensured. The happiness works only if you can leave the house.

Céline et Julie was never meant to be a wildly popular film, yet its ethos comes from the oldest kinds of romance and adventure that made the motion picture business. The very title of the film is an allusion to those silent comedies where Mabel Normand and Fatty Arbuckle did this

and that together. The thought of rescuing a kid is as old as Chaplin. The mixture of thrills and farce is the history of the show. At the same time, this is the work of a fine, learned critic and a lifelong pursuer of movie narrative and its relationship with our dreams.

Rivette had made *Paris Nous Appartient,* a Parisian story about paranoia, thirteen years earlier. He had directed Anna Karina in *La Religieuse* (1966), taken from Diderot, and a great scandal in France. He had made *L'Amour Fou* (1969), about actors, and in *Out One* (1974, a film of over twelve hours), he had encouraged actors to improvise and develop the story of conspiracy. He made *Céline et Julie Vont en Bateau* next as a distillation of his career and his love of cinema, but now paranoia had become bliss. The metaphor for the process of moviegoing is accessible and serene. But there are threats in its world, and I wonder if the little girl is named for the woman murdered and exploited in Hitchcock's *Vertigo* (1958), a character we never meet. But "madeleine" also links Proust and the candies Céline and Julie need to suck before their movie starts to run. In its insight, its sweet analysis, its humor, and its faith in circling stories, and paying close attention, this is just one of those movies from the 1970s that let a cineaste feel he possessed life—until the candy ran out.

•

I have tried to show how our attitudes to love, identity, desire, and responsibility have been shaped by moviegoing. These topics come together in the large subject of acting: Of whether we are ourselves or someone playing ourselves. And whether the movies have been good for us. The influence of our movies is not just a cultural sidebar, like an evening a week set aside for our fun. It was the engine of our time, the signal of so many screens to come; it is a model for how we look and decide, whether we participate or are content to be spectators.

So I close this section with a comparison of a political leader who became the figure in an astonishing motion picture and a movie star who made it all the way to the White House. The movie is *Hitler: A Film from Germany* (1977), made by Hans-Jürgen Syberberg. The career is that of Ronald Reagan, one of the most mysterious and important Americans of the twentieth century. This comparison is not made with any sense that these two men were similar in personality, intent, or impact, or that they stand for some blunt contrast of evil and good. They are together because their public and their world regarded them as figures in history and media, actors playing on the largest stage, the anthology of their own screen

moments. They are here because of the unholy mixture of politics and personality from which we suffer, and which is a comprehensive enactment of the technologies considered in this book.

Syberberg was born in Nossendorf in Pomerania in 1935 and was an adolescent in East Germany before settling in Munich at the age of eighteen. He made a few documentaries in the 1960s, notably on the performers Fritz Kortner and Romy Schneider, but then, in the 1970s, he entered on a period of intense activity such as no one could have predicted: he made *Ludwig: Requiem for a Virgin King* (1972), *Karl May* (1976), and *The Confessions of Winifred Wagner* (1978), all of which revealed his knowledge of and obsession with the cultural history of modern Germany and its stew of purpose, idealism, neurosis, and insanity. Syberberg is talented beyond doubt, but he often displayed an overweening arrogance that led him into grave troubles later. At the Telluride Film Festival in 1983, when he was there to show his film of *Parsifal*, he declared without irony that he thought one day the Goethe Institute might be renamed the Syberberg Institute. That was a warning of the man who would later damn himself with anti-Semitic remarks and frequent statements exposing his sympathy for some Nazi ideas.

But that is not enough to destroy or restrict his Hitler film; it only brings more interest to it. The work is more than seven hours and displays an ambition Syberberg found lacking in most movies:

> Today's movie-house movie has, in my opinion, been the locus of a deteriorated form of Aristotelian dramaturgy—deteriorated into boulevard triviality—for the past fifty years, without poetic, aesthetic or intellectual innovation. A reactionary form of culture in the hands of shopkeepers and functionaries. Even the admirable exceptions had no trailblazing consequences, and the so-called underground cinema was restricted to private undertakings without historical relevance. Truly underground. The great inventions of the modern theater, with its interest in traditions of epic dramaturgy over the course of history, have never been grasped and assimilated by the cinema. The motion picture has not known how to use the spiritual and intellectual legacies of Aeschylus and Sophocles, of the mystery play and Shakespeare, of the German Romantic theater, Sturm und Drang, the revolutions of German classicism before Brecht, and Homer, or Dante and Bach, of what Wagner understood as a Gesamtkunstwerk.

It is an orthodoxy of movie history that the new medium effortlessly took over from the stage. Cineastes are expected to despise and avoid the theater. So it's arresting for someone to say, wait a minute, the eloquence and passion of live enactment did not simply lie down under the onslaught of the movies. It has carried on and, at this point, it seems likely to outlive the movie house as a public entertainment and as commentary on the complexities of our experience. The liveness of theater is returning, and paradoxically it is something that Syberberg saw as a newfound destination for film itself. The first thing to be said about his Hitler film, no matter that it is a projected performance, is that it reminds us of the participation of theater and strives to shatter the illusionism, the fetishized reality, of movie house movies.

The shattering exists in its collage: this is a movie where actors, puppets, real speeches, film clips, back projections, dramatization, lecture, and reverie conspire to present the facts about Adolf Hitler and the myriad ways in which he has been understood or digested. Yes, the film is immense and time-consuming, and it requires knowledge of what Hitler did and said and of the German history he looms over—but if Hitler is important, is that too much to ask? The film played outside Germany—in America it was distributed by Francis Coppola's Zoetrope operation, and it had British funding through the BBC—but it is principally a work from and for Germany. Susan Sontag, one of Syberberg's admirers, said he was addressing the cultural melancholy (or self-pity) in which a country or person cannot digest or properly mourn the grief for what it has done. So, Germany, Syberberg says, has moved on after the Holocaust and Hitler without coming to terms with it. You may not agree with that, but the pressing point is to wonder whether America, say, has been through the same necessary mourning over Hiroshima, Iran, Chile, Vietnam . . . the list goes all the way through Latin America to the Middle East, and it numbers the "trouble spots" where the self-declared source and arbiter of modern liberty has offered comfort for tyrants, neglect of freedom fighters, corruption, and exploitation. In other words, the strangled ongoing documentary that television news has given us over more than fifty years and that has left the United States at the end of its moral tether.

Susan Sontag recognized the intellectual energy and risk in Syberberg's Hitler film—it may be related to this outpouring that he did not do too much afterward. "The film tries to be everything," she wrote, and it is implicitly a defiance of ordinary documentary, especially its passive mock-aesthetic notion that documentary should deprive itself of words, com-

mentary, and argument—as if it were a flawless testament instead of a mere imprint of appearance. She added: "Syberberg belongs to the race of creators like Wagner, Artaud, Céline, the late Joyce, whose work annihilates other work. All are artists of endless speaking, endless melody—a voice that goes on and on." Godard is the only political filmmaker to rival Syberberg, but Godard was too tight-lipped. He lacked intellectual generosity or the willingness to seem unsure. You can call Syberberg crazed, arrogant, or crypto-fascist, but you should see his movie, too. *Hitler: A Film from Germany* is the work that most captures the natural helpless montage television has made of history in our age. It is a film, or a version of epic theater, that allows us the feeling that we might examine and admit our own history, instead of being its eternal victims.

Don't we need such a movie about Ronald Reagan? It would have nearly as much to contain as any work on Hitler, and most of the material is so much jollier. Think of all the times Reagan passed in front of our cameras with a wave and a grin and a quick one-liner, and realize how far that flourish had become a gloss for public behavior in fifty years of silly movies. I don't pass judgment on his presidency: he maybe violated the Constitution; he undermined economic morality; but he also presided over the fall of that "evil empire," the Soviet Union, he survived an assassination attempt, he revived American spirits and gave much of the nation an odd sense of ease or relaxation. He cheered us up, just as he had often lifted a scene in a picture with brisk good nature. Even the people who know the damage of his administrations conclude that he was a good guy, a nice fellow, because that was all he had ever set out to play—no wonder he gave up movie acting after he had to slap Angie Dickinson's face in Don Siegel's television version of *The Killers* (1964). That wasn't nice, or true to Ronnie, and he was determined at all times to resemble himself, to be like Ronald Reagan.

It didn't matter finally whether he was a good or a bad president. For he was the embodiment of that moment in *Network* when Ned Beatty's boss lectures Peter Finch on his responsibilities to corporate America and what he must do and say. "Why me?" asks the amazed Finch—his character's name is Howard Beale. (He wasn't going to take it anymore, but he takes it now.) "Why me?" And Beatty answers, "Because you're on television, dummie!" Reagan had been on television long before anyone thought of the White House, in days when his presidency referred only to the Screen Actors Guild (1947–52).

It was unthinkable then that the American electorate would ever vote

for an actor, let alone a minor one. That was a time when Gore Vidal's warning not to vote for anyone who has been told what to say and where to move and when, all his life, still seemed potent and decisive. Since then we've had another actor, the far-fetched Arnold Schwarzenegger, as governor of Californa, no matter that he seemed to spell the state with a capital *K*. There may be other actors who win big jobs. More important, no one can now get office, or run for it, without possessing a viable or actorly television personality. He or she must be presented as a self we can admire. This is not just being "photogenic," it's being persuasively natural on moving film without seeming stupid. (It's Crosby and not Hope; it's Dean Martin, not Jerry Lewis.) John Kennedy had it. Nixon lacked it. Reagan had it. Obama seemed to have it until he needed it. Will there be an election where no candidate has it?

But Reagan excelled at it because he had served so long as a supporting actor. So he had a modesty, a deference, a supporting-actor openness, that Kennedy or Obama would not permit in themselves. They believed they were well cast in the job. Reagan suspected he was lucky because he had few assets beyond the collected scenarios of Warner Bros. in the 1940s. And the secret to it all is that in these media-ridden times, when there is so little presidential authority left, perhaps we might as well have someone like Reagan, someone who can be on TV. He passed our time pleasantly and left a vague impression of well-being, even when he put his foot in it. The office of the presidency has been blurred and inhibited by television coverage and spin, and by that Reagan ease. How can a president be so relaxed? He doesn't remember everything.

It was Jack Germond on *The McLaughlin Report* who, when asked if Reagan had known about Iran-Contra, said, "They told him, but he forgot." Reagan was a career forgetter, long before any suspicion of Alzheimer's. From reading radio commentaries during the war, he believed he had been present at events he never witnessed. As the journalist Tom Shales would point out, "When are they going to realize that with Ronald Reagan 'seemed' and 'was' are one and the same?" In *Murder in the Air* (1940), a fifty-five-minute B picture, where he plays "Brass" Bancroft, there is a cockamamie plot McGuffin about a destructive ray (the Inertia Projector), and it stuck with him as the Strategic Defense Initiative, not just difficult to achieve but maybe ridiculous, and later called Star Wars, referring to the fantasy of the George Lucas movies.

Some memory losses were over matters of fact. When asked by a Los Angeles grand jury in 1962 whether he had participated in the 1952 Screen Actors Guild waiver that allowed MCA and Revue Productions

(and only them) to be both producer and agent (bringing them great profits over seven unrivaled years), he reckoned he had been out of town filming *Cattle Queen of Montana* at the time. In fact, the dates for that were wrong, but no one on the jury was enough of a movie buff to know. (Very soon thereafter, Reagan was paid $75,000 for a cheap Western, *Law and Order*, as negotiated by Lew Wasserman, or MCA, his own agency.)

The montage would have to include the observations, sometimes from family members, that his winning public amiability sometimes dried up if you were with him alone—because in those predicaments, he didn't always know or possess the script. At a school event, he introduced himself to his own son, Michael, as if they were strangers. Some believed there was not just boredom but emptiness behind the grin. Many actors know that troubling hole. Even those of us who feel increasingly that we are playing ourselves sense the abyss.

Is there a Syberberg available to make that film? I don't think so—it's hardly suited to the patriotic euphoria of a Ken Burns or the patient witness kept by Frederick Wiseman. Werner Herzog might do it, but the maker needs to be an American. Our current documentary perspective does not really permit Syberberg's "endless voice." It is afraid to think out loud; it still believes the camera is reliable enough.

The closest we have come to that Reagan movie is the unexpected book *Dutch*, by Edmund Morris, published in 1999. Morris was an esteemed academic biographer at work on a multivolume life of Theodore Roosevelt (it had won him a Pulitzer Prize already) when he was diverted by an invitation to do an authorized biography on Reagan. So he watched the man and talked to him, and did all that professional biographers are meant to do. But the book didn't quite come to life, because Morris believed there wasn't an entire person there. So he was brave enough to get into scenario, or "Ronald Reagan's own way of looking at his life." There are sections of *Dutch* written as fiction, or in an imagined attempt to match the manner with which Reagan perceived, and liked, himself. There is this passage, where Morris talks to Reagan about good and evil:

"So you do believe in the power of human goodness."

"Of course!" he said, contact lenses twinkling. "That's what it's all about."

The twinkle slid off as he turned to speak to Kathy [his secretary], and with it slid my reflection from his eyes, and all consciousness of me from his brain.

Morris couldn't know that, but he felt he had to say it in an authorized biography. *Dutch* was mocked and deplored, and it's hard to claim it works "properly." But its inside approach, the resort to scenario, was intuitively stimulating. For Reagan was always hoping to be a cut-and-print acted character, and that meant we had to slip aside, too, from citizenry to audience. We may never get back.

DREAD AND DESIRE

Francis Ford Coppola and his daughter, Sofia, on the set of *The Godfather: Part II*

DREAD AND DESIRE

In 1947 a prescient poetic imagination had seen a streetcar passing by in an American city. It was named Desire, after one of the routes in New Orleans, and Tennessee Williams came to it after he had tried other titles. "Desire" was a mark of voodoo, perhaps, or of subterranean and surreal needs ready to battle the external grid system of a New Orleans unaware how nature and a spirited female force, Katrina, would soon carry it back in time, and not alert to the way sixty years was only a blink or a flicker in the film strip.

But in *A Streetcar Named Desire*, the Tennessee Williams play, the vehicle of desire, Blanche DuBois, is seen to be crazed so that finally she is taken off to an asylum. Stanley Kowalski knows she is dangerous, disorderly, and a bad example. He is a new man, a Polack American home from the war, his mean head filled with barrack-room law, his rights, and a crass materialism that likes to smash minor property to show his authority. So he picks up the chinaware in his own home and clears the table. And in his iconic and tight jeans and what was perceived as his audacious physicality you could feel his manhood. So he gets the disturbing sister-in-law out of his house, and he rapes desire—that is his way of killing it.

The film of *Streetcar* that followed in 1951 hoped to be the stage production transferred. The only cast change had Jessica Tandy replaced by Vivien Leigh. But the movie had many censorship problems over its suggestion of sexual violence. At one time a "happy ending" was proposed, and Lillian Hellman delivered a script for it. By the early 1950s, the Hollywood Production Code was still in force, so that words, actions, and hints allowed onstage could not be filmed.

But the pressure was mounting. The careers of Marilyn Monroe, Elizabeth Taylor, Grace Kelly, Brigitte Bardot, Sophia Loren, Jeanne Moreau, and many others cannot be followed without some realization of clothes,

restraint, and shyness falling away. In *Some Like It Hot* (1959), Marilyn seems to be falling out of her dress when she sings "I'm Through with Love." In *To Catch a Thief* (1955), on their picnic, when Kelly asks Cary Grant whether he'll have a leg or a breast, she isn't just talking cold chicken. He responds, "You decide" (a very Grantian hesitation), but is that a tribute to feminist decision making or the male's sultanate view of the movie harem?

Sometimes, in a spirit of optimism, the new woman was hailed as a step toward "feminist" advance. Soon enough, Faye Dunaway's Bonnie would be helping the diffident Clyde to his orgasm, Audrey Hepburn's Holly Golightly would be interpreted as a free spirit instead of a shopping escapist, and in *Klute,* the aggressive loneliness of Jane Fonda and her taut body were read as unstable independence instead of a concession to the Godardian idea that prostitution and being an actress were a dark sisterhood.

The breakdown of censorship in the 1960s could be interpreted as liberation. But as with many radical shifts in that era, the real impact was complicated. Female nudity and female sexual readiness were much more evident on our screens, and some said this was good for women. Yet all knew it was what men would pay for, and at the executive and creative levels, men still determined what got made and shown. So in Peter Bogdanovich's *The Last Picture Show* (1971), Cybill Shepherd showed us her breasts (and prompted the director to abandon his wife, Polly Platt, for her), but the actors' penises stayed out of sight.

As female bodies became more visible, their glamour declined. But the private parts of men became more illustrious and fetishized. In turn, this began to bring to public attention the possibility that men were erotic icons, too, and that movies might be bisexual, or multisexual, or gay.

The industry said there were some movies aimed at men (Westerns, gangster flicks, war) and some more suited to women (romances, tearjerkers, mother movies). But they were as reluctant to give up any portion of the audience as they were to acknowledge the quantity of homosexuals working in film—and watching them. With Astaire and Rogers, their films could not be enjoyed without a male viewer saying to himself, "It sure would be swell to have Ginger in my arms, but it would be great to be able to move her—they call it dancing—the way Fred does. And he is so elegant, so cool, so nice, so gentle, so silly, so . . . gay?" Equally, the woman in the audience can say to herself that it would be terrific to have a partner as athletic and considerate as Fred—but "Don't I wish I looked like

Ginger, or had her dress?" The old adage was that she gave him sex appeal, and he lent her class. But we got both.

The normal history of film is of an art, a business, and the famous people who contributed to it and who made modern celebrity. But if commercials are small movies, and if pornography has a place in the list of films made, then there must be larger issues of understanding in play. So film introduced us to a mass medium, leading us away from inner truth to appearance, confusing us over reality and fantasy, and helping us go from a state of sexual innocence or ignorance to claiming sexuality as a right. Suppose the vital history of the medium has been in making novices and strangers accustomed to sex and to seeing the chance of pleasure or desire's fulfillment. Suppose that meant being drawn to both sexes.

In Ford Madox Ford's novel *The Good Soldier* (published in 1915, the year of *The Birth of a Nation*, and far beyond Griffith's film in its human understanding), there are several characters of whom the narrator can say quite reasonably that they did not know how babies were made. These are not uneducated figures. They are wealthy pillars of society. Most of them seek sexual gratification and seem to know where to get it. But they do not apprehend the role of sex in either their own experience or the development of the culture. At that social level, few innocents like that exist any longer. In a hundred years sex has developed as an experience and a theory. It is where we grow up? And in positing the curious gap between the inner and outer aspects of sex, what it feels like and what it looks like, movie may have had a value beyond that of individual films. Thus, stardom is less about the people on-screen than those watching them. It involves the discovery of desire.

In Montgomery Clift's breakthrough film, Howard Hawks's Western *Red River* (1948), he played the adopted son who opposed John Wayne's tyrannical rancher, and took his herd of cattle from him, incurring lethal vengeance. Clift was handsome; he was beautiful. Not everyone thought he could be convincing as a robust Western hero—including Wayne. Did the insiders know he was bisexual? That's less clear than Hawks's belief that Clift was exciting box office and a worthy opponent for Wayne—even in the concluding fistfight. Still, Clift had to be taught how to work with guns on his hips, a hat on his head, and a horse between his thighs. How well he managed can be seen on the screen. He was a good enough actor to impress Wayne and Hawks, and to hold the camera.

And yet . . . Clift's character wears fringed buckskin (a costume you might purchase in a gay store now). He has private movie talk with

Cherry Valance (John Ireland) about their guns, the innuendo of which was noticeable at the time. Then, at the close of the picture—where the script had originally called for a death—the girl (Joanne Dru), who has been propositioned by both men along the trail, tells them to stop fighting and grow up, because anyone can see they love each other.

To the movie public for just a few years, Clift was an ideal romantic hero, someone Hawks had made seem valiant and effective in *Red River*. The same pattern held in other Clift pictures. *A Place in the Sun* is a blighted love story and a social allegory in which Clift meets an ordinary girl and has sex with her. The girl, Shelley Winters, is as deglamourized as wardrobe and makeup could permit. But then Clift sees and meets a girl from the screen. He has already seen an image that represents her, on a highway billboard, as he hitches a ride. She is the eighteen-year-old Elizabeth Taylor, staggeringly attractive and with a childlike tenderness. So Clift thinks to dump the pregnant Shelley and a humdrum life for the limitless horizon with a radiant Liz and "a place in the sun." This "place" seems perfect but only as an infant's haven.

Although Clift only contemplates murder, a providential accident intervenes. Winters drowns, and because Clift knows he is guilty in his heart, he goes to his death. This guilt in the soul rhymes tidily with the lust in the heart that affected nearly everyone at the movies in those days. The tragedy in George Stevens's expert film seems fixed on Clift and Taylor and the innovative telephoto close-ups that enshrined their last embraces. But there's more, if you are prepared to see how the American dream of rising above your station and claiming your place in the shining light of happiness may be dangerous. In short, be careful with the huge fantasy urging of the movies. (As the film arrived, and made its impact, the Sands Casino opened in Las Vegas, with the engraved motto over the doorway, "A Place in the Sun.")

•

In 1972, *Last Tango in Paris* had been hailed as a new world, or an available apartment where anything could happen. There were other flutters of orgy: Nicolas Roeg's *Don't Look Now* (1973) had an unusual and delicate scene in which Julie Christie and Donald Sutherland made uninhibited love and were intercut with glimpses of them dressing afterward. It was only an aside and a joke at the expense of the normal undressing scenes. It was there to say, "We can do this now," in a picture the title of which reminded us about seeing things.

In American film, sex receded as soon as the chance of showing it had been won—with a few honorable exceptions. The new powers, Spielberg and Lucas, never seemed interested in love on the screen. Film was their sex. Brian De Palma was fixed on voyeurism (*Dressed to Kill*, 1980; *Body Double*, 1984) but aware of little else. Philip Kaufman made an authentically sexy film, *The Unbearable Lightness of Being* (1988, from Milan Kundera), under cover of a European art house film. In Japan and then all over the world, Nagisa Ôshima's *In the Realm of the Senses* (1976) explored the sadomasochism in passion. Marco Bellocchio's *Devil in the Flesh* (1986) had what was said to be the first filmed, or depicted, blow job—so at last the common practice of executive offices saw the artistic light of the dark.

It wasn't truly a first for fellatio. In June 1972 a sixty-one-minute American film had opened in "pornographic" or "adult" venues. It was called *Deep Throat* and concerned a young woman who discovered that her clitoris was in her throat. The actress was credited as Linda Lovelace, though her real name was Linda Boreman. The picture was marketed with the poster catchphrase "How Far Does a Girl Have to Go to Untangle Her Tingle?" Perhaps that encouraged a sense of feminist self-discovery, and this was a moment in history when many educated, middle-class women were discovering that they might have an orgasm.

Film historians were not surprised when uglier truths emerged. The picture had cost $50,000 at the outside, and Boreman had been paid just $1,250, money that went to a husband who compelled her to make the film and may have abused her in the process. The auteur, writer-director Gerard Damiano, was supposed to have a third of any profits, but he was forced out of the enterprise with a mere $25,000. How much did the film earn? No one knows, but $100 million seems reasonable, granted that the film was banned in many places and its release was controlled by organized crime figures who may have learned how to fudge attendance income from the film business.

Still, no earlier "dirty" movie had sold so many tickets to respectable people. Even the *New York Times* admitted the film existed, though the newspaper kept its title to *Throat*. The world was shifting again. While it's fair to say that apostles of desire were often let down by the screen's long-anticipated orgy—a lot of us are inclined to fall asleep after an orgasm—the creative pursuit of sexuality was confounded by the onset of pornography and its dwelling on routine climaxes without any moral narrative.

Some predicted that pornography would never reach through our entire

culture. But the technology never knows defeat: it is our cockroach. Porno movie theaters were condemned, harrassed, and closed for years. When Travis (Robert De Niro) takes Betsy (Cybill Shepherd) to a porn flick in Martin Scorsese's *Taxi Driver* (1976), it is a fatal block to their relationship and a sign of his mental disturbance. But when Erika Kohut (Isabelle Huppert) goes on her own to a pornographic movie in Michael Haneke's magnificent *The Piano Teacher* (2001), and watches the image of a woman lying on her back taking an engorged blue-black cock (there is no better word) in her mouth, it would seem that her loneliness or pathology needs that relief if she is to carry on being such a great teacher of Schubert and living with her awful mother. The rift in her being is more convincing than the guilt or regret that Michael Fassbender is carrying in *Shame* (2011). Reports tell us that 70 percent of women in the West have watched pornographic films at some length, while the business generates around $13 billion a year, which is about $3 billion more than theatrical movies now take in America. But porn *is* movies, just like surveillance footage, and movies have always dealt in sexual excitement.

The attempt to isolate "red-light districts" where porn was shown, sold, and enacted seems as quaint now as hoop skirts. In the short age of video stores, there were "Adult" sections, often behind transom doors that spoke of the Wild West. Clerks were not supposed to rent those tapes to people under eighteen, but I have known infants who crawled beneath the transom and had to be retrieved before they had studied too many of the cassette covers. (This was in the era of VHS.) All safeguards fell aside as cable television offered pornographic channels, only for that après 10:00 P.M. delight to be surpassed and censorship ridiculed by the Internet. In July 2011 a search for "hardcore movies" on Google produced fifty million results instantaneously.

Like so much movie over the decades, hard core is sensational but monotonous. You can't credit what you're seeing, yet you can't wait for your chance to get away—it resembles a weekend in Las Vegas, and breeds as many dismayed losers.

Hardcore movies range in length from a minute to over two hours. I have viewed only a tiny fraction of the fifty million, and I am excluding such genres as bestiality, but still I feel confident about the pattern of what I will call heterosexual hard core. There are five actions, or books of the testament: vaginal intercourse, anal intercourse, cunnilingus, fellatio, and what is called the cum shot. The women look like movie women. They are young (the word *teen* is often used in the promotional tag lines

and that gets close to the law; it is illegal to broadcast hard core with people under eighteen). They are frequently very attractive, slender, but with big breasts. The men are not as good-looking, though they are well endowed. Most pubic hair in both sexes has been eliminated—for greater visibility. There is another point about the films that a film critic notices: the anonymous settings are usually very well lit, and shot in high-key photography, and the camera prefers extended takes. There are intricate, probing movements to get a better view. It is not quite Max Ophüls or Kenji Mizoguchi, but the shooting style and its relevance to the action is invariably more fluent and interesting than one finds in today's average feature film.

The women are sometimes called "sluts." The men often talk to them abusively. Occasionally the women seem to be in pain or distress, though this can be hard to distinguish from ecstatic conditions. Characteristically, the women are obedient and imprisoned, the visual centerpiece, but without character, voice, or script beyond the moaned "Fuck!" and "Oh yes!" They seem always on the point of orgasm without quite getting there. The climax of most of the films involves the man withdrawing his cock from extensive fucking of the woman, masturbating, and then spraying his semen on the patient, open eyes and mouth of the woman.

The films are very matter-of-fact. It is important that the viewer believe he or she is seeing something intimate and actual, a record of the action. But the viewer learns that few facts can be trusted. The feelings are simulated or acted out. The female orgasm is invisible and uncertain, so it is not trusted. The male cum shot establishes that the man will not climax within the woman, but upon her. He retains his power and his loneliness. There is also a terrible sense of hollow reality despite the unbroken scrutiny of the filming. The sum effect of it all is to ascertain that sex has sunk to a performed process without meaning or desire. The light is bright. The image is carnal. But the members of the mass are imprisoned by privacy, the essential stance of watching hard core and the realization that movie and its yearning are at a terminal state.

If you haven't, you should see for yourself, and begin to realize why desire's fruition in lovemaking has withered on our screens. But if there is no desire left, why do we look, except to observe the torture and the hell?

•

Desire can take us to the brink of damage and dread. The people watching movies have always wondered how to reconcile the two. In *The Birth*

of a Nation (1915), we watch as John Wilkes Booth (played by the future director of *White Heat,* 1949, Raoul Walsh) prepares to shoot Lincoln. D. W. Griffith took pains to make his set for Ford's Theatre look like the real thing. So there is an inescapable urging from our pained history and our injured innocence to stop Booth from doing what we know he will do. It's like the boy's cry to Harry Houdini in E. L. Doctorow's novel *Ragtime*: "Warn the Duke!" (the archduke, who is on his way to Sarajevo in June 1914). But just as irresistible is the energy that movie suspense has built in us that whispers, "Shoot the gun!"

The violence doesn't have to be physical. There is a film called *Damage* (1992), from a novel by Josephine Hart. David Hare adapted it, and Louis Malle directed it in 1992. I used to think the film was flawed, but I find I can't forget it. Jeremy Irons plays a leading British politician. He lives in a very nice house with his wife (Miranda Richardson). They have two children; one is a pleasant if naïve young man (Rupert Graves) who gets engaged to a curious foreign girl, Anna (Juliette Binoche). Anna is beautiful but icy. She rarely speaks or communicates beyond routine small talk. She is cut off, like a screen, but if you touch the screen, it has scalding erotic fantasy. She will do anything, as a dream, or a nightmare. So Irons has a dreadful affair with her—wonderfully filmed as something devouring but involuntary, like a fatal illness—and the son dies when he discovers what has been happening. There is no need of moral commentary in the film; it would be stupid. The process simply admits, of course, we do damage because we need it as much as we need love.

But if a film like *Damage* teaches us something pitiless and uncomfortable about human and social nature, there are more films that make us wonder how far the separation from reality in the cinema's technology enforces the loss of pity. When the Production Code yielded in the 1960s to change, most of the early attention went to sexual opportunity. But as sexuality seemed culturally disappointing, so the other old taboo, violence, came into its own. And in some crucial and shocking moments, sex and the violence are inseparable.

Sam Peckinpah's *Straw Dogs* was filmed in 1971. An American mathematician, David (Dustin Hoffman), takes his new wife, Amy (Susan George), back to the part of the English countryside where she was raised. (They filmed in Cornwall.) He wants to escape America because of its violence. The wife discovers young men from her youth, who may have romanced her once. They are a building crew repairing the couple's cottage. They lure the husband away on a fool's errand. Then one of the men approaches Amy.

She is stretched out on a sofa—we watch or don't, but what are the movies if we don't watch? Amy protests his sexual advance. She says, "No!" repeatedly. The man pulls off her blouse and removes her underpants. He penetrates her and he fucks her, and in the process she is aroused enough to feel pleasure and to stroke his head. (This may be my reading of the scene, but Peckinpah was usually good enough to deliver his intention.)

After the first man takes Amy, a second man appears and tells number one to hold her down so that she can be unequivocally raped. The twenty-year-old Susan George (thirteen years Hoffman's junior) was cast as Amy, and she knew there was a rape scene in the script. But as the shooting developed, Peckinpah became more intimidating—his own sexual attitudes, his use of drink, and his misogyny were all mixed up in this. He regarded himself as an artist, and in *The Wild Bunch* (1969), at least, he had made a fine picture. But the actress was becoming increasingly nervous: "I dreaded that rape scene . . . Sam kept saying he was going to shoot the greatest rape scene ever put on film. He went on and on about it and he'd be very visual in his descriptions of the things he was expecting, physical things that he was going to film."

In a panic, George went to the producer, Dan Melnick, and asked to have the details of the scene itemized in advance. Peckinpah complained but complied, but his list of actions and humiliations made the actress even more alarmed. She begged for limited nudity and showing things with her eyes. There was a compromise: she shows her breasts but not really more in the week it took to film the double rape. I want to stress that the scene is essential to the story (if you want this story): it motivates a violent, lethal revenge on the crew by Hoffman's husband. The filming is done with hideous impact, and Peckinpah, no matter how troubling, was very talented. But it's naïve to say the scene is done only from the victim's point of view. It shudders with a horrible detachment, a voyeurist privilege, a threshold to inhumanity. It is a chance to see a rape. You cannot miss Peckinpah's curiosity or your own mixed feelings.

But rarely with rapes are huge, unknown crowds encouraged to watch and charged for the spectacle. *Straw Dogs* predates the widespread availability of hardcore movies, and as a scenario, it is more inventive than that genre. As motion picture, it is lit and shot with an intimacy that may be nauseating; there is even music (by Jerry Fielding) that is unnervingly seductive. Still, what makes this scene appalling is its instinct for our predicament and advantage at the movies. Just as once—in Muybridge, Lumière, and Griffith, for example—we noted the sense of miracle and shared wonder in being able to see (let there be light), by the time of

Straw Dogs we are at odds with ourselves as to whether we should be looking.

As soon as that issue is raised, we are into the vexed area of consequence, which applies equally to sex and violence—and even to the larger matter of how we perceive and place ourselves in the world as a whole. In a nutshell, the questions are simple: Does motion picture affect us? How has it lasted a hundred years and more if there wasn't an impact and an imprint? Were we not amused, excited, frightened, and moved? Weren't we entertained? And if we regard it as beyond dispute that people growing up learned more about how to speak and pause and think from the movies, and sometimes came to consider hitherto alien ideas—such as the humanity of blacks, women, cartoon characters, and murderers—then isn't it reasonable to suppose that a sense of story and order has also been communicated, along with notions on how to behave, dress, undress, be violent, and have sex? The possibility of being photographed in surveillance is at the heart of the widespread fear we have about privacy being invaded.

There are those who think hardcore movies may be useful. They allege that this stuff may be watched by solitary, or lonely, people who find relief in the experience sufficient to offset otherwise violent and antisocial impulses. There is no evidence for this theory, so it is hard to resist the implication that sexual and violent energy are related, along with undue loneliness and antisocial urgings. In other words, some deep-seated guilt or dread remain attached to sex. On the other hand, some people may learn useful things about sex from hard core: what to do and how to do it. It may still be the case that plenty of healthy young men and women don't know enough about these things, because the fear or dread is enough to keep it from being a topic of education in schools or in the home. So "Sex Ed" may teach kids how pregnancies occur, but it is shy of recommending pleasure.

Some of us may watch hardcore movies because we derive more stimulation, excitement, or pleasure from screened sex than from the real thing. For this book, at least, I watch them as a historian or a commentator on film, which means that I try to describe the cinematic experience. Just as if I am writing about Ophüls, Renoir, or Welles, that involves the filmic expressiveness of a particular moment.

That's why the structural monotony and the camera's openness in hard core are so instructive, yet so antagonistic. Susan George got off lightly (though I think she felt damaged by *Straw Dogs*, and if you search

for her on the Net, that dire scene is always there). She kept some privacy. She did it with her eyes. And if her Amy yielded for a moment or two, still the character was allowed to be outraged. She was able to signal the nature of the violence, and the condition of her imprisonment. But in hard core the slavery is borne without protest, with a "sexy" smile and a camera as wide open as the woman's orifices. The filmmakers, unseen behind the camera, often ask, "Well, what are you going to show me today?" They make it plain that their process is at our service: we want to see, without being seen. One day soon (with some skillful lighting) there may be a camera inside the vagina for the cum shot, or the bombs bursting in air.

Ah, well, you say, that's just hard core. But the threat and the safeguard of simulation go all the way through the feature films we esteem and enjoy. It is even true in "documentary" that the vaunted truthfulness of film is unreliable. As long ago as the 1960s most of us in the "free world" had seen about twenty thousand represented killings on film and television by the age of twenty without being aware of a massacre. By now that figure must be so much greater, for it was in those same 1960s that screened violence was liberated.

•

Violence and horror date as fast as technology. But at the movies very little is allowed to stand in their way, and we sometimes feel they are in alliance. If a new technology is discovered, a film subject will arise to demonstrate it. So how a thing is done can blind us to what is being done. In 1979, as it opened, my wife and I went to see the original *Alien* (1979). We knew little about it in advance—there was a greater innocence then in the publicity process—and when the creature, a raw, infant version of what was to come, burst out of the chest cavity of Kane (played by John Hurt), my wife got up, told me I could stay if I liked, but she was going home.

I stayed. She was afflicted by nausea, outrage, and the shrewd estimate that, if this happened that early in the picture, what worse sights were to come? She wasn't having a good time. I suppose I was caught in the lofty notion that a film critic and historian wasn't there for "fun." That meant my wife was a truer moviegoer than I was. She was attending to Kane—I knew that John wasn't actually hurt. (Thirty-three years later he's still with us, still looking ravaged.) I could tell myself it was "only a movie," but for my wife, it was an experience and a story in which she was involved. She responded as if she had been there in the room on the spaceship *Nostromo*.

Years later we had a son, Nicholas, and I was writing a book about the four *Alien* films. My son got wind of this and asked if he could see *Alien*. I said, no—he was too young. His mother agreed. This was in the age of the VHS cassette, when a child of his age, more or less, saw whatever his parents decided was fit for him. But he persevered, until one day I said, very well. He would sit beside me on the sofa, and the instant he became afraid, I would turn the video off. What idiots we are to think we can teach people terror—surely it is in the blood. Nicholas's bedroom had a door with a peephole, and he told us much later that he used to lie there in the dark wondering if something was coming through the peephole. He was too brave to tell us he was afraid.

So I showed him *Alien*, in our living room, in the daylight, on a twenty-inch television. As usual, the scuttling, screeching crab broke out of Kane's chest like a kid out of school. Nicholas did not waver. "That's cool," he said. "How did they do it?"

I was reminded of his question a few years later, in 2001, by the film *Conspiracy*, a dramatization of the 1943 Wannsee Conference on the technology of the final solution. Made for TV, the film was written by Loring Mandel (based on the minutes of the conference) and directed by Frank Pierson. It has Kenneth Branagh playing Heydrich, with Stanley Tucci as Eichmann. It is just a group of men in discussion at a table. They don't waste time over whether their solution should be acted on. They know that. But they are passionately at odds over how it can be done. Eliminating several million people is easier said than done—or it was in 1943.

Violence had been nagging at restrictive censorship for several years, and often it went hand in glove with its showier sister, sex. The fusillade at the end of *Bonnie and Clyde* was the outlaws' manifestation of love and orgasm. And that key moment of the late 1960s—working on so many levels that it left an awed hush in theaters—was evidence of the great advantage violence had over sex. When sex arrived, it was contingent on the modesty of the players and on that dismayed discovery that sexual experience was still invisible. But violence would find an expressiveness that started in the province of makeup and then discovered the technological freedoms of the late twentieth century. If you wanted it (and apparently we did), bodies could disintegrate before your eyes. As a physical thing, let alone as a metaphor, it might be more erotic than sex.

For the finale of *Bonnie and Clyde*, Warren Beatty and Faye Dunaway had their clothes wired and loaded with small charges and sachets of

blood that could be timed to give the impression of their being shot over and over again. Then the director, Arthur Penn, elected to slow the motion just a little so the violence and the death were . . . well, what is the word? Prolonged for our study? Made poetic? Rendered as romantic glory?

The preparation of costumes was a feature of Peckinpah's *The Wild Bunch*, along with slow-motion elongations learned from Akira Kurosawa. Some said this was beauty; some wondered if it was the start of a new cruelty. It was not perverse for cameramen to suggest slow motion, or for makeup people to think of blood sachets. It was inventive and professional, and both had been used before, just as the history of movie is full of fights—think of the battles in Fritz Lang's *Kriemhild's Revenge* (1924); or of Canino slugging Marlowe in *The Big Sleep* (1946) and then letting the ball bearings drain out of his hand; think of the prolonged fist fight between John Wayne and Victor McLaglen in *The Quiet Man* (1952; and McLaglen had once fought Jack Johnson in the ring); think of the girl screaming in *Kiss Me Deadly* (1955) after the suggestion that torturing pliers have been taken to her body—no, you don't see more than her bare legs hanging down, like meat on a hook, but try wiping away her screams.

But those were what, in hindsight, we might call clean fights, reliant on what big strong men might do (or think of doing), with the benefit of cutting and stand-ins. Violence built in the 1970s, as technological innovation spread. Was it a prosthesis and some available blood substitute that allowed Roman Polanski to slit Jack Nicholson's nose in *Chinatown*? That was nasty but funny. But the revelation that Noah Cross had raped his own daughter was the kind of plot detail that films had not always permitted themselves. When Cross's daughter, Evelyn (Faye Dunaway), is killed, the bullet goes through her eye socket, and we get a shocking glimpse of the damage. But there is more: at the close of the film, with Evelyn dead, not only is Cross not arrested or put away, but he also has his daughter (or granddaughter) to himself, and he seems to be an unchallenged power in Los Angeles. By the 1970s, film was more wounded or cynical: the wickedness went unanswered (*The Parallax View*, 1974), and dangerous men remained on the streets (*Taxi Driver*, 1976).

In that concluding slaughter in *Taxi Driver*, when Travis kills anyone he can find, the Ratings Board felt too awash in bright blood, and so they asked that the scene be printed "down," not denied but tamed a little. That was a sign of rampant developments in the science of film, or what George Lucas would call Industrial Light and Magic (a company founded in 1975).

Special effects, screen moments in which the imaginary is made visible, are as old as the movies. Welles scratched the film stock to mimic newsreel for the obituary of *Citizen Kane*. At the end of Mizoguchi's *Ugetsu Monogatari* (1953), a crew hustled actors, their hearth, and its lighting into place in the course of an unbroken panning shot to allow Genjuro the potter a few hours in which he could believe the worst damage had not been done. That was a trick; it was art; it was magic, and movie.

There is a moment near the end of *The Godfather* when an assassin breaks in on Moe Greene on his Las Vegas massage table. He looks up and puts on his spectacles to see who it is. In an instant, a lens shatters and blood flows out of his eye. No, they didn't shoot the actor, Alex Rocco, but we wanted Greene dead because of his arrogant treatment of Fredo, and because he was not one of our guys. The panache gets me just as it did at the end of *Red River*, where Tom Dunson comes striding through the herd that Matthew Garth took from him, and he seems insouciant—unless you look through the Western romance to the helpless document of 1947, with John Wayne just a little padded at the midriff, and anxious about the horns his hand flaps at. That's a cheat, too, but it's cheating in the cause of a great illusion.

What troubles me, and what seems to have frightened away so many moviegoers in the last twenty years or so, is the way photography and its attempt to record life have yielded to a range of special effects, building toward computer-generated imagery, and the depiction of people who have never lived as actors or characters—and of their death and destruction. The ultimate conclusion of that great energy and its orgy of simulated killing is in the video game entertainment that has long since surpassed theatrical moviegoing, though it steadily trades upon children's appetite for toys and triggers.

The mise-en-scène of many video games is exciting and compelling. As in some pornography, it consists of a ceaseless forward-tracking shot, attached to some fetishistic weapon, with a flickering subscreen on which a player's score or kill count is advancing. There is an intense concentration on this forward attention and on the shooting that works through a remote-control button. In some games, the elaborate weapon is at the very front of the screen, aimed forward, and it seems to be in our hands. You fire away.

If you're skilled at these games, you can kill a couple of hundred by the hour, and if you're hesitant about the "violence" or feel any kind of

shame, it may help that the victims are generally faceless. The lavish splatter of blood, or red, is something you have to get used to, along with fragmented corpses. The impersonality of the figures is often uniformed and monopolized by weapons, and it's hard to ignore their fascistic character. I don't know what this does to life, much less on any measurable basis. But I know what it feels like and the feeling has to do with dread and the uncanny contradiction that what I am seeing is there but not there, that it is lifelike but as apart as the screen. Kids at play will tell you, "It's only a game," if you protest, but then they boast that the army uses some of these games for training.

TO OWN THE SUMMER

Steven Spielberg has so much more mystery than shows in his still young eyes. I can never make up my mind about him. I watched him recently on television, in conversation with his composer over the years, John Williams. He seemed so young, so earnest, as if he were just beginning. It was hard to remember what a defining success he is, until one looked at the nearly crouched awe in Williams. Spielberg is a phenomenon; it's easier to say that than to work out the components of artist, businessman, and entertainer. I'm sure he'd say they're all the same.

I have enthused over some films of the early 1970s, American and otherwise. These were challenging pictures that were well received by many critics; they altered the way we thought about ourselves and introduced new attitudes to the cinema and what it might be. They were not always cheerful experiences, but they left one excited about film. You could call a film "mainstream" then and expect to have people hopeful about it. *The Godfather* was that kind of show.

Robert Altman's *Nashville* (1975) was attached to the American bicentennial, though without any conventional optimism: it beheld a panorama of liars, freaks, frauds, and crazies and settled for the vague feeling that, despite all the wreckage, perhaps as a country we must be doing something right. It cost $2.2 million and it grossed $9.9 million in that United States. Altman said it didn't really make any money, which means that very little got back to him. Martin Scorsese's *Taxi Driver* (1976) was a psychotic pilgrim's progress in which, thirty years earlier, the loner would have had his desperate fling and ended shot to pieces. Now he was free again, a strange, isolated figure, frightened and frightening, a disconcerting celebrity. That film cost $1.3 million and grossed $28.2 million. Milos Forman's *One Flew Over the Cuckoo's Nest* (1975) had us watch an ami-

able, enlivening rebel whose bumpy mind is flatlined by a drab institution. It cost $4.4 million; it grossed $112 million domestically; and it won Best Picture.

I fear there would be little chance of getting such projects made today in the mainstream of American film. But we are still seeing remakes or duplications of another work from 1975, a milestone entertainment yet maybe a millstone, a brilliant exercise, a model of reassuring disaster: Steven Spielberg's *Jaws*, one of the most influential movies ever made in America.

Spielberg is a decisive achiever in American show business, unrivaled in his record, so close to genius as to be infuriating, and exactly the kind of fellow the business has always wanted to believe in. Not that *Jaws* is simply his film or vision. It was a commercial enterprise. As anyone on the picture will tell you, the shark was a technology and a nightmare (long before computer-generated imagery). Some say it was the hardest film ever made in movie history, and pictures in such jeopardy survive only if the gamblers stay steady and make their own luck. Just because it was business doesn't mean it was businesslike.

Peter Benchley, the grandson of Algonquin Round Table humorist Robert Benchley, had had an idea for a novel about a white shark that terrorizes a resort community. Doubleday gave him a starter advance of $1,000 (it grew to $7,500), and after much rewriting, the novel became an object of excitement. It would not be published until 1974, but already in 1973, Bantam had bought the book for paperback for $575,000. Universal wanted the film rights. An executive at the studio, Jennings Lang, had alerted his boss, Lew Wasserman. They were thinking of Hitchcock to direct, with Paul Newman as the police chief. Then the studio's humble story department read and reported and said they were not impressed. In that clerical gap, the independent producers David Brown and Richard Zanuck (the son of Darryl Zanuck) stepped in and said they'd buy it independently, and let Universal produce. So the studio would have the film, but on reduced profit terms. It was Zanuck and Brown who assured Benchley they would look after the project personally and who made the deal with the novelist: $150,000 and 10 percent of the net profits, plus $25,000 to be part of the screenplay (plus money for any sequels—if they blew the shark up, they'd put it back together again; it was their shark).

Outside the story department at Universal, everyone who read the galleys was fired up, even the young director Steven Spielberg, who had

lifted the galley from Zanuck's desk. But Spielberg seems to have been the first person to read the book twice, and ask himself the awkward question "How on earth, or on water, do you film this?" That's why he was always torn about doing the picture.

•

That summer of 1974, Spielberg was twenty-seven. Born in Cincinnati, he was raised in Phoenix, Arizona, and he had been making "amateur" films since childhood. There is a still of him shooting *Firelight* (1964, a two-hour effort, on 8 mm) at the age of seventeen—staring past the tiny Bolex camera at his actress—that is the epitome of the narrow intensity of a film-mad kid with a one-track mind. Anyone who has taught film knows the look, and realizes that it is both awesome and alarming.

Under an early contract with Universal, he had made a television movie, *Duel*, in 1971 (it was later released in theaters), that is a perfect diagram (with terror) and a sign of what was to come. Dennis Weaver is an innocent motorist on a desert road pursued by a malignant truck. The irrational menace comes from horror films, but it is also part of being a kid in the atomic age, when demons may lurk in the desert. *Duel* earned him promotion, and in that summer of 1973, Spielberg was doing *The Sugarland Express* (1974), another film about transportation, at Universal for Brown and Zanuck. It is the story of a young mother (Goldie Hawn), just out of jail, who frees her convict husband and then kidnaps a cop in order to rescue their baby from an adoption home. Involving an immense police pursuit, the film is a triumph of informational logistics, and a tragedy— the husband will be killed, the baby cannot be freed, the woman is devastated.

The Sugarland Express had excellent reviews. Pauline Kael called it "one of the most phenomenal debut films in the history of movies," but the film did poorly, and left Spielberg very disappointed. The look on his face in that still photograph was not ready for critical glory without a pay-off. That's why Spielberg is so instructive: he has always wanted to be a comprehensive American success, and never seemed to notice how that commodity might turn suspect. So he was not obvious casting for *Jaws*. Lew Wasserman was surprised when Brown and Zanuck proposed the kid. He thought that *Sugarland* had been a "downer," and bosses mistrust that gloomy tendency in young talent. It can be a sign of doing a project for its own sake—the fatal kiss of privacy. So John Sturges (*The Magnificent Seven*, 1960; *The Great Escape*, 1963) was talked about as director,

but he may have been put off by the producers saying they thought *Jaws* was just a small picture, doable for $1 million. Despite the producers' backing, Spielberg was uncertain. He said he didn't want to get known for just trucks and sharks. He had liked the Goldie Hawn character in *Sugarland*. He had a wide sentimental streak, but Wasserman told him that in casting Hawn, he had set the audiences up for the lovable kook from *Rowan & Martin's Laugh-In*, a woman who'd end up happy. Spielberg had decided he didn't much like the characters in *Jaws* (there was romantic and sexual betrayal in the book), and was ready to side with the shark. You can feel that in the opening sequence, when the shark goes at the skinny-dipping kid in a way that releases our energy.

When you know how *Jaws* the film turned out, it's hard to grasp how nearly it foundered. A very young director, without a hit, was allowed to extend the schedule from 55 days to more than 150, and the budget from $3.5 million to close to $12.0 million. He thought he was going to be fired. He wanted to quit. The elaborate work to build and control a mechanical shark (named "Bruce") produced insoluble problems. In the script (by Carl Gottlieb and Benchley, but with other hands enlisted), there was a climactic scene where the shark was meant to leap out of the water and crush the boat. The production controller, William Gilmore, recalled:

> The shark was supposed to come out of the water with tremendous energy. Take one was no good. The shark came out of the water kind of like a dolphin walking along the water and fell on the boat. We assumed it was a rehearsal and that the second take was going to be better. It wasn't. The shark sort of came up like a limp dick, skidded along the water, and fell onto the boat.

That scene never happens in the film, of course, and that's part of why the schedule was tripled. At one point Spielberg resolved that a lot of the time we need not see the shark (because "Bruce" couldn't act and couldn't be engineered). He called that going "the Hitchcock way," doing it by suggestion. To this day, the possibility remains that the crew came back from the shoot off Martha's Vineyard with a mass of shaky material that was then made into a movie by the editing of Verna Fields (she was raised to be a vice president at Universal after *Jaws*), by the throbbing underwater menace delivered in the score by John Williams (the closest we get to the shark's mind), by the perseverance of Brown and Zanuck (and Wasserman),

and by Spielberg, of course, who may have felt lost on many occasions but who proved an indefatigable learner.

At the level of vivid comic book characters, Richard Dreyfuss and Roy Scheider gave astute performances, while Robert Shaw made an authentic cliché sea dog (in the school of Robert Newton's Long John Silver) out of Quint. Quint is half man, half sea creature, and in his long speech on the sinking of the *Indianapolis* in 1945 (originally written by John Milius, but rewritten by Shaw himself), *Jaws* comes the closest it will get to human interest. Quint must die—but he knows it. Otherwise the film is about mechanical triumph, suspense payoff, and "mission accomplished," a phrase that will grate one day, though it suggests how many presidents learned leadership at the movies. The jubilation of the survivors at the end of *Jaws* comes from the ethos of comradeship in Second World War films. George W. Bush was honorably discharged from the Air Force Reserve in 1973.

There were great doubts over the picture; there always are—making a picture can be a matter of ignoring or defying them. Spielberg would tell the press, "It's a disaster movie only if it doesn't make money. Then it's a disaster." Peter Benchley had seen or heard enough of the script and the filming to share misgivings with the *Los Angeles Times*: "Spielberg needs to work on character. He knows, flatly, zero. Consider. He is a twenty-six-year-old who grew up with movies. He has no knowledge of reality but the movies. He is B-movie literate. When he must make decisions about the small ways people behave, he reaches for movie clichés of the forties and fifties."

There was one of the first warnings about the generation of young directors who had been to film school, or only to the movies all their life— was it possible they knew too little to deal with human realities? If so, there was an available answer poised: delete the complexity of the realities. Spielberg had impressed Zanuck and Brown with his skill and zeal, but also because his inexperience in life kept him in synch with the young audience they anticipated. So be it, but the contrast with what Orson Welles knew and felt at twenty-six (his age when *Kane* opened) is hard to avoid.

Jaws was previewed in Dallas on March 26, 1975, and the reaction was so intense that the Medallion Theatre decided to put on a second screening later that night. The audience screamed when they were supposed to; they laughed at the right moments. The shark worked at last. Robert Shaw had guessed this: his salary was up to $300,000 by then with overages, and he offered to trade most of it back for just 1 percent of the profits. Brown and Zanuck were tempted, but their nerve held.

Two days later, there was a second preview in Long Beach. The reaction was the same. Co-screenwriter Carl Gottlieb was there in the men's bathroom at the theater when Lew Wasserman; Sid Sheinberg, the president of Universal; Henry Martin, in charge of sales and distribution; and Charles Powell, publicity and promotion, decided how they were going to handle *Jaws*. Instead of opening in just two cities and a few theaters, Wasserman called for massive television advertising ($700,000 worth) just before and during the opening weekend and going out into maybe eight hundred theaters. This was not entirely original, but it was the sort of plan that smelled of distributor anxiety and an attempt to forestall review damage. David O. Selznick had done it with *Duel in the Sun* in 1946.

Something tempered the first enthusiasm for outlets, so *Jaws* opened on June 20 in 409 theaters in the United States and grossed over $7 million in its first weekend. That was astonishing. But schools were just out, and the kids were going to the beach anyway. Spielberg had cut or adjusted some horrific moments to get a PG rating instead of an R. What was more startling was that the box office doubled in the second week. (That sort of surge never happens today.) By June 29 the figure stood at $21 million. A week later (after the July 4 holiday) it was nearly $37 million. The film was in profit already. By early September the number was $124 million, surpassing *The Godfather* as all-time champ. Its first run, domestically, would settle at $260 million, with a worldwide gross of $470 million. Just before the film's release, Brown and Zanuck gave Spielberg 2.5 percent of the net profits—his original deal had had no points and a modest salary.

The reviews were in disagreement. In the *New York Times*, Frank Rich said, "Spielberg is blessed with a talent that is absurdly absent from most American filmmakers these days: this man actually knows how to tell a story on screen." But Molly Haskell in *The Village Voice* complained, "You feel like a rat, being given shock treatment." Decades later, in a rhapsodic monograph on the film, the English writer Antonia Quirke said, "Right before our eyes Spielberg is inventing the almost aggressive purposelessness of his Indiana Jones mode. *Jaws* is perhaps the most tonally comprehensive thriller ever made—sheer exhilaration at lacking an agenda or a subject in any classical dramatic sense. The film is sometimes nothing more than a dance to music. Spielberg never meant anything really. But neither did Fred Astaire."

Spielberg would have winced at the suggestion that he "never meant

anything really," just as he was aggrieved to be left out of the Oscar nominations for Best Director (the film won only for editing and music). He claimed that as *Jaws* earned more money, the Academy lost interest in it—but that had never happened with *The Godfather*. If anything, the Academy may have learned to ignore "Steven" when they saw how much that irritated him. He didn't get an Oscar for directing until *Schindler's List* (1993), a film loaded with agenda and meaning, on which he took no salary.

Still, Quirke has a point. There are so many matters about which *Jaws* is not interested: the sea, the people in the community, the shark, the idea of corruption in the town. Even the danger is spurious. (Spielberg may have gone mad making it work, but you know he doesn't believe in this threat any more than he believed in triceratops in *Jurassic Park*.) All these elements are sketched in instantly and never developed any more than the characters. Quint is harsh and intimidating. Brody is afraid of the sea. Hooper is cheerful. The shark isn't. (Yet what does the shark want?) These are figures in a dance where the thing Rich calls storytelling flattens everything into action. But what is story without character or moral consequence? "Agenda" can be an offputting word, but why should "meaning" be rejected? You cannot see *Taxi Driver* without asking who Travis is and what has made him. Roman Polanski had identified what we treasure in *Chinatown* by insisting on the defeat of Jake Gittes. But when you see *Jaws* you are gravity-free, and just as entertained as if watching a *Tom and Jerry* cartoon. You lose Quint, but who cares? You're asked to watch the screen and its plasticity, and not the quality of life that may exist within the screen. We are wowed, but are we engaged? The notion of "roller coaster" movies came into being around this time, and it's provocative: on a roller coaster you are caught up moment by moment, physically and nervously, and afterward you are agog with incoherent talk about it. But part of the fun is that the commotion meant nothing. The sensation eclipsed sensibility.

There was no industrywide conference to confirm or enact the principles of *Jaws*. But there didn't need to be. So much had been demonstrated: the potency in opening wide, and then wider (like three thousand screens? four thousand?); the opportunity of the summer season for kids at liberty, and the chance of their becoming repeat viewers; the whole economy of a blockbuster film that could suck its money in so fast; the combination of great danger or adventure without any lasting "downer"; the possibility that audiences were ready to see and revel in things that

could not happen in life—and still take the illusion seriously. Plus the outline of franchising, of taking a situation and repeating it until there was no one left with patience. Give them something they know they like—make it like fast food.

The movies had always been on to that trick. The comics, silent and sound, did the same routines over and over, from Chaplin and Keaton through the Marx Brothers and Hope and Crosby to Dean Martin and Jerry Lewis. But with the comics we forgave that sameness because we enjoyed the personality of the comedians. The impetus within franchising is the reliable situation in so much television—the sitcoms, the Westerns, the police stories, the family shows. Always the situation endures, like the pitch in the advertising that held such shows in place. That is an endorsement of security in worrying times, just as it is an avoidance of drama or resolution. Because television had set up the precept that the show was so consistent, we didn't need to watch every week or every minute. You could leave the room for a few minutes, come back, and know where you were. Our attentiveness had been compromised. It was a covert message—and the messengers didn't need to be aware of it—but we were being told we didn't really have to watch. Who cares if we're there so long as it is "on"?

In the next decades, this tendency would receive exponential encouragement from movie systems that photographed things that never could happen: computer-generated imagery. A mechanical shark need never be such a trial again. Well, you may say, *King Kong* (1933) could not have happened, not on Skull Island or in New York. But if you put *King Kong* and *Jaws* in the same sentence you have to feel the naïve poetic impulse that inspires the earlier film, and the cold-blooded detachment in *Jaws*. People do care about the ape. *King Kong* trembles with shaky effects. *Jaws* is as smooth as its cutting, but smoothness can kill emotion. Kong is a tragic character. He has his inappropriate desire, while the shark is just a streamlined source of energy, a convenient killer, a current in the sea, a vector in the game.

•

As I write, Spielberg is nearing sixty-five and coming up on one more of his busy seasons: in the same month, he will release *The Adventures of Tintin* (his first animated film) and *War Horse*—it reminds one of the even stranger concurrence, when he was doing *Schindler's List* and *Jurassic Park* in the same year. This is more than talent, prowess, energy, opportunity,

and the clout that meant all those films would hang upon his decision. It's more that his imagination has taken on the versatility of the movie screen: it can play anything, and follow it with anything else. It's as if Beethoven were doing the Eroica Symphony *and* "Have Yourself a Merry Little Christmas" at the same time. Not that *Schindler's List* and *Jurassic Park* are in those same classes. Am I old-fashioned in being so shaken by the contrast or the clash?

This turns on the possibility of creative character. If you look at the body of Alfred Hitchcock's work, there are missteps, follies, sidebars, to be sure, but what drew attention and admiration for Hitch was the inability to shake off some motifs: suspense, voyeurism, guilt, fear. I have tried to describe those things at work and suggest that Hitchcock himself became distressed by them. He did not float in air alongside his films. They were business entertainments, but his mind emerged from them.

It would be going too far to say that Spielberg has none of that. He has his motifs: success, children, stylistic impersonality, and being exemplary. Long before the fascinating and often heartfelt adventure of DreamWorks, a new studio, made in partnership with Jeffrey Katzenberg, an executive from Disney, and David Geffen, an entrepreneur in music and recording, Spielberg had been a sustaining executive producer or godfather for so many people and ventures. That list is larger than the roll of films he directed, and it includes *Back to the Future* (1985) and *Who Framed Roger Rabbit* (1988; both by Robert Zemeckis); TV series such as *The Pacific* and *Band of Brothers*; the two Clint Eastwood pictures *Flags of Our Fathers* (2006) and *Letters from Iwo Jima* (2006); and the recent *True Grit* (2010, by the Coen brothers) and J. J. Abrams's *Super 8* (2011), which is a gesture of tribute to Spielberg's own beginnings in moviemaking.

With or without DreamWorks SKG, Spielberg has been a studio or a house. Can anyone conceive of American pictures since 1970 without him? You can describe that in terms of a net worth of $3 billion or in a list of all his awards. It could be offered as an example of wanting to be a huge entertainer and a prophet of our nature and our history—that's the shift from *Jurassic Park* to *Schindler's List*, or from *E.T.* to *Poltergeist*, credited to Tobe Hooper but guided by Spielberg and one of the most alarming visions of kids disappearing into a television set. He can do action at a level that seems matchless—the main story of *Schindler's List* and the battles in *Saving Private Ryan*—but then he can spoil those pictures with

the underlining that gives us the girl in the red dress in Kraków and that asks Ryan to earn the sacrifice made for him.

Is it youthfulness that cannot quite trust his own work or our response? Is it his fear of our stupidity? Is it even something like the lack of experience Peter Benchley noted as he looked at *Jaws*? The motif of childhood never goes away, and it is the core of his best film, *Empire of the Sun* (1987), in which the boy Christian Bale is the young J. G. Ballard captured in Shanghai as the war begins and struggling to endure in a Japanese prison camp. That is a film in which the balance of history and one boy's life is eloquent and unforced. (Tom Stoppard did the script with uncredited work from Menno Meyjes.) In any measure, it is a film about life, loss, and the capacity to equate the two. There is nothing childish in the regard for the boy; it's a film for grown-ups.

There is a similar gravity in other films—*Munich* (2005), *A.I.* (2001), and even *The Terminal* (2004), a fine, neglected comedy. And yet I cannot forget or see past the determined youthfulness in Spielberg himself, the urge to live up to the oldest models of movie entertainment and to play dazzling games in which nothing is more real or holding than it was in *Jaws*. Call it the drive to make great shows that are about nothing except letting the light play on the screen for a couple of hours and keeping the faces of the audience as open and exalted as the faces in *Close Encounters of the Third Kind* (1977) whenever they face the light. When he made that film, Spielberg was asked if he believed in UFOs and he said no, but he believed in people who believed in them. So *Close Encounters* can be read as a film about the movies themselves and the wonder that light casts on a watching face. If ever you doubt the movies, look at the faces watching the screen.

Spielberg is what Cecilia, the narrator of Scott Fitzgerald's *The Last Tycoon*, calls "a marker in industry." (Talking in 1940, she names Edison, Lumière, Griffith, and Chaplin, as well as Monroe Stahr, as the select group.) It is touching how old-fashioned Spielberg's attitudes are in a medium of accelerating technological renewal (most of which he has embraced). But does his celebration of a few children and the childlike compensate for the way he represents a culture that has resolved to be childish? No matter the patronage he has offered to other filmmakers, I wonder what he thinks about the erosion of the mainstream entertainment movie. No one has done more to defend the standard of the "movie" as it was being made when he was born (in 1946). Is he Indiana Jones or Schindler? Well, he has tried to be both. Anyone aiming at the audience

wants everyone. But his country and his culture have made the other choice, of going with the unattached, floating myth and adventurous élan of Indie. And surely the maker of *Schindler's List*, who claimed that film was a turning point in his own education and his Jewishness, must know that some decisions lead to catastrophe.

In December 2012, if all goes according to schedule, Spielberg will release *Lincoln*. In making that film he has used the book *Team of Rivals*, by Doris Kearns Goodwin, and a screenplay written first by John Logan and Paul Webb, and then by Tony Kushner. I am reminded of John Ford's *Young Mr. Lincoln*, which opened in June 1939, on the eve of cataclysm, and I daresay at Christmas 2012 there will be uncommon need for a "Lincolnesque" film, fit to play at the White House and to chain gangs in remote parts of the country. I cannot believe that Spielberg will do anything but an accomplished and inspiring job. Still, if he is to dig into the heart of people and their society, I suspect the venture may depend more on Daniel Day-Lewis as Abraham Lincoln. For somehow the great and saintly man has to speak to the harsh and insufferable competitiveness in Day-Lewis's Daniel Plainview in Paul Thomas Anderson's *There Will Be Blood* (2007).

BRAVE NEW NORTHERN CALIFORNIA WORLD

In the 1960s, despite the social and racial turmoil in America, despite assassinations and the wound of Vietnam, it was possible for young men in love with the movies to believe an extraordinary opportunity was coming into their possession. Perhaps the movies belonged to them. This led to an experiment in Northern California that inspired film kids across the country and substantially altered the medium. For a moment, at least, these "brats" could believe they were in charge, riding into the future on new technology and economics. Then an older truth sank in: that the technology had been riding them.

George Lucas was born in 1944 in Modesto in the Central Valley of Northern California, a plain agricultural town, a node on the truck blast of Route 99, about midway between Yosemite and San Francisco, but culturally remote from those beckoning places. The son of a stationer, George was raised in Modesto and he loved fast cars, new music, and hanging out with the kids, all of which can be seen in what is still his most personal and enjoyable picture, *American Graffiti* (1973). He made amateur movies as a teenager and he managed the transfer from junior college to the University of Southern California in 1965, when it was the oldest film school in America, with a heavy stress on production. He made friends at USC with people such as John Milius and Walter Murch, the latter born in New York in 1943, the son of a distinguished painter, a young man drawn equally to sound, poetry, literature, and filmmaking. In addition, Lucas met Steven Spielberg, who was an apprentice director at Universal (and George's junior by two years), and Francis Coppola, five years older, who had gone from Hofstra to the University of California at Los Angeles and who had already won a reputation as an inventive filmmaker and a natural leader working on very low budgets.

Lucas rose from being a poor student to a star, and he won a competition that offered the prize of observing the making of a proper film—it turned out to be Coppola's production of *Finian's Rainbow* (1968), with Fred Astaire and Petula Clark. It's a bad film, but those can be as educational as the good ones. Lucas was an uncredited production assistant, and he took on the equally vague "production associate" position on Coppola's next film, *The Rain People* (1969), a road picture that ended up in the Bay Area with a concerted group feeling that it might be healthier for young film people to stay there rather than go back to the graveyard of Los Angeles. In the late 1960s it was tempting for artistic kids to see San Francisco as a waiting haven. The Beat generation was a living memory. The city also had the charm that the West Coast had exerted on New York filmmaking in the earliest days—out of sight, out of mind, a place where the new boys could make their own rules, and perhaps reinvent Hollywood. The city was shaking with unprecedented music.

The new empire sprang to life: in a few years, in an amazing burst of activity, Coppola had delivered the two parts of *The Godfather* and *The Conversation* (1974). Only the latter was actually shot in the Bay Area, but Coppola adhered to his own ideal, took up residence in the city, and used Walter Murch as a key craftsman who led the trend toward enriched sound—no longer just talk and music, but an inner atmosphere. (*The Conversation* could be called a film about sound, and most of its postproduction was carried out by Murch as Coppola turned to the second *Godfather* film.)

Meanwhile, Coppola was doing all he could to help make a career for his associate George Lucas, who was as reserved as Francis was gregarious. This dark or shy side of Lucas was evident in his first feature, *THX 1138* (1971), a piece of paranoid science fiction that was a gloomy enlargement of a short Lucas had made at film school. This was made for Coppola's company, American Zoetrope. Coppola was executive producer, and Walter Murch did the sound montage. But the film found no reliable audience, and Lucasfilm, the company George had set up in 1971, was foundering.

Then, in friendly competition, Coppola challenged Lucas to make a mainstream picture (like *The Godfather*) that might establish his career. Lucas went back in his imagination to the world of Modesto, cars, kids, and girls. Doing most of the writing himself, he came up with *Another Quiet Night in Modesto*, or *American Graffiti*. Several studios turned it down, despite the current fashion for films by and about kids. But Univer-

sal agreed to take it on at $700,000 when Coppola said he would function
as producer. Lucas shot some in Modesto and mostly in San Rafael. He
close-carpeted the movie with jukebox music of the 1960s and made disc
jockey Wolfman Jack into a mythic guru figure. Walter Murch ran the
sound, and George's new wife, Marcia Lucas, was the chief editor. The
cast was made up of kids from TV or about to become household names
in the shows that spun off from *Graffiti*. Compared with another road
film, *Easy Rider* (1969), or some of the strikingly radical (or alarming)
films of 1973 (*The Exorcist, Mean Streets, The Long Goodbye*), *American
Graffiti* was sweeter, less threatening, and closer to the ethos of network
television. It had a relaxed feeling for how tense and anxious kids can be.
All the actors seemed to believe they were getting their big chance, and
the cast included Richard Dreyfuss, Ron Howard, and Harrison Ford.
Late in the day, Universal felt the film might work and threw in some
marketing money. Nevertheless, as it opened in August 1973 (another
summer picture), production and promotion had reached only $1.25 mil-
lion. Then the film grossed $55 million, a figure that has passed $250
million in time with rerelease revenue and video rental income. It was a
kids' film, with prospects of sexual adventure and the shadow of Vietnam
hanging over the young men (the end titles tell us that one character was
killed in Vietnam while another went to Canada). But it was wholesome
fun fit for the parental generation, set in 1962 and uncritical of the rela-
tive innocence of that time. *American Graffiti* was actually a good deal
less foreboding or anguished than *Rebel Without a Cause* (1955), and it
shows how securely Lucas was formed by an earlier age and its cinema.

Universal had given Lucas a two-picture contract, for *American Graf-
fiti* and something called *Star Wars*. No matter the success of the first
film, the bosses at Universal could not envisage what *Star Wars* would be,
as Lucas struggled to write it and to work out the array of special effects
that would be required. The project was hanging in the balance, even if it
was about to reshape the art and the business. Universal faltered, but
Twentieth Century–Fox said it would take on the venture. It was scared
of science fiction and wary of Lucas and his taciturn demeanor, so it
agreed only to a development deal, with step payments that exposed
Lucas personally to his debts from *THX 1138*. Nevertheless, Lucasfilm had
the insight to insist on retaining the merchandising rights for the film—
toys, T-shirts, games, food and drink, whatever you could think of—
rather than ask for more upfront money. In time, industry analysts would
decide that was the worst deal a film studio had ever made (though there

is intense competition). Such residual sources of income had hardly been appreciated in the golden age. The first significant awareness of toys, clothes, and souvenir memorabilia came with the television show *The Adventures of Davy Crockett*, which played suitably in 1954, when George was ten.

Star Wars (1977) had many sources: it was a return to Saturday morning adventure movies, serials with cliffhangers; it was in awe of the majestic imaginings in Kubrick's *2001* (1968), yet it had been raised on the television coverage of space shots in the 1960s and '70s. This was an era in which NASA and Apollo were fixtures on television. Later on, it would also be proposed that Lucas was inspired by the anthropological writings of Joseph Campbell. More important was his readiness to take off into a new realm of special effects.

Lucas had been dismayed in his deal with Fox to learn that the studio was closing down its special-effects department. Yet he envisaged countless scenes such as no one had ever seen before. He assigned John Dykstra (an assistant on *2001*) to begin experimenting in Van Nuys, but this was only the prelude to a new culture in which photographic methods would be increasingly harnessed to the computer. In 1975, while working on the film, Lucasfilm founded a new operation, Industrial Light and Magic, which would soon move to Marin, north of San Francisco, at what would be called Skywalker Ranch, begun in 1978 at a cost of $100 million.

Another seedbed had been George Lucas's great talent for making money, which should never be overlooked in celebrating the artistic pursuit. So *Star Wars* was an untidy mixture of vision, confusion, and opportunity. It overcame its own childish dialogue, the problems in making the effects look polished, and the oddity of its young cast: Harrison Ford, Carrie Fisher, and Mark Hamill. Plus R2-D2 and C-3PO. Plus Alec Guinness and James Earl Jones—the early plan was Orson Welles as the voice of Darth Vader, but it was felt that he was too identifiable.

Star Wars, the first film, was released on May 25, 1977, after it had gone considerably over budget ($13 million finally) and driven Lucas to the point of nervous collapse. The hesitation on the part of Fox can be felt in that the film's U.S. opening was at only forty-three screens. Never mind: the eventual American gross was $460 million; the overseas added $314 million. In the future, *Star Wars* would build to a series of six films (with a worldwide gross of $4.2 billion, which does not count the merchandising revenue). The first two sequels came in 1980 and 1983, *The Empire Strikes Back* and *The Return of the Jedi* (directed by Irvin Kersh-

ner and Richard Marquand, respectively). They did extraordinarily well, though not as well as the original.

But those first three *Star Wars* pictures set new standards in the dream of futuristic combat, the creation of characters that came from robots or animated films, and the mass of associated merchandising. If you were the right age at the right time (say ten in 1977), then these are your movies forever. They were also the basis of a new industry founded on a series of films (a franchise), a complete world of special effects, and an approach to story that began and ended in adolescence. In addition, along with *Jaws*, the *Rocky* films, *Animal House*, the films of John Hughes, and the *Indiana Jones* pictures, the industry regained confidence in entertainment for a certain "demographic," the age range twelve to twenty-four. Moreover, the industry was now a collection of conglomerates that saw movies not just for their own sake but as material that would serve their other electronic arms—for a time that meant video, but so much more was to come. *Star Wars* set the bar higher. If you were going to make a film, why not a blockbuster? It's the fallacy of Las Vegas again, and a mood in which the production of small, challenging pictures for grown-ups would become harder and harder to maintain.

Though not perceived at first, the frantic action in these films, allied to special effects, was a harbinger of the return of animation. If a movie was "animated" (as in very lively), with fast cuts, popping sound effects, and surface-deep characters, all thrown together in furious action, wasn't that a way of defining movie animation? And wasn't the animated film a medium that could only stress the worked-over flatness of the screen? Once again, the illusion or hope of reality was being pushed back into the past.

Through the 1960s and '70s, Disney had gone into decline: the old animators were passing (Walt died in 1966), and it was thought that cartoons were just for television and Saturday mornings. Disney made a lot of live-action films, and one masterpiece that mixed live action and cartoon, *Who Framed Roger Rabbit* (with Spielberg as a coproducer). But animation was about to be revivified.

This was stimulated by the adjacency of Lucasfilm and the electronics industry, just fifty miles down the peninsula, in the area known as Silicon Valley. Apple was founded in 1975. It was in this symbiosis that movie recognized the possibilities of the computer in saving time and money, and then in allowing a startling range of new effects. The most decisive figures in modern moving images have been not Lew Wasserman, the team that comprised DreamWorks, or the agent turned executive Mike Ovitz,

who seemed central and supreme for two decades, until he was gone. It was Steve Jobs and the other innovators who have altered our scope of seeing and communicating, and with it our contact and contract with reality.

In 1979, Lucasfilm formed a small section of itself to explore animated features. It was called the Graphics Group at first, and the mood of their eventual films shares a lot with the feelings in George Lucas's first films, though what became Pixar has a faith in warmth and moving us that would have made Frank Capra smile. The *Toy Story* pictures are state of the art, but their sentiments and values go back to the 1950s, when Pixar's creative leader, John Lasseter, was born—and the audience insists on loving the stuff. *Toy Story 3* (2010) grossed $1 billion worldwide— sooner or later Pixar is going to break the Academy's resistance to animation and win a Best Picture Oscar.

With regret and abiding affection for its people, Lucas sold away Pixar to Apple and Steve Jobs for $5 million in 1986. It was a deal to put beside his original merchandising coup on *Star Wars*. In 2006, Pixar was sold to Disney for $7.4 billion. Under Jobs, and with his encouragement, Lasseter was freer to develop computer animation. *Toy Story*, in 1995, conceived and made at the Pixar headquarters in Emeryville (also in the Bay Area), was the first computer-generated animated movie.

Between 1999 and 2005, George Lucas turned to three more *Star Wars* movies (a trilogy of "prequels" in the saga) with a new and joyless cast and titles it's hard to remember. The credits say Lucas directed these films, but with increasingly sophisticated effects and diminishing narrative energy. The next generation of kids and their young parents assured the world that they were happy with the "new" *Star Wars* pictures, and huge sums of money were made. But can the honest moviegoer detect a director? The second *Star Wars* series treated us like huddled and automatic consumers: they reduced movies to the level of fast food, filling stations, and those ads that are so familiar we chant along with them.

Lucas has vast premises now in Marin and San Francisco. Industrial Light and Magic thrives; that name is one of his most impressive strokes and the appropriate latest description of what we once called cinema or movies. With a net worth of over $3 billion, Lucas is a great entrepreneur, and a marker in industry—which is fine. Alas, his career and his contented lack of personality have also changed our expectation about the directing of films.

•

So in the San Francisco area in the mid-1970s, American film appeared to be having its renaissance, and a lot of people behaved like princes. Lucas, Murch, and Coppola all came to live in the Bay Area, where they attracted other filmmakers, every hopeful kid and his script, and sophisticated postproduction houses that helped develop the new technologies. Industrial Light and Magic grew, but Coppola had the Zoetrope building or buildings in North Beach, and Saul Zaentz (who had produced *One Flew Over the Cuckoo's Nest*) adapted his recording company, Fantasy, into a base for *Amadeus* (1984) and then, later, *The English Patient* (1996). Philip Kaufman (born in Chicago in 1936) came to Northern California, where he did a witty but frightening remake of *Invasion of the Body Snatchers* (1978) before using the hitherto unnoticed location resources of the area, and a lively young cast, to make *The Right Stuff* (1983), a merry mix of Hawks and Preston Sturges, an affectionate satire on American glory, but a film that was ahead of its audience, in part because one of its chief characters (John Glenn, played by Ed Harris) was also trying to be taken seriously as a presidential candidate.

Francis Coppola was the center of all this: after the *Godfather* films, he had Oscar glory and a lot of money; he spilled over with reckless creative ideas; he had a flamboyant, nearly manic-depressive energy; he was an inevitable godfather himself. So he did everything he could think of. He started a magazine; he produced operas; he opened restaurants; he gave parties; he planned a resort in Belize; and he enlisted for special projects Tom Luddy, a Berkeley graduate, a movie theater manager, and then the innovative program director at the Pacific Film Archive. It was through Luddy that Coppola became host to so many foreign directors and their projects. So Zoetrope produced the restored version of Abel Gance's *Napoléon* (1927). It opened and promoted Hans-Jürgen Syberberg's *Hitler: A Film from Germany* (1977), and produced movies as varied as Carroll Ballard's *The Black Stallion* (1979, a true family entertainment) and Paul Schrader's *Mishima* (1985, avant-garde and banned in Japan). Further, the wrecked Nicholas Ray was given space at Zoetrope as he tried to complete his experimental psychodocumentary *We Can't Go Home Again* (1976).

As for Coppola himself, he took on the project of Vietnam, though that scheme had been initiated by others—by Lucas and John Milius— before it became the great white whale for Francis to pursue. It was a film that could not have been undertaken without the business's respect for the man who had made *The Godfather*, or without Coppola's own creative

daring. But it was beset by disasters, as if it were a warning not to trust open-ended foreign ventures. Coppola decided to shoot most of it in the Philippines, where bad weather, the vagaries of local army support, and mounting costs added to the director's uncertainty over what to film and what *Apocalypse Now* might be "about."

At the eventual Cannes opening (where the film won the Palme d'Or), Francis would say, "It's not about Vietnam, it *is* Vietnam." That was exhaustion speaking, and a sign of filmmakers going overboard in self-concern. Vietnam *was* worse than the movie. Far worse. Still, Harvey Keitel had to be dropped for Martin Sheen. Marlon Brando turned up for work as Kurtz out of shape and apparently unaware of the Joseph Conrad material, *Heart of Darkness*. He wanted to discuss the part while Francis was striving to find a way of filming his great hulk. Coppola wondered if he was losing his mind, his nervous control, his picture, and even his family. His wife, Eleanor, published a diary book on the ordeal, *Notes*, one of the most poignant accounts of what people risk in making any movie. Here is her entry for April 8, 1978:

> This morning I asked Francis what his inner voices were telling him to do. He said they tell him to do nothing, don't push, don't act, just wait. The complete opposite of the way he is used to being. He said he was afraid that his voices were telling him to be alone, with no one in his life. He said, "Can't you see how scared I am, Ellie? You are saying, 'Hurry up and define our marriage, I'm not waiting much more.' United Artists is saying, 'Hurry up and finish the film, we can't hold off the banks and the exhibitors much longer.' And part of me is saying, 'Just tough it out, don't make some quick resolution in order to get off the hook.'" He said the more he works on the ending, the more it seems to elude him, as if it is there, just out of view, mocking him. He said, "Working on the ending is like trying to crawl up glass by your fingernails."

Well in advance of its opening there were hostile press stories about the imminent disaster—there was by then a backlash in the media against the brilliant but arrogant kids who seemed to have taken over film. *Apocalypse* was confused, and it was hard to believe that Coppola himself had a clear or settled version of it. But it had breathtaking sequences (for example, those involving Robert Duvall as Colonel Kilgore, and in the feeling of a jungle growing on blood and drugs), an authentic sense of horror,

and an aura of America's imperial decay. (In 2001 it looked a better film still when Coppola released *Apocalypse Now Redux*, a restored version, with several scenes that had been dropped in 1979.)

As a person, Coppola was troubled yet volatile. He seemed to have established a Northern Californian alternative, yet he nursed dreams of taking over a new Hollywood. So he moved to premises in Los Angeles to make *One from the Heart*, a deliberate throwback to the studio look of the 1940s. It is exquisite and well worth seeing, with color photography by Vittorio Storaro, gorgeous sets by Dean Tavoularis, a haunting score by Tom Waits, and the overall influence of Michael Powell, who was now director emeritus at Zoetrope. As a modest $2 million aside, it might have seemed a wonder of charm and pure cinema. But at $25 million and with more bad publicity over excess and mania, it was a disaster that plunged Coppola into debt. Few crazy indulgences or shattered budgets offend America as much as those in the arts.

Soon after the film opened to scathing press, I saw Coppola at his Rutherford home in Napa. The driveway sported a child's warning signs, made by Sofia Coppola, who was then eight. They were intended to frighten the bailiffs who might be coming to take the family furniture or the house. Francis was down, black and blue and broke, until he started cooking a meal. Then his enthusiasm came back. The Rutherford house was next to the old Niebaum winery, and Coppola had an idea to make something of it. He would repay his debts eventually. He has carried on as a filmmaker. He has been able to see Sofia make films. (*Lost in Translation*, 2003, is her best.) But some think his heart and his wealth now depend on the winery and his interest in food and drink. No scenes are more touching in *The Godfather* than those set at the table. He is a figure in the cultural landscape such as few American directors can match. In his special way, impulsive yet manipulative (a mix of Sonny and Michael Corleone), he used the 1970s to redefine the status of the American moviemaker. He is our Griffith, though he will die richer and happier than that pioneer, able to look back on a career that transcended the old-movie attitudes toward crime—so long as it was organized, in the family, and just business. We are agreed now, I fear, that American business is ready to go beyond the law and society's moral principles. No great American director has had a darker vision or won Best Picture with it.

A little in advance of *One from the Heart* (1982) there had been a more emphatic and far-reaching failure (admittedly not in Northern California). Michael Cimino (born in New York in 1943) had gone from Yale and

studying with Lee Strasberg to working for Clint Eastwood. Then, in 1978, he directed *The Deer Hunter*, using Vietnam and the working-class hinterland of America to tell a story of Dostoyevskyan brothers. The actors were too old to be new soldiers; the film had many elements that jarred with the facts of Vietnam. But it remains a devastating work, and it won Oscars for Best Picture and direction, as well as for Christopher Walken. (That Best Picture Oscar was presented by John Wayne in what would be his final public appearance, coming down a long, tricky staircase with style.) Thus it was no surprise at the time that United Artists hired Cimino to write and direct an epic Western to be known as *Heaven's Gate*.

The earliest budgetary ideas for the picture (under $10 million) were buried under eventual costs of over $40 million, thanks to remote locations that required hours of travel every day, frequent reshooting of the same scenes, the introduction of fresh action as the shooting progressed, and the gamble on Cimino's part that United Artists was too heavily invested to close the project down. We know the details of this thanks to the meticulous reportage and the rueful tone of Steven Bach's book *Final Cut*—and Bach was at the time one of the UA executives responsible for the film.

Bach's book is candid but not vengeful. After the dust had settled, he came to this conclusion:

> One thing is certain: I believe there to have been not one day or one moment in the turbulent history of *Heaven's Gate* in which Michael Cimino intended anything other than to create "a masterpiece," a work of lasting art. His certainty that he was doing so conditioned that history and much of the behavior of those around him. He did not set out to destroy or damage a company but believed he would enrich it, economically and aesthetically.

This may have been too far from "a cheap form of amusement." Bach and Cimino were defending different things, art and business, and somehow history had brought them into awkward overlap. By dint of his own chronic maneuvers and the company's helpless respect, Cimino was allowed to behave like Lucian Freud painting a portrait. That is a perilous way of making a movie, but Freud was a great painter—and sometimes he abandoned a picture because it was not working out. It is next to impossible to abandon a movie, and very hard to press on, after the first few

days, in the knowledge that it is not going to work out. Once that picture opens, however, anyone who can deserts the ruin.

Cimino was obliged to release the film in a shorter form than he had hoped for (149 minutes), but still with the roadblock of the Harvard graduation as its opening. (There is a more promising opening some twenty-five minutes later, as the Kris Kristofferson character arrives in Johnson County, Wyoming.) The premiere (on November 19, 1980) was a scene of gloom, and it was the 219-minute version. Bach felt the silence in the theater: "The audience was either speechless with awe or comatose with boredom. I began sweating icy rivulets in that silence that roared with quiet disdain."

In the *New York Times*, Vincent Canby called the film "an unqualified disaster," and many other critics were damning. Their verdict was supported by an eventual gross of less than $4 million. Not long afterward, United Artists itself was ended, the company that had been created to defend independent filmmaking and that had a roll of honor as great as any studio (from Fairbanks's *Thief of Bagdad* to *Annie Hall*, from *Red River* to *Some Like It Hot*). It was absorbed by Kirk Kerkorian's M-G-M and is still somewhere in that digestive tract. Michael Cimino is alive still, and a man of mystery. His career has never regained the power of *The Deer Hunter*. He has not directed a complete film since 1996. But the full version of *Heaven's Gate* looks better as time passes, and is further proof—if it was needed—that self-conscious artists can make something extraordinary, and then kill it.

There was another source of disquiet over *Heaven's Gate*: the film offered some explanation of the United States itself in which power and money tried to oppress immigrants and the labor movement while owning the land. That text is much clearer now, but by 1980 there had been a swing back toward nonthreatening movies and tranquil entertainment. No one wants to knock tranquil entertainment so long as it is as inspiring as Fred Astaire, Rin Tin Tin, Buster Keaton, Hawks on the trail, and Preston Sturges with Stanwyck and Fonda. But by the late 1970s there began to be fewer grown-up pictures meant to disturb and provoke. The *Rocky* franchise was based on the increasingly farfetched dream of a Wallace Beery figure supplanting a Muhammad Ali. (*Rambo* would be harder to stomach.) Steven Spielberg's *E.T.* was less a film made for kids than a picture designed to have adults feel like kids again. Clint Eastwood's *Dirty Harry* series shifted from being an attack on the impossible position of the police to the glorification of a very macho loner. Above all, Spielberg

and George Lucas joined forces on a grandiose new version of Saturday morning serials with *Raiders of the Lost Ark*, a booming franchise, and fun at first, but having so little to do with the real world. Meanwhile, the restored business confidence of a Hollywood that was more than ever the subsidiary holdings of major international corporations asked the old question: What have the movies got to do with life? And the expanding realm of special effects had its own retort: Why, this isn't really life anymore. And why should it be?

Not everything was depressing. Woody Allen was at his best in the years from *Annie Hall* to *Radio Days*. Terrence Malick's beautiful debut with *Badlands* (1973) was not quite sustained by the studied look of *Days of Heaven* (1978), and that was followed by substantial absence. Martin Scorsese was a genius in turmoil in the years from *Taxi Driver* to *Raging Bull*.

The new possibilities for independent film impressed most people: John Sayles's *Return of the Secaucus Seven* (1979) was a literate feature film about lifelike characters, made for $60,000 and released and appreciated. That way ahead would be taken up by Steven Soderbergh with *sex, lies, and videotape* (1989), by the overall enterprise known as "Sundance," Robert Redford's naïve but well-intended attempt to use the fruits of *The Way We Were* (1973) and such films to bolster the development and production of small-audience films. There was even one of the best films ever made in America, David Lynch's *Blue Velvet*, so complete an immersion in sexual awakening that many sober critics found it shocking and disgusting.

By 1986, the year of *Blue Velvet*, something else was apparent at the movies: as you sat in the dark, you sometimes saw young members of the audience walking out of the film and heading for the lobby. Were they going to the bathroom, in search of a smoke or candies? Were they bored by the picture? Perhaps, but the lobbies were increasingly stocked with games to play on screens. It was becoming an amusement arcade. The process had begun with Pong (released by Atari in 1972), but then came games of increasing complexity and interaction. These screens were tiny compared with the movie screen, the image was often coarse, and the material was violent or nerve-jangling. One came off those games buzzing. The screen had found a new way of being. And today people sometimes play the latest version of those games in front of the movie, on their cell phone, offering their blue glowworm against the screen's light.

WHAT IS A DIRECTOR?

Here is Anthony Minghella, the director of *Truly Madly Deeply* (1990) and *The English Patient* (1996), facing up to reality:

> The film community has all these redefinitions of terms, often amusing: net profit means no profit, residuals mean no profit, producer equals liar, lawyer equals frustrated agent, agent equals frustrated director, director equals frustrated actor. The decoding mechanism is one that you learn over time . . . A decade later, I have a primer of some description for understanding that when somebody rings up and "they're very excited," what they mean is "hello," when somebody says, "I love your work," what they mean is they know you're a director . . . "You can cast anybody you like" means you don't have casting control.

"Ant" was not a cynic, yet he may have discovered the need to pretend to be cynical, worldly, or amused, if he was going to survive making big pictures for such as the Weinstein brothers. After a few weekend retreats with the bosses you learn to talk their way, and sometimes you wonder if you are becoming more like them. It's a lesson in a kind of bipolarity worth bearing in mind when you think of all the old pros who lasted: Hawks, Capra, Lang, Ford, Vidor, Hitchcock, Lubitsch, Wilder, Wyler, Minnelli, Scorsese, and so on. What actors they had to be. Then consider the ones who didn't last in that way—Welles, von Stroheim, von Sternberg, Nicholas Ray, Preston Sturges—or the ones who broke away and found their escapes: John Cassavetes, Kubrick, Terrence Malick, Michael Cimino.

In what we now call the golden age of Hollywood, directors did as

they were told, swallowed the lies and the language, and fretted over their imprisonment in private. They hated their vulnerability under the system, and told horror stories about the arrogance of those who ran the studios, gave them their contracts, and then trampled on their vision as a matter of right and business habit. These disappointments might be vented in the directors' pleasant houses in the hills, to their second (rather younger) wife, within earshot of the new Chagall and the European sports car they had just bought (to make themselves feel better). Their anger was being bought off, and in time that deal was sweetened by agreements to recognize "residuals" and "profit" participation. Just agreements, you understand.

There were directors who managed to stay moving targets, shifting from one studio to another on short-term contracts and building a body of work that French- and then English-speaking critics would later call an oeuvre (as if it had been designed as such from the start). John Ford and Howard Hawks are such worldly heroes, and perhaps the smarts or resolve of some of their loner heroes was modeled on the directors' own survival. They did good work over five decades. After that prolonged struggle, is it any wonder that many good American movies are metaphors for handling the system, the daily grind that faced ambitious directors?

Others became studio men: it meant stomaching Harry Cohn, but Frank Capra served Columbia (and raised the status of the place) throughout the 1930s. At Warner Bros., Michael Curtiz was regarded as a guy who could shoot anything, and to this day his facility often masks the question of personality, no matter that his credits include *20,000 Years in Sing Sing* (1932), *The Charge of the Light Brigade* (1936), *Yankee Doodle Dandy* (1942), *Casablanca*, (1942), and *Mildred Pierce* (1945). Preston Sturges had an exceptional run at Paramount, during which he was allowed to ignore the war to make sublime comedies (*The Lady Eve*, 1941; *Sullivan's Travels*, 1941; *The Palm Beach Story*, 1942; *The Miracle of Morgan's Creek*, 1944). He had so many rows with studio executives he began to feel he was a misunderstood genius, so he branched out, went independent, and fell apart. The wit, the insouciance, and the mercurial charm others loved, and which Sturges worked hard to maintain, turned into frustration and sorrow. He had a better money deal as an independent, but he soon wished he had never left "home." The most domesticated director is probably Vincente Minnelli, who worked all his life at M-G-M and turned out a flow of films that includes *Meet Me in St. Louis* (1944), *Madame Bovary* (1949), *Father of the Bride* (1950), *The Bad and the Beautiful* (1952), *An American in Paris* (1951), *Lust for Life* (1956), and *Gigi* (1958).

The concept of "home" meant not just your own parking space on the lot and regular checks in the bank. It ensured a supply of material, stars, and craftsmen, and the greatest virtue of the factory system was that so many of those assignments were blessings. Minnelli married one of his stars (Judy Garland), and that may not have been the wisest step they ever took, but Garland's work in *Meet Me in St. Louis* is a testament to affection and trust enhancing beauty and film presence. There's a legend that the studio abused and exploited Garland, though her own mother did worse. But there were also people at the studio who loved her and wanted to look after her. Then look at the other credits: producer Arthur Freed worked with Minnelli twelve times; Conrad Salinger, an orchestrator, had ten films with him; and the head of design at Metro, Cedric Gibbons, presided throughout the director's career.

There's no reason to sentimentalize the "crew." But anyone who has ever made a movie knows the benefit of practice and familiarity: in how to photograph a star; in how to construct sets that will facilitate shooting and scheduling; in the balance of color and the clarity of sound; in the idea of order and story that builds in the editing; and in the relatively re-laxed way in which an assigned director may pursue his style and his preoccupations. Minnelli is often called a "stylist," or someone in search of beauty, but those tasks can be aided by an effective factory system. It follows that Minnelli was more or less willing to direct films that were about whatever the studio and the story department wanted them to be about.

You can argue an offsetting problem in this factory attitude toward the nature of film: that all the films began to look and feel alike; that a way of shooting that was efficient and economical became a way of seeing that standardized life and experience and turned it toward being an advertise-ment. There's no doubt that this "movieness" (once so exciting) became stale, unwittingly comic, and a spur to parody and rebellion. But if you believe that making a film is one of the most exhausting and unpleasant jobs ever devised—here is Minghella again: "In the end . . . directing is about survival and stamina"—then the factory and the team could be a kindly climate that let directors make a lot of films. Between 1942 (when he was thirty-nine already) and 1976, Minnelli made or worked on thirty-nine pictures. (At the age of forty-nine, David Fincher has made nine feature films.)

So team is one mercy, but then consider two other liberties: such di-rectors did not have to raise the money for their ventures, and raising

money is ugly enough to scar your sense of creative integrity—in Hollywood, take note, the sense of it was more important than the thing itself. Then, when "your" film was finished, it became "theirs" and passed smoothly into what was called distribution and exhibition—it might do well or less well in the marketplace, but an audience was waiting for it all over the country, and the director was told, "The numbers are nice." You know what that means.

The public was as much a part of the team as an orchestrator or a focus puller, and for most of Minnelli's working life, the audience came to the movies out of habit. The distribution enterprise—with Metro it was Loew's Inc.—made the prints, the trailers, and the posters, and paid for them. It had the theaters lined up; it arranged for the collection of money; it ran the publicity machine and might even have composed interviews with Minnelli to save him time. So for those who regard Vincente Minnelli as a true artist, it must be said that many of his choices were made for him. And choices can kill you as easily as arrangements. Minnelli died at eighty-three; Minghella was fifty-four.

Teamwork now is less common or protective, though there are strong allegiances, such as Martin Scorsese having Thelma Schoonmaker as his editor, the association of Steven Spielberg and composer John Williams, and the bond between director Oliver Stone and cinematographer Robert Richardson in finding the unstable, color-noir look of *JFK* and *Nixon*. You could add the history of J. Roy Helland, who did Meryl Streep's hair and makeup on everything from *Sophie's Choice* to *The Iron Lady*. But people are hired and pictures are made, as independent as well as one-off ventures. Studio money, or money that derives from the corporations that own them, has to be negotiated and gambled over—sometimes over a period of years, sometimes over a weekend. A director at the level of Scorsese has agents and lawyers to handle that business, but he may spend more time (on and off) trying to develop a project than he ever will in the shooting. Scorsese went personally broke on *Gangs of New York*.

Preparing a project can last a matter of years, with a concomitant fatigue, anger, and despair that can do damage to the fluency or playfulness of a venture. It requires a public persistence or stamina that is often at odds with the privacy of composition or meditation in much artwork. You have to sit there and listen to the producer and the money from Minneapolis tell you about their bridge game, their bridgework, or whether they will get to sleep with the actress (so they are interested in the casting). There is sometimes a force in artistic independence that simply refuses to

be that ingratiating or compromising. Such intransigence characterized Orson Welles, John Cassavetes, Nicholas Ray, and Erich von Stroheim, to name just a few. But decades after the reported death of the film factory, it is hard and daunting for a real independent to make a movie.

If you want to make art, don't give up your day job. There are weekend painters and writers who teach by day (or deliver the mail) and treasure the evenings for their own work. But movie takes pride in being all-consuming, and sometimes offers itself as more than life. And thus the dilemma of many independent filmmakers—by which I mean those who don't know where the next film is coming from—can be very tough. Two of the most impressive films I have seen while writing this book are *Winter's Bone* and *The Arbor*. You may not have seen them, or heard of them, but they're worth talking about in the attempt to convey the life of a director, and I'm sure they were both done in the glorious if vain hope of reaching the masses.

•

Debra Granik, the director of *Winter's Bone*, was born in Cambridge, Massachusetts, in 1963. She attended Brandeis before taking an MFA in film production at New York University. She made her first feature, *Down to the Bone*, in 2004, and it won prizes at Sundance, and elsewhere, notably for the performance by Vera Farmiga as a young mother attempting to recover from cocaine addiction. It was well reviewed, but its tough subject and remorseless treatment had difficulty finding proper distribution in the United States. Like so many first films, it was made for very little, with dribs and drabs of money gathered over a long period. With a reported gross income of $20,000, it was just one of the worthwhile films that gain respect and admiration while bringing the filmmaker to bankruptcy. So that person has to ask herself, what do I really want to do?

It was six years before Granik was able to complete her second feature, *Winter's Bone*, about a seventeen-year-old girl, Ree, who tries to look after her mother, brother, and sister in the rural Ozarks while searching for her father, who faces a court date. If he doesn't make that date, the family risks losing its house. The story came from a novel being written by Daniel Woodrell (published in 2006). This picture cost around $2 million, and again the funding was raised over a long period of time, with many setbacks along the way. But the picture got "proper" American distribution, from Roadside Attractions, which placed it in fewer than a hundred theaters. Still, it was noticed. In *New York* magazine, David

Edelstein wrote, "For all the horror, it's the drive toward life, not the decay, that lingers in the mind. As a modern heroine, Ree Dolly has no peer, and *Winter's Bone* is the year's most stirring film."

Its festival showings prompted foreign rights deals, and word of mouth (the essential backup to good reviews) brought in a gross income of around $12 million. Edelstein is correct in his judgment, but by "horror," he means the tough lives and the hardships people must battle with, and he is alluding to the physical harshness of life in the locations all found in rural Missouri. Ree has terrible problems to face, but this is not a horror film. If it had been—if Ree had been threatened by a mad killer in that same rural setting, and if the film had been loaded up with blood and suspense—its commercial horizons might have altered. Granik wanted to make a film that observed life honestly and was fair to the novel. So she ended up with a slice of life that many potential viewers would find uncomfortable—whereas the unhindered slipping into another genre, that of a slasher movie, might have been as sensational a coup as *The Blair Witch Project* (budget $60,000; gross revenue $248 million).

The people behind *Winter's Bone* were delighted with their success. Many who had worked on spec got a little money. The picture received four Oscar nominations: John Hawkes for Best Supporting Actor; Jennifer Lawrence for Best Actress; Debra Granik and Anne Rosellini for Best Adapted Screenplay; and for Best Picture itself. Those nominations did not lead to a win, but they must have helped enlarge the audience for the movie. Still, at the age of forty-nine, Debra Granik has not yet announced a next project. That doesn't mean she lacks ideas or hopes, and her chances of fund-raising must be easier after *Winter's Bone*'s impact. But it's evident already that her commitment to difficult material and the honesty in dealing with it will not be easily shaken. Which doesn't mean the temptations won't be there for something that might be called "Blood on the Bone."

Yet I am even more impressed by Clio Barnard's film *The Arbor*, which opened in Britain in 2010. This is a tricky film to describe, but it is a study of the life, work, and aftermath of Andrea Dunbar who had a brief London career as a playwright before drinking herself to death in 1990. Dunbar came from Bradford, in the north of England, and from a street fancifully named the Arbor. The film includes actual footage of Dunbar, but the great body of it is a creative amalgam of sound interviews with her children and friends that are played out on-screen by actors who are "voicing" to the soundtrack rather in the way that in a musical the actors mime to the playback recording.

The layering takes getting used to, but its daring is to mingle Brechtian techniques with the raw emotion of the story that unfolds. In the *Guardian* in London, Peter Bradshaw said of it, "The effect is eerie and compelling: it merges the texture of fact and fiction. Her technique produces a hyper-real intensification of the pain in Dunbar's art and her life, and the tragic story of how this pain was replicated, almost genetically, in the life of her daughter Lorraine." *The Arbor* has found a form that digs into the disconcerting way film is both fact and fiction. For me it surpasses the defined but confined story of *Winter's Bone* because its ambition is greater without any loss of emotion.

●

Clio Barnard was raised in Yorkshire and attended art school in Newcastle and Dundee before doing an advanced project at Britain's National Film School. She was helped to make *The Arbor* by Artangel and the UK Film Council, and her picture cost close to £600,00. Artangel is a foundation that helps many different forms of art, and its beneficiaries have included Atom Egoyan, director Steve McQueen, Douglas Gordon, and John Berger. *The Arbor* received good reviews in Britain but did disappointing business: about £60,000 from fifteen theaters. An executive at Artangel says that the numbers were of "no interest at all." The foundation is out to recognize artists, and Clio Barnard was one of four go-ahead projects out of a thousand applicants.

When *The Arbor* came to America, in 2011, though it won a prize at the Tribeca Film Festival (Best New Documentary Filmmaker, which is hardly an adequate description) and had some positive reviews, it did wretched business: its gross was a little over $20,000 on very few engagements.

The project took about four years, during which time Barnard taught film studies at the University of Kent and had a leave of absence. She wants to make other films, and is hopeful of getting money from the Film Fund. But the competition is intense. Artangel has a policy (which Barnard admires) of supporting no more than one project from any one person. And the UK Film Council was closed in March 2011, with many of its functions being passed over to the British Film Institute. This is local politics, you may say, but it is the situation that so many filmmakers face all over the world, and it is the pressure that weighs on them to do something more "commercial"—if they knew what that was. It's hard enough to know what you want to do.

•

The most independent thing about any artistic venture is the wayward and lonely need that insists on doing it. Debra Granik and Clio Bernard may notice that they are a novelty in another way. In the age of Minnelli, from the 1940s through the '60s and into the silver '70s, it was so unusual to see a woman directing. They could edit, they could write scripts, they could be girl Fridays, and they could be beautiful. Some women worked cannily behind the scenes: Katharine Hepburn persuaded Louis B. Mayer to do *The Philadelphia Story*. Ida Lupino made a run of intriguing B pictures in the 1950s. In 1970 the actress Barbara Loden, then married to Elia Kazan, managed to make *Wanda*, on 16 mm, a fragile picture about a forlorn woman who tags along with a male criminal enterprise. It deserves to be a classic, but it took the risk of eliminating male romance—not just the way men might fall in love with women, but also the cultural climate in which men never question their own prowess and bravery. This cult is there in *The Godfather* (made in the age of alleged feminism), where the female characters have no larger function than having the male doors closed on their anxious faces or being the hero's sexual reward.

Barbara Loden died without making another film. Exceptional male careers have trailed away, too, when once the men might have been expected to work far longer. Brian De Palma, someone valued highly by Pauline Kael, has not in years matched the savage progression or cruel humor of *Scarface*. Bob Rafelson, Peter Bogdanovich, and William Friedkin, for various reasons, went into decline or withdrawal. Bob Fosse, Sam Peckinpah, and Hal Ashby died too young. Monte Hellman, Walter Hill, and Phil Kaufman made too few films. Paul Schrader, as well as being a bold and pioneering screenwriter (and a good critic), made *American Gigolo* (1980), *Mishima* (1985), and *Auto Focus* (2002), but has difficulty getting directing jobs now. Alan Rudolph has nearly retired—and retirement can be an honorable profession—leaving us to recall the wit and humor of *The Moderns* (1988, which is a better Paris dream than Woody Allen's recent *Midnight in Paris*). Michael Cimino was never the same again after *Heaven's Gate*, and is now a recluse who gathers more rumors than projects.

Coppola has not been his old self for decades, and George Lucas's comeback felt drained of creative need. Billy Wilder spent many final years in his office with half a dozen Oscars and a row of unproduced scripts that no one would green-light because he was deemed "too old."

He was bitter and funny, still, and he was about the age of Clint East-wood now. But youthfulness by then had invaded the executive class, and sometimes those new men (and women) were hard-pressed to believe that anyone that old might understand their world and its movies, even if the new vice presidents kept posters for *Double Indemnity* and *Sunset Blvd.* on their walls in homage.

So there's all the more reason to respect the stamina of a few old men now (whether they like that label or not) who have soldiered on in difficult times. In 2011, *Midnight in Paris* proved the most commercially success-ful film Woody Allen had made and won an Oscar for Best Screenplay, which helped suggest that his core audience—urbane, urban, middle-aged liberals—had learned to live with their distaste when he photographed and then married the adopted daughter of his long-term companion, Mia Farrow. Or perhaps that constituency had just faded with the years.

"Woody" was seventy-six that year, and an institution as well as a chronic filmmaker: he seems uncomfortable without a project, and he has managed to find budgetary levels that work well enough, just as he has been locked into recycling his own anxious attitudes. (Despite his melan-choly, he has ended up with a net worth around $40 million.) He is a film buff from the 1960s, yet he realizes how far that supportive audience has disappeared. Talking to *Sight & Sound* in 2011 about the "influence" of Preston Sturges and the Marx Brothers, he said:

> I think those kinds of films are gone—they're history. Films from that era and with that sophistication—Sturges, who you mentioned, and also I was a great fan of Ernst Lubitsch—they don't resonate with most audiences in the United States. We have an audience—and it is an intelligent audience—that is more technological.
>
> It's true what Marshall McLuhan said—"the medium is the message"—and the technology is the message, so you see films that are, in a certain sense, not apparently about anything. They may have silly plots, and there's not much of a story, but they are about a technology.

The same old whimsical anhedonia inspires his comedies, though sometimes "inspires" is a generous word. We should be grateful for a comic turn of mind in an age that has made its comedies increasingly coarse and juvenile. Yet I'm not sure Allen exactly believes in comedy as a re-sponse to life, rather than a wisecracking routine for holding attention

and deflecting greater depth. Actors seem to like working for him, but he gives them little direction or challenge. He makes films about social groups, but his eye is uninterested in space or arrangement—indeed, he tends to convert his scripts into films with scant joy or fascination in the process. (The contrast with Altman is most pointed in this respect.)

Allen had a striking arrival where he was more given to slapstick and catching the sexual and satirical voice of the early 1970s: *Bananas* (1971), *Everything You Always Wanted to Know About Sex but Were Afraid to Ask* (1972), and *Sleeper* (1973), culminating in *Annie Hall* (1977), the rare occasion where a player, Diane Keaton, brought unstrained charm to an Allen film. Then he made *Interiors*, a doomed imitation of Ingmar Bergman. Pauline Kael snapped that *Interiors* was "deep—on the surface." Fair enough, but so were the comedies superficial, and Allen would surely have a wisecrack about the necessity of staying shallow if you're not going to drown. There are some original and arresting films, such as *Manhattan* (1979), *Stardust Memories* (1980), *Zelig* (1983), *The Purple Rose of Cairo* (1985), and *Radio Days* (1987, blessed by not having Woody as an actor), which may be his finest work. And then the list goes on, as if Allen has been growing older but hardly changing. It's an open question as to whether his pictures will last or seem more profound—something that has happened with some of the best American comics, from Buster Keaton to W. C. Fields. Those two seem to be broken but brave souls facing the abyss. Woody Allen only complains about that predicament, and declines to be a fictional person—he is there like his own brand image more than an actor or a character. He has never let us, or possibly himself, into his own heart, and when a man works so hard, that omission becomes disconcerting.

•

No one could charge Clint Eastwood with not changing, and he is another filmmaker compelled to work as if Hollywood still existed and were waiting patiently to enact his wishes. It is an extraordinary journey, worthy of Dreiser, and possibly more interesting than Eastwood's films. Eastwood was born in San Francisco in 1930 and grew up middling poor, rather wild as the son of an itinerant father, but enjoying the good old movies. He did a spell of military service as a lifeguard, and it was his physique and his looks that got him into the Universal talent school.

He made a few movies in small parts and then won a regular role in the TV series *Rawhide* (1959–66), where he began to appreciate underplaying,

and the prospect of directing. He went to Spain (for $15,000 and coach airfare) for the Italian director Sergio Leone and made the *Dollars* trilogy of films as the Man with No Name, iconic and superior to the point of camp, raffishly dressed and hysterically tight-lipped, but eventually these films gave him authority and stardom in America. (They now seem an early sign of the Esperanto of action films: very noisy, but like silent films in that so little of interest was said. And yet, that cheerful din gave us the two *Terminator* films, the best things James Cameron has done, and the divided soul of Arnold Schwarzenegger, a presenter of self in everyday life.)

By 1971, Eastwood had directed his first film, *Play Misty for Me*, an efficient suspense story that flirted with mocking his macho image. In the same year, for director Don Siegel (an important mentor), he made *Dirty Harry*, which helped introduce the loner or rogue cop with a taste for lengthy one-liners, though Harry owed something to *Bullitt* (1968) and Steve McQueen—two San Francisco cops and two actors born just weeks apart.

In the 1970s he made a franchise out of *Dirty Harry*, he did a couple of films with an orangutan, and a good Western with a lot of unexpected humor, *The Outlaw Josey Wales* (1976), after he had fired Philip Kaufman as his director when Kaufman seemed not to share Eastwood's preference for first-take shooting. There was growing interest in Eastwood and the journey he had made, but I'm not sure the public at large, or the critical community, yet rated him as too different from Sylvester Stallone (and *Rocky* was acclaimed years before Eastwood got prizes). So the flash-forward can be made very dramatically.

Eastwood has won Best Director and Best Picture Oscars for *Unforgiven* (1992) and *Million Dollar Baby* (2004). He has received the Irving Thalberg Award and the American Film Institute Life Achievement Award, and he is a member of the Légion d'Honneur. He was mayor of Carmel in California (without party affiliation), and he is probably among the most highly esteemed Americans alive now. President Obama, in giving him an arts and humanities award, said his films were "essays in individuality, hard truths and the essence of what it means to be American." Not even Eastwood would deny the care with which from the early 1980s he went about cultivating or rehabilitating his image (which does include having seven children by five different women). There is no crime in that, but the campaign for respect helps us understand the nature and determination of the man, and seldom fits with the outsider roles he played before the age of fifty.

So what is to be said about Eastwood the filmmaker? He is some-where between a modest and a reluctant actor who understood Gary Cooper's treasured economy, though he has rivaled it very seldom and never had access to Cooper's inner anguish. As a director, he is at best efficient, economical, and quick. As an icon, he is often confused: *Unfor-given* is still talked about as an anti-Western, where men are mortal, flawed, and inept—until his character, Will Munny, reverts to being the angel of death (as if recalling Leone) at the end of the film and shoots down every enemy in sight. Eastwood has played heroic too many times, and entered into that aura so completely, that he lacks an edge of intelli-gent doubt that marks so many of the best directors. Still, as a director, he has made one outstanding film, *Mystic River* (2003, derived from a Den-nis Lehane novel), where the quality of life penetrates recesses that the regular Eastwood hardly knows exist. The distance between *Play Misty for Me* and *Mystic River* is large enough to remind us how hard Eastwood studies. He can be earnest and dogged; there is even a hint in his recent years of Stanley Kramer in his appetite for important subjects. So, moving on from the orangutan, he has made films about Iwo Jima, Nelson Man-dela, and J. Edgar Hoover under an increasing cloak of respectability.

But as a producer, he is without equal—and not just in his own time. He has worked independently a great deal. Even when he helped sustain Warner Bros. fiscally, he lived close to Carmel and had his own small world, Malpaso Productions, at the studio, along with his team, some of whom ended up being fired if they incurred his wrath. He made a fortune for himself and for his studios—his films are said to have grossed $1.68 billion domestically, and he is reported to have a net worth of $85 million. He has enabled several documentaries on jazz and popular music, and he has shown private generosity to people close to him. He is tough, limited yet aware of his limits, ambitious and cautious, practical and decision-oriented, and able to dress his essential conservatism in liberal language and gestures. He might have had a chance of running an old studio, or being president of the United States. But he has done something more than presidents can manage: he has continued to exist in that past where a movie star (or a leader) can be rich, honored, and beloved—trusted, even. It is not sensible to rate him as an artist, but his is exactly the type of career that old Hollywood wanted. There will never be anyone like him again.

SILENCE OR SINATRA?

In the previous chapter I considered Clio Barnard and Clint Eastwood, as if they might be contemporaries and colleagues. I'm sure they'd be polite if they met, but they do not have a lot in common. The public knows one and not the other; their degrees of "success" are worlds apart. Yet Barnard's one film has a depth of intelligence and emotion that I doubt Eastwood has considered. That doesn't mean she's a "genius" while he is just a classic entertainer, or that one label is harder to earn than the other. They are both of them dedicated to their attempts to communicate. I suspect there have been moments when Clint sought artistic prestige while Clio longed for a limo. And in this chapter, I want to explore that slippery ground where directors (or even producers) wonder if or how they are noticed.

Let me suggest someone who has a case for being the most effective director of his time. He was born in 1959 and his name is Tim Van Patten. There is a fair chance you have not heard of him, a reminder that, with television, you are not always watching, even if the set is on and your gaze is more or less given to the screen. Van Patten has never made a theatrical movie, but he has directed some of the best material of our time, twenty episodes of *The Sopranos*, more than anyone else. That's about sixteen hours of film (let's say eight feature films) in the years from 1999 to 2007. There are few movie directors who worked that steadily in those years for the big screen, and Van Patten was doing other work, too, as a director for hire (episodes of *Deadwood*, *The Wire*, and *Sex and the City*, among others). Any professional would say he did a very good job: his episodes were delivered on time, fitting their on-air slot; they maintained the several narratives lines of *The Sopranos* and kept up with its many characters; they had a tough, elegant, and ironic look, as applied to sex, violence, and the domestic interiors of this family, without venturing into what

might be called personal expression. It was not the point of these epi-
sodes that the audience noticed individual style, directing, or a single
personality (though Van Patten did share in an Emmy for another series,
The Pacific). If there was an arresting or unusual episode, it usually came
from a concept in the writing. There were other frequent directors for
The Sopranos: John Patterson did thirteen episodes; John Coulter made
twelve. There were other recognizable names (with credentials in the
movie business) who directed: Steve Buscemi did four, and there were
single episodes by Lee Tamahori (*Mulholland Falls* for the big screen),
Peter Bogdanovich (*The Last Picture Show*), and Mike Figgis (*Leaving Las
Vegas*). David Chase directed two episodes: the pilot and the finale.

•

Born in Mount Vernon, New York, in 1945 (and then raised in New Jer-
sey), Chase was the man behind *The Sopranos*, after a career that had
spent years on *The Rockford Files* and *Northern Exposure*, without making
him known outside the television business. But by the time he came to
The Sopranos, he was called its "creator," a term that is generally too
sweeping for the film industry. Moreover, Chase would say later that the
series emerged from his own experiences growing up and was often
rooted in his life—Tony's mother, Livia (Nancy Marchand), was said to
be based on Chase's own mother. But his aim was to propose that a leader
in organized crime might be a very ordinary man instead of an epic
figure—thus at the start of the first series, Tony has decided to see a
shrink (Lorraine Bracco) because he's afraid of being dysfunctional. He's
depressed, a condition that never occurs to Jimmy Cagney in the 1930s or
Michael Corleone in *The Godfather*.

We think of *The Sopranos* now as a certain success, not just the win-
ner of twenty-one Emmys or what David Remnick in *The New Yorker*
would call "the richest achievement in the history of television," but a
show that did so much to establish cable television: the average audience
went from over three million on the first series to as high as twelve mil-
lion. Still, nothing is certain at the start.

Chase had a deal with HBO to write and direct the pilot. But when he
turned in the script, HBO hesitated: formed in 1972, the cable channel
had developed slowly. Chase was worried about their commitment and
looking to get some extra funding to turn that pilot into a movie for the-
aters. Only then did the channel decide to move ahead. Chase was an
intense and untiring controller, and not the easiest leader of a team—but

maybe he had his own anxieties about being dysfunctional, too. You can't be a creator for six series without a symbiotic exchange between you and your chief character.

Six series (and eighty-six episodes) sounds grand in hindsight, but it was never clear-cut at the time. Any TV series waits in trepidation for its first renewal; and every TV success is then under pressure to keep going after that because the revenue is so great, especially with the bonus of syndication and boxed DVDs. *The Sopranos* has been called a great modern novel (though it had more purchasers than any novel could dream of), but that doesn't mean Chase was always confident about its dramatic arc or literary shape. There were slow stretches on-screen, resting periods, and delays in its production. You could miss a run of episodes without losing touch. And yet a key to the show was that millions of people tried to watch every episode, and this was before we had easy access to storing television shows and watching them on demand at our convenience. Just as Hollywood was giving up the ghost on narrative, David Chase had created a serial, and found an audience eager for it. It had participant suspense, that old asset of the movies. *The Sopranos* also indicated the new leverage of cable television, with language, sexuality, and violence that the movie business (and that dinosaur, network television) were fearful of matching. By today, HBO has nearly thirty million subscribers (more than the number of people who go to the movies in a week).

I daresay Chase had fluctuating ideas about how to end his story, or whether any ending would satisfy his wish to deal with an "ordinary" man. After eighty-six episodes, life gets heightened or stressed. So many television series get crazier as they dig deeper into themselves but respond to the pressure to be different. Trails were laid for several ways of closing, but when it came to it, Chase directed the finale himself with an enigmatic fadeaway (one of the most stylistically self-conscious moments in all the seasons) that left us uncertain. Death might be coming, or another cup of coffee: it is the vagary of life itself, even if *The Sopranos* never gave a hint of being documentary, and rarely looked like anything except a movie from the 1970s. Said Chase:

> My goal was never to create a show. Television . . . was never part of my life goal. I wanted to be a filmmaker. I wanted to make movies. I got hired to do a TV show. The money got into my head, and I kept snorting that money for a long time. I went from term deal to development deal to development deal. I wasn't Aaron Spelling

[a prolific TV producer—*Charlie's Angels, Dynasty, Starsky and Hutch, The Love Boat*, and many others], but that didn't matter. I didn't want to be that. I never wanted to be somebody who had more than one show. I don't know how people do that. I never wanted to have a series.

How good was it? The answer hardly mattered if enough people had decided with David Remnick that it had vindicated and transformed television. I would say that Tony never became as commanding or as disturbing as Michael Corleone. But we should recall that the second part of *The Godfather* was itself an afterthought and an attempt to offset some of the reactions to the first film. (Both *The Godfather* and *The Sopranos* raised fears that anyone might think they represented all Italian Americans.) No question that David Chase was in charge—of writing, casting, and production of anything a controller noticed—but I don't think I know anything more about him than that. He's like that other Creator: he did an astonishing job, and did it quickly, and there it was, from "Let there be light" to De Niro's matching mauve shirts and ties in *Casino*. But you don't know the kind of person the creator was, and more or less he left the game for us to play with.

As a team effort, *The Sopranos* was beyond dispute, and it reminded us that, throughout its history, television has worked fuller and more cost-conscious days than the movies, with standing crews as ever-present as Chase himself. By the end of the show, Chase was reportedly on a salary of $15 million a season. He has talked about making a movie—is that like Tony seeking a shrink? Equally, by 2011, HBO was generating $1 billion a year from the international market alone.

In the same era, HBO has had many other series to proclaim: *Oz* and *Sex and the City* (which actually started before *The Sopranos*), *The Wire, Curb Your Enthusiasm, Entourage, Deadwood, Six Feet Under, Big Love, Boardwalk Empire*, and *True Blood*. To say nothing of a lively documentary enterprise and movies, many of which had a historical or biographical slant: I've mentioned *Conspiracy* already, but then there's *Introducing Dorothy Dandridge* (with Halle Berry); *Wit* (directed by Mike Nichols and starring Emma Thompson as a cancer patient); *John Adams*, a seven-part miniseries with Paul Giamatti and Laura Linney (directed by Tom Hooper); *Longford* (another Hooper film, written by Peter Morgan), with Samantha Morton and Andy Serkis as the Moors murderers, Myra Hindley and Ian Brady, and Jim Broadbent as Lord Longford; *Citizen Cohn*,

with James Woods as Roy Cohn; and *Barbarians at the Gate*, a pioneering account of modern business fraud, a trend that leads to *Too Big to Fail* (directed by Curtis Hanson), with William Hurt playing Hank Paulson.

It is probable that if you are reading this book, you subscribe to HBO, and to other "premium" channels: Showtime has created *Weeds*, *Dexter*, and *Homeland*; AMC made *Rubicon*, though that was so dense and enigmatic it failed to be renewed. David Chase is not the only creator—David Milch originated *Deadwood*, cocreated *NYPD Blue* with Steven Bochco, and introduced *Luck* with Michael Mann; David Simon created *Homicide: Life on the Street* (that was NBC) and *The Wire*; *Boardwalk Empire* comes from Terence Winter, who wrote twenty episodes of *The Sopranos*; Alan Ball devised *Six Feet Under* and *True Blood* (he also wrote the movie *American Beauty*); *Sex and the City* was originated by Darren Star.

Downton Abbey was created by Julian Fellowes (who scripted Altman's *Gosford Park*). That show is an exception in that it played on PBS, but it reminds us how far the creative and business models for premium cable series are British. In fact, *Downton Abbey* feels like a BBC show, though actually it was made for Britain's commercial television network. But the old tradition of British drama or plays that were really films and of the serialization of classic literature is vital to the HBO model and what PBS in America called "Masterpiece Theatre." Another landmark was *Brideshead Revisited* (1981), 659 minutes in 11 episodes, adapted from Evelyn Waugh by John Mortimer, and directed by Charles Sturridge and Michael Lindsay-Hogg. (It, too, was made by a commercial channel, Granada.) Maybe the best of all the BBC movies was *The Singing Detective* (1986), written by Dennis Potter, the finest playwright for British television, directed by Jon Amiel, and with Michael Gambon as Philip Marlow, a hospital-imprisoned writer of private-eye fiction unable to escape memories of his past. I'm not sure there has ever been anything more searching or troubling on being caught up in the movies than this six-part drama.

Now, it's hard to conceive of Alistair Cooke introducing *The Sopranos* in a Masterpiece format, but it is a mark of cultural failure that PBS has originated so few important or dangerous series, let alone things that smack of the actual, dysfunctional America, such as *The Sopranos*, *The Wire*, or *Big Love*. (By contrast, *The Singing Detective* dwells with such hurt, such mixed feelings, on the influence America has exerted on the world in its dreams.)

It is a tribute to America's premier cable channels that they have made money, and terrific entertainment, from views of a country in growing

trouble. (HBO's most characteristic Everyman figure may be Larry David!) No wonder so many ambitious and creative filmmakers have given up on the condescending attitude toward television that prevailed in mainstream American filmmaking from the first days of the small screen until the 1990s.

•

One of the most intriguing directorial debuts for a premier cable channel was the pilot episode of *Boardwalk Empire*, shown in September 2010 and directed by Martin Scorsese, who is also an executive producer on the series. That year, Scorsese was sixty-eight, yet he also opened a feature film, *Shutter Island*, and two documentaries, *A Letter to Elia* (on what Kazan had meant to Scorsese growing up) and *Public Speaking* (about Fran Lebowitz). Was this a busy year, or one in which the maestro might have assigned some projects to associates? *A Letter to Elia* was codirected with Kent Jones, but Scorsese's appetite for film is not much drawn to delegation. Thus, in 2011, he completed and opened a documentary, *George Harrison: Living in the Material World*, and a 3-D feature film, *Hugo*, adapted from *The Invention of Hugo Cabret*, a novel in pictures by Brian Selznick (a first cousin, twice removed, of David O. Selznick). By the time the latter opened, in November 2011, Scorsese was in preproduction for *Silence*, a project he had been nursing for years, about Jesuit priests in seventeenth-century Japan. As he spoke about it, *Silence* seemed like a project along the austere lines of *Kundun* (1997) or *The Last Temptation of Christ* (1988), and a mark of the director's early desire to be a priest. "It's about the very essence of Christianity. It's about who Jesus really is, in a sense. It's based on a true story. Some priests went there in his name and tried to bring 'salvation' to the Japanese. At a certain point the Japanese turn on them, try to kill them, and the priests felt they had to leave." But in case that spiritual material might seem to compromise his marketability, or prove too hard to make (even with Daniel Day-Lewis), Scorsese had other projects being developed, *Sinatra*, with Leonardo DiCaprio in the lead role, and *The Wolf of Wall Street*.

Silence or *Sinatra*? It's the imprint of a versatility or split personality that prevails in the American movie world two decades after Steven Spielberg did *Jurassic Park* and *Schindler's List* at nearly the same time. It's also a proof of Scorsese's restless energy, his headlong way of speaking, the nervousness of his authority, money problems, and his attempt to fulfill an old Hollywood goal, that of making high art and a crowd-pleaser

at the same time. Along with his rapturous knowledge of film history, his meticulous facility with the medium, and his pitch-perfect imitation of a movie-mad kid, this is what has made Scorsese the cherished godfather and role model in modern American film. And *Hugo* is an unashamed celebration of being film-mad as well as a plea to save all the old movies, using the despondent figure of Georges Méliès at the close of his life as a central character. There was widespread relief among directors when Scorsese at last got an Oscar for directing and the Best Picture award for *The Departed*. He deserved so much more, even if *The Departed* was not his best work.

The tumult or torment in Scorsese may be too interesting to settle for words like "genius" or "creator." It is the striving and the endless tension in "Marty" that are most impressive, and that drive the violence in his work. This is not just the various ways of killing or abusing people, though no one can deny that compulsive habit in films from *Goodfellas* (1990) to *Casino* (1995) to *The Departed* (2006). I suggested, in talking about *Raging Bull* (1980), that Scorsese could not separate himself from fraternal rivalry and its hidden attractions. He is haunted by the life and death of gangsters, and endlessly drawn to filming killings. But this is not just shooting spectacular deaths, or needing them in his stories. It is as if filming and story are a pretext for fearful rhapsodies of violence—consider the repetition of De Niro catching fire at the close of *Casino*, and then the sumptuous brutality in the disposal of the Joe Pesci character and his brother in a hole in the desert.

Pesci and De Niro are one of the most frightening warped love stories in modern film. Put that beside Scorsese's lack of interest or achievement with women on-screen (though Sharon Stone is a loving gift to misogyny in *Casino*), and it's possible to feel a smothered pulse of homoeroticism in Scorsese's work that is the more suggestive because it is not acknowledged. (The most telling American films about gay feelings have been made not directly but obliquely, in films that are ostensibly confident about manhood, dames, and violence.) Scorsese has persisted with the confrontation between boys dressed up as men. *The Age of Innocence* tried to deal with women and society, but it is not as true to Edith Wharton as Terence Davies's English film *The House of Mirth*, which has an exceptional, fatalistic performance from Gillian Anderson as Lily Bart.

Scorsese may have worked too much—there are films that seem rushed, overcalculated, or gloating, and that blur cinematic dazzle with human uglinesss—*Cape Fear* (1991), *Gangs of New York* (2002), *The Departed*

(2006), *Shutter Island* (2010)—but time and again he explores the medium like a surgeon at a massacre. *Taxi Driver* and *Raging Bull* are landmarks. In its complex use of music as a base, *Casino* is as engrossing as it is brutal, and a knowing and compromised portrait of the mind-set of Las Vegas. Scorsese gazes at the place like a would-be priest, in horror. But the movie-mad kid can't look away. When I first saw *Casino*, I thought it was just Marty doing gangsters again. It is that, but there's more. The De Niro character (Sam Rothstein) is a terrible man, but he's also a martyr figure, patient and stupid, trying to trust his wife, Ginger, hoping to see his "brother," Nicky, shape up, striving to keep order (hanging his pressed pants in the closet of his office rather than risk creasing them by wearing them). Amid the garishness of Vegas, the foul chant of its language, the head in the vise, the blow jobs, and the bravura smaller parts (James Woods, L. Q. Jones, Frank Vincent, Don Rickles), there is a spirituality, the cockeyed naïveté of a questing soul who knows he will burn, if not at the stake then in the front seat of his car. The ultimate riddle in Vegas is that while many people go there for a few days because it promises an adventure with hell, the characters in *Casino* have a helpless sense of heaven there. Las Vegas is a biblical city, and no other film has delivered that so fully.

Scorsese looks at clothes, décor, and male gesture like a cobra scrutinizing a charmer. You feel he is realizing his own desires, or bringing them to life: he hungers for his own imagery as a fantasy made vivid. No one is more alive in the moment, or such a defender of history. He has fought to preserve films, to celebrate their past, and to revive neglected triumphs. He was a saint of generosity and admiration to Michael Powell, and he surely learned from the repressed extremism in many Powell films. That at the age of seventy he wants to do Frank Sinatra says so much about him: it ought to be a young man's subject, and the American movie has so often relied on kids like Orson Welles, Irving Thalberg, and all the dudes going out on Friday nights. But in movies these days, a seventy-year-old has to pass for a kid to stay alive.

By 1963, aged twenty-one, Scorsese was about to complete his BA in film studies at New York University and was making a short film, *What's a Nice Girl Like You Doing in a Place Like This?* On graduating, he went for an MFA, too, and later he would dedicate *Raging Bull* to his teacher at NYU, Haig Manoogian, who had just died.

Also in 1963, Quentin Tarantino (of Irish, Italian, and Cherokee descent) was born in Knoxville, Tennessee, places he has been loyal to in

the talk in his work. Aged two, in a family that split up before he was born, he moved to Torrance, California, and never went beyond high school. He saw movies instead, and built up his knowledge and his unrestrained rapid-fire talk about motion pictures by working as a clerk in a video store in Manhattan Beach. (Video began to take off as Tarantino reached his late teens.) So maybe you didn't need to go to film school, in the way the generation of Coppola, Lucas, and Scorsese had assumed.

He had tried to work as an actor, but a chance meeting with Lawrence Bender prompted him to start writing screenplays—anyone could hear that Tarantino exulted in his ability to deliver impromptu riffs on hard-boiled talk. It was like a teenager who had been programmed by the history of film noir and then had a shot of adrenaline in his heart. (Tarantino seems fascinated by drugs, and sees film as a companion to them.) So he wrote what became *True Romance* (1993) and *Natural Born Killers* (1994), the latter for Oliver Stone, rather as Stone once got his break dreaming up tough Cuban talk for Al Pacino in *Scarface*. In a world where the pitch is a vital step in getting any film made, a director has to be able to talk a meeting into silence, awe, and green-lighting.

Then, in 1992, he made his directing debut with *Reservoir Dogs*, a seething pastiche of noir in which the black-suited figures were named after colors (like the balls in pool or snooker). The film was full of references, quotes, and lifts—probably more than Tarantino remembered. He admitted trying to do a new version of Kubrick's *The Killing* (1956), and other video-store dogs cited the marked debt to *City on Fire*, a Hong Kong film of 1987 by Ringo Lam.

As for "reservoir dogs," it was prison slang for rats or snitches, but it was also possible that Tarantino came up with the title when he garbled the name of *Au Revoir les Enfants* ("that reservoir film"), another 1987 film, by Louis Malle. We've most of us met video store clerks who play games with titles, talk in dialogue, and seem to have been up all night watching three screens.

Tarantino's first plan was to film *Reservoir Dogs* on 16mm for as little as he could manage. In the end, it cost about $1.2 million (with Harvey Keitel, Mr. White, putting up some of the money). *Raging Bull* is in love with movies, to be sure, but it does convey a sense of boxing and New York, as well as male chauvinism, brotherhood, the festering boredom of night-club life, and the bond between violence and sex. By contrast, *Reservoir Dogs* gives the impression of knowing and caring about nothing from life.

Whatever it has came from movies or comic books, and the color-coded status of the gang members is a foreshadowing of video games. (There would be a video game from the film in 2006.) It is hypnotic, and the talk and many set piece shots are as mannered as if six Marx Brothers had done a course on James Ellroy for their rhetoric major in prison. Though frequently blood-soaked, the film reaches a cruel nadir when Mr. Blonde (Michael Madsen—his character's real name is Vic Vega) razors off the ear on a bound and gagged cop, to a musical accompaniment ("Stuck in the Middle with You"), and does a prowling, shuffling dance while luxuriating in the prospect of torture. Blonde tells the cop, "I don't give a fuck what you know, but I'm going to torture you, regardless."

Tarantino would have said it was only a movie (he forgave those who walked out on the film); and he might have added that movies had no other purpose than to extend and advance cinematic forms. *Reservoir Dogs* lays out a trinity of young male aspirations that is still with us: the kick of lyrical badmouth, the idealization of gangsterism, and an assumed familiarity with both that comes from movies. This is Mr. White before doing the jewelry store heist:

> "When you're dealing with a store like this, they're insured up the ass. They're not supposed to give you any resistance whatsoever. If you get a customer, or an employee, who thinks he's Charles Bronson, take the butt of your gun and smash their nose in. Everybody jumps. He falls down screaming, blood squirts out of his nose, nobody says fucking shit after that. You might get some bitch talk shit to you, but give her a look like you're gonna smash her face next, watch her shut the fuck up. Now if it's a manager, that's a different story. Managers know better than to fuck around, so if you get one that's giving you static, he probably thinks he's a real cowboy, so you gotta break that son of a bitch in two. If you wanna know something and he won't tell you, cut off one of his fingers. The little one. Then tell him his thumb's next. After that he'll tell you if he wears ladies' underwear. I'm hungry. Let's get a taco."

Reservoir Dogs made its modest money back, though Miramax (founded in 1979) did not market it with gusto. In fact, the film played better in England, where interest in cruelty and video technology seemed ahead of American standards. At that point, sensing a dynamic new talent as well as a practitioner whose taste for guns, language, and music played to a

young audience, Miramax said they would finance Tarantino's next film. For just over $8 million they got *Pulp Fiction*, which won the Palme d'Or at Cannes and grossed close to $300 million across the world.

Pulp Fiction (1994) was one of the most influential pictures made in America since the advertised death of pictures. It helped excite a new younger generation about movies, rather as *Easy Rider* had done. Its unceasing reliance on classic movie situations, with so many scenes of violence and foul language, was a sneer of rejection for older audiences. But its intricate formal structure as a narrative encouraged the idea that a film was just a set of scenes that had no relationship with closure or meaning. It made a shape, like a snake eating its tail. The film hoped to imitate its title, but it was shot to resemble old Technicolor, still wet from the processing baths. The music was chosen lovingly, the cast was worthy of a poster, but the characters had no backstory or dramatic provenance. They were figures from a movie landscape, frequently caught in the Mexican standoff pose that seems built into Tarantino's DNA and ready to take priority over any other kind of meeting. At least *Pulp Fiction* had a few women: *Reservoir Dogs* had been strictly male, with allusions to homosexual urges. The nonstop rhythm of violence was offset by droll literary conversations about hamburgers, breakfast, foot massages, the Bonnie situation, cleaning the back of a car of blood, brains, and skull fragments, and whether God was there or not.

When Vincent Vega (John Travolta) takes Marcellus's wife, Mia (Uma Thurman), out for the night, the film does not bother with the possibility that they may begin to like each other. There is not enough mind or sentiment in them to reach that conclusion, and Tarantino is not much interested in sex on-screen. But as iconography, their night is a catalogue of pop culture references—in the diner they visit, Jack Rabbit Slim's, where standins represent the stars, and in their slinky version of the twist, where the film nods to Travolta's past. (*Pulp Fiction* did a lot to revive his strange career.)

Every section and nearly every shot is a set piece in a line for which Tarantino takes no kind of realistic or narrative responsibility. That helps account for the energy and freshness of the film, and indicates how many American films at the turn of the century were formally stagnant, and short on excitement. You could not resist Tarantino's own thrill, and it drew attention to the crazy verbosity of his lowlifes. Why do Vincent and Jules (Samuel L. Jackson) do the job they do? So they can talk. The actors (notably Bruce Willis) seemed excited that their normal pattern of over-

paid and conventional inertia has briefly given way to chatter and danger. Harvey Keitel's Winston Wolfe is not just a master fixer but a drug called spiel. It is a film that might have gone on forever, just as its convoluted structure is available for further loops and intersections. If you ever wonder why your own kids think it's fatuous for a film to seek their emotional involvement, or for its story to be sincere or dramatic, *Pulp Fiction* had the cheerful thrust of getting those archaic hopes to walk the plank.

To talk of this postmodern stress on form for form's sake, and movie trashing literary traditions, it may come as a surprise to note how successful the film was with its wide-eyed detachment. Yes, the actors loved the trick as well as the talk, and the film was as funny in desperate moments as, say, *Some Like It Hot* or *The Shining*. So many ghosts were being given up—and exorcism was dear to the heart of the young movie audience. There had been a picture about that show, ridiculous exploitation, but as gripping in 1973 as *Carrie*'s white hand reaching out from the black grave in 1976. The film of *The Exorcist* was a telling case: terrifying and revolting when it opened; addled and comic on rerelease in 2000. It was a sensation you could not preserve, because its impact—the phantom of meaning—depended entirely on the superstition and the anticipation of 1973.

Pulp Fiction has lasted. It is a beautiful maze as knowing and insolent about the prehistory of films as *Kane*. So it left you wondering if Quentin Tarantino might prove as smart or as doomed as Orson Welles. You remembered that Welles himself had not been able to pull his kid's trick off for long. And *Citizen Kane* had never been the box office coup that *Pulp Fiction* managed.

Tarantino is nearing fifty now, and there have been hiatuses in his career. But has he made progress? He has never found the comedy or the elegance of *Pulp Fiction* again. *Jackie Brown* may be underrated, but the two-part *Kill Bill* seems to me a sign of a general absence of any personal subject matter that doesn't come out of pulp fiction. That problem was glaring with *Inglourious Basterds* (which is Tennessee guys against the Nazis, with a lengthy standoff scene in a bar that is an abyss or interval in the arc of the film). The idea of nitrate film burning Adolf Hitler is full of comic potential, but the film never approaches the soaring, musical brio of *Pulp Fiction*, and it leaves one wondering how much or how little Tarantino knew about the war, as opposed to war movies. There may be a level of education now in which some young people are ready to settle for

our slipshod pop-cultural "meanings" of history or what they pick up in the family atmosphere called Facebook. But Tarantino needs more than his merry admission of helplessness in the current climate of filmmaking. Did he deliver everything he had in *Pulp Fiction*? Would it matter if he never made another film?

In case you are uncertain, that is not omniscient, objective history (wherever that treasury is hiding), it's vulnerable opinion. But history has to include opinion, and I am dealing with Scorsese and Tarantino out of an interest in the question how does a director make a career, a living, or even art in unsteady times? How does he or she keep finding the stamina without wondering why survival is so pressing? So it's useful to note that Scorsese had never had an unequivocal hit until *The Departed* (and that was a restrained success), while *Pulp Fiction* trumped its own budget by a factor of more than thirty. The kids and the critics were alike in believing they had seen something so astonishing it redefined the possibility of cinema and its role in our experience. The power of the light show had been reasserted, along with the invitation: come ready to be dazzled but leave your feelings at home. If you look at *Pulp Fiction* now you already feel some of the nostalgia you might get in watching *Casablanca*. But it's not easy to think of a middle-aged Tarantino. He has said he will retire by the time he is sixty, or sooner than that if digital eclipses film—and that is happening. The new kid sensation could soon seem old-fashioned.

•

David Lynch is sixty-five and increasingly difficult to define. At first he appeared to be an exceptional yet typical example of someone who noticed film during an art school education. Born in Missoula, Montana, the son of a research scientist in the Department of Agriculture, he attended the School of the Museum of Fine Arts in Boston, the Pennsylvania Academy of Fine Arts, and the American Film Institute Conservatory. He has been a painter all his adult life, and he has talked about the darkness in his painting in a way that helps one watch his films:

> Color to me is too real. It's limiting. It doesn't allow too much of a dream. The more you throw black into color, the more dreamy it gets . . . Black has depth. It's like a little egress; you go into it, and because it keeps on continuing to be dark, the mind kicks in, and a lot of things that are going on in there become manifest. And you

start seeing what you're afraid of. You start seeing what you love, and it becomes like a dream.

The potential slide toward dream in cinema was there from the beginning—and it is present in the work of directors who would hope they were down to earth. An Astaire-Rogers musical seems like a business proposition. People still marvel at how hard Fred worked striving for ease. But if you plunge into one of those films suddenly (in the way the surrealist leaders went to cinemas in the 1920s), you see only the proud unlikelihood of a dance scene so that it's easier to feel the erotic rapture of those two figures in their whirling embrace. Last night I watched *The Searchers* (1956) again. I know the film. I know the places in Monument Valley where it was shot. But coming upon it unexpectedly on television, I saw how the burnished ochre mesas were obviously psychological forces, loaded with the threat of rape and revenge that impel the film. This awareness lasted just a moment, and then the plot reassembled itself and actual landscape resumed. I doubt John Ford felt this, or needed to—he had identified Monument Valley as his world years earlier. I have discovered that David Lynch is generally not comfortable talking about such things. But Lynch is a filmmaker who does not flinch from his allegiance to surrealism. He was also the creator of a primetime series on ABC television, *Twin Peaks*, that was a hit, no matter that its opposition was *Cheers*—until the network destroyed the story's power by insisting that it settle the riddle of who killed Laura Palmer.

At art school, Lynch made short films that were abstract, symbolic, and what we mean by "experimental" when we can't identify the genre or the commercial aim the film believes in. (Of course, it is possible to make a movie that has no commercial aim.) His first feature, *Eraserhead* (1977), was in that same vein. But something in Lynch was attracted to the chance of a regular movie for a large audience, and it seemed to hinge on his abiding sense that appearance screens us off from a world of savagery, ecstasy, and the dreamlike. (He had lived a lot in Los Angeles.) So, at Mel Brooks's invitation, he made *The Elephant Man* (1980), based on both fact and a stage play. It was a heartfelt picture, not afraid of sentimentality, direct and pleading, and reluctant to intrude on John Hurt's fine performance, but it may have helped Lynch discover a release for his own feelings.

Next, he moved on to work for Dino de Laurentiis on the science-fiction picture *Dune* (1984). Dino and Lynch were so different that their partnership seemed arranged as a test. But the tycoon was impressed

with the kid, and said he would give him the money ($6 million) to make what proved to be *Blue Velvet* (1986). Dino granted Lynch final cut, and left him alone.

As Lynch described it:

> At a certain point Dino wanted to see the film. We were working in Berkeley [at Fantasy], so the editing team flew down to LA and took it over to the screening room. Dino invited a lot of people in his company to come to the screening. And Dino says whatever he wants to say, in front of whoever's there. And so I was just *waiting* for something horrible to happen! At the end of the film Dino said something like "Bravo!" He was *shocked* at how much he liked this film, and understood this film! It was a beautiful thing.

Then there was a test screening, right after a showing of *Top Gun*. His agent told Lynch it had been a great screening, but the next day, when the director called de Laurentiis, the real word came down: "Ah, it is DISASTER. Come to my office. We talk." Yet Dino held firm. The film was shown selectively to a few critics, without alteration, and they came out raving. At least, I did.

The film frightened or offended many people—and it was heartening to see that threat restored to the dark. Blandness and security spoil cinema the way domestic lighting humbles television. *Blue Velvet* is a violent mystery, but don't expect to follow it in every detail. It is also a parable on coming of age, in which Jeffrey (Kyle MacLachlan), the ideal boy of folklore, encounters dark unknowns and falls into a sadomasochistic affair with a femme fatale—or is she just a woman who feels she is dying?— Dorothy Vallens (Isabella Rossellini, who became Lynch's lover afterward), while still clinging to his young sweetheart (Laura Dern). Beyond that, the film resides in the sublimely inexplicable: you cannot say what it "means" when the Dean Stockwell character mimes to Roy Orbison's "In Dreams," but you can hardly breathe because of his suave mainline into your neurotic imagination. Dennis Hopper's Frank is fearsome, but another child, too, and the unhindered power of the film lets us know that his wildness is as unrestricted as that of the figures in Luis Buñuel's *Un Chien Andalou*. Anything could happen, and we feel exposed as desire and dread roam through that openness like shooters in a video game. Here is a film that knows the Jekyll-and-Hyde brotherhood of those two states. But as in a dream, we are allowed to watch such disturbing rites without flinching:

these are just shapes on a screen. Whereas Tarantino sets up the ear scene in *Reservoir Dogs*—he gloats over it—Lynch comes upon his shockers with absolute calm.

David Foster Wallace would sum up the impact of *Blue Velvet* on a new movie audience:

> [It] helped us realize that first-rate experimentalism was a way not to "transcend" or "rebel against" the truth but actually to honor it. It brought home to us—via images, the medium we were suckled on and most credulous of—that the very most important artistic communications took place at a level that not only wasn't intellectual but wasn't even fully conscious, that the unconscious's true medium wasn't verbal but imagistic.

Blue Velvet opened in Ronald Reagan's America as the movies were becoming a business again that did not appreciate wild trespassers. It was more controversial than any other picture of its time, and its sexuality and obscurity may have kept the largest audiences away. People can guess what may terrify them. But it was talked about, like a foul ghost in the house. The curious folksiness of Lynch himself, who could be an extra from a provincial coffee shop (and happy to be so identified), had grabbed the subconscious as if to shout out, "It's alive!," the famous cry from the 1931 *Frankenstein*, when life is not simply vitality but a dangerous extension of humanity.

Despite the talk, *Blue Velvet* barely covered its outlay in the domestic market. The sane and amiable critic Roger Ebert attacked the film for what he saw as exploitation of eroticism and its lead actress:

> Rossellini is asked to do things in this film that require real nerve. In one scene, she's publicly embarrassed by being dumped naked on the lawn of the police detective. In others, she is asked to portray emotions that I imagine most actresses would rather not touch. She is degraded, slapped around, humiliated and undressed in front of the camera. And when you ask an actress to endure those experiences, you should keep your side of the bargain by putting her in an important film.

Isabella Rossellini did not share Ebert's distaste, but Lynch admitted that several actresses had declined the role, as if they "could smell a rat."

Some talked to Lynch and gave him useful notes, one of them Helen Mirren. (Go that way, and the film shifts in our mind: Mirren would have to dominate Jeffrey; but Rossellini lets him feel his new power and its cruelty.) It was then that the director met Rossellini for the first time and realized she wasn't just a model. Today, Ebert might reappraise his response, for the film has passed beyond outrage to a point where it's easier to recognize Lynch's serenity in making it. He is not disturbed or aroused by his own vision. There is a matter-of-fact point of view. I don't know if *Blue Velvet* was ever meant to be an "important" film, and I'm not sure I trust that genre. But it's one of the most piercing and involving films in this book. Set in the cosy small town of Lumberton, North Carolina, and playing off archetypal images of the heartland, it is doggedly American. Its companion in recent years in the uncovering of a surreal inscape is Lynch's *Mulholland Dr.* That is his Los Angeles story and an autopsy on how Hollywood uses actresses, a film where blond glamour and a corpse-like grayness sit side by side in a challenging double role for Naomi Watts.

These films are "difficult" if you strain to understand everything immediately—and once our films had assured us, and themselves, that everything could be grasped immediately. It was a way of saying we wouldn't condone difficulty. Lynch works best if you relax, and come back for more. But most people reckon to see a film just once. Pauline Kael always claimed that was her policy. It's another way of adoring *now*. But gradually—since *Kane*, at least—pictures had been made for that sophisticated pleasure in all the arts: coming back later to see how the experience resembles itself. So film becomes less a process that requires an opening night (in which we are opened up to the novelty) than a museum to which we may return. But will people still be excited enough to make movies if that *now* is withdrawn? Don't you sometimes feel that few people any longer take still photographs with the urgency or excitement that gripped Muybridge or Lartigue or Capa? Aren't they pictures of pictures, or of the catalogue of photography? Hasn't television, on and on, always *on*, and now streaming, made it clear that we can't quite watch anymore? Six hours a day of American television, done over two or three decades, can leave you with the numb discovery that all the irony and superiority you were feeling has turned to waterlogged depression.

Blue Velvet still feels like a dangerous now, and a great film, though "great" becomes as silly and redundant as "important." It speaks to our yearning better than it explains a movie. But in this chapter there have been at least three films of a high order: *Blue Velvet*, *Pulp Fiction*, and

Casino. It's good to remind ourselves of that in a climate where it's easy to think that the movies might be withering. They might be. But we have seen amazing things near death; and if the movies are dying, the long-running funeral has been a show to behold. The ghost has a half-life, even if he lives in a museum.

He may talk to himself in the night, going over the lines from movies: "Nobody's perfect" and "Rosebud"—isn't there a disconnect there, a subtle difference of philosophy? Or "Tomorrow is another day" and "I could have been a contender"—American mottos, yearning for the future and the past, delusion and self-pity. Does the ghost ever hear other lines in his over-look? "You saw nothing in Hiroshima" or Ozu's "Isn't life disappointing?"

THE NUMBERS AND THE NUMBNESS

More than many film books that talk about the quality of movies, this book has quoted numbers—what films cost and what they made. I can't be confident in all these numbers. Lynda Obst, a movie producer (she did *Sleepless in Seattle*), once wrote a memoir on Hollywood called *Hello, He Lied*, and nowhere is the habit of wishful thinking more common than with the numbers. But the urge to be serious and important in picture-making, to be good or better, can hardly hold its head up unless it promises numbers. It's like the dilemma from a film I've referred to several times, Preston Sturges's *Sullivan's Travels* (1941), where the director of popular comedies (such as *Hey Hey in the Hayloft* and *Ants in Your Pants of 1939*) yearns to do a picture about hard times and sad lives. He intends to call it *O Brother, Where Art Thou?* He means well; he says he wants to suffer and put that on the screen. But this man has been raised in the large rooms and sunny self-esteem of Beverly Hills, so he probably nurses a secret hope that his bold departure might yet prove a sleeper smash: not just a Best Picture possibility, but a hit! Think of the numbers.

The matter of "the numbers" is contingent on the frequent hope in filmmakers that film and screens can put us in touch with the larger world, an interaction that reaches from Chaplin's sincere wish to have us all feel like one community to Mark Zuckerberg's estimate that the function of Facebook is "to make the world more open and connected."

As it reaches nearly a billion subscribers, Facebook claims that it is used by five hundred million people every day. This is a prodigy of our time (and Facebook was founded only in 2004), as wondrous as the movies seemed in the 1920s. Such a force, family or collectivization, carries a burden of responsibility. The huddled masses have so much dread and desire: they need direction, a commanding story, or a sweet dream—and

openness can be a lack of direction that yields eventually to more em-
phatic, brutal answers. Zuckerberg is as vague as Chaplin on what he
means by "open and connected." In David Fincher's acidic *The Social
Network* (2010), you may gauge how close Zuckerberg is to being out of
his depth. He says his toy will give us more choice with things such as
music, movies, and restaurants. (I haven't heard him mention job oppor-
tunities or freedom from terrorism.) But so many of us are uncertain
about surviving, and suspicious of anything that makes that much money.
Zuckerberg is said to have a net worth of $17.5 billion.

Facebook is an evolved movie system: it involves us looking at screens
and converting our desire into a fee payment or a surrender to ads. Its
aura of youthful generosity and utility belies how easily it could be turned
into a system of surveillance and control. That slippery process was out-
lined already in the 1920s and early '30s in Germany by Fritz Lang, in his
Mabuse films. Facebook already takes our earnest admissions about our-
selves and trades them for advertising. Twitter has not yet made a profit,
but it has little trouble finding investors—because they are gambling on a
future when the money turns around.

It is very hard to make a movie without hiring equipment and the
people who can operate it, without purchasing place, time, rights, and op-
portunities. Nor is it any easier to make a film without feeling the great
desire to show it to others. And then to make more films. Moreover, once
you ascend that staircase of economic progress and cultural reach, it is
hard to step off. As he made *sex, lies, and videotape* (a breakthrough "inde-
pendent" movie, in 1989), Steven Soderbergh wrote a journal that admit-
ted the poverty he was in and the miracle of having a chance at a movie.
Twenty-two years later, Soderbergh is a kind of tycoon: he makes films
steadily; he lives in Los Angeles; he produces and enables movies by
others—and, to his credit, he involves himself in experiments as well as
mainstream pictures. He knows and lives by the rhetoric of balancing the
two, and so he has directed the two-part *Che* (2008, a sympathetic por-
trait of Guevara) as well as the "real-life" people's lawyer movie *Erin
Brockovich* (2000), and *Ocean's Eleven, Twelve,* and *Thirteen* (2001, 2004,
and 2007, respectively). He also produced *Confessions of a Dangerous
Mind* (2002, George Clooney's directorial debut, and a neglected film).
Soderbergh is still not fifty. He has clout and credentials and he has made
some enjoyable pictures, though nothing yet is better than *sex, lies and
videotape.*

I don't know him, but he is said to have a net worth of $40 million,

which can be as awkward as any other net worth because it means he must keep striving, working, and balancing if his standard of living is not to drop.

So Soderbergh, who began full of a rather sour, or cool, idealism, has to negotiate with stars, franchising, international rights, DVD deals, and raising large sums of money for which he admits a sense of responsibility and good fortune. And he's candid:

> I think it's a real privilege to make a living doing this job . . . You walk into a room and say, "I'm imagining this," and they give you millions of dollars to go out and make it real. . . . They should be betting on the career of somebody. By definition the really smart people in this business are the ones making the stuff. That has to be the case. Making it is harder than sitting in an office and decid-ing what should be made. It doesn't mean I should walk around feeling like a smart guy . . . There's a lot of fear in the room. So when you talk about things that are difficult to describe in writing but are crucial to the creative success of a movie, that's tricky. You're saying, "You're just going to have to trust me . . ." I don't like to say those words, and they don't like to hear them, and there's no question that in the last two years there are certain words in meet-ings that you can't say. Words like "elevated," "smart," "better." You literally can't indicate at any point that you're going to do anything that won't be understood by a below-the-average audience member.

The *Ocean's* films have been central to Soderbergh's position, and they demonstrate the easy wisdom of franchising: if you make something that works, make it again. When they came out, in the years 2001–2007, few audiences recalled the Frank Sinatra version from 1960. The new fran-chise took ironic pleasure in criminality, wealth, and wisecracks; it had a package of likeable stars; and it played to the endless fantasy of a big kill-ing and a bigger payday. It's not hard to see Soderbergh identifying with Clooney and the guys in the gang; they are much closer to him than he is to Che Guevara. Che wanted one kind of opportunity in the world, Soderbergh sought another. Danny Ocean's good guys (or the good bad guys) triumphed with several male fantasies (albeit in suicide city). There was an air of Robin Hood about it because the money had been stolen from a shark or a sheriff, Terry Benedict (Andy Garcia). Thus it was possi-ble to forget how Benedict had picked up the money from us, the people.

Think instead that Benedict had also taken Danny's wife (Julia Roberts). Her role in the picture is so spineless and convenient it could take the edge off the fun.

Everyone knows now that the *Ocean's* films were big successes. Yet the three films saw a moderate revenue decline: $450 million; $362 million; $311 million. Not enough slippage to break many hearts, perhaps, but reason to think some spectators had worked out the con and that three times down this road might be enough.

But when is enough enough? Franchising was always the solution for bosses who couldn't think of a new story, or a whole story, one that reached a narrative and moral conclusion. The James Bond pictures (begun in 1962 with *Dr. No*) are the pioneering modern franchise—if "modern" still fits—and more recent examples have been Adam Sandler being himself and the *Die Hard*, *Lord of the Rings*, *Spider-Man*, *Twilight*, the *Harry Potter* pictures, where a rascal studio (Warner Bros.) actually broke one book into two films to stretch out the bounty.

In serious books about movies, Adam Sandler is rarely examined. On principle, a lot of people (cable subscribers, perhaps) tend to think as badly of him as they do of franchising—though if *The Sopranos* and *Boardwalk Empire* aren't as much franchises as serials then we're kidding ourselves. Sandler is too interesting to ignore. It is said that every dollar paid to him in salary has produced $9 in gross revenue. Many of his films are tedious and painful, or not "better." Since he has gained self-confidence, he has happily played himself, to such an extent that his good nature and his casual sense of fun have tended to make scripts redundant—so maybe they are no longer written. And yet Sandler was unusually controlled and surprising in Paul Thomas Anderson's *Punch-Drunk Love* (2002), and he did enough in Judd Apatow's *Funny People* (2009) to suggest that it might have been a worthwhile exploration of being a professional comedian, and rather more daring than a lot of Woody Allen pictures. That it didn't reach that far is a sign of his audience being lazily content with Sandler's happy-go-lucky attitude to his own work.

On November 11, 2011, a new Sandler film, *Jack and Jill*, opened along with Lars von Trier's *Melancholia*. Could two films be more different, or illustrative of the idea that filmgoing is still full of variety?

That weekend in November was not a good time in the world at large. Unemployment in America was officially at 9 percent, though that figure was deemed as unreliable (or corrupt) as the fiscal status of Greece or Italy, which were coming to pieces with threats of "contagion." Another American debt crisis committee was drifting toward stalemate. It had been the

week of Joe Paterno, the scandal at Pennsylvania State University, and the reports of a ten-year-old boy being raped in a shower by the team's defensive coordinator. Joe Frazier had died. Kim Kardashian's marriage had ended after seventy-two days. Eddie Murphy had stepped away from being the host at the next Oscars. The Dead Sea was dying. Republican presidential candidate Rick Perry had been unable to remember every government department he meant to shut down. There was word of higher radiation in Japan than had been anticipated, and every reason to think that the state of global warming and the permafrost in Siberia were making their gradual way toward catastrophe. You can arrange these items in whatever order you think fit. But on that Friday night, you had those new films to choose from.

Jack and Jill is excruciating. It's about a Los Angeles advertising executive who seems to be happy: he has Katie Holmes as a wife and two adorable children. (The film is an extended advertisement, as if unaware that we are accustomed to keeping ads short.) But he has a twin sister who comes to visit at Thanksgiving. He hates her, and you will, too (yet Sandler plays both parts). The idea of twins locked in revulsion and resemblance is very promising: it inspired the David Cronenberg film *Dead Ringers* (1988), which was frequently funnier and always nastier and more intelligent than *Jack and Jill*, and it is embedded in the Jekyll-and-Hyde myth just as it picks up the pattern of doubling in so many of our most impressive pictures, from *M* through *Vertigo* and *Persona* to *That Obscure Object of Desire*. There is this piquant extra in the Sandler film: that Jack wants to get Al Pacino to appear in a commercial. This comes to pass in enjoyable ways. (A. O. Scott in the *New York Times* said it was Pacino's best acting in years.) Sandler coproduced and helped write the script, all for $20 million up front and a slice of the gross. One clue to Sandler's following comes in this review, by Mick LaSalle in the *San Francisco Chronicle*:

> So *Jack and Jill* is a strange one, with successful bits and big moments of satisfying comedy, interspersed with long sections that are just annoying. You may still be on the fence about it, so here's a last morsel of information that should tip you one way or the other: *Jack and Jill* was made with a children's audience in mind, so it abounds with flatulence and excretion jokes. Jill eats Mexican food.
> Case closed.

In the November 11 issue of the *Chronicle*, LaSalle gave the same visual rating to *Jack and Jill* and to Lars von Trier's *Melancholia*: a little man

sitting upright in his theater seat, not applauding, not leaping out of his chair, but not slumped back in a coma.

Melancholia is a festival film, and von Trier is a festival director. Once upon a time, film festivals were special events that often assisted the commercial release of a picture in foreign countries. By today, however, festivals have become a self-sufficient circuit of distribution in a world less sympathetic to foreign films. In the larger Bay Area of San Francisco there are now more than seventy film festivals in a year. These represent sectional interests, different languages, and the simple urge in outlying suburbs or towns to promote local business. The creative directors of most festivals report fewer worthy films, though more and more get a screening. The funding of festivals becomes more strained, and if film-makers are to appear in person, the budget has to take care of their travel, their hotel, and perhaps their companion. There are a few large festivals with a history—Venice, Cannes, Toronto, New York, London—and there are smaller events for connoisseurs, such as Telluride, Sundance, and Pordenone. Many of those are marketplaces for other festivals and for the few foreign-language films that can afford subtitling and an opening.

•

Lars von Trier was born in Copenhagen in 1956 and came to prominence in 1984 with *The Element of Crime*, a mannered if not ostentatious thriller. He looked like a noir stylist hoping to develop an international career. But in the early 1990s he was a leading figure in the Dogme 95 movement, a northern European attempt to purify cinema. With Thomas Vinterberg, in 1995, he nailed a set of theses to the door to filmmaking: no extravagant commercial funding; no genres; shoot on location, not in a studio; sound must be recorded live; use color (because it is lifelike); there should be no opticals or special effects (stay with the world as is); the camera must be handheld; the director should not be credited.

This drive for integrity was dogmatic and shallow, but there was a germ of interest in every insistence: films had become absurdly expensive; Renoir had believed in locations and live sound; the Soviet cinema had restricted itself to state funding; many felt that Hollywood genres were archaic and inflated by effects; nearly every director was indifferent to whether other directors got credit. Von Trier lived by or ignored his Dogme in *Breaking the Waves* (1996), *Dancer in the Dark* (2000), *Dogville* (2003), *Antichrist* (2009), and then *Melancholia*.

I found *Melancholia* prolonged, pretentious, and insufferable. But in

Entertainment Weekly, Lisa Schwarzbaum wrote, "A giant achievement. A work of genius. A movie masterpiece," while in the *Wall Street Journal,* Joe Morgenstern called it "a film that sweeps you up and takes you out of yourself." (Any critic knows that kind of rhetoric, and has used it, but it may be worth asking how far its suppositions conform with Dogme 95.)

Melancholia is in three parts: there is a prologue, laden with Wagner's overture to *Tristan und Isolde,* a montage of images in which we see the impending collision of one planet with another. Much of this is beautiful, arresting, and very promising.

The second part is a wedding between Michael and Justine, at a grand country estate in Sweden. It may be a real place, but it seems as symbolic as Shaw's *Heartbreak House.* We meet the family, and the occasion is as awful as weddings often are. But the couple insist that they are happy. They kiss endlessly and they break away to have sex. Still, there is a flaw in the serenity: Justine is suffering from melancholy, depression, or bipolar disorder. It is not spelled out clinically, but Kirsten Dunst does an impressive if unsettling job at conveying the outer symptoms. (Characters on the big screen and in the bright light who lack energy quickly seem alien or anathema.) She becomes less gregarious or happy. She has sex with a passing acquaintance in a bunker on the estate's golf course. The marriage breaks up even as it is being celebrated.

The third part is named for Claire (Charlotte Gainsbourg), Justine's sister. The estate is owned by Claire and her wealthy husband, John (Kiefer Sutherland). The wedding is over. Justine is close to catatonia, but Claire is increasingly distraught because the planet of Melancholia is approaching Earth. Will there be a collision? John, who has a modest telescope and knows how to do the calculations, assures Claire that it will pass by safely. Justine moon-bathes on the bank of a stream in the woods, allowing us to see that Kirsten Dunst has an exceptionally beautiful body—I'm not sure this display is statistically associated with depression, though it can often be found in art movies looking to hold an audience.

I won't give away the ending: you should suffer yourself. At 136 minutes, *Melancholia* needs cutting—unless you feel it could go on forever. (J. Hoberman admitted in *The Village Voice* that "When I left the theatre, I felt light, rejuvenated and unconscionably happy.") It is a simple enough story, granted that the resonance wants to be immense—its reach is quite like that of its close contemporary, Terrence Malick's *The Tree of Life.* Both films opened at Cannes in 2011, when *Tree of Life* won the Palme d'Or, while Kirsten Dunst took the prize for Best Actress. Prizes are foolish, we

all agree, and those at Cannes have a record of eccentricity to live up to. But to reward Kirsten Dunst while not honoring Charlotte Gainsbourg is beyond eccentricity.

Melancholia cost over $7 million, accumulated in small amounts from many sources, and when it opened in the United States, it did quite well: $270,000 from nineteen screens on its first weekend. After four weeks, as word and reviews spread, it had grossed $2 million. Although it deals with clinical melancholy and the end of the world, the film has a curious air of money. Just about every character is wealthy, well dressed, and amply provided with sleek household appliances. The common man or the huddled masses are nowhere to be seen, despite that Dogme severity. (Bourgeois audiences appreciate the screen's world looking nice. Poverty can upset them. These are legacies from advertising.)

The one item in the Dogme code that persists in *Melancholia* is the faith in handheld camera work. This seems like voodoo thinking. If a tripod counts as unfair technology, why pick up a camera at all? If the camerawork in the film is viscerally or neurologically disturbing, that is not necessarily art any more than a badly proofread version of *Paraside Lust* would be a literary breakthrough. The fixed base, or stability, of shots—in that they are anchored to a tripod—is a convention of order and respect and an aid to attention. If architecture is an art and a social function, isn't it best if the buildings don't fall down? If Facebook is a community, isn't it preferable that no one is hacking its intimate information?

You can see the film to make your contribution to the argument. But the most conventional character in *Melancholia* (though he cracks before the end) is the most orthodox of performers: it's Kiefer Sutherland as John. He's also the most believable and interesting person in the film, and I found this from Sutherland himself, who came to work with von Trier in a high state of anticipation. This comes from a published interview:

> "There's one constant in every job I've ever done, which is you get to work in the morning, you read it through with the other actors, the director or you and the director block it out, you rehearse it and you shoot it. That constant has never been broken," he says.
>
> Until that inaugural morning on set when von Trier led him and [Charlotte] Gainsbourg to a door and told them to walk through and start the scene.
>
> "I realize we're not going to block it, we're not going to rehearse it, he's just going to shoot it. I panicked," he recalls.

"Once I surrendered to that, there was an unbelievable freedom to it. What it did for me is it did deconstruct everything I knew about what I'm used to doing as an actor. I was so busy trying to kind of figure out between Charlotte and I in the middle of making the scene, trying to hit the points I thought were important, I became completely unaware of where the camera was, never saw it, actually. I was in a moment and that was a huge education for me."

Kiefer Sutherland is a case worth studying. He was an actor for years, probably more notable in supporting parts (*A Few Good Men*, 1992; and *Freeway*, 1996) than when he starred in low-budget pictures. But in 2002 his life and his image altered as he became vital to one of the most intriguing and influential television series of the twenty-first century, *24*. As Jack Bauer, secret agent at the Counter Terrorist Unit, he was another "JB," a taciturn superman who kept saving the world. But his world was vulnerable to technologies Bond had never thought of: not just nuclear wipeout, but data retrieval, surveillance, cell phones, and torture. I don't mean that American torture was new, but it was for the public, and in *24* it got a strange, uncritical attention that told us it had been there for a while without our noticing. The show had a striking first season, and a very good second, but it was pitching its own dramatic stakes so high that hysterical and inadvertent self-parody were likely.

Sutherland's Bauer was faultless and appealing in what was already an archaic acting style. He was also, from 2002–10, a producer on the show and one who took a close interest in the story line and the numbers. When he had done *A Few Good Men* (1992, playing the surly southern sergeant), he earned $250,000. By now—and there may be a *24* movie—he has a net worth of $65 million.

Good luck to him: a hit has always been ready to change the world for the lucky few. But *24* is part of a pattern of reiteration with raised blood pressure that affects us, too. Some of the executives (Alex Ganser, Howard Gordon) behind *24* moved on in 2011 to the series *Homeland*, on Showtime. Once again, the first season (which concluded on December 18, 2011) was something not to be missed. It resembled *24* in that it brought terrorist threats to the doors of American government. It went a little further in suggesting how American crimes had given a sense of justifiable revenge to the terrorists. Above all, *Homeland* was valuable in presenting a family context, with several female characters who were original and involving.

It's the story of a Marine sergeant, Nicholas Brody (Damian Lewis), who has been kept prisoner in Syria and Iraq by a terrorist for eight years. When he comes back to America, a very smart but troubled CIA agent, Carrie Mathison (Claire Danes), suspects that he has been turned in captivity and is now a terrorist in waiting in Washington, D.C. Brody has a family—a wife who has been having an affair in his absence, a young son, and a teenage daughter (Morgan Saylor) anxious to rebuild a relationship with her father.

The point about the show is that we cared deeply for maybe half a dozen characters, and as the series advanced, it became clear that Danes was giving a vivid and disconcerting performance as a deteriorating victim of bipolar illness. In every dramatic sense, *Homeland* cried out for resolution, maybe not as devastating as that in *Reservoir Dogs* (where no one is left alive), but with tragedies, damage, and even lessons or conclusions. I know, that recipe sounds formulaic or old-fashioned, but anyone who followed *Homeland* will know what I mean about the story's gathering need for a convincing ending—and the last episode of season one was not the normal hour, but ninety minutes.

In that twelfth episode, the show suffered from conflicting urges—to tidy up, while indulging a frenzy of implausibility—but it left all the key players available for a second season (announced at the end of October). Don't you want to see more of Carrie, Brody, and the others? Don't the actors and the writers deserve steady work? Aren't we making money? The answers are obvious, and you have to have known actors and writers to understand their insecurities. So Carrie will be on the brink again, until the brink becomes the cliff on which her integrity is hanging.

Still, in the business, the hourly reports on box office numbers for a first weekend are desperate or delirious. That is why there are always so many nervous people in the room called movies, increasingly unaware that their space might be part of a much larger house. *Jack and Jill* grossed about $26 million in its opening weekend (November 11–13). That was at the low end of expectation for an Adam Sandler picture. Interpreting these figures is habitual now but unreliable; it's more spin than history, yet our taste for so much discourse has shifted that way. *Jack and Jill* finished second on the weekend, about $7 million below *Immortals*, an R-rated swords-and-sandals epic. Some observers felt Sandler might have lost part of his regular audience to that film and to the way young males (the sixteen-to-twenty-four age range) were seeing fewer films and playing more video games. November 8 had also marked the release of the video game *Call of*

Duty: Modern Warfare 3, with $400 million in immediate sales in the United States and the United Kingdom. No movie has ever approached that number on a first weekend.

Call of Duty had competition. Only a few days earlier, *Battlefield* 3 had appeared, nearly as successful, and in the *New York Times*, Seth Schiesel said that "Visually the depth of field and rendering quality in *Battlefield* 3 [made it] . . . the most visually realistic shooter on the market." He added that "*Call of Duty* isn't trying to be realistic; it's trying to be fun." He concluded his "critic's notebook" piece on the front page of the *Times* Arts section, with a color illustration: "Both games are ultimately about letting men have their virtual taste of combat without getting off the couch or up from the computer. Would many of us really prefer a draft?"

I have put these titles in italics to make them seem comparable to movie titles. Yet their performance is at a quite different altitude, one that reminds us of the earlier sway of movies. So it's deflating to add that Clint Eastwood's *J. Edgar* (which opened on November 9, 2011) grossed $11.5 million in its first weekend. That meant a little over a million people saw the Eastwood picture. In the next three weeks, it fell off by 54, 49, and 68 percent. It was a disappointment, if not quite a flop, for Eastwood and Leonardo DiCaprio. But it's a lackluster film, spoiled by the customary caution that is seldom mentioned as part of Clint's public image.

The culture of the opening weekend is predicated on impatience and forgetfulness, yet franchising seems to suggest the system believes in loyalty. There are newspaper articles and Internet items that gossip over these numbers, and try to explain what they mean. But they are as irrelevant to the real progress of "the business" of screens as the daily oscillations in the Dow are to our economy. One way or another, the business maintains that its box office income is vibrant, but the number of people going to see a movie in a theater declines. Everyone knows that one day everything will stream; this is happening already, and that's why there are moves in Congress and from the MPAA to "outlaw the piracy" of new movies. Then the defenders of the Internet protest that we should not interfere with the Net's "liveliness." By the time movies are available on your computer or your thumbnail or a chip in your head, it will be left to museums and archives to maintain a few big screens—if they can find proper prints to show.

•

We have come to a strange pass for the movies and their shining light if the depression of *Melancholia* is out there with a genre called "shooters."

Sadness and tragedy have a necessary place in fiction and drama; that's what *Homeland* deserved. But isn't depression antagonistic to the light itself, and close to what Lew Wasserman regarded as a "downer"? Isn't it as upsetting as watching kids—your own kids—building their kill counts? There was a time when it would have been unthinkable for Fred Astaire to sing "Never Gonna Be Depressed," and then sink into a heap in a corner of one of those deco sets. He believed in being an entertainer. But maybe Fred's and Hollywood's reign of happiness and its stress on well-being left a hangover that taught us how far we were falling short in the American pursuit. Movies gave us a heady idea of fun, but was it an unkind education? Are we left with no better choice than having a draft, seeing the fun in *Call of Duty*, or joining in the family of Facebook?

Can't there be a difference between dread and depression? In advance of AIDS, *Alien* (1979) was a haunting metaphor of bodily betrayal, and a great show. Directed by Ridley Scott, it cost $11 million and grossed $185 million. In 2012 Scott offered *Prometheus*, which tried to recapture the fears and tropes of the original. That cost $120 million and quickly grossed twice that amount. But the profit ratio on *Alien* was 17 to 1; to match that, *Prometheus* would need to earn $2 billion. People still dream about *Alien*; they are forgetting *Prometheus*.

EPILOGUE: I WAKE UP SCREENING

How many funerals have there been for the death of cinema?

The coming of sound was termination for some people. *Photoplay* magazine mocked the claim that sound had been perfected: "So is castor oil," it said. Then the audience dropped off in the 1930s. In 1951 there was David Selznick wandering in an empty studio and crying, woe is us—we betrayed our chance, we made so few worthwhile pictures. Television seemed the obvious and natural way of watching moving imagery, including movies. Later in the 1950s, attendance fell for good and a few smart films nudged us and said, "Aren't movies stupid?" We killed Technicolor; we betrayed black and white. From 1960, for a few years, Godard was a surgeon excising every stale convention with a look of contempt and superiority. Then video was offered as an easier way of seeing more pictures. We gave up cinematography for digital. We knew that so many movies had been lost for all time, and still there were too many to see. One day in July 2007, Michelangelo Antonioni and Ingmar Bergman died, not together, but as if in a pact that wanted to teach us something. Yet the ghosts go on about their business, like Michael Myers in *Halloween* or the Living Dead hearing their cue. We still like to look.

•

In San Francisco, it is 7:00 A.M. on a Saturday morning (August 27, 2011). I am on the sofa, ready, in the old way; it is nearly time for the match (and a 90-minute game is like an old movie). Since about 1953, I have followed a London soccer team, Chelsea. For years I stood on the terraces in southwest London in crowds close to seventy thousand watching the Blues. It is a habit and a devotion. But here, six thousand miles away, I can watch Chelsea versus Norwich, live, as it happens (it's 3:00 P.M. in London), on

high-definition color television, with a little tea and toast. This is playing
on Fox Sports, and part of our cable package (which rents at about $200
a month), whereas if I were in London, I doubt I would afford a ticket to
be at the stadium (at least fifty pounds). See how enabling the screen and
the media are these days? And in that very game (a 3–1 victory for Chel-
sea), a new player, Juan Mata, made his debut and you could see—you
had to see—the way he turned and moved, his fluent instincts, the soccer
of it. Seeing something can still be as moving as watching a naked woman
in Muybridge turn to the right, or waiting for the moment in Gene Kelly's
"Singin' in the Rain" number when he spins and the camera soars above
him. At seventy, I have found nothing to match motion and emotion run-
ning together. John Wayne walking, a child making its first movements,
Juan Mata—they all do it for me. I like to watch.

But as I watch the game, I realize the screen is not just the benign il-
lusion of Stamford Bridge, where Chelsea play. There are two constant
insignias stamped on my screen, top left corner and top right, for Bar-
clays, the bank that sponsors the Premier League, and for Fox Sports, the
channel that is showing the game. Very well, I sigh, those companies have
a claim of ownership, even if it seems crass to assert it at every instant.
But that is not all. Periodically, in a panel that comes and goes, they warn
me of other matches they are about to show. Let's be gracious; let's say
that this is a useful service and not just brutal advertising and a reminder
that I am not at the game.

There is more still. At the ground, for the television cameras, there is a
low billboard, a constructed electronic screen, no more than four feet high,
that reaches from one end of the ground to the other. It is programmed
with very basic verbal messages that move and change throughout the
game. In the course of the match, there were signals on behalf of Barclays,
Fox, Thomas Cook (the travel company), Samsung ("Experience the fu-
ture of TV"), Adidas, Singha Beer, the gear worn by Chelsea players, and
even messages in Chinese characters.

The skill and intimacy of the camera coverage are better than ever. Is
any documentary practice more sophisticated? In addition, the coverage
can go to slow-motion, close-up angles on any controversial or dramatic
play. Many sports fans admit that what you see on the TV coverage sur-
passes being there. And TV is vital to the crazed economics of major
sports, which steadily pushes old fans from being able to go to the game.
So the experience itself is in question. Where sports once existed for their
own sake, they are now there to sustain television. In Britain, the attempt

by Rupert Murdoch to undermine the BBC began with the campaign to get more important sporting events on his network, Sky (formed in 1990).

That seems like an archaic struggle now, just as once it was a surprise to see moviegoers playing video games in the theater lobby. But so much has changed, and so much of it for the better that sometime it feels pushy to insist on the loss. In the 1970s, teaching film at an American university, a teacher had to hire a film on 16 mm and project it for the class, stopping and starting the show for the purposes of "film study." That depended on the school's having a projector, the teacher's knowing how to operate it, and some worthy pictures' being in distribution.

That clumsy yet exciting operation was overtaken by "video" in the late 1970s. That novelty has gone through many transitions in just over thirty years, from Betamax and videodiscs to VHS and DVD, with necessary upgrades of equipment along the way, but it is a gift for teaching. Not that the film industry showed much early awareness of this, but video also rescued the theatrical business. It appeared to the public as an obvious extension of television, just as they had once felt television was natural heir to the big screen. In the 1980s and for twenty-five years or so, video rental stores had a flood of hitherto unavailable titles. Not just the new films, not just movies that might have been denied theatrical release, but the treasury of "old movies." For anyone from the 1950s and '60s, who sometimes waited years to see certain titles, it was a breathtaking liberty. By today, thanks to companies like Criterion, a pantheon of classics is available with variant versions, interviews with the filmmakers, and shot-by-shot analyses conducted by scholars.

This is the state of modern cinephilia, which amounts to the happy and self-contained study of the art of cinema in the way a minority studies opera, ballet, and literature. Such people do see some films on theater screens, even if it's not a movie print being projected. But most cinephiles live in apartments where shelves of DVDs and VHS tapes compete with bookshelves. In doing this book, I have frequently picked out a DVD and looked at it, often just a scene, to refresh my memory over a detail. In turn, movies have increasingly become cliplike, or the collected quotations from themselves. The total experience suffers from fragmented attention. It is not just our children who have attention-deficit "problems." The condition, along with so much else, is in the technology. As Woody Allen is quoted in this book, that is what has taken over from Lubitsch and Preston Sturges.

There is a book called *The Death of Cinema*, by Paolo Cherchi Usai.

He is senior curator at the George Eastman House archive and director of the L. Jeffrey Selznick School of Film Preservation. So you can guess where he stands. But he has some arresting facts. His book was published in 2001, and he said then that in 1999 the world had produced 1.5 billion hours of moving imagery. He predicted that 100 billion hours would be made in one year by 2025.

That footage or mileage is so overwhelming that it's absurd to think of keeping it all. Cherchi Usai feels the tsunami of technology:

All our talk about budgets and legal rights, about the digital age and the vinegar syndrome [the way acetate prints naturally deteriorate] is meaningless if it does not preserve a thing that is no less precious than moving images themselves, the right to see them. . . . Life is short, and cinema won't last forever. But for now it's still here. It may become something else, but so what if it does? There are worse things. Physical pain. Not enough food, or none at all. Being alone. Losing interest in the art of seeing.

Cherchi Usai is a defender of the cause—Martin Scorsese did the preface to his book—yet I find it encouraging for him to admit that there are things more important than cinema. Do you recall what Francis Coppola said introducing *Apocalypse Now*, "It *is* Vietnam"? No, not quite. Film and its followers often join in a kind of rapt myopia that says nothing is more important. Richard Brody's thorough and understanding book on Jean-Luc Godard is called *Everything Is Cinema*, as if to embrace many of Godard's runic sayings—such as "The cinema is Nicholas Ray." (The "Everything" line was one Godard gave Brady.) I knew Ray a little in his last years, and the truth was more complicated and demanding. "Everything" is available to be served by cinema, but our ordinary everything existed long before cinema and it will thrive still when the word has been abandoned.

I also echo something Paul Schrader said as long ago as 1990:

Whenever I get a chance I persuade students who are interested in films to stay away from film majors and take a hard-core undergraduate major in a traditional liberal-arts subject, because in the end nothing will stand you in better stead for making films. You can learn about films later, but you're never going to have a chance to read the classics or psychology or philosophy the way you would

in college, because that is where the mold is cut. If you don't cut the mold with a liberal education you are a less interesting person, and a less interesting film-maker.

Alas, in twenty-one years, that advice has been neglected, though Terrence Malick is one example of the liberal arts background, and more, as well as one of the finest eyes we have ever had. He translated Heidegger and taught philosophy at MIT. I know a sixteen-year-old so entranced by Malick's *The Tree of Life* that he watched it five times in a couple of months, always on his computer screen. The film was still playing in theaters where he lived, but he had no interest in seeing it there. I like that kid (he is a young man now), but I feel he and I are not quite of the same species.

Whatever one's view of *The Tree of Life*, surely its eye deserves a large screen. I loved that light and space in *Badlands*, Malick's directorial debut, though I think Malick's energy has moved fatally from narrative to introspection. Perhaps it is philosophy. My young friend might respond, Well, wouldn't you rather be alone in a gallery with a Chardin painting than have a mob of people trying to get a better view than you? Fair point. Wouldn't you rather hear Mahler on an immaculate CD, without audience distractions? No, that's going too far: I want to see and feel the heave and bustle of the orchestra. But why shouldn't a young man insist that he gets more out of Malick's reverie if he is close to that state himself, without the theater of distraction?

In a 2010 article in *The Toronto Star*, Geoff Pevere analyzed the nature of being at the movies—at least in Toronto. In his research Pevere talked to the Canadian filmmaker Atom Egoyan, who had taken his seventeen-year-old son to see *The Social Network*. They had liked the movie, but not what Egoyan described as "the way people were talking to each other, like absolutely out loud, having conversations as though there was no sense of this as an experience that needed a degree of respect or consideration, was amazing. It was as though they were watching in their living room . . . They were talking, they were texting each other, there were all these other sources of light in the room."

Respect for the experience as opposed to immersion in the technology? It's part of this argument that cinephiles—flinching from the violent action and cutting of short-attention movies—have espoused "slow cinema." This can be many things: Andy Warhol did slow cinema, and so did Antonioni (the out-the-window shot in *The Passenger* might make an audience

restless today). Then there were Mizoguchi, Ozu, Renoir even, Tarkovsky, Béla Tarr, and Theo Angelopoulos, who died in early 2012 at the age of seventy-six.

Angelopoulos was a Greek and a radical who had lived through Nazi occupation, civil war as the Communists tried to overthrow the government, the era of the junta of colonels, and then the Balkan horrors to the north. He once said that the twentieth century began and ended with Sarajevo—and there were always more people than the Archduke deserving to be warned. He made films that reflected on that history, with reference to the Greek myths, and in what he called sequence cinema—long takes, elaborate camera movements, few close-ups, and an attempt to dwell in distance and landscape. He is not to everyone's taste but *The Travelling Players* (1975), *Voyage to Cythera* (1984), *Landscape in the Mist* (1988), *Ulysses' Gaze* (1995), and *Eternity and a Day* (1998), at least, are masterworks, scarcely capable of being felt properly except on a theatrical screen. For years, Angelopoulos would not let his films be shown on VHS, but DVD and its greater fidelity tempted him. Still, *The Travelling Players* is close to four hours and only just over a hundred shots.

When Angelopoulos died, a friend, Mark Feeney (the author of *Nixon at the Movies*), e-mailed me:

> He did things with film (on film?) that others hadn't done. That's awfully rare—and, as done by him, awfully moving, too. It isn't just the duration and foreign-ness of his movies that worked against his reputation, I think, but their profundity. We live in an age uninterested in profundity to the point of negligence. Or should that be fear?

So many young people who say they are studying film nowadays do not see many movies projected large in theaters—in packed theaters—in flawless 35 mm prints, nitrate or acetate. Readers know how many theaters have gone from their neighborhoods. They realize that the screens have shrunk in size, while standards of projection and sound have deteriorated. What they may not know is how many of the old film companies, once they have invested in a good DVD version of a picture, believe their duty is done so that they may scrap their old prints—and even the negative.

There has always been an antagonism between film production and the task of archiving. The business is happy to wear prints out and then

discard them. But technology changes the argument very quickly. In his editorial for the January 2012 *Sight & Sound*, Nick James reported the spread of digital projection at the expense of film prints:

> January 2012 will apparently mark the point at which there will be more digital screens in the world industry than analogue, and by the end of 2012 it is estimated that 35 mm projection's share of the global market will decline to 37 per cent. What's more, mainstream usage of 35 mm will have vanished from the USA by the end of 2013,with Western Europe set to be all digital in the mainstream one year later.

So the argument that there is something precious in the projection of film has been lost already. But there are other consequences. In 2007, the Academy published a report, "The Digital Dilemma," that declared all forms of digital storage and archiving were unreliable—and you know how often digital prints on television break up into a mosaic. For a moment, the archives adopted that stance, but now digital standards have been accepted even there. As Nick James makes clear, the future is open and a source of great vulnerability.

In the summer of 2002 the theatrical business in America sold 653 million tickets. By the summer of 2011 that figure was 543 million. There are alternatives: not just Criterion, but Netflix, which nearly ousted the video store, and Turner Classic Movies, which is dedicated to good prints of classic films (silents, too), with background information to interest the ordinary viewer. But Netflix is moving more and more to offering fewer films and more TV series. TCM knows it has an aging audience: there are enough people over forty-five who dislike most new movies and prefer to seek out the history of the medium. They might not know what cinephilia is, yet they are contributing to it. But as a business and a sensation—as a light hitting the masses—it was always what was happening *now*. And many young people believe that *now* is their last asset or energy. As Lewis Lapham told Truthdig, "With electronic media there is no memory, it's always the eternal present, which is constantly dissolving and contributing to a great social anxiety."

So video becomes antique. At nearly the same moment that video appeared, another screen came into our lives: the personal computer. At first it seemed dauntingly large and complicated. Surely it was beyond understanding—and even if it worked, wasn't it just a glorified calculator-

typewriter? When *now* takes over, it never falters or admits mistake; it is our implacable guilt-free passion. The novelty voted "Machine of the Year" by *Time* magazine in 1980 will have two billion versions of itself in the world by 2014, no matter that smartphones and computer tablets are taking over more of its functions. This is a far broader phenomenon than what we might call movies, but it has been a point of this book to see that the light and the dark, ways of looking and responding, sending or saving, are more significant than whether a few of us think this movie is better than that.

Or even whether a movie is subject to copyright, as something created by talented individuals. Most American films are still the copyright of companies, and those enterprises are indignant about piracy—the way pictures can be stolen away on the Internet, without any income for the rightful owners. Tom Rothman, co-chief executive of Fox Filmed Entertainment, says, "Our mistake was allowing this romantic word—piracy— to take hold." But Disney and Jerry Bruckheimer have made great hay on a *Pirates* franchise, and all the big players will go to streaming video in a weekend when the moment is right.

Theatrical performance of movie is a sentimental stronghold, and we know it will pass away. If you look at the remaining buildings where movies still play, and at their forlorn attempt to be glamorous while asking twelve dollars or more for a ticket, it is a wonder how long the natural transmission of new movies to our television set or by the Internet has been delayed.

Some kids play video games, in intense groups, for longer than it would take to project Syberberg's *Hitler: A Film from Germany* (442 minutes), or they revel over one-minute shots on YouTube. The technology has come to the aid of a culture that wearied of narrative and moral suspense a long time ago. Disillusion with narrative showed itself already in the late 1950s and early '60s. Jerry Lewis talked to the camera and the audience. Billy Wilder's *Some Like It Hot* ends with the aghast face of Jack Lemmon staring out at us and the whole apparatus of movie as if to say, "Do you expect me to take this seriously? Do you expect me to take 'seriously' seriously?" That bereft nihilism is Godardian, and only a year before *Breathless* opened.

Godard's first films, fifty years old now, are full of inserts— photographs, paintings, bits and pieces of movie, posters on walls, and words inscribed on the screen, abbreviated shots. They are marvels of brusque prescience in foreseeing the untidy mosaic of levels, insets, and layers that I got at my soccer match and that kids take as commonplace in

the multiplicity of screens before them—and that erode their and our need for concentration, narrative, or responsibility. Not that Godard is aroused enough now to be any comfort. In 2005, queried on his famous belief in Nicholas Ray, he confessed, "It's not possible to see the films. You can only see them on DVD, which I don't like very much, because the screen is too small." Asked about film's ability to reinvent itself, he said, "It's over. There was a time maybe when cinema could have improved society, but that time was missed." It sounds like another funeral.

If you add up the broken pieces a young person sees in a day, the chaos is like the earliest years of movie, when a viewer saw so many things we would call shorts, or clips, or bites. They were not whole movies, but the debris from an explosion in the culture, where reality seemed to be scattered everywhere we looked. It is the bang that made cubism, the machine gun, and shellshock.

In the last ten years especially there has been a plethora of books and articles worrying over this scattering of attention. They range from Martin Lindstrom's *Brandwashed: Tricks Companies Use to Manipulate Our Minds and Persuade Us to Buy,* to Evgeny Morozov's *The Net Delusion: The Dark Side of Internet Freedom.* They talk about deficit disorders and alleged miracles of application, from the optimism that Twitter explains the uprising in Cairo in 2011 to anxiety over what happens next in Egypt.

In the *New York Times* in May 2011 the pediatrician Perri Klass wrote an article, "Fixated by Screens, but Seemingly Nothing Else," that said,

> The situation that video games provide "is really about the pacing, how fast the scene changes per minute," said Dr Dimitri Christakis, a pediatrician at the University of Washington School of Medicine who studies children and media. If a child's brain gets habituated to that pace and to the extreme alertness needed to keep responding and winning, he said, the child ultimately may "find the realities of the world underwhelming, understimulating."

The experts disagree; that is their business. So sometimes firsthand accounts are useful. Here is a sixteen-year-old, writing to the *New York Times* in 2010 in reaction to an article on "Growing Up Digital, Wired for Distraction":

> Cynicism aside: Teenagers are dysfunctional. Anything remotely educational or not associated with "Gossip Girl," Facebook or the

like is seen as pointless—when it's actually quite the reverse. Dependency on these technological media will result in a shallow and socially inept generation.

The teenage brain has evolved into a vestige—an appendix of sorts. Read. Draw. Go to the museum. Do something that's not completely mindless. School has stigmatized learning. Of course we're going to shut off our brains and rot in front of a computer— it's just easier. YouTubing, watching "Glee," playing Xbox? These are passive activities with easily attainable yet meaningless highs.

Just a kid? The film critic Antonia Quirke (I quoted her on *Jaws*) is old enough to be that young woman's mother, and she sent me this e-mail reporting on the sudden riots that hit north London in August 2011 and that seemed to be organized by cell-phone connections:

About 100 children (some as young as 9) in an estate directly over the canal all gathered on Monday night at dusk and started yelling and screaming and photographing each other (this fixation with commemoration freaks me out most of all. I was up at Hampstead ladies pond the other day when a group of 16-year-olds were all photographing each other ALL day. Every action was merely a set-up for a snap, every sensation a pose) and it got louder and louder, like the drums in *King Kong*, it was truly AWFUL. I called the police who told me, "It's like world war 2 out there tonight. Don't leave the boat" [Quirke lives on a canal barge] and so I didn't. Then they all ran off and joined the riots down the road. Sudden and total silence.

It was John Berger who first noted that while a photograph seemed to summon presence, it also evoked absence. The base function of film and its successors is not just to join reality but to adjust to the screens that keep us from it. Watching television footage of the devastation in Japan in March 2011, I saw an endless shot of empty automobiles carried in tidy, prim reverse on the flood, backing and turning corners in a multistory parking garage. I was horrified and helpless, but I thought it was comic. I wondered if it was a scene from a Jacques Tati film. When my youngest son saw the second plane enter the World Trade Center tower on live television he asked, "What movie is that from, Dad?"

The film form has always been fascinated by the screen, and the way

it converted "reality" or the prospect of it into a set (a place where some defined action would occur). In the same way, the makers of film have been challenged by the thing they call off-screen space. The thought of getting "into" the screen from our off-screen space has always been alluring, just as infants believe there must be real people behind or within the screen, while older children want to enter its flat world because the lovely, lifelike dream seems to be there and "on." Buster Keaton played with the fancy in *Sherlock Jr.* (1924), Godard in *Les Carabiniers* (1963), and Woody Allen in *The Purple Rose of Cairo* (1985). But there are other ways of doing it: the past, the flashback, can be an interior or inset existence, so tempting but elusive. In Alf Sjöberg's *Miss Julie* (1951), the past and the present share the frame together. We feel that overlap in *Citizen Kane*, and we see it in an array of optical effects—wipes, fades, and dissolves (not common now)—that remind us of the existence of the screen. The best thing about 3-D is to say, look, it's all a trick on one screen. From the early days of sound (which was rich with off-screen suggestions), movie was drawn to another inner flatness, the mirror, as a double of its own existence and an unconscious way of saying, "Look at the show. Look at yourself. Are you there? Are you 'on'?"

In François Truffaut's 1969 picture, *Mississippi Mermaid*, Jean-Paul Belmondo has been tricked into marriage by Catherine Deneuve, who pretends to be his mail-order bride invited to the faraway island of Réunion. He knows she's "wrong," but she is so lovely that he falls for her, or into her—so enigmatic and yet so potent, she is a screen that slides into his life, like a blade. Then she vanishes, with the money from his tobacco plantation. She is his movie, and he wants to run it again just as most of us, when young, carry a movie's dream home in our head and start to play it again, with variants and extensions.

So he goes back from Réunion (a dot in the Indian Ocean) to France, looking for her. He has a breakdown and one day, while he is in the hospital with other patients, there she is, Deneuve, on a screen, a television screen, dancing in a nightclub. So he pursues her and confronts her, and straightaway, like an actress who had the lines ready, she confesses and tells him a rigmarole of explanation while she sits in front of her mirror and the film presents her as a double image. He doesn't need to hear it. He loves her still, so he believes her even while he can see the warning in the looking glass behind the real woman.

You could go back over the history of the movies and make an anthology of such moments, where the form of a film is saying, "Can you trust

what you're seeing?" But in 1998 one picture caught the whole duplicity. *The Truman Show* (1998) was so complete an insight that if it had been the first film you ever saw you might never have needed to see another.

Truman Burbank (Jim Carrey) lives in Seahaven, a hideous display of perfection, a perpetuity of advertising. The buildings are new, bright, flawless, and impersonal. The sun shines as steadily as lighting. The people are amiable; they smile. And the production didn't have to build this warning of a place, as Fritz Lang built *Metropolis*. They found it, in the designed community of Seaview, Florida, an "ideal" place to live, they say. Truman seems happy there. He is cheery with everyone, although Jim Carrey's nervy good nature never wipes away the thought that he might snap and turn into . . . the Grinch, Stanley Ipkiss (*The Mask*, 1994), *The Cable Guy* (1996), or worse. He has always felt unstable with repressed possibilities.

But Truman begins to wonder what is happening. How is it that other people seem always in the same place every day, uttering the same banal lines? Perhaps this has struck you about your life, too, until you wonder whether each new day is just one more take, a way of getting it right, or keeping it from going wrong, life as a loop, a way not to worry. "You have a good day!" the extras insist. Truman hears talk on his car radio: it seems to be a crew that might be looking at him and making him the center of attention or a show.

Indeed, there is a thing called *The Truman Show*, a television reality show, 24/7, before that phrase was common, and it's just Truman's life: having breakfast, going to work, chatting with his wife, Meryl (Laura Linney), and being asleep. It's a bland, safe life and a parody of all the positive, high-key "we'll-sort-it-out" television shows of the 1950s and '60s. It's also a payoff for any thought you ever had that it wasn't just that the shows served the commercials; they were helpless extensions of them.

Andrew Niccol had written the script on spec, without a deal or any money. Once it was bought (by producer Scott Rudin), and once Peter Weir was established as director, then Niccol did many rewrites, attempting to get the tone Weir wanted. This storyline could have turned dark or horrific; it might have been a new version of *Invasion of the Body Snatchers*— for this bland Seahaven is emptiness occupying us. Weir preferred to keep a balance between desire and dread; he wanted us to be uncertain at most moments, whether we were amused or afraid.

I can't rid myself of simultaneous feelings of admiration and loathing for Christof (Ed Harris), the director of the show or its auteur. He's a mas-

ter at what he does, and we like good directors, don't we? Yet it's just as clear that the movie he's making, the Show, is ghastly, dead, and so conformist as to be a complacent, residential fascism with Seahaven as the new model camp.

Like a young hero, Truman determines to escape. The big movie of his life (the death of his father at sea) has given him the jitters over taking to the water. But he is brave. He gets a small boat and sails away from Seahaven, until he reaches that place where the sea meets the great dome protecting and imprisoning *The Truman Show*. It is a diorama, an effect, but it is a screen—as in a screen that masks something as well as showing us. It is one of the most expressive moments in the history of film, and you must see the movie to find out what happens next.

•

There is another naked use of other screens within the obvious movie screen, called back projection. It was an industrial and economic convenience: a screened background image could be projected on a sound stage in front of actors who tried to give the impression of being in the real location. One standard use of this device was for scenes with a person in a car. The actor pretended to drive while sitting in a mock-up of a vehicle as the road unwound behind him. Fans could blow breeze on him—the sight of wind is one of the loveliest things.

Back projection declined as a habit as audiences became more critical, or as our need for credibility in the dream proved nagging. But Alfred Hitchcock persisted with it later than anyone. It's not just Janet Leigh in the car in *Psycho*, but also the detective, Arbogast, falling backward on the staircase in the same film. People said, "Oh, that's just Hitch. He liked to keep everything under control. He preferred being in a studio. He was too large to get out and about." He was also an intuitive genius who felt the dislocation of back projection as a model for our separation and unease. Seen today, his use of it begins to look avant-garde or daring.

Back projection had a variant, the traveling matte shot where a second image was married with a first. For *Gone With the Wind*, the artist Jack Cosgrove did elaborate background paintings on glass that were bonded with foreground action. The trick there was meticulous and unnoticed; it was a part of the illusion. But tastes have changed. When Michael Powell and Emeric Pressburger made *Black Narcissus* (1947), instead of going to Tibet (where the story was set), they built exquisite sets with painted-glass perspectives to represent the Himalayas. (Alfred Junge was the art

director.) When the film was released, Powell cried out proudly, "You can't tell we're not there!" Perhaps in 1947 the eye was deceived. If you look at the same film today, you know it is fake, but it is the artifice that is most appealing. Nowadays we always know we're not there.

The neurotic urge persists in filmmaking—to have it fool the eye—but the eye has become more numb and less confident. Who can forget the theatrical aplomb of Lars von Trier putting the city of *Dogville* (2003) on a marked-up stage, with a diorama sky behind it? Wasn't the folding up of whole blocks of Paris in Christopher Nolan's *Inception* (2010) a landmark in surrealism's dream?

Inception is a rare kind of picture nowadays. It's filled with technology *and* emotion. It cost about $160 million and it grossed over $800 million. It won several Oscars for craftwork, and was nominated for Best Picture, though not for Nolan's direction. In those areas it lost to *The King's Speech*, by Tom Hooper, which cost $15 million and grossed about $138 million. *The King's Speech* was a pleasant picture about an ordinary king dealing with a small personal problem. It was entertainingly acted and expertly dressed and it had the veneer of an independent picture that carried reassurance and no threat. It could have been made in 1937–38, and so anyone fond of the movies of that moment took heart and comfort. *Inception*, on the other hand, wanted to introduce marvels we had not seen before in the service of a brand-new, half-wry yet disturbing portrait of the mind at work, awake, in dreams, or approaching death with dread and desire. It was an attempt at a mainstream movie, but it was drawn to neurology and dream, and one day it will loom over *The King's Speech* as much as *Kiss Me Deadly* (1955) now seems modern and poisonous while *Marty* (Best Picture in 1955) is hard to sit through.

Of course, this is esoterica now. Not even the secure place of film in the universities can persuade us that these differences of opinion matter. This may be the place to admit, and apologize for, the people and films omitted or shortchanged in this book: Michael Haneke, Krzysztof Kieslowski, Satyajit Ray, Abbas Kiarostami, Chen Kaige, Zhang Yimou, Wong Kar Wai, Andrei Tarkovsky, Aleksandr Sokurov, Madonna, and so many others you can add. On the other hand, I made space for Muybridge, *I Love Lucy*, television as a whole, the money and the deals, pornography and video games, the cell phone, streaming, and all the things that make up the shapes on our screens. This is a history of a larger process than "cinema is everything," and it is a book about worrying over the general impact of moving imagery and our becoming more removed from or helpless

about reality. Mark Zuckerberg is very optimistic about Facebook and the other social media of the last twenty years. He believes they spread openness and connectivity, and does not seem to notice the havoc that has come in the same era to our understanding, our economy, our community, and our belief that we can sustain ourselves.

So trying not to worry is a great goal, but deciding not to worry may be a larger mistake encouraged by our screens. Looking at video games and pornography for this book, as I had not done before, was not comforting. But in the twenty-first century, I have had exceptional experiences with a range of pictures that would include *Faithless* (2000, made by Liv Ullmann from an Ingmar Bergman script), *Moulin Rouge, Mulholland Dr., The Piano Teacher* (2001), *The Best of Youth* (2003), *Birth* (2004), *A History of Violence* (2005), *The Lives of Others* (2006), *No Country for Old Men* (2007), *There Will be Blood* (2007), *Red Riding* (2009), *The Way Back* (2010), *The Arbor* (2010), *A Separation* (2011), or Sarah Polley's *Stories We Tell*.

We can see most of those tonight, or in nights to come, along with *My Man Godfrey* (1936), *Midnight* (1939), and *Keeper of the Flame* (1942)—three films that have not been mentioned so far. (In *Godfrey*, William Powell says, "The only difference between a man and a derelict is a job." Unemployment is a deficit disorder, too.) No matter how small the screen has become, it is big enough to hold all our films. But its montage grows more profuse and uncontainable all the time. One hundred billion hours in 2025? So it's a game, just like awarding the Oscars, to propose the best films ever made.

In 2002 the London movie magazine *Sight & Sound* held its critics' poll on the best films. Since 1952 the magazine has run this poll at ten-year intervals; it is probably the most illustrious of top tens. And in 2002 the results were as follows: *Citizen Kane* (the top film since 1962), *Vertigo*, Renoir's *La Règle du Jeu*, the first two parts of *The Godfather*, Ozu's *Tokyo Story*, *2001*, *Battleship Potemkin*, *Sunrise*, *8½*, and *Singin' in the Rain*. That is still only a collection of opinions against which we can nurse our disagreements. But what is notable is that the newest film in the top ten went as far back as 1974, *The Godfather: Part II*.

Another poll is set for 2012, and I will be surprised if *Kane* is dislodged—after all, it is a terrific film (as the RKO ads said in 1941), and it is not easy to believe it has been overshadowed. But isn't movie made by and for young people? Shouldn't there be something more recent, more *now*? Or is insisting on *Kane* just another funeral observation? Orson's youth is still dazzling and intimidating, but why is it unsurpassed?

•

Cinephilia and cinema must look after themselves, but we may have a harder time of it. I mean the mass society that was first identified through novelties such as electric light, photography, and film shows, and by world war, genocide, indoctrination, and that ultimate huddling effect, poverty. It was enchanting in those first decades to see that film was a natural extension of photography and graphic arts, of theater, musical performance, and literature. It was harder to perceive that the deeper significance of a mass medium was to occupy most of the people enough of the time, to reconcile them in hardship, and to let them feel the great crowd was a "togetherness," a pact and a purpose (as opposed to a basis for impersonality, fear, and loneliness). That process reached its climax in the Second World War, when—whether it looked like Hope and Crosby or agonizing newsreel—the movie screen was helping us feel a common purpose and the hope of its victory.

The victory of the Second World War was not shared universally. Some countries were defeated and devastated. Some of the principle battlegrounds remained unfree though their threatened liberty had prompted war. Chill pressures of imminent destruction and endemic cruelty dominated the cultural atmosphere. The number of displaced persons was beyond care or solution. But the victory was widely identified as American (especially in American eyes), and it reinforced the widespread feeling that the movies were American, so that Hollywood was briefly a cultural center. That attitude was often contested. Nations wanted their own pictures, and many put out great work, but the public at large abided by the notion that so many climatic conditions of film—space, light, music, glamour, romance, suspense, being good-looking—were American tricks.

No one quite admitted that other ingredient, fantasy, and its constant struggle with the factual nature of film. As American victory hardened into empire, so the uninhibited element of fantasy fed into the American soul. It bred several dangerous fallacies: that happiness was an American right; that individuals could be free in a mass society; that American power would endure because the United States was the greatest of all nations. All those foolish principles are endangered now, and the steady process of watching a glorious but unattainable reality has warped our judgment and made us bitter. That is why the transition from movies to commercials was so disastrous and why the adoption of advertising in American television has been as damaging as the reluctance to have a

welfare state that can sustain a mass society. These problems exist in much of the rest of the world, because the inspiration and the lies of Hollywood have gone far afield. But the crisis is sharpest in America, which has now moved so swiftly from confidence to its opposite.

I hope it's clear how much I love movies and was shaped by classic American and French cinema. It may be one day that a few decades of film (let's say from 1915 to the late '50s) will be looked back on as a halcyon period, like German-Austrian music from Bach to Mahler, some of which was played to sweeten the days in the concentration camps. The history of the shining light and the screen suggests we have learned to feel detached from reality, grief, and politics. So many people, from Lenin and Chaplin to Zuckerberg and Jobs, have believed that moving imagery on screens might unify and enlighten the world. Isn't it pretty to think so? The screen has also distanced us; it has made us feel powerless, helpless, and not there. The array of watching devices that have swept over "cinema" in the last thirty years will accelerate and spread, and of course they are helpful and profitable—just look at the economy they have produced. Might they also be the lineaments of a coming fascism? Don't be alarmed, it will be so much more polite or user-friendly than the clumsy version of the 1930s, but as deadening as the shopping malls of Americana, the nullity of so many of its schools, the unending madness of its advertising, and the stony indifference of technology.

•

This book is a love letter to a lost love, I suppose. It has the semblance of being a history, but it might be some kind of novel, called *The Moviegoer*. I am probably not American enough to diagnose this country from the inside. Yet I am no longer English enough to be an outsider. Still, I know what Don DeLillo meant in *White Noise* (1985, just before *Blue Velvet*) when he looked at "the most photographed barn in America" and said, "They are taking pictures of taking pictures." As I near completion (December 2011), *Fear Factor* is coming back on NBC television, with contestants in a three-thousand-gallon tank of cow blood (USDA certified) trying to retrieve the severed hearts of cows with their teeth. About time. But why severed? Cut to David Foster Wallace:

> A certain subgenre of pop-conscious postmodern fiction, written mostly by young Americans, has lately arisen and made a real attempt to transfigure a world of and for appearance, mass appeal,

and television; and that, on the other hand, televisual culture has somehow evolved to a point where it seems invulnerable to any such transfiguring assault. Television, in other words, has become able to capture and neutralize any attempt to change or even protest the attitudes of passive unease and cynicism that television requires of Audience in order to be commercially and psychologically viable at doses of several hours per day.

Imagine what it felt like in the 1880s to see photographs and series like those taken by Eadweard Muybridge. Imagine that night in Paris in 1895 when the very slow and friendly locomotive came toward the screen and people felt fear or excitement. Remember the face of Margaret Sullavan looking into the empty mailbox in *The Shop Around the Corner*. Think of *Psycho* in 1960 and asking the movie not to do anything like the shower scene again. Imagine the man in *The Moviegoer*, the Walker Percy book, seeing what had to be William Holden and feeling that a casual movie was strolling down the street. You can still sense the marvel of having this shining version of reality there before you as a plaything and a philosophy. It was a time in which the mere act of looking and wanting to see possessed an innocence and an energy. It seemed like a way of growing up. How lucky to be alive then and there.

•

Who knows how much will change between this book passing from my hands to yours? You should be ready for the loss of theaters and video stores. Be open to something like Apple TV, activated by voice controls. But notice some sly "necessary" institutional control of its menu, if order is to be preserved. The technology is so potent and dynamic now that "entertainment" can run very close to social stability and political unease. Not every nation wants a "Spring."

Be prepared for the word "movie" being replaced by "hits" or "bites"—or "viddies" (a term Anthony Burgess used in *A Clockwork Orange* in 1962). There may be astonishing, obscene, and horrific innovations—we will chase fear and longing to the end. There may even be new works of art as profound as *The Passion of Joan of Arc* (1928), *Citizen Kane* (1941), *The Magnificent Ambersons* (1942), *Ugetsu Monogatari* (1953), *Céline et Julie Vont en Bateau* (1974), or *Mulholland Dr.* (2001).

That last film is typical of a natural trend toward old movie forms being appropriated. Lynch's film is not just its own story but an anthology

on the "blonde in Hollywood." For all its arresting originality, it wants to bring other movies and sad women to our mind. Moreover, cheeky kids are remaking classics all the time with impunity: on YouTube there is a short version of the Al Pacino *Scarface*. It is 1 minute and 40 seconds, and it is all the uses of "fuck" in the film. This joke went up in 2006 and six years later it has had 1.9 million hits. *Scarface* is a pretty good nasty entertainment: its marriage of violence and flash makes rascals of us all. But the short version reappraises it in so thorough a way I'm not sure I have time now for the long version. Short versions could become a cult—as well as longer versions. Another YouTube marvel is the seventy-four-second dissolving montage of Lindsay Lohan growing older: as of April 2012 it got six million hits.

Douglas Gordon's *24 Hour Psycho* (1993) may be the grandest example of interfered-with film. It is the Hitchcock classic played at two frames per second, a rate that makes a twenty-four-hour viewing. I must admit, I have only seen part of it, which is not unreasonable or impractical, though it is a mark of our new habit of watching just a fragment of things on-screen.

24 Hour Psycho is both tedious and every bit as potent as the 1960 movie. It is *Psycho* without sound, fear, or suspense; and without those atmospheres the picture is revealed as beautiful but poignant: to see Norman and Marion trapped together in dread slowness is to weep for them. (I have also enjoyed the text of a play, *Mote—Motel* with a letter dropped out—by José Teodoro, that makes new stories out of *Psycho*.)

The deliberation of *24 Hour Psycho* allows us so much more access to time, repetition, and the mechanics of filmmaking. I believe Hitchcock would have welcomed this "invasion" and watched it endlessly, for it's a lesson in his way of working in advance. It seems like a dreamy, nearly infinite rehearsal for the film, as well as a distant, inching memory of it. It makes *Psycho* feel ancient, like the cave paintings in Werner Herzog's *Cave of Forgotten Dreams* (2010)—the perfect description for the great film archive.

You have to see it, or part of it. Did Gordon have the right to do it? I don't know, but rights are going out of fashion. He had the means and the mind, and I understand his own claim, that it "is not simply a work of appropriation. It is more like an act of affiliation."

The appropriation doesn't have to come as a film. Am I alone in finding more pleasure in Geoff Dyer's book *Zona* than in Andrei Tarkovsky's film *Stalker*, to which the book is devoted? If I had to choose between all of Godard's work and his *Histoire(s) du Cinéma* (1988–98), I'd take the *Histoire(s)*. This was an eight-hour video, shown as a film, but it comes in

other forms, including a set of books. It is the piece of creative criticism Godard was born to deliver. If you want something similar, but more lyrical, there is Chris Marker's CD-ROM *Immemory* (1998 and 2008), which is an interactive labyrinth on Godard's subject. At the age of ninety-one, Marker was the least known master of film, but he was still e-mailing friends beautiful photographs of people riding on the Paris Métro that are as entrancing as the few mobile seconds from *La Jetée*.

This kind of creative anomaly with film first struck me in 2000 in Paris at the Centre Pompidou, where I saw the exhibition "Hitchcock et L'Art," conceived by Guy Cogeval and Dominique Paini, which had premiered in Montreal. This was not just a survey of art works that had influenced Hitch, but a new Hitchcock experience. There was a darkened room with spotlights picking out objects on blood-red silk—the knives, scissors, telephones, keys, watches, and poison that figure in his films. There were sets and rooms from his world. The visitor was more than just a voyeur; he was in the screen. That is the next big thing: us in their movies. As it was, the show seemed to me as stimulating as the best films Hitchcock made.

I have even tried such games myself.

In the late 1970s and early '80s, I taught at Dartmouth. The school had a modest but very useful library of films, most of them on 16 mm. One item was *The Clock*, made by Vincente Minnelli in 1945. It's a romance, in black and white, in which a young soldier (Robert Walker) has a two-day leave in New York and meets a girl (Judy Garland) and falls for her.

The film runs ninety minutes, and the Dartmouth print of it was on two 16 mm reels of exactly the same length. So my show was a mathematical idea before it was anything else.

I asked the projectionist—a sympathetic man named Jerry Cate—to help me. In the theater where films were run for classes there was a screen wide enough to play two 16 mm images without overlap. So Jerry set up two projectors side by side but sufficiently apart. On the left-hand projector he threaded up reel one of *The Clock*, to play forward, with sound. On the right-hand projector, he loaded the second reel, with all the film on the lower, or uptake, reel, to play in reverse and without sound.

—We started the two projectors at the same time.

So the film ended as it began. The story was moved forward and played backward from its finale concurrently. The two halves met tidily in the middle. The audience yelled with glee. We did not damage the print.

The effect was ravishing: it may be the most exciting film show I have ever seen—and it meant that *The Clock* took only forty-five minutes. (For the committed film watcher, the saving in time is liberating.) You may be able to try it for yourself, though those projectors and prints are harder to find nowadays.

How was it ravishing? It woke the audience up. I don't mean that the Dartmouth students were asleep or inattentive. But this was a fusion of narrative, cinema, and technology that no one had witnessed before. Looking at the screen was miraculous again. And if that sensation ever disappears, then our whole adventure with the movies and the screen is over. Nothing will remain but us being intimidated by the stupid promises of advertisements and other lies.

Backward motion is fantastic—it is as lovely as it is uncommon, or impossible: with people running in reverse upstairs (like Danny in the snowy maze in *The Shining*); pouring coffee from a cup to the pot; bursting out of the water in a pool, arcing through the air and coming to rest on a diving board that was trembling until the person landed. You look at these things as if you had never seen film before—the exhilaration is exhausting and transporting.

You also discover what a sweet, artificial thing story is. That is not a mocking of narrative, simply a revelation that story is just a series of tricks or steps, a mechanism, not too hard to guess in advance, and as systematic and serviceable as, say, a staircase—and as logical and mathematical. A story is something made and made up; it is a disguise of life, artfully and kindly done, but not life. It is lifelike. And stories are so artful, so manufactured, that they might as easily run backward or forward— Christopher Nolan did that with *Memento* (2000), but most flashbacks begin to play the same game. In short, you get the idea and the chance to see that movie is not just the illusion of reality (the fallacy of being there on the screen with its figures) but an artefact, a design, a game, a trick, an illuminated screen.

Thus the screen is as vital as the film, yet while every film is different and itself, the screen is always the same: patient, available, uncritical. It is timeless time on which the silly or suspenseful action of the clock's hands do their dance of movement and liveliness. So we laugh and cry, and hope for the ghosts to be happy. That is what we call "movie." But the screen is truth, or knowledge, and the absence of those things. It is fate, eternity, and implacability. If you wish, it's god. And moviegoing, for decades, was people sitting in the dark, bathing in the spill of light from the screen and

the possibility it afforded of a perfect or improved life. Whether it is Renée Falconetti as Joan of Arc or Judy Garland as Alice Maybery in *The Clock*, those figures are the ideals of happiness or spiritual fulfillment.

But if reverse motion is so beautiful and revelatory, doesn't that reopen your eyes to the same wonderment in forward motion? I know it's hard, because you are so used to forward motion, and it does so resemble life in cunning and artificial ways. But if you recall the age in which film was just still frames magicked into life you may appreciate that the artifice, the design and playfulness of reverse is there in forward, too. You are seeing a superb, insolent attempt to mimic, steal, and tease life. I realize that most films try hard to make you believe in the forward motion and the momentum of a story, a dream, or an experience. But none of them can escape the power of intervention in the story and its reality. That is why cutting is so important an assertion of unreality—even greater than that of music playing in the air of the desert in *Lawrence of Arabia*.

You are not watching life. You are watching a movie. And if, maybe, the movie feels better than life, then that is a vast, revolutionary possibility, and no one knows yet whether it is for good or ill, because the insinuation of dream does so much to alter or threaten our respect for life. Dissatisfaction and doubt grew in step with film's projection of happiness.

The last source of delight is the opportunity in that odd presentation of *The Clock* to see that the most profound subject in all movie is time and the way it passes, and resembles itself. "Once upon a time" we say—once upon a time there were these young women in Paris, Céline and Julie, and they used to visit a house where a film was always playing. The players never noticed them watching—it was the old voyeur advantage. And then, in time, Céline and Julie . . . well, I promised not to tell you what happens to them, because story does matter even if it's been happening now for nearly forty years.

In that showing of *The Clock* it was far easier to notice the abstraction of certain shots—close-up and long shot, fades and moving camera shots—because the process opened up the technology of narrative as well as the mechanics of projection. The views were no longer natural; they felt chosen; they radiated intention and their own framing capacity. Suddenly, you realized that *The Clock*, like time, was always in a circle, or a *ronde*. Everything has happened before, and will again—with tiny, vital differences that belong to us. And that is why we have to keep looking, to see our differences. And listening makes a curious, alternative existence,

as real as speech and sound effects, yet as fantastic as music—lovely, impossible, lunatic, and phantom. It is like sex, and that's why there is so little need to try showing sex itself in movies. We like to watch because we love the idea of attraction, and think of it as "desire."

But it can be dread, too.

Liv Ullmann in Ingmar Bergman's *Persona*

NOTES

ACKNOWLEDGMENTS

INDEX

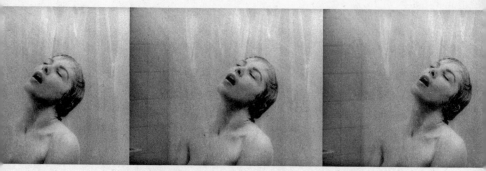

Janet Leigh in *Psycho*, another splash, half a second from twenty-four hours

Prologue: Let There Be Light

4 "In the movie films": E. L. Doctorow, *Ragtime* (1975), p. 297.

ON EADWEARD MUYBRIDGE
See E. M. Muybridge, *Complete Human and Animal Locomotion* (1979); see also Gordon Hendricks, *Eadweard Muybridge: Father of the Motion Picture* (1975), and Rebecca Solnit, *River of Shadows: Eadweard Muybridge and the Technological Wild West* (2003).

Part I: The Shining Light and the Huddled Masses

A CHEAP FORM OF AMUSEMENT

15 "The poor kid is actually thinking": Scott Eyman, *Empire of Dreams: The Epic Life of Cecil B. DeMille* (2010), p. 47.

16 "nothing is of greater importance": Thomas Edison, *Moving Picture World*, December 21, 1907.

16 "These places are the recruiting stations": Anna Shaw quoted in Eileen Bowser, *The Transformation of Cinema, 1907–1915* (1990), p. 38.

16 "How could a man": Irene Mayer Selznick, *A Private View* (1983), p. 26.

ON LOUIS B. MAYER
See Bosley Crowther, *Hollywood Rajah: The Life and Times of Louis B. Mayer* (1960); Charles Higham, *Merchant of Dreams: Louis B. Mayer, M.G.M. and the Secret Hollywood* (1993); Scott Eyman, *Lion of Hollywood: The Life and Legend of Louis B. Mayer* (2005).

ON MOVIE MOGULS
See Neal Gabler, *An Empire of Their Own: How the Jews Invented Hollywood* (1988).

18 "Never mind now": Selznick, *A Private View*, p. 17.

ON D. W. GRIFFITH
See Richard Schickel, *D. W. Griffith: An American Life* (1983); Karl Brown, *Adventures with D. W. Griffith* (1973); Melvyn Stokes, *D. W. Griffith's* The Birth of a Nation: A

History of "The Most Controversial Motion Picture of All Time" (2007); J. Hoberman, "First Movie in the White House," *London Review of Books*, February 12, 2009.

18 "I have thought": Schickel, *D. W. Griffith*, p. 33.

20 "It is another demonstration": Ibid., p. 156.

20 "Never let me hear": Ibid., p. 192.

22 "He stepped out": *New York Times*, April 30, 1915.

23 "My father said": Selznick, *A Private View*, p. 15.

23 "someone put the sun": Robert Towne, *Chinatown: A Screenplay* (1983), Preface and Postscript, n.p.

23 "Did you know that guy?": Lawrence Weschler, "The Light of L.A.," in Weschler, *Vermeer in Bosnia: A Reader* (2004), p. 300.

23 "so radically different": Robert Irwin quoted in ibid., p. 301.

24 "It is like writing history": See Schickel, *D. W. Griffith*, ch. 10, pp. 272–309.

24 "It was David Wark Griffith": Michael Powell, *A Life in Movies* (1986), p. 94.

ON CHARLES CHAPLIN

See Charles Chaplin, *My Autobiography* (1964); Kenneth S. Lynn, *Charlie Chaplin and His Times* (1997).

25 "The stage manager came on": Chaplin, *My Autobiography*, pp. 21–22.

ON BUSTER KEATON

See Rudi Blesh, *Keaton* (1966); Tom Dardis, *Keaton: The Man Who Wouldn't Lie Down* (1979).

ON DOUGLAS FAIRBANKS

See Alistair Cooke, *Douglas Fairbanks: The Making of a Screen Character* (1940); Richard Schickel, *Douglas Fairbanks: The First Celebrity* (1976).

ON LOUISE BROOKS

See Barry Paris, *Louise Brooks* (1989); Louise Brooks, *Lulu in Hollywood* (1982); Kenneth Tynan, "Louise Brooks: The Girl in the Black Helmet," *The New Yorker*, June 11, 1979.

31 "It was sexual hate": Brooks, *Lulu in Hollywood*, p. 98.

32 "Better for Louise Brooks": *Variety*, December 11, 1929.

THE ERA OF SUNRISE

ON F. W. MURNAU AND *SUNRISE*

See Lotte Eisner, *Murnau* (1973); Lucy Fischer, *Sunrise: A Song of Two Humans* (1988).

35 "The screen has": Murnau, "Films of the Future," *McCall's*, September 1928.

35 "There is a tremendous energy": Murnau, *New York Times*, October 16, 1927.

37 "He had a German assistant director": Janet Gaynor, quoted in program for Channel 4, a British TV channel, screening of *Sunrise* (1995).

37 "They say I have": Murnau in Channel 4 program.

41 "Prolong it!": Eyman, *Empire of Dreams*, p. 153.

41 "Working for Mr. DeMille": Gloria Swanson, *Swanson on Swanson* (1980), p. 110.

43 "the most important picture": Robert Sherwood, *Life* and *McCall's*, February 1928.

43 "Murnau's city often seems": Molly Haskell, "Sunrise," *Film Comment* (Summer 1971).

43 "the open secret": Thomas Elsaesser, "Secret Affinities: F. W. Murnau," *Sight & Sound* (Winter 1988–89).

44 "People say that": Virginia Woolf, "The Cinema," *Arts*, June 1926.

ON SCANDALS
See David Yallop, *The Day the Laughter Stopped: The True Story of Fatty Arbuckle* (1976); Robert Giroux, *A Deed of Death: The Story Behind the Unsolved Murder of the Hollywood Director William Desmond Taylor* (1990); *The Memoirs of Will Hays* (1955).

45 "This is what comes": Henry Lehrman, quoted in Kenneth Anger, *Hollywood Babylon* (1975), p. 30.

47 "Their boredom becomes": Nathanael West, *The Day of the Locust* (1939), p. 178.

ON THE ACADEMY
See Anthony Holden, *Behind the Oscar* (1993); "The Envelope Please," in Richard Koszarski, *An Evening's Entertainment: The Age of the Silent Feature Picture, 1915–1928* (1990).

ON MURNAU
49 "I should like to make": Quoted in Lotte H. Eisner, *Murnau* (1973), p. 197.

THE CINEMA OF WINTER
51 "The years immediately following": Lotte Eisner, *The Haunted Screen* (1969), p. 9.

51 "A cold, somber atmosphere": The published screenplay of *The Cabinet of Dr. Caligari* (1972), p. 41.

52 "I am a camera": Christopher Isherwood, *Goodbye to Berlin* (1939), p. 1.

54 "that city where reality": Siegfried Kracauer, introduction to the screenplay for *Caligari*, p. 5.

55 "At last I understand": Screenplay for *Caligari*, p. 100.

57 "Look here, boys": Erich Pommer, "Carl Mayer's Debut," in ibid., p. 28.

ON FRITZ LANG
See Lotte Eisner, *Fritz Lang* (1976); Patrick McGilligan, *Fritz Lang: The Nature of the Beast* (1997); *Fritz Lang: His Life and Work—Photographs and Documents*, ed. Rolf Aurich, Wolfgang Jacobsen, and Cornelius Schnauber (2001).

60 "They build things big": Quoted in McGilligan, *Fritz Lang*, p. 107.

61 "When the sun": Screenplay for *Metropolis* (1973), p. 19.

63 "a wonderful, stupefying folly": Pauline Kael, *Kiss Kiss Bang Bang* (1967), p. 309.

63 "But on the other hand": Luis Buñuel in *An Unspeakable Betrayal: Selected Writings of Luis Buñuel* (2000), pp. 100–101.

65 "Lang could have stayed": Gottfried Reinhardt, quoted in McGilligan, *Fritz Lang*, p. 180.

M

In additm ion to the books referred to on Lang in the last chapter, see Stephen D. Young-kin, *The Lost One: A Life of Peter Lorre* (2005).

67 "no violence": Lang in interview with Peter Von Bagh, in *Fritz Lang Interviews* (2003), p. 151.

68 "We, too, should keep": Screenplay for *M* (1968), p. 108.

68 "The evil little man": Ibid., p. 15.

69 On Lang and *Fury*, see McGilligan, *Fritz Lang*, p. 223.

69 On the San Jose lynching, see Harry Farrell, *Swift Justice: Murder and Vengeance in a California Town* (1992).

70 "I want to escape": Screenplay for *M*, p. 104.

STATE FILM—FILM STATE

See Jay Leyda, *Kino: A History of the Russian and Soviet Film* (1960); *Kuleshov on Film*, ed. Ron Levaco (1975); *The Film Factory: Russian and Soviet Cinema in Documents, 1896–1939*, ed. Richard Taylor and Ian Christie (1994); Ronald Bergan, *Sergei Eisenstein: A Life in Conflict* (1999).

76 "A new revolutionary state": Stanley Kauffmann, "Potemkin," in *Great Film Directors*, ed. Leo Braudy and Morris Dickstein (1978), p. 235.

78 "for us film is": Lenin to Anatoly Lunacharsky, quoted in *Sovietskoye Kino*, no 1–2, 1921, p. 10.

79 "At regular intervals": Sergei Eisenstein, "The Cinematic Principle and the Ideo-gram," in *Film Form: Essays in Film Theory* (1949), p. 37.

86 "A small boy": Screenplay for *Battleship Potemkin* (1968), p. 74.

89 "In utter confusion": Sergei Eisenstein, *Immoral Memories, An Autobiography* (1983), p. 85.

THE EXTRAORDINARY ADVENTURES OF MR. BOLSHEVIK IN THE WEST

See Eisenstein, *Immoral Memories*; Harry M. Geduld and Ronald Gottesman, *Sergei Eisenstein and Upton Sinclair: The Making and Unmaking of* Que Viva Mexico! (1970); Anthony Arthur, *Radical Innocent: Upton Sinclair* (2006).

91 "The projection of the dialectic system": Eisenstein, "A Dialectic Approach to Film Form," in *Film Form*, 1949, pp. 45–46.

92 "'A lot depends on'": Eisenstein, *Immoral Memories*, p. 147.

92 "more dreadful than": Ibid., p. 148.

93 "What interested me": Ibid., p. 156.

94 "Once more rings out": Sergei Eisenstein, "A Sequence from *An American Tragedy*," in *The Film Sense* (1947), p. 240.

94 "When I was a boy": Lewis J. Selznick, quoted in Budd Schulberg, *Moving Pictures: Memoirs of a Hollywood Prince* (1981), p. 64.

95 "positively torturing": David O. Selznick to B. P. Schulberg, October 8, 1930, *Memo from David O. Selznick*, ed. Rudy Behlmer (1972), p. 27.

95 "On pictures": Eisenstein, *Immoral Memories*, p. 149.

95 "In retrospect": Schulberg, *Moving Pictures*, pp. 369–70.

96 "a picture according to his own": Geduld and Gottesman, *Sergei Eisenstein and Upton Sinclair*, p. 22.

96 "The grotesque laughing": "First Outline of *Que Viva Mexico!*," *The Film Sense*, p. 254.

97 "Eisenstein loose": Geduld and Gottesman, *Sergei Eisenstein and Upton Sinclair*, p. 212.

99 "will not moralize": Eisenstein, *Immoral Memories*, pp. 1–2.

99 "life had passed": Ibid., p. 3.

ON LENI RIEFENSTAHL

See Rainer Rother, *Leni Riefenstahl: The Seduction of Genius* (2002); Steven Bach, *Leni: The Life and Work of Leni Riefenstahl* (2007).

101 "In the end": Bach, *Leni*, p. 122.

ON MELCHIOR LENGYEL AND *NINOTCHKA*

See Maurice Zolotow, *Billy Wilder in Hollywood* (1977); Ed Sikov, *On Sunset Boulevard: The Life and Times of Billy Wilder* (1998); Scott Eyman, *Ernst Lubitsch: Laughter in Paradise* (1993).

104 "Russian girl saturated with": Quoted in Zolotow, *Billy Wilder*, p. 79.

105 "This movie is": Ibid., p. 75.

1930s HOLLYWOOD

See Thomas Schatz, *The Genius of the System: Hollywood Filmmaking in the Studio Era* (1988); David Bordwell, Janet Staiger, and Kristin Thompson, *The Classical Hollywood Cinema: Film Style and Mode of Production to 1960* (1985); Ethan Mordden, *The Hollywood Studios: House Style in the Golden Age of the Movies* (1988).

107 On viewing figures, see Joel W. Finler, *The Hollywood Story* (2003), pp. 364–67

ON THALBERG

See the books on Louis B. Mayer, and Mark A. Vieira, *Irving Thalberg: Boy Wonder to Producer Prince* (2009); Roland Flamini, *Thalberg: The Last Tycoon and the World of M-G-M* (1994); Gavin Lambert, *Norma Shearer: A Biography* (1990).

108 "people run out": Harry Rapf, in Samuel Marx, *Mayer and Thalberg: Make-Believe Saints* (1975), p. 189.

109 On Marie Dressler, see Higham, *Merchant of Dreams*, p. 204.

109 "Like my dear old friend": See Wallace Beery biography on IMDb.com.

ON KING VIDOR

See King Vidor, *A Tree Is a Tree: An Autobiography* (1953); *King Vidor on Film Making* (1972); Directors Guild of America (DGA) Oral History, interviewed by Nancy Dowd and David Shepard, *King Vidor* (1988); Raymond Durgnat and Scott Simmon, *King Vidor, American* (1988).

112 "All the wooden structures": DGA Oral History, p. 2.

112 "One day I had a talk": Vidor, *A Tree*, p. 111.

114 "Well, I suppose": Ibid., p. 145.

115 "Just because I stop you": Ibid., p. 150.

116 On Vidor and the Directors Guild, see David Thomson, "The Man Who Would Be King," *DGA Quarterly* (winter 2011).

116 "I was glad to get out": DGA Oral History, p. 281.

ON JOSEF VON STERNBERG

See Josef von Sternberg, *Fun in a Chinese Laundry* (1965); Steven Bach, *Marlene Dietrich: Life and Legend* (1992); O. O. Green (Raymond Durgnat), "Six Films of Josef von Sternberg," *Movie* 13 (Summer 1965).

117 "I saw Fräulein Dietrich": von Sternberg, *Fun in a Chinese Laundry*, p. 231.
119 "Turn your shoulders": Ibid., p. 253.

ON FRANK CAPRA

See Frank Capra, *The Name Above the Title* (1971); Joseph McBride, *Frank Capra: The Catastrophe of Success* (1992); Bob Thomas, *King Cohn: The Life and Times of Harry Cohn* (1967); Dan Callahan, *Barbara Stanwyck: The Miracle Woman* (2012); Raymond Carney, *American Vision: The Films of Frank Capra* (1986).

120 "You know": McBride, *Frank Capra*, p. 307.
120 "I feel as happy as": Mason Wiley and Damien Bona, *Inside Oscar* (1996), p. 57.
121 "I was just an innocent": McBride, *Frank Capra*, p. 326.

ON JOHN FORD

See Joseph McBride, *Searching for John Ford: A Life* (2001); Scott Eyman, *Print the Legend: The Life and Times of John Ford* (2001); Tag Gallagher, *John Ford: The Man and His Films* (1986).

ON GARY COOPER

See Larry Swindell, *The Last Hero: A Biography of Gary Cooper* (1980); Patricia Neal, *As I Am* (1988); Jeffrey Meyers, *Gary Cooper, American Hero* (1998).

ON FRED ASTAIRE

See John E. Mueller, *Astaire Dancing: The Musical Films* (1985).

FRANCE

125 "The cinema doesn't suit": Jean Renoir, *My Life and My Films* (1974), p. 45.
On Méliès, see John Frazer, *Artificially Arranged Scenes: The Films of Georges Méliès* (1979).
129 "Fantômas was a genius": Suzy Gablik, *Magritte* (1970), p. 48.
131 "This is a film": Nelly Kaplan, "*Napoléon*," in *British Film Institute Film Classics*, vol.1 (originally published separately in 1994), p. 51.
132 "Gance does not": François Truffaut, *The Films in My Life* (1978) p. 33.
133 "simply one of the funniest": Kael, *Kiss Kiss Bang Bang*, p. 287.
133 "The clearest": Gerald Mast, *A Short History of the Movies* (1976), p. 245.
134 "We willingly admit": René Clair, *Four Screenplays* (1970), p. 221.
136 "Beware of the dog": Jean Vigo, *Vers un Cinéma Social* (1930), quoted in screenplays for *L'Âge d'Or* and *Un Chien Andalou* (1968), p. 81.

ON LUIS BUÑUEL

See John Baxter, *Luis Buñuel* (1994); Luis Buñuel and Jean-Claude Carrière, *My Last Sigh* (1984); Raymond Durgnat, *Luis Buñuel* (1990).

138 "Once Upon a Time": Original shooting script for *Un Chien Andalou* in screenplays for *L'Âge d'Or* and *Un Chien Andalou* (1968), p. 93.

ON JEAN VIGO
See P. E. Salles Gomes, *Jean Vigo* (1972); Marina Warner, *L'Atalante* (1993).

RENOIR

See Jean Renoir, *Renoir, My Father* (1962); Jean Renoir, *My Life and My Films* (1974); Jean Renoir, *Letters*, ed. Lorraine LoBianco and David Thompson (1994); Alexander Sesonske, *Jean Renoir: The French Films, 1924–1939* (1980).

144 "She was sixteen": Renoir, *Renoir, My Father*, pp. 398–99.
144 "We went . . . nearly": Renoir, *My Life and My Films*, p. 49.
145 "This betrayal marked": Ibid., p. 108.
146 On *Boudu Sauvé des Eaux*, see Richard Boston, *Boudu Sauvé des Eaux* (1994).
149 On *Partie de Campagne*, see screenplay, *L'Avant Scène du Cinéma* 21 (1962).
150 "a film of pure sensation": Truffaut, *The Films in My Life*, p. 38.
150 "trapped, almost wounded": Kael, *Kiss Kiss Bang Bang*, p. 342.
150 On *la caméra stylo*, see Alexandre Astruc, "The Birth of a New Avant-Garde: La Caméra-Stylo" (1948), in *The New Wave*, ed. Peter Graham (1968), pp. 17–23.
151 "cowardly pacifism": Guillermo Cabrera Infante, *A Twentieth-Century Job* (1991), pp. 305–9.
151 "We had an argument": Renoir, *My Life and My Films*, p. 166.
154 "'Gentlemen, tomorrow we shall'": Screenplay for *The Rules of the Game* (1970), p. 168.
154 "an exact description": Interview between Renoir and Marcel Dalio in ibid., p. 6.
154 "I was deeply disturbed": Ibid., p. 9.

AMERICAN

See Simon Callow, *Orson Welles: The Road to Xanadu* (1995), and *Orson Welles: Hello Americans* (2006); Orson Welles and Peter Bogdanovich, *This Is Orson Welles*, ed. Jonathan Rosenbaum (1992); John Houseman, *Run-Through* (1972): Robert L. Carringer, *The Making of "Citizen Kane"* (1985); Pauline Kael, "Raising Kane," in *The Citizen Kane Book* (1971), which also includes the shooting script and the cutting continuity; Peter Conrad, *Orson Welles: The Stories of His Life* (2003).

159 "Mankiewicz's contribution?": Welles and Bogdanovich, *This Is Orson Welles*, p. 52.
161 On the "Rosebud" rumor, see Gore Vidal, "Remembering Orson Welles," *United States, Essays 1952–1992* (1993), p. 1197 (originally published in the *New York Review of Books*, June 1, 1989).
161 "was a hero": Welles and Bogdanovich, *This Is Orson Welles*, p. 87.
161 "a great motion picture": *The Hollywood Reporter*, March 12, 1941.
161 "a film possessing": *Variety*, April 15, 1941.
161 "It comes close": Bosley Crowther, *New York Times*, May 2, 1941.
162 "the majority of": Archer Winsten, *New York Post*, May 2, 1941.
162 "It's as if you never": Cecilia Ager, *PM*, May 1941.
163 "fatuously overrated as": James Agee, *The Nation*, December 26, 1942.
163 "an exciting, but hammy": Manny Farber, "The Gimp," *Commentary* (June 1952), and in *Farber on Film: The Complete Writings of Manny Farber*, ed. Robert Polito (2009), p. 394.
163 "But by now the lesson," Farber, *Farber on Film*, p. 397
166 a shallow masterpiece: See Kael, "Raising Kane," p. 4.

AMBERSONS

167 "overdirected his masterpieces": Gilbert Adair, *Flickers* (1995), p. 95.

168 On *Ambersons* at 132 minutes: See Jonathan Rosenbaum, "Appendix: The Original *Ambersons*," in Welles and Bogdanovich, *This Is Orson Welles*, pp. 454–90.

170 "a labyrinth with": Jorge Luis Borges, "An Overwhelming Film," *Sur*, 1941, and in *Borges In/And/On Film*, ed. Edgardo Cozarinsky (1988), p. 77.

HOWARD HAWKS: THE "SLIM" YEARS

See Todd McCarthy, *Howard Hawks: The Grey Fox of Hollywood* (1997); Slim Keith, with Annette Tapert, *Slim: Memories of a Rich and Imperfect Life* (1990); Robin Wood, *Howard Hawks* (1968).

171 "seriously dumb" and "truly intelligent": Keith, with Tapert, *Slim*, p. 57.

172 "was ill a great part": Ibid., p. 60.

173 "But what do you do": Lauren Bacall, *By Myself* (1979), p. 120.

173 "If anything": Keith, with Tapert, *Slim*, p. 87.

175 "I don't know which": Ibid., p. 90.

175 "Hawks's behavior": McCarthy, *Howard Hawks*, pp. 543–44.

FILMS WERE STARTED

See Charles Drazin, *The Finest Years: British Cinema of the 1940s* (1998); Charles Barr, *Ealing Studios: A Movie Book* (1993); Raymond Durgnat, *A Mirror for England: British Movies from Austerity to Affluence* (1970).

ON GRAHAM GREENE

See *Mornings in the Dark: The Graham Greene Film Reader*, ed. David Parkinson (1993); Graham Greene, *A Sort of Life* (1971), and Graham Greene, *The Pleasure Dome: The Collected Film Criticism, 1935–40*, ed. John Russell Taylor (1980).

ON ALEXANDER KORDA

See Michael Korda, *Charmed Lives: A Family Romance* (1980); Karol Kulik, *Alexander Korda* (1975); Simon Callow, *Charles Laughton* (1987).

ON MICHAEL BALCON

See Michael Balcon, *Michael Balcon Presents: A Lifetime of Films* (1969).

182 "very conventional": Michael Powell, *A Life in Movies*, p. 225.

ON ALFRED HITCHCOCK

See Patrick McGilligan, *Alfred Hitchcock: A Life in Darkness and Light* (2003).

ON JOHN GRIERSON

See James Beveridge, *John Grierson: Film Master* (1978); Jack C. Ellis, *John Grierson: Life, Contributions, Influence* (2000).

ON HUMPHREY JENNINGS

See Alan Lovell and Jim Hillier, *Studies in Documentary* (1972); *The Humphrey Jennings Film Reader*, ed. Kevin Jackson (1993).

ON MICHAEL POWELL AND EMERIC PRESSBURGER

See Michael Powell, *A Life in Movies* (1987) and *Million Dollar Movie* (1992); Ian Christie, ed., *Powell, Pressburger and Others* (1978); Kevin Macdonald, *Emeric Pressburger: The Life and Death of a Screenwriter* (1994).
186 "To stop this foolish production": Christie, ed., *Powell, Pressburger and Others*, p. 107.

ON LAURENCE OLIVIER

See Terry Coleman, *Olivier* (2005); Laurence Olivier, *Confessions of an Actor: An Autobiography* (1985).

ON ROBERT HAMER

See Drazin, *The Finest Years*, pp. 71–88.

ON CAROL REED

See Nicholas Wapshott, *Carol Reed: A Biography* (1990); Charles Drazin, *In Search of the Third Man* (1999); Graham Greene, *Mornings in the Dark*, pp. 429–34; Rob White, *The Third Man* (2003).

BRIEF ENCOUNTER

See Kevin Brownlow, *David Lean: A Biography* (1997); Noel Coward, David Lean, Ronald Neame, and Anthony Havelock-Allan, "*Brief Encounter*: A Screenplay," in *Masterworks of the British Cinema* (1990); Richard Dyer, *Brief Encounter* (1993); Stephen Silverman, *David Lean* (1989); Gene D. Phillips, *Beyond the Epic: The Life and Films of David Lean* (2006).
191 "When emotion threatens": Lindsay Anderson, *Sequence* (1951).
195 "She looks quite ordinary": Roger Manvell, *The Film and the Public* (1955), p. 157.

WAR

197 "He rested in the padlocked entrance": J. G. Ballard, *Empire of the Sun* (1984), p. 55.
199 "How wonderful was": John Boorman, *Adventures of a Suburban Boy* (2003), p. 19.
199 "There we were": Ibid., p. 19.
200 "We don't make hate pictures": Axel Madsen, *William Wyler: The Authorized Biography* (1973), p. 215.

ON *CASABLANCA*

See Aljean Harmetz, *Round Up the Usual Suspects: The Making of* Casablanca (1992); Rudy Behlmer, *Inside Warner Brothers, 1935–1951* (1985).

ON JEAN-PIERRE MELVILLE

See Ginette Vincendeau, *Jean-Pierre Melville: An American in Paris* (2003); Rui Nogueira, *Melville on Melville* (1972).

ITALIAN CINEMA

See Pierre Leprohon, *The Italian Cinema* (1972).

ON LUCHINO VISCONTI

See Geoffrey Nowell-Smith, *Luchino Visconti* (1967).
212 "Visconti brought to the project": Ibid., p. 39.

ON ROBERTO ROSSELLINI

José Luis Guarner, *Roberto Rossellini* (1970); Roberto Rossellini, *My Method: Writings and Interviews*, ed. Adriano Apra (1987); Peter Brunette, *Roberto Rossellini* (1987).
214 "You feel that": Rossellini, *My Method*, p. 221.
215 "I made a child": Ibid., p. 21.

ON VITTORIO DE SICA

218 "So we're in rags?": Leprohon, *The Italian Cinema*, p. 98.
219 "one of the first examples," André Bazin, *What Is Cinema?*, vol. 2 (1972), p. 48.
220 "Plainly there is not enough": André Bazin, Ibid., p. 50.
221 "Have I already said," Ibid., p. 82.

ON MICHELANGELO ANTONIONI

See Seymour Chatman, *Antonioni, or The Surface of the World* (1985); Ian Cameron and Robin Wood, *Antonioni* (1968).

INGRID SEES A MOVIE

See Laurence Leamer, *As Time Goes By: The Life of Ingrid Bergman* (1986); Ingrid Bergman and Alan Burgess, *Ingrid Bergman: My Story* (1981).
224 "If you need a Swedish actress": Bergman and Burgess, *Ingrid Bergman*, p. 4.

SING A NOIR SONG

ON FILM NOIR

See Raymond Borde and Étienne Chaumeton, *Panorama du Film Noir Américain, 1941–1953* (1955); *The Film Noir Reader*, ed. Alain Silver and James Ursini (1996); Foster Hirsch, *Film Noir: The Dark Side of the Screen* (1981); *Kings of the Bs: Working Within the Hollywood System*, ed. Todd McCarthy and Charles Flynn (1975); Paul Schrader, "Notes on Film Noir," *Schrader on Schrader*, ed. Kevin Jackson (1990); Eddie Muller, *Dark City: The Lost World of Film Noir* (1998).
231 On *Detour*, see Noah Isenberg, *Detour* (2008); interview with Edgar G. Ulmer, *Kings of the B's*, pp. 377–409.
231 "Click! . . . Here it was": Patrick Hamilton, *Hangover Square* (1941), p. 15.

ON THE MUSICAL

See John Russell Taylor and Arthur Jackson, *The Hollywood Musical* (1971); Ronald Haver, *A Star Is Born: The Making of the 1954 Movie and Its 1983 Restoration* (1988); Emanuel Levy, *Vincente Minnelli: Hollywood's Dark Dreamer* (2009); Stephen Harvey, *Directed by Vincente Minnelli* (1989); Aljean Harmetz, *The Making of* The Wizard of Oz (1977); John Mueller, *Astaire Dancing* (1985); Stephen M. Silverman, *Dancing on the Ceiling: Stanley Donen and His Movies* (1996); Richard Dyer, "Peach Perfect" (on *Meet Me in St. Louis*), *Sight & Sound* (January 2012).

Part II: Sunset and Change

243 "Hollywood's like Egypt": Ben Hecht, *A Child of the Century* (1954), p. 467.

243 "A few good movies": Ibid., p. 467.

ON *SUNSET BLVD.*

See Maurice Zolotow, *Billy Wilder in Hollywood* (1977); Ed Sikov, *On Sunset Boulevard: The Life and Times of Billy Wilder* (1998).

244 "There's a speed limit": Dialogue from *Double Indemnity.*

246 "But it seemed to me": Alfred Hayes, *My Face for the World to See* (1958), p. 14.

246 On *Queen Kelly*, Swanson, and Kennedy, see Cari Beauchamp, *Joseph P. Kennedy Presents: His Hollywood Years* (2009).

247 "You bastard": Zolotow, *Billy Wilder in Hollywood*, p. 168.

248 On cinema attendance figures, see Finler, *The Hollywood Story*, pp. 378–79.

248 On *The Best Years of Our Lives*, see A. Scott Berg, *Goldwyn* (1989); Axel Madsen, *William Wyler* (1973).

248 "This is one of the very few": James Agee, "What Hollywood Can Do," *The Nation*, December 7, 1946.

251 On television statistics, see Finler, *Hollywood Story*, p. 375.

252 On William Paley, see Sally Bedell Smith, *In All His Glory: The Life of William S. Paley* (1990).

253 "because of the size": Ibid., p. 186.

253 "Television offers": Ibid., p. 362.

258 On the name "Loman" and Fritz Lang, see Arthur Miller, *Timebends: A Life* (1987), pp. 177–78.

259 On *I Love Lucy*, see Stefan Kanfer, *Ball of Fire: The Tumultuous Life and Comic Art of Lucille Ball* (2003).

260 "I've never found her": Groucho Marx, quoted in ibid., p. 60.

260 "like a two-dollar whore": Kanfer, *Ball of Fire*, p. 65.

261 "He is a Latin-American": Jesse Oppenheimer quoted in ibid., pp. 122–23.

261 "The show was built": Susan Sontag quoted in Kanfer, *Ball of Fire*, p. 308.

263 "The only red thing": Kanfer, *Ball of Fire*, p. 170.

ON LAS VEGAS AND GAMBLING

See Russell R. Elliott, *History of Nevada* (1987); Sally Denton and Roger Morris, *The Money and the Power: The Rise and Reign of Las Vegas and Its Hold on America, 1947–2000*; David Thomson, *In Nevada: The Land, the People, God, and Chance* (1999).

266 "Los Angeles had seen": Reyner Banham, *Los Angeles: The Architecture of Four Ecologies* (1971), p. 124.

ON JAMES STEWART'S NEW DEAL

See Jonathan Coe, *James Stewart: Leading Man* (1994); Mark Eliot, *Jimmy Stewart: A Biography* (2006); Jeanine Basinger, *The "It's a Wonderful Life" Book* (1986).

271 "Frank [Capra] really saved": Quoted in McBride, *Frank Capra*, p. 524.

271 On Lew Wasserman, see Kathleen Sharp, *Mr. & Mrs. Hollywood: Edie and Lew Wasserman and Their Entertainment Empire* (2003); Connie Bruck, *When Hollywood Had a King: The Reign of Lew Wasserman, Who Leveraged Talent into Power and Influence* (2003).

271 On Myron Selznick, see David Thomson, *Showman: The Life of David O. Selznick* (1992); Mary Mallory, "Agent Provocateur: The Tradition and Influence of Myron Selznick on the Motion Picture Talent Agency Business," University of Texas master's thesis, 1990.

273 On 1950s Westerns, see Robert Warshow, "The Westerner," *The Immediate Experience* (1962); *The BFI Companion to the Western*, ed. Edward Buscombe (1988).

274 "they were great": Anne Edwards, *Ronald Reagan: The Rise to Power* (1987), p. 452.

274 "a good upright": Ibid., p. 453.

ON *FROM HERE TO ETERNITY*

See Bob Thomas, *King Cohn: The Life and Times of Hollywood Mogul Harry Cohn* (1967); Frank MacShane, *Into Eternity: The Life of James Jones, American Writer* (1985); interview with Daniel Taradash, *Backstory 2: Interviews with Screenwriters of the 1940s and 1950s* (1991).

274 "It was the typical gesture": Fred Zinnemann in *Fred Zinnemann: An Autobiography* (1992), p. 117.

275 "Cohn always liked": Taradash, *Backstory 2*, p. 317.

275 "I believe they went": Ibid.

276 "immensely fine": MacShane, *Into Eternity*, p. 133.

276 "fourteen-carat entertainment": Farber, *Farber on Film*, p. 447.

276 "uses a hard light": Ibid., p. 446.

276 "that it is too entertaining": Ibid., p. 447.

276 On Clift and Brando, see Patricia Bosworth, *Montgomery Clift: A Biography* (1978); Peter Manso, *Brando: The Biography* (1994).

ON ELIA KAZAN

See Elia Kazan, *A Life* (1988); Richard Schickel, *Elia Kazan, A Life* (2005); *Kazan on Kazan*, ed. Michel Ciment (1974); Jeff Young, *Kazan: The Master Director Discusses His Films* (1999); *On the Waterfront*, ed. Joanna E. Rapf (2003).

ON PADDY CHAYEFSKY

280 "You play charades": Betsy Blair, *The Memory of All That: Love and Politics in New York, Hollywood, and Paris* (2003), p. 218.

280 "Rarely has a single picture": *Variety*, February 14, 1956.

ON HUMPHREY BOGART

See A. M. Sperber and Eric Lax, *Bogart* (1997); Bacall, *By Myself* (1979).

ON NICHOLAS RAY

See Bernard Eisenschitz, *Nicholas Ray: An American Journey* (1993); Patrick McGilligan, *Nicholas Ray: The Glorious Failure of an American Director* (2011); Nicholas Ray, *I Was Interrupted*, ed. Susan Ray (1993).

281 "Reared . . . in a household": John Houseman, *Front and Center* (1979), p. 178.

282 "a maniacal fury": *New York Times*, May 18, 1950.

282 "In Hollywood, a Howard Hawks": Truffaut, *The Films in My Life*, p. 143.

ON ROBERT ALDRICH

See *Robert Aldrich*, ed. Richard Combs (1978); Alain Silver and James Ursini, *What Ever Happened to Robert Aldrich? His Life and Films* (1995).

ON *THE NIGHT OF THE HUNTER*

See Davis Grubb, *The Night of the Hunter* (1953); Simon Callow, *The Night of the Hunter* (2000) and *Charles Laughton: A Difficult Actor* (1987); Preston Neal Jones, *Heaven & Hell to Play With: The Filming of* The Night of the Hunter (2002).

284 "Present!": Callow, *The Night of the Hunter*, p. 32.

284 "audacious": Bosley Crowther, *New York Times*, September 30, 1955.

285 "To make only one film": Robert Benayoun, *Dossiers du Cinéma* (1971).

ON *SWEET SMELL OF SUCCESS*

See Kate Buford, *Burt Lancaster: An American Life* (2000); Alexander Mackendrick, *On Film-Making: An Introduction to the Craft of the Director*, ed. Paul Cronin (2004).

285 "was like dripping lemon": Buford, *Burt Lancaster*, p. 183.

286 On Tony Curtis, see Tony Curtis with Peter Gollenbock, *American Prince: A Memoir* (2008).

286 "Burt and Sandy started arguing": Ibid., p.181.

ON ALFRED HITCHCOCK

On *Rear Window*, see also Francis M. Nevins, Jr., *Cornell Woolrich: First You Dream, Then You Die* (1988).

On *Vertigo*, see Dan Auiler, *Vertigo: The Making of a Hitchcock Classic* (1998); François Truffaut, *Hitchcock* (1967).

295 "Social problems present themselves": Joan Didion, "Good Citizens," *The White Album* (1979), p. 88.

296 On Sergius O'Shaughnessy, see Norman Mailer, *The Deer Park* (1955).

297 "Who should come out": Walker Percy, *The Moviegoer* (1960), p. 15.

297 "He is an attractive fellow": Ibid., p.15.

297 "Holden has turned down": Ibid., p. 16.

ON DEATHS

297 "He idealized womanhood": Lillian Gish, with Ann Pinchot, *The Movies, Mr. Griffith and Me* (1969), p. 353.

297 "We have new ways of seeing": Schickel, *D. W. Griffith*, p. 613.

ON MARILYN MONROE

Anyone browsing in this section of the book will be aware that the subtitles to film books are a rich but repetitive and over-egged domain. So in the hopeless task of finding, or writing, an adequate book on Marilyn Monroe, I'll simply offer this selection of subtitles: "Private and Undisclosed," "The Complete Last Sitting," "The Biography," "The Lost LOOK Photos," "A Case for Murder," "Intimate Exposures," "The Secret Life," "From the Private Archive," "In Her Own Words," "My Story," "Metamorphosis" . . .

300 "She was psychotic": Axelrod, *Backstory 3* (1997), p. 11.

ON JAPAN

See Donald Richie, *One Hundred Years of Japanese Cinema* (2005), and *The Films of Akira Kurosawa* (1999); Akira Kurosawa, *Something Like an Autobiography* (1983); Noel Burch, *To the Distant Observer: Form and Meaning in the Japanese Cinema* (1979); David Bordwell, *Ozu and the Poetics of Cinema* (2007); Paul Schrader, *Transcendental Style in Film: Ozu, Bresson, Dreyer* (1972).

301 "I thought I'd seen": Dialogue from *Objective, Burma!*

FRANCE IN THE 1950S: ROBERT BRESSON AND MAX OPHÜLS

See François Truffaut, "Une Certaine Tendance du Cinéma Français," *Cahiers du Cinéma*, January 1954.

306 "not beautiful images": Robert Bresson, *Notes on the Cinematographer*, trans. Jonathan Griffin (1986), p. 45.

307 "When a sound": Ibid., p. 37.

307 "a man alone": Schrader, *Schrader on Schrader*, p. 163.

307 "[Bresson] did not want": François Leterrier, *Express*, September 21, 1956.

307 "the most important film": Truffaut, *The Films in My Life*, p. 191.

308 "In this country": Kael, *Kiss Kiss Bang Bang*, p. 306.

308 On Max Ophüls, see *Souvenirs* (2002); Richard Roud, *Max Ophüls: An Index* (1958); Susan M. White, *The Cinema of Max Ophuls: Magisterial Vision and the Figure of Woman* (1995).

310 "For the first time": Truffaut, "Max Ophuls Is Dead," *The Films of My Life*, p. 234.

ON INGMAR BERGMAN

The Bergman script for *A Doll's House* is in the David O. Selznick archive at the Harry Ransom Center in Austin, Texas.

312 "When Harriet had": Ingmar Bergman, *The Magic Lantern* (1988), pp. 178–79.

314 "He was by no means": Ingmar Bergman, *Images: My Life in Film* (1990), p. 125.

ON AMERICAN FILMS OF THE LATE 1950S

On Douglas Sirk, see Jon Halliday, *Sirk on Sirk* (1971); Edinburgh Film Festival, *Douglas Sirk*, ed. Laura Mulvey and Jon Halliday (1972).

317 "In *Written on the Wind*": Rainer Werner Fassbinder, "Six Films by Douglas Sirk," in Edinburgh Film Festival, *Douglas Sirk*, pp. 100–101.

317 On Otto Preminger, see Foster Hirsch, *Otto Preminger: The Man Who Would Be King* (2007).

318 On *Rio Bravo*, see McCarthy, *Howard Hawks*; Robin Wood, *Rio Bravo* (2003).

318 On *Some Like It Hot*, see Sikov, *On Sunset Boulevard*.

319 "Plain goodness": Saul Bellow, "The Mass-Produced Insight," *Horizon*, January 1963, p. 111.

ON *HIROSHIMA MON AMOUR*

See Marguerite Duras, screenplay to *Hiroshima Mon Amour*, *L'Avant-Scène du Cinéma* 61–62 (July–September 1966).

ON THE FRENCH NEW WAVE AND FRANÇOIS TRUFFAUT

See Antoine de Baecque and Serge Toubiana, *Truffaut: A Biography* (1999); François Truffaut, *Correspondence 1945–1984*, ed. Gilles Jacob and Claude de Givray (1990);

Truffaut, *The Films in My Life* (1978); James Monaco, *The New Wave: Truffaut, Godard, Chabrol, Rohmer, Rivette* (1977); *The New Wave*, ed. Peter Graham (1968); *Cahiers du Cinéma: The 1950s*, ed. Jim Hillier (1985); *Cahiers du Cinéma: 1960–1968*, ed. Jim Hillier (1992); *Positif 50 Years: Selected Writings*, ed. Vincent Amiel, Robert Benayoun, Thomas Bourgignon, and Emmanuel Carrère (2003).

324 On Henri Langlois, see Richard Roud, *A Passion for Films: Henri Langlois and the Cinémathèque Française* (1983).

325 "I won't conceal": Truffaut to Marcel Moussy, June 21, 1958, in Truffaut, *Correspondence*, p. 121.

326 On *Les Quatre Cents Coups* at Cannes, see de Baecque and Toubiana, *Truffaut*, pp. 133–35.

326 "Never has the festival": *Elle*, May 8, 1959.

ON JEAN-LUC GODARD

See Richard Brody, *Everything Is Cinema: The Working Life of Jean-Luc Godard* (2008); Colin MacCabe, *Godard: A Portrait of the Artist at Seventy* (2003); Richard Roud, *Godard* (1968).

327 "It's disgusting": Quoted in Brody, *Everything Is Cinema*, p. 50.

328 "When Jean Seberg": Truffaut, *The Films in My Life*, p. 140.

329 "an incredibly introverted": Jean Seberg quoted in David Richards, *Played Out: The Jean Seberg Story* (1981), pp. 84–85.

329 "I'm in the midst": Ibid., p. 86.

329 "*À Bout de Souffle* was modeled": Roud, *Godard*, p. 36.

330 "The Americans are good at": Interview with Godard, *Cahiers du Cinéma* 171 (October 1965).

331 "For a long time": Godard in *Le Monde*, March 18, 1960.

333 "You talk to me": Godard, screenplay for *Pierrot le Fou* (1965), p. 62.

337 "*Vivre Sa Vie* suggests": Brody, *Everything is Cinema*, p. 138.

ON CHRIS MARKER

See Catherine Lupton, *Chris Marker: Memories of the Future* (2005); Chris Marker, *La Jetée: Ciné-Roman* (1992).

ON ANDY WARHOL

See *The Andy Warhol Diaries*, ed. Pat Hackett (1989); Patrick S. Smith, *Andy Warhol's Art and Films* (1980); Stephen Koch, *Stargazer: Andy Warhol's World and His Films* (1973 and 1985); *Who Is Andy Warhol?*, ed. Colin MacCabe, Mark Francis and Peter Wollen (1997).

340 "I wrote a great number": Ronald Tavel quoted in Jean Stein, *Edie: An American Girl*, ed. George Plimpton (1982), p. 232.

340 "Her physicality was": Robert Rauschenberg quoted in ibid. p. 250.

ON MICHELANGELO ANTONIONI

343 Monica Unvital and Jeanne Morose: Manny Farber in "Clutter," *Farber on Film*, p. 609.

344 "*L'Eclisse* . . . continues": Seymour Chatman, *Antonioni, or the Surface of the World* (1985), p. 64.

Part III: Film Studies

349 "I don't want to make a film": Steven Spielberg in Carl Gottlieb, *The Jaws Log* (1975), p. 66.

351 "talent histogram": *Movie* 1 (June 1962).

351 "The politique des auteurs": Andrew Sarris, *Film Culture*, 1962–63; see also Sarris, *The American Cinema* (1968).

353 On film and the novel, see John Harrington, *Film and/as Literature* (1977); George Bluestone, *Novels into Film* (1957).

353 "A good subject": Aldous Huxley to Robert Nichols, 1926, quoted in Virginia M. Clark, *Aldous Huxley and Film* (1987), p. 17.

354 "One tries to do": Huxley to Eugene F. Saxton, November 2, 1939, quoted in *Letters of Aldous Huxley*, ed. Grover Smith (1969), p. 450.

354 On Monroe Stahr, see F. Scott Fitzgerald, *The Last Tycoon* (1941).

354 On Faulkner and Hawks, see McCarthy, *Howard Hawks*; Andrew Sinclair, *Writers in Hollywood, 1915–1951* (1990).

355 On "Turnabout," see McCarthy, *Howard Hawks*, pp. 177–86.

355 "We stood against": Ernest Hemingway, *The Sun Also Rises* (1926), p. 24.

356 "like film waiting": Vladimir Nabokov to Dmitri Nabokov, quoted in *Vladimir Nabokov, His Life, His Work, His World: A Tribute*, ed. Peter Quennell (1979), p. 129.

356 On *Psycho*, see Stephen Rebello, *Alfred Hitchcock and the Making of Psycho* (1990); Raymond Durgnat, *A Long Hard Look at "Psycho"* (2002); Philip J. Skerry, Psycho *in the Shower* (2009); David Thomson, *The Moment of Psycho: How Alfred Hitchcock Taught America to Love Murder* (2009).

357 "Since I have become": François Truffaut to Alfred Hitchcock, June 2, 1962, in Truffaut, *Correspondence*, p. 177.

358 On Tippi Hedren, see Donald Spoto, *The Dark Side of Genius: The Life of Alfred Hitchcock* (1983).

359 "Anyway, Mr. Nabokov": Alfred Hitchcock to Vladimir Nabokov, November 19, 1964, in *Vladimir Nabokov: Selected Letters, 1940–1977*, ed. Dmitri Nabokov and Matthew J. Bruccoli (1989), p. 363.

360 On Joseph Losey, see David Caute, *Joseph Losey: A Revenge on Life* (1994).

361 "There was a meeting," *Conversations with Losey*, ed. Michel Ciment (1985), pp. 225–26.

362 "almost malignant": Penelope Gilliatt, *The Observer*, November 17, 1963.

362 "the best film": Philip Oakes, *Sunday Telegraph*, November 17, 1963.

363 On Stanley Kubrick, see Vincent LoBrutto, *Stanley Kubrick: A Biography* (1997); John Baxter, *Stanley Kubrick: A Biography* (1999); Michael Herr, *Kubrick* (2001).

363 On *Lolita*, see in addition to the several books on Kubrick, Alfred Appel, Jr., *Nabokov's Dark Cinema* (1974); Vladimir Nabokov, *Lolita: A Screenplay* (1974); Richard Corliss, *Lolita* (1994); Brian Boyd, *Vladimir Nabokov: The American Years* (1992).

364 "unusually compelling": *Lolita: A Screenplay*, p. viii.

364 "a graceful ingénue": Ibid., p. ix.

364 "a first-rate film": Ibid., p. xii.

364 "could one reproduce": Ibid., p. 110.

364 "I would have advocated": Ibid., pp. ix–x.

365 "He's an incredibly": George C. Scott, quoted in LoBrutto, *Stanley Kubrick*, p. 238.

366 On James Bond, see Simon Winder, *The Man Who Saved Britain: A Personal Journey into the Disturbing World of James Bond* (2006).

367 On *Blow-Up*, see Roger Ebert, *The Great Movies* (2002); the screenplay to *Blow-Up* (1967); Bert Cardullo, *Michelangelo Antonioni: Interviews* (2008).

369 Arthur Knight said: *Playboy*, December 1966.

369 "I know it when I see it": Justice Potter Stewart, concurring opinion, *Jacobellis v. Ohio*, 378 US 184 (1964).

370 On the Production Code, see Jack Valenti, *This Time, This Place: My Life in War, the White House and Hollywood* (2007).

373 "Bernardo Bertolucci's *Last Tango in Paris*": Pauline Kael, "Tango," *The New Yorker*, October 28, 1972, and Kael, *Reeling* (1977), pp. 52–53.

374 "Is it on?": The screenplay to *Blue Movie* (1970).

375 On Brando's deal on *Last Tango in Paris*, see David Thompson, *Last Tango in Paris* (1998), p. 16.

376 "I had one of the most": Marlon Brando, with Robert Lindsey, *Brando: Songs My Mother Taught Me* (1994), p. 425.

376 "it would have completely changed": Ibid., p. 425.

378 "*Last Tango in Paris* received": Ibid., pp. 425–26.

378 "Maria Schneider's freshness": Kael, "Tango," p. 60.

379 "Long shot of": Screenplay to *Pierrot le Fou* (1969), pp. 37–38.

383 On Jerry Mander, *Four Arguments for the Elimination of Television* (1977), pp. 51, 113, 155, 261.

385 On *Bonnie and Clyde*, see Mark Harris, *Scenes from a Revolution: The Birth of the New Hollywood* (2008).

386 "We described a scene": Robert Benton talking to Harris, in ibid., p. 13.

386 "Actually . . . I have no admiration": François Truffaut to Elinor Jones, July 2, 1965, quoted in de Baecque and Toubiana, *Truffaut* (1999), p. 212.

386 On Warren Beatty, see Peter Biskind, *Star: How Warren Beatty Seduced America* (2009).

387 On Arthur Penn, see Robin Wood, *Arthur Penn* (1967); Nat Segaloff, *Arthur Penn: American Director* (2011).

388 "Nobody was too keen": Estelle Parsons talking to Harris, *Scenes from a Revolution*, p. 249.

388 "You know what": Screenplay for *Bonnie and Clyde* (1972 and 1998), p. 153.

389 "If I have to get up": Harris, *Scenes from a Revolution*, pp. 326–27.

389 "a cheap piece": Bosley Crowther, *New York Times*, August 14, 1967.

389 "The film critic": Crowther quoted in Robert Steele, "The Good-Bad and the Bad-Good in Movies: *Bonnie and Clyde* and *In Cold Blood*," *Catholic World*, May 1968.

389 "a squalid shoot-'em-up": Joe Morgenstern, *Newsweek*; both reviews are extracted in the screenplay for *Bonnie and Clyde*, p. 218.

390 "*Bonnie and Clyde* brings": Pauline Kael, "Crime and Poetry," *The New Yorker*, October 21, 1967, and in *Kiss Kiss Bang Bang*, pp. 47–63.

393 On Roger Corman, see Roger Corman, *How I Made a Hundred Movies and Never Lost a Dime* (1998); *Roger Corman*, ed. Paul Willemen, David Pirie, David Will, and Lynda Myles (1970).

394 On Peter Bogdanovich, he has done so much, but it is worth stressing his earliest, groundbreaking works, the monograph interviews with Orson Welles (1961), Howard Hawks (1962), and Alfred Hitchcock (1963) done for the Museum of Modern Art in New York.

395 On Bob Rafelson, see the multi-film set of movies made by BBS, issued on DVD by Criterion, 2010.

396 On Jack Nicholson, see Patrick McGilligan, *Jack's Life: a Biography of Jack Nicholson* (1994).

396 "Only when I breathe": Robert Towne, *Chinatown: A Screenplay* (1983).

397 On Robert Altman, see Mitchell Zuckoff, *Robert Altman: The Oral Biography* (2009); Patrick McGilligan, *Robert Altman: Jumping Off the Cliff* (1989).

398 "the slide area": Gavin Lambert, *The Slide Area: Scenes of Hollywood Life* (1959).

399 "Why should I": Francis Coppola in Peter Cowie, *The Godfather Book* (1997), p. 10.

400 "An ice-blue terrifying movie": Al Ruddy in Cowie, *The Godfather Book*, p. 8.

401 On Brando and *The Godfather*, see Cowie, *The Godfather Book*, p. 13.

402 On Walter Murch, see Murch, *In the Blink of an Eye: A Perspective on Film Editing* (2001); Michael Ondaatje, *The Conversations: Walter Murch and the Art of Film Editing* (2004); David Thomson, "Conversation with Walter Murch," *The Believer* (March-April 2011).

402 "it will be as quickly forgotten": William F. Buckley, *New York Post*, March 14, 1972.

402 "overblown, pretentious," Arthur Schlesinger, Jr., *Vogue*, April 1972.

402 "one of the most brutal": Vincent Canby, *New York Times*, March 14, 1972.

402 "the spaciousness and strength": Pauline Kael , *New Yorker*, March 18, 1972.

406 "The young Marvin": John Boorman, *Adventures of a Suburban Boy* (2003), pp. 135–36; see also Pamela Marvin, *Lee: A Romance* (1997).

407 "It's occasionally amusing": François Truffaut to Nestor Almendros (n.d.), quoted in de Baecque and Toubiana, *Truffaut*, p. 326.

408 "which was true": Dirk Bogarde, letter to Dilys Powell, January 24, 1974, in *Ever, Dirk: The Bogarde Letters*, ed. John Coldstream (2008), p. 87.

408 On Federico Fellini, see Peter Bondanella, *The Cinema of Federico Fellini* (1992); Tullio Kezich, *Federico Fellini: His Life and Work* (2006).

409 On Roman Polanski, see Roman Polanski, *Roman by Polanski* (1984).

409 On *The Passenger*, see Mark Peploe, Peter Wollen, and Michelangelo Antonioni, screenplay for *The Passenger* (1975).

410 On Luis Buñuel, see Luis Buñuel and Jean-Claude Carrière, *My Last Sigh* (1983); *Luis Buñuel's* The Discreet Charm of the Bourgeoisie, ed. Marsha Kinder (1999).

411 "Physical scenes don't bother me": Catherine Deneuve, quoted in John Baxter, *Buñuel* (1994), p. 282.

412 On Rainer Werner Fassbinder, see Robert Katz, *Love Is Colder Than Death: The Life and Times of Rainer Werner Fassbinder* (1987); Christian Braad Thomsen, *Fassbinder: The Life and Work of a Provocative Genius* (1991); Susan Sontag, "Novel into Film: Fassbinder's *Berlin Alexanderplatz*," *Where the Stress Falls* (2001).

412 "I wanted to make": Katz, *Love Is Colder Than Death*, p. xiii.

412 "I worked so fast": Ibid., p. 81

412 "You can't make films": Fassbinder, "Six Films by Douglas Sirk," p. 95.

413 On Jacques Rivette and *Céline et Julie Vont en Bateau*, see *Jacques Rivette: Texts and Interviews*, ed. Jonathan Rosenbaum (1977); Hélène Frappat, *Jacques Rivette: Secret Compris* (2001).

415 "Today's movie-house movie": Hans-Jürgen Syberberg introduction, *Hitler: A Film from Germany* (1982), p. 19.

416 "The film tries": Susan Sontag, Preface to *Hitler: A Film from Germany*, pp. xv–xvi.

417 On Ronald Reagan and the movies, see Dan Moldea, *Dark Victory: Ronald Reagan, MCA, and the Mob* (1986); Anne Edwards, *Early Reagan: The Rise to Power* (1987).

419 "Ronald Reagan's own way": The back-flap blurb to Edmund Morris, *Dutch: A Memoir of Ronald Reagan* (1999).

419 "'So you do believe'": Morris, *Dutch*, p. 647.

Part IV: Dread and Desire

DREAD AND DESIRE

427 On *Deep Throat*, see Linda Boreman, *Toronto Sun*, March 20, 1981; Al Goldstein, *Screw*, June 5, 1972; Roger Ebert, "Inside Deep Throat," *Chicago Sun-Times*, February 11, 2005.

427 On pornography, see Legs McNeil and Jennifer Osborne, *The Other Hollywood: The Uncensored Oral History of the Porn Industry* (2005).

430 "Warn the Duke!": E. L. Doctorow, *Ragtime* (1975), p. 11.

430 On *Straw Dogs*, see David Weddle, *"If They Move . . . Kill 'Em!": The Life and Times of Sam Peckinpah* (1994).

431 "I dreaded that rape scene": Ibid., pp. 419–20.

433 On *Alien*, see David Thomson, *The Alien Quartet* (1998); Kathleen Murphy, "The Last Temptation of Sigourney Weaver," *Film Comment* (July–August 1992); "Making *Alien*: Behind the Scenes," *Cinefantastique* 9, no. 1 (July 1979); Amy Taubin, "Invading Bodies," *Sight & Sound* (July 1992).

TO OWN THE SUMMER

See Carl Gottlieb, *The Jaws Log* (1975 and 2001); Antonia Quirke, *Jaws* (2002); Joseph McBride, *Steven Spielberg* (1997).

440 "one of the most phenomenal": Pauline Kael, *The New Yorker*, March 18, 1974.

441 "The shark was supposed": Gottlieb, *The Jaws Log*, p. 156.

442 "Spielberg needs to work": Peter Benchley quoted in *Los Angeles Times*, July 7, 1974.

442 On *Jaws* preview, see Gottlieb, *The Jaws Log*, p. 216.

442 On Robert Shaw, see ibid., pp. 207–8.

443 in the men's bathroom: Ibid., p. 216.

443 On the numbers on *Jaws*: McBride, *Steven Spielberg*, pp. 253–54.

443 "Spielberg is blessed": Frank Rich, *New York Times*, June 27, 1975.

443 "You feel like a rat": Molly Haskell, *Village Voice*, June 23, 1975.

443 "Right before our eyes": Quirke, *Jaws*, p. 69.

446 On DreamWorks, see Nicole LaPorte, *The Men Who Would Be King: An Almost Epic Tale of Moguls, Movies, and a Company Called DreamWorks* (2010).

447 "a marker in industry": F. Scott Fitzgerald, *The Last Tycoon* (New York: Penguin, 1960), p. 35.

BRAVE NEW NORTHERN CALIFORNIA WORLD

See Peter Cowie, *Coppola* (1989) and *The Godfather Book* (1997); Tom Shone, *Blockbuster: How Hollywood Learned to Stop Worrying and Love the Summer* (2004); J. W. Rinzler, *The Making of* Star Wars: *The Definitive Story Behind the Original Film* (2007); Michael Rubin, *Droidmaker: George Lucas and the Digital Revolution* (2005).

449 "brats": See Michael Pye and Lynda Myles, *The Movie Brats: How the Film Generation Took Over Hollywood* (1984).

456 "It's not about Vietnam": Quoted by Geoffrey Dunn, *San Francisco Chronicle*, August 12, 2001.

456 "This morning I asked Francis": Eleanor Coppola, *Notes* (1979), p. 254.

458 On *Heaven's Gate*, see Steven Bach, *Final Cut: Dreams and Disaster in the Making of* Heaven's Gate (1985).

458 "One thing is certain": Ibid., p. 415.

459 "The audience was": Ibid., p. 360.

459 "an unqualified disaster": Vincent Canby, *New York Times*, November 19, 1981.

WHAT IS A DIRECTOR?

461 "The film community": *Minghella on Minghella*, ed. Timothy Bricknell (2005), p. 143.

462 On Michael Curtiz, see Sidney Rosenzweig, *Casablanca and Other Major Films of Michael Curtiz* (1982); Harmetz, *Round Up the Usual Suspects*.

462 On Preston Sturges, see Diane Jacobs, *Christmas in July: The Life and Art of Preston Sturges* (1992); *Preston Sturges on Preston Sturges*, ed. Sandy Sturges (1990).

462 On Vincente Minnelli, see Vincente Minnelli, *I Remember It Well* (1990); Stephen Harvey, *Directed by Vincente Minnelli* (1990); James Naremore, *The Films of Vincente Minnelli* (1993); Emanuel Levy, *Vincente Minnelli: Hollywood's Dark Dreamer* (2009); *Vincente Minnelli: The Art of Entertainment*, ed. Joe McElhaney (2009).

463 "In the end": *Minghella on Minghella*, p. 170.

466 "For all the horror": David Edelstein, *New York*, June 6, 2010.

466 On *The Arbor* and Clio Barnard, interview with Clio Barnard, November 18, 2011.

467 "The effect is eerie": Peter Bradshaw, *The Guardian*, October 21, 2010

467 On Artangel, interview with Michael Morris, November 28, 2011.

468 On women in film, see Molly Haskell, *From Reverence to Rape: The Treatment of Women in the Movies* (1987); Jeanine Basinger, *A Woman's View: How Hollywood Spoke to Women, 1930–1960* (1995).

468 On Barbara Loden and *Wanda*, see Kazan, *A Life*, pp. 792–95.

469 On Woody Allen, see Eric Lax, *Conversations with Woody Allen* (2007).

469 "I think those kinds": Interview with Woody Allen, *Sight & Sound*, April 2011, p. 19.

470 "deep—on the surface": Pauline Kael, *The New Yorker*, September 25, 1978.

470 On Clint Eastwood, see Richard Schickel, *Clint Eastwood: A Biography* (1997); Patrick McGilligan, *Clint: The Life and Legend* (2002)

471 On Don Siegel and Eastwood, see Peter Bogdanovich, "Working Within the System: Interview with Don Siegel," *Movie* 15, 1968; Don Siegel, *A Siegel Film: An Autobiography* (1996).

471 On Steve McQueen, see Marc Eliot, *Steve McQueen: A Biography* (2011).

471 On *The Outlaw Josey Wales*, see McGilligan, *Clint*, pp. 256–70.

471 "essays in individuality": President Obama at the White House, February 25, 2010—later Eastwood admitted to Katie Couric on television that Obama was a "nice fella," but he didn't think much of him as a president.

SILENCE OR SINATRA?

473 On Tim Van Patten, see filmography and biography, IMDb.com.

474 "the richest achievement": David Remnick, *The New Yorker*, June 24, 2007.

475 "My goal was never": David Chase, quoted in Mark Lee, "Wiseguys: A Conversation Between David Chase and Tom Fontana," *Written By*, May 2007.

478 On Martin Scorsese, see *Scorsese on Scorsese*, ed. David Thompson and Ian Christie (2004); Annette Wernblad, *The Passion of Martin Scorsese: A Critical Study of the Films* (2010); Richard Schickel, *Conversations with Scorsese* (2011).

478 "It's about the very essence": Schickel, *Conversations with Scorsese*, p. 367.

478 On the Sinatra project, announced in 2011 but not started, see IMDb.com.

480 On Quentin Tarantino, see Jami Bernard, *Quentin Tarantino: The Man and His Movies* (1995); *Quentin Tarantino: Interviews*, ed. Gerald Peary (1998).

482 "I don't give": Screenplay of *Reservoir Dogs* (2485).

482 "'When you're dealing'": Ibid.

485 On David Lynch, see *Lynch on Lynch*, ed. Chris Rodley (1997 and 2005); Michel Chion, *David Lynch* (1995); Greg Olson, *David Lynch: Beautiful Dark* (2008); George Toles, "Auditioning Betty in Mulholland Drive," *Film Quarterly* 58 (2004); Thierry Jousse, *David Lynch* (2010).

485 "Color to me": David Lynch biography, IMDb.com.

487 "At a certain point": *Lynch on Lynch*, p. 148.

487 "Ah, it is DISASTER": Ibid., p. 149.

488 "[It] helped us realize": David Foster Wallace, "David Lynch Keeps His Head," *A Supposedly Fun Thing I'll Never Do Again* (1997), p. 201; also on Wallace in general, see Jenny Turner, "Illuminating, horrible etc.," *London Review of Books*, April 14, 2011.

488 "Rossellini is asked": Roger Ebert, *Chicago Sun-Times*, September 19, 1986.

488 "could smell a rat": *Lynch on Lynch*, p. 141.

THE NUMBERS AND THE NUMBNESS

491 On Lynda Obst, see *Hello, He Lied and Other Truths from the Hollywood Trenches* (1997).

491 On *Sullivan's Travels*, see Jacobs, *Christmas in July*.

491 "to make the world": Mark Zuckerberg on *The Charlie Rose Show*, November 7, 2011.

492 On Steven Soderbergh, see the book *sex, lies, and videotape* (1990), which includes the script and an extensive journal on the making of the picture.

493 "I think it's a real privilege": Steven Soderbergh biography, IMDb.com.

495 "So *Jack and Jill* is": Mick LaSalle, *San Francisco Chronicle*, November 11, 2011.

496 On Lars von Trier, see *Lars von Trier: Interviews*, ed. Jan Lumholdt (2003); Jack Stevenson, *Dogme Uncut: Lars von Trier, Thomas Vinterberg, and the Gang That Took on Hollywood* (2003).

497 "A giant achievement": Lisa Schwarzbaum, *Entertainment Weekly*, November 15, 2011.

497 "a film that sweeps you": Joe Morgenstern, *Wall Street Journal*, November 11, 2011.

497 "When I left the theatre": J. Hoberman, *Village Voice*, May 18, 2011.

498 "'There's one constant'": Pam Grady, "Jack Bauer Visits the Odd World of Lars von Trier," *San Francisco Chronicle*, November 13–19, 2011.

501 "Visually the depth of field": Seth Schiesel, "Recruiting the Inner Military Hero in Men," *New York Times*, November 16, 2011.

501 On piracy, see Edward Wyatt, "Lines Drawn on Antipiracy Bills," *New York Times*, December 15, 2011.

Epilogue: I Wake Up Screening

505 There is a book called: See Paolo Cherchi Usai, *The Death of Cinema: History, Cultural Memory and the Digital Dark Age* (2001).

506 1.5 billion hours . . . 100 billion hours: Ibid., p. 111.

506 "All our talk": Ibid., p. 127.

506 The "Everything" line: See Brody, *Everything Is Cinema*, p. xiii.

506 "Whenever I get": Schrader, *Schrader on Schrader*, p. 214.

507 "the way people were talking": Atom Egoyan, quoted in Geoff Pevere, "The Digital Revolution: Part 1," *Toronto Star*, December 7, 2010.

508 "He did things with film": Mark Feeney to David Thomson, e-mail, January 26, 2012.

509 "January 2012 will": Nick James, *Sight & Sound*, January 2012.

509 the Academy published a report: Academy of Motion Picture Arts and Sciences, "The Digital Dilemma," 2007.

509 On the numbers for 2002 and 2011, see David Germain, "Hollywood's Summer Story: More Dollars, Fewer Fans," *Yahoo! News*, August 31, 2011.

509 "With electronic media": Interview with Lewis Lapham, *Truthdig*, September 4, 2011.

510 "Our mistake was": Tom Rothman, quoted in Wyatt, "Lines Drawn on Antipiracy Bills."

511 "It's not possible": Jean-Luc Godard in Geoffrey Macnab, "Cinema Is Over. Its Time Was Missed," *Guardian Weekly*, May 6–12, 2005.

511 "The situation that": Perri Klass, "Fixated by Screens, but Seemingly Nothing Else," *New York Times*, May 10, 2011.

511 "Cynicism aside": Letter to *New York Times*, November 26, 2010.

512 "About 100 children": Antonia Quirke to David Thomson, e-mail, August 11, 2011.

512 On John Berger, see *Ways of Seeing* (1972), the book that was derived from the BBC television series.

516 "You can't tell": Powell, *A Life in Movies*, p. 563.

517 "The only difference": William Powell in *My Man Godfrey* (1936).

517 On critics' poll, see *Sight & Sound*, September 2002.

519 "They are taking pictures": Don DeLillo, *White Noise* (1985), p. 13.

519 On *Fear Factor*, see Brian Stelter, "It's Back and Even More Disgusting," *New York Times*, December 12, 2011.

519 "A certain subgenre": David Foster Wallace, "E Unibus Pluram: Television and U.S. Fiction," *A Supposedly Fun Thing I'll Never Do Again*, p. 49–50.

521 "is not simply a work of appropriation": "Douglas Gordon: what have i done," *The Guardian*, November 16, 2009.

521 On *Stalker*, see Geoff Dyer, *Zona: A Book About a Film About a Journey to a Room* (2012).

522 including a set of books: Jean-Luc Godard, *Histoire(s) du Cinéma* (1998).

522 "Hitchcock et L'Art": *Hitchcock et L'Art: Coïncidences Fatales*, ed. Guy Cogeval and Dominique Paini (2000).

ACKNOWLEDGMENTS

This book owes its genesis to my agent, Steve Wasserman. He conceived the notion of a one-volume history of film and suggested it to me. I was immediately interested, and added to Steve's framework the need to examine all the complicated effects film and screens have had on us. Equally, Steve was a constant support throughout the project. I have said to him several times that he is an agent who might easily have been a publisher or a writer. In fact, as I completed the book, he became a publisher—though he remains my agent, too. What this mysterious status means for his lucky clients is not just that he is a very effective agent but an exceptional reader and friend.

Jonathan Galassi at Farrar, Straus and Giroux bought the proposal and proved to be a superb, masterly publisher who handled this author's loss of confidence as well as its excess, and who briefly employed my son. Paul Elie edited the book itself and did a magnificent job, patient and incredulous, suggesting areas I had not covered, changing the order of some things, and looking at every sentence like a doctor. I was not always as kind or generous to him as I should have been, and I have apologized for that in person. Having edited the book, Paul set off on a new career as a writer, but I was ably cared for by Sarah Crichton, Dan Piepenbring, Mareike Grover, and Karen Maine, who were kind, thoughtful, humorous, and enthusiastic, especially in the matter of illustration and preparing the text. Still, I want to note the great care and skill of Jenna Dolan, the copy editor who saved me from many errors and made suggestions worthy of an editor. Nor should I forget an old friend, Simon Winder, in London, who is the British publisher for the book.

But most important of all was the careful reading by Mark Feeney, an old friend and a brilliant man, who made a masterful show of barely noticing my vulgarity, lack of education, and aging memory while gently correcting those very things.

In the film business, more or less, I have to thank the company of several people over the decades: Tom Luddy, most of all; three Selznicks—Irene, Jeffrey, and Danny; Joseph Losey, who allowed me to watch some of *The Servant* being shot; Nicholas Ray, who once let me think I was feeding him scrambled eggs; Peter Bogdanovich, Bob Rafelson, Stephen Frears, David Hare, Paul Schrader, Michael Powell, Thelma Schoonmaker, Martin Scorsese, Harry and Mary Jane Ufland, Bertrand Tavernier, Francis Ford Coppola, Walter Murch, Jim Toback, Robert Towne, Tom Sternberg, Saul Zaentz, Anthony Minghella, Michael Fitzgerald, and Philip Kaufman.

As a freelance writer, I depend on the kindness of editors, and so I thank all of the

following for encouragement, ideas, and assignments: above all, Leon Wieseltier at *The New Republic*; Patrick McGilligan; Tim de Lisle, Laurence Earle, and Jenny Turner—all at *The Independent on Sunday*; Michael Hann and Andrew Pulver at *The Guardian*; Scott Foundas, Ann Kolson, Alex Bilmes, Nick James, Geoff Andrew, John McMurtrie, Steve Erickson, Greil Marcus, Andy Olson, Virginia Campbell, Vendela Vida, and Robert Silvers.

Then there are friends, some of whom know a lot about film, while some are happily unconcerned about it, and none the worse for that: Doug McGrath, Pierre Rissient, Kris Samuels (at Stanford), Edith Kramer, Susan Oxtoby, Judy Bloch and Steve Seid (at the Pacific Film Archive), Meredith Brody, Gary Meyer, Julie Huntzinger, Terry Gelenter, Michael Fox, Ken Connor, Antonia Quirke, Laura Morris, Jamie and Philip Bowles, Bill and Lili Holodnak, Ann Binney, Holly Goldberg Sloan and Gary Rosen, Michael Ondaatje and Linda Spalding, Susan Kakides, Leslee Dart, Geoff Pevere, Hank Lauricella and Mary Pickering, Rainer Rother, and Gerhard Midding. At the San Francisco Film Festival I have benefited from Peter Scarlett, Graham Leggat, and Bingham Ray, the last two dead in less than a year when far too young. In the same city, I am a grateful regular of Le Video, at Ninth and Irving, a stronghold staffed by wonderfully knowledgeable people. Michael Barker is not just a friend and a man who sees many films, he also distributes some of the best. Friendship with Richard and Mary Corliss, Andrew Sarris and Molly Haskell, and Richard Jameson and Kathleen Murphy has been full of insight. I value them all enormously. I also need to thank Darcy Hettrich and the whole operation of Turner Classic Movies.

Many of the themes in this book were developed in a radio series I wrote for the BBC called *Life at 24 Frames a Second*, which played in 2011. I am especially grateful to the two people who helped create that show, Mark Burman and Isabel Lloyd.

There are other friends at other publishers who have taught me so much: Sonny Mehta, Jonathan Segal, Bob Gottlieb, Shelley Wanger, Carol Carson, Katherine Hourigan, and Kathy Zuckerman (all at Knopf), and Will Balliett.

My special thanks go to David W. Packard (to whom the book is dedicated). He is an astonishing multitasker, but one of his passions is the Stanford Theatre in Palo Alto, where beautiful 35 mm prints reign, and another is the preservation of film and the collection of related material and archives. He has been very generous to me personally, though he prefers the word "gentlemanly." I hope this book will encourage him to try more films made after 1960.

Then there is family, the people with whom I have gone to the movies—Anne, Kate, Mathew, and Rachel. More recently, Lucy, Nicholas, and Zachary, who figure in this book in ways that barely hint at how much I love and depend on them.

INDEX

Page numbers in *italics* refer to illustrations.